"Ambitious, tireless, hounded by doubt and despair, and ultimately triumphant, Audubon is as complex and fascinating a figure as a biographer could hope to encounter, and with *John James Audubon*, Rhodes offers a superb biography that shares its subject's abiding interest in precise and complete representation." —*The Boston Globe*

"Splendid. . . . Rhodes presents something more than a scrupulously researched portrait of a self-actualized genius: Through an understanding of the life and times of this flawed but likeable character, we can trace the beginnings of our own complex national identity." —*Entertainment Weekly*

"Rhodes constructs a sympathetic portrait of Audubon and places him in his historical and cultural context. . . . His book is replete with descriptions of Audubon's observations on birds and offers a detailed description of avian life." —*American Scientist*

"An evocative account not only of the birds Audubon drew so vividly but of his usually ill-fated business ventures, his many friendships and, above all, his intensely emotional, often volatile, relationship with his wife." —*Chicago Tribune*

"Masterful. . . . A lively, interpretive tour through the personality, travels, business ventures, accomplishments and foibles of an extraordinary man." —*Nature*

"Rhodes makes a compelling case that Audubon is worthy of the attention as a groundbreaking artist of nature, one of the great self-made Americans of all time." —*The Oregonian*

"Engrossing, gracefully written, and handsomely illustrated." —*Newsday*

"Audubon's colorful life story has been told from many perspectives, but Richard Rhodes, a skilled researcher and historian, proves there is still fresh ground to be worked. He illuminates the American frontier of the early 1800s with a deft use of precise details." —*Houston Chronicle*

"Deeply felt—truly absorbing because of its author's immersion in the subject." —*The Atlanta Journal-Constitution*

"Rhodes' style is crisp and unembellished; the many dramatic events of Audubon's life and his own words propel the reader at a lively clip." —*Audubon* magazine

P9-CIV-799

ALSO BY RICHARD RHODES

Masters of Death

Why They Kill

Visions of Technology

Deadly Feasts

Trying to Get Some Dignity (with Ginger Rhodes)

Dark Sun

How to Write

Nuclear Renewal

Making Love

A Hole in the World

Farm

The Making of the Atomic Bomb

Looking for America

Sons of Earth

The Last Safari

Holy Secrets

The Ungodly

The Ozarks

The Inland Ground

RICHARD RHODES

JOHN JAMES AUDUBON
THE MAKING OF AN AMERICAN

Richard Rhodes is the author of twenty books,
including novels and works of history, journalism,
and letters. His *The Making of the Atomic Bomb*
won a Pulitzer Prize for General Nonfiction, a
National Book Award, and a National Book Critics
Circle Award. *Dark Sun*, about the development of
the hydrogen bomb, was one of three finalists for a
Pulitzer Prize in History. A Kansas native, he has
frequently explored American history and biogra-
phy in articles for national magazines. He lives in
Half Moon Bay, California.

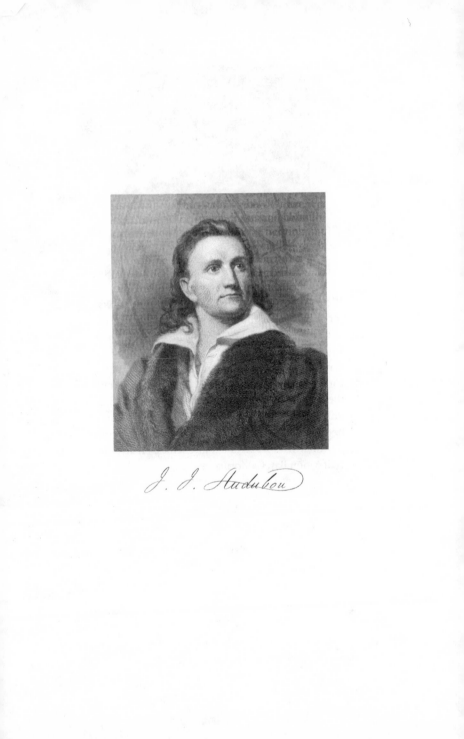

J. J. Audubon

JOHN JAMES

AUDUBON

The

Making of an American

RICHARD RHODES

VINTAGE BOOKS
A Division of Random House, Inc.
New York

FIRST VINTAGE BOOKS EDITION, APRIL 2006

Copyright © 2004 by Richard Rhodes

Grateful acknowledgment is made to the University of Oklahoma Press for permission to
reprint excerpts from *Audubon in the West* by John Francis McDermott. Copyright © 1965 by
University of Oklahoma Press. Reprinted by permission of the University of Oklahoma Press.

The Library of Congress has cataloged the Knopf edition as follows:
Rhodes, Richard.
Audubon : the making of an American / Richard Rhodes.—1st ed.
 p. cm.
Includes bibliographical references (p. 481).
1. Audubon, John James, 1785–1851. 2. Ornithologists—United States—Biography.
3. Animal painters—United States—Biography. I. Title.
QL31.A9R524 2004
598'.092—dc22
2003069489

Vintage ISBN-10: 0-375-71393-X
Vintage ISBN-13: 978-0-375-71393-4

Author photograph © Deborah Brown-Penrose
Book design by M. Kristen Bearse

www.vintagebooks.com

Printed in the United States of America
10 9 8 7 6 5 4 3 2

FOR DON BOARMAN

In the beginning,
all the world was America.

JOHN LOCKE

CONTENTS

Part Three THE BIRDS OF AMERICA

Part One

THE MAKING

OF AN

AMERICAN

One

MIGRATION

THE SHARP CRIES OF GULLS wheeling above the East River docks welcomed the handsome young Frenchman to America. Crossing from Nantes in late summer, he had been a month and a half at sea and he was grateful for the solidity of New York cobblestones. That August 1803 he was four months past his eighteenth birthday, barely fledged, but the United States was hardly older: Lewis and Clark were just preparing to depart for the West. His father owned a plantation called Mill Grove on Perkiomen Creek near its junction with the Schuylkill River northwest of Philadelphia, close above Valley Forge, and that was where he was going. His father was a former sea captain and retired French Navy officer who had commanded a corvette in the final battle of the American Revolution. Jean Audubon had sent his cherished only son to America to escape conscription into the forces Napoleon was mustering for his war with England, joined the previous May.

Wherever the young man went he watched the birds. Birds moved through the human world at will. In their large freedom they lived rich lives in parallel with people and people hardly knew. On his passage from Nantes, at the Grand Banks off Newfoundland where his ancestors had fished for cod, far out at sea, he had scattered ship's biscuit on the deck and drawn migrating brown titlarks (American pipits)* down from the heavens to feed. "They came on board wearied," he would remember and write thirty years later, "and so hungry that the crumbs of biscuit thrown to them were picked up with the greatest activity."

He studied birds for the fables they enacted—he carried La Fontaine's *Fables* with him as a guide—and beyond fable he studied them to learn their habits, the patterns and systems of their lives. Studying birds was how he mastered the world, and himself. Leaving his friends, his father and his country had dis-

*Current names where different appear in parentheses throughout the book.

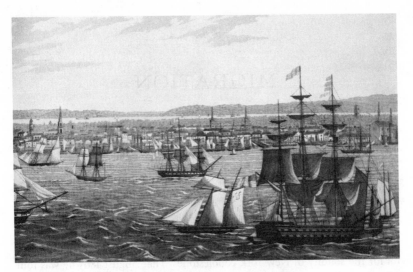

Manhattan from the East River.
Aquatint engraving (detail) after Robert Havell, Jr.

heartened him. The long hours of sailing brought "deep sorrow or melancholy musing. . . . My affections were with those I had left behind, and the world seemed to me a great wilderness." Then the New World rolled across the horizon, a real and physical wilderness beyond its settled rim. He had begun drawing birds in France. Now, "prompted by an innate desire to acquire a thorough knowledge of the birds of this happy country, I formed the resolution, immediately on my landing, to spend, if not all my time in that study, at least all that portion generally called leisure, and to draw each individual of its natural size and coloring." This is retrospect, of course, but it catches the eighteen-year-old's excitement and bravado.

His name—his new name, his name as of the day he had boarded ship—was John James Audubon. In France for the previous ten years he had been Jean-Jacques Fougère Audubon. (Fougère—"fern"—was an offering to placate the Revolutionary authorities, who scorned the names of saints.) From his birth on April 26, 1785, until 1793 he had been Jean Rabin, his father's bastard child, born on Jean Audubon's lost Caribbean sugar plantation on Saint Domingue (soon to be renamed Haiti) to a twenty-seven-year-old French chambermaid, Jeanne Rabin, who had died of infection within months of his birth. His father's wife in France, Anne Moynet, a generous older widow whom Jean

Audubon had married long before, had welcomed her husband's natural son to Nantes and raised him as her own, but his stigmatic birth was a secret John James was sworn to hide: in France bastard children were denied inheritance.

To complicate his identity further, he began using the name LaForest, enlarging on Fougère: John James LaForest Audubon.

He was taller than the average of his day, lean and athletic, unself-consciously vain:

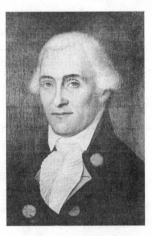

Captain Jean Audubon,
John James's father

> I measured five feet, ten and one half inches, was of fair mien, and quite a handsome figure; large, dark, and rather sunken eyes, light-colored eyebrows, aquiline nose and a fine set of teeth; hair, fine texture and luxuriant, divided and passing down behind each ear in luxuriant ringlets as far as the shoulders.

Five feet nine is nearer the truth—taller than his father, who was five feet five. His hair was chestnut, his beak of a nose certifiably French. But without question women found him handsome. "He is the handsomest boy in Nantes," his adoptive mother had written her husband once, "but perhaps not the most studious."

He could sing, dance, play the flute, the violin and the recorder-like flageolet, fence, hunt, shoot and ride and draw. He was volatile, excitable and vivacious. Young as he was, people already liked to be around him—men and women both.

Before he could learn American birds he had to learn English. His father had asked the captain of his ship of passage, John Smith, to watch over him. Leaving the ship to cash the letter of credit his father had given him, striding along Greenwich Street above the Battery, John James was staggered by the first symptoms of a life-threatening fever. He remembered it as yellow fever, and it may have been; the jaundicing and frequently deadly infection was a common summer scourge. In 1793 an epidemic that refugees had carried from Saint Domingue had killed nearly five thousand people in Philadelphia, and it had struck again that summer of 1803 in New York as well. Audubon's illness made

Smith's mission imperative. The captain saw his charge delivered to a board-inghouse outside Philadelphia operated by two good Quaker women and left him in their care. Nursing him back to health, the women taught him Quaker English. He thee'd and thou'd his intimates ever after.

WHEN JOHN JAMES'S NURSES thought he was well enough to travel, they sent word to his father's agent in Philadelphia, and soon a prosperous Quaker lawyer carriaged to their boardinghouse to fetch the young man away. Miers Fisher had negotiated the purchase of Mill Grove for Jean Audubon in 1789. Twenty-three hundred English pounds in gold and silver—roughly $200,000 today—bought 284 acres of fair Pennsylvania farmland and woods with a two-story dormered fieldstone mansion set high on a steep lawn, stone barns and outbuildings and working water-powered flour and sawmills down the lawn beside the broad Perkiomen. The property was meant to be an investment. Jean Audubon had begun his maritime career at twelve as a cabin boy on his father's merchant ship out of Les Sables-d'Olonne downriver from Nantes on the west coast of France below the Loire. He had advanced to apprentice sailor and eventually captained ships of his own, fishing on the Grand Banks and hauling cargo. Many profitable voyages later, he had acquired a sugar plantation and refinery on Saint Domingue, France's most prosperous colony, where sugar and indigo worked by half a million African slaves supplied two-thirds of pre-Revolutionary France's overseas trade. But slave uprisings in Guadeloupe and Martinique and the first stirrings of revolution in France and on Saint Domingue itself had alerted the shrewd *négociant* to potential disaster. The funds he used to buy Mill Grove came from the hasty sale of a portion of his Les Cayes plantation. Two years later, back in Nantes and an officer in the Republi-can Guard, he arranged to have his only son and the boy's younger half-sister, Rose, the daughter of a second, quadroon mistress, delivered to him from Saint Domingue. The ship entered the Loire in June 1791 with Rose listed on the manifest as Jeanne Rabin's daughter, obscuring her mixed race; the revolution that eventually established the Republic of Haiti engulfed the island in August.

At Miers Fisher's country house northwest of Philadelphia young Audubon improved his English further, but by Quaker standards his recreations were shocking. Fisher "was opposed to music of all descriptions," he complains, "as well as to dancing, could not bear me to carry a gun, or fishing-rod, and, indeed, condemned most of my amusements." Fisher had impressionable daughters and adolescent sons. As soon as he could decently do so, he delivered his client's wayward heir on to Mill Grove to board with its less observant

Quaker tenant William Thomas and Thomas's wife and several sons. John James counted Fisher's departure "a true deliverance" but at least in recollection honored him: "This was only because our tastes and educations were so different, for he certainly was a good and learned man." Fisher arranged for Thomas to pay John James a quarterly allowance subtracted from his $400 annual lease, and the young man settled in.

Mill Grove delighted him. "Hunting, fishing, drawing, and music occupied my every moment; cares I knew not, and cared naught about them." But since his father had by then lost most of his wealth in the revolutions of France and Saint Domingue, what would be the young man's occupation? Jean Audubon had expectations of Mill Grove. The property was known for its mineral deposits, particularly lead. Lead, with its low melting point and high density, was a valuable commodity at a time when hunting with muzzle-loading flint-locks was nearly universal, Quaker lawyers excepted. Hunters ramrodded their weapons with powder, paper and ball each time they fired and routinely carried lead and bullet molds to make their own balls.

In April 1802 Miers Fisher had alerted his Nantes client to his property's promise:

> [At] about the expiration of the [first] five years' [lease], or probably before, [William Thomas] discovered what he thought a very rich lead mine on the premises & communicated the discovery to me, at the same time producing a sample of the ore. Upon inquiry I found that he thought it to exist there in very great quantities & seemed desirous to purchase the land; I told him I had no authority to sell it . . . but promised to inform thee thereof. . . . In this expectation I have kept him on the place ever since & he has paid his rent with more punctuality than is usual with tenants here. . . . He is the only person who knows where the mine is to be found, & will not disclose it until he has some benefit allotted to him for his discovery. . . . He has a very high opinion of it—I have had a sample of it assayed & am assured it will yield about 60 or 70 percent of lead from the 100 lb. of ore. . . . Therefore come in person or employ a confidential friend to judge for thee in this important affair—it may be sufficient to restore all thy losses.

Letters traveled slowly and uncertainly in the age of sail, and another year passed before Jean Audubon could send someone to represent him, a young Frenchman supposed to be knowledgeable about ores and mining. Francis Dacosta had arrived in Philadelphia in the spring of 1803, a few months before John James, carrying Jean Audubon's power of attorney. He was authorized to

sell Thomas the Mill Grove acreage that lay across the Perkiomen from the main house in exchange for the location of the lead vein, but Miers Fisher thought such a move unwise—what if the Perkiomen bottomland covered even more valuable veins of ore?—so Dacosta pried the location of the vein from Thomas by paying $300 of his $400 annual lease that May and promising more. Corresponding with Dacosta about these first negotiations, Jean Audubon revealed his parental program: "Remember, my dear sir, I expect that if your plan succeeds, my son will find a place in the works which will enable him to provide for himself, in order to spare me from expenses that I can only with difficulty support." Dacosta had taken rooms in Philadelphia that fall to wait out the winter before opening up the mine, which meant John James could continue carefree at Mill Grove at least until spring.

To cut a proper figure a young man needed a horse. Thomas had none to spare. An English family had bought the larger plantation up the hill to the south and across the road and was just moving in; John James might inquire there. On November 11 he did and met William Bakewell, the patriarch, a sturdy, educated squire from Derbyshire by way of New Haven, Connecticut, where he and his brother Benjamin had owned and operated an ale brewery until it burned down the previous winter. The Bakewells had arrived only two days before; William turned John James over to his guest, General Andrew Porter of nearby Norristown, and went about his business.

William Bakewell was a blunt and skeptical man, a Unitarian connected to Joseph Priestley, the experimental chemist, discoverer of oxygen and ammonia and religious reformer who had emigrated to America in 1794 and founded a colony near Northumberland, Pennsylvania, where William had also bought land. ("A feather-bed to catch a falling Christian," the Bakewell family physician, Erasmus Darwin, had jokingly called Unitarianism, but dissent was dangerous business—mobs burned down Priestley's house and other dissenting leaders found themselves transported among common criminals to Botany Bay.) William had seriously considered buying a farm in the Shenandoah Valley before Porter pointed him to the Greek Revival mansion with its lush estate and wide view of Valley Forge southward across the Schuylkill. He chose it for its fertility and accepted its odd name, Fatland Ford. "It is not improbable," he wrote a Derbyshire cousin, "that the name of the ford [on the Schuylkill below the mansion] was taken (tho' rather vulgarly expressed) from the quality of the land as it is very fertile indeed."

John James pursued his horse buying. William Bakewell returned his call and found him away but left his card and an invitation to go hunting. Audubon may have been away—he claimed he was out looking for birds—but

he had a chip on his shoulder about the English, who had twice jailed his father as a prisoner of war in his maritime years. His father had dismissed the boy's prejudice magisterially, telling him "thy blood will cool in time. . . . Thou has not been in England; I have, and it is a fine country." The young man's blood cooled early in the new year 1804 when he encountered William Bakewell and his pointers pursuing grouse in the snow-silenced woods along the Perkiomen. "I was struck with the kind politeness of his manner, and found him an expert marksman. Entering into conversation, I admired the beauty of his well-trained dogs, and, apologizing for my discourtesy, finally promised to call upon him and his family." Mrs. Thomas had been encouraging him as well, coaching her boarder that the Bakewells had attractive and interesting daughters.

Audubon called at the Doric-columned, pedimented two-story mansion house just after the middle of January 1804:

> It happened that [William Bakewell] was absent from home, and I was shown into a parlor where only one young lady was snugly seated at her work by the fire. She rose on my entrance, offered me a seat, and assured me of the gratification her father would feel on his return, which, she added, would be in a few moments, as she would dispatch a servant for him. Other ruddy cheeks and bright eyes made their transient appearance, but, like spirits gay, soon vanished from my sight; and there I sat, my gaze riveted, as it were, on the young girl before me, who, half working, half talking, essayed to make the time pleasant for me. Oh! may God bless her!

This vision was Lucy Green Bakewell, the Bakewells' firstborn child and oldest daughter, named after her mother, two days away from turning seventeen. She was tall, slim, graceful, poised, modest and lovely to look at, with a turned-up English nose and smoky gray eyes— in the recent estimate of one of her cousins, "a fine lively girl." She was also, as Audubon would discover, intelligent, loyal, well read, musical, meticulous, a good horsewoman and an athletic swimmer.

Her father came in from his chores and introduced the rest of the family: Lucy's brother

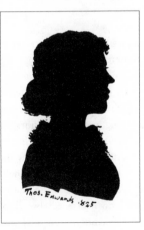

*Lucy Bakewell
in an 1825 silhouette*

Thomas, one year younger than she and about to leave for New York to work for his Uncle Benjamin in the import-export business; her little brother William, who was four; her adolescent sisters Eliza, Sarah and Ann. Mrs. Bakewell was ill and did not appear. Mr. Bakewell asked Lucy to organize lunch, and a dazzled young man watched her go: "She now arose from her seat a second time, and her form, to which I had previously paid but partial attention, showed both grace and beauty; and my heart followed every one of her steps." By the end of the luncheon, as the men prepared to hunt, Audubon had reason to believe that she had noticed him as well and liked what she saw.

Lunch begat a return invitation to dinner at Mill Grove. The frozen Perkiomen was swept for skating. Mrs. Thomas set her sons to trap pheasants and quail, and the whole Bakewell family sat to dinner. Afterward, John James remembered, "we all repaired to the ice on the creek, and there in comfortable sledges, each fair one was propelled by an ardent skater." Lucy's ardent skater was Mr. Audubon. "Tales of love may be extremely stupid to the majority," he defended his memories, "but to me . . . every moment was . . . one of delight."

Miss Bakewell and Mr. Audubon began to see each other. She improved his English; he taught her French. They made music together, singing, playing the piano and the violin. They read books to each other. They walked their adjoining woods and went riding. They exchanged childhoods, hers in Derbyshire, his along the Loire. They discovered their common love of country life and distaste for cities. The one reserved but steadfast, the other flamboyant and bold, both gifted at friendship, they began to fall in love.

AUDUBON IN REMINISCENCE preferred to Byronize his youth to the point of parody:

> I was what in plain terms may be called extremely extravagant. I had no vices, it is true, neither had I any high aims. I was ever fond of shooting, fishing, and riding on horseback; the raising of fowls of every sort was one of my hobbies, and to reach the maximum of my desires in those different things filled every one of my thoughts. I was ridiculously fond of dress. To have seen me going shooting in black satin smallclothes, or breeches, with silk stockings, and the finest ruffled shirt Philadelphia could afford, was, as I now realize, an absurd spectacle, but it was one of my many foibles, and I shall not conceal it. I purchased the best horses in the country, and rode well, and felt proud of it; my guns and fishing-tackle were equally good, always expensive and richly ornamented, often with silver. . . .

I was extremely fond of music, dancing, and drawing. . . . I was, like most young men, filled with the love of amusement, and not a ball, a skating-match, a house or riding party took place without me. Withal, and fortunately for me, I was not addicted to gambling; cards I disliked, and I had no other evil practices. I was, besides, temperate to an *intemperate* degree. I lived . . . on milk, fruits, and vegetables, with the addition of game and fish at times, but never had I swallowed a single glass of wine or spirits until the day of my wedding. . . . All this time I was as fair and as rosy as a girl, though as strong, indeed stronger than, most young men, and active as a buck.

Extravagant he may have been, although where the money came from for all this supposed silk and silver and horseflesh is not clear—he was ever prone to exaggeration. But if extravagant, John James was also generous, opening his home to young French-speaking friends, one of whom pursued Lucy so ardently that her father finally had to warn him off. He helped with the spring plowing and planting at Fatland Ford. His real work even then, however precocious it may seem, was his committed investigation of the natural world around him in Pennsylvania, focused on observing, collecting, mounting and drawing birds.

He said he had a particular goal in mind from the beginning. He wanted to make art of bird illustration: to bring the birds he drew back to animated life, "to complete a collection not only valuable to the scientific class, but pleasing to every person." Standard ornithologies, such as they were, depicted stuffed specimens in profile, accurate in fine detail but unrealistic and lifeless. At the beginning of the nineteenth century, hardly any American birds had been described. "The first collection of drawings I made of this sort were from European specimens, procured by my father or myself. . . . They were all represented *strictly ornithologically*, which means neither more or less than in stiff unmeaning profiles." In America, at Mill Grove, he began to experiment.

To draw birds in Audubon's day, before the invention of photography, it was necessary to shoot them. Ornithologists relied on professional hunters for their fieldwork. They could do so because wild birds were hunted in quantity for market then, just as fish are hooked and netted today, on the assumption that their supply was inexhaustible. Not only game birds but also songbirds were collected by the dozens and hundreds and sold for food. To supply ornithologists the hunters skinned their catch, stuffed the skins with frayed rope and sent the dried, stuffed skins along to be measured and drawn. Audubon had prepared his earlier specimens this way. At Mill Grove, however, he experimented both with sketching in the field and with arranging his freshly

killed subjects unstuffed. "I betook myself to the drawing of specimen[s] hung to a string by one foot," he ridiculed one early attempt, "with the desire to shew their every portion as the wings lay loosely spread as well as the tail—in this manner I made some pretty fair signboards for poulterers!"

His favorite field excursion—he called such excursions rambles—took him along the ledge of rocky bluff above the southern bank of the Perkiomen. He and Lucy regularly walked there together. From the bluff he could observe kingfishers perched above the creek. Often fish hawks (osprey) appeared, and sometimes even a white-headed eagle (bald eagle). On one of his early Perkiomen rambles he found a cave that he began using as a solitary study, retreating under its arched entrance with paper and pencils and sometimes with a book such as Maria Edgeworth's educational *Tales* or La Fontaine's *Fables*. (Edgeworth, the daughter of one of Erasmus Darwin's closest friends, was another connection with Lucy.) That winter John James had noticed a clean but empty nest attached above the entrance of the cave "as if the absent owner intended to revisit it." Early in April 1804, when "the buds were already much swelled, and some of the trees were ornamented with blossoms, yet the ground was still partially covered with snow, and the air retained the piercing chill of winter," he discovered to his delight that a pair of pewee flycatchers (Eastern phoebes) had arrived and occupied the nest.

"I concluded that they must have just come, for they seemed fatigued. . . . Insects were yet few, and the return of the birds looked to me as prompted more by their affection to the place, than by any other motive." He began visiting the black-billed, dusky-olive pair every day until they grew comfortable with his presence. He watched them patch and reline their mud nest, "render[ing] it warm by adding a few large soft feathers of the common goose, which they found strewn along the edge of the water in the creek."

On a later visit the female remained on the nest while the male flew in and out of the cave bringing her insects, and that afternoon when they both flew off Audubon found the first egg. In six days he counted six eggs, the female spending less and less time in the nest after each laying, keeping the eggs laid earlier cool as if to deliberately retard their development until the whole batch was assembled, after which she settled down to brood. Audubon was both excited and frustrated:

> One day whilst watching the habits of [the pewees] I looked so intently on their innocent attitudes that a thought struck my mind like a flash of light, that nothing after all could ever answer my enthusiastic desires to represent nature, than to attempt to copy her in her own way, alive and moving! Then,

on I went with forming hundreds of outlines of my favorites, the pewees—
how good or bad I cannot tell, but I fancied I had mounted a step on the
high mount before me. I continued for months together in simply outlining
birds as I observed them either alighted or on wing but could finish none of
my sketches.

Lucy joined him on his visits to the pewee cave. Her father, wary of
romance, had already cautioned her about spending so much time with the
young Frenchman. He judged Audubon's family prosperous—Mill Grove, he
wrote a relative, was "about the value of [Fatland Ford], the land & house not
equal but it has a flour mill & a sawmill on it"—but thought Lucy too young
yet for courting. At corn-planting time a hired hand's warning that the couple
had begun escaping observation in a Perkiomen cave kept him awake at night.
He decided to question William Thomas. The Mill Grove tenant told him
about the pewees and relieved his concern. But the cave visits were more sig-
nificant than Thomas or William Bakewell knew. In that first springtime, only
months after they met, it was in the Perkiomen cave that Lucy first told the
young man she had come to call "LaForest" that she returned his love. He
mixed their feelings with those he ascribed to the pewees in his later descrip-
tion of the birds, writing of their "remarkable and curious twittering . . . while
both sat on the edge of the nest at those meetings. . . . It was the soft, tender
expression, I thought, of the pleasure they both appeared to anticipate of the
future. Their mutual caresses, simple as they might have seemed to another,
and the delicate manner used by the male to please his mate, riveted my eyes on
these birds, and excited sensations which I can never forget."

If Audubon had found his love, he had not yet solved his drawing problem.
When sketching from life refused to work for him, he tried suspending his
freshly killed bird specimens like puppets. "By means of threads I raised or
lowered a head, wing, or a tail and by fastening the threads securely I had
something like life before me, yet much was wanting—when I saw the living
bird I felt the blood rise in my temples and almost in despair spent a month
without drawing, but in deep thought."

Puppetry led him next to the idea of constructing a manikin, a sort of Uni-
versal Bird. During his limited course of formal art training in France, which
had not progressed as far as life studies, he had worked from manikins as well
as from Classical sculpture. Thinking about manikins, he "cogitated how far a
manikin of a bird would answer for all of them? I labored in wood, cork and
wires, and formed a grotesque figure which I cannot describe in any other
terms than by telling you that when sat up it was a very tolerable looking

'Dodo'! A friend present laughed heartily and raised my blood by assuring me that as far as [I] might wish to represent a tame gander or bird of that sort my model would do. I gave it a kick, demolished it to atoms, walked off and thought again."

The "friend present" was a visitor from Nantes, Ferdinand Rozier, the son of one of Jean Audubon's closest friends among the Nantes maritime bourgeoisie. Rozier was a shrewd, stocky, thoroughly French twenty-seven-year-old who spoke little English, an experienced sailor who had already rounded the Horn of Africa and traveled as far into the Indian Ocean as Mauritius (where the dodo had been harried to extinction more than a century before). Lucy thought Rozier crude when she met him after being away for a month in New Haven visiting her aunt Sarah Atterbury, whence her father had banished her to retard her courtship. When she returned the rye was ready to cut, hot work from which the young people cooled themselves at the end of the day swimming in the Perkiomen millpond.

Francis Dacosta opened up the Mill Grove lead mine that summer. Audubon almost certainly lent a hand. A newspaper report called the mine Dacosta's "property," which was not yet true. "The vein proves to be a regular one," the report continued breathlessly, ". . . its thickness from one foot to 15 inches. . . . Two tons of that beautiful ore were raised in a few hours, and one ton more at least was left in the bottom of the pit, which is yet but nine feet deep. From the situation of this mine, its nearness to navigation and market, its very commanding height, its richness in metal, and the large scale it forms on; it is thought by judges to be one of the first discoveries yet made in the U.S." The ore assayed 85 percent lead oxide, each 100 ounces of which carried 2½ ounces of fine silver worth $3. Dacosta evidently believed in the mine. In December he signed a mortgage for 31,000 francs, $6,200, for a one-half interest in Mill Grove, which on paper at least represented a 30 percent profit for Jean Audubon.

John James dreamed the solution to his bird-animation problem. "Long before day, one morning, I leaped out of bed fully persuaded that I had obtained my object." He ordered up a horse, refused to say where he was going and rode off at a hard gallop toward Norristown, five miles away. Not surprisingly, since it was still dark, the town was not yet awake, so Audubon rode on down to the Schuylkill and took a morning bath. Back in Norristown a little later he entered the first shop he found open, bought lengths of wire of several different gauges and galloped back to Mill Grove. Mrs. Thomas thought he was crazy when he rejected breakfast and called for his gun:

Off to the creek and down with the first kingfisher I met! I picked the bird up and carried it home by the bill, I sent for the miller and made him fetch me a piece of soft board—when he returned he found me filing into sharp points pieces of my wire, and proud to show him the substance of my discovery, for a discovery I had now in my brains, I pierced the body of the fishing bird and fixed it on the board—another wire passed above his upper mandible was made to hold the head in a pretty fair attitude, smaller skewers fixed the feet according to my notions, and even common pins came to my assistance in the placing [of] the legs and feet. The last wire proved a delightful elevator to the bird's tail and at last there stood before me the real manikin of a kingfisher!

Too excited to be hungry, Audubon sat down then and there and drew the bird's now animated and three-dimensional outline, using a drawing compass to match the outline to the dimensions of the specimen. "My honest miller stood by me the while and was delighted to see me pleased. Reader, this was what I shall ever call my first attempt at drawing actually from nature, for then even the eye of the kingfisher was as if full of life before me whenever I pressed its lids aside with a finger." Sharpened wires embedded in a board onto which he could impale his fresh specimens in life-like attitudes set up his subjects in a context his previous art training had made familiar. It was a simple system that he could rig from easily available materials wherever he might go in search of birds, and by scribing a grid into the board he could use its parallax to work out the foreshortening that transferring life-like attitudes from three dimensions to two would require.

(The arrangement of Audubon's mounting board has been something of a mystery to art historians. A young assistant who saw one many years later and described it in a letter resolves the mystery: "Now, the dear man had his chalks upon the table and upright in front of him was a pine board upon which was secured in position by means of long thin pins, the bird whose likeness he was transferring to the cardboard before him." That is: the grid board was set on edge, with the wires pointing toward the artist, and the specimen was impaled on the wires. This arrangement put the grid behind the specimen and made the bird seem to float in space in whatever position Audubon decided to arrange it.)

To cap that fundamental summer, nineteen-year-old John James Audubon asked for the hand of seventeen-year-old Lucy Green Bakewell. William Bakewell liked his young French neighbor and thought him suitable, but found a

way to delay. "A Mr. Audubon," he wrote an English cousin, "a young man from France whose father owns a farm next to mine, has solicited Lucy's hand, but as I made it a point that his father should be informed first, the business was deferred (indeed they are both young enough) till he hears from France." Lucy's mother also liked her daughter's suitor and was happy that her firstborn daughter might settle near her. John James immediately wrote his father, who immediately wrote Dacosta:

> My son speaks to me about his marriage. If you would have the kindness to inform me about his intended, as well as about her parents, their manners, their conduct, their means, and why they are in that country, whether it was in consequence of misfortune that they left Europe, you will be doing me a signal service, and I beg you, moreover, to oppose this marriage until I may give my consent to it. Tell these good people that my son is not at all rich, and that I can give him nothing if he marries in this condition.

Dacosta disliked his patron's son. He thought John James put on airs—by claiming, for example, that he owned Mill Grove. If so, the sin was one that Dacosta had also committed in the matter of the mine. When he confronted the younger man the two squared off. Audubon, reminiscing later for his sons, says Dacosta "took it into his head that my affection for your mother was rash and inconsiderate. He spoke triflingly of her and of her parents, and one day said to me that for a man of my rank and expectations to marry Lucy Bakewell was out of the question." Given Dacosta's instructions from Audubon's father and his awareness of the retired French officer's financial reverses, it seems likely Dacosta meant that the Bakewells were above the Audubons, not the other way around. Whatever he meant, John James understandably took umbrage. "If I laughed at him or not I cannot tell you, but of this I am certain, that my answers to his talks on this subject so exasperated him that he immediately afterward curtailed my usual income . . . and wrote to my father accordingly."

Then tragedy intervened to delay a further resolution: on September 30, after ten days of severe dysentery, Lucy's mother died. A relative considered it "a great loss to her family, but for herself a happy release; for I have always understood she was greatly averse to going to America." Lucy disagreed; she thought her mother had almost begun to like Pennsylvania and Fatland Ford, if "not quite as well as New Haven." Some of the Bakewell neighbors avoided the funeral for fear of contagion, but Audubon and Rozier attended. William had an octagonal burial ground marked out along the border of one of his

fields. He discounted contagion from his wife's fatal illness, since he and Lucy had nursed her without becoming infected. He had sent for a physician, who had bled her and prescribed medications. On the Sunday before her attack they had taken a ride to a neighbor's "where she eat a great number of peaches, some not ripe"; he thought the peaches might have contributed to her "fatal catastrophe."

After the funeral came grief, William wrote his Derbyshire cousin, Euphemia Gifford:

> For the first week we were capable of scarcely anything but walking to & from the grave. Afterwards I had to attend to my wheat sowing & to the erection of a [building]. Such occupations and the necessity there was of arousing myself to fulfill the duties I owed to my children are on these occasions of great service. . . .
>
> On Sunday I took little William on a walk to the grave, & asked him who was laid there? He said "my Mamma" but on seeing some hickory nuts lying near, he picked them [up] & began to crack them as if nothing had happened. In such young minds the impression is soon effaced. . . .
>
> Lucy naturally looks forward & probably like many young persons expects a state of complete happiness with her intended. He is much disappointed with having not received any letter from his father whose approbation I made it a point of his attaining.

With younger brothers and sisters to organize and servants to direct, Lucy was needed at home. Audubon waited impatiently to hear from his father. William Thomas encouraged his belief that Dacosta was scheming to defraud them all. Audubon might have returned to France that autumn to expose Dacosta's perfidy and obtain his father's permission to marry the graceful young woman he loved, but the reason Jean Audubon had sent him abroad— to avoid conscription—still applied, and despite his Byronic airs John James was a loving and dutiful son. Then an almost fatal accident was succeeded by a crisis of infection, and the two near-death experiences changed his mind.

"I SHALL SAIL ON A SHEEP"

AUDUBON'S ACCIDENT OCCURRED at the end of a day of duck hunting on the frozen Perkiomen, the hunters on ice skates, bundled against the cold and armed with flintlock shotguns and light, long-barreled fowling pieces. Besides Audubon, always an instigator and a leader, the party included Lucy's younger brother Tom and several of their friends. As they skated home at dusk laden with ducks, later than they probably intended, Audubon tied his handkerchief to a stick for a guidon to lead the way:

> We were skating swiftly along when darkness came on, and now our speed was increased. Unconsciously I happened to draw so very near a large air-hole that to check my headway became quite impossible, and down it I went, and soon felt the power of a most chilling bath. My senses must, for aught I know, have left me for awhile; be this as it may, I must have glided with the stream some thirty or forty yards, when, as God would have it, up I popped at another air-hole, and here I did, in some way or other, manage to crawl out. My companions, who in the gloom had seen my form so suddenly disappear, escaped the danger, and were around me when I emerged from the greatest peril I have ever encountered. . . . I was helped to a shirt from one, a pair of dry breeches from another, and completely dressed anew in a few minutes . . . our line of march was continued, with, however, much more circumspection.

Perhaps compounded by this exposure, complications from an abscess laid Audubon low in early December 1804, with fever intensifying to delirium. Lucy had him moved to Fatland Ford, where she could nurse him. It was ten days before his fever broke, by which time he was so weak that when he got up to try to walk he fainted. Lucy made him stay in bed until after Christmas, reading to

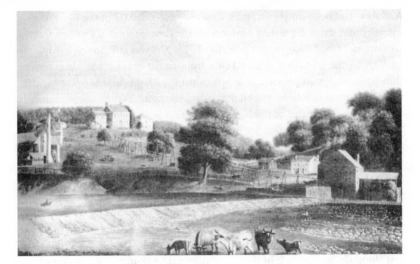

Mill Grove on the Perkiomen.
Oil by Thomas Birch, c. 1830, with lead works at left below house

him to curb his restlessness—he was never a man happy to sit still, except when he was observing birds. As he gained strength he must certainly also have passed the time by drawing. He could only have glimpsed out a window a Christmas Day demonstration of an experimental steam-powered threshing machine in the Fatland Ford barnyard, but he heard about it in detail. Its inventor was a young mechanic and millwright newly arrived from Scotland, David Prentice. In the English Midlands tradition of technological entre-preneurship, Lucy's father William Bakewell had sponsored the thresher's development.

Since her mother's death, Lucy and her father had drawn closer to her young Frenchman, intimacy that his illness in their midst would have enlarged. He would not have told them the circumstances of his birth, but he did tell them about his childhood in France. It was chaotic. France's civil wars had closed most of its schools, the real reason—not his supposed truancy—that his for-mal education was deficient. ("None were good in France at this period," he would write; "the thunders of the Revolution still roared over the land, the Revolutionists covered the earth with the blood of man, woman, and child" and they were "dreadful days.") The guillotine had been installed as the official method of execution in France just two months after six-year-old Jean Rabin arrived at Nantes in 1791 with his four-year-old half-sister Rose. Though Jean

Audubon had been a colonist and a slave owner, he had taken the Revolution's measure and shrewdly joined his lot with the Revolutionists. The Revolution consumed its own. No one was safe after Louis XVI was guillotined late in January 1793—the execution required two drops of the heavy blade—and tens of thousands of loyalist peasants rose up against the Revolutionists in the Vendée, the *département* that bordered Nantes below the Loire. Skeptics were criminals as far as the Committee of Public Safety was concerned. "We must rule by iron those who cannot be ruled by justice," Saint-Just demanded in words that Robespierre endorsed. ". . . You must punish not merely traitors but the indifferent as well."

The Vendéan counterrevolution began in mid-March 1793 when the peasants advanced on Nantes armed with scythes and blunderbusses. The National Guard Blues engaged the ragged peasant army outside the city walls, but the Vendéans fought shrewdly enough that they were not defeated until June. On March 7, only days before the storm broke, "Jean Audubon, commanding the war sloop *Cerberus*, vessel of the Republic, aged forty-nine years, native of Les Sables d'Olonne, department of La Vendée, and Anne Moynet his wife, aged fifty-eight years," just had time to arrange his two natural children's adoption at the Nantes town hall, shielding them with the Audubon name and protecting their inheritance.

Counterrevolution was not the worst of it; the worst was the Terror that descended on Nantes in October in the person of a nightmarish Representative, Jean-Baptiste Carrier, sent out from Paris bent on reprisal. "I ought to warn you," he wrote back to his Committee superiors, "that there are people in the prisons of Nantes arrested as champions of the Vendée. Instead of amusing myself by putting them through the formalities of a trial, I shall send them to their place of residence to have them shot." Deeming shooting and guillotining inefficient, he ordered victims by the hundreds tied together naked in pairs— "Republican marriage," this indignity was called—loaded onto barges, *gabarres*, and the barges sunk mid-river in the Loire. "Sentence of deportation was executed *vertically*," Thomas Carlyle reports Carrier writing with bloodthirsty sarcasm. "Or why waste a gabarre," Carlyle continues, "sinking it with them? Fling them out; fling them out, with their hands tied: pour a continual hail of lead over all the space, till the last struggler of them be sunk! . . . And women were in that gabarre. . . . And young children were thrown in, their mothers vainly pleading: 'Wolflings,' answered the Company of Marat, 'who would grow to be wolves.' " For months thereafter, says Carlyle, "clouds of ravens darken the River; wolves prowl on the shoal-places." The putrefying flesh contaminated the river to such an extent that the health authorities were forced to

ban fishing. "Kill and kill," Carrier was heard to rage, and "butcher children without hesitation."

Carrier hardly distinguished between Revolutionaries and Loyalists; the Audubons were nearly destroyed. "Mr. Audubon," William Bakewell wrote his Derbyshire cousin that winter, ". . . gives us some horrid accounts of the cruelties practiced during the time of that monster Robespierre & his agents Carrier & others in Nantes where his father lives. His parents with himself & sister were imprisoned for a considerable time & made their escape in a very dangerous manner."

Losing his mother in infancy, separated from whoever mothered him afterward on Saint Domingue when he was shipped off to France at six, just months ahead of bloody revolution, enduring dreadful days as a young boy in Nantes when Carrier was emptying the prisons with slaughter and his family feared for its life, was a full burden of trauma for a child. In maturity Audubon would expunge the stigma and the trauma from his family story by relocating his birth to Louisiana and to "a lady of Spanish extraction . . . as beautiful as she was wealthy" when he knew full well that he was the bastard son of the chambermaid Jeanne Rabin. Similarly, an important early memory, which he himself believed to be "one of the curious things which perhaps did lead me in after times to love birds, and to finally study them with pleasure infinite," displaces the violence he experienced as a child onto a cherished bird.

The story Audubon told might as well be one of La Fontaine's fables. He said the incident occurred in Nantes. Saint Domingue is more likely; he called himself an "infant," and would Anne Moynet have kept, as he said, "several beautiful parrots and some monkeys" including "a full-grown male of a very large species" in the cold of maritime France? One morning when he was being served breakfast, a parrot in the room asked for its breakfast as well, "*Du pain au lait pour le perroquet Migonne!*"—"Bread and milk for the parrot Migonne!" Whereupon the big male monkey, which Audubon called a "man of the woods," probably thinking that the parrot was presumptuous, walked "deliberately and uprightly toward the poor bird" and "at once killed it, with unnatural composure. The sensations of my infant heart at this cruel sight were agony to me. I prayed the servant to beat the monkey, but he, who for some reason preferred the monkey to the parrot, refused. I uttered long and piercing cries, my mother rushed into the room, I was tranquillized, the monkey was forever afterward chained, and Migonne buried with all the pomp of a cherished lost one."

Great talents have deep roots. In another reminiscence Audubon traced his attachment to birds back to the time when he had just learned to walk and to

speak. "They soon became my playmates; . . . I felt that an intimacy with them . . . bordering on phrenzy must accompany my steps through life. . . . None but aerial companions suited my fancy. No roof seemed so secure to me as that formed of the dense foliage under which the feathered tribes were seen to resort." His father was his first guide and mentor, taking the boy for walks, picking flowers and catching birds for him, sharing his enthusiasm for them and his years of observation from the decks of ships and the shores and forests of France, North America and the Caribbean. It was his father who first encouraged him to observe them, who "would . . . speak of the departure and return of birds with the seasons, would describe their haunts, and, more wonderful than all, their change of livery; thus exciting me to study them."

With a child's natural avarice he came to wish to possess birds totally. That wish was inevitably frustrated, he wrote, because "the moment a bird was dead, however beautiful it had been when in life, the pleasure arising from the possession of it became blunted." Whatever effort he gave to preservation, "I looked upon its vesture as more than sullied. . . . I wished to possess all the productions of nature, but I wished life with them. This was impossible." What was to be done? "I turned to my father, and made known to him my disappointment and anxiety. He produced a book of *illustrations*. A new life ran in my veins. I turned over the leaves with avidity; and although what I saw was not what I longed for, it gave me a desire to copy nature. To Nature I went, and tried to imitate her."

So a desire literally to revivify the dead lay at the heart of the boy's struggles to learn to draw birds in lifelike attitudes. The metaphors Audubon used to characterize his early attempts at drawing clearly connect them to his experiences of trauma. "My pencil gave birth to a family of cripples," he wrote. "So maimed were most of them that they resembled the mangled corpses on a field of battle compared with the integrity of living men." But the worse his drawings, the more beautiful the originals seemed to him. He understood that his efforts were obsessive: "To have been torn from the study would have been as death to me." Yet he also saw that he had moved as he matured from trauma to creativity: "Although I felt the impossibility of giving life to my productions, I did not abandon the idea of representing nature." He was not the first, nor would he be the last, to turn traumatic childhood experience into adult preoccupation and profession, even into art.

By January he was recovered enough to lace his skates back on and challenge the Perkiomen airholes that had prostrated him. A neighbor, David Pawling, was amazed:

Today I saw the swiftest skater I ever beheld; backwards and forwards he went like the wind, even leaping over large air-holes fifteen or more feet across, and continuing to skate without an instant's delay. I was told he was a young Frenchman, and this evening I met him at a ball, where I found his dancing exceeded his skating; all the ladies wished him as a partner; moreover, a handsomer man I never saw, his eyes alone command attention; his name, Audubon, is strange to me.

There had been time during his illness for John James to think through his situation and decide what to do about it. He probably discussed his choices with Lucy and her father as well. Early in February he rode southeastward on the icy winter roads to Miers Fisher's house outside Philadelphia to inform him of his plans to sail for France. He would return to France to expose Dacosta and convince his father to dismiss the man, "but even more to obtain my father's consent to my marriage with my Lucy." From Fisher's house he rode on to Philadelphia to confront Dacosta himself. "I . . . entered his room quite unexpectedly, and asked him for such an amount of money as would enable me at once to sail for France and there see my father." Dacosta smiled tightly. "Certainly, my dear sir," he responded. The overseer gave Audubon a sealed letter of credit and he returned to Mill Grove.

Lucy understood that his trip was "in consequence of the letters to his father having miscarried" and that he "intend[ed] returning this fall." That he was willing to risk conscription was a measure of his love for her; she must have feared for him. He parted from her sadly on February 28, traveling on horseback in the company of a recent Fatland Ford guest, a young Englishman named Thomas Pears who worked with Tom Bakewell at his Uncle Benjamin's import-export business in New York. Benjamin Bakewell and his family had emigrated to America in 1794, the same year as Joseph Priestley, and then had coaxed his brother William across in 1801. His wife's widowed sister Sarah Palmer had emigrated as well—she assisted Priestley in editing the Unitarian *Theological Repository*—and it was to her New York residence that John James rode: Pears was her daughter's fiancé. The ninety-mile journey through winter snow took the two young men three days. Audubon remembered when he ferried the Hudson River seeing schooners coming in to the New York wharves piled like coal barges with mounds of passenger pigeons caught upriver; in the New York markets the palatable birds sold for a cent apiece.

Dacosta's letter was addressed to his New York banker. John James called on the man the next day. "He read [it], smiled, and after awhile told me he had

nothing to give me, and in plain terms said that instead of a letter of credit, Dacosta—that rascal!—had written and advised him to have me arrested and shipped to Canton." At least Dacosta had advised his banker to refuse funds. It took all of Sarah Palmer's powers of persuasion to convince the young hothead to give up his plan "of returning at once to Philadelphia and there certainly murdering Dacosta."

John James sent word of his dilemma to Fatland Ford, and Lucy persuaded her father to endorse his brother's lending her fiancé $150 to pay for his passage. William Bakewell used the occasion to ask Audubon to locate a quality Spanish jackass in France to ship back to Fatland Ford for stud service breeding mules, hybrid animals produced by crossing a jack with a mare that are superior to their parents in vigor and intelligence. Cooling his heels in New York for another week waiting for a ship bound direct for Nantes, John James enjoyed a round of parties, competed with his future cousins in a friendly bout of painting, paid to watch an elephant perform and joined the Bakewell men on a bucket brigade one cold night fighting an East River warehouse fire.

If he had been able to look over his father's shoulder on March 9, when Jean Audubon was writing Dacosta unaware that his son was about to leave for France, John James would have known he had his work cut out for him. "I am [vexed], Sir," Jean Audubon challenged his difficult Philadelphia partner; "one cannot be more vexed at the fact that you should have reason to complain about the conduct of my son." It was not possible to recall his son to France, as Dacosta had evidently requested; "the reasons which made me send him out still remain," and in any case "only an instant is needed to make him change from bad to good; his extreme youth and petulance are his only faults, and . . . he can be of great service to you if you use him for your own benefit. . . . This is my only son, my heir, and I am old." But Jean Audubon was not yet prepared to grant his son permission to marry. "When Mr. Miers Fisher shall have shown my letter to the would-be father-in-law, he will see that he is mistaken in his calculation upon the assumed marriage to his daughter, for if it should take place without my consent, all help on my part would cease from that instant; this . . . is what you may say to the would-be father-in-law, that I do not wish my son to marry so young."

John James sailed on Tuesday, March 12, 1805, on the *Hope*, a New Bedford brig with a newly wed captain. The vessel was leaky, and the captain put in at New Bedford for a week of repairs before once again setting sail. Nineteen days out from New Bedford they entered the Loire and anchored at Paimboeuf, the Nantes lower harbor at the Loire estuary 75 kilometers downriver from the town.

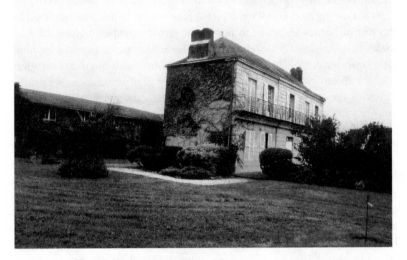

La Gerbetière, the Audubon family house in Couëron, as it appears today

The Audubons owned a two-story limestone villa with a swelled slate roof, La Gerbetière, in the village of Couëron, on the river between Nantes and Paimboeuf. During Audubon's childhood the cool, cream-colored house with a formal garden and an orangery surrounded by a high wall had been the family's summer residence, an easy walk from the extensive forested marshes below Couëron that Cistercian monks had drained in medieval times and where the boy had hunted birds. With Jean Audubon's retirement he, Anne and Rose had moved to La Gerbetière permanently, soon after Dacosta had left for the United States in the spring of 1803. The French customs officer who boarded the *Hope* at Paimboeuf sent John James upriver on his barge to Couëron's Port-Launay landing. By late evening the prodigal son was striding up the familiar grass-covered lane from the landing, along the narrow road between limestone walls on the crest of the rise to the La Gerbetière gate and into the arms of his parents. He had written them of his coming, but the *Hope* had been swifter than the boat carrying the mail; "to them my appearance was sudden and unexpected. Most welcome, however, I was; I found my father hale and hearty, and *chère maman* as fair and good as ever."

The first order of business was setting his father straight about Dacosta, which Audubon says he did immediately. He also says his father gave him permission to marry as soon as he received answers to his letters to William Bakewell, but in fact Jean Audubon expected his son to find a way to support

himself before he took a wife. To avoid conscription—he would be twenty years old on April 26, ripe for military service—John James was instructed to stay out of Nantes and close to home. His father would undertake the purchases that Benjamin Bakewell had asked his niece's fiancé to make for him, John James wrote William Bakewell in May in enthusiastic but ungrammatical English: "Be so good as to assure your brother that we business is fine. . . . I gived it up to my papa he wants that honor I cannot refuse him, for me poor fallow I must [stay at] housse as if I was very ill." France, Audubon explained many years later, when he had mastered English, "was at that time in a great state of convulsion; the republic had, as it were, dwindled into a half-monarchical, half-democratic era. Bonaparte was at the height of success, overflowing the country as the mountain torrent overflows the plains in its course. Levies, or conscriptions, were the order of the day, and . . . my father felt uneasy lest I should be forced to take part in the political strife of those days." He put it more colorfully in his May letter to Lucy's father, alluding to *Don Quixote* in the matter of the jackass and revealing his accented pronunciation phonetically; the letter was pure Audubon in its determination to accomplish its purposes despite impediments:

> I am here in the Snears of the eagle he will plock me a little and then I shall Sail on a Sheep have good wind all the way and as soon a[s] [there is] land under My feet My compagnon of fortune Shall Carry Me Very Swiftly I [as]Sure you [to you]—
> . . . Pray your brother to excuse Me if I do not right to him . . . ; present him if you please the respect of My father and family; Kiss all your[s] for me Without forget[ting] Lucy.*

Amused, William Bakewell sent Audubon's letter on to his Derbyshire cousin Euphemia Gifford, warning her that she "must make it out as you can for I cannot exactly understand it. . . . His 'compagnon of fortune' is an ass of the Spanish kind which I desired him to procure me for breeding mules. I do not understand his snares of the eagle but suppose it is that the government are wishing to put him in requisition for the army."

Confinement to Couëron was confinement to a paradise of birds. John James befriended his family's thirty-five-year-old physician, Charles-Marie d'Orbigny, a French Navy officer and a passionate naturalist who shared with

*Hereafter, the spelling and punctuation of Audubon's journal entries and correspondence will be standardized.

his new protégé a Saint Domingue birth. He lived nearby with his young second wife and young son. "The doctor was a good fisherman, a good hunter, and fond of all objects in nature," Audubon wrote. "Together we searched the woods, the fields, and the banks of the Loire, procuring every bird we could, and I made drawings of every one of them—very bad, to be sure, but still they were of assistance to me."

Bad or good, John James's Couëron bird drawings, done in pastel and pencil, were the best he could manage at the time, largely self-taught as he was; he meant to give the collection to Lucy when he returned to the United States and he worked hard on it. On June 4 he drew a greater redheaded linnet. On June 6 he diverted from birds to draw a fat, furry marmot complete with two pellets of scat dropped behind it like the eggs he sometimes included in his bird drawings; hunters find animals' characteristic feces almost as useful as their prints in tracking them. He titled the drawing *Marmotte de Savoye*. He was always a quick study. In the first fourteen days of July he drew a grosbeak, a nightingale, a nut robber, a *goelette*, a sedge sparrow and a creeper, the last two on the same day, July 13. D'Orbigny taught him to weigh and measure his specimens and introduced him to the ten volumes on birds of the Comte de Buffon's bestselling forty-four-volume *Natural History*, which significantly included field observations, something most contemporary ornithologies lacked.

In August John James and Rose stood up beside Charles and Marie-Anne d'Orbigny as godparents to their newborn second son Gaston-Édouard. Their firstborn, Alcide-Charles, was then a lively toddler, not quite three. Testifying to their father's gifts as a mentor, both sons were destined to become distinguished naturalists, Alcide famously so for his studies in South America, which would rival Charles Darwin's.

Another mentor young Audubon learned from was François René André Dubuisson, an herbalist and mineralist who owned a shop on the Rue Saint Jean in Nantes and may have supplied medicinals to d'Orbigny and pastels to Audubon. Dubuisson would be appointed director of the first museum of natural history in Nantes in 1806 (the museum opened its doors in 1810). In a dispute with the town many years later he claimed to have taught Audubon ornithology.

While his son was out drawing birds, Jean Audubon corresponded with Dacosta to resolve the disputes about the lead mine that divided them. Dacosta had stopped mining to wait for properly signed and notarized partnership papers to come from France. The inevitable vagaries of shipping had delayed them, but the suspicious Dacosta concluded they had never been sent, to compromise his authority. "You are about to appeal to the supreme court to prove

your ownership," Jean Audubon wrote him in exasperation in mid-June; "is there any living being who can contest it? If our deeds, granted in France, have not their full force in [the United States], nothing can annul them for us who are French. You shall do in this matter what you like; the greatest objection is this, that it stops your operations; but who is to blame? It is due to distance, and not to any negligence." Another letter full of complaints arrived from Dacosta a week later. Jean Audubon replied immediately. If Mill Grove needed a new roof, he wrote, "would it not be better for me to send some slate from here? This would perhaps be less expensive, and well nigh everlasting." Dacosta had proposed that the elder Audubon should come to Philadelphia himself. "If such had been my intention," the old sea captain responded dryly, "I should have done it long ago. I am still troubled with an inflammation of the lungs; and one ought not to be ill in a foreign country. . . . You ask me to bring you money. . . . You know better than anyone else what was my position when I sold to you; by that alone you must know how difficult this would be for me." The mine would have to pay for itself, he concluded; "I salute you."

Reviewing his difficulties with Dacosta, the speculative nature of the mine and his son's need to establish himself in business in order to marry, Jean Audubon decided to revise his American arrangements. His son needed a partner who could negotiate with Dacosta without rancor. He turned for counsel to his old colleague and friend Claude François Rozier, the father of John James's Mill Grove visitor Ferdinand Rozier. Within the year Claude Rozier had bought half of Jean Audubon's doubtful remaining share of his Les Cayes plantation to help him raise cash. Their sons were friends; now the two fathers determined to make them partners.

CHANGE WAS COMING TO Fatland Ford as well. When Lucy wrote her Derbyshire cousin Euphemia Gifford at the beginning of September 1805 she revealed that she had not been away from Fatland Ford since her mother died; "indeed I do not know how it is possible for me to be spared." Her cousin had asked about the servants. "The Hollander is improved," Lucy reported, "but the Swiss whom we thought the best is become worse. I have much ado to make her milk the cows clean and I am often obliged to go with her." Udders not carefully stripped clean at the end of each milking soon dry up. "How people forget their former situations; when they came here they were thankful for linsey gowns and now, though my Papa bought each of them a printed cotton, yet nothing would do but a white dimity, and they have each, out of some money

given them, bought one." In 1805 the United States was rich in land but short of labor, a lack that gave servants leverage they had not had in Europe.

The summer had been the hottest since they had moved to Pennsylvania, Lucy went on, "tho' our house is high [and] we catch the breeze if any is stirring." She was reading Anna Seward's new biography of her childhood physician Erasmus Darwin, who had died in 1802. She still expected "Mr. Audubon" to return that autumn, which means she had not yet heard from him. She reminded Euphemia Gifford that she had previously sent her a parcel with a view Audubon had drawn of Fatland Ford and another drawn by her brother Tom; the parcel also included a ring her fiancé had plaited from Lucy's mother's hair. She had saved more of her mother's hair; "when he returns he will make another." With few images available of their loved ones and those drawn or painted, Audubon and his contemporaries found hair to be an intimate, emotionally meaningful keepsake, in absence as well as in death.

Euphemia Gifford must have noticed how self-possessed her eighteen-year-old American second cousin sounded; the responsibilities Lucy had assumed since her mother died had matured her.

A letter from Derbyshire crossed Lucy's in the mail, prompting her to write her cousin again a few days later. Letters were commonly written on single sheets of paper which were then folded up to make their own square envelopes, addressed on the outside and sealed with red or black sealing wax impressed with the writer's personal seal. To add a message to a sheet already filled with text, the letter-writer simply rotated the sheet ninety degrees and wrote crosswise over the previous text, writing that could be read by isolating each line from its confusing background with a ruler. So Lucy's father added a crosswise postscript to her September 7 letter to share with his cousin the verse he had composed for his wife's marble tombstone:

> A lovely form, a mind devoid of art,
> (With all the kind affections of the heart)
> A tender mother, and a faithful wife,
> In duty's varied path she moved through life.
> He who bestows hath right to take away.—
> In humble faith this hope we keep in view:
> The pow'r that form'd us, will our lives renew.

Even for English country gentry, the Bakewells were literate to an unusual degree.

With Lucy Green Bakewell's tombstone settled and the customary year of mourning barely passed, William Bakewell on December 10 took a new wife, thirty-eight-year-old Rebecca Smith, the previously unmarried daughter of a Philadelphia land speculator. She was small and thin—"of a delicate form," Tom Bakewell observed, and "very much liked by us all." When he met her for the first time the following summer, Tom "hardly knew how to call her mamma, nor could I help speaking to her as a stranger," but he felt that she "certainly does all in her power to make us happy (or rather them, for I have only seen her a few days . . .)." William's sister Sarah Atterbury suspected that Euphemia Gifford, with whom all the Bakewells corresponded, "would be surprised to hear my brother William had so soon taken another wife," but she didn't know "how he could possibly do without one with such a large family and only those young girls"—she meant Lucy and her three younger sisters—"to manage it." When Sarah Atterbury visited Fatland Ford to meet Rebecca, she was "much pleased with our new sister and think her in every way calculated to make them all comfortable." She thought little William, who had cracked hickory nuts in distraction at his mother's grave, was "as fond of her as he was of his own mama." Lucy wrote more guardedly that "my Papa has in our present Mamma supplied the place of our former one as well as we could wish."

IN THE MAYOR'S OFFICE IN COUËRON in December 1805, six days after William Bakewell married Rebecca Smith at Fatland Ford, the Bishop of Nantes united Rose Audubon, John James's eighteen-year-old half-sister, to thirty-five-year-old Gabriel-Loyen du Puigaudeau, a prosperous rentier and family friend whose brother Joseph had served in the French Navy under Rose's father. John James witnessed the ceremony, as did Ferdinand Rozier. Audubon had known the du Puigaudeaus since at least 1800, when France's wars had forced him to leave school prematurely at fourteen for military training. "I entered the navy and was received [as] a midshipman at Rochefort much against my inclinations." At Rochefort Joseph du Puigaudeau had been his immediate superior. The stubborn fourteen-year-old had rewarded him by trying to run away. He was quickly caught, endured his father's "severe reprimand" but only continued at Rochefort for a year—his intractable seasickness cannot have recommended him to the navy—returning to Nantes with his father when Jean Audubon was pensioned from naval service because of disabilities at fifty-seven in January 1801.

In the weeks after Rose's wedding Audubon had time to draw a wagtail and

a green finch, finishing out a large collection. Then the snares of the eagle tightened around him once again. "I underwent a mockery of an examination," he writes, "and was received as a midshipman in the navy, went to Rochefort, was placed on board a man-of-war and ran a short cruise." When he returned to La Gerbetière, his father quickly used his navy contacts to loosen the snares enough to slip them off.

First Jean Audubon and Claude Rozier helped their two sons draft a partnership agreement, which the young men signed at Nantes on March 23, 1806. It declared that they were "intending to go to the United States. . . . Upon our arrival we will take possession of the farm of Mill Grove, and we will call to account Mr. Dacosta, who has the power of attorney of Mr. Audubon père. We shall take measures to improve the establishment, or make an investigation of the lead mine . . . and before continuing the work already begun we will determine if the expenditures made by Mr. Dacosta have been and can still be advantageous to us." They agreed to split half the profits of Mill Grove's farm production (the other half presumably went to Dacosta), to spend six months investigating possible businesses they might engage in and then "apply ourselves to some commercial occupation, whether inland or maritime," to "make any journey in order to procure information" with an eye out for merchants who might consign goods to Claude Rozier and to divide equally both their profits and their losses. They resolved "to maintain friendship and mutual understanding" and to submit any disagreements to binding arbitration. If one of them died—always a present possibility, even for robust young men, in an age of perilous ocean voyages and epidemic disease—the other would execute his business estate for a commission of 10 percent.

The two fathers next arranged false passports for their sons. "I had a passport stating I was born at New Orleans," Audubon wrote. ". . . Rozier's passport was a Dutch one, though he did not understand a single word in that language." Just before they sailed, Claude Rozier, Anne Moynet and Jean Audubon handed them a power of attorney giving them authority over their parents' American affairs. After wrenching goodbyes—neither son would see his father alive again, nor Audubon his *chère maman* or his sister and brother-in-law— the two partners departed Nantes for New York on Saturday, April 12, on the *Polly*, Captain S. Sammis, having paid the captain 525 livres, $125, the day before. "We were fairly smuggled out of France," Audubon commented, "for [Rozier] was actually an officer attached to the navy."

It seemed that every able-bodied man of military age was trying to get away. At St.-Nazaire "an officer came on board to examine the papers of the many

passengers. On looking at mine he said, 'My dear Mr. Audubon, I wish you joy; would to God that I had such papers; how thankful I should be to leave unhappy France under the same passport.' " Audubon added, "Indeed, our passengers were a motley crowd; two days out, two monks appeared among us from the hold where our captain had concealed them." Two young French noblemen traveling under assumed names to avoid conscription competed on the voyage for the attentions of the attractive young daughter of a traveling U.S. congressman. One of them rescued the girl's bonnet when a line that a sailor dropped knocked it overboard. The other was furious, Audubon wrote, looking "as black as a raven." At dawn the passengers woke to gunfire. "On gaining the deck it was found that a challenge had been given and accepted, a duel had positively taken place, ending, alas! in the death of the rescuer of the bonnet. The young lady felt this deeply, and indeed it rendered us all very uncomfortable."

Two weeks out of France they were chased and overtaken by an English privateer, the *Leander*. "We were running before the wind under all sail, but the unknown gained on us at a great rate, and after a while stood to the wind-ward of our ship, about half a mile off. She fired a gun, the ball passed within a few yards of our bows; our captain heeded not, but kept on his course" flying the American flag. ". . . Another and another shot was fired at us; the enemy closed upon us" and Sammis sensibly hove to. The privateer sent over two offi-cers and a dozen armed sailors who checked the captain's papers and searched the ship. "Every one of the papers proved to be in perfect accordance with the laws existing between England and America," Audubon wrote indignantly. The privateer was "nothing but a pirate" and the English officers "robbed the ship of almost everything that was nice in the way of provisions, took our pigs and sheep, coffee and wines, and carried off our two best sailors." They stole the ship's gold as well, but Audubon had managed to hide his and Rozier's stake wrapped in old clothes under a reel of cable in the bow of the ship and it went undiscovered.

Outside New York harbor Captain Sammis heard from a passing fishing boat that two British frigates were working the coast impressing sailors. To avoid them, wrote Audubon, he sailed "for the east end of Long Island Sound, which we entered uninterrupted by any other enemy than a dreadful gale, which drove us onto a sandbar in the Sound, but from which we made off unhurt during the height of the tide and finally reached New York" on May 27. A relieved Benjamin Bakewell welcomed the two adventurers and put them up. "Mr. Audubon (Lucy's beau) arrived from France a few days ago to the

great satisfaction of his & her friends," he reported to Euphemia Gifford, "as from the difficulty of leaving France which all young men now find we were apprehensive he would be retained. He is a very agreeable young man, but volatile as almost all Frenchmen are." When they had recovered their land legs the two partners, Audubon tall and slim, Rozier short and broad, rode off to Mill Grove like a latter-day Don Quixote and Sancho Panza (with or without the jackass Audubon did not say), ready to tilt with Francis Dacosta and claim their future.

Three

SETTLING THE INTERIOR

THE YOUNG COUNTRY TO WHICH John James Audubon and Ferdinand Rozier returned in the spring of 1806 was barely settled beyond its eastern shores. In the first decade of the nineteenth century France counted a population of more than 27 million and Britain about 15 million, but only 6 million people yet thinly populated the United States, two-thirds of them living within fifty miles of Atlantic tidewater. In European eyes, America was still an experiment. It remained to be seen if the experiment would succeed.

Although the federal government had moved in July 1800 to the Potomac wilderness that would become the national capital, Philadelphia was still the young nation's most populous and civilized city; its more than seventy thousand people supported more wealth, industry and science than either New York or Boston. The Bank of the United States was located there. The city was paved and lighted. Water flowed in wooden pipes and some effort had been made to clean up the slaughter yards and the Delaware River waterfront. The crushed-stone Germantown and Perkiomen Turnpike had been completed in 1804, a permanent wooden bridge over the Schuylkill in 1805. A primitive but serviceable wagon road extended from Philadelphia all the way to Pittsburgh, one of only three such roads through the Alleghenies, two of them originating in Pennsylvania.

In the heart of the city, on Chestnut Street between Fifth and Sixth, Charles Willson Peale's Philadelphia Museum occupied the tower and the upper floors of the Pennsylvania State House, where the Constitution of the United States had been hammered out in the summer of 1787—the building that would come to be called Independence Hall. The great mastodon skeleton that Peale had unearthed in 1801 near Newburgh, New York, had not yet been relocated to the State House from nearby Philosophical Hall, where it dominated a room entered through the arched jawbones of a whale. But some two hundred

*Charles Willson Peale revealing the Long Room
of his Philadelphia Museum, with its lifelike bird displays*

mounted specimens of four-legged animals, including bison, occupied the
Quadruped Room beyond the State House lobby, and around a corner from
the quadrupeds, the high-ceilinged, hundred-foot Long Room displayed more
than seven hundred American birds. In European museums, bird specimens
were typically presented isolated from their habitat against white backgrounds.
Peale innovatively displayed his stuffed birds in lifelike attitudes amid natural
objects—stones, bushes, sand, tree branches—and with watercolored skies and
landscapes behind them. "By showing the nest, hollow, cave or a particular
view of the country from which they came," he explained, "some instances of
their habits may be given."

Peale, a portrait painter with a large family, had backed into the museum
business trying to devise exhibits that would draw paying audiences. His por-
trait gallery of Revolutionary War heroes—he was a veteran of the war—had
evolved to panoramic historical and landscape displays combining painted
backdrops with actual objects, which led in turn to natural history displays. He
was particularly interested in birds. To preserve his specimens against the rav-

ages of beetles and other insects, he pioneered the use of arsenic solutions brushed onto the bird skins from the inside, and to make his models lifelike he wrapped the skins over carved wooden forms rather than merely stuffing them with fray. Beads of black sealing wax substituted for eyes, or Peale blew small glass spheres, opened them from the back and carefully painted irises onto their interiors. His bird specimens—a brace of Chinese golden pheasants from the Royal Aviary in Paris that Gilbert du Motier, the Marquis de Lafayette, had given George Washington; a white-headed eagle fierce on a boulder with a fish in its claws—flew, walked, paddled or perched as if alive in their tiers of glass-fronted cases. (Peale coined "white-headed" in preference to "bald," although "bald" in this case referred not to bare skin but to something shining or white, as in "piebald," an older meaning of the word.)

Miers Fisher, the Quaker lawyer, was a charter member of the museum's Board of Visitors—a trustee. The museum's mineral displays included a substantial sample of Mill Grove lead ore that Francis Dacosta had donated to alert potential investors. Audubon knew Peale's Museum well, praising it long afterward as "so valuable and so finely arranged!" In his Mill Grove days he probably visited it frequently; its collection of native American birds was the most comprehensive in the world, demonstrating in three dimensions how birds could be presented "in the attitude of life" and in their natural settings.

He assembled a natural history collection of his own at Mill Grove that summer. Lucy's stout little brother Will toured it enthusiastically and idolized its proprietor:

> Audubon took me to his house where he and his companion, Rozier, resided, with Mrs. Thomas for an attendant. On entering his room, I was astonished and delighted to find that it was turned into a museum. The walls were festooned with all kinds of birds' eggs, carefully blown out and strung on a thread. The chimney-piece was covered with stuffed squirrels, raccoons, and opossums; and the shelves around were likewise crowded with specimens, among which were fishes, frogs, snakes, lizards, and other reptiles. Besides these stuffed varieties, many paintings were arrayed on the walls, chiefly of birds. He had great skill in stuffing and preserving animals of all sorts. He had also a trick in training dogs with great perfection, of which art his famous dog Zephyr was a wonderful example. He was an admirable marksman, an expert swimmer, a clever rider, possessed of great activity [and] prodigious strength, and was notable for the elegance of his figure and the beauty of his features, and he aided nature by a careful attendance to his dress. Besides other accomplishments he was a musician, a good

fencer, danced well, and had some acquaintance with legerdemain tricks, worked in hair, and could plait willow baskets.

Audubon and Rozier spent the first part of the summer pulling together information about the Mill Grove lead mine and trying to form a company to capitalize the expenses necessary to exploit it. "[I] returned with a partner . . . and entered in[to] business," Audubon described that summer, "for the thought of marriage brought ideas so new to me that I began with pleasure in the way to secure my future wife and family the comforts we had both been used to." Lucy's father saw the two young men seemingly unoccupied, and misunderstood. "Don't like their being here in idleness," he complained to his journal, adding that "Mr. Audubon did not bring his father's permission to marry nor the $150 lent him." The partners soon realized that Dacosta was far more optimistic about the mine's prospects than the circumstances justified—none of the Bakewells had invested in it despite its proximity to Fatland Ford—and wisely took Miers Fisher's advice to extricate themselves and find some other line of work. Rozier began negotiations with Dacosta in late June. Since Audubon considered Dacosta his enemy, he stayed clear.

Never comfortable being idle, he used the time for birding. In 1804, curious whether the pewees returned from year to year to their nest above the entrance of the Perkiomen cave, he had attached light threads to the legs of the nestlings, the first recorded instance of bird banding in America. "These they invariably removed," he writes, "either with their bills, or with the assistance of their parents. I renewed them, however, until I found the little fellows habituated to them; and at last, when they were about to leave the nest, I fixed a light silver thread to the leg of each, loose enough not to hurt the part, but so fastened that no exertions of theirs could remove it." By October 8 all the pewees had departed. The following spring, shortly before he left for France, Audubon found two recent arrivals that still carried silver threads nesting in a Mill Grove grain shed. Now, in his third season of observation, he returned to the cave, discovered the old mud-daubed grass nest gone and then spotted a new one that a pair of pewees had built higher up. "I observed at once that one of the parent birds was as shy as possible, while the other allowed me to approach within a few yards. This was the male bird." From the female's shyness he concluded that the male had taken a new mate. He had scolded the miller's son in the past for killing birds to cut up for fish bait. He sought the boy out and asked him about the pewees. "I found that he had killed the old Pewee and four young ones. . . . The male Pewee had brought another female to the cave!"

On July 21 at Mill Grove he drew a bird he identified from Buffon as a whip-poorwill. It was instead a similar bird, a common nighthawk, barred white near the base of its primaries and lacking the white corners of the whippoor-will's tail, but the mistake was Buffon's; Audubon's drawing is accurate enough for modern correction. He drew an osprey that summer, noting "Perkiomen Creek" on the drawing as the place of collection. In mid-August he drew a wood thrush, that potbellied, black-speckled relative of the robin, the 209th addition to his burgeoning American list. One day at Fatland Ford, after helping Lucy weed the garden, he lounged with her in the shade watching an annoyed Thomas Pears sweating to master the heavy, willow-handled cradle scythe that farmers used in that era to harvest grain. Pears was learning to farm to prepare for his upcoming marriage to Sarah Palmer. *I'd rather be a merchant,* Audubon mocked. He would be soon enough.

Then summer was gone. Since Jean Audubon and Francis Dacosta owned Mill Grove in common, Rozier first had to negotiate a division of the property into two parts: the 171 acres across the Perkiomen and the 113½ acres that included the mansion house, the outbuildings, the mills and the mine. Dacosta had agreed to pay $800 with interest in three years to adjust the difference in value between the two parcels, to buy the 113½-acre parcel from Jean Audubon for $9,640.33 (giving bond for the down payment and signing a mortgage, since he had little capital himself) and to pay $4,000 for the mineral rights from the first proceeds of the mine, if any. As Rozier astutely explained in a letter to his father, "The mine may promise much at the beginning, and after that yield nothing. . . . An enterprise of this kind can be properly conducted only by a capitalist or a company"—neither of which described two young Frenchmen trying to establish themselves in a new country. "We have regarded this mine as a lottery which can make the fortune of the promoter or lead him into great losses." They of course still had 171 acres of good Perkiomen bottomland to sell; Rozier wrote that they had decided not to let it go for less than $8,000, an estimate of its value he had solicited from several local farmers. In the meantime, he concluded, speaking for Audubon as well as himself, "we are determined to go into trade, to cover our expenses, and to choose for ourselves some kind of serious work that can lead us to an honorable establishment."

Audubon and Rozier rode in to Philadelphia on September 5, 1806, to sign the agreement with Dacosta, but before they did so Audubon took a fateful step: now twenty-one years old, he stood before the clerk of the Pennsylvania District Court and declared his desire and intention to become a citizen of the United States.

By the time Thomas Pears and Sarah Palmer were married at Fatland Ford, early in October, Audubon had moved to New York, to learn the import-export business clerking for Benjamin Bakewell. Lucy's younger brother Tom already worked at the Bakewell offices at 175 Pearl Street. Lacking English, Rozier began clerking in Philadelphia for a Bakewell French affiliate, Laurence Huron. Benjamin wrote Euphemia Gifford in November that he found Tom "extremely useful, steady and attentive. Mr. Audubon is also with me. The losses his father sustained by the Revolution in the W[est] Indies have rendered it necessary his son should apply to business & he is come to be with me preparatory to his commencing for himself." (In the same November letter, Bakewell remarked a moment in American history: "The party who went to explore the sources of the Missouri"—Lewis and Clark—"have returned after visiting the Pacific Ocean.")

Lucy's uncle would have welcomed her fiancé for his expected Bakewell connection alone, but the successful merchant also gained thereby an affiliation with Rozier's father Claude, a major wholesaler of French goods out of Nantes. Benjamin exported American commodities to Europe in his own fleet of ships, including grain, coffee, sugar and indigo. (The indigo plant was still a major crop on Southern plantations, where Eli Whitney's cotton gin, invented in 1793, was facilitating an accelerating conversion to upland cotton. Soaking the macerated plants extracted the dye, which was dried to a crystalline dark-blue crumble that was shipped in barrels.) Bakewell traded the commodities for cargoes of European manufactured goods that he resold in New York at profits of 20 percent or more.

On his employer's behalf Audubon corresponded regularly with Claude Rozier, who shipped the American firm consignments of linen, wine, gloves and lace. Old, ill and concerned to see his son settled, Rozier's father almost immediately began encouraging the two young men to open a business of their own. "In several of your letters," Audubon wrote him eagerly in April 1807, "you intimate that if we decide upon establishing a retail shop, you can keep us constantly employed; our ideas upon this subject are in perfect accord, and it would be indeed a pleasure if we could start under the auspices and good advice of Mr. Bakewell here; objects well chosen, favorably bought, and shipped with care, are always sure of meeting a good sale." In May, after consulting with Ferdinand, Audubon sent Rozier père a request for an initial consignment that included 60 dozen green or gray morocco leather powder flasks with copper mountings, 60 dozen powder flasks in mahogany leather, 100 leather boxes, 100 Swiss music boxes and 100 one-gross boxes of sealing wax

wafers in assorted colors. He asked as well for "good books in English" from Paris, which Bakewell had assured him they could sell at a profit in the United States. Not neglecting his art, he slipped into his list a request for "3 boxes of pastels, good, well assorted." That books in English could be imported profitably from Paris signaled the primitive state of American book publishing. That the would-be firm of Audubon & Rozier saw its primary market in firearm equipage and wax for sealing letters pointed its future toward the trans-Appalachian frontier.

"You can judge that I have learned to shave Messrs the Americans since I have been with Mr. B. B.," Audubon went on to assure Claude Rozier with the cocky self-confidence of a twenty-two-year-old. Rozier probably found the young man's Mill Grove dealings more credible. When he had visited there in early April, Audubon wrote, "I rented it [out] for a year, being unable to do better for the present." Although the partners hoped to pay Rozier for his goods from the proceeds of liquidating their Mill Grove parcel, "the land, which we cannot sell [at present] without a great disadvantage, keeps us very short of cash, and prevents us for the moment from dealing on as large a scale as we should desire; but with your kindness in sending us the materials for starting a grand retail shop with different articles [on credit], it will aid us very much."

Audubon enclosed with his letters to Rozier letters to his father written in fractured but improving English. In an April letter he appealed for the consent to marry that Jean Audubon still cautiously withheld:

> I am allways in Mr. Benjamin Bakewell's store where I work as much as I can and passes my days happy; about th[r]ee weeks ago I went to Mill Grove . . . and had the pleasure of seeing there my Biloved Lucy who constantly loves me and makes me perfectly happy. I shall wait for thy Consent and the one of my good Mamma to Marry her. Could thou but see her and thou wouldst I am sure be pleased of the prudency of my choice. . . . I wish thou would wrights to me ofnor and longuely think by thy self how pleasing it is to read a friend's letter. . . . Do remember to send me thy portrait in miniature dressed as an officer it will cost thee little and will please me much. . . . We feel very inclined to set up in a retail store which would do us a great deal of good.

In a May note that included a bill of lading for "a small box containing nineteen species of seeds" and "a bottle of [preserved] reptiles for M. d'Orbigny," Audubon referred to Tom Bakewell as his brother-in-law, which must have

given his father pause, but winningly added, "If thou findest in my letter anything which displeases thee, remember that I am thy son."

As the seeds and reptiles indicated, living in New York had not slowed Audubon's naturalizing. The shores and markets of a Manhattan Island still largely rural teemed with wildlife. He could cross the city of seventy-five thousand people in minutes at his characteristically swift, vigorous walk. Though the whole island was platted, construction hardly extended above Washington Square.

*Audubon's shell duck
(common merganser)
in his mature style*

He drew a black surf duck and a golden-eyed duck on December 28, 1806. Soon after the New Year he drew a robin and an American merganser ("commonly called a Shell Duck," he noted on the drawing). February drawings included a pintail and a widgeon. On a March drawing of a rare and beautiful male canvasback he noted in French-English macaronic, "Les Oiseu est nomme Canvas Back Canard very much esteemed par les Americans and very rare ici lui est male et etais beau." His field notes of ducks, published later, almost always comment on their palatability, indicating that his specimens did double duty as painting subjects and dinner, a frugal application of his limited funds and a measure as well of how fast he drew. "My duck collection is up to 27 from this country," he wrote Charles d'Orbigny proudly on April 29, "and I know that five or six of them are not seen abroad."

When he wrote d'Orbigny that April, not the first time he had done so, no responses had yet arrived from Couëron. Eager to improve himself, Audubon found a new mentor closer to home, the thirty-three-year-old New York physician and U.S. Senator Samuel Latham Mitchill, who hired him to mount specimens. The son of a Long Island Quaker farmer and an honors graduate of the great medical school at Edinburgh University, handsome and childless, Mitchill was a Jefferson supporter and polymath who had served in the House before moving on to the Senate; Jefferson called him "the Congressional Dictionary." In 1797 he had cofounded the first scientific journal in the United States, the *Medical Repository.* He had taught chemistry at Columbia College and written extensively on New York geology before he entered Congress in

1801. Personally he was genial, prolific, verbose and, according to an early biographer, "perfectly honest and sincere but almost ridiculously vain," all qualities that would have recommended him to Audubon. "Tap the Doctor at any time and he will flow," Mitchill liked to say of himself, as if he were a maple tree.

During Audubon's tenure as Mitchill's assistant his neighbors complained of the smells coming from his workroom. The city sent a constable to investigate: body-snatching could still raise a riot, as it had done in New York only a few years earlier. The young journeyman taxidermist exhumed no corpses, but he may have been stuffing fish; in 1815 his mentor would publish a pioneering study of New York fishes. Mitchill's library would have been important to Audubon, who was teaching himself ornithology in a time when most reference materials were in private hands. The physician had recently sponsored an American edition of Erasmus Darwin's two-volume treatise *Zoonomia; or, the Laws of Organic Life,* another connection between them; Darwin's long poem *The Botanic Garden* was Lucy's favorite book.

After less than a year in Benjamin Bakewell's counting rooms Audubon was ready to claim his future. "In a short time we are leaving for a voyage upon the Ohio," he wrote Claude Rozier in mid-July, ". . . which I believe will be very advantageous to us. We hope to sell Mill Grove this autumn, which we shall do, however, only at a profit." At the beginning of August 1807 he and Ferdinand Rozier borrowed $3,600 (about $55,000 today) from Benjamin Bakewell, giving him a note payable in eight months, and used the loan to buy $2,500 in merchandise, which they shipped ahead to Louisville, Kentucky. The frontier town founded on the Ohio River in 1778 by George Rogers Clark was booming, with about one thousand families in residence, and the two young immigrants had decided it would be a good place to open a general store.

Since Audubon had not yet left New York on August 22—he drew a "sprigtail duck" that day—he may have joined the August 17 crowd watching Robert Fulton and Robert Livingston's *North River* steamboat pull away from the docks and head up the Hudson River billowing black smoke on its maiden voyage to Albany, with an overnight stop at Clermont, Livingston's Hudson estate. Samuel Mitchill had helped push through the New York legislature the bill that granted Fulton and Livingston a monopoly on steamboat transportation on New York rivers. The great challenge to settling the vast American interior was its lack of roads. Remedying that lack would require capital investment on a scale far beyond the immediate means of the young nation. Fulton, among others, understood that the Western rivers could serve as natural roads for commerce and settlement if steam power could be applied to driving boats.

Although it was fitted with sails as well as side paddle wheels, the 142-foot-long *North River* was only 14 feet wide and shallow-drafted, a design intended less for the deep-channeled Hudson than for the rivers of the Mississippi drainage, beginning with the Ohio—where the firm of Audubon & Rozier was about to open its doors.

The two young men said their goodbyes and left from Mill Grove on the last day of August 1807. If it saddened Lucy and her LaForest to be parted again after the long separation they had already endured, they could at least expect that this one might finally remove the last impediments to their marriage.

Within months Audubon was back to claim his bride. Louisville had welcomed Audubon & Rozier—the partners had reordered powder flasks and ordered shot bags within a month of their arrival—but American entanglement in the long war between England and France had limited their immediate success. The country had been outraged the previous June when a British man-of-war, the *Leopard,* had fired on the U.S. frigate *Chesapeake,* killing three sailors and wounding eighteen, and then had dragged off four suspected British deserters, three of whom turned out to be Americans. Audubon and Rozier had tasted British determination to dominate the seas in the *Polly's* encounter with the *Leander.*

Thomas Jefferson was leaning toward war with England that autumn. During a dinner at the President's on November 3 with Samuel Mitchill in attendance, John Quincy Adams reported in his diary, "Dr. Mitchill mentioned Mr. Fulton's steamboat as an invention of great importance. To which Mr. Jefferson, assenting, added, 'and I think his torpedoes a valuable invention too.' " (Adams also confirms Mitchill's reputation for volubility. "The Doctor knows a little of everything," he added to his note on the dinner conversation, "and is communicative of what he knows.")

But Jefferson found Congress unwilling to pursue a war with England. When he learned in early December that George III had ordered all British naval officers to enforce the impressment of sailors from merchant vessels and that Napoleon had ordered the French navy to blockade not only British but also American ships, he began thinking instead of how to punish both nations. Believing that they depended on U.S. grain and other commodities for their food, Jefferson (as Adams wrote) "recommended in unequivocal terms an immediate embargo": all American ports closed to export shipping and severe restrictions on imports. The House and the Senate both passed the Embargo Act on December 22, 1807, and Jefferson signed it into law the same day.

As a result, by the end of January 1808 commodity merchants such as Benjamin Bakewell had lost everything. "The cause," he wrote his Derbyshire cousin, "is solely owing to the Embargo which this Government has thought proper to lay & which has so affected many merchants in this place that failures to the amount of some millions of dollars have already taken place & more are duly expected. I have assigned over for the benefit of my creditors the whole of my property, my furniture and apparel." William Bakewell had gone immediately to his brother's aid. "He has the mortification to find his past labors fruitless," Lucy's father wrote, "& that he must begin the world anew. . . . I went over to New York to see what was best to be done. . . . He has suffered much uneasiness of mind & I was afraid of his health for some time."

Tom, Lucy's brother, had gambled with the Embargo and done better: "Thomas is in New Orleans," William Bakewell wrote. "He sailed from New York a little before this unfortunate affair in a ship of my brother's with a cargo of merchandise chiefly French such as claret, olive oil, & some manufactures. He has met with good sale for them. . . . Thomas was by agreement with my brother to have half the profits of the adventure." His father was proud of him: "It is not a very common case that a youth not yet twenty years of age should have sufficient judgment & stability to be entrusted with such a charge."

Audubon & Rozier had meant to pay off their loan, due on April 7, with the proceeds from commodity speculations. Thus they had bought tobacco in Kentucky and shipped it eastward for New York sale. Audubon had sought and received a further $1,500 advance from Benjamin Bakewell on December 31, just before exports crashed, to buy indigo to ship to France for sale; Rozier had shipped a cargo of hams to the West Indies. With exports and imports embargoed, both investments were lost, nor could the partners sell their tobacco. They were forced to return East at the beginning of April to arrange to extend their $3,600 loan.

The embargo effectively cut off correspondence between the United States and Europe, and no record survives to indicate whether or not Audubon had at last received his father's permission to marry. He was legally an adult, however, and with or without his father's permission, John James Audubon, novice Louisville merchant, almost twenty-three, and Lucy Green Bakewell, prosperous farmer's daughter, just twenty-one, were married by a Presbyterian minister under gray skies in the parlor at Fatland Ford on Tuesday, April 5, 1808. Thursday the partners' loan extension was entered into the Benjamin Bakewell books (the firm was operating under receivership) and they shipped off on freight wagons what William Bakewell called "a considerable quantity of mer-

chandise . . . together with Lucy's furniture." Friday, April 8, their business done, a joyful LaForest and his beloved Lucy left with Rozier on the stagecoach to Pittsburgh to begin their life together. There were snow flurries that morning, muddy thaw. From the budding trees they passed on the Lancaster pike the returning birds sent them birdsong.

Four

LOUISVILLE IN KENTUCKY

THE JEHU CRACKING HIS WHIP, traces jingling on its four fresh horses, the stagecoach left Philadelphia at four a.m. and made good time on the fine pike to Lancaster, sixty-one miles, changing teams along the way and arriving for dinner at four in the afternoon. ("Jehu," the universal stagecoach driver honorific, was biblical drollery, II Kings 9, verse 20: Jehu, son of Jehoshaphat, rode out in his chariot against Joram, King of Israel, *"and the driving is like the driving of Jehu . . . for he driveth furiously."*) Ferdinand Rozier had kept a diary of his previous journey west, a journey he and the Audubons now duplicated. In early spring 1808 the fields were not yet green; in September 1807, when Rozier had traveled, the hemp had been mature in the central Pennsylvania fields, a crop to supply the young nation's demand for rope. Rozier had noted "good taverns" every two miles, which might have reminded Audubon that he had tasted wine for the first time on his wedding day—his previous abstinence had annoyed his friends and family in Couëron. After dinner the stage hauled on nine more miles to an indifferent tavern where they spent the night, with a view in the morning of a new bridge "with two immense arches" spanning the Conestoga River.

From there up to Elizabethtown, Rozier complained, "the roads were miserable, and we suffered a severe jolting and shaking up." At Elizabethtown the jehu added two more horses to make a coach-and-six and carried them on to breakfast at Middletown. The road improved to Harrisburg, where they "discovered a very beautiful river called the Susquehanna." Coach-and-six and passengers crossed the Susquehanna on "a large flatboat propelled by a sweep [oar] of generous proportions" while the voluble captain told them fish stories. A change of horses sixteen miles beyond the Susquehanna at Carlisle, a night's rest at a tavern at Walnut Bottom between imposing high mountains north and south and on in the morning to Shippensburg for breakfast. "This village

Floating the Ohio by flatboat

had only one long street," Rozier scorned it, "and presented an appearance far from pleasing."

"After the two first days we commenced climbing the mountains," Lucy would report to Euphemia Gifford. At Chambersburg they bought tickets for the next stage that would haul them over the successive hundred miles of mountain ridges—the Appalachians, the Alleghenies and the Laurels—and the road soon became a badly rutted trace from which neither stones, boulders nor tree stumps had been cleared.

On their earlier trip west Audubon and Rozier had hiked up the first steep mountain, three miles in three and a half hours, because the road was so bad "that it seemed well nigh impossible for any vehicle to ascend." Lucy had intended to walk as well, she wrote, "for whilst the stage is going up or down the mountains they move by as slow as possible [and] the great stones beneath the wheels make the stage coach rock about most dreadfully." It was raining, however, unpleasantly wet and chill—they had rain most of the way—and she decided instead to ride inside the coach for shelter. Near the summit the lumbering vehicle rocked too far, lurched and overturned, the horses ran away dragging the coach sideways and Lucy banged around inside, "a sad accident," Audubon remembered, "that nearly cost [her] life." When they caught the horses and pulled her out she was bruised and battered but not broken.

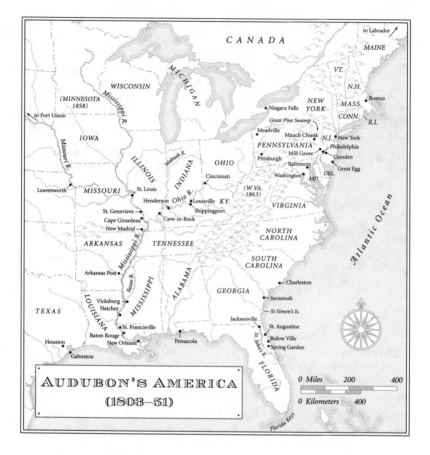

AUDUBON'S AMERICA
(1803–51)

"Very stony and disagreeable" was her summary curse on the Eastern mountains afterward, but she said nothing about the accident in her May letter to her cousin, only wished that Gifford "could have enjoyed the variety of beautiful prospects as we did on our journey without partaking of the fatigues." She also wished that her cousin "were acquainted with the partner of my destiny. It is useless to say more of him to you at so great a distance, than that he has a most excellent disposition which adds very much to the happiness of married life."

If Audubon and Rozier had been worn out by the time they had descended the mountain to McConnelsburg, Lucy must have been sick with exhaustion as well as sore. They could hardly stop: they went on. The next day a thirty-two-

mile trek delivered them to a tavern within two miles of the Juniata River, which they crossed in the morning in a leaky flatboat and followed along in its narrow channel between high mountain walls to Bedford, another hard and tiresome day. Then day by day it was Bedford to Somerset, Somerset to Laurel Hill, more stumpy, stony roadbed from Laurel Hill to Greensburg, and finally Greensburg to Pittsburgh, where they stayed two weeks.

Lucy disliked Pittsburgh, down at the bottom of the bowl where the Monongahela and the Allegheny joined to form the Ohio, where emigrants crowded to begin their long float into Kentucky. "High mountains on all sides environ Pittsburgh," she told her cousin, "and a thick fog is almost constant over the town; which is rendered still more disagreeable by the dust from a dirty sort of coal that is universally burnt. Coal is found at the surface of the earth in the neighborhood of this place, which is really the blackest looking place I ever saw." Another contemporary traveler, the Reverend Timothy Flint, thought Pittsburgh's soul was blacker than its brick buildings, fattening "on the spoils of the poor emigrants that swarmed to this place." Rozier with his merchant's eye noticed less fastidiously "a remarkable commerce" and thought the Ohio River there "most beautiful."

Their wagonloads of merchandise and furniture caught up with them at Pittsburgh. The wagons out of Philadelphia were big commercial Conestogas, oxen-hauled. Commodities were hardly worth the return journey on bad roads, which is why the value of Western farmers' wheat was less than half the Eastern value, but the wagons hauled back higher-value products and rarities: whiskey or wild Kentucky ginseng for the China trade.

From Pittsburgh to Louisville the newlyweds and their sturdy partner were to travel by flatboat. Their contemporary Timothy Flint, a Harvard-educated Yankee Congregationalist, saw the same Pittsburgh waterfront they did:

> The first thing that strikes a stranger from the Atlantic, arrived at the boat-landing, is the singular, whimsical and amusing spectacle of the varieties of watercraft, of all shapes and structures. There is the stately barge, of the size of a large Atlantic schooner, with its raised and outlandish-looking deck. . . . Next there is the keel-boat, of a long, slender and elegant form, and generally carrying from fifteen to thirty tons. This boat is formed to be easily propelled over shallow waters in the summer season. . . . Next in order are the Kentucky flats, or in the vernacular phrase, "broadhorns," a species of ark, very nearly resembling a New England pig-stye. They are fifteen feet wide, and from forty to one hundred feet in length, and carry from twenty to seventy tons. Some of them . . . used by families in descending the river, are

very large and roomy, and have comfortable and separate apartments, fitted up with chairs, beds, tables and stoves. It is no uncommon spectacle to see a large family, old and young, servants, cattle, hogs, horses, sheep, fowls and animals of all kinds, bringing to recollection the cargo of the ancient ark, all embarked and floating down on the same bottom.

The flatboats were called broadhorns because two long, hornlike steering oars extended out and back from their broad fronts; another steering oar mounted on the stern for a rudder added a sort of tail. Besides these larger river conveyances, Flint mentions " 'covered sleds' or ferry-flats," pirogues "hollowed sometimes from one prodigious tree," common skiffs and dugouts as well as "monstrous anomalies reducible to no specific class of boats," concluding that "you can scarcely imagine an abstract form in which a boat can be built that . . . you will not see actually in motion." They even built ocean-worthy hulls at Pittsburgh, up to 450 tons' capacity; floated down the Ohio and the Mississippi filled with cargo, they were unloaded at New Orleans, outfitted with sails and masts and sailed across the seas to puzzle foreign harbormasters with their mid-continent port of origin. Ingenuity flourished on the American frontier not only because new conditions required innovation but also because no private or governmental agency restrained it.

Since flatboats lacked engines for returning upriver and sails were useless, as Lucy explained, "owing to the many turns on the river which brings the wind from every quarter in the course of an hour or two," the broadhorns were built at Pittsburgh, floated one-way to their destination and dismantled, the lumber used or sold. So the flatboat the Audubons chose would have been new. "Perfectly flat on all sides," Lucy remembered it, "and just high enough to admit a person walking upright." Roofed over, that is, and with portholes. "Men, women and children huddled together," Audubon wrote of flatboats generally, "with horses, cattle, hogs and poultry for their companions, while the remaining portion was crammed with vegetables and packages of seeds. . . . The roof or deck of the boat was not unlike a farm-yard, being covered with hay, ploughs, carts, wagons and various agricultural implements, together with numerous others, among which the spinning wheels of the matrons were conspicuous." Wooden boxes were also conspicuous on this occasion with Audubon & Rozier merchandise, as was Lucy's furniture. "Even the sides of the floating mass," Audubon added, "were loaded with the wheels of the different vehicles, which themselves lay on the roof"—wheels, of course, of wood and iron, cart and wagon wheels; vulcanized rubber would not be invented for another thirty-one years. For provisions the Audubons bought Pittsburgh

bread, beer and hams. "Poultry, eggs and milk," Lucy noted, "can always be had from the farm houses on the [river] banks" along the way.

In spring, with the river running high, the seven-hundred-mile float from Pittsburgh to Louisville took ten days. "The boat is carried along by the current," Lucy informed her cousin, "and in general without the least motion, but one day we had as high a wind as to make some [of] us feel a little seasick. . . . There are not many extensive prospects on the river as the shores are in general bounded by high rocks covered with wood." She was remembering only half the view; other travelers, including her husband, noted the Ohio's regular alternation between bluffs and bottoms: "Nearly the whole length of the river, the margin on the one side is bounded by lofty hills and a rolling surface, while on the other, extensive plains of the richest alluvial land are seen as far as the eye can command the view." There were islands as well, Audubon wrote, some of them substantial, "and the winding course of the stream frequently brings you to places where the idea of being on a river of great length changes to that of floating on a lake."

Sounds traveled far on the river. Audubon reported hearing cattle bells at night from the farms along the way, "the hooting of the Great Owl or the muffled noise of its wings as it sailed smoothly over the stream [and] the sound of the boatman's horn as it came winding more and more softly from afar." By day he heard birdsong. Timothy Flint mentioned "fiddles scraping continuously" and boatmen dancing on the decks, which were "seductions . . . irresistible to the young people that live near the banks of the river" who were drawn from their isolated farmsteads down to the river to listen—and sell perishables.

The Audubon boat floated past more sluggish flatboats on the river and a plenitude of game on the shores: wild turkeys, grouse, deer, even perhaps bison and elk, still to be seen occasionally in those days east of the Mississippi. They moored at small towns along the way; Lucy apologized to her cousin for not sending sketches: "Mr. Audubon regretted he had not his drawing implements with him as he would have taken some views for you." Mr. Audubon liked to pretend he had no head for mercantile matters, but here he was without his drawing tools, too busy setting himself up in marriage and in trade; his young bride promised Euphemia Gifford he would take up his pencil again "when he has got a little more settled and arranged his business." Among the parcels aboard would have been his large wooden, tin-lined portfolio cases, his artistic capital, packed with hundreds of journeyman drawings of French and American birds.

Flint noticed that beginning at Steubenville, sixty-five miles downriver from Pittsburgh, "the river seemed to develop its character for broadness and fertil-

ity" after the narrower passage through the western Pennsylvania piedmont. "Here we first began to notice the pawpaw, the persimmon, and other new and beautiful shrubs and plants, peculiar to this climate." There were "wide, clean sandbars stretching for miles together, and now and then a flock of wild geese, swans, or sandhill cranes, and pelicans, stalking along on them. . . . The bottom forests everywhere displayed the huge sycamore, the king of the western forests." Virgin sycamores with their mottled white bark, beeches, hickories, walnuts, chestnuts, maples, tulip trees and oaks filled the forests, many trees "crowned with verdant tufts of the viscus or mistletoe . . . and the trunks entwined with grapevines, some of them in size not much short of the human body." Grapevines muscular as anacondas hung down from the tree canopy all the way to the forest floor; the mistletoe, a parasite tapped into the branches of the crown, formed spheres the size of bushel baskets of glossy evergreen leaves. In April the dogwoods were blooming, white sprays emerging along the riverbanks from the pale-green background of new leaves. What a wedding gift for Lucy: "I was gratified by the sight of a great variety of foliage and flowers."

"We glided down the river," Audubon concluded, "meeting no other ripple of the water than that formed by the propulsion of our boat. Leisurely we moved along, gazing all day on the grandeur and beauty of the wild scenery around us." They tied up at the Louisville dock in early May 1808.

THE OHIO RIVER PRESENTED only one barrier to navigation on its winding thousand-mile course from Pittsburgh to the Mississippi: the Falls of the Ohio, a series of rock ledges at about mile 604 that extended across the river to form rapids. Descending twenty-two feet in two miles, the Falls made for hazardous passage in low water, but above them on the Kentucky side Beargrass Creek shaped a natural harbor where it entered the river. George Rogers Clark had built a fort on an island in the river near there in 1778. Louisville, named after Louis XVI in gratitude for French support of the American Revolution, was platted in 1779 on what was then still the Virginia shore (Kentucky became a state in 1792).

Louisville became one of Audubon's favorite places. Its appearance, he wrote, "would please even the eye of a Swiss. It extends along the river for seven or eight miles, and is bounded on the opposite side by a fine range of low mountains, known by the name of the Silver Hills." Given the town's setting directly above the Falls and its growth as a center of salt production from nearby mines—salt for preserving meat was a vital and heavily trafficked commodity before the invention of refrigeration—he and Rozier "had marked

Louisville as a spot designed by nature to become a place of great importance." Another reason for settling there, for Audubon at least, was the local abundance of fish and game—and birds. "But above all, the generous hospitality of the inhabitants, and the urbanity of their manners, had induced me to fix upon it as a place of residence."

The newlyweds took rooms at the Indian Queen Hotel, three meals a day served in the dining room, liquor in the boot room, cigar smoke everywhere and the wash pump outside in the yard. Lucy put a brave face on their boarding in a May 27 letter to her wealthy English cousin, fearing to seem *déclassé*: "I cannot quite tell how I shall like Louisville as I have only been here three weeks and have not yet got a house, but I have received every attention from the inhabitants. . . . Where we board we have every accommodation wished and are as private as we please." Three weeks along, her husband busy restocking and drumming up business, she was restless: "I am very sorry there is no library here or bookstore of any kind for I have very few [books] of my own and as Mr. Audubon is constantly at the store I should often enjoy a book very much whilst I am alone."

When they went East the partners had left their business in the care of their clerk, a bright young Kentuckian with medical ambitions named Nathaniel Pope; once the store was running smoothly again Audubon was proud to show off his bride to the Louisville gentry. "My young wife, who possessed talents far above par, was regarded as a gem, and received by them all with the greatest pleasure." Their new friends soon drew her out. "The matrons acted like mothers towards my wife [and] the daughters proved agreeable associates." Frontier people were famously hungry for company. If Audubon went off trading or traveling, they rescued Lucy from the boredom of her hotel room, and sometimes when her husband came back he had to "spend a week or more with these good people before they could be prevailed upon to let us return to our own residence." Attractive, talented and exotically transatlantic, the Audubons were popular in Louisville.

The town was full of Clarks. The newlyweds' new acquaintances included General George Rogers Clark himself, a red-haired six-footer, now mostly bald at fifty-six, whose log cabin at the Point of Rocks across the river in Clarksville overlooked the Falls (at Clark's invitation Audubon spent time there observing ospreys nesting soon after he arrived); General Jonathan Clark; and his brother William Clark, Meriwether Lewis's co-captain, also tall and red-haired—"our great traveler," Audubon called him—who was newly married and settled in St. Louis but who sometimes came to visit relatives. The Clark brothers' sister Lucy, her husband William Croghan, an Irish-born former major in Washing-

ton's army who had known Audubon's father in the war, and their son George, with whom Audubon hunted, became close friends. The Croghans' Locust Grove plantation five miles upriver of the Falls, with its hillside Georgian red-brick mansion overlooking the river, must have reminded Audubon of Mill Grove and La Gerbetière. Creeks, rivers and bayous of magnificent flow were fundamental continuities of his life. Lewis and Clark had recuperated for three weeks at Locust Grove on the Corps of Discovery's return from the West in October 1806 before going on to Washington to report.

Since the Falls challenged navigation, a second, smaller community, Shippingport, had established itself on the river two miles below Louisville, owned and operated by men who shared with Audubon descent from the French maritime bourgeoisie. Tarascon, Berthoud and Company of Philadelphia, a firm of French merchants and shipbuilders, had moved out to Pittsburgh at the turn of the century to build boats for the river traffic and oceangoing hulls to float to New Orleans for outfitting and sale. The Pittsburgh operation shut down after a large schooner hull broke up shooting the Falls. Louis and John Tarascon and James Berthoud moved their boatbuilding operations and their families below the Falls to Shippingport, where the Tarascons already had business. Louis Tarascon had built a large water-powered flour mill at the base of the Falls in 1803 and expanded into tobacco warehousing and rope manufacture. His 1,200-foot rope walk—on which workmen walked back strands of twine while braiding them into rope for ships' rigging—was the longest in the country.

The senior Berthouds, James and Marie-Anne-Julia, reminded Audubon of his parents. It was whispered that they were French nobility who had escaped the Revolution. Their son Nicholas, at twenty-two one year younger than Audubon, started as a fishing partner and evolved into a business associate. The Tarascons and the Berthouds became the Audubons' closest friends. The French families had built elegant houses for themselves in Shippingport, but beyond the residential enclave it was a rough town. "At Shippingport," a traveler noted in his diary a decade later, "is Tarascon's Mills, a very large & extensive mill on the falls. This town is the suburbs of Louisville & is situated at the foot of the Falls. A great part of the shipping business is done at this place & the merchants have stores here, although they do their business at Louisville. Shippingport is a vile rascally place & the inhabitants consist principally of vagabond boatmen & whores." No doubt Louisville had higher aspirations, but drinking, gambling, fighting and horse racing were common there; one early Louisville amusement that visitors remarked was putting horses at stud in the public streets.

By June Audubon was finding time to add to his drawings of birds, taking advantage of the populous habitat of the Falls. He mentions seeing white pelicans at this time "on the sand-bars of the Ohio, and on the rock-bound waters of the rapids of that majestic river." On Sunday, June 5, he completed two drawings of orchard orioles collected at the Falls. On June 20 he drew a summer red bird (tanager), on June 24 a female woodpecker, on June 29 male and female indigo

The 1808 belted kingfisher

buntings, all Falls collections. He used his sharpened-wire mounting-and-gridding system routinely now to set up his specimens, which he drew at life size. As his skills improved he destroyed whole batches of earlier drawings in annual bonfires, partly because he found them wanting, partly to force himself to further improvement. Long afterward he was grateful that in 1808 he had sent some thirty drawings to Lucy's cousin Euphemia Gifford in Derbyshire, where they had been carefully preserved. From that gift giving he was able to salvage an early portrait of a least flycatcher "procured [near Louisville] while searching the margins of a pond" for which he had no later drawing.

In July he drew a female blue-gray gnatcatcher and an immature summer warbler that he thought was an unidentified species—what was called at that time a nondescript—both collected at the Falls. He drew a lively, intensely alert female belted kingfisher in profile standing on a tree branch, its near eye directly engaging the viewer, as almost all Audubon's birds do, its aquamarine body plumage set off by its white collar and white, rufus-streaked breast. Its spiky blue crest and its long bill, adapted for plunge-diving, make its head seem large for its body and short legs. Identifying the kingfisher from Buffon, Audubon noted its point of collection as "Chute de L'Ohio July 15, 1808," and added two delicate pencil drawings of individual feathers to detail the distinctive patterns of its primaries and its undertail coverts. Of his current series of drawings the kingfisher was "No. 110."

One species Audubon observed at the Falls, the Canada goose, soon left the neighborhood, a departure Audubon attributed to Louis Tarascon:

> When I first went to the Falls of the Ohio, the rocky shelvings of which are often bare for fully half a mile, thousands of wild geese . . . rested there at

night. . . . I knew a gentleman, who had a large mill opposite Rock Island, and who used to kill the poor geese at a distance of about a quarter of a mile, by means of a small cannon heavily charged with rifle bullets; and, if I recollect truly, Mr. Tarascon in this manner not unfrequently obtained a dozen or more geese at a shot. This was done at dawn, when the birds were busily engaged in trimming their plumage with the view of flying off in a few minutes to their feeding grounds. This war of extermination could not last long: the geese deserted the fatal rock, and the great gun of the mighty miller was used only for a few weeks.

Whether Tarascon was killing geese for fun or, less reprehensibly, to feed his family or his workers, Audubon does not say, but his tale was only the first of many he would tell that illustrated the profligacy of frontier hunters—himself sometimes included.

On Independence Day, Lucy, John James, Ferdinand Rozier and their young clerk Nat Pope joined what Audubon called "the whole neighborhood" of Louisville for a Kentucky barbecue, an all-day celebration on a freshly groomed glade in the beech woods along Beargrass Creek that Audubon would remember nostalgically and chronicle. Families had been preparing food all week, he wrote; the sun was shining; flowers perfumed the air; "the little birds sang their sweetest song in the woods." The families arrived in loaded wagons and built fires while "waiters of all qualities were disposing the dishes, the glasses, and the punch-bowls, amid vases filled with rich wines. 'Old Monongahela' filled many a barrel for the crowd."

From their family groups the young men and women rode forward into the glade, the women dressed in white, and "in a short time the ground was alive with merriment. A great wooden cannon, bound with iron hoops, was now crammed with home-made powder; fire was conveyed to it by means of a [powder] train, and as the explosion burst forth, thousands of hearty huzzas mingled with its echoes." Orations followed, after which "fife and drums sounded the march . . . and as they changed to our celebrated 'Yankee Doodle,' the air again rang with acclamations."

Then came the feast. "Each denizen had freely given his ox, his ham, his venison, his turkeys, and other fowls," as well as "flagons of every beverage used in the country," fish from the Ohio, "melons of all sorts, peaches, plums and pears [sufficient] to stock a market." More speeches, toasts and replies, more drinking by the menfolk. Dancing was the climax of the day for the young people, John James and Lucy elegant among them, "double lines of a hundred fair ones extended along the ground in the most shady part of the woods, while

here and there smaller groups awaited the merry trills of reels and cotillions"—the cotillion a French import, a predecessor to the square dance, with line dancing and elaborate steps and interchanges. "A burst of music from violins, clarinets and bugles gave the welcome notice, and presently the whole assemblage seemed to be gracefully moving through the air." For those who chose not to dance, Audubon recalled, there was talk ("the ingenuous tale of the lover, the wise talk of the elder on the affairs of the State, the accounts of improvement in stock and utensils, and the hopes of continued prosperity to the country at large, and to Kentucky in particular"), target shooting and horse racing, "while others recounted their hunting exploits, and at intervals made the woods ring with their bursts of laughter."

As the sun set they lit fires, the dancers still dancing, "casting the long shadows of the live columns far along the trodden ground and flaring on the happy groups, loath to separate." The stars came out, "supper now appeared on the tables, and after all had again refreshed themselves, preparations were made for departure. The lover hurried for the steed of his fair one, the hunter seized the arm of his friend, families gathered into loving groups, and all returned in peace to their happy homes." Elsewhere Audubon recalled "the simplicity and whole-heartedness of those days" when he first moved out beyond the settled districts of France and the United States to the trans-Appalachian frontier: "I shot, I drew, I looked on nature only; my days were happy beyond human conception, and beyond this I really cared not."

If Audubon's recollections of his life in Louisville are softened with nostalgia, they still catch the innocence of an emigrant generation that was overwhelmingly young—as late as 1820, 58 percent of the American population was under twenty. It was as well the first American generation to be released by the widening scope of opportunity and the open frontier from the well-intentioned social and economic tyranny of its elders. Individualism was not a feature of the American national character imported from Europe. It emerged and evolved in response to the conditions of continental settlement, and the era of its emergence coincided with the evolving lives of John James and Lucy Audubon.

LATER IN JULY MAJOR CROGHAN happened to ask Audubon "if I had seen the trees in which the Swallows were supposed to spend the winter, but which they only entered, he said, for the purpose of roosting. Answering in the affirmative, I was informed that on my way back to town, there was a tree remarkable on account of the immense numbers that resorted to it, and the place in

which it stood was described to me." Since chimney swallows disappeared in the winter, they were commonly believed to hibernate—even to burrow into the mud like frogs. At twenty-three Audubon had already moved beyond simple collection to field observation, and now he went to see William Croghan's remarkable tree.

"I found it to be a sycamore, nearly destitute of branches, sixty or seventy feet high, between seven and eight feet in diameter at the base." Forty feet up it tapered to a diameter of about five feet and the hollow stump of a two-foot branch projected off from the main trunk. Examining and tapping the tree, Audubon concluded that it was hard but hollow. Since swallows were flying over the woods at four in the afternoon but not approaching the tree, he rode in to Louisville, stabled his horse and returned nearer dusk on foot.

"The sun was going down behind the Silver Hills; the evening was beautiful; thousands of Swallows were flying closely above me, and three or four at a time were pitching into the hole [of the hollow branch] like bees hurrying into their hive." He pressed his head against the trunk, "listening to the roaring noise made within by the birds as they settled and arranged themselves, until it was quite dark, when I left the place, although I was convinced that many more had [yet] to enter. I did not pretend to count them, for the number was too great, and the birds rushed to the entrance so thick as to baffle the attempt." Back in Louisville "a violent thunderstorm passed suddenly over the town" and Audubon speculated that the swallows in their tumult had been scudding home to safety to avoid the storm.

Chimney swallows—American swifts

He lay awake most of the night worrying that the swallows might migrate away before he could count them. That worry got him up before dawn, when he hiked back out of town to the tree and leaned his head against it to listen for activity. After twenty minutes of silence he was startled alert: "Suddenly I thought the great tree was giving way, and coming down upon me. Instinctively I sprung from it, but when I looked up to it again, what was my astonishment to see it standing as firm as ever. The Swallows were now pouring out of it in a black continued stream." His head against the tree again, he listened to the roar inside, which reminded him of a "powerful stream" turning a large mill wheel. Like bats from a cave, the birds needed more than thirty minutes to exit their sycamore tower, after which they "dispersed in every direction with the quickness of thought" and the noise ceased.

Audubon had to see the sycamore's interior. He enlisted a hunting buddy to help him. They threw a line over the stump of broken branch and used the line to pull a rope over and back down to the ground, and then Audubon shinnied up the sycamore trunk "without accident" carrying a fifteen-foot probe of giant cane "and at length seated myself on the broken branch." But the hole was black, and his probing at the full length of the cane "touched nothing on the sides of the tree within that could give any information. I came down fatigued and disappointed."

The next day, more determined than ever, he hired a woodcutter who axed a hole into the base of the sycamore. "The shell was only eight or nine inches thick, and the axe soon brought the inside to view, disclosing a matted mass of exuviae, with rotten feathers reduced to a kind of mold, in which, however, I could perceive fragments of insects and quills. I had a passage cleared, or rather bored through this mass, for nearly six feet." Boring the hole took so long that Audubon feared the birds would notice the light from below and abandon the tree, so he had the hole closed. The swallows followed their routine for the next several days, long enough to lull them.

Then Audubon and his hunting buddy visited the tree at night with a dark lantern—a lantern with doors that could be closed to hide its light. Cautiously they removed the boards that covered the hole. Audubon leading, they "scrambled up the sides of the mass of exuviae," which must have crawled with beetles and other scavengers. Up inside the hollow tree it was silent:

> Slowly and gradually I brought the light of the lantern to bear on the sides of the hole above us, when we saw the Swallows clinging side by side, covering the whole surface of the excavation. In no instance did I see one [on top of] another. Satisfied with the sight, I closed the lantern. We then caught and

killed with as much care as possible more than a hundred, stowing them away in our pockets and bosoms, and slid down into the open air. We observed that, while on this visit, not a bird had dropped its dung upon us. Closing the entrance, we marched towards Louisville perfectly elated.

They took the specimens to do a population count. Of a total of 115 birds, 87 were adult males and only 6 were females. The remaining 22 were immature specimens that could not be sexed. Audubon "had no doubt that they were [the] young of that year's first brood, the flesh and quill-feathers being tender and soft." He calculated the interior surface area of the tree to be 375 square feet. If a bird covered a space of 3 by 1½ inches, which Audubon thought was "more than enough," each square foot would contain thirty-two birds. "The number of Swallows, therefore, that roosted in this single tree was 9000." He set up one of them on his wire grid and drew it on July 27.

Continuing his investigation, Audubon examined the hollow sycamore on August 2 and concluded that it still sheltered about the same number of birds as before but that the proportion had shifted toward females and young. After that he checked the tree daily. "On the 13th of August, not more than two or three hundred came there to roost." On August 18 he saw not one bird near the tree but "a few scattered individuals . . . passing [overhead], as if moving southward." One night in September he crawled back inside the tree and found it empty. In February 1809, "when the weather was very cold," satisfied that all the swallows had left the region, he sealed the tunnel.

In May he noticed swallows returning to the tree to roost. Early in June he tried an experiment, plugging the hollow branch where the birds entered the tree with a bundle of straw tied to a string so that he could pull the plug from the ground: "The result was curious enough; the birds as usual came to the tree towards night; they assembled, passed and repassed, with apparent discomfort, until I perceived many flying off to a great distance, on which I removed the straw, when many entered the hole, and continued to do so until I could no longer see them from the ground." Five years later he paid the great hollow sycamore a last visit. Swallows were still using it to roost. Eventually, he heard, a storm took it down.

Lucy's first pregnancy ripened through the winter of 1808–9. The Audubon & Rozier partnership was surviving but not thriving; Jefferson's embargo continued to depress business until March 1809, when the President reluctantly signed a Non-Intercourse Act that limited the ban on shipping to only France and Britain. Benjamin Bakewell's son Thomas—not Lucy's younger brother Tom but her cousin—wrote Audubon & Rozier in December that the tobacco

they had shipped East the previous year had not sold and was by now unsalable. Since they still had their Mill Grove parcel to sell, they did not lack resources, but it was becoming obvious to them that they would have to change their long-term plans. In May, Lucy's eighth month, Audubon returned to Philadelphia on business. He collected five chestnut-sided warblers at the beginning of the month "on a very cold morning near Potts-grove, in the State of Pennsylvania. There was a slight fall of snow at the time, although the peach and apple trees were already in full bloom." He collected a Kentucky warbler at Fatland Ford when he visited there to see Lucy's family and to discuss with her father selling the Mill Grove parcel.

Audubon returned to Louisville in time to join a swan-hunting expedition to the mouth of the Ohio—probably a hunting party organized by the men of the Shippingport French community—where he collected and drew both a male and a female solitary flycatcher (blue-headed vireo). Lucy probably had something to say about her husband traipsing off four hundred miles downriver when she was near term. She was not known to be shy at dressing Audubon down when he needed correction. Perhaps chastened, he was at her side when she bore their firstborn son, Victor Gifford Audubon, a handsome and healthy baby, at the Indian Queen on June 12, 1809. She was then twenty-two, John James twenty-four.

ALEXANDER WILSON

W HEN BENJAMIN BAKEWELL'S BUSINESS FAILED in the aftermath of the Jefferson embargo, he had seriously considered a change of career. "He has the mortification to find his past labors fruitless," his brother William had reported to Euphemia Gifford, "& that he must begin the world anew.... He seems to dislike engaging in a commercial life & proposes to become a cotton planter in the Southern or Western states, should he be able to manage the purchase of a plantation. If to deserve success was to command it he would not have failed, but you know him & I need not say more on this point." But Lucy's uncle had not in fact become a planter; with help from an English importer who was a personal friend, Thomas Kinder, one of the trustees appointed to oversee his failed business, he had reestablished himself in Pittsburgh manufacturing glass, and by late 1809 he was again prospering.

"The present business ... succeeds beyond our expectations," Bakewell wrote with relief that November. "The glass we make is nearly equal to what used to be imported from England, and we could sell much more than we can at present make." Thomas Jefferson had hoped his embargo would stimulate American enterprise, and in Benjamin Bakewell's case at least it had. But Bakewell's new business was constrained by the young nation's continuing lack of skilled labor: "Our principal inconvenience arises from the difficulty of obtaining workmen. We have only three who are glass-blowers & our furnace would not cost more if we had nine. We shall take some apprentices, but so much depends upon habit in the formation of the glass, that we do not expect to receive much advantage from them for some years." His son Thomas had recently joined the business; Bakewell hoped Thomas's training in chemistry could be applied to developing colored glasses, a new and potentially lucrative line.

The ice had just begun breaking up on the Monongahela in mid-February

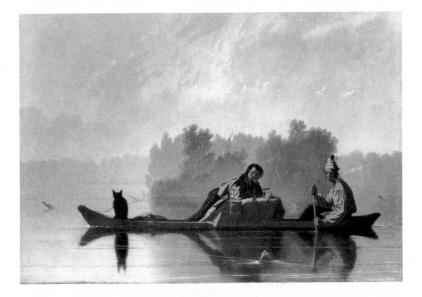

1810 when a lean, irascible forty-two-year-old Scotsman named Alexander Wilson arrived in Pittsburgh on the same stage that had taken the Audubons west from Philadelphia in 1808. Pittsburgh looked to this wanderer like "a collection of blacksmith shops, glass houses, breweries, forges and furnaces"; he thought a perspective view of the town "with the numerous arks and covered keel boats preparing to descend the Ohio, the grandeur of its hills and the interesting circumstance of its three great rivers—the pillars of smoke rising from its furnaces, glass works, &c. would make a noble picture." He soon found his way to Benjamin Bakewell's glass factory.

Wilson knew something about noble pictures. Among the few objects he was carrying on his long, solitary excursion through the frontier wilderness were the first two volumes of his lifework, *American Ornithology*. Volume two had just been published in Philadelphia the month before. Though he had no previous artistic or scientific training and was in fact a master weaver, Wilson had experience with publishing in his native country. His Burnsian comic ballad *Watty and Meg* had been a best seller—as many as 100,000 penny broadsides had been sold in Scotland and England in 1793—but when he turned to sharp political satire, attacking the new mills that were putting craft weavers out of work, he had encountered official hostility. Two years in a Paisley jail for what was judged to be extortion—he or someone close to him had sent a libelous satire to the mill owner who was its subject and demanded a five-

Alexander Wilson.
Portrait by Rembrandt Peale

guinea bribe to suppress its publication—had encouraged him to emigrate in 1794. In Scotland he had supported himself as an itinerant peddler and had come to know British birds on his long walks between villages and towns. On his arrival in America, walking up from Newcastle to Wilmington, Delaware, he had remarked the "flat woody country [that] looked in every respect like a new world to us from the great profusion of fruit that everywhere overhung our heads, the strange birds, shrubs, &c." The new century found him making a bare living as a schoolteacher at a school near Gray's Ferry on the Schuylkill downriver a few miles from Fatland Forge. At some point he had visited the nearby botanic garden of William Bartram, the American naturalist, and Bartram, then past sixty, had befriended him.

Bartram's celebrated *Travels* included illustrations of native birds among its flora and fauna. They certainly influenced, and may have inspired, Wilson's decision in 1804 to study and collect "all the birds in this part of North America" and to illustrate and publish a comprehensive ornithology. The melancholy but self-possessed Scotsman had proceeded to teach himself drawing as well as ornithology, sending his early bird drawings to Bartram for identification and correction. In Philadelphia he had taken his idea of publication to the best engraver in America—Alexander Lawson, a big, rawboned younger countryman. Lawson had turned him down because the project would be expensive and Wilson had no money, whereupon Wilson had even taught himself engraving, thinking to do that work himself. Eventually he found a publisher willing to support his grand project, and Lawson agreed to engrave Wilson's awkward but improving drawings. At Lawson's house Wilson found close friendship with Meriwether Lewis after Lewis returned from the Pacific—Lawson's daughter thought the two men similar in character, both quiet and observant. "I remember perfectly [Wilson's] brilliant eye," Malvina Lawson recalled, "and hair black as an Indian's, and as straight." Miers Fisher, the Quaker lawyer who advised Jean Audubon, had also befriended Wilson and supported his *American Ornithology* with multiple subscriptions.

Private subscriptions traditionally funded expensive works of natural history such as Wilson's. His projected ten volumes sold for $120, to be paid in

installments as volumes were received. Authors undertook the labor of finding subscribers, sometimes scouting customers while traveling to conduct whatever research was necessary to produce their books. Despite his almost antisocial reserve, Wilson was passing through Pittsburgh in the spring of 1810 to just such double purpose, building upon his experience as a peddler. "I began a very diligent search in the place the day after my arrival for subscribers and continued it for four days," he wrote Lawson. "I succeeded beyond expectation having got 19 names of the most wealthy and respectable part of the inhabitants. The industry of the town is remarkable; everybody you see is busy. . . . The glass [factories], of which there are 3, have more demands for glass than they are able to answer. Mr. Bakewell, the proprietor of the best, shewed [me] yesterday a chandelier of his manufacture highly ornamented . . . for which he received 300 dollars." Bakewell, knowing his nephew-in-law's passion for birds, almost certainly encouraged Wilson to look up Audubon when he got to Louisville.

Wilson had meant to walk next to Chillicothe, a distance of more than two hundred miles, but his new Pittsburgh acquaintances warned him that the road was impassable because of spring floods. Instead he bought himself a rowboat, which he christened *The Ornithologist,* waited a few days for the ice to break up and pushed off. "My stock of provisions consisted of some biscuit and cheese, and a bottle of cordial, presented me by a gentleman of Pittsburgh; my gun, trunk, and greatcoat occupied one end of the boat; I had a small tin, occasionally to bail her, and to take my beverage from the Ohio with; and bidding adieu to the smoky confines of Pitt, I launched into the stream. . . . The weather was warm and serene, and the river like a mirror except where floating masses of ice spotted its surface, and which required some care to steer clear of; but these, to my surprise, in less than a day's sailing, totally disappeared."

Floating and rowing down the Ohio, Wilson glimpsed the smoke of maple sugar camps rising above the forest and "grotesque log cabins" along the shore; passed broadhorns and arks crowded with families; endured exposure to rain, hail and snow; listened at night to the howling of wolves—an old squatter he met claimed he had lost sixty pigs to wolves and wildcats since Christmas— detoured to visit several Indian mounds and rowed up a creek to salty Big Bone Lick to examine mastodon bones and "the ancient buffalo roads to this great licking place." Near the lick he shot ducks and emerald-green Carolina paroquets. He skinned twelve of the big scarlet- and yellow-headed parrots, the only parrot native to North America, and built a makeshift cage for one he had wounded to tame as a traveling companion; it was soon eating the cockleburs he pulled to feed it, a favorite food. In Cincinnati he reviewed the contents of

an Indian mound with its excavator, the physician and educator Daniel Drake. Chasing turkeys on Saturday, March 17, he unintentionally delayed his arrival at the Falls of the Ohio until after dark, when the roar of the unfamiliar Falls made a night passage seem foolhardy. "I cautiously coasted along shore, which was full of snags and sawyers [i.e., uprooted trees stuck in the riverbed, hazards to passage], and at length, with great satisfaction, opened Bear Grass Creek, where I secured my skiff to a Kentucky boat, and, loading myself with my baggage, I groped my way through a swamp and up to the town." With his tamed paroquet squawking on his shoulder, he paid for a bed at the Indian Queen.

Wilson and the Audubons missed each other on Sunday, though they shared the same hotel; John James, Lucy and their baby may have been away visiting friends. Wilson meant to resume his walking tour after passing the Falls. Since he no longer needed *The Ornithologist,* he took time to find a buyer for it, but there was no shortage of boats in Louisville, and he got only half what he had paid for it in Pittsburgh. "The man who bought it wondered why I gave it such a droll Indian name. 'Some old chief or warrior, I suppose?' said he." Wilson's social and educational insecurities made him intolerant. On a walk down to Shippingport to inspect the Falls he noticed that Louisville had not yet drained its surrounding swamps, which even then people understood had something to do with the prevalence of fever. "Every man here is so intent on the immediate making of money," he speculated harshly, "that they have neither time nor disposition for improvements, even where the article health is at stake."

After "rambling round the town with my gun" on Monday morning dropping off letters of introduction, Wilson walked into Audubon & Rozier's with his two volumes in hand to see if the man to whom Benjamin Bakewell had recommended him was sufficiently interested in birds to buy a subscription. Audubon looked up from the table where he was working, noticed the visitor's "long, rather hooked nose, the keenness of his eyes, and his prominent cheekbones" and "thought I discovered something like astonishment in his countenance." Why Wilson should have been astonished, Audubon doesn't say; perhaps he was astonished that the man he understood to be an exceptional bird enthusiast and the proprietor of a general store was so young.

As Audubon told the story, Wilson proceeded to make his subscription pitch, "opened his books, explained the nature of his occupations, and requested my patronage." The young merchant was about to sign up when his partner checked him. "My dear Audubon," Rozier cautioned him in French, "what induces you to subscribe to this work? Your drawings are certainly far better, and again you must know as much of the habits of American birds as this gentleman." To Wilson's obvious disappointment Audubon put down his

pen. "Vanity and the encomiums of my friend prevented me from subscrib-ing," he explained his change of mind, adding that "even then my collection was greater than his." But in fact he would use Wilson's work in the years to come as a basic reference to identify unfamiliar birds; as successive volumes appeared he would sometimes have to hunt from town to town up and down the Mississippi Valley for copies, and must have regretted not subscribing when he had the chance. A more credible reason for Rozier's caution was the precarious state of their finances. Audubon & Rozier was within weeks of clos-ing its doors and moving downriver to what its proprietors hoped would be a better venue. One hundred twenty dollars was a considerable extravagance at a time when 36 cents bought a hot meal, and a night's lodging went for less than a dollar—it had cost the two French émigrés together only $5 more for cabin passage from Nantes to New York in 1806. Audubon's self-restraint is further evidence that he was not the irresponsible businessman his detractors have painted him to be. His pride would not allow him to cite financial embarrass-ment as the reason he changed his mind about subscribing to Wilson's ground-breaking work, however; even vanity was a better excuse.

Wilson's diary confirms what Audubon said happened next: "Mr. Wilson asked me if I had many drawings of birds. I rose, took down a large portfolio, laid it on the table, and shewed him . . . the whole of the contents, with the same patience with which he had shewn me his own engravings." Audubon reported that Wilson was surprised, and he probably was, but not for the rea-son Audubon thought, that "he never had the most distant idea that any other individual than himself had been engaged in forming such a collection." Benjamin Bakewell would have alerted Wilson to the quality and extent of Audubon's collection. Well-meaning people often tell artists and writers that a relative of theirs has work worth seeing, but undiscovered originals are even rarer than undiscovered birds. Prepared to see inferior work, Wilson was sur-prised that Audubon's was artistically superior. "Examined Mr. [Audubon]'s drawings in crayons," Wilson noted without rancor in his journal—"very good. Saw two new birds he had, both *Motacillae*." Two nondescripts, both fly-catchers, piqued Wilson's interest. Audubon says Wilson asked him if he meant to publish, "and when I answered in the negative, his surprise seemed to increase." Given the quality of Audubon's drawings, Wilson was probably also relieved. The visitor sat down to study his young competitor's work more closely, and they arranged to go birding together.

For the next several days the two men kept company. "I presented [Wilson] to my wife and friends," Audubon wrote, "and seeing that he was all enthusi-asm, exerted myself as much as was in my power to procure for him the speci-

mens he wanted. We hunted together, and obtained birds which he had never before seen." Their hunt on Tuesday took them to a cluster of ponds outside of town where cranes were nesting—whooping cranes, both men thought. Audubon told Wilson "that the white birds were the adults, and that the grey ones were the young," a mistake Wilson dutifully repeated in the eighth volume of his *Ornithology;* in fact the "grey ones" were sandhill cranes, the two species nesting together as they sometimes do. The mistake is venial, not mortal, an indication of the primitive state of ornithology; despite their occasional confusion, Wilson and Audubon knew more about American birds than any other naturalists of their day. On their hunt to the ponds they saw passenger pigeons as well; in December Audubon had collected and drawn one at the Falls.

Wilson approved of Audubon sufficiently to give him a manuscript copy of the *Synopsis* he had prepared as an advertisement for his *American Ornithology,* a convenient checklist of birds that Audubon kept at hand for decades. And Audubon approved of Wilson sufficiently to propose that they "open a correspondence . . . which I thought might prove beneficial to us both." He did more than that. "Thinking that perhaps he might be pleased to publish the results of my researches, I offered them to him, merely on condition that what I had drawn, or might afterwards draw and send to him, should be mentioned in his work, as coming from my pencil." Audubon's offer was extraordinary given the improving quality of his drawing. Wilson, the better writer at that point but a perpetual loner, had no intention of sharing whatever reputation and success his work might earn; he told Audubon dismissively, "I must *trudge* by myself." The words stung, but Audubon had observed Wilson's "retired habits," which he thought "exhibited either a strong feeling of discontent, or a decided melancholy," had listened to Wilson mournfully playing "Scotch airs . . . sweetly on his flute" at the Indian Queen, which had made even Audubon sad—"I felt for him," he recalled—and in any case he had a stagnant business to rescue and a wife and infant son to support. Nothing came of his offer.

By Friday Wilson was ready to move on. He said he "left my baggage with a merchant of the place"—given his week's activity, this must be Audubon—"to be forwarded by the first wagon; and set out on foot for Lexington, seventy-two miles distant." He had sold no subscriptions in Louisville. His intolerance took over when he sat down that night to summarize the visit in his journal. He had long complained of never having married or fathered children, as Audubon had, and from the perspective of his long-standing poverty Audubon's situation would have seemed prosperous. Bitterly he expunged the handsome, successful young Frenchman from his record:

March 23. . . . I bade adieu to Louisville, to which place I had four letters of recommendation, and was taught to expect much of everything there; but neither received one act of civility from those to whom I was recommended, one subscriber, nor one new bird; though I delivered my letters, ransacked the woods repeatedly, and visited all the characters likely to subscribe. Science or literature has not one friend in this place. Everyone is so intent on making money that they can talk of nothing else; and they absolutely devour their meals that they may return the sooner to their business. Their manners correspond with their features.

When Audubon read this journal entry many years later he was insulted, as who would not be? ("To have said that science or literature had not one friend there," he wrote then, "is as incorrect as to affirm that not one act of civility was shewn to him at Louisville is ungracious and unjust.") In 1810, in the wake of Wilson's departure, he felt he had helped, not hindered, his solitary visitor, and Wilson's program, Wilson's methods, Wilson's handsome volumes of birds drawn from life (but not life-sized) set a striking example of where his own burgeoning collection might carry him.

"LOUISVILLE DID NOT GIVE US UP," Audubon recalled of this time of transition in his life, "but we gave up Louisville." If there was too much competition in Louisville, Audubon also "longed to have a wilder range" for his birding. News arrived from Fatland Ford at the beginning of May 1810 that William Bakewell had succeeded in selling the Mill Grove bottomland parcel for $7,998.50—about $114,000 today—and had sent the proceeds to New York to cover the Audubon & Rozier account with Benjamin Bakewell's successors, the Kinder brothers. Lucy's father wrote that he "felt as if a great burthen was taken off my back now it is all finished"; so must the two young partners have felt relieved of their large commercial debt. Lucy as well; the Kinder brothers wanted her to sign a renunciation of any claim of dower to make the land title good, which she did. The partners and their clerk closed out their Louisville store, packed their remaining stock and their private possessions onto a flatboat and prepared to move farther downriver.

For Audubon's "wilder range" they chose a riverfront town on the edge of a pioneer settlement, Henderson, Kentucky, 125 river miles below Louisville at the junction of the Ohio and Green Rivers, upstream only 176 miles from Fort Defiance, where the Ohio merged with the Mississippi. "The country around [Henderson] was thinly peopled," Audubon remembered, "and all purchasable

provisions rather scarce." In the years immediately before the American Revolution, a North Carolina lawyer and land speculator named Richard Henderson had tried to buy most of what was now Kentucky from the Cherokee Indians, allying himself with Daniel Boone to exploit his claim. The Virginia House and Senate eventually voided the deal and compensated Henderson's land company with 200,000 acres around the Ohio-Green River junction. Henderson itself was founded in 1792. By 1800 it had a population of 205, but it had stalled commercially in the first decade of the new century, its population declining by 1810 to 159. Settlers unfamiliar with the fertility of grasslands had preferred the forested Green River margins to the prairies upstream, a region they called the Barrens or the Southside. When they learned of the high corn and tobacco yields a few pioneer squatters were achieving in the Southside, they removed there by the thousands. The Kentucky legislature accommodated them by passing homestead acts in 1795 and again in 1797. Rivers were their highways, however, and since it fronted on the Ohio, Henderson seemed to be well positioned to benefit from the increasing upriver settlement and to grow.

In the meantime, it was superb hunting and birding country. "Few as the houses were [in Henderson]," Audubon recalled, "we fortunately found one empty. It was a log *cabin,* not a log *house,* but as better could not be had, we were pleased. . . . Our neighbors were friendly, and we had brought with us flour and bacon-hams. Our pleasures were those of young people not long married, and full of life and merriment; a single smile from our infant was, I assure you, more valued by us than all the treasures of a modern Croesus would have been." The two partners divided the work of Henderson storekeeping according to their talents: Rozier minded the store while Audubon and Nat Pope hunted and fished. (Lucy, of course, cooked, cleaned, gardened, preserved food, made cloth and clothing and took care of her child.) Audubon remembered that their markup was high but their sales were small, and therefore "our guns and fishing-lines were the principal means of our support, as regards food." Later in life Audubon would be accused of neglecting his family and his business for birding, and his own tendency to portray himself as an aristocratic artist indifferent to commercial gain encouraged the misconception. In fact his hunting and fishing fed them all: "The woods were amply stocked with game, the river with fish; and now and then the hoarded sweets of the industrious bees were brought from some hollow tree to our little table. Our child's cradle was our richest piece of furniture, our guns and fishing-lines our most serviceable implements."

The cane is long gone from the shores of the Ohio. In Audubon's day the river bottomland above and below Henderson was one vast canebrake, the

clear river itself half a mile wide. Cane, the giant perennial grass *Arundinaria gigantea,* one of only two native American bamboos, grew in dense profusion ten to twenty feet high wherever the soil was rich and wet, with woody stems like corn and fernlike compound leaves that it shed in the spring when new leaves emerged. Birds nested in the cane; it sheltered deer and other wild game; settlers turned their cattle and hogs into it to graze as bison had grazed it in Daniel Boone's day.

"If you picture to yourself one of these canebrakes growing beneath the gigantic trees that form our western forests," Audubon wrote, "interspersed with vines of many species, and numberless plants of every description, you may conceive how difficult it is for one to make his way through it, especially after a heavy shower of rain or fall of sleet, when the traveler, in forcing his way through, shakes down upon himself such quantities of water, as soon reduces him to a state of the utmost discomfort. The hunters often cut little paths through the thickets with their knives, but the usual mode of passing through them is by pushing oneself backward, and wedging a way between the stems. To follow a bear or a cougar pursued by dogs through these brakes is [a difficult and dangerous task]." Farmers cleared the canebrakes for pasture by piling up the cane and burning it, and when the moisture between the cane joints turned to steam and burst the stems, "the sounds resemble discharges of musketry" that often frightened people floating by on the river.

Too restless to hold a rod, Audubon usually fished with a trotline. "As catfishes weigh from one to an hundred pounds, we manufactured a line which measured about two hundred yards in length, as thick as the little finger of some fair one yet in her teens . . . wholly of Kentucky cotton. . . . The main line finished, we made a hundred smaller ones, about five feet in length, to each of which we fastened a capital hook." For bait they used live frogs, "a hundred . . . as good as ever hopped." They tied one end of the trotline to a sycamore on shore, played out the baited lines and sank the other end far out in the river weighted with a heavy stone. The next evening they went out to check their lines:

> The heavens have already opened their twinkling eyes. . . . How calm is the air! The nocturnal insects and quadrupeds are abroad; the bear is moving through the dark canebrake, the land crows are flying toward their roosts, their aquatic brethren towards the interior of the forests, the squirrel is barking his adieu, and the barred owl glides silently and swiftly from his retreat, to seize upon the gay and noisy animal. The boat is pushed off from the shore; the mainline is in my hands; now it shakes; surely some fish has been

hooked. Hand over hand I proceed to the first hook. Nothing there! But now I feel several jerks stronger and more frequent than before. Several hooks I pass; but see, what a fine catfish is twisting round and round the little line to which he is fast! Nat, look to your gaff—hook him close to the tail. Keep it up, my dear fellow!—there now, we have him. More are on, and we proceed. When we have reached the end many goodly fishes are lying in the bottom of our skiff. New bait has been put on, and, as we return, I congratulate myself and my companions on the success of our efforts; for there lies fish enough for ourselves and our neighbors.

Once, when the white perch were running and Audubon was fishing for them with a rod, he had caught a large catfish instead. After he dragged it home he found a white perch in its stomach. "The perch had been lightly hooked, and the catfish, after swallowing it, had been hooked in the stomach, so that, although the instrument was small, the torture caused by it no doubt tended to disable the catfish. The perch we ate, and the cat, which was fine, we divided into four parts, and distributed among our neighbors." (In Audubon's Louisville days, his Shippingport friend Nicholas Berthoud supplied him with an even better fishing story: a catfish Berthoud caught on a trotline in the deep pool below the Falls of the Ohio that he opened in Audubon's presence proved to have swallowed a whole suckling pig.)

The Audubons planted a garden beside their log cabin, and while they waited for its produce there were wild harvests to collect: plums, grapes, black walnuts and pecans, berries of many kinds, pawpaw—the largest edible fruit native to America, mango-shaped, weighing as much as a pound, creamy as custard and tropically perfumed. Cane shoots made good pot herbs if sufficiently boiled.

With Rozier selling whiskey, gunpowder, linsey-woolsey and other common goods out of their log cabin and Nat Pope and John James hunting and fishing their food, Audubon's bird collection grew. That year he stopped using French for the captions of his drawings. He kept detailed field notes. On May 29, for example, having collected a king rail, he wrote that it was "an excessively shy bird, runs with great celerity; and when caught, cries like a common fowl." It weighed 11 ounces, was 20½ inches long, and its "alar extent"—the length of its wing feathers—was 22 inches.

In June he drew a red-winged starling (red-winged blackbird) and a male catbird. In July he drew an ivory-billed woodpecker—the largest of the woodpeckers, spectacularly handsome, big as a raven—then common, now sadly extinct. He associated the ivory-bill with the work of the Dutch artist Anthony

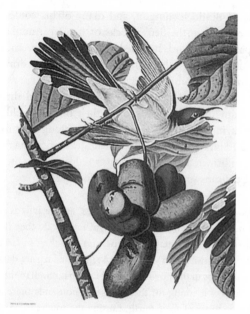

Pawpaw with yellow-billed cuckoo
in Audubon's mature style

Vandyke, perhaps especially Vandyke's well-known 1633 portrait of a red-haired, black-and-white-suited James Stuart. "The broad extent of its dark glossy body and tail, the large and well-defined white markings of its wings, neck, and bill, relieved by the rich carmine of the pendent crest of the male, and the brilliant yellow of its eye, have never failed to remind me of some of the boldest and noblest productions of that inimitable artist's pencil. So strongly indeed have these thoughts become engrafted in my mind, as I gradually obtained a more intimate acquaintance with the Ivory-billed Woodpecker, that whenever I have observed one of these birds flying from one tree to another, I have mentally exclaimed, 'There goes a Vandyke!' " He learned quickly to be wary handling it. "When taken by the hand, which is rather a hazardous undertaking, they strike with great violence, and inflict very severe wounds with their bill as well as claws, which are extremely sharp and strong. On such occasions, this bird utters a mournful and very piteous cry."

In August he drew a scarlet tanager. Through the summer he found white pelicans "so abundant that I often killed several at a shot, on a well-known sand bar which protects Canoe Creek Island." For this kind of hunting he used

a double-barreled flintlock shotgun, and many of his contemporaries also reported multiple kills in the dense flocks of the day. Audubon at least was studying and painting the birds he killed. He collected numerous specimens to observe variation and to find the best possible specimen to draw.

By Indian summer "a hundred heavy-bodied pelicans . . . ranged along the margins of the sandbar in broken array." They groomed their plumage by drawing their feathers one by one through their bills. "Should one chance to gape, all, as if by sympathy, in succession open their long and broad mandibles, yawning lazily and ludicrously." The forest canopy beyond the river had turned red and gold and brown and the placid river reflected the autumnal blaze. As the sun set, the pelicans stirred themselves to feed:

> Clumsily do they rise on their columnar legs, and heavily waddle to the water. But now, how changed do they seem! Lightly do they float, as they marshal themselves, and extend their line, and now their broad paddle-like feet propel them onwards. In yonder nook, the small fry are dancing in the quiet water, perhaps in their own manner bidding farewell to the orb of day, perhaps seeking something for their supper. Thousands there are, all gay, and the very manner of their mirth, causing the waters to sparkle, invites their foes to advance toward the shoal. And now the Pelicans, aware of the faculties of their scaly prey, at once spread out their broad wings, press closely forward with powerful strokes of their feet, drive the little fishes toward the shallow shore, and then, with their enormous pouches spread like so many bag-nets, scoop them out and devour them in thousands.

On October 28 the sandhill cranes arrived at the Long Pond, a slough back-water that drained into the Ohio. (Audubon called them sandhill cranes in his notes but still thought them to be a gray variant of the white whooping crane even though the whooper is distinctly larger and has black primaries; both are red-crowned.) He observed them from behind a large cypress tree as they dug in the mud "uncovering the large roots of the great water-lily, which often run to a depth of two or three feet. Several cranes are seen in the same hole, tugging at roots or other substance, until they reach the object of their desire, which they greedily devour." From his perspective, as they dug they seemed to bury themselves; they reminded him, he wrote, "of a parcel of hogs or bears at their wallowing spots, [and] I could plainly see the color of their eyes, which is brown in the young and yellow in the adult."

Audubon engaged birds with the intensity (and sometimes the ferocity) of a

hunter because hunting was the cultural frame out of which his encounter with birds emerged. In early nineteenth-century America, when wild game was still extensively harvested for food, observation for hunting had not yet disconnected from observation for scientific knowledge. Much of what seems contradictory in his narratives—learning birds, studying birds, concerning himself with their population dynamics and stresses but also killing birds for food and for sport, sometimes in great numbers—follows from this fact. To argue that he should have known better is anachronistic and nostalgic. Animals are killed today in far greater numbers—domestic animals slaughtered for food—but they are killed by hired workers behind closed doors.

So the climax of Audubon's encounter with sandhill cranes on Long Pond in November 1810 is dissonant, but no less thrilling in its sense of two species encountering each other across the immense space of difference that divides them: "After observing them as long as I wished, I whistled, on which they all at once raised their heads to see what the matter might be." A man hides behind a cypress tree barely thirty yards from hundreds of the big gray, red-crested, rooting birds, he whistles—and the sandhills all look up together in a coordinated ballet, their attentions focused on the source of the sound.

He fired at them then, disabling seven with a single charge. "Those which were in different holes farther off, all flew away, uttering loud cries, and did not return that afternoon." Now the hunter steps aside in the narrative and the naturalist comes forward: "In the course of a week these birds turned up the earth, and dug holes all over the dry parts of the ponds. As soon as heavy rains fill the pools, the cranes abandon them, and resort to other places." Biology emerged in the nineteenth century from the craft skills and observations of medicine, agriculture, hunting, domestic breeding and sport; in Audubon the emergence is evident within the experience of one singular and gifted individual.

FERDINAND ROZIER WAS unhappy in Henderson. The town was populated with Americans of English descent and Rozier, Audubon says, "spoke English but badly," which means he rarely got to talk. Shrewd but unsophisticated, he grated on Lucy's nerves. He was lonely. In his unhappiness he fixed on the idea of once more starting over, this time in a place more like home: Ste. Genevieve, a settlement that French trappers had founded in the 1720s below St. Louis on the Mississippi about one hundred miles north of the Ohio-Mississippi junction, near the Ozark lead-mining district. Audubon was willing to move across the Mississippi, as Daniel Boone had done before him, but "not being quite

sure that our adventure would succeed as we hoped," he arranged for Lucy and Victor Gifford, their toddler, to stay behind in Henderson until he could take the measure of the place.

By then Adam and Elizabeth Rankin, a physician and his wife who were leading Henderson citizens, had befriended the Audubons. The Rankins owned a farm with a spacious log house, Meadow Brook, three miles southeast of town. Elizabeth was Adam Rankin's third wife; the physician was twice a widower and the father of thirteen children. The Rankins were delighted to add Lucy to their family as a governess and tutor while her husband went off to reconnoiter the Louisiana Territory frontier.

In December 1810 the young partners hired a sixty-foot flatboat and had it loaded with barrels of whiskey, gunpowder and dry goods—stores they thought to sell for a good profit in Ste. Genevieve in midwinter. They expected an easy float down the Ohio, but hauling up the Mississippi a hundred miles against the current, rowing or towing—"cordelling"—would be arduous. When they realized they were risking the rivers freezing and barring their way, Audubon, Rozier, Nat Pope, Audubon's dog and their hired crew boarded the flatboat and cast off hurriedly a few days before Christmas 1810, the air over the chilling river heavy with snow.

BY FLATBOAT TO
STE. GENEVIEVE

THE FLATBOAT WAS "NEW, STAUNCH AND TRIM," Audubon recalled, with four bow oars for rowing and a sixty-foot steering oar made from a single slender tree trunk, but it was open to the weather except for a covered stern that served as a cabin, and the first night on board was dismal, the men huddled in their greatcoats under driving snow and sleet. By daylight the storm had ended and they could shake off the snow and look around. They found themselves opposite the mouth of the Cumberland River, 117 miles below Henderson, where "the Ohio River widens and becomes a truly magnificent stream bordered by vast trees." They had floated through the night at more than six miles an hour.

In another hour they passed the mouth of the Tennessee River and saw that a hard freeze had clamped down on the land. The severe cold "had frozen all the neighboring lakes and lagoons," sending "thousands of wild waterfowl . . . flying to the river and settling themselves on its borders." They did some shooting and floated more slowly in the lower river, making only fifty-three miles on the second day and night. By the third morning they had come to Cache Creek, a minor river with "deep water and a good harbor" that emptied into the Ohio from the northwest, six miles above the Ohio-Mississippi junction.

They turned into the Cache to join a keelboat anchored there. It carried a party of a dozen French-Canadian trappers led by Jules de Mun, whom Audubon calls a "French artist." Another Saint Domingue émigré and the grandson of a marquis, de Mun was also bound for Ste. Genevieve, coming up the Mississippi; from him they learned that the larger river, flowing colder water from its upper reaches, was thickly iced over and impossible to ascend.

Having raced the freezing of the Mississippi and lost, there was nothing for them to do but camp and await a thaw. The six miles of peninsula between the

Cache and the acute junction of the two rivers, rich alluvial bottomland that the rivers overflowed when they flooded, was "covered with heavy black walnut, ash and pecan trees, closely tangled canes and nettles that . . . in summer [grew] at least six feet high." The Cache was running full, filled with fish and crowded with migrating ducks, and on its banks the denuded white-barked sycamores that towered above the snow attracted noisy, flashing green flocks of Carolina paroquets—the stalked, buff-colored seed balls that hung from the bare trees like Christmas ornaments were another favorite food. Nearby, smoke rising from multiple fires, was an encampment of some fifty Shawnee Indian families who had come to harvest pecans and hunt deer, bear and raccoon.

Audubon was delighted to go out hunting with de Mun, a sportsman as indifferent to bad weather as the young artist. When the Shawnees learned of Audubon's willingness to barter knives, scissors and other useful implements for birds and unusual animals—he knew a few words of Shawnee, and some of the Indians spoke passable French—they helped him collect, shared lore and even set traps for small game. Rozier, a good businessman but "neither hunter nor naturalist . . . sat in the boat, brooding in gloomy silence over the delay."

Waking early on Christmas morning, "while I was straining my eyes to discover whether it was fairly day dawn or no," Audubon heard sounds of preparation from the Shawnee camp, gathered his gear and followed them to find a hunting party of men and women loading a canoe:

> I had heard that there was a large lake opposite to us where immense flocks
> of [trumpeter] swans resorted every morning, and asking permission to join

them, I seated myself on my haunches in the canoe, well provided with ammunition and a bottle of whiskey, and in a few minutes the paddles were at work, swiftly propelling us to the opposite shore [of the Ohio]. . . . On landing, the squaws took charge of the canoe, secured it, and went in search of nuts, while we gentlemen hunters made the best of our way through thick and thin to the lake. . . .

When the lake burst on our view there were the swans by hundreds, and white as rich cream, either dipping their black bills in the water, or stretching out one leg on its surface, or gently floating along. According to the Indian mode of hunting, we had divided, and approached the lagoon from different sides. . . . As the first party fired, the game rose and flew within easy distance of the party on the opposite side, when they again fired, and I saw the water covered with birds floating with their backs downwards, and their heads sunk in the water, and their legs kicking in the air. When the sport was over we counted more than fifty of these beautiful birds, whose [feathers] were intended for the ladies in Europe.

Averse to menial labor, the Shawnee hunters sounded a conch at the end of the day to draw the women from their pecan gathering to collect the swans. Across the Ohio and back at camp the women stirred up a supper of pecans fried in bear fat, the men settled down at their fires and the women worked through the evening skinning the birds. Making his rounds the next morning—he was always curious about the life of the world—Audubon noticed that one of the women had been delivered of twins during the night and none the worse for wear was busy tanning deerskins. "She had cut two vines . . . and made a cradle of bark in which the newborn ones were wafted to and fro with a push of her hand, while from time to time she gave them the breast."

Skillful at woodcraft and a good shot, generous with gifts and information, Audubon made friends easily in the wilderness. Three Shawnees invited him to join them on a bear hunt:

A tall, robust, well-shaped fellow assured me that we should have some sport that day, for he had discovered the haunt of one of large size, and he wanted to meet him face to face; and we four started to see how he would fulfill his boast. About half a mile from the camp he said he perceived his tracks, though I could see nothing; and we rambled on through the canebrake until we came to an immense decayed log, in which he swore the bear was. I saw his eye sparkle with joy, his rusty blanket was thrown off his shoulders, his

brawny arms swelled with blood, as he drew his scalping-knife from his belt with a flourish which showed that fighting was his delight.

Although the bear was hibernating, the Shawnee hunter revealed his opinion of a European's value as a backup by advising Audubon to climb a small tree, "because a bear cannot climb one, while it can go up a large tree with the nimbleness of a squirrel." Audubon took the judgment in good part and complied, while the two other Shawnees "seated themselves at the entrance [to the fallen tree], and the hero went in boldly. All was silent for a few moments, when he came out and said the bear was dead, and I might come down." The Indians cut a length of vine, crawled into the tree, looped the vine around the dead bear and dragged it out. "I really thought that this was an exploit," Audubon wrote. "Since then I have seen many Indian exploits, which proved to me their heroism." That Indians might be heroic was not a common opinion in Kentucky in 1810.

De Mun and his trappers disappear from Audubon's narrative in the course of these tales, leaving the two partners, Nat Pope and their flatboat crew. Did the de Mun party float back down the Mississippi to wait for the spring thaw? The Shawnees did, with pecans gathered and the game growing scarce, two weeks after Audubon's party arrived at Cache Creek. "They made up their packs, broke up their abodes, put all on board their canoes and paddled off" to ride the Mississippi down to the Arkansas, where they customarily made their winter quarters. Their example stirred discussion among the flatboat crew. Rozier, "my impatient partner," begged Audubon to "cross the bend and see if the ice was yet too solid for us to ascend the river."

So with two crewmen he pushed through the snow and cold to the Mississippi. If they followed the Cache upstream about six miles to where it rounded a bluff, they would have had to cross no more than eight miles of canebrake and bottomland to reach the big river. There they found that "the weather was milder, and the ice sunk so as to be scarcely perceptible." Encouraged, they followed the eastern Mississippi shoreline upriver another ten or eleven miles to a point on the bank opposite the promontory village and trading post of Cape Girardeau. Hailing across the river eventually produced a canoe that pushed off with a crew of seven. At its arrival on their side "a stout swarthy man" leaped ashore and introduced himself as the son of Louis Lorimier, the French-Canadian who had founded Cape Girardeau as a trading post in 1793 under commission from the Spanish Governor General of Louisiana. Lorimier had married a Shawnee princess, which explains the son's coloring. Audubon described their problem and young Lorimier "stated that he was ... a good

pilot on the river, and would take our [flat]boat up provided we had four good hands, as he had six. A bargain was soon struck; their canoe hauled into the woods, some blazes struck on the trees [to mark the location of the canoe], and all started for Cache Creek."

They spent the last night at the encampment making "tugs"—tow ropes— of bullhide and cutting and shaping oars, "and at daylight we left the creek, glad to be afloat once more in broader water. Going down the stream to the mouth of the Ohio was fine sport; indeed, my partner considered the worst of the journey over; but alas! when we turned the point, and met the mighty rush of the Mississippi, running three miles an hour, and bringing shoals of ice to further impede our progress, he looked on despairingly." Lorimier ordered the lines ashore. They left one man on board to steer. On shore "it became the duty of every man 'to haul the cordelle,' which was a rope fastened to the bow of the boat. . . . Laying the rope over [our] shoulders, [we] slowly warped the heavy boat and cargo against the current. We made seven miles that day up the famous river." Although Audubon was a slim man who weighed about 150 pounds, he had great endurance. "While I was tugging with my back at the cordelle," he recalled cheerfully of the laborious hauling, "I kept my eyes fixed on the forests or the ground, looking for birds and curious shells."

The next day they made ten miles. They had a sail on board, but the wind was ahead and the sail thus useless. Two more days they slipped and hauled along the shore. Audubon says he slept at night in his buffalo robes "as uncon- cerned as if I had been in my own father's house." Then Lorimier called a halt: "The weather became severe, and our [pilot] ordered us to go into winter quarters, in the great bend of the Tawapatee Bottom," which was still a good twenty miles below Cape Girardeau.

At Tawapatee "the waters were unusually low, the thermometer indicated excessive cold, the earth all around was covered with snow, dark clouds were spread over the heavens, and as all appearances were unfavorable we quietly set to work." They moored the big flatboat close to shore and began unloading. Some of the men felled large trees above the boat to make a temporary jetty to deflect the ice coming down the river. "In less than two days, our stores, bag- gage and ammunition were deposited in a great heap under one of the magnif- icent trees of which the forest was composed, our sails were spread over all, and a complete camp was formed in the wilderness." They packed a barrier wall of snow around the camp to block the wind and built a "huge fire that illumi- nated the forest," with "a flame that would roast you at the distance of five paces."

This turn of events deeply depressed Rozier, which Audubon found amus-

ing. "The sorrows of my partner . . . were too great to be described. Wrapped in his blanket, like a squirrel in winter quarters with his tail about his nose, he slept and dreamed away his time, being seldom seen except at meals." For Audubon, in contrast, "a new field was opened to me, and I rambled through the deep forests, and soon became acquainted with the Indian trails and the lakes in the neighborhood." The name Tawapatee probably derived from the Shawnee word for the North American elk, "wapiti," an animal that had once thrived in great numbers in the rich alluvial bottomland forests of the Mississippi, the Missouri, the Arkansas and their tributaries. One of those tributaries, the Osage, took its name from the dominant tribe of Native Americans that lived along its margins, and soon Audubon began to encounter Osages as well as Shawnees along the Tawapatee trails. They "gradually accumulated" around the flatboat camp, drawn by the novelty and the opportunity for gifts and bartered goods.

The Osages fascinated Audubon. He found them "well-formed, athletic and robust men, of a noble aspect, [who] kept aloof from the others. They hunted nothing but large game, and the few elks and buffaloes that remained in the country." When the first French explorers encountered the Osages in the seventeenth century along the Missouri River's tributaries they had been shocked by their size; at a time when the average European was five feet four, the average Osage male stood six feet tall, a consequence of the varied and healthy Osage diet of buffalo, venison, wapiti, river mussels, squash and corn. The Osages, who bathed in the river twice a day, had been shocked in turn by the French explorers' stink and had attributed it to the unnatural confinement of their clothing. They named the French the Heavy Eyebrows (and the English, who came along later wearing swords, the Long Knives) and coveted their metal, their horses and their guns. Though they were never modest, the Osages called themselves the Little Ones to keep a low profile before their gods.

"Being a new race to me," Audubon continued, "I went often to their camp, to study their character and habits; but found much difficulty in becoming acquainted with them. They spoke no French, and only a few words of English, and their general demeanor proved them to be a nobler race. . . . They stood the cold much better than the Shawnees, and were much more expert with bows and arrows." The Osages were a proud people. Their response to the continuing encroachments of the Europeans on their vast territory between the Arkansas and the Missouri west of the Mississippi had been not to adapt, as the Shawnees and the Cherokees did, but to intensify their religious practices and

thus to become more Osage. Not learning the Europeans' languages was part of that resistance. But as well as proud the Osage men were notably vain, and it was through their vanity that Audubon (no stranger to vanity himself) found a way to communicate: "They were delighted to see me draw, and when I made a tolerable likeness of one of them with red chalk, they cried out with astonishment, and laughed excessively." In the years to come, portraiture would support Audubon through a crucial transition; here in the early weeks of 1811 he was already finding it useful to establish his distinction and win allies.

Audubon and most of the rest of his party, Rozier excepted, occupied themselves with hunting, until "the surrounding trees began to look like butcher stalls." Their "cooking utensils formed no mean display, and before a week had elapsed, venison, turkeys, and raccoons hung on the branches in profusion. Fish, too, and that of excellent quality, often graced our board, having been obtained by breaking holes in the ice of the lakes. It was observed that the opossums issued at night from holes in the banks of the river, to which they returned about daybreak; and having thus discovered their retreat, we captured many of them by means of snares." Audubon also spent time "investigating the habits of wild deer, bears, cougars, raccoons and turkeys, and many other animals, and I drew more or less by the side of our great campfire every day." At night he and Nat Pope "chased wolves. . . . The beasts prowled on the river ice, crossing to and fro, howling and sneaking about the camp for bones."

Their bread gave out, "and after using the breast of wild turkeys for bread, and bear's grease for butter, and eating opossum and bear's meat until our stomachs revolted," he and Pope took off westward "in search of Indians with cornmeal." They allowed themselves the distraction of a deer hunt, hung the deer they shot in a tree, wandered around lost until nearly dark, struck an Indian trail, followed it until "many *shoe-tracks*" confused them, followed the tracks and found themselves circled back to their own camp, feeling stupid. Rozier, "finding that we had no wheaten loaves in our hands, and no bags of meal on our backs, said we were boobies; the boatmen laughed, the Indians joined the chorus, and we ate some cold raccoon, and stumbled into our buffalo robes, and were soon enjoying our sleep." The next day they tried again, found the river, hiked within sight of Cape Girardeau on the opposite shore, made a fire, ate dried bear (or, in another version of the tale, "pumpkin that had withstood the frost") and slept the night in an abandoned log cabin. "That night I wrote in my journal exactly as I do now," Audubon noted proudly in recollection.

Daylight revealed a wonderland, turkeys roosting in the trees, "the trees cov-

ered with snow and icicles, shining like jewels as the sun rose on them; and the wild turkeys seemed so dazzled by their brilliancy that they allowed us to pass under them without flying." Someone came canoeing across the river and carried back the message of their needs, and after an all-day wait they received "a barrel of flour, several bags of Indian [corn]meal and a few loaves of bread." They stashed the barrel, hung the meal bags in a tree "to preserve them from the wild hogs," impaled the loaves on their gun barrels and long after midnight delivered the bread and the good news to their camp mates. The next day four other men cobbled together a sledge and sledged the provisions over the snow to the camp.

They spent six weeks in all on Tawapatee Bottom. "The Indians made baskets of cane, Mr. Pope played on the violin, I accompanied with the flute, the men danced to the tunes, and the squaws looked on and laughed, and the hunters smoked their pipes with such serenity as only Indians can, and I never regretted one day spent there."

Late February took the adventure to dramatic climax:

> The waters had kept continually sinking, and our boat lay on her side high and dry. On both sides of the stream, the ice had broken into heaps, forming huge walls. Our pilot visited the river daily, to see what prospect there might be of a change. One night while, excepting himself, all were sound asleep, he suddenly roused us with loud cries of "the ice is breaking! get up, get up, down to the boat lads, bring out your axes, hurry on, we may lose her, here let us have a torch!" Starting up as if we had been attacked by a band of savages, we ran pell-mell to the bank. The ice was indeed breaking up; it split with reports like those of heavy artillery, and as the water had suddenly risen from an overflow of the Ohio, the two streams seemed to rush against each other with violence, in consequence of which the congealed mass was broken into large fragments, some of which rose nearly erect here and there, and again fell with thundering crash. . . . To our surprise, the weather, which in the evening had been calm and frosty, had become wet and blowy. The water gushed from the fissures formed in the ice, and the prospect was extremely dismal. When day dawned, a spectacle strange and fearful presented itself: the whole mass of water was violently agitated, its covering was broken into small fragments, and although not a foot of space was without ice, not a step could the most daring have ventured to make upon it. Our boat was in imminent danger, for the trees which had been placed to guard it from the ice were cut or broken into pieces and were thrust against her. It

was impossible to move her; but our pilot ordered every man to bring down great bunches of cane, which were lashed along her sides; and before these were destroyed by the ice, she was afloat and riding above it. While we were gazing on the scene, a tremendous crash was heard, which seemed to have taken place about a mile below, when suddenly the great dam of ice gave way. The current of the Mississippi had forced its way against that of the Ohio; and in less than four hours, we witnessed the complete breaking up of the ice.

With their flatboat afloat they hastened to load their cargo and abandoned their camp to the Osages and Shawnees—they "parted like brethren," Audubon recalled. Poling against the floating ice, they moved the boat upriver. The next bottom above Tawapatee was Bois Brulé, a name which river men had Americanized to "Bob Ruly." They decided Cape Girardeau was too small to be a market for their great load of goods, but Audubon had time to meet there and be impressed with his pilot's French-Canadian father, Louis Lorimier, as Meriwether Lewis had been when the Corps of Discovery had stopped at Cape Girardeau seven years before. Lorimier, sixty-three years old, was "not exceeding four feet six inches in height, and thin in proportion, looking as if he had just been shot out of a popgun." His nose, "a tremendous promontory, full three inches in length," was "hooked like a hawk's beak, and garnished with a pair of eyes resembling those of an eagle." His hair, plastered down with pomade, was drawn back into "a long *queue* rolled up in a dirty ribbon, which hung down below his waist"—another observer reported that Lorimier would use his braided hair as a whip to encourage his horse.

"The upper part of his dress was European," Audubon continues, "once rich but now woefully patched and dilapidated, with shreds of gold and silver lace here and there. The fashion of his waistcoat [was] as antique as that of his nose." He wore tight buckskins with "big, iron knee-buckles" to hold up "Indian hunting gaiters" and moccasins "of the most beautiful workmanship." Audubon notes that "his manners were courteous and polished" but doesn't say, perhaps didn't know, that Lorimier was illiterate. In Cape Girardeau "he was looked upon as a great general and was held in highest esteem."

Lorimier had been working for the British when he joined the Shawnee leader Blackfish's army that captured Daniel Boone and his saltmakers at Blue Lick in the winter of 1778. George Rogers Clark had avenged the raid in 1782— Boone had already escaped—by destroying Lorimier's Ohio trading post and nearly taking his life. The Spanish encouraged Lorimier to establish his Red

House trading post at Cape Girardeau to draw Indians to discourage Americans from crossing the Mississippi to settle, but the Louisiana Purchase had transferred ownership of the territory and here they were.

On upriver Audubon and his party hauled their flatboat, cordelling dangerously around the Grand Tower, "a noble and massive pyramid of rock" according to the contemporary traveler Timothy Flint, "rising perpendicularly out of the bed of the river, in which it forms an island." Audubon wrote that the "current rushes with great violence" around it, and opposite the high tower a bluff called Devil's Oven deflected another current inward, making the cordelling even more difficult—"but we passed on without accident." And finally they came to Ste. Genevieve, a mile up Gabourie Creek from the river.

"AN OLD FRENCH TOWN," Audubon called Ste. Genevieve. The houses had whitewashed mud walls and almost everyone spoke French. The Audubon & Rozier goods so laboriously hauled upriver found a favorable market, especially the whiskey, and what the partners had bought for 25 cents a gallon they sold for $2. Audubon was impressed to meet "the Frenchman who accompanied Lewis and Clark to the Rocky Mountains"—Toussaint Charbonneau, disappointed with farming on the Missouri on a tract of land William Clark had sold him and preparing to return to fur trading with one of his Snake wives, who was ill. Audubon mentions only Charbonneau; if the wife was Sacagawea he failed to list her, but he did say "I was delighted to learn from *them* many particulars of their interesting journey."

Timothy Flint would find "a considerable degree of refinement" in Ste. Genevieve. Audubon to the contrary thought the town "small and dirty." He was lonely and homesick: "I found at once it was not the place for me; its population was then composed of low French Canadians, uneducated and uncouth, and the ever-longing wish to be with my beloved wife and [child] drew my thoughts to Henderson, to which I decided to return almost immediately. Scarcely any communication existed between the two places, and I felt cut off from all dearest to me." Though he still spoke English with a heavy French accent, Audubon had probably stopped thinking in French and certainly had ceased thinking of himself as a Frenchman. He was married to a woman born in England; his son had been born in the United States; he was not yet legally a citizen of his new country but he already felt himself to be an American, and he was ready to go home.

Rozier, in contrast, liked Ste. Genevieve, where Audubon said almost contemptuously his partner "found plenty of French with whom to converse."

Audubon "proposed selling out to him, a bargain was made, he paid me a certain amount in cash, and gave me bills for the residue." After signing a quitclaim for their goods and any debts due them on April 6, 1811, Audubon set out on foot for Henderson.

ONCE MORE HE WAS ON HIS OWN. With his gun, his knapsack and his dog, he had himself rowed east across the Mississippi into Illinois Territory. "The weather was fine, all around me was as fresh and blooming as if it had just issued from the bosom of nature." He would have to walk about 165 miles, diagonally southeast across the Illinois prairie to the Ohio River ferry at Shawneetown. It would be a harder walk than he expected: "[As] soon as I had left the river lands and reached the prairies, I found them covered with water, like large lakes." He had no intention of retreating to Ste. Genevieve, however. "The thoughts of my Lucy and my boy made me care little what my journey might be. Unfortunately I had no shoes, and my moccasins constantly slipping made the wading extremely irksome; notwithstanding, I walked forty-five miles and swam the Muddy River." Forty-five miles in, say, twelve hours is almost four miles an hour, a mile every sixteen minutes wading ankle-deep in cold water over slippery wet grass: throughout his life Audubon would always be a phenomenal walker, on good roads managing even a series of eight-minute miles, walking as fast as many people run.

He passed only two cabins that first day and amused himself watching deer wading the flooded prairie as he was, nervously flicking their white tails. The prairie was scattered with buffalo skulls, white bones with black horns that barely broke the foot-deep water, harbingers of the greater slaughter yet to come farther west. Squatters in what sounds like a dugout—"a mound covered with trees through which a light shown"welcomed him at the end of the day: "while the lads inspected my fine double-barreled gun, the daughters bustled about, ground coffee, fried venison, boiled some eggs and made me feel at home." He slept on a bearskin; the woman of the house served him breakfast, and since offering to pay for frontier hospitality would be an insult, he "gave each of the boys a horn of [gun]powder—a rare and valuable article to a squatter in those days."

The second day he walked through woods where "many small crossroads now puzzled me," but he made forty-five miles and dined and slept that night with an Osage hunting party that was already up and gone when he woke the next morning. By four o'clock he had reached the first salt well outside Shawneetown; in thirty minutes more he found Henderson friends come to

buy salt hailing him at the Shawneetown inn. The United States government owned the salt wells, which drew the same opalescent, sulfurous brine from the water table as the nearby Saline River. Leased to private operators, the wells were worked by slaves rented from slave owners in Kentucky, the brine piped to broad boiling pans set over fires at the edge of the forest that supplied the firewood. A ferry ride and one more day of walking and Audubon was home at the Rankins' "with my wife beside me, my child on my knee." Lucy had celebrated her twenty-fourth birthday on January 18 while he was away; a few weeks after her husband rejoined her he turned twenty-six, his years and the April date coinciding.

Though he probably saw it at night over the Illinois prairie, Audubon never mentioned the Great Comet that first appeared low in the southern sky that April 1811 and moved north and brightened through the summer and fall. The significant events he chose to record were more often bird sightings and collections than comets or politics. On May 7 he collected and drew two males of a species he called the carbonated warbler, never seen again, a speckled yellow-breasted bird with brown primaries and white wing coverts, possibly young Cape May warblers; they were searching for insects in a blooming dogwood tree. On May 22 he drew a green-crested flycatcher and a pewee on the same sheet. The next day he drew a bank swallow, the smallest of the swallows, and early in June a Carolina paroquet.

He visited the Kentucky Barrens upriver from Henderson in June and was surprised at their prairie lushness: "Flowers without number . . . sprung up amidst the luxuriant grass; the fields, the orchards, and the gardens of the settlers, presented an appearance of plenty, scarcely anywhere exceeded; the wild fruit-trees, having their branches interlaced with grapevines, promised a rich harvest; and at every step I trod on ripe and fragrant strawberries." On the Barrens in the early mornings and at dusk he pursued what became his annual study of the pinnated grouse—the greater prairie-chicken—"heard its curious boomings, witnessed its obstinate battles, watched it during the progress of its courtships, noted its nest and eggs, and followed its young until, fully grown, they betook themselves to their winter quarters." The grouse was so abundant in those days, he remembered long afterward when it had become scarce, that it was scorned; it would enter farmyards and "feed with the poultry, alight on the houses, or walk in the very streets of the villages."

The summer of 1811 was the hottest in memory, bringing a drought that burned out crops. There were other oddities that year besides the Great Comet: a lemming-like southern migration of squirrels that drowned by the thousands trying to cross the Ohio, and in late September a solar eclipse. The first

steamboat on the Western waters, the 371-ton *New Orleans,* 26 feet wide, 140 feet long and painted sky blue, left Pittsburgh in September on its maiden voyage to its namesake city; when it approached Louisville after dark on October 1 in a bluster of steam, smoke and sparks, the unlettered concluded that the comet had fallen into the river. The Audubons had been there since midsummer, staying at the Indian Queen and visiting friends while Audubon explored business opportunities. They had intended to go on to Pennsylvania to visit Lucy's family at Fatland Ford—her father had not yet seen his first grandchild—and to look into collecting on Francis Dacosta's Mill Grove mortgage, but news had come that her brother Tom was traveling west to Louisville on his way to New Orleans and had a business proposal for them. "We determined to wait . . . for him," Lucy reported, "that we might not miss each other" on the road. Swimming, horseback riding, Audubon hunting and birding, they waited through the summer and into early fall.

The New Orleans, *the first steamboat on Western waters*

BIRDS IN FLIGHT

TOM BAKEWELL FINALLY ARRIVED in Louisville in September 1811. After working for the Kinders in New York for the past three years he had proposed to receive consignments independently from a company of Liverpool merchants, Martin, Hope & Thomley; waiting for confirmation of this arrangement from England had delayed him. He hoped to open a commission business in New Orleans selling Liverpool goods and buying cotton, and he wanted Audubon for a partner: "The French qualities of Mr. A. in language & nationality, it was thought [would] be an advantage in so Frenchified [a] place as New Orleans," he explained, "& [we] concluded that Mr. A. should join me there [in] the new house of Audubon & Bakewell." Audubon's French background may have been one reason Lucy's brother solicited his partnership, but the money he might invest was certainly also important. During the next year Audubon would send his brother-in-law "almost all the money I could raise." To confirm their connection the two new partners had address cards printed up in Louisville: *Audubon & Bakewell, Commission Merchants, New Orleans.*

From Louisville Bakewell traveled on to New Orleans to get started while Audubon trekked out to Ste. Genevieve once again to try to collect on his former partner's bills. Rozier was unable to pay him in full because his spare funds had been invested in a nearby lead mine. Audubon took what he could get— not much.

Dissolving one partnership and negotiating another had thus consumed half a year, most of it spent traveling or waiting. Such tedious delay was typical of business transactions in an era that lacked rapid communications. Far from neglecting his business for hunting and bird collection, Audubon, always enterprising, used those activities productively to fill days that otherwise would have been idle.

Fatland Ford, c. 1897

When he returned to Louisville at the end of October he found a letter from Lucy's uncle Benjamin complaining that Audubon & Rozier still owed him $55. Audubon wrote his former partner asking him to send his share directly to Bakewell; he would settle his debt when he got to Pittsburgh. Finally, on November 4, 1811, he, Lucy and two-year-old Victor Gifford set out to cross the mountains eastward to winter at Fatland Ford, encouraged by the prospect of making a fresh start in New Orleans in the spring.

"We were on horseback and Gifford rode before his Papa all the way," Lucy proudly wrote her cousin Euphemia Gifford afterward. "Now the difficulties and fatigue are over I can scarcely realize that I have rode on horseback nearly eight hundred miles." Their route took them southeast to Lexington in the Bluegrass region of central Kentucky, then northeast into forested Ohio through Chillicothe and Zanesville to Wheeling and from Wheeling up to Pittsburgh, a route of flat rich woodlands where Lucy noted "some cultivated farms which diversify the scene a little," but the "chief part of the road is through thick woods, where the sun scarcely ever penetrates."

Traveling in cold November and even getting wet fording rivers, Lucy knew her cousin would "easily conceive I must have suffered from cold and fatigue considerably at that season, but the prospect before me of seeing my family and friends after an absence of nearly four years buoyed my spirits, and enabled me to endure more than in any common cause I perhaps should have done." They warmed and rested for four days in Pittsburgh with Lucy's uncle and aunt.

Despite the weather, traveling on horseback made sense at a time when the roads were barely passable by carriage. Lucy was probably remembering the coach accident on her emigration west when she reported that the roads from Pittsburgh to Philadelphia were still "really most dreadful . . . at all seasons of the year and a continued shelving of rocks and stumps or roots of trees." The entire journey from Louisville to Philadelphia took them twenty-four days. Audubon left a rare record of how travelers at that time sustained their living transportation along the way:

> I rose every morning before day, cleaned my horse, pressed his back with my hand, to see if it had been galled, and placed on it a small blanket folded double. . . . The surcingle [a belt strapped around a horse's belly to hold packs], beneath which the saddle-bags were placed, confined the blanket to the seat, and to the pad behind was fastened the great coat or cloak, tightly rolled up. The bridle had a snaffle bit [a simple crosspiece a horse takes in its mouth to secure its bridle]; a breastplate was buckled in front of each skirt, to render the seat secure during an ascent; but my horse required no crupper [a strap that loops under a horse's tail to prevent the saddle from slipping forward during a descent], his shoulders being high and well-formed. On starting he trotted off at the rate of four miles an hour, which he continued. I usually traveled from fifteen to twenty miles before breakfast, and after the first hour allowed my horse to drink as much as he would. When I halted for breakfast, I generally stopped two hours, cleaned the horse and gave him as much corn blades as he could eat. I then rode on until within half an hour of sunset, when I watered him well, poured a bucket of cold water over his back, had his skin well rubbed, his feet examined and cleaned. The [feed] rack was filled with [corn] blades, the trough with corn, a good-sized pumpkin or some hens' eggs, whenever they could be procured, were thrown in, and if oats were to be had, half a bushel of them was given in preference to corn, which is apt to heat some horses. In the morning, the nearly empty trough and rack afforded sufficient evidence of the state of his health.

The scarcity of oats indicated the frontier conditions of local fields: settlers typically girdled trees to kill them to open up a field, after which corn could be planted in mounds, Indian-style; but the bare dead trees left standing made it difficult to plow and till sufficiently to plant grain even if the settler had an ox or a plow horse, which most did not.

The Audubons dismounted at Fatland Ford around the end of November. Lucy found her sisters Sarah and Ann "very much grown since I left them." Eliza, closer in age to Lucy, was temporarily blind in one eye from a condition that treatment fortunately appeared to be improving. Eliza had just rejected a suitor she doubted would make her happy. If William Bakewell seemed worn and aged, he and his second wife Rebecca were well. Lucy's youngest brother Will, now eleven, was especially happy to see his much-admired brother-in-law.

Audubon had not forgotten Alexander Wilson, and in early December he rode into Philadelphia to look him up. After Wilson left Louisville in 1810, he had traveled down to Natchez and New Orleans drawing and collecting, parrot in tow, before returning by sea from New Orleans to New York—losing his parrot overboard a few days out. On the Natchez Trace, the five-hundred-mile ridgeline trail from Natchez to Nashville laid out by pre-Columbian Native Americans for their trade, he had stopped at a place called Grinder's Stand. His friend Meriwether Lewis had died there on October 17, 1809. In the same room where Lewis expired, Wilson had elicited Mrs. Grinder's testimony to his last hours, the only contemporary account of that loss. (Lewis had shot himself in the head and chest and then tried to cut his own throat in a fit of disoriented severe depression symptomatic of neurosyphilis.) Now Audubon found Wilson drawing a "White-headed Eagle" at Peale's Museum, using as a model the popular display of a stuffed bald eagle perched on a stone with a catch of fish under one foot. Audubon either joined Wilson at drawing the Peale display on this occasion or drew it later; the engravings subsequently made and published from their drawings do not match each other, but in both the birds are similarly posed. The point is important because Audubon would be accused of copying his eagle from Wilson's. Though both men made field collections of bald eagles in the course of their research, both appear to have depicted the Peale Museum's display in their published engravings.

Wilson received him civilly, Audubon recalled, and took him along to Rembrandt Peale's new exhibition room. One of several sons of the museum founder named after famous artists, thirty-three-year-old Rembrandt Peale had recently returned from training and working in Paris and had converted a former Walnut Street stable into what he called Rembrandt's Picture Gallery. The exhibition Wilson took Audubon to see included Peale's panoramic *Napoleon Crossing the Alps,* as well as a life portrait of Napoleon, whom Audubon admired. Despite his civil collegiality, Wilson pointedly said nothing further about birds or drawings to Audubon. The younger artist took the hint:

"Feeling, as I was forced to do, that my company was not agreeable, I parted from him; and after that I never saw him again."

At Mill Grove Audubon inspected Dacosta's lead mine, which looked neglected. Dacosta had made no money on the mine, ruling out at least for now another source of funds to invest in Audubon & Bakewell. "I am very much afraid that we will never get anything out of this bad bargain," Audubon wrote Rozier on December 9. Lucy's father had indulgently agreed to help Tom set himself up in New Orleans, however, so the new partnership would be adequately capitalized. Lucy's stepmother was less than friendly—she nursed various grievances, financial and personal, against her husband's children as well as Audubon—and by the time he wrote Rozier, Audubon had already decided to minimize the friction at Fatland Ford by going on alone to New Orleans. Once the partnership was established he could return to gather up his family.

He was proud of the sturdy horse he had ridden east from Henderson and now was riding again west. It was a bay Spanish barb he had bought in Henderson from a man named Barrow, who had acquired it in turn newly caught from the Osages living around the upper Arkansas River and ridden it home from beyond Natchez unshod. After Audubon had test-driven the large-headed, broad-chested animal by jumping it, riding it through a challenging swamp, swimming it in the Ohio and shooting from the saddle, he had paid $50 in silver for it and named it Barro.

At the crossings of the Juniata River, in western Pennsylvania near Bedford, Audubon encountered a wealthy Continental entrepreneur with international connections named Vincent Nolte who was on his way to New Orleans on a $300 horse, with a servant riding behind him leading a second high-priced mount. When Audubon made bold to praise Nolte's horse, the Italian-born German "not very courteously observed that he wished I had as good a one." They discovered they were both planning to stop in Bedford for the night. Audubon asked Nolte when he expected to arrive. "Just soon enough to have some trouts ready for our supper," Nolte told him, "provided you will join [me] when you get there." Audubon's horse pricked up its ears, he claimed, length-ened its pace, and carried its rider to the inn far enough ahead of the competition to allow him time to order the trout, put Barro away and stand at the door ready to gloat a welcome when Nolte finally arrived.

Probably because his expensive horse lost the race, Nolte remembered the meeting differently. He had crossed to New York from Liverpool that year in stormy September, the ship losing two masts along the way—he attributed the storms in part to the Great Comet, which he believed had also "beneficially

affected the vintage on the Rhine"—had sent a young associate ahead to Pitts-burgh to purchase two flatboats for the float down to New Orleans and then had set out on horseback from Philadelphia in December at about the same time as Audubon. After crossing Laurel Mountain one very cold morning he had stopped for breakfast "at a small inn, close by the Falls of the Juniata River," and the landlady had asked him to share a table with "a strange gentleman" whom she had already seated:

> The latter personage . . . struck me as being what in common parlance is called an odd fish. He was sitting at a table before the fire with a Madras handkerchief wound around his head exactly in the style of the French mariners, or laborers, in a seaport town. I stepped up to him and accosted him politely with the words, "I hope I don't incommode you by coming to take my breakfast with you." "Oh no sir," he replied with a strong French accent that made it sound like "No, sare." "Ah," I continued, "you are a Frenchman, sir?" "No, sare," he answered, "hi emm an Heenglishman." "Why," I asked in return, "how do you make that out? You look like a French-man, and you speak like one." "Hi emm an Eenglishman, becas hi got a Heenglish wife," he answered. Without investigating the matter further, we made up our minds at breakfast to remain in company and to ride together to Pittsburgh. He showed himself to be an original throughout, but at last admitted that he was a Frenchman by birth and a native of La Rochelle. However, he had come in his early youth to Louisiana, had grown up in the sea-service and had gradually become a thorough American. "Now," I asked, "how does that accord with your quality of Englishman?" Upon this he found it convenient to reply, in the French language, "When all is said and done, I am somewhat cosmopolitan; I belong to every country." This man . . . was Audubon.

Audubon in a bandanna and with a heavy French accent are credible con-temporary views, but the repartee between the two men, if authentic, surely reveals Audubon pulling Nolte's leg: a La Rochelle nativity, a childhood in the sea service—Audubon was playing at being a sailor that day. A few inns later Nolte has Audubon springing up from breakfast, exclaiming in French, "Now I am going to lay the foundation of my establishment" and nailing one of his New Orleans address cards to the tavern door. Nolte understood that Audubon & Bakewell would deal in pork, lard and flour and concluded privately "that competition of this nature could not amount to much."

The cosmopolitan German and the flamboyant French-American parted

company in Frankfort in January 1812 after Audubon had caught a ride from Pittsburgh to Cincinnati on Nolte's flatboats and the two had journeyed together on horseback from Cincinnati to the Kentucky capital, where Nolte heard "a great deal of talk about a highly-gifted lawyer" who had "distinguished himself in the taverns and streets" during the recent Congressional elections "by all sorts of brawls and fisticuff battles"—thirty-five-year-old Henry Clay, soon to be elected Speaker of the U.S. House. Nolte and Audubon would meet again, to Audubon's great good fortune.

Soon after this comedy of horses and inns, a little after two o'clock in the morning on December 16, 1811, the first of three massive sequences of earthquakes centered near New Madrid in the Missouri Territory bootheel on the Mississippi River, about forty miles below Cape Girardeau, shook the North American continent. The "shakes" or "rockings," as contemporary newspapers called them, were felt from northern Canada to the Gulf and from the East Coast to the Rockies; in modern terms all three major quakes would have registered well above 8 on the Richter scale and two out of three closer to 9. Many

The great earthquakes of 1811–12
destroyed much of New Madrid, Missouri Territory

lesser shocks were also damaging. An engineer in Louisville using an early form of seismograph he had invented counted 1,874 shocks up to March 15. Twelve of these besides the major three were felt as far away as Washington, D.C., and two of the twelve probably also measured above Richter 8. Both Audubon and Nolte recorded their experiences of quakes on January 23 and February 7, after they had gone their separate ways. Benjamin Bakewell on December 22 reported to Derbyshire both the earlier departure from Pittsburgh of the first steamboat, the *New Orleans,* and the first quakes:

> We have had an interesting object in this place lately which if it succeeds will be of great importance to it. It is a boat burthen 400 tons pulled by steam which proceeds at the rate of 5 or 6 miles per hour against a current of 3 miles per hour. We have also a great mill turned by steam which succeeds very well.
>
> We were a little alarmed last week by 2 shocks of an earthquake which were very sensibly felt in some parts of the town & the adjacent country. None of our family were sensible of it.

The first big shock had lasted about four minutes; the second, which occurred at about seven a.m. and was even bigger, about ten minutes. It seems the Benjamin Bakewells were sound sleepers.

The *New Orleans* had been waiting at Louisville for the Ohio to rise sufficiently to allow it to pass over the Falls. It had done so successfully on December 15 and was anchored at Shippingport when the earthquakes began. The builder, Nicholas Roosevelt, had intended to travel at night to demonstrate the advantage of steam power, but the continuing earthquakes changed all the Mississippi river markers and confused the pilot, and once on the Mississippi the *New Orleans* prudently tied up after sundown. It passed safely through the earthquake zone around New Madrid and reached Natchez on January 2, 1812.

The quakes rocked cradles and rang church bells in the Ste. Genevieve area. The New York physician Samuel Latham Mitchill, compiling a detailed narrative, heard from a Henderson resident that "We had to flee from our houses. Several chimneys were thrown down, and many others so wrecked and cracked as to be very dangerous."

Around New Madrid fissures opened in the earth; some of them, when they clapped shut, threw jets of sand, water and mud higher than the treetops. One fissure ejected a fossil skull of an unknown species of ox. The ground undulated and trembled; there were waterspouts and sand blows—funnel-like cir-

cular subsidence holes, some of them fifty or more feet across, that swirled open and blew sand into the air. "The houses of brick, stone and log are torn to pieces," the *New York Evening Post* reported, "and those of frame thrown upon their sides. The ground near [New Madrid] has sunk so low that the tops of the tallest trees can hardly be seen above the water." There was extensive flooding. Much of the town was shaken down and swept into the Mississippi. Trees swayed, beat together and fell by the thousands; more than two hundred square miles of forest was destroyed.

The banks of the Mississippi gave way in thousand-foot-long chunks of soil and timber, producing swells like tidal waves that made many think the river had reversed its course. Fully loaded boats floated by with their entire crews swept away and drowned. Other boats were thrown up onto shore or smashed by trees that fell with the falling riverbanks. Floating trees and dirty foam covered the river.

Audubon remembered an afternoon encounter while he was riding through the Kentucky Barrens—probably one of the major aftershocks on January 23, when he was returning to Henderson from Pennsylvania. He noticed the sky darken, heard a distant rumbling and spurred his horse, hoping to find shelter against what he thought was an approaching storm. His horse knew better. It slowed to a walk, placing its feet as carefully "as if walking on a smooth sheet of ice." Audubon thought the animal had foundered and was about to dismount when

> He all of a sudden fell a-groaning piteously, hung his head, spread out his four legs as if to save himself from falling and stood stock still, continuing to groan. I thought my horse was about to die, and would have sprung from his back had a minute more elapsed, but at that instant all the shrubs and trees began to move from their very roots, the ground rose and fell in successive furrows, like the ruffled waters of a lake, and I became bewildered in my ideas, as I too plainly discovered that all this awful commotion in nature was the result of an earthquake.

Several other riders, including Vincent Nolte, described similar experiences with their horses and momentary disorientation.

"Shock succeeded shock almost every day or night for several weeks," Audubon continued, adding characteristically that "I for one became so accustomed to the feeling as rather to enjoy the fears manifested by others." One manifestation of those fears was a return to religion. The Great Awakening that

had opened at the beginning of the nineteenth century with an outdoor revival in the Green River country upriver from Henderson had slowly declined across the decade, but during and after the earthquakes people flocked again to revivals. In the states and territories that constituted the earthquake zone the number of Methodists increased from 31,000 in 1811 to 46,000 in 1812, when the increase outside the zone was only one percent. Baptist conversions similarly soared—"Baptists are all *shakers*" anyway, one wag said. Skeptics called these converts "earthquake Christians" and predicted correctly that many of them would backslide after the earthquakes stopped.

Native Americans responded with similar concerns. A captive of the Osages at the time of the quakes, John Dunn Hunter, reported, "The Indians were filled with great terror, on account of the repeated occurrences of violent tremors and oscillation of the earth; the trees and wigwams shook exceedingly; the ice which skirted the margin of the Arkansas river was broken in pieces, and most of the Indians thought that the Great Spirit, angry with the human race, was about to destroy the world." Since the Audubons had agreed early in their marriage never to discuss politics or religion, they left little record of their religious beliefs, but John James's cool schadenfreude suggests he judged the quakes to be natural events rather than supernatural portents.

The first New Madrid earthquake on December 16 loosened the ice on the Ohio and opened the river again to travel. Nolte rode hurriedly to Shipping-port to take advantage of the open water, had his flatboats reprovisioned and recommenced his float. He reached New Madrid on February 6 and, curiously, sat up late drawing a caricature of James Madison in a general's uniform taking orders from his wife Dolley. "It was said that [Madison] was under petticoat government," Nolte explained. He costumed Dolley Madison salaciously in military dress, including red tights such as Jefferson was rumored to have brought home from Paris after his tour of duty as U.S. Ambassador to France:

> I had just given the last touches to the somewhat dilapidated red hose when there came a frightful crash, like a sudden explosion of artillery, and instantly followed by countless flashes of lightning; the Mississippi foamed up like the water in a boiling cauldron, and the stream flowed rushing back, while the forest trees near which we lay came cracking and thundering down. This fearful spectacle lasted for several minutes . . . and seemed as if [it] would never end. . . . I clambered up to the roof of our boat. What a spectacle! Our flats were indeed still floating, but far away from the shore

where we had moored them at nightfall. The agitated water all around us, full of trees and branches, which the stream, now flowing in its proper current, was rapidly sweeping away, and a light only here and there visible from the town—in short, a real chaos. . . . At sunrise the whole terrible scene was disclosed to our gaze, and the little town of New Madrid, sunken, destroyed, and overflowed to three-fourths of its extent, lay more than five hundred paces from us, with some of its scattered inhabitants here and there visible among the ruins. Our boats were fixed in the middle of an island formed by fallen trees, and several hours passed before the crew could cut a passage for them and get them out.

Only the sparse population of the earthquake region spared the country a calamitous human disaster.

That February 1812 Audubon hiked once more to Ste. Genevieve to attempt another collection from Rozier, crossing the Illinois prairie with an Osage hunting party. Rozier owed him $1,000, but he was not yet prepared to pay it. Back in Henderson, word came from Tom Bakewell in New Orleans that the impending war with England, which Madison had been expecting since November, had made it impossible so far for him to establish their partnership. Audubon decided to return to Pennsylvania to rejoin Lucy and Victor. Before he left he attended a wedding at the Rankins' that one of the many earthquakes made especially memorable. After the wedding ceremony, supper and an evening of dancing, everyone had gone to bed. "We were in what is called, with great propriety, a *Log-house,* one of large dimensions, and solidly constructed." The earthquake struck in the dark hours before dawn:

> Fear knows no restraints. Every person, old and young, filled with alarm at the creaking of the log-house, and apprehending instant destruction, rushed wildly out to the grass enclosure fronting the building. The full moon was slowly descending from her throne, covered at times by clouds that rolled heavily along, as if to conceal from her view the scenes of terror which prevailed on the earth below. On the grass-plat we all met, in such condition as rendered it next to impossible to discriminate any of the party, all huddled together in a state of almost perfect nudity. The earth waved like a field of corn before the breeze; the birds left their perches, and flew about not knowing whither; and the Doctor [i.e., Adam Rankin], recollecting the danger of his [bottles of medicines], ran to his shop room to prevent their dancing off the shelves to the floor . . . with so little success, however, that before the shock was over he had lost nearly all. . . .

The shock at length ceased, and the frightened females, now sensible of their dishabille, fled to their several apartments.

Audubon reached Fatland Ford in time for the spring migrations. On March 12 he drew a swamp sparrow. Lucy may have collected it for him, since he later uniquely attributed the drawing to her. On April 22 he drew a spotted sandpiper and a yellow-rumped warbler. Three days later he shot a small male hawk "whilst in pursuit of a Dove, which it would doubtless have secured, had I not terminated its career." It was in fact a pigeon hawk, a merlin, a bird Audubon knew, but the specimen's unusual gray back and gray-and-black-striped tail feathers misled him into believing that he had discovered a new species. Napoleon was on his way to Russia at the time—"in the zenith of his glory," Audubon wrote, not knowing how soon the glory would fade—and since the hawk was small and Napoleon at five feet six inches was small enough that his soldiers had nicknamed him "the little corporal," Audubon named his find *Le Petit Caporal*. In the drawing, executed with confident authority, the pigeon hawk stands erect and military in profile on a fence stake with its wings slightly opened, its breast flared and highlighted and its eye fixed on the viewer. Audubon said he drew it in the position in which he first discovered it. If so, the pose itself, confidently Napoleonic, may have suggested the connection with the French emperor.

On April 26, 1812, Audubon celebrated his twenty-seventh birthday at Fatland Ford. The next day he drew both a white-throated sparrow and a song sparrow. Then in early May he moved to free his birds from the anchored poses of ornithological tradition, drawing first a whippoorwill and then a female nighthawk both *in flight*, something he had not done successfully

The breakthrough whippoorwill, finished on May 7, 1812

before. Unlike birds posed on branches or standing on the ground, birds in flight required foreshortening to create the illusion of depth across the span of their wings or down the length of their bodies. Since Audubon's limited formal art training had not progressed to foreshortening, he had to learn that complicated technique on his own by trial and error. He improved gradually across a span of years; the technique never became second nature to him. It was important in another way as well: it separated his work from strictly scientific illustration, which avoided foreshortening because the necessary distortions made it impossible to use such an illustration to check measurements; for that purpose a foreshortened drawing was "inaccurate." A modern critic calls the two drawings "marvels of an increasingly rich pastel technique" as well. With his breakthrough to drawing birds in flight, Audubon at twenty-seven abandoned strict illustration and committed himself to expressive art.

Occasionally Audubon was able to draw from live models. He did so when he could. A pair of house wrens nested in a hole in an outside wall of his studio at Fatland Ford that spring; he and Lucy noticed them when he worked at drawing while she read to him:

> The male was continually singing within a few feet of my wife and myself, whilst I was engaged in portraying birds of other species. When the window was open, its company was extremely agreeable, as was its little song, which continually reminded us of its happy life. It would now and then dive into the garden at the foot of the window, procure food for its mate, return and creep into the hole where it had its nest, and be off again in a moment. Having procured some flies and spiders, I now and then threw some of them towards him, when he would seize them with great alacrity, eat some himself and carry the rest to his mate. In this manner, it became daily more acquainted with us, entered the room, and once or twice sang whilst there. One morning I took it in to draw its portrait, and suddenly closing the window, easily caught it, held it in my hand, and finished its likeness, after which I restored it to liberty. This, however, made it more cautious, and it never again ventured within the window, although it sang and looked at us as at first.

Audubon encouraged his twelve-year-old brother-in-law Will Bakewell to climb the trees along the Perkiomen to collect nests, "much to the annoyance of my father," Will remembered, "who feared I would fall and break my neck."

To placate his father-in-law's fears, Audubon arranged a demonstration: he had Will jump from one of the highest trees in the Fatland Ford orchard "to show with what ease and certainty he could catch me if I should fall." Will knew better: "Whenever I got up in one of the large trees in the forest, or on the side of the cliffs of the rivers in quest of eagles' or hawks' nests, it was plain to see by [Audubon's] watchful eye and anxious countenance that he was not unmindful of how much might depend upon his strength and dexterity in catching me in case a branch or the bark (which latter was, after all, all I had to hold by) should give way."

Will retrieved more than a nest one day in late May 1812 when he and Audubon went out collecting together. "The woods were all alive with the richest variety" of birds, Audubon wrote, so many choices that the two collectors "kept on going without shooting at any thing." Will spotted a nest at the height of a line of woods they were crossing, and as Audubon's eye found it they both realized it held a sitting bird. Unable to decide if it was a crow's or a hawk's nest, they concluded that Will should climb the tree and bring down an identifying egg. When he wrote about the incident Audubon said the tree was middle-sized; Will to the contrary remembered "a high tree in the woods near the Perkiomen." Will called down when he reached the nest that the bird was a hawk, unable or unwilling to fly. Audubon "desired him to cover it with his handkerchief, try to secure it, and bring it down together with the eggs." Will "passed a silk handkerchief over [it]," collected the eggs and carried bird and eggs to his hero. "I looked at it with indescribable pleasure," Audubon remembered, "as I saw it was new to me, and then"—his Aesopian side emerging, or his memories of the Terror—"felt vexed that it was not of a more spirited nature, as it had neither defended its eggs nor itself."

Back at Fatland Ford Audubon showed the female broad-winged hawk to the Bakewells and carried it to his studio to draw it. His description of the incident supplies a rare glimpse of the details of that process:

> I put the bird on a stick made fast to my table. It merely moved its feet to grasp the stick, and stood erect, but raised its feathers, and drew in its neck on its shoulders. I passed my hand over it, to smooth the feathers by gentle pressure. It moved not. The plumage remained as I wished it. Its eye, directed towards mine, appeared truly sorrowful, with a degree of pensiveness which rendered me at that moment quite uneasy. I measured the length of its bill with the compass, began my outlines [in pencil], continued measuring part after part as I went on, and finished the drawing without the bird

ever moving once. My wife sat at my side, reading to me at intervals, but our conversation had frequent reference to the singularity of the incident. The drawing being finished, I raised the window, laid hold of the poor bird and launched it into the air, where it sailed off until out of my sight, without uttering a single cry or deviating from its course.

In the drawing Audubon made he presented the hawk grasping a branch of a pignut hickory tree, its cream-colored, brown-speckled breast toward the viewer, its wings flared open, its left wing behind and extremely foreshortened and its head twisted away so that it looks back across its shoulder apprehensively as if startled and ready to take flight. Some years later Audubon would add an alert but composed male above and to the left of the female to complete the drawing.

WAR WITH ENGLAND had been years in the making. Since 1803 the British had impressed into naval service more than ten thousand American citizens forcibly taken off American ships—"torn from their country and everything dear to them," Madison charged in the war message he sent to Congress on June 1, 1812, ". . . dragged on board ships of war . . . and exposed . . . to risk their lives in the battles of their oppressors." Across the same decade a thousand U.S. merchant ships had been seized and sold. Worse from the point of view of the Western War Hawks in Congress—men like Henry Clay and John C. Calhoun—was British incitement of the Indians to raid settlements on the trans-Appalachian frontier, attacks the War Hawks thought could be reduced by conquering Canada. "If the English do not give us the satisfaction we demand," even Jefferson wrote in response to a British attack on an American ship, "we will take Canada, which wants to enter the Union; and when, together with Canada, we shall have the Floridas, we shall no longer have any difficulties with our neighbors." It would have made equal sense to declare war against France, since Napoleon had also imposed a blockade on American ships and seized half as many as the British, but the British had challenged American sovereignty, treating the young nation as if it had no right to exist and must inevitably return to British rule. The War of 1812 would be a second American Revolution, diminished but decisive. Congress granted Madison's appeal and declared war on June 18. The British responded by blockading American ports, effectively reinstalling the 1808 embargo.

As if to reaffirm his loyalty to the country he had adopted and enjoyed by

then for nine eventful years, Audubon went in to Philadelphia on July 3 and presented his sponsors, answered the questions and took the oath. Relinquishing his French citizenship, he became a citizen of the United States of America in time to celebrate its thirty-sixth Independence Day.

Lucy was entering the fifth month of her second pregnancy by then and beginning to show. It was obvious that the war would delay the début of Audubon & Bakewell in New Orleans, though the Audubons still had a general store in Henderson. Rebecca Bakewell, who dominated her increasingly distracted and silent husband, wanted them gone. When they heard that William Clark was offering passage from Pittsburgh to Louisville on his flatboat to anyone who wished to return home before the war increased the risks of travel through frontier country where British-supplied Indians might raid—sometime in July 1812—they said their goodbyes and set off.

The Ohio was running low water, which made for a long float. Not until August 10 was Audubon able to write Rozier from Shippingport, where he was staying with his friends the Berthouds. He nudged his former partner gently about the money Rozier owed him: "I have no doubt your lead is selling very well, this article having increased considerably [in value] since the war." In Philadelphia he had heard from his father and from Rozier's brother and urged Rozier to write his family; letters could be delivered safely to Europe on the boat that made exchanges of prisoners of war. Audubon thought he would "probably descend to New Orleans this autumn with N[icholas] Berthoud."

The war convinced Berthoud instead to stick close to home. Since the river was low, John James and Lucy decided to float from Shippingport to Henderson in a skiff—a "large, commodious and light" rowboat they bought and manned with a crew of two "stout Negro rowers," probably rented slaves. On the smooth summer river they watched catfish surfacing to chase fish that leaped from the water in "a shower of light." They heard fish beneath the boat making "a rumbling noise, the strange sounds of which we discovered to proceed from the white perch, for on casting our net from the bow we caught several of that species, [after which] the noise ceased for a time." Not far from Henderson they heard what they thought were "the yells of Indian warfare" and hastened to the opposite shore, where they "discovered that the singular uproar was produced by an enthusiastic set of Methodists . . . holding one of their annual camp meetings under the shade of a beech forest"—earthquake Christians not yet backslid.

Home for now would once again be the Rankins' big log house at Meadow Brook. There in August 1812 Audubon was working on a gory watercolor of an

otter caught in a trap, its paw bloody and its teeth bared, blood on its mouth signaling that it had been surprised at gnawing off its own leg, when Tom Bakewell walked in. He had hiked the Natchez Trace to Nashville and then found his way up to Henderson. He told Audubon unhappily that they had been "defeated in the brilliant prospects at New Orleans by the war." Audubon & Bakewell, Commission Merchants, New Orleans, into which the Audubons had sunk most of their capital, had never opened its doors.

FLOCKING TO KENTUCKY

M Y PECUNIARY MEANS WERE NOW MUCH REDUCED," Audubon summarized the consequences of the failure of Audubon & Bakewell to establish itself in New Orleans in the summer of 1812. Though Lucy was expecting again, her husband seems not to have despaired of supporting his family. He still had his log-cabin general store at the corner of Main and Mill Streets in Henderson, an Audubon & Bakewell partnership now. The town was commercializing (it would triple in size between 1810 and 1820) and the county was growing toward five thousand residents. Henderson was becoming a tobacco market, with new tobacco warehouses under construction and the state of Kentucky preparing to locate a tobacco inspection point there. Audubon told Ferdinand Rozier in August that because of the British blockade of U.S. ports all kinds of merchandise were "extremely scarce and very dear, everywhere." At the end of the summer, determined to do something for himself, the young merchant and artist "took to horse, rode to Louisville with a few hundred dollars in my pockets, and there purchased, half cash, half credit, a small stock, which I brought to Henderson.... The little stock of goods brought from Louisville answered perfectly, and in less than twelve months I had again risen in the world."

The Audubons' second son, John Woodhouse, was born in Dr. Adam Rankin's log house outside Henderson on November 30, 1812. Prospering, and having increased to a family of four, John James and Lucy decided the time had come to buy a place of their own. A substantial log house set back on a one-acre lot next to their store on Main Street conveniently became available early in the new year after its previous owner died. Much like the Rankin house, it was a hewn-log double-pen, a story and a half high—the equivalent of two log cabins seven logs high with four-log lofts, set side by side with a passageway between, the passageway boarded in and both wings covered over with a com-

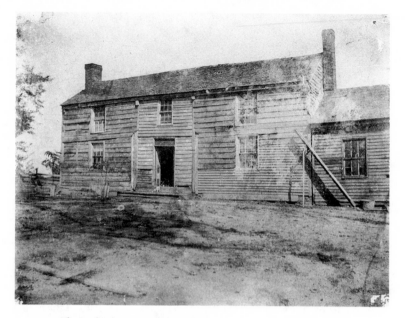

The Rankin house in Henderson, where the Audubons sometimes lived

mon roof, with a chimney at each end. A stable, a smokehouse and a productive orchard completed the property. The Audubons moved in early in 1813. Tom Bakewell bought a single-pen log cabin nearby but evidently did not live there. Since he was still a bachelor, his sister and brother-in-law welcomed him into their home.

Constructing buildings with logs, which has come to seem so characteristically American, was in fact an early borrowing from the Baltic woodland culture of the Eastern Finns, a small colony of whom settled in the Delaware River Valley in the early 1650s. They brought with them not only log-cabin technology but also the split-rail fence, a borrowing in turn from the Lapps, who used split-rail enclosures to confine reindeer. British, Dutch and German immigrants arrived in America with no tradition of log construction. They adopted the Finnish technology because it suited the conditions of trans-Appalachian backwoods pioneering. The army of young Scotch-Irish pioneers who settled Kentucky (the median age of the U.S. white population in 1810 was only sixteen) carried it over the mountains along with their traditions of squatters' rights and vigilante justice. As members of the frontier economic and cultural elite, the Audubons were only nominally pioneers. They purchased rather than

built the buildings they occupied, but they thrived on frontier life. "The pleasures which I have felt at Henderson," Audubon would tell his sons nostalgically, "and under the roof of that log cabin, can never be effaced from my heart until after death."

Once again, in May 1813, Audubon journeyed to Ste. Genevieve to try to collect from Ferdinand Rozier. He had long since sold his Spanish barb for a good profit and rode another horse. He found his thirty-five-year-old former partner newly married to Constance Roy, an eighteen-year-old French-American who would bear the sturdy and increasingly successful businessman ten children across their long life together. Since Audubon apparently did not visit Ste. Genevieve again, on this visit Rozier probably paid him the $1,000 he owed.

On the advice of experienced prairie travelers Audubon had outfitted his horse for the journey with a hooded cloak of light linen that covered all but the animal's nostrils. The Illinois tall-grass prairie between Ste. Genevieve and Henderson was beautiful in May, Audubon wrote, greening with big and little bluestem, side-oats gramma and other native prairie grasses brightened with "millions of variegated flowers," butterflies "of the richest colors," hummingbirds and bees—native wild bees as well as the honeybees that had thrived on the prairies since their early introduction from Europe. But the prairie was infested at that season with a scourge of buffalo gnats that seldom bothered people but could kill calves and fawns by exsanguination and horses by sheer torment.

As it turned out, Audubon had misunderstood the full extent of the danger. He had left gaps in the linen covering that allowed the gnats entry and they attacked his horse in clouds. "I had ridden a considerable distance when on a sudden he actually began to dance; he snorted, leaped, and almost flew from under me. This took place near the Big Muddy River, for which I instantly made, and plunged the horse into the stream to quiet him. But upon reaching the shore, his motions were languid—his head drooped—and it was with difficulty that I reached a squatter's hut, where the poor animal died in a few hours." The gnats were not poisonous, as Audubon believed, but they were still deadly; his horse probably died of shock as well as loss of blood.

Audubon walked the rest of the way to the Shawneetown ferry and upriver to Henderson to find Lucy gravely ill with a summer fever. Within days it struck him as well. Malaria was endemic in Kentucky at that time. Other summer fevers, among them typhoid and yellow fever, came and went. Whatever the cause of the Audubons' infection, Rankin probably treated it with powdered Peruvian cinchona, a bark that is a natural source of quinine. Bleeding was still also a treatment for fever. The old humoral theories had begun to be

challenged, but doctors still prescribed powerful cathartics such as senna, castor oil, aloes, jalap root and calomel for many illnesses. Cupping and blistering were believed to draw out "poisons." However the Audubons were dosed, they were hardy enough to recover from their illnesses as well as their treatment by midsummer.

Alexander Wilson in Philadelphia had worse luck. The previous fall, collecting in the hills above Haverhill, New Hampshire, on the Connecticut River, he had attracted the attention of local patriots by his unusual behavior and had been seized as a British spy. As soon as he explained himself he was released, but the experience reminded him of his imprisonment for debt in Scotland and drove him to a winter of anxious overwork preparing his seventh volume. Publication was delayed, and because he was one full volume behind, his publisher withheld the royalties he should have earned by then. In mid-August he was making up a list of birds he had yet to draw and describe when he was stricken with dysentery. He died on August 23, 1813, at forty-seven, the eighth volume of his *American Ornithology* in press. His engraver Alexander Lawson's daughter Malvina assessed Wilson's accomplishment in her reminiscences in terms Audubon would have endorsed:

> I think that a great moral lesson may be drawn from his life. When a man in seven years becomes famous as a man of science and as a draughtsman whose birds live forever, without any other help than the cheering voice of friendship to aid him in his new standing, it seems almost a miracle. When we think of Wilson shouldering his gun and setting out for the wilderness, not only of nature, but of ignorance and prejudice, and after months of wearying travel, returning with his drawings and specimens, worn out with fatigue and oppressed by poverty, to sit down to the composition of a work as truthful, as beautiful and as charming to read as any romance, what a sermon on the virtues of faith and perseverance! And to all his other trials was added the fact that killed him—the dishonesty of his publisher.

That August 1813 Tom Bakewell, handsome and persuasive, concocted a new scheme for moving up from what he called dismissively "the smaller scale of storekeeping in Henderson." The town was growing and Henderson County was growing. The Ohio River a block northwest of their store connected them to downriver markets (and with the advent of the steamboat, to upriver markets as well). The steam engine offered a reliable source of power in high water and low, and the Ohio bottomland forests across the river were a reliable source of fuel. Building construction was advancing from logs to sawn

boards. What Henderson needed was a steam-powered grist- and sawmill. If Audubon would invest, Tom would raise a loan for his share from his father. The Scottish mechanic David Prentice, whose steam thresher experiments William Bakewell had supported at Fatland Ford, might be induced to move from Philadelphia to Henderson to build the engine.

In the midst of these discussions word came from Thomas and Sarah Pears back in Pennsylvania that the British blockade was ruining farming—Europe was even then the primary market for American grain—and they were thinking about selling their farm and moving west. When Tom left Henderson in August to approach his father at Fatland Ford, he carried

Handsome Tom Bakewell as Audubon sketched him in 1820

with him letters from Audubon to Prentice and the Pearses inviting them to visit Henderson and discuss investing in the proposed Audubon & Bakewell mill. Lucy supported the invitation in a separate letter to Sarah Pears, her cousin.

The passenger pigeons were flocking to Kentucky that year. Audubon encountered them over the Barrens on an autumn buying trip to Louisville for his store. They were beautiful birds with gray-blue backs and wings, black-spotted wing coverts, light brown-red breasts and throats with highlights along the lower neck of gold, red and emerald green. They had small heads and slender necks and their bodies were elongated compared with the familiar rock pigeons of city streets, "steered by a long well-plumed tail" that in the male was formed of pale-blue feathers that faded to white at the tips, with two black middle feathers. Passenger pigeons fed on mast—on acorns, beechnuts and chestnuts—as well as fruit, insects, seeds and worms. On this encounter Audubon was "struck with amazement" at their numbers, as many had been before him, and simply tried to count them:

> I dismounted, seated myself on an eminence, and began to mark with my pencil, making a dot for every flock that passed. In a short time finding the task which I had undertaken impracticable, as the birds poured in in countless multitudes, I rose, and counting the dots then put down, found that 163 had been made in twenty-one minutes. I traveled on, and still met more the farther I proceeded. The air was literally filled with Pigeons; the light of

noonday was obscured as by an eclipse; the dung fell in spots, not unlike melting flakes of snow; and the continued buzz of wings had a tendency to lull my senses to repose.

Waiting for midday dinner at Young's Inn, at the confluence of the Salt River with the Ohio about twenty-five miles below Louisville, Audubon watched "immense legions still going by, with a front reaching far beyond the Ohio on the west, and the beechwood forests directly on the east of me." When he reached Louisville, shortly before sunset, "the Pigeons were still passing in undiminished numbers, and continued to do so for three days in succession." Conservatively calculating a flock flying in a column a mile wide and passing overhead for three hours at sixty miles an hour (a speed he justified by pointing out that passenger pigeons had been shot in New York with Carolina rice in their craws), Audubon concluded that his hypothetical flock would number 1.1 billion birds. Alexander Wilson had calculated more than 2 billion for a comparable flock, which he thought was "probably far below the actual amount." A modern expert estimates the total number of passenger pigeons in that era as around 3 billion, 25 to 40 percent of all the breeding birds in America.

In Louisville, Audubon noted, "the people were all in arms" to hunt pigeons. "The banks of the Ohio were crowded with men and boys, incessantly shooting at the pilgrims, which there flew lower as they passed the river." At the height

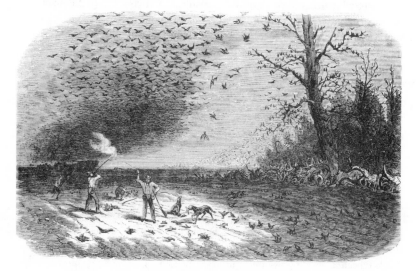

Shooting passenger pigeons

he had seen them earlier they had been above rifle range. In Louisville "multitudes were thus destroyed. For a week or more, the population fed on no other flesh than that of Pigeons, and talked of nothing but Pigeons." Even the air, he said, smelled of them—not surprising considering the wagonloads of dung they dropped.

They were "passenger" pigeons because they moved from region to region seeking food, not because they migrated. Local people simply called them wild pigeons, Audubon said. Their immense flocks had been recorded in North America as early as 1534 (on Prince Edward Island, by Jacques Cartier). Both Native Americans and European-Americans harvested them in vast numbers, preferring the young and tender squabs. The schoonerloads that Audubon had noticed when he crossed the Hudson in 1805 were only a minor example. On a visit to the Shawneetown salt works Audubon found the slaves who made salt "wearied with killing Pigeons as they alighted to drink the water issuing from the leading pipes, for weeks at a time." Some observers compared their flocks in flight to clouds; for Alexander Wilson they made "a space on the face of the heavens resembling the windings of a vast and majestic river." In their multitudes they were hardly considered worth the price of the powder and shot necessary to slaughter them, and would not be listed as a game bird for decades to come. They roosted in the Kentucky forests for several years, causing immense destruction, before moving on. Audubon would encounter them again.

In December he began speculating in real estate—another sign that the Audubons were prospering—buying two more town lots in Henderson on the west side of Third Street between Green and Elm. He also decided to branch out to storekeeping sixty miles downriver in Shawneetown. When Tom returned that month from Pennsylvania he approved the expansion, and the store opened in January 1814 with a young associate, David Apperson, in charge. In the next three years the partners would divide profits from Shawneetown of more than $6,000.

William Bakewell had agreed to lend his son $4,000 to invest in the steam mill. Pears had expressed interest in the project as well; he was in the midst of selling his farm and proposed to visit Henderson in the spring. Prentice, the mechanic, was interested but wanted more information.

Tom also brought sad news of his father's decline and of the near state of war between the Bakewell children and their stepmother. Benjamin Bakewell passed on to Derbyshire what Tom had told him when he stopped in Pittsburgh on his return: "I am much concerned to hear of the great change that has taken place in my brother's manners & habits. Instead of that activity & vivacity he used to possess I am told he uses little exercise & will sit nearly a whole

evening without speaking to anyone. Another very great change is that instead of being sole arbiter in his family, he has scarcely a voice in the concerns of it whether they be important or trivial." Eliza, Lucy's attractive younger sister, would tell Sarah Pears that her father "appears to have entirely lost all affection for her and for all but his wife! [Her] stepmother . . . has robbed them of their father's love . . . will not even suffer him to bestow the smallest presents upon any of them [and] makes their home life wretched." Lucy had felt the estrangement on her visit the year before and reluctantly had accepted it, but she worried about her siblings. Eliza and Will were both planning their escape; she let them know she was prepared to welcome them.

The Audubons led busy lives as young Henderson gentry. They were the talk of the town. They took morning rides together. In the evenings they made music together, Lucy playing a piano they had shipped out from Fatland Ford, John James playing the violin, the flute, the flageolet or the guitar. They swam the Ohio for exercise, powering across a half mile of river to the Indiana shore and back. As steamboats began docking at Henderson a sport developed of diving from their decks, but Audubon was remembered for diving from the bow, swimming the length of the boat underwater and popping up beyond the stern. He was a crack shot at rifle matches, hitting bull's-eyes and barking squirrels with the best of them. (Barking a squirrel involved dislodging it from a tree by shooting away the chunk of bark on which it stood.) On derby days he raced horses in the Henderson streets, Lucy cheering him on. He taught a braggart a lesson about fencing when a supposed master of the broadsword came to town claiming he had fought in all of Napoleon's wars. His students set him up with Audubon, who reluctantly agreed to a match with wooden swords when the Frenchman insisted no man could touch him. Audubon expertly cracked the man's shins and dropped him writhing to the ground.

As old-time residents told a Henderson interviewer, William Alves, many years later, Audubon's developing sense of *noblesse oblige* extended to law enforcement as well. Pirates preyed on flatboats along the river. Audubon was disgusted with a sheriff's deputy who had summoned a mere boy to help him arrest a "river pirate." He insisted the deputy summon him instead. That done, they went off "in search of the offender, Mr. Audubon in the lead." They found him at the riverbank preparing to escape in his canoe and challenged him. He dismissed the deputy as a coward but decided Audubon looked like a fighter and proceeded to advance on him "with a long, dangerous, murderous-looking knife." Audubon took up a nearby oar to defend himself. The pirate continued to advance. Audubon warned him to stop. When he didn't, "Mr. Audubon let drive with the oar . . . and felled the fellow, apparently dead, to

the ground." On inspection the pirate was found to have sustained a depressed skull fracture "about the size of a silver dollar." Adam Rankin was sent for; Alves calls him "the leading practitioner then here." Rankin reviewed the fracture, took a gimlet from his pocket, drilled it through the skin into the depressed skull bone and popped out the fracture with the skill of a coachmaker popping out a dent in sheet metal. "The fellow was then marched up the hill," Alves concludes, "and away to the old log lockup to await the pleasure of the squire."

The Henderson residents whom Alves interviewed characterized Audubon as "a man of scrupulous honesty" who "placed the highest value possible upon his word, holding it in all things the equal of his bond." He was "somewhat of a connoisseur in his tastes," they thought, and "men took advantage of him" because "he would go his whole length doing for others while his own was left undone."

Kentucky was a slave state, and as many others did there, the Audubons kept slaves. Between 1813 and 1819 they bought and sold a total of nine boys, men and women, investing at least $10,500. Audubon is circumspect about them in his writings, typically calling them servants. His father had worked large numbers of slaves on his sugar plantation on Saint Domingue before the revolution there that Toussaint Louverture led. The Audubon slaves cooked, did household chores, cleaned and stocked the store, maintained the property and the animals and assisted Lucy at tending garden and John James at boating and hunting. On land the Audubons bought across the street in 1814, their slaves dug a pond that Audubon stocked with fish as well as turtles for turtle soup. Slavery was still a local problem in the United States at that time. The importation of slaves into the country had been outlawed by an act of Congress in January 1808. The great demand for slaves to work on cotton plantations in the Deep South that followed from the invention of the cotton gin and the development of upland cotton varieties had only begun to build. Hardly anyone defended slavery in the first two decades of the nineteenth century, but neither the federal government nor the free states were prepared to share the burden of compensating slave owners for emancipating the human beings that constituted their chief property. Owning slaves was another measure of the Audubons' prosperity, a moral luxury that hardship would eventually humble and reverse.

The presence of slaves in the Audubon ménage goes a long way toward explaining how John James and Lucy had time for the many activities that filled their lives in Henderson. Even so, stocking and running two stores, buying and selling real estate and planning and building a steam mill limited

Audubon's bird collections during this period of his life; he was often forced, he wrote, "to put aside for a while even the thoughts of birds . . . to attend more closely to the peremptory calls of other necessary business." His travels, which some believed to be primarily birding expeditions that neglected business, to the contrary were "attended with many difficulties and perplexing disappointments," so much so that they had "several times made my mind waver whether I should or should not abandon [birds] forever." Rather than Audubon the insouciant, during this period he was his father's son, Audubon the merchant, trying to succeed as a businessman and neglecting his art. If he made any drawings of birds between 1815 and 1820, none have survived.

Another event may have contributed to the hiatus in drawing, although when it occurred is unclear. Henderson, a river town, was infested with Norway rats. Once when Audubon was going to Philadelphia on business he reviewed all his drawings, "placed them carefully in a wooden box, and gave them in charge to a relative" to protect them. Who that relative was Audubon chooses not to say. Did he give the box to Tom to store in the spare cabin? Did Lucy mind it? Whoever kept it for him, when Audubon returned and opened it he found that "a pair of Norway rats had taken possession of the whole, and had reared a young family amongst the gnawed bits of paper, which . . . represented nearly a thousand inhabitants of the air!" The drawings were all, or nearly all, destroyed. The loss so depressed Audubon that he suffered insomnia "and the days passed like days of oblivion." In time he recovered, he said, "took up my gun, my notebook and my pencils and went forth to the woods as gaily as if nothing had happened. I felt pleased that I might now make much better drawings than before." He had regularly destroyed earlier drawings to force himself to improve, which must have mitigated this involuntary loss. Within a few years he had filled his portfolio again with far better work.

He collected when he could. He drew a great horned owl on September 30, 1814, after nearly losing his life hunting it. The bird had fallen onto a willow-anchored sandbar when he shot it. Running up to retrieve it, he suddenly found himself "sunk in quicksand up to my armpits, and in this condition must have remained to perish, had not my boatmen come up and extricated me by forming a bridge of their oars and some driftwood, during which operation I had to remain perfectly quiet, as any struggle would soon have caused me to sink overhead."

Unable to wander the forest with any frequency, Audubon contrived to surround himself with birds at home. He caught wood ducks, a bird he considered beautiful, fast and wary, with a bag net, or he ordered his pointer bitch Juno to collect ducklings when their mothers sent them to hide on the shore before

IVORY-BILLED WOODPECKER

PIGEON HAWK,
Audubon's "Le Petit Caporal"

BROAD-WINGED HAWK

PASSENGER PIGEON

CAROLINA PAROQUET

BROWN PELICAN

PAINTED BUNTING

SWALLOW-TAILED HAWK

taking flight: "Juno would return with a duckling held between her *lips*," he remembered, "when I would take it from her unhurt." With a dozen or more ducklings retrieved he placed them in empty flour barrels and covered the barrels, hoping to tame them quickly:

> But whenever I went and raised their lids, I found all the little ones hooked by their sharp claws to the very edge of their prisons, and the instant that room was granted, they would tumble over and run off in all directions. . . . They fed freely on cornmeal soaked in water, and as they grew, collected flies with great expertness. When they were half-grown I gave them great numbers of our common locusts [i.e., cicadas] yet unable to fly, which were gathered by boys from the trunks of trees and the "iron weeds," a species of wild hemp very abundant in that portion of the country. These I would throw to them on the water of the artificial pond which I had in my garden, when the eagerness with which they would scramble and fight for them always afforded me great amusement. They grew up apace, when I pinioned them all, and they subsequently bred in my grounds in boxes which I had placed conveniently over the water, with a board or sticks leading to them, and an abundant supply of proper materials for a nest placed in them.

He kept and raised a male sparrow hawk (American kestrel)—a reddish-brown bird with transverse black bars on its back and scapulars, grayish-blue wing coverts and a deep orange-brown cap on its head surrounded by a dark band. It was only beginning to fledge and was still covered with soft white down when he heard it crying for food and found it lying near a log, fallen from the nest and unable to fly:

> I took it home, named it Nero, and provided it with small birds, at which it would scramble fiercely, although yet unable to tear their flesh, in which I assisted it. In a few weeks it grew very beautiful, and became so voracious, requiring a great number of birds daily, that I turned it out, to see how it would shift for itself. This proved a gratification to both of us: it soon hunted for grasshoppers and other insects, and on returning from my walks I now and then threw a dead bird high in the air, which it never failed to perceive from its stand, and towards which it launched with such quickness as sometimes to catch it before it fell to the ground.

When wild kestrels began chasing it Nero took up residence behind one of the Audubons' window shutters, "where it usually passed the night." As an

adult it liked to assault the wood ducks. "[Nero's] courageous disposition often amused the family, as he would sail off from his stand and fall on the back of a tame duck, which, setting up a loud quack, would waddle off in great alarm with the Hawk sticking to her." Audubon lost his small hawk to a furious hen when it tried to steal one of the hen's chicks.

One of Audubon's favorite birds was a wild tom turkey he had caught when it was a days-old chick:

> It became so tame that it would follow any person who called it, and was the favorite of the little village. Yet it would never roost with the tame Turkeys, but regularly betook itself at night to the roof of the house, where it remained until dawn. When two years old, it began to fly to the woods, where it remained for a considerable part of the day, to return to the enclosure as night approached. It continued this practice until the following spring, when I saw it several times fly from its roosting place to the top of a high cotton[wood] tree, on the bank of the Ohio, from which, after resting a little, it would sail to the opposite shore, the river being there nearly half a mile wide, and return towards night. One morning I saw it fly off, at a very early hour, to the woods, in another direction. . . . Several days elapsed, but the bird did not return. I was going toward some lakes near Green River to shoot, when, having walked about five miles, I saw a fine large gobbler cross the path before me, moving leisurely along. Turkeys being then in prime condition for the table, I ordered my dog to chase it and put it up. The animal went off with great rapidity, and as it approached the Turkey, I saw, with great surprise, that the latter paid little attention. Juno was on the point of seizing it, when she suddenly stopped, and turned her head towards me. I hastened to them, but you may easily conceive my surprise when I saw my own favorite bird, and discovered that it had recognized the dog, and would not fly from it; although the sight of a strange dog would have caused it to run off at once. A friend of mine happening to be in search of a wounded deer, took the bird on his saddle before me, and carried it home for me. The following spring it was accidentally shot, having been taken for a wild bird, and brought to me on being recognized by the red ribbon which it had around its neck.

Hunters were hunters, then as now.

HAVING SOLD THEIR FARM during the winter at more than 100 percent profit, the Pearses moved out to Pittsburgh in the spring of 1814 to park Sarah

and the children with the Benjamin Bakewells while Thomas Pears went on to Henderson to study its prospects and decide whether to invest in the steam mill. Lucy's sister Eliza may have traveled with them and also stopped over in Pittsburgh, or she fled her father's house a little later; she was there at least by summer. Pears was impressed with Audubon & Bakewell's profits and agreed to invest $4,000 in the mill if Tom would do likewise. That would leave Audubon responsible for the balance, and to know what the total might be they wrote David Prentice for an estimate.

Sarah Pears was no Lucy Audubon, however. When her husband, who knew her well, wrote her that summer gingerly proposing their resettlement, she invoked the war news of the past two years—three failed attempts by U.S. forces to invade Canada, the bloody lost battle against the British and their Indian allies at Frenchtown and the massacre of Americans that followed at Raisin River, the Battle of the Thames when the British retreated and Tecumseh was killed—to express her fear of living on the frontier. "What do you think of the state of public affairs," she asked her husband rhetorically, "if the war is carried on with the vigor which the English talk of? Do you think that we shall be as safe at Henderson as elsewhere, and do you suppose that it will affect the business that you propose carrying on there?" Pears responded that Henderson was a long way from the battlefront; as for the Indians, "Be assured that an Indian would sooner be bitten by a rattlesnake than be in sight of a Kentuckian."

Prentice wrote that he had wished for many years to move west "but being in a pretty decent way here I did not choose to leave a certainty for an uncertainty. . . . I think that the erecting of a steam engine for you will bring me into notice, and I am therefore willing to employ myself . . . for very little compensation." The Scottish mechanic's idea of "very little compensation" was $3 a day, travel expenses, free room in Tom's cabin and free board at Lucy's table. He would build a sixteen-horsepower engine for $4,000, "including castings, blacksmithing and wages for hands to set the flywheel in motion." The three partners agreed to Prentice's terms and to financing the mill. They thought $15,000 should cover the investment, committing Audubon to a $7,000 share.

Eliza spent the summer enjoying Pittsburgh in the company of her cousin Thomas Bakewell, Benjamin's son, only to have him confess to her one day that he had loved her "ever since he knew what love was, but that he thought it so improbable that she would ever be induced to like him or that she should be unmarried when he should be of a proper age and in circumstances to settle, that he had studiously concealed his affection from everyone, even from his family." Whereupon he proposed to her, she sadly turned him down, and

pained to be causing pain to people who were family and who had taken her in, she left the Bakewells to stay with Pittsburgh friends.

When Lucy heard of her sister's dilemma, she sent word to Eliza to come out on her own. Lucy learned as well that her father had suffered a stroke that summer. William Bakewell himself described what happened after he had seemingly healed, in November. "I have had an inflammation of the brain," he wrote Euphemia Gifford, "in August similar to what I had 14 years ago, but I am recovered. Dr. Darwin [had] recommended Digitalis [for the previous illness] & I advised the Physician I sent for to use the same remedy. I was extremely ill of the headache, I was cupped, bled, & blistered, but providentially I got over it." He had thought of selling his farm—Pears's profit had made an impression—"on account of my daughters but I will try it in a year or two [when] the war is over. They have not any society in this neighborhood now Mr. & Mrs. Pears are gone." Rather than sell he had let it on shares, "which is a great relief to me & Mrs. Bakewell. It is difficult to get laborers in these war times."

Tom and Audubon met Eliza and Will in Louisville at the beginning of November. Tom went on to Philadelphia to purchase stock for the stores; Audubon delivered the young people to Henderson. Pears collected his family as well, his wife grudgingly agreeing that she would "prepare myself for a wilderness and half savages except Mr. Audubon's family and a few others." David Prentice floated down from Pittsburgh with his wife, Margaret, and

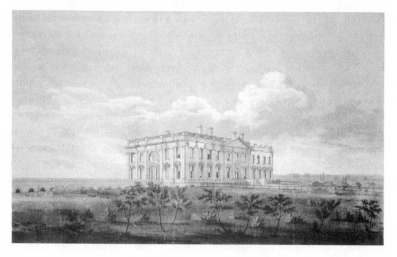

The White House after its burning

their children; he planned to devote the winter to building a steam engine for his keelboat as a pilot model of the big mill engine. (The small steamboat he built, christened the *Zebulon M. Pike* for the explorer and War of 1812 commander, was the first boat to ascend the Mississippi above the mouth of the Ohio under steam power and the first to reach St. Louis, in 1817.) The social rounds that followed the arrival in Henderson of so many new people lasted for days, after which eligible young men began to call on Eliza, among them the Audubons' Shippingport contemporary Nicholas Berthoud. Will, now fourteen, entered into an apprenticeship with Audubon & Bakewell. All but the Prentices moved in with the Audubons; Lucy, nearly at term in her third pregnancy, had her hands full.

The hopes and tensions in the families gathering in Henderson mirrored the hopes and tensions in the nation that year. In March at Horseshoe Bend on the Tallappoosa River, a tributary of the Alabama, Andrew Jackson's forces had routed the Red Stick Creeks, systematically slaughtering some nine hundred warriors, after which Jackson had demanded and received from the Creek nation, in compensation for its making war, more than half of its ancestral lands in what is now Alabama and Georgia, some 23 million acres. At the end of August the British had sacked and burned Washington, not yet the imperial city but a rude outpost where gangs roamed and few chose to live, the President's house unfinished, the Capitol undomed, an unbridged marsh between the two centers of flickering federal authority where cows grazed, locals fished and Congressmen walked down from their boardinghouses to shoot birds. A young Lutheran minister named John Bachman, whom Audubon would later befriend, was on his way to Charleston in January 1815 to take up a pastorship. Stopping off to see the ruins, he noted somberly "the traces of devastation and death . . . visible in the half-covered graves along the highway between Baltimore and Washington. The blackened walls of the Capitol at Washington, and the destruction in every part of the city, presented an awful picture of the horrors of war." Ironically, the British burned Washington in retaliation for the burning of York by Zebulon Pike's men, who were retaliating in turn for losing fifty-two men, including Pike, to a powerful British explosive mine set off to rout their amphibious assault.

By December Jackson had reached New Orleans, which a British armada of sixty ships carrying fourteen thousand troops was approaching. Jackson would defeat them decisively in January 1815 and become a national hero—*after* a peace treaty was signed by its American and British negotiators in Ghent on December 24. Resigned to the long delays inherent in the delivery of mail by sailing ship, the negotiators had agreed that the outcomes of battles fought in

the interim before news of the treaty arrived would be respected as faits accomplis. As Audubon would do later with bird and animal specimens he shipped to England, the British shipped home the body of their fallen general, Sir Edward Michael Pakenham, preserved in a hogshead of rum.

That December 1814 Lucy was delivered of a daughter, named Lucy in memory of her mother Lucy Green Bakewell, missed more than ever in reflection on her successor. The little girl was born with hydrocephalus, a congenital defect in which the passageways are blocked that normally drain the fluid continually produced in the ventricles below the brain, causing the head to swell and the brain to be compressed—"dropsy of the head," as Lucy's sister Ann would describe it, "a disorder she had . . . from birth." Audubon wrote Victor later of their Henderson years that "this place saw my best days, my happiest, my wife having blessed me with your brother Woodhouse and a sweet daughter. I calculated to live and die in comfort. Our business was good [and] of course we agreed. But I was intended to meet many events of a disagreeable nature." Those events emerged through the years that saw the great mill built on the banks of the Ohio.

Nine

THE BAD ESTABLISHMENT

N EWS OF THE PEACE TREATY BETWEEN England and the United States reached New York on a British warship on the evening of February 11, 1815, in the person of a secretary to the American negotiators, Henry Carroll. "In less than twenty minutes after Mr. Carroll arrived at the City Hotel," the *New York Evening Post* reported, "the public exhilaration shewed itself in the illumination of most of the windows in the lower part of Broadway and the adjoining streets. . . . The street itself was illuminated by lighted candles, carried in the hands of a large concourse of the populace; the city resounded in all parts with the joyful cry of *a peace! a peace!*"

The treaty hardly resolved the conflicts that had led to the war. It agreed on little more than that the two nations had been at war and now would be at peace. But the United States had shown that it was prepared to defend itself and survive. "We have entered into a conflict with one of the most powerful nations of the earth," crowed the editor of New York's *National Advocate*, ". . . and . . . before three years have rolled away, we have beaten and discomfited that enemy by sea and by land. . . . The people have been tried and found faithful. . . . They have demonstrated to the world that they are republicans in principle; that they are the proper conservators of their own rights; and that they merit the blessings of such a government as they now enjoy."

The war had disrupted the American economy. Exports had shrunk from $108 million in 1807 to only $7 million in 1814. The British naval blockade and a further Congressional embargo had stimulated domestic production—an average of sixty-five factories per year opened their doors in the United States between 1812 and 1815—but supply never caught up with demand. The federal government, which derived most of its revenue from tariffs, had to borrow heavily to finance the war. (The national debt peaked in 1815 at $127 million, six times the average annual federal revenue in that era.) Since New England and

The Audubon & Bakewell mill

its preponderance of American banks opposed the war (the New England states seriously considered seceding from the Union, a precedent the South would later notice and invoke), new banks were chartered elsewhere in the country to meet the need. By 1815, 120 new banks had been added to the 88 in operation in 1811. In that era, banks rather than the federal government printed the banknotes that served Americans as currency. Banks had been required previously to redeem their paper in specie—gold and silver—but the heavy demands of the war had led the government to agree in 1814 to suspend specie payments between banks outside New England. That suspension was a license to print money for new banks that often were capitalized with nothing more than the promissory notes of their stockholders, secured with the bank's own stock. Unredeemed banknotes had thus doubled to $46 million between 1811 and 1815. With a reduced supply of goods and an increased supply of banknotes, prices had inflated sharply during the war. The price of cotton had doubled. Prices for imported commodities had increased by more than half, for domestic commodities by as much as a third.

It was on this rising tide that the Audubons had prospered. Besides their investments, their prosperity revealed itself in their accumulating household goods. At the Indian Queen in Louisville at the beginning of their marriage, Lucy had complained of having no books to read; now the Audubon library

approached 150 volumes. Four silver candlesticks, a silver teapot and cream jug and three dozen assorted silver spoons brightened Lucy's table along with knives and forks. No fewer than nine tables—of cherry, walnut, poplar and ash—served throughout the log house, three walnut and cherry bureaus, a large walnut desk, twenty Windsor chairs, four mirrors, five bedsteads, four featherbeds, fifteen blankets and a cherry crib. The Audubons kept thirty head of hogs and two cows with calves, as well as wild and domestic ducks. Lucy rode a sorrel mare using a sidesaddle. For his hunting and bird collecting John James could choose among a fowling piece, a duck gun, a double gun and a smooth rifle. With musical instruments, a map of the world, kitchen utensils, pots and pans, curtains, damask tablecloths, French towels and much more—including, of course, an increasing portfolio of bird drawings—the Audubons' house was well stocked with furnishings.

The expansion of money and credit continued after the war ended, fueling a boom in real estate prices and speculation in public land. Circulating banknotes increased further in 1815 from $46 million to $68 million, and both the U.S. Treasury and the Bank of the United States chose not to demand redemption in specie of all this paper as it moved from bank to bank. With credit cheap, farmers borrowed heavily to pay for improvements, which made more business for merchants, who borrowed to expand. "The whole of our population," a Pennsylvania state senator summarized dryly, "are either stockholders of banks or in debt to them."

Steam flour mills had gone into operation in 1809 at Pittsburgh and in Lexington, Kentucky. A third such mill began operating in Marietta, Ohio, in 1811. In Henderson, 1815 saw little progress on the Audubon & Bakewell mill; acquiring a suitable site along the river seems to have been the problem. David Prentice had finished building the small steam engine for the *Zebulon M. Pike* and had steamed up to Pittsburgh and back in the spring of 1815 to test its operation. Nicholas Berthoud, now actively courting Eliza Bakewell, traveled down frequently from Shippingport. Lucy nursed her weak and mortally disabled little girl while her two growing sons thrived. John Woodhouse, who had been fragile in his first year of life, had become a robust two-year-old; Victor Gifford was a lively and talkative six. Sarah Pears complained of life among the rustics and the savages, which drove her husband Thomas to drink. She particularly resented Lucy, who coped successfully with frontier living while still maintaining herself and her family in meticulous elegance. Sarah, less capable, thought Lucy put on airs.

Finally in March 1816 these tangled lines of life and commerce unknotted. Eliza had welcomed Nicholas's proposal of marriage. Both the Audubons ap-

proved, and the gala wedding in Henderson drew guests from Louisville and Shippingport. Eliza's aunt Sarah Atterbury, when she heard of the marriage back in Pennsylvania, identified the groom to Euphemia Gifford as "another Frenchman" and reported with relief that Tom, Lucy's brother, "spoke highly of him." She worried that the other young Thomas in the family, Benjamin Bakewell's son, whom Eliza had spurned, might not be able to bear the news; all the Pittsburgh Bakewells and Sarah Atterbury too had been "in hopes she would have changed her sentiments in favor of him."

On March 16, 1816, the Henderson village trustees granted Audubon & Bakewell a ninety-nine-year lease on two hundred feet of riverfront land directly across from the partners' general store for a payment of $20 per year and they began building their mill. At some point during the lease negotiations Sarah Pears, who was expecting, had convinced her husband to withdraw from the project and return with his family to Pittsburgh. Though Audubon would remember later that "Thomas Pears lost his money," Audubon & Bakewell in fact bought him out, a refund of his investment that the young partners could ill afford.

Henderson was no place for a bachelor. Tom found time in the midst of building the mill to choose a bride, Elizabeth Rankin Page, a daughter of one of Benjamin Bakewell's business associates. They were married in Pittsburgh on July 27. Elizabeth moved out to Henderson with her new husband that summer, accepted the Audubons' hospitality and quickly came to despise frontier life even more than had Sarah Pears.

The mill was built above the Ohio River on a massive foundation of stone slabs laid four and a half feet thick, the slabs hauled to Henderson from somewhere far upriver or below—there was no such stone available in that part of Kentucky or Indiana. (A Henderson contemporary told William Alves that Audubon had two small steamboats built to haul stone.) The joists to support the roof and floors of the four-story wooden building, laid close together wall to wall, were unhewn local logs not less than a foot in diameter. "No weight that could ever have been placed on the first floor of the mill," an early Henderson historian writes, "could have made an impression." The historian identifies the unpainted exterior weatherboarding as "whipsawed out of yellow poplar." The shaft and gears that turned the three pairs of mill wheels—"two pair of French burrs," as Audubon described them, "and one pair of Laurel Hill stones"—were also made of wood.

By December, before the mill was even finished, Elizabeth had soured Tom on Henderson and determined to return East with or without him to bear their first child. On the last day of the year the couple sold Audubon their cabin and

lot on Locust Street for $771. For another $275 Audubon also took off their hands the lot Tom had recently bought from David and Margaret Prentice. Tom rationalized the breakup of the partnership:

> [Henderson] never having had any allurements for me, & still less *endearments* since I was married, as Elizabeth dislikes it very much, I have dissolved partnership with Mr. Audubon, he taking all the property and debts due to A[udubon] & B[akewell], & agreeing to pay all their debts, for which I take loss to about $5,000, & he is to pay me $5,500, after all the debts owing by A & B are paid, which sum of $5,500 is to bear 20 pct per annum until paid on the above condition. . . . As we are both liable for the debts due by A & B, I have agreed to remain here & give my assistance to Mr. A till [the] 1st of July next & to let the business be carried on in the name of the firm as usual.

Tom told his father he considered Audubon "to have the best of the bargain" despite the load of debt that Audubon had generously assumed, but in fact Lucy's brother was maneuvering to cut his losses while taking advantage of what he had learned; partnering with Prentice in Pittsburgh, he intended to build steamboats for the river trade as well as a more efficient steam mill near the Bakewell glass factory.

The expensive mill that Tom Bakewell had proposed building in Henderson without even determining if the region's grain production could support it now became Audubon's responsibility alone. "It was the first mill in all this section of Kentucky," William Alves was told, "and was a great convenience." Audubon remembered it differently. He remembered a steam mill that went up "at an enormous expense, in a country then as unfit for such a thing as it would be now for me to attempt to settle in the moon." He also remembered that the mill "worked very badly," which may have been the project's more determining flaw. Prentice built steam engines with poor tolerances, as Tom confirmed to his father: "Mr. Prentice has an excellent head, but no hands—we have a very good engine put up in a very slovenly imperfect manner which we are remedying by degrees ourselves. He is a capital man to prescribe, but not to administer—his advice & opinion in matters of his profession are invaluable but his execution worthless."

Tom's decision to dump the mill on Audubon before it was even operational may also have been influenced by the extensive crop failures of 1816, a year that came to be called "the year without a summer," "poverty year" or "eighteen hundred froze to death." Benjamin Franklin had speculated as long before as 1784 that a sufficiently large volcanic eruption such as one that had occurred

in Iceland in 1783 might reduce sunlight and chill the earth—the winter of 1783–84 had been bitterly cold throughout Europe, where Franklin then lived. In 1816, following the eruption the previous year of Mount Tambora on the Indonesian island of Sumbawa, sleet and snow fell in Illinois in April and there were hard frosts in early June from Canada down to Virginia, thirty-degree cold and snow later in June, frosts that killed corn and garden vegetables in July and killing frosts again at the end of September. Three successive corn plantings failed, forcing many families to eat their seed corn to survive—if they had any left. Ice-crusted snow two feet deep covered the ground that winter in Ohio and Kentucky, starving out the turkeys and the deer. People went hungry and some starved in Canada and Europe and throughout the northern United States. Partly in consequence, a wave of migration surged out of New England that eventually populated the Middle West. As with the New Madrid earthquakes, the hard times prompted another religious revival.

It was probably during the disastrous summer of 1816, when people frantically sought wild sources of food to substitute for the failed produce of their gardens and fields, that Audubon observed a great slaughter of passenger pigeons in a stretch of forest along the Green River. Will Bakewell, now sixteen, joined him on at least one of the several excursions Audubon made to the area. His well-known and phantasmagoric narrative, comparable to William Hornaday's later narrative of the slaughter of the buffalo, is worth giving at length:

[The Wild Pigeons' curious roosting-place] was, as is always the case, in a portion of the forest where the trees were of great magnitude, and where there was little underwood. I rode through it upwards of forty miles, and, crossing it in different parts, found its average breadth to be rather more than three miles. . . . I arrived there nearly two hours before sunset. Few Pigeons were then to be seen, but a great number of persons, with horses and wagons, guns and ammunition, had already established encampments on the borders. Two farmers from the vicinity of Russelsville, distant more than a hundred miles, had driven upwards of three hundred hogs to be fattened on the Pigeons which were to be slaughtered. Here and there, the people employed in plucking and salting what had already been procured were seen sitting in the midst of large piles of these birds. The dung lay several inches deep, covering the whole extent of the roosting-place like a bed of snow. Many trees two feet in diameter, I observed, were broken off at no great distance from the ground; and the branches of many of the largest and tallest had given way as if the forest had been swept by a tornado. Everything proved to me that the number of birds resorting to this part of the forest

must be immense beyond conception. As the period of their arrival approached, their foes anxiously prepared to receive them. Some were furnished with iron pots containing sulfur [to burn to asphyxiate them], others with torches of pine knots, many with poles, and the rest with guns. The sun was lost to our view, yet not a Pigeon had arrived. Everything was ready, and all eyes were gazing on the clear sky, which appeared in glimpses amidst the tall trees. Suddenly there burst forth a general cry of "Here they come!" The noise which they made, though yet distant, reminded me of a hard gale at sea, passing through the rigging of a close-reefed vessel. As the birds arrived and passed over me, I felt a current of air that surprised me. Thousands were soon knocked down by the pole-men. The birds continued to pour in. The fires were lighted, and a magnificent, as well as wonderful and almost terrifying, sight presented itself. The Pigeons, arriving by thousands, alighted everywhere, one above another, until solid masses as large as hogsheads were formed on the branches all round. Here and there the perches gave way under the weight with a crash, and, falling to the ground, destroyed hundreds of the birds beneath, forcing down the dense groups with which every stick was loaded. It was a scene of uproar and confusion. I found it quite useless to speak, or even to shout to those persons who were nearest to me. Even the reports of the guns were seldom heard, and I was made aware of the firing only by seeing the shooters reloading.

No one dared venture within the line of devastation. The hogs had been penned up in due time, the picking up of the dead and wounded being left for the next morning's employment. The Pigeons were constantly coming, and it was past midnight before I perceived a decrease in the number of those that arrived. The uproar continued the whole night; and as I was anxious to know to what distance the sound reached, I sent off a man, accustomed to perambulate the forest, who, returning two hours afterward, informed me he had heard it distinctly when three miles distant from the spot. Towards the approach of the day, the noise in some measure [having] subsided, long before objects were distinguishable, the Pigeons began to move off in a direction quite different from that in which they had arrived the evening before, and at sunrise all that were able to fly had disappeared. The howlings of the wolves now reached our ears, and the foxes, lynxes, cougars, bears, raccoons, opossums and polecats were seen sneaking off, whilst eagles and hawks of different species, accompanied by a crowd of vultures, came to supplant them, and enjoy their share of the spoil.

It was then that the authors of all this devastation began their entry amongst the dead, the dying and the mangled. The pigeons were picked up

and piled in heaps, until each had as many as he could possibly dispose of, when the hogs were let loose to feed on the remainder.

Will Bakewell added that during the morning he and Audubon "filled four large bags, containing nine or ten bushels, with pigeons killed by upper branches of the trees (that were broken by the weight of the birds) falling on those roosting below." He also described the devastation that the pigeons themselves caused, a concern to frontier settlers who counted on forest mast to sustain their domestic animals: "After the passenger pigeons left this neck of the woods the trees were so much broken and stripped of their limbs as to have the appearance produced in western and southern forests by the hurricanes they sometimes experience." But while this 1816 slaughter may have been occasioned in part by the summer crop failures, overharvesting of the vast flocks of passenger pigeons would continue throughout the nineteenth century until the species finally became extinct, when a comparable but sustainable commercial slaughter commenced in the twentieth century of domestic fowl.

The steam-powered grist mill took a year to build; the sawmill, on a lower adjoining lot, one year more. Early in 1817, before either project was finished, Audubon began an increasingly desperate search for new partners to share the expense of building and lighten the burden of debt. He found partners but came to believe he "was gulled by all these men." He expanded at retail as well, opening a branch store in Vincennes, Indiana, and another downriver on the Mississippi managed by Nat Pope.

In June he wrote his father and his brother-in-law in Couëron, investigating the possibility of his returning to France or their selling their French holdings and moving to America. Judging by his father's response, he seems to have claimed that he was doing well—he was, at least on paper, since he was expanding—and even that he had made a fortune. In September Jean Audubon replied realistically in the negative: "We would just be small people there whereas here we enjoy full consideration for our mores, our honesty, and although not really rich, our complete independence. From this, my friend, judge if it would not be reckless to move at our age." At seventy-three he would welcome seeing his son again, but he thought Audubon would be wiser to stay in America:

> The country you live in is the best, the richest and beyond compare to any other, you do good business there. Your enthusiasm is quite forgivable. You

left France too early and in a state of shock to know what you can enjoy here. Your wife, having left Europe at a young age, could only have known the unhappiness that her father experienced in England and chose the United States instead, basing her choice, no doubt, on the great freedom you could find there—which is now only equal to ours.

(In further exchanges in 1817 between Henderson and Couëron to endorse his brother-in-law Gabriel du Puigaudeau as his father's executor, Audubon identified himself legally as "Jean Rabin, Creole from Santo Domingo." Creole in this context means a French citizen born abroad; beyond question, Audubon knew who his mother was and where and under what circumstances he was born.)

Tom and Elizabeth Bakewell left in July with their newborn son. Will Bakewell and the Prentices went with them. Lucy's younger sisters Ann and Sarah arrived to take Will's place. They were there in the early winter to comfort their sister and brother-in-law when little Lucy died of hydrocephalus. "Alas!" Audubon wrote his sons much later, "the poor, dear little one was unkindly born, she was always ill and suffering; two years did your kind and unwearied mother nurse her with all imaginable care, but notwithstanding this loving devotion she died, in the arms which had held her so long, and so tenderly." He and Lucy were devastated. "The loss of my darling daughter affected me much," he recalled; "my wife apparently had lost her spirits." As if they could not bear to exile their little girl in the snow and cold of winter, they buried her in the garden of their house.

FINALLY THE FLOUR MILL was up and running. Audubon took to calling it the "bad establishment" because it "worked worse and worse every day." But whether it worked well or ill, it needed firewood to turn water to steam, and the sawmill nearing completion needed logs to whipsaw into lumber. Near the end of the year 1817 Audubon decided to apply for a federal land grant for a square mile of timbered Wabash River bottomland near Vincennes, Indiana. To do so he needed the endorsement of a Revolutionary War veteran; the purpose of such grants had been to reward the men who had fought for American independence. The veteran Audubon found, Jacob Gall, had the virtues of willingness and availability, but he was a drunkard and a thief. Gall endorsed the land-grant application in exchange for a $300 loan and an order for twenty-five hundred trees cut and delivered to the sawmill at one dollar each. With the

proceeds of the loan he got drunk enough to be jailed for disturbing the peace, requiring a disgusted Audubon to post $180 bail as well.

To cut firewood Audubon hired a gang of "hard-fisted Yankees," as he called them, who had turned up on a flatboat seeking work. He lent them axes, oxen and lengths of chain for hauling and set them to it; they began making regular deliveries from the Vincennes tract.

Audubon hunted snow geese on the tract that spring of 1818. "When the young Snow Geese first arrive in Kentucky," he wrote of the experience, ". . . they are unsuspicious and therefore easily procured. In a half-dry half-wet pond running across a large tract of land on the other side of the river in the State of Indiana, and which was once my property, I was in the habit of shooting six or seven of a day. This, however, rendered the rest . . . wild . . . and I was sorry to find that they had the power of communicating their sense of danger to the other flocks which arrived." He found that he could catch the geese "in large traps," however, "and several were procured before the rest had learned to seize the tempting bait in a judicious manner." The hard-fisted Yankees seized the tempting bait as well, absconding downriver with Audubon's tools and oxen, while Gall sold the land-grant tract out from under him to a local partnership. The woodcutting equipment was never recovered, and though he was innocent of any complicity in the false sale, it embroiled Audubon in a lawsuit with the partners Gall had cheated.

The Louisiana Purchase is usually considered an unalloyed good (by European-Americans, at least), more than doubling the size of the United States and opening the way to western expansion, but the burden it imposed on the young nation's rickety financial system was partly responsible for the business depression and subsequent panic that bankrupted the Audubon enterprise along with most other mercantile enterprises on the trans-Appalachian frontier. The "Louisiana debt," as it was called, was due in autumn 1818 and early 1819, and had to be paid in specie. To accumulate the necessary gold and silver the Bank of the United States in the summer of 1818 began requiring the redemption in specie of state bank balances and notes. The state banks, in response, began calling in their outstanding loans and notes, shrinking the money supply. Debtors scrambling for cash sold their holdings of goods and land at sacrifice. Prices fell quickly and heavily. This deflation made debts contracted during the previous period of expansion even more onerous and difficult to repay.

Responding to these conditions, the Audubons began selling off the Henderson real estate they had bought on speculation. They sold twelve tracts of

land in 1818 for a return of only $7,000 and used the money to begin paying their mill and general-store creditors.

Audubon's father died suddenly in Nantes on February 19, 1818. Audubon learned of the loss from his brother-in-law Gabriel du Puigaudeau in early summer, but the sad news came with news of a vicious lawsuit filed by Jean Audubon's nieces and nephew that sought to exclude John James and his half-sister Rose from their father's small remaining estate by labeling them "illegitimates." Audubon wrote in July expressing his hope of visiting France to console his mother and sister. Public knowledge of his illegitimacy could further undermine his precarious position in Henderson, however, and to protect his family as well as himself at a time when mail was far from secure, he stopped communicating with Couëron—effectively forfeiting any inheritance he might claim. His father had anticipated the challenge to his estate in his will; any such challenge triggered a change of beneficiaries and passed the entire estate undivided directly to his widow Anne Moynet.

Comic relief from these tribulations arrived in Henderson in late summer 1818 in the eccentric person of one Constantine Samuel Rafinesque, a manic French-American polymath naturalist whose life experiences curiously parallel Audubon's own: born in Constantinople, raised in Leghorn, Italy, where his family had moved to escape the Terror; emigration to America and a clerkship in Philadelphia. But Rafinesque had written his first scientific paper at thirteen, read widely, spoke half a dozen languages and had been everything from a drug manufacturer to a whiskey distiller to an American consular secretary in Palermo. Samuel Latham Mitchill, the physician and former senator, had befriended him and helped him find work as a tutor after he had lost everything when the ship that was returning him from Sicily in 1815 ran aground off New London. Now he was descending the Ohio in a flatboat collecting specimens for a book to add to his growing bibliography, which by the end of his life would encompass nearly one thousand entries.

Audubon was walking on the riverbank when he noticed Rafinesque landing "with what I thought [was] a bundle of dried clover on his back." Behind this curiosity's broad, phrenologically distinguished forehead his black hair fell long and lank, keeping company with a full beard; his "long loose coat of yellow nankeen"—a durable cotton twill—was "much the worse of the many rubs it had got in its time, and stained all over with the juice of plants." Rafinesque had a letter of introduction to Audubon from the Tarascons, whom he had met in Shippingport, and had come to Henderson "expressly for the purpose of seeing my drawings, having been told that my representations of birds were

accompanied with those of shrubs and plants, and he was desirous of knowing whether I might chance to have in my collection any with which he was unacquainted."

The first plant Rafinesque failed to recognize as he looked over Audubon's drawings he declared did not exist; when Audubon marched him back to the riverbank to see one, he "danced, hugged me in his arms, and exultingly told me that he had got not merely a new species, but a new genus." Back in the house once more Rafinesque went systematically through the drawings making notes, which Audubon says "were of the greatest advantage to me, for, being well acquainted with books as well as with nature, he was well fitted to give me advice"—that is, to identify the plants in Audubon's drawings and give him their Latin names. Audubon introduced the enthusiastic collector to a small beetle strong enough to carry a candlestick on its back; during the demonstration the candlestick "change[d] its position as if by magic." He noticed the holes in Rafinesque's stockings and the man's aversion to soap but forgot his oddities in the rush of "his agreeable conversation."

His visitor's gullible mania for finding new species piqued Audubon's frontier sense of humor. After a night enlivened by the uproar Rafinesque made chasing bats around his room, and several days of independent collecting, Audubon ran his guest ragged in the summer heat and humidity pushing his way backward through a dense Ohio canebrake, startling a bear, suffering a downpour, receiving "many scratches from briars, and now and then a twitch from a nettle," until Rafinesque "seriously inquired if we should ever get alive out of the horrible situation" and "threw away all his plants, emptied his pock-

Audubon's mock "Devil-jack diamond fish"
as Constantine Rafinesque sketched it in his notebook

ets of the fungi, lichens and mosses which he had thrust into them, and finding himself much lightened, went on for thirty or forty yards with a better grace."

The three weeks Rafinesque lived with the Audubons allowed ample time for more elaborate practical jokes. Most elaborate—and the most trouble to Audubon afterward when the hoax was revealed—was his invention of new species of fish and mollusks to feed Rafinesque's mania, complete with drawings and detailed descriptions. The devil-jack diamond fish as Rafinesque described it in his *Ichthyologia Ohiensis, or Natural History of the Fishes inhabiting the River Ohio and its tributary Streams* was typical; Audubon seems to have concocted it by crossing an alligator with a paddlefish and kiln-firing the scales:

> This may be reckoned the wonder of the Ohio. It is only found as far up as the Falls, and probably lives also in the Mississippi. I have seen it, but only at a distance, and have been shown some of its singular scales. Wonderful stories are related concerning this fish, but I have principally relied upon the description and figure given me by Mr. Audubon. Its length is from 4 to 10 feet. One was caught which weighed four hundred pounds. It lies sometimes asleep or motionless on the surface of the water, and may be mistaken for a log or a snag. It is impossible to take any other way than with the seine or a very strong hook, the prongs of the gig cannot pierce the scales which are as hard as flint, and even proof against lead balls! Its flesh is not good to eat. It is a voracious fish: Its vulgar names are Diamond fish (owing to its scales being cut like diamonds) Devil fish, Jack fish, Garjack, &c. . . . The whole body is covered with large stone scales laying in oblique rows, they are conical, pentagonal, and [pentahedral] with equal sides, from half an inch to one inch in diameter, brown at first, but becoming the color of turtle shell when dry: they strike fire with steel! And are ball proof!

Rafinesque's "I have seen it, but only at a distance" surely excuses Audubon from any blame for wasting ichthyology's time with tall tales. The "eccentric naturalist," as Audubon called him, disappeared one day with all his "grasses and other valuables" without saying goodbye, but had the good grace to send a letter of thanks to relieve the Audubons' concern that he might have "perished in a swamp, or . . . been devoured by a bear or a gar-fish." They were sorry to lose him: "We were perfectly reconciled to his oddities, and, finding him a most agreeable and intelligent companion, hoped that his sojourn might be of long duration." When Audubon wrote humorously about the episode later, he thoughtfully assigned Rafinesque a pseudonym to protect him from general ridicule.

Ann Bakewell returned to Pennsylvania at the end of the summer. Her sister Sarah stayed in Henderson, too sick to leave (she had probably been struck by one of the summer fevers, although she had not yet left Henderson in January 1819). Ann remembered her eighteen-month visit as "the happiest part of my life" up to that time. She would have stayed, but she was needed at Fatland Ford. William and Rebecca Bakewell had intended to travel out to Henderson to visit and to retrieve their unmarried daughters now that regular steamboat service was available, and their daughters had even hoped, Ann told Euphemia Gifford, to "have persuaded them to remain" in Kentucky, but William Bakewell's declining health made travel impossible. "Not that his bodily health is so bad," Ann's stepmother Rebecca explained in her first letter to her Derbyshire relation, "his memory & speech are the most affected, he seldom utters any other word than yes. When I look back on the extraordinary colloquial powers he formerly possessed & compare it with his present situation, my distress is scarcely to be conceived. . . . His conversations had for several years been declining. He frequently spoke of it & lamented it, at most times he could express himself better by writing but since the severe illness he had about fourteen months ago it has been quite a task." Whatever Ann's siblings felt about their stepmother, Ann at home found reason to respect her: "Her attention to my Father is unbounded, and if she had no other claim on my regard that alone would be sufficient to entitle her to my lasting gratitude."

Seventeen steamboats plied the Western rivers in 1817; by 1820 there would be sixty-nine. From 1815 onward, steamboats reliably ascended from New Orleans to Louisville and even to Pittsburgh in three or four weeks, compared with three or four months for keelboats in the old cordelling days—"convinc[ing] the despairing public," as a contemporary wrote of one such passage in 1817, "that steamboat navigation would succeed on the western waters." A Swedish diplomat of the day expected steam navigation in the United States and Russia to "act most powerfully in drawing men together and in binding the inhabitants of the most distant regions into fraternal union," but new technologies are always predicted to unite and to pacify when they more commonly fracture and arouse, at least in the shorter term—the same virtues would be claimed in a later decade of the nineteenth century of the telegraph and of radio in the twentieth. What steamboats were doing in the trans-Appalachian west in 1818, as Tocqueville noticed a decade farther on, was "facilitating rapid communications between the diverse parts of this vast body"—functioning, that is, as Brobdingnagian waterborne stagecoaches and mailbags. And what they were beginning to communicate was different from what Swedish diplomats and philosophic French travelers might expect, a Cincinnati writer observed:

An Atlantic citizen who talks of us under the name of backwoodsmen would not believe that such fairy structures of oriental gorgeousness and splendor . . . had ever existed in the imaginative brain of a romancer, much less that they were actually in existence, rushing down the Mississippi as on the wings of the wind, or plowing up between the forests and walking against the mighty current "as things of life," bearing speculators, merchants, dandies, fine ladies, everything real and everything affected in the form of humanity, with pianos, and stocks of novels, and cards, and dice, and flirting, and lovemaking, and drinking, and champagne, and on the deck, perhaps, three hundred fellows who have seen alligators and neither fear whiskey or gunpowder. A steamboat, coming from New Orleans, brings to the remotest villages of our streams and the very doors of the cabins a little Paris, a section of Broadway, or a slice of Philadelphia, to ferment in the minds of our young people the innate propensity for fashions and finery.

This yeast had not yet been proofed in Henderson, but technological entrepreneurs like Tom Bakewell, David Prentice and John James Audubon were alert to the possibilities, which explains why Audubon had accepted in partial reimbursement for Tom's share of the Audubon & Bakewell debts a promissory note for $4,250 from a Henderson man named Samuel Bowen for the purchase of a small Bakewell & Prentice steamboat. Trying to repossess the steamboat in early 1819 when the note proved uncollectible almost got Audubon killed.

"HOPES ARE SHY BIRDS"

L IKE MANY WHO SUFFERED FINANCIAL DISASTER in the Panic of 1819, Audubon blamed himself. "The purchasing of too many goods sold on credit—of course lost—reduced us, divided us," he diagnosed his failure a year later. Even a decade afterward, explaining himself to his sons, he was still "fully persuaded the great fault was ours, and the building of that accursed steam mill was, of all the follies of man, one of the greatest, and to your uncle [Tom Bakewell] and me the worst of all our pecuniary misfortunes." Audubon was closer to the mark when he referred to "a *revolution* occasioned by numberless quantities of failures" that "put all to an end." Not many escaped what one historian calls "America's first great economic crisis and depression"; if Audubon was to blame for extending his investments at a time of increasing money supply and easy credit, his was a common fault. As the governor of Ohio read in a report prepared for him in 1820, "One thing seems to be universally conceded, that the greater part of our mercantile citizens are in a state of bankruptcy—that those of them who have the largest possessions of real and personal estate . . . find it almost impossible to raise sufficient funds to supply themselves with the necessaries of life—that the citizens of every class are uniformly delinquent in discharging even the most trifling of debts."

"How I labored at that infernal mill!" Audubon told his sons—"from dawn to dark, nay, at times all night. . . . We also took it into our heads to have a steamboat in partnership with the engineer who had come from Philadelphia to fix the engine of that mill. This also proved an entire failure, and misfortune after misfortune came down upon us like so many avalanches, both fearful and destructive." The avalanche of the steamboat that almost got Audubon killed broke loose in April 1819 when the one-year $4,250 promissory note that Samuel Bowen and his partners had given Prentice & Bakewell to purchase the *Henderson* (which Tom Bakewell had signed over to Audubon) came due.

Flooding on the Mississippi

Audubon hoped to collect the payment or, even better, repossess the boat to set himself up in the potentially lucrative steamboat business.

But when Audubon went looking for Bowen, he discovered the man had taken off for New Orleans in the *Henderson* with an accomplice named Wilson and intended to dispose of it there. Since Tom Bakewell had given Audubon the Bowen promissory note to cover that much of Tom's share of Audubon & Bakewell's obligations, losing his collateral or failing to collect on the note would mire Audubon $4,250 deeper in debt. To recover the small steamboat from Bowen, he set off urgently for New Orleans in an open skiff with two of his slaves manning the oars.

Audubon passed his thirty-fourth birthday on the Mississippi on April 26. Below New Madrid he observed an eagles' nest in a cypress tree, the only significant detail of his chase to New Orleans that he later wrote down. Coincidentally, the Reverend Timothy Flint was also floating down the river at that time—in his case on a keelboat—a few days behind Audubon. Flint saw what Audubon must also have seen as he passed the bay where the White River emptied into the flood, "that spectacle so common in the spring on the Mississippi—a dense forest of the largest trees, vocal with the song of birds, matted with every species of tangled vegetation, and harboring in great numbers the turkey-buzzard, and some species of eagles; and all this vegetation apparently

rising from the bosom of dark and discolored waters. I have never seen a deeper forest except of evergreens."

In New Orleans Audubon found himself a day late and a dollar short. Bowen refused to repay the note. Audubon took him to court on May 12 to attach the *Henderson*. A judge issued the attachment, but when a deputy sheriff went looking for the boat, he discovered that Bowen had turned it over to "prior claimants" shortly before Audubon arrived, to satisfy other debts—like his pursuer, Bowen also was juggling assets in his struggle to survive the Panic. Audubon added fraud to his charges against the Henderson businessman, but since the steamboat had left New Orleans, removing the assets in question from the court's jurisdiction, the judge dismissed the case. Frustrated and angry, Audubon put out word around town that Samuel Bowen was a thief, sold the two slaves who had rowed him downriver, took an upriver Mississippi steamboat to the mouth of the Ohio and walked the last 130 miles home.

James Berthoud, Audubon's elderly Shippingport friend and Nicholas's father, was visiting Henderson at the time. He warned Audubon of what was to come, and it came:

> On my arrival old Mr. Berthoud told me that [Bowen] had arrived before me and had sworn to kill me. My affrighted Lucy forced me to wear a dagger. [Bowen] walked about the streets and before my house as if watching for me, and the continued reports of our neighbors prepared me for an encounter with this man, whose violent and ungovernable temper was only too well known. As I was walking toward the steam mill one morning, I heard myself hailed from behind; on turning, I observed [Bowen] marching toward me with a heavy club in his hand. I stood still, and he soon reached me. He complained of my conduct to him at New Orleans, and suddenly raising his bludgeon laid it about me. Though white with wrath, I spoke nor moved not till he had given me twelve severe blows, then, drawing my dagger with my left hand (unfortunately my right was disabled and in a sling, having been caught and much injured in the wheels of the steam-engine), I stabbed him and he instantly fell.

Audubon chose not to explain his strategy for this encounter, but waiting until Bowen attacked him in full view of witnesses (and he adds that "others . . . were hastening to the spot" who "now came up and carried [Bowen] home on a plank") must have been intended to establish self-defense. A battered Audubon staggered home. Bowen's friends were not sympathetic. "Thank God, his wound was not mortal," Audubon reported, "but his friends

were all up in arms and as hotheaded as himself." They armed themselves and converged on Audubon's house. James Berthoud had survived the French Revolution and was certainly prepared to face down a Kentucky mob from the Audubon porch. He looked grand, an eyewitness reported, "with his white hair floating in the wind as he harangued the crowd who had come to whip Mr. Audubon who was lying wounded in the house. . . . His appearance and his appeal had such an electric effect on those roughs that they cooled down and looked at the grand old man as a spirit from another world." Which he was.

Charged with assault and battery, Audubon defended himself in court before Judge Henry P. Broadnax. A Virginia aristocrat with high standards of personal honor, Broadnax found that Audubon had acted in self-defense and dismissed the charges. He told the defendant afterward, "Mr. Audubon, you committed a serious offense—an exceedingly serious offense, sir—in failing to kill the damned rascal." No doubt Audubon was relieved to be exonerated, but he was still short almost $5,000 that he needed to pay his debts.

Audubon had left New Orleans on the last day of May. Now in June he turned over his stores to his creditors, who presumably took back whatever stock remained unsold. With banknotes nearly worthless, barter in any case had almost entirely replaced cash sales. Lucy was near term with their fourth child. "I had heavy bills to pay which I could not meet or take up," Audubon recalled painfully. "The moment this became known to the world around me, that moment I was assailed with thousands of invectives; the once wealthy man was now nothing." The only choice left him was to sell out.

In April he had offered to sell his "undivided half of the Henderson Steam Mill" in the *Louisville Public Advertiser,* noting that it had "been in operation for two years, the engine is on the condensing principle, and, with the improvements that are now making to it, [it] will be one of the best in the union; a wharf of one hundred twenty feet in length has just been completed." As they had not been before, the wealthy Berthouds were now prepared to buy. Doing so would help the Audubons by converting their goods and property into cash, but the fact that the Berthouds were willing to pay what the sale indentures call "current money" indicates that the goods and property had real value. On July 13, 1819, Nicholas Berthoud paid Audubon $14,000 for his interest in the steam mill. According to Henderson old-timers, the mill "did all the grinding for the farmers living around and many miles [away]" for several years after the Berthouds acquired it—confirming the claim Audubon had made for it in his advertisement. Nicholas also bought the Audubons' seven remaining slaves that day for $4,450 and took over the Vincennes timber tract. For the Audubons' house and land and all their household goods and personal

property, down to Lucy's silver, the cherry crib, the piano and other musical instruments, the books, all John James's guns, Lucy's horse and saddle and John James's drawings and drawing instruments—as the indenture summarized, "all the furniture, utensils, paintings, drawings and stock"—Nicholas paid $7,000. Audubon told his sons he "parted with every particle of property . . . keeping only the clothes I wore on that day, my original drawings and my gun," which implies that Berthoud included those possessions in the sale to put them beyond the reach of Audubon's creditors and then quietly returned them to him afterward. He kept the family silver, however.

More than $25,000—more than $344,000 today—was not enough to fully satisfy Audubon's debts. He paid out every penny, left Lucy and the boys in Henderson—lodged probably with the Rankins—and set out walking to Louisville to look for work, deeply depressed. This "saddest of all my journeys" became "the only time in my life when the Wild Turkeys that so often crossed my path, and the thousands of lesser birds that enlivened the woods and the prairies, all looked like enemies, and I turned my eyes from them, as if I could have wished that they had never existed"—black depression indeed when John James Audubon counted even the birds among his enemies.

Lucy at least had not failed him, though she was certainly scarred. "*She* felt the pangs of our misfortunes perhaps more heavily than I," he told his sons gratefully, "but never for an hour lost her courage; her brave and cheerful spirit accepted all, and no reproaches from her beloved lips ever wounded my heart. With her was I not always rich?"

Audubon's creditors awaited him in Louisville. No sooner did he arrive than he was arrested and thrown into jail for debt. A friend alerted him to Kentucky's new bankruptcy law and he invoked it to win his release: "I took the benefit of the act of insolvency at the Louisville Court House, Kentucky, before Judge Fortunatus Crosby & many witnesses." When Lucy learned that her husband had been jailed she was frantic to go to his aid despite her advanced pregnancy. She had intended to travel to Louisville later by steamboat when Audubon had found work, but he had not yet sent her the fare. Someone, probably Adam Rankin, contacted another of the Audubons' many senior friends, Kentucky's U.S. Senator Isham Talbot, who sent his carriage to Henderson from his home in Frankfort to pick up Lucy and the boys and deliver them to Shippingport, where Eliza and Nicholas Berthoud took them in. Not long after Lucy arrived to find John James out of jail but bankrupt, she delivered her fourth child, a daughter. They named the little girl Rose, as Audubon told his sons, "on account of her extreme loveliness, and after my own sister Rosa."

His sister was on his mind because he was thinking of traveling to France to see her and his adoptive mother Anne Moynet, probably to set up in business with them. He was too broke to travel. He asked Tom Bakewell and Nicholas Berthoud, both of them in the boatbuilding business, to help him find work as a clerk on a steamboat. Both refused, wary that he might run off and leave them with debts to pay and his family to support. If they unkindly misjudged Audubon, they even more egregiously underestimated Lucy. Bankrupted, with a newborn infant to care for, living at charity in her younger sister's house, Lucy yet sustained her husband as he faced such suspicions from his in-laws; as he wrote in his journal, she "gave me a spirit such as I really needed, to meet the surly looks and cold receptions of those who so shortly before were pleased to call me their friend."

PEOPLE WHO SURVIVE PERSONAL DISASTER often undergo fundamental change. Audubon identified the onset of such transformation that 1819 summer in his memoir to his sons:

> After our dismal removal from Henderson to Louisville, one morning, while all of us were sadly desponding, I took you both, Victor and John, from Shippingport to Louisville. I had purchased a loaf of bread and some apples; before we reached Louisville you were all hungry, and by the riverside we sat down and ate our scanty meal. On that day the world was with me as a blank, and my heart was sorely heavy, for scarcely had I enough to keep my dear ones alive; and yet through these dark days I was being led to the development of the talents I loved.

Audubon had not been fully trained in portraiture, but the limited training he had received as a boy in France had evidently included drawing facial features. He had drawn portraits of Osages on his first expedition to Ste. Genevieve and had probably done a few other portraits informally in the years since 1810. In August 1819 in Shippingport he attempted a likeness of his elderly friend James Berthoud in pencil and black chalk on 8 by 10-inch paper, a somewhat idealized profile, sallow but serene. Berthoud, seated and facing right against a dark background, wears a black cap pulled down to cover his forehead and most of his ears, with his reading glasses set jauntily on his cap like a headband. Audubon then drew Marie-Anne-Julia Berthoud, James's wife, in profile facing left, making a matched pair of the elderly couple's portraits; she wears a white lace shawl and cap and is more realistically rendered, weath-

Nicholas Berthoud,
drawn by Audubon in 1819

ered and almost scowling. A third portrait, of Nicholas, long-faced and handsome in a black coat and starched stand-up collar, his thick black hair extending to a sideburn trimmed below his ear, Audubon presented to Eliza with a note saying it was drawn "by her affectionate brother, 1819—August." (He probably drew Eliza as well, to complete the set; if so, that drawing has been lost.)

Singing for his supper by drawing the Berthouds' portraits, Audubon was also discovering a way to support his family. "Nothing was left to me but my humble talents," he reconstructed his reasoning later. "Were those talents to remain dormant under such exigencies? Was I to see my beloved Lucy and children suffer and want bread in the abundant state of Kentucky? Was I to repine because I had acted like an honest man? Was I inclined to cut my throat in foolish despair? No!! I *had* talents, and to them I instantly resorted." Birds he had taught himself to draw in more than a decade of labor; his portraits—the facial features at least, if not the hands and clothing—were confident from the beginning, implying previous training.

He was well enough trained to have deliberately borrowed the profile style then popular in the French community in America. A French artist named Charles-Balthazar-Julien Fevret de Saint-Mémin, a royalist in exile, had invented a bulky machine he called a physiognotrace that outlined a subject's profile at life size directly on paper. Once the machine had transferred the profile, Saint-Mémin finished the drawing with pencil and chalk. Based in Philadelphia after 1803, Saint-Mémin had worked all over the Middle Atlantic. Louis Tarascon had a Saint-Mémin of himself in his Shippingport house that Audubon must have seen; "with its pursed lips and high white collar," writes the art historian Linda Partridge, who discovered this connection, it "is especially close to Audubon's profile of Nicholas Berthoud."

Sometime that summer after Audubon drew his portrait, James Berthoud died. The artist eulogizes him as "a particularly good man and I believe the only *sincere* friend of myself and [my] wife we ever had."

The Berthoud portraits led to others, and soon Audubon was busy and solvent again:

To be a good draughtsman in those days was to me a blessing; to any other man, be it a thousand years hence, it will be a blessing also. I at once undertook to take portraits of the human "head divine" in black chalk, and . . . succeeded admirably. I commenced at exceedingly low prices, but raised these prices as I became more known in this capacity. . . .

In the course of a few weeks I had as much work to do as I could possibly wish, so much so that I was able to rent a house in a retired part of Louisville.

People hungered for portraits in that era before photography, and besides being a good draftsman, Audubon always worked fast. Like a doctor he began to be called out day and night to attend people on their deathbeds, and at least once, he recalled, "a clergyman residing at Louisville . . . had his dead child disinterred, to procure a facsimile of his face, which, by the way, I gave to the parents as if still alive, to their intense satisfaction."

While he sustained his family with the proceeds from his portraits, Audubon began again energetically collecting and drawing birds. "In this particular," he wrote insightfully, "there seemed to hover round me almost a mania, and I would even give up doing a head, the profits of which would have supplied our wants for a week or more, to represent a little citizen of the feathered tribe." Birds had been his escape from the Terror in Nantes and Couëron; now he turned to them to escape from the shame and humiliation of public failure. "During my deepest troubles I frequently would wrench myself from the persons around me, and retire to some secluded part of our noble forests. . . . This never failed to bring me the most valuable of thoughts and always comfort, and, strange as it may seem . . . it was often necessary for me to exert my will, and compel myself to return to my fellow beings."

More than distraction drove his renewed interest in birds. Always an enthusiast, he had all but abandoned his art for commerce during his Henderson years. Commerce had failed him and even shamed him. Now in Shippingport in long conversations with Lucy he saw that his art might salvage their future. He thought that he "drew birds far better than I had ever done before misfortune intensified, or at least developed, my abilities," and he was right. "Having a tolerably large number of drawings that have been generally admired, I concluded that perhaps I could not do better than to travel, and finish my collection or so nearly that it would be a valuable acquisition. My wife hoped it might do well." Tempered by adversity in the country he had adopted and come to love, he began consistently signing his drawings with an unambiguously American form of his name: "John J. Audubon."

In the autobiographical essays he wrote at various times in his life, Audubon remembered a later date for his decision to move on from commerce to art. A letter an influential friend wrote on his behalf corrects him. Robert S. Todd was a Lexington, Kentucky, businessman and politician and the father of two-year-old Mary Todd (later to marry Abraham Lincoln). On February 12, 1820, Todd wrote General William Lytle recommending Audubon for employment. Lytle, one of the founders of Cincinnati, was affiliated with Cincinnati College, a new institution incorporated by the Ohio legislature only twelve months before:

> Dear Sir—You will very much oblige me by making immediate enquiry of the Trustees of your College whether or no they wish to employ a professor of French and drawing. Mr. Audubon of this place would I think accept the appointment, if the salary would be made an object. He is eminently qualified for both or either. You have no doubt seen some of his paintings in this place and of course will be able to judge on that subject for yourself. *He has nearly finished a collection of American birds,* and is anxious to see Wilson's *Ornithology* to ascertain whether or no there is any bird in his collection which he Mr. Audubon has omitted to paint.... The opportunity of employing Mr. Audubon must not be neglected as he would be a great acquisition to your institution.

By then Audubon had surfeited the Louisville hunger for portraits, at least for portraits at $5 a head. Cincinnati, upriver 140 miles from Louisville, offered a fresh field. The town of ten thousand had been booming before the Panic—

Daniel Drake, M.D.

two hundred new brick and timber houses had been built there in 1819—and was still coasting: its banks had not yet failed. A contemporary observer of the Cincinnati scene noticed "a large steam grist mill, three large steam boats on the stocks, and two more on the Kentucky side of the river, and a large ferry boat.... The beach is lined with keel boats, large arks for carrying produce, family boats and rafts of timber.... Merchants' shops are numerous and well frequented."

Daniel Drake, the leading Cincinnati physician, scholar and naturalist who had shown Alexander Wilson an excavated Indian mound a decade earlier, was trying to staff a new med-

ical school, was a trustee of Cincinnati College and was organizing a new Western Museum within the college modeled on Peale's Museum in Philadelphia. Audubon's lack of formal education would have disqualified him for a college professorship. Drake deflected him to the museum, which needed portraits of trans-Appalachian notables for its portrait gallery, painted landscape backgrounds for its specimen display cases and fish, bird and quadruped taxidermy. To entice the restless outdoorsman indoors Drake offered him a substantial salary of $125 a month, the equivalent of twenty-five $5 portraits, about $1,700 today.

One final blow staggered Audubon before he left Louisville for Cincinnati. Lucy and infant Rose had been sick with fever that autumn. Lucy had recovered, but Rose had slowly succumbed. "How I have dwelt on her lovely features when sucking the nutritious food from her dear mother," Audubon anguished. "Yet she was torn away from us when only seven months old."

AUDUBON REMEMBERED CINCINNATI as a flourishing place, and it was. Once Lucy arrived with the boys, they rented a small house. Audubon easily filled their larder from the exceptional local markets and the nearby woods. "Our living here is extremely moderate," he noted in his journal; "the markets are well supplied and cheap, beef only two and a half cents a pound, and I am able to provide a good deal myself; Partridges [i.e., quail] are frequently in the streets, and I can shoot Wild Turkeys within a mile or so; squirrels and Woodcock are very abundant in the season, and fish always easily caught." Timothy Flint had visited the Cincinnati markets in 1817 and found lines of Conestoga wagons, "fowls, domestic and wild turkeys, venison . . . all sorts of fruits and vegetables, equally excellent and cheap. . . . In one quarter there are wild animals that have been taken in the woods; cages of redbirds and parroquets; and in another, old ladies, with roots, herbs, nuts, mittens, stockings, and what they call 'Yankee notions.' "

At the Western Museum Audubon's immediate superior was Robert Best, "an Englishman of great talent" who had been supporting himself as a watchmaker until the museum came along. Audubon and Best worked industriously together augmenting, arranging and finishing—Audubon's verbs—the museum's displays, which included mammoth and giant sloth bones, several hundred stuffed birds, quadrupeds and fish, Indian artifacts, Egyptian antiquities and the tattooed and preserved head of a Maori chief, as well as devices that demonstrated principles of mechanics and electricity. Audubon worked on the fauna while Best built the demonstration machines.

Soon enough the Panic arrived, however, annulling the pledges the museum society's members had made: "Mr. Best and I found, sadly too late, that the members of the College museum were splendid promisers and very bad paymasters." Audubon continued working at the museum, but with payment of his salary deferred from month to month, he "returned to my portraits and made a great number of them, without which we must have once more been on the starving list." In April he added regular classes at Miss Deeds's school for "females of all ages," which advertised "Drawing & Painting by Mr. Audubon" in the *Cincinnati Western Spy* on March 25. In early May he added classes at a second female academy. Students liked him; a Louisville pupil judged him "very good natured and . . . a perfect master of the art." Before long he left the academies and opened a painting school of his own, "to which I attended thrice per week, and at good prices"—cutting out the middlemen.

Daniel Drake, like Audubon a handsome, industrious man born in 1785, was rapidly going broke himself. Before the end of the year he would have to give up his elegant home, which a colleague remembered "was usually the scene of a party whenever a notable stranger was in the city," and move into a log cabin, feelingly named Mount Poverty. In lieu of paying Audubon's salary, Drake offered him public recognition and a creative new prospect.

Soon after the artist began working at the museum, Drake approved a public display there of his bird drawings. They won high praise. The *Cincinnati Inquisitor Advertiser,* reviewing the one-man show, thought "the style & execution of these paintings . . . are so very superior, that we believe we hazard nothing in saying, there have been no exhibitions west of the mountains which can compare with them. Good judges have indeed declared they excel all other similar works in the United States."

Then the U.S. government's Long Expedition, having started from Pittsburgh at the beginning of May, docked its curious new steamboat at Cincinnati on May 9. Major Stephen Long had decided to stop off for a few days to have the steam engine adjusted while the expedition physician, William Baldwin, who had become severely ill, was moved ashore and treated. As the leading physician in Cincinnati, Drake was called. The Long Expedition was the exploratory arm of a larger Yellowstone Expedition that Secretary of War John C. Calhoun had proposed after the War of 1812 to show the flag to the British and the Indians on the upper western reaches of the Missouri River, now United States territory as part of the Louisiana Purchase. Long's scientific staff included two of Charles Willson Peale's protégés: Peale's nineteen-year-old son Titian Ramsey Peale, an artist and taxidermist, and John Bartram's great-grandson Thomas Say, a self-educated entomologist then collecting specimens for a pro-

jected *American Entomology.* (Peale père had painted the explorers before they left the East, quipping that "if they lost their scalps, their friends would be glad to have their portraits.")

Inevitably Drake gave these notables a tour of his museum rooms. Titian Peale was gullible enough to write down Drake's Cincinnati-boosting estimate that "the present population is said to exceed 25,000," but he thought the museum showed little progress, having only "a few articles collected for that purpose, mostly fossils and animal remains." Audubon's portfolio was another matter, as much a surprise to the Philadelphians as it had been ten years before to Alexander Wilson: "Well do I recollect how [Major Long], Messrs. T. Peale, Thomas Say and others stared at my drawings of birds at that time."

The Long Expedition departed the following week in its narrow-gauge steamboat, the *Western Engineer,* custom-built for Western rivers at 75 feet long and only 13 feet wide, with a stern paddlewheel, howitzers and other cannon, a bulletproof pilothouse, a detachable square-rigged mast and a bow thrusting forward the scaly carved head of a large serpent, through the mouth of which the waste steam vented (to "give . . . to the Indians the idea," Titian Peale supposed, "that the boat is pulled along by this monster"). Audubon could watch it go aware that the United States government favored scientific collection in

The Long Expedition's Western Engineer *with its serpent figurehead, sketched by Titian Peale in 1819*

the great wilderness beyond the settling frontier where for ten years he had made his home, aware as well that the work he had already accomplished informally and without remuneration made experts stare.

A month later on Saturday evening, June 10, in the Cincinnati College chapel, to celebrate the public opening of the museum after two years of preparation, Drake delivered an "Anniversary Discourse on the State and Prospects of the Western Museum Society," during which he gave Audubon's work prominence and pointed to a way it might be completed. Audubon had been interested in Drake's college and museum in the first place, as Robert Todd's February letter of introduction had explained, because its library might contain volumes of Alexander Wilson's *American Ornithology* that he had not yet seen and against which he could compare his collection. Now Drake invoked Wilson in describing the museum's holdings and specified what was missing in both:

> It would be an act of injustice to speak of our ornithology, without connecting with it the name of Alexander Wilson. To this self-taught, indefatigable and ingenious man we are indebted for most of what we know concerning the natural history of our [American] birds. His labors may have nearly completed the ornithology of the middle Atlantic states, but must necessarily have left that of the western imperfect. When we advert to the fact that most birds are migratory, and that in their migrations they are not generally disposed to cross high mountains, but to follow the course of rivers; when we contemplate the great basin of the Mississippi, quite open to the north and the south, but bounded on the east and west by ranges of lofty mountains, while the river itself stretches through twenty degrees of latitude, connecting Lake Superior and the Gulf of Mexico, it is reasonable to conjecture, that many birds annually migrate over this country which do not visit the Atlantic states, and might, therefore, have escaped the notice of their greatest ornithologist in the single excursion he made to the Ohio.

Audubon knew that excursion, of course, because on his way down the Ohio Wilson had stopped in at Audubon's Louisville store and stared like the experts of the Long Expedition at his drawings—drawings not nearly as skillful or as extensive then as they were now. Drake, continuing, might have been reading Audubon's mind:

> As a proof of this supposition, it may be stated that Mr. Audubon, one of the excellent artists attached to the Museum, who has drawn, from nature, in

colored crayons, several hundred species of American birds, has, in his portfolio, a large number that are not figured in Mr. Wilson's work, and which do not seem to have been recognized by any naturalist.

Here then was Audubon's program for completing his collection. When he wrote U.S. Representative Henry Clay of Kentucky six weeks later seeking a letter of introduction (which Clay promptly sent), he laid out his plan in almost exactly these terms: "After having spent the greater part of fifteen years in procuring and drawing the birds of the United States with a view to publishing them, I find myself possessed of a large number of such specimens that usually resort to the Middle States only. Having a desire to complete the collection before I present it to my country in perfect order, I intend to explore the territories southwest of the Mississippi." These territories would include "the Red River, [the] Arkansas, and the countries adjacent." He would be "a naturalist [visiting] the frontier forts and agencies of the United States." Rising from the ruins of his mercantile career, Audubon had reimagined himself as a one-man ornithological expeditionary force. And if he had not thought of publication when Wilson asked him about it in Louisville in 1810, he was thinking of it now.

With his pay still promised but not yet forthcoming in June 1820 and his museum work largely done, Audubon left the museum and concentrated on portraiture. His portraits had improved steadily with practice and he drew them now in three-quarter profile and even fully frontal: Robert Best's father and mother, English people in old-fashioned Cromwellian dress; General and Mrs. William Lytle, a handsome older man with bristled hair and a distant look, his lace-capped wife a delicate beauty; the Reverend and Mrs. Elijah Slack, done in pencil, both worthies short and round, he in a Masonic ceremonial coat decorated with feathers, she in a lace-collared dress with her hair pinned up on one side in a large curl. Slack, who was president of Cincinnati College and taught chemistry there, gave Audubon a letter of introduction that mentioned his purpose "of completing a collection of drawings of the birds of the United States, which he proposes to publish at some future period—he has been engaged in our museum for 3 or 4 months & his performances do honor to his pencil." The money from the portraits went into Lucy's purse to tide her over.

While the Audubons organized themselves for John James's absence on expedition, they worked through the rest of their plans. He expected to be gone seven or eight months, from October to April or May, covering the southern migrations down the central Mississippi flyway, the winter season on the lower

Mississippi and the spring return northward. He would collect and draw as many birds as possible, keeping an eye out for new species and filling in the gaps in his existing collection, which would travel with him in two waterproof tin-lined wooden portfolio cases. For identifications he would carry his battered copy of the bird volume of William Turton's translation of Linnaeus. As Lucy told Euphemia Gifford later, the birds would all be "drawn from nature [in] the[ir] natural size and embellished with plants, trees or views [of their surroundings] as best suits the purpose." He was perfectly capable of drawing the backgrounds himself, but his only really talented Cincinnati student, eighteen-year-old Joseph Mason, drew plants superbly and was eager to join the expedition as an assistant. Mason was "of good family," Audubon noted in his journal, "and naturally an amiable youth, he is intended to be a companion & a friend." The young man would go with him to keep him company and do the embellishments while Audubon concentrated on birds.

How would he fund his expedition? Audubon would have to leave every penny they could scrape up with Lucy to support her and the boys until she could collect his promised pay from the Western Museum, $1,200, enough to keep them comfortably for a year or more (she eventually collected $400). With two young boys she was not yet in a position to take up teaching; as she told her cousin: "My two children occupy nearly the whole of my time, for I educate them myself." Audubon had sustained his family by hunting. He concluded he could barter his hunting for boat passage, supplying game for passengers and crew. For cash he could do portraits along the way.

Who would engrave and publish a collection of American birds drawn at life size on the largest sheets of art paper then manufactured, more than two feet wide and three feet high? Contrary to what he wrote later, Audubon understood from the beginning that no one in America had the resources and the experience to produce a multivolume work on the scale he was planning. A letter from Lucy to her cousin Euphemia Gifford in April 1821 documents from the outset Audubon's plan for European publication:

> The various losses and misfortunes of my husband's affairs you have probably heard of and for the last year he has supported us by his talent in drawing and painting. . . . This last year we have spent in Cincinnati where Mr. Audubon combined a drawing school with a situation in the Museum, and taking portraits of various sizes and kinds; at the same time he is prosecuting a large work on Ornithology which when complete he means to take to Europe to be published. . . . It is his intention to go first to England,

and I hope it will be in my power to accompany him and visit once more those scenes of happy childhood.

By October he was ready. He would take with him the clothes on his back, his gun and its tackle, his violin and flute, the Turton volume, his cherished copy of La Fontaine's *Fables*, watercolors, brushes, pencils, chalks, his large and small portfolios, sheets of art paper rolled into a tubular tin case, wire to rig his mounting system on any convenient piece of board, paper for letter writing and a new ledger for journal keeping that he had bought at the shop of a Cincinnati bookbinder ("W. Pounsford, Three doors north of the Presbyterian Church," its label read), with marbled blue endpapers and unruled pages. A Cincinnati hunting brother of his joined him looking for a boat: Samuel Cummings, a civil engineer and river trader, would make the voyage to chart the Ohio and Mississippi channels for a guide he planned to publish. On the river they found a cargo flatboat bound for New Orleans with a vigorous young captain, Jacob Aumack, who was willing to take Audubon on as the boat's hunter; Joseph Mason could work the galley and wash dishes.

At four-thirty in the afternoon on Thursday, October 12, 1820, Audubon kissed his beloved Lucy, Victor Gifford and John Woodhouse goodbye, boarded Jacob Aumack's flatboat and stowed his gear. Victor was now eleven, John almost eight, aware that their father would be gone for long months. The boat's great longhorn oars creaked in their oarlocks as Aumack's crew levered them to push off from shore. Audubon's family anxiously watched the boat sweep out into the main channel, catch the current, align, steady and float out of sight around the bend, gliding down the Ohio into a future more demanding and fraught with risk than Lucy or John James could possibly have imagined. "Hopes are shy birds flying at a great distance, seldom reached by the best of guns," Audubon would write in his journal a few weeks downriver. Whether he would succeed he did not yet know, but he was "ready to exert to keep, and to surmount—"

Part Two

AMERICA

MY

COUNTRY

DOWN THE MISSISSIPPI

W ITHOUT *ANY MONEY*," John James Audubon departed Cincinnati on Jacob Aumack's flatboat bound for New Orleans in mid-October 1820. "My talents are to be my support," he confided to his journal that day, "and my enthusiasm my guide in my difficulties." Aumack and another flatboat captain, named Lovelace, had lashed their boats together to pool their crews; the river was low and the current sluggish. They floated through the night but had only made fourteen miles by daybreak. Audubon, his eighteen-year-old assistant Joseph Mason and his friend Samuel Cummings prepared their guns, went ashore and disturbed the autumn forest with the crack of gunshots and a haze of black-powder smoke warming up their pot-hunting skills. They bagged thirty quail, a woodcock, twenty-seven gray squirrels, a barn owl and a juvenile turkey buzzard. Audubon shot a young yellow-rumped warbler that he subsequently drew—it was "in beautiful plumage for the season"—and then dissected, finding its stomach full of small flies and a few seeds. In his journal he quarreled with Alexander Wilson for assigning the warbler to a new species, staking out ornithological territory as he collected for the first time with publication in mind.

In the days ahead as they descended the Ohio, Audubon searched out the birds that he hoped might restore his name and reputation. He winged a fish hawk (osprey) at the mouth of the Big Miami River, "a handsome male in good plumage" that tried to slash Joseph's hand when he reached for it, and noted that all the hawks and eagles "throw themselves on their backs to defend themselves." He was mortified when a hermit thrush he shot, the first one that he had collected, was too damaged to draw. He killed four small grebes with one charge of birdshot out of a flock of thirty that escaped by diving or flying off, "the second time I have seen this kind, and they must be extremely rare in this part of America."

Natchez

On Sunday morning, heavy frost riming the boat, a north wind blowing hard and cold, he shot two telltale godwits (greater yellowlegs). Later the three hunters killed teal, doves and quail for the flatboat pot, and for Audubon "fortunately another hermit thrush, *Turdus solitarius.*" Aumack hailed a steamboat, the *Velocipede,* that they boarded for diversion; Audubon met several of his friends and was handed a letter the *Velocipede* was carrying from Will Bakewell to Lucy, which he opened and read. Out hunting again he collected a Carolina wren, while Captain Aumack shot a mallard. On board the flatboat Audubon dissected the grebes, which they then cooked and ate—they proved "extremely fishy, rancid and fat." At ten o'clock at night the steersman ran onto a rock shoal in the low water. "Roused from sound sleep," they had to wade the cold river to take the boats off. The next day Audubon was sick but drew the hermit thrush anyway, which then frugally became "fat and delicate eating."

Monday he noted seeing wood grouse, ducks, loons, cormorants, crows and cow buntings and shooting quail and turkey for the pot. Tuesday produced "4 Ravens—many Winter Hawks—some Red-breasted Thrushes or Robins—the woods full of grey & black squirrels." Turkey and quail in great numbers launched themselves ambitiously over the river from the Ohio forest intending

to fly into Kentucky, but many were "destroyed falling in the stream from want of strength." Audubon saw flights of chimney swallows migrating southwest and collected a "fine American Buzzard" that was feeding on a gray squirrel on a tree stump. The next day he worked under deck in the flatboat; "drawing in a boat where a man cannot stand erect gave me a violent headache."

Bird collection and drawing consumed him, but behind the preoccupation of that hopeful work his nerves were raw. Approaching Louisville he wrote cryptically that he was "anxious to know my fate—I am comfortably situated and would be sorry to be obliged to part with them"—"them" presumably referring to the Aumack party. Was he fearful his business creditors might detain him, or does this entry refer to the keelboat Nicholas Berthoud was just then loading at Shippingport for a luxurious mercantile cruise downriver to New Orleans? Audubon continued in the Aumack boat and skipped Louisville in his next journal entries; Lucy's brother-in-law, whom he almost certainly sought out when Aumack stopped at the river city before shooting the Falls, evidently chose not to offer him passage.

As they approached Henderson on the following Wednesday, November 1, Audubon's frustration grew: "Extremely tired of my indolent way of living, not having procured anything to draw since Louisville." When he had walked away from Henderson after he sold off all his possessions, he had left with a friend a dog he needed now for hunting—"Dash, a slut," he listed her, using the neutral frontier term for a female dog that later became a pejorative. He was too embarrassed to go into Henderson himself; Mason and Cummings took the skiff and went on his behalf to collect the retriever. While they were gone Audubon watched three unfamiliar birds that sounded something like ravens and looked like brown pelicans struggle in the rising wind to land in the branches of a red maple tree. He would see such birds again on the lower Mississippi and finally identify them as double-crested cormorants.

His friends returned upriver with the dog at one in the morning on November 2 after a hard row against the current and the wind. A few hours later Aumack put in at the Indiana shore opposite Henderson. Audubon blamed the violent wind for the crudeness of the drawing he made of the town, but added bitterly that he could "scarcely conceive that I stayed there 8 years . . . for it undoubtedly is one of the poorest spots in the Western country according to my present opinion." They left harbor at daybreak; floating past the place of his humiliation, he "looked on the mill perhaps for the last time, and with thoughts that made my blood run almost cold bid it an eternal farewell."

Beyond the emotional gauntlet of Louisville and Henderson his spirits lifted and he noticed his surroundings again:

The Indian Summer, this extraordinary phenomenon of North America, is now in all its splendor, the blood-red raising sun and the constant smoky atmosphere is undoubtedly not easily to be accounted for. It has often been supposed that the Indians firing the prairies of the West were the cause, but since we have left Cincinnati the eastwardly winds have prevailed without diminishing in any degree the smoke.

Along the Ohio in the next days he listed seeing a butcher bird, a swamp blackbird, a winter wren, a turkey vulture he brought down at 120 yards with a rifle ball, a snow goose, several northern divers and sandhill cranes, wood grouse, woodpeckers, godwits, loons, robins, sparrows, paroquets, ducks and even gulls. He watched hawks driving vultures to ground and shot a large buck, but Dash had forgotten her pointing and retrieving skills "for the want of employment" and the buck was lost in the cane.

Sunday morning, November 5, having catalogued the myriad birds he had seen or collected, he catalogued his companions on the two boats for his sons, feeling homesick and imagining "how sweet this may be to you & myself some years hence, while sitting together by the fireside looking at your dear mother reading to us." Aumack they had met; "he is a good, strong young man, generously inclined, rather timorous on the river, yet brave, and accustomed to hardships." Lovelace, the captain of the second flatboat, was a "good-natured rough fellow, brought up to work without pride, rather anxious to make money—playful and fond of jokes & women." The merchant aboard who owned most of the cargo, Shaw, was a Bostonian; Audubon thought he was "weak of constitution but strong of stomach" and "would live well if at anyone else's expense." Of the crew he mentioned Ned Kelly, a young man who was "handsome if clean" and "always happy," with a tendency to brag; two carpenters from Pennsylvania "of a great sameness of character"; and Joseph Seeg, a lazy drunkard who had already managed to scorch his clothes passing out too close to the fire and who was "much like the last of everything, the worst part." All those English novels he and Lucy had read together had sharpened his pen.

Thirty-seven days after they left Cincinnati, on November 17, the flatboats debouched from the Ohio into the Mississippi. They had averaged only about fourteen miles a day coming down from Cincinnati on the low river, but the slow passage had benefited Audubon's observing and collecting: half a dozen new drawings thickened his portfolio. Leaving the Ohio felt like leaving family and safety. He remembered hauling up to Ste. Genevieve with Ferdinand Rozier in the winter of 1810 in a flatboat loaded with profitable whiskey and chasing Samuel Bowen to New Orleans the previous year in a skiff. "Now I

enter [the Mississippi] *poor,* in fact *destitute* of all things and relying only on that providential hope, the comforter of this wearied mind." The limpid Ohio merging with the turbid, milky Mississippi suggested a fable, which muted into a description and then an envious encounter:

> The meeting of the two streams reminds me a little of the gentle youth who comes into the world, spotless he presents himself, he is gradually drawn into thousands of difficulties that make him wish to keep apart, but at last he is overdone, mixed and lost in the vortex.
>
> The beautiful & transparent water of the Ohio when first entering the Mississippi is taken in small drafts and looks the more agreeable to the eye as it goes down surrounded by the muddy current, it keeps off as much as possible by running down on the Kentucky side for several miles but reduces to a narrow strip & is lost. I saw here two Indians in a canoe. They spoke some French, had beaver traps uncommonly clean kept, a few venison hams, a gun, and looked so independent, free & unconcerned with the world that I gazed on them, admired their spirits & wished for their condition. . . . I bid my farewell to the Ohio at 2 o'clock p.m. and felt a tear gushing involuntarily. Every moment draws me from all that is dear to me, my beloved wife & children.

"Here the traveler enters a new world," he concluded hopefully.

In 1820 the lower Mississippi between the Ohio and Natchez was still a wilderness. The Reverend Timothy Flint on a similar passage compared it to "the most retired regions of Hindustan or central Africa." For Audubon it would have reverberated with the lush language of a narrative that had swept France in 1801, two years before he left for America—Chateaubriand's didactic fiction *Atala,* a landmark of the Romantic movement in France. Audubon's surviving writings do not mention *Atala,* but a sixteen-year-old Frenchman born in a New World he barely remembered can hardly have missed reading it: by 1802 it had gone through five French editions; its characters had been borrowed for theatrical productions, dinnerware and clock decorations, posters and wax models sold in the stalls along the Seine.

Its theme was nature as consolation for the iniquity of man, its central character a young Frenchman named René (Atala is the Indian princess he falls in love with). René arrives in Louisiana in 1725 "impelled by passion and sorrow," joins the Natchez Indians as a warrior, ascends the Mississippi (which Chateaubriand transcribes as "the Meschacebe") with the tribe by pirogue to hunt beaver and along the way listens to the adventures of a blind sachem

named Chactas. Chateaubriand's evocation of the American wilderness, in phrases such as "The magnificent wilds of Kentucky spread out before the eyes of the astonished young Frenchman," conceivably encouraged Audubon's decision to move to Kentucky in the first place as well as his resolve to collect and draw the birds of the Mississippi flyway after his commercial career failed; the language of such early encounters can be deeply influential.

If he thought of Chateaubriand now, he may have remembered the young French writer's descriptions of a "Meschacebe" Chateaubriand never actually saw on his five-month visit to the United States in 1791:

> Down avenues of trees, bears may be seen drunk with grapes, and reeling on the branches of the elm trees; caribou bathe in the lake; black squirrels frolic in the thick foliage; mocking birds and Virginia doves no larger than sparrows fly down to grass patches red with strawberries; green parrots with yellow heads, crimson-tinged woodpeckers and fire-bright cardinals spiral up to the tops of the cypresses; hummingbirds sparkle on the jasmine of the Floridas, and bird-catching serpents hiss as they swing, like lianas, from the forest domes.
>
> While in the savannahs beyond the river everything is permeated with silence and calm, here, on the contrary, everything stirs and murmurs. Beaks pecking against the trunks of oak trees, the rustle of animals moving about or grazing or grinding fruit stones between their teeth, the rippling of waves, feeble moanings, muffled bellowings and gentle cooings, all fill this wilderness with a primitive and tender harmony.

Elsewhere Chateaubriand invents floating islands of dead trees carrying "green serpents, blue herons, pink flamingoes and young crocodiles" and "a bison heavy with years breast[ing] the waves and find[ing] repose among the high grasses" which "might be taken for the god of the river, casting a satisfied eye over the grandeur of his waters and the wild abundance of his shores." Audubon's delight in the American wilderness may well have been shaped in part by his early reading of *Atala* and its successor episode *René*, where Chactas and a saintly missionary, Father Souël, both learn "what sorrow had driven this well-born European to the strange decision of retiring into the wildernesses of Louisiana." At least the parallels are striking.

Audubon knew what sorrows had driven him, and the reality of the Mississippi was harder than Chateaubriand's romance. "Ivory-billed Woodpeckers are now plenty, bears, wolf &c.," he noted on Sunday, November 19, when the

temperature was in the sixties, "but the country [is] extremely difficult of access, the canes extending in many places several miles from the river."

He reviewed his drawings on Sundays, shaved and bathed and changed his shirt as he had promised Lucy he would do, "and often have been anxious to see the day come, for certainly a shirt worn one week, hunting every day and sleeping in buffalo robes at night soon became soiled and disagreeable." He "liked to spend about one hour in thoughts devoted to my family" on Sunday, contemplating a miniature of Lucy he carried that he had painted.

Painting the miniature had occasioned a breakthrough in his technique for drawing birds. He had originally worked entirely in watercolor, but he worried that his watercolors "wanted softness," and it had been tedious to build a depth of color that way. "I sat for a long time very dispirited at this," he wrote later about his breakthrough, "particularly when trying in vain to imitate birds of soft and downy plumage such as that of most owls, pigeons, hawks and herons." Then a happy accident came to his aid:

> One day after having finished the miniature portrait of the dearest friend I have in this world a portion of the face was injured by a drop of water which had dried on the spot, and although I labored a great deal to make amend for this, it was all in vain. Recollecting just then that . . . I had drawn heads and figures in different colored chalks, I resorted to a piece that matched the tint intended for the part, applied the pigment, rubbed the place with a cork stump and at once produced the desired effect!
>
> My drawings of owls, pigeons or herons were much improved by applications of such materials, indeed after a few years of patience some of my attempts began almost to please me and I have continued the same style ever since.

Audubon probably never saw Albrecht Dürer's unsurpassed early-sixteenth-century animal studies done in rubbed chalks, inks and watercolor washes, but like Dürer he taught himself to mix media successfully in his search for graphic techniques that might produce lifelike textures and surfaces.

On Tuesday the flatboats docked at New Madrid in a high wind. From a thriving settlement before the great earthquakes, the principal waystop between St. Louis and Natchez, the town had been reduced to an "almost deserted village . . . one of the poorest that is seen on this river bearing a name." The people who lived there were "poor wrecks" in "blooded & greased" buckskins, Audubon thought, for whom "to kill a neighbor is but little more

than [to kill a] deer or raccoon." He met people he knew, and the contrast he saw through their eyes between his former and present conditions depressed him.

Then on Thursday, November 23, listening to the sweet songs of robins at Little Prairie below New Madrid, he "shot a beautiful White-headed Eagle, *Falco Leucocephalus*, probably 150 yards off. My ball went through its body." He and Joseph returned immediately in the skiff to the flatboat, where Audubon wired the eagle up and began drawing it, four days of hard work that he finished on Monday. "That noble bird weighed 8½ lb," he noted happily, "measured 6 feet 7½ [in wingspan], his total length 2 feet 7½—it proved a male, the heart extremely large. My ball having passed through his gizzard I could not see any of the contents." Bald eagles were becoming numerous on the river by then; they hunted in pairs and roosted high in the trees above their eight-foot nests, swooping down to attack any prey that passed below them.

Everyone on the flatboat was sick that Monday from having eaten too much venison over the weekend; Audubon had shot a nine-point buck on the previous Friday that had weighed 162 pounds dressed. His physical distress, or the exhaustion of four days of drawing, might explain the anxiety he felt when he studied his miniature of Lucy that day: "I thought it was altered and looked sorrowful, it produced an immediate sensation of dread of her being in want— Yet I cannot hear from her for weeks to come—but hope she and our children are well."

On Tuesday, confined to the boat by rain, he essayed a first brief autobiography for his sons. Significantly, it does not mention two claims he would soon make to pad his credentials in the competitive New Orleans milieu: that he was born in Louisiana or that he had studied under Napoleon's favorite Neoclassical painter, Jacques-Louis David. He says only that he had been told his mother "was an extraordinarily beautiful woman [who] died shortly after my birth," and that he "studied mathematics at an early age and had many teachers of agreeable talents."

There was so much smoke on the river that they made no progress that day; "it was impossible to see beyond 20 or 30 yards." Joseph was now unhappily "obliged to officiate as cook [and] does not appear to relish the thing." To pass the time they "played a great deal on the flutes" and Audubon reviewed his drawings, "read as much as I could and yet found the day very long and heavy, for although I am naturally of light spirits . . . when off from my home I have often dull moments of anguish."

In the next days the margins of the river filled up with birds of every kind. Audubon watched two eagles copulating: the male came on "like a torrent,"

covered the female and "cackled shrill until he sailed off, the female following him and zigzagging herself through the air." He studied the black beards of the turkeys he shot—the strange tuft of hairlike feathers that hangs down forward from the center of the breast like a misplaced queue—and concluded that their length corresponded to the turkey's age; older hens as well as cocks seemed to sport them, though the cocks' were longer. The woods were "literally filled with paroquets [and a] great many squirrels"—as well as snowbirds, golden-winged woodpeckers, geese, mallards, mergansers, flocks of teal. He hauled in a sixty-four-pound catfish that "looked fat" and skinned it with "a strong pair of pincers." He saw hundreds of the cormorants he had not yet identified and flocks of sandhill cranes.

Aumack winged a bald eagle and brought it live on board; "the noble fellow looked at his enemies with a contemptible eye." Audubon tethered it to a fifteen-pound pole and it surprised him by jumping overboard dragging the pole and swimming powerfully away; Joseph took the skiff and retrieved it. Its partner "hovered over us and shrieked for some time, exhibiting the true sorrow of the constant mate." (Audubon's phonetic spelling of "hovered" in the original text—"overed"—reveals his persistent French accent.) When he climbed to the deck that night to confirm the security of their landing in a strong current, "the eagle hissed at me and ruffled itself in the manner that owls do generally."

More than once on the long float down from Cincinnati Jacob Aumack had reminded Audubon that he was aboard on Aumack's sufferance. The captain's condescension made the proud artist almost physically ill. "Never be under what is called obligations to men not aware of the value or the meanness of their conduct," Audubon wrote one night as a rule his sons should follow, adding, ". . . & of all things *never go for nothing* if you wish to save mental troubles & bod[ily] vicissitude." As they neared a cutoff of the Arkansas River on December 9, a Saturday, Audubon planned to visit Arkansas Post, an old trading post and fort about ten miles up the Arkansas that had recently become the Arkansas territorial capital. He hoped to leave the flatboat "if there is what the Kentuckians term a *half-chance*" because "our commander's looks and actions are so strange that I have become quite sickened." He still had in mind his original plan of exploring Osage country, the upper reaches of the Arkansas and Neosho Rivers and the Ozark Plateau, still wilderness. "Wrote to my Lucy and lived on sweet potatoes," he complained to his journal that night. "How surly the looks of ill fortune are to the poor."

The cutoff was "full and run[ning] violently, the water a dull red clay color," when Aumack, Audubon, Mason and one of the carpenters, Anthony Bodley,

left in the skiff at ten o'clock on Sunday morning; they were "forced to land to make a natural cordelle of several grapevines and pull up by it." The distance to the main channel of the Arkansas was seven miles "that appeared at least 10 to us." They passed the White River, "a beautiful clear stream," which emptied into the cutoff. At the main channel they left the skiff and walked "through cypress swamps and round ponds and canebrakes" until they reached a farmstead owned by a Frenchman named Duval, who was already undressed for bed but graciously "put on shoes & clothing and led us 7 miles through the mud & water to the post." At the only local tavern, "wearied, muddy, wet & hungry the supper was soon called for, and soon served, and to see 4 wolves tearing an old carcass would not give you a bad idea of our manners while helping ourselves, the bright staring eyes of the landladies notwithstanding."

The next day Audubon learned to his disappointment that the territorial governor, James Miller, the Indian agent and the Osage missionaries had all departed upriver to scout a site for the state capital at what is now Little Rock. He met an old Pittsburgh acquaintance, however, who told him "that he had for several years past gone up to the Osage Nation about 960 miles and that his last voyage he fell in with [Thomas] Nuttall the botanist and had him on board for 4 months—that many species of birds were in that country unknown in this and that the navigation was an agreeable one . . . that he would be extremely happy of my company . . . and that if I did not go with him at present that he hoped I would meet him when coming down the Arkansas next spring or summer." In his eagerness, "so strong is my enthusiasm to enlarge the ornithological knowledge of my country," Audubon allowed himself to dream briefly that he might be "rich again and thereby able to leave my family for a couple of years."

Rich he was no longer, but he enjoyed the strenuous excursion as well as the experience of being treated with respect, and he returned with the others to the flatboat in a good mood. Coming downriver they had met a party of Osages and bartered a few coins and some gunpowder for two venison hams. "Whenever I meet Indians," Audubon wrote, "I feel the greatness of our Creator in all its splendor, for there I see the man naked from His Hand and yet free from acquired sorrow."

Below the Arkansas the Gulf suite of flora and fauna gradually replaced the Appalachian and Midwestern. Ivory-billed woodpeckers became more plentiful—Audubon records their "constant cry of *Pet Pet Pet*"—and Spanish moss, which he called "Spanish beard," began softening the lines of the cypress trees. He labored to draw a marsh hawk he had collected while it was feeding on a swamp sparrow, human predator superseding avian predator: "When I

approach[ed] him before I shot he saw me first and flew a few yards where he sat tearing at his prey until death reached him." Green willows lined the shores and the weather was "much like May—at Henderson," 60 to 65 degrees Fahrenheit. Two days before Christmas they came to the Yazoo, "a beautiful stream of transparent water, covered with thousands of geese & ducks and filled with fish," and he and Mason stalked the black, pelican-like birds they had seen upriver but had not yet identified. After crawling for three hundred yards along the shore and chasing a swimming cormorant in the skiff, Joseph finally shot one, its head and neck out of the water "looking much like a snake." Audubon "took it up with great pleasure and anxiety—but I could not ascertain its genus—for I could not make it an Albatross, the only bird I can discover any relation to."

Christmas day Aumack brought down a great-footed hawk (peregrine falcon), much to Audubon's delight. When they tied up at Natchez the next day, Tuesday, wedging in among a hundred other keelboats, flatboats, barges and several steamboats, the artist stayed aboard finishing his hawk drawing and writing a long letter to Lucy. A little before dusk he went up on deck and watched hundreds of carrion crows (black vultures) "flying constantly low over the shores and alighting on the houses." (He learned later that they came to feed on the dead carcasses of animals thrown into a Natchez sinkhole used as a disposal site. In an era when large animals were the engines that powered most transportation, scavenger birds served to dispose of their bodies much as rendering plants serve for animal disposal today.)

He finished on Wednesday, cleaned up and climbed the steep road cut into the side of the bluff that led from Natchez-under-the-Hill to upper Natchez, crowded with "hundreds of carts, horse and foot travelers." There "to my utmost surprise I met Nicholas Berthoud, who accosted me kindly and asked me to go down to New Orleans in his boat—I accepted his offer." Berthoud had letters for him from Lucy and the boys. "These circumstances put me in high spirits, and we proceeded towards the best hotel in the place, that of Mr. Garnier."

Upper Natchez was considerably more prosperous than the mean district below the hill, with "avenues of regularly planted trees," but still "too narrow to be handsome" and "rendered less interesting by the poorness & irregularity of the houses, few of which are of bricks." Bales of cotton were stacked everywhere awaiting shipment—cotton was picked beginning in late July and continuously through the Christmas holidays. Audubon, flat broke, got busy hustling up some portrait commissions. "Unfortunately," he commented wryly in his journal, "naturalists are obliged to eat and have some sort of garb." A

local portrait painter named Cook allowed him to set up in the painter's rooms and generously found him two commissions at $5 each.

When Audubon sat for dinner at the hotel that night he was surprised at his awkward manners, embarrassment that evoked a brief sardonic essay:

> Having not used a fork and scarcely even a plate since I left Louisville, I involuntarily took meat and vegetables with my fingers several times; on board the flatboats, we seldom eat together and very often the hungry cooked; this I performed when in need by plucking & cleaning a duck or a partridge and throwing it on the hot embers; few men have eat a teal with better appetite than I have, dressed in this manner. . . .
>
> Such life is well intended to drill men gradually to hardships, to go to sleep with wet muddy clothing on a buffalo skin stretch[ed] on a board, to hunt through woods filled with fallen trees, entangled with vines, briars, canes, high rushes and at the same time giving under foot, [which] produced heavy sweats, strong appetite, and keeps the imagination free from worldly thoughts. I would advise many citizens, particularly our Eastern dandies, to try the experiment—leaving their high-heeled boots, but not their corsets, for this [item] would no doubt be serviceable whenever, food giving way, they might wish to depress their stomachs for the occasion.

Berthoud invited Audubon to share his lodgings. He moved up from the flatboat. John Garnier, the hotelier, "a French gentleman of agreeable manners," found him a partial set of Wilson's volumes to consult. On Friday, December 29, while Audubon was executing two more portrait commissions, a cold front blew in, bringing snow and cold, the temperature dropping quickly from 72 to 36 and then down to 25 on Saturday, when he spent the day copying names and descriptions from the Wilson volumes into his journal. Aumack left that day. Cummings went with him; Mason stayed with Audubon.

Sunday morning they went down to the river early to load the Berthoud keelboat in warming weather. The boat master, a man named Dickerson, had arranged to be towed downriver by a steamboat, the *Columbus.* Waiting for the steamboat delayed their departure until one in the afternoon. Then, roped to the sidewheeler's stern, they sped down the river. Audubon had planned to draw during the afternoon. Setting up, already miles away, he discovered that the smaller of his two portfolios had been left behind on the Natchez dock. He had asked Berthoud's servant to carry it aboard and the man had forgotten it. Besides fifteen hard-earned drawings, three of them of nondescripts that he

had not yet identified, it had held the miniature of Lucy. He immediately wrote Garnier asking him to advertise for it and have someone look for it, "but no hopes can I have of ever seeing it when lost amongst 150 or 160 flatboats and houses filled with the lowest of characters—no doubt my drawings will serve to ornament their parlors or will be nailed on some of the steering oars. . . . Should I not get it again, it may retard my return home very considerably." He was "nearly made sick" by losing it.

The loss also made him pensive; on the first day of the new year 1821 he reviewed his life and realized he had no idea what the future would bring:

> This day 21 years since I was at Rochefort in France, I spent most of the day at copying letters of my father to the minister of the navy—
>
> What I have seen and felt since would fill a large volume—the whole of which would end at this day January 1st, 1821. I am on board a keelboat going down to New Orleans the poorest man on it. . . . What I have seen and felt has brought some very dearly purchased experience, and yet yesterday I forgot that no servant could do for me what I might do myself; had I acted accordingly, my portfolio would now have been safe in my possession.
>
> Not willing to dwell on ideal futurity, I do not at present attempt to foresee where my poor body may be this day 12 months.

At noon the *Columbus* stopped at Bayou Sarah, a village named for the clear creek, or "bayou" (from the Choctaw *bayuk*), that flowed down through the forest and emptied into the river there. Audubon recorded "many flatboats, 3 steamboats and 2 brigs waiting for cotton" from the many plantations around the town of St. Francisville on the bluff half a mile inland. The *Alabama* put off just as the *Columbus* put in, and the *Columbus* captain decided to disconnect the Berthoud boat to race the *Alabama* to Baton Rouge "to procure the freight there." So on a "beautifully fair" day the Berthoud crew took up rowing again.

Floating down from Bayou Sarah Audubon was charmed by the beauty of the river and its environs. "The plantations increase in number, and the shores have much the appearance of those on some of the large rivers of France, their lowness excepted. . . . The whole is backed by a dark curtain of thickly moss-covered cypresses—flatboats are landed at nearly every plantation. . . . Travelers on horseback or gigs go by us at full gallop as if their life depended on the accelerity of their movements—I have seen more common crows since Natchez than I ever saw in my whole life before, the shores and trees are covered with them." The weather cooled. They "passed through a large cotton

Plantations along the Mississippi above New Orleans.
Bayou Sarah appears just east of map center.

plantation yet unplucked [that] looked like if a heavy snow had fell and frozen on every bud." Audubon drew the boat master's likeness and was paid in gold. When high winds slowed the boat and it put in to wait them out he and Mason went hunting in the swamps, which were filled with birds. Joseph "made his first attempt from nature," drawing the female of a pair of terns they collected; Audubon "was very much pleased with his essay."

Below Baton Rouge and Bayou Lafourche cotton gave way to sugar and they approached New Orleans:

> These immense sugar plantations looked like prairies early in summer for scarce a tree is to be seen, and particularly here, where the horizon was bounded by cleared land. . . . The gardens were beautiful; roses in full bloom revive the eye of the traveler who for eighty days has been confined to the smoky inside of a dark flat-bottomed boat. The wind entirely lulled away at sunset—the moon's disk assured us of a fine night and we left our station to drop within a few miles of the city. Tomorrow perhaps may take us there, yet so uncertain is this world, that I should not be surprised if I never was to reach it—the further removed, the stronger my anxiety to see my family again presses on my mind—and nothing but the astonishing desire I have of completing my work keeps my spirits at par.

The river, wide and deep and certain, carried them down at night as they slept. Sunday morning, January 7, 1821, they woke to the crescent city, the largest city west of the Appalachians: "At *New Orleans* at last."

THE FAIR INCOGNITO

W HEN AUDUBON AND HIS ASSISTANT Joseph Mason left their keel-
boat to go into New Orleans on Sunday morning, January 7, 1821, they
noticed first of all the mobs of fish crows working the docks and the river,
"dashing down to the water like gulls for food." There were steamboats and
hundreds of flatboats anchored in the river, tall-masted "ships of many nations,
each bearing the flag of its country," and bales of cotton stacked along the levee
waiting to be loaded. Mason went off on his own to look around. Audubon
almost immediately encountered David Prentice, the mechanic who had built
his ill-fated Henderson steam mill, who pointed him to the office of Gordon,
Grant & Company, British cotton factors. There he found Nicholas Berthoud
with a note from Lucy accompanying a pair of gloves she had made for her
brother-in-law for Christmas but no letter for him. Disappointed to learn that
the post office where his letter lay would be closed until Tuesday, he at least
heard that his family was well. Monday the city was celebrating the sixth
anniversary of the Battle of New Orleans, which had spared it from British
occupation and made Andrew Jackson a national hero.

Walking out with Berthoud Audubon met so many Louisville gentry along
the rue de la Levée that he decided it was too tedious to list them all in his
journal. One he did mention and would see again was George Croghan, his
thirty-year-old Louisville hunting partner, the son of William and Lucy Clark
Croghan, who owned a plantation nearby. Berthoud and Audubon ended up at
the house of an old friend of Berthoud's father who invited them to stay for
dinner. Though the noisy company at table treated him respectfully despite his
shabby clothes, Audubon disliked its "French gayety"—"I thought myself in
Bedlam, everybody talked loud at once"—and retired to the keelboat with
what he called "a bad head hake, occasioned by drinking some wine." Joseph

returned unimpressed with the polyglot city of forty thousand. Their real complaint was that they were ill-dressed and nearly broke.

New Orleans then was essentially what is now the French Quarter, built of brick, tile, stucco and wrought iron in the wake of major fires in 1788 and 1794. In the city's French era the old Indian Market along the waterfront had been roofed over. The Halles, as it was still called, surprised Audubon and Mason the next morning in its variety. Besides vegetables, fruits, meat, game and fish from the Mississippi Valley, the Gulf and the West Indies, "we found vast many Mallards, some Teals, some American Widgeons, Canada Geese, Snow Geese, Mergansers, Robins, Bluebirds, Red-winged Starlings, Tell-tale Godwits—everything selling extremely high." The poulterers wanted $1.25 for a pair of ducks, $1.50 for a goose, more than Audubon could afford. He was amazed to see even barred owls cleaned and offered for sale for 25 cents each—the Creoles, he says, used them to make gumbo. Unable to buy a bird to paint, he went off to watch the Battle of New Orleans celebratory parades and had his pocket picked, the thief netting a wallet empty of anything more valuable than Audubon's letters of introduction to the governor of Louisiana from the likes of Henry Clay. When he saw Berthoud later that day and told him of his loss, Nicholas called him a greenhorn, which thoroughly annoyed him.

The letter from Lucy that he collected at the post office on Tuesday left Audubon with "spirits very low," as Lucy's were in Cincinnati, where she had so far received not one dollar from the managers of the Western Museum. His luck with the painter in Natchez who had found him portrait commissions determined him to introduce himself to the prominent painters of New Orleans. William Croghan knew one, John Wesley Jarvis, a flamboyant and successful portraitist who kept a studio in Custom House Street. In the rain on that sultry January day Audubon paid Jarvis a first brief visit, finding a hand-some, dark-haired man with sensual features and a cleft chin.

A nephew of the founder of Methodism and christened with his name, Jarvis had been pointed to a painting career as a boy in Philadelphia by the dis-tinguished American physician Benjamin Rush. After years of success in Balti-more and New York he had begun wintering in the South, in Charleston and then in New Orleans, where he bragged he arrived with empty pockets, "spent 3000 dollars in six months and brought 3000 [more] to New York." Once a week he started six portraits at $100 to $150 each, an hour per sitting across a six-hour day, deftly painting his subjects' faces and then turning the canvas over to his two assistants to fill in the background and drapery. Audubon, no stranger to rapid production, was impressed with the quality of Jarvis's work. Nothing came of this first meeting, but it may have been the occasion for an exchange that Audubon recorded later. "Do you paint, sir?" he said Jarvis asked him, meaning paint in oils. "I replied 'Not yet.' 'Not yet! What do you mean?' 'I mean what I say: I intend to paint as soon as I can draw better than I do at present.' 'Good,' said [Jarvis], 'you are quite right, to draw is the first object.' "

Audubon left the encounter depressed. He wished he had stayed in Natchez. He felt exposed and hid out on the keelboat "opposite the market," which he now maligned as "the dirtiest place in all the cities of the United States." At the end of the day he wrote to John Garnier, the Natchez hotelier, to encourage him to look harder for the missing portfolio. With the rain still torrential the next morning he stayed in and wrote his brother-in-law Gabriel du Puigaudeau and his adoptive mother Anne Moynet, letters two years overdue that he had delayed from embarrassment at his business failure and concern that his creditors might involve his family in their debt collection and make his illegitimacy public. From Jacob Aumack's flatboat, which had just arrived, his friend Samuel Cummings came aboard looking even poorer than Audubon and stayed to dine.

Thursday brought a little encouragement from Alexander Gordon, the young English cotton factor, who introduced him to the British consul. When Audubon showed the two men his portfolio, Gordon praised his work highly

and the consul confirmed that it was publishable. Visiting the Halles that day Audubon picked over blue cranes (little blue herons), coots, ducks, snow geese, killdeers, a heron and a sandhill crane, while Joseph systematically canvassed every boat in the river that had stopped at Natchez for information about the lost portfolio. Still intending to travel farther into the American wilderness in pursuit of new birds, Audubon sought out David Prentice to collect a letter of introduction to Dr. George Hunter, an elderly Philadelphia mineralogist resident in New Orleans. In 1804 Thomas Jefferson had appointed Hunter to explore the Red and Ouachita Rivers with William Dunbar of Natchez and a party of soldiers from the New Orleans garrison—the first scientific expedition into the newly purchased Louisiana Territory. Audubon hoped that Hunter might advise and endorse him.

It was warm, the frogs were piping, and Audubon had no work yet. Friday in some desperation he introduced himself to the artist who painted scenery at the St. Philip Theatre. Fogliardi, the scene painter, liked Audubon's work and took him to meet the directors. Audubon says they "very roughly offered me $100 per month to paint with Mons. L'Italian." Mason would reveal later that Audubon had demanded $8 a day for himself and $5 a day for Mason, which the directors had rejected; the monthly salary was presumably their counteroffer. Painting scenes would not have been beneath him—he had painted backgrounds for the display cases at the Western Museum, after all—but he had the good sense even when he was broke of not undervaluing his time. He ended the day with a visit to his old acquaintance Roman Pamar, a china merchant whom he had known since his shopkeeping partnership with Ferdinand Rozier—Pamar had helped him make bond when he sued Samuel Bowen in New Orleans over the missing steamboat in 1819—but even that visit was frustrating: "Audubon was poor today and [Pamar] knew it when I made my bow."

He braced himself to solicit John Wesley Jarvis directly on Saturday, January 13:

> I rose early tormented by many disagreeable thoughts, nearly again without a cent, in a bustling city where no one cares a fig for a man in my situation. I walked to Jarvis, the painter, and shewed him some of my drawings. He overlooked them, said nothing, then leaned down and examined them minutely but never said they were good or bad—merely that when he drew an eagle, for instance, he made it resemble a lion, and covered it with yellow hair and not feathers. Some fools who entered the room were so pleased at seeing my eagle that they praised it, and Jarvis whistled. I called him aside while Joseph rolled up our papers and asked him if he needed assistance to

finish his portraits, i.e., the clothing and grounds. He stared, I repeated my question and told him I would not turn my back to anyone and for such employment and that I had received good lessons from good masters. He then asked me to come the following day and he would think about it.

With nothing better to do, Audubon followed Nicholas Berthoud on his rounds. They stopped at Roman Pamar's warehouse, where to Audubon's surprise Pamar asked him what he charged for a portrait drawing. Twenty-five dollars, Audubon told him. "But I have three children," Pamar bargained puckishly, "and you may put them all on one piece." That would cost $100, Audubon countered. One of Pamar's daughters was in the room. Berthoud suggested Audubon sketch her. "A sheet of paper was procured, my pencil sharpened and sitting on a crate I was soon at work and soon finished; the likeness was striking; the father smiled, the clerks stared at me amazed and the servant was dispatched to shew my success (as it was called) to [Mrs. Pamar]." Pamar seemed to settle the bargain by telling Audubon to do his best and set his own price. If he could have collected half the money that day he would have, but Pamar's eldest daughter would not be available for several days. "How I calculated on 100 dollars," Audubon wrote fervently of the encounter; "what relief to my dear wife and children." He might be broke, but he intended to send the money to Lucy anyway, trusting that he would soon find more work. The opportunity cheered him, and later he and Joseph took a long walk across New Orleans toward Lake Pontchartrain, where they saw an alligator.

Jarvis questioned Audubon intently on Sunday morning and then "very simply told me he could not believe that I might help him in the least." Though Jarvis may have meant no more than that he already had enough help, Audubon took the rejection as a judgment on his ability. "I rose, bowed, and walked out without one word, and no doubt he looked on me as I did on him as an original and as a cracked man."

Sunday in New Orleans was a day for strolling. Audubon found the levee "crowded by people of all sorts as well as colors, the market very abundant, the church bells ringing, the billiard balls knocking, the guns [of hunters] heard all around." Associating all the way back to his time in Pennsylvania with the abstemious Miers Fisher, he added, "What a display this for a steady Quaker of Philadelphia or Cincinnati—the day was beautiful and the crowd increased considerably—I saw however no handsome women and the citron hue of almost all is very disgusting to one who likes the rosy Yankee or English cheeks." He was missing Lucy; ironically, the mixed-race culture of New Orleans had come to it directly from his birthplace (after a stopover in Cuba)

in the wake of Toussaint Louverture's revolution—as had yellow fever. To distract himself he rowed out into the river, shot a fish crow, carried it on board the keelboat, wired it up and began drawing it, but that evening at supper with a French acquaintance he "saw some white ladies and good-looking ones" and was even drawn afterward to the Quadroon Ball, passing Condé Street on his return to the boat. Without a spare dollar for admission he could only listen to the "noise" of the music before heading on home "as we are pleased to call it."

Mrs. Pamar temporarily disappointed him: she wanted her daughters done in oils, a medium that Audubon had not mastered. For the next four days he listed only the dates in his journal, "cutting [the] matter short . . . I spent them running about to procure work." Then it dawned on him that people might have trouble extrapolating from his bird drawings to portraiture, so he drew an old acquaintance's likeness "purposely to expose it to the public." Pamar was impressed and immediately signed up for a portrait of his eldest daughter Euphemia, none too soon: "By the time we receive the pay for it, we will be penniless." A letter arrived from Lucy that "ruffled my spirits sadly"—she was not happy to be left behind unsupported with two children to care for. Then across the next nine days, January 19 through 27, Audubon finished a portrait a day at $20 or $25 each: the British consul, Euphemia Pamar, Pamar himself, the two younger Pamar daughters and four men, netting him $220. Sunday,

A fish crow dining on crab

January 28, when he began drawing a brown pelican, he described himself happily as "fatigued, wearied of body but in good spirits having plenty to do at good prices and my work much admired—only sorry that the sun sets."

The brown pelican, which he finished on Monday, had come to him from Jacob Aumack, who had collected it on a nearby lake. The species rarely turned up as far north as New Orleans ("I was assured that these birds were seen in immense flocks in the neighborhood of Buenos Aires," Audubon would write), and Alexander Wilson had not described it. Audubon drew it boldly on a full ("elephant") sheet, 26 by 38 inches. He was still only approaching his mature technique, but he had progressed far beyond his Henderson days. The pelican fills the sheet horizontally, its head, neck and body organized from left to right in a reversed S-curve, its beak dropped open, one foot raised as if it is about to fly. Most of the drawing is done in pastel, but the pelican's pouch combines pastel and watercolor, and its pastel feathers are detailed with fine pencil hatching. After he finished it he "collected my earnings, purchased a crate of Queen's ware [from Roman Pamar, for $36.33] for my beloved wife, wrote to her" and sent her $270. By the end of the week, having finished more portraits, he could afford to hire a woman to cook and clean and a hunter to pursue specimen collections at $25 a month.

By mid-February Nicholas Berthoud was preparing to return to Shippingport, presumably arranging with a steamboat to tow his keelboat behind it up the Mississippi and the Ohio. Audubon decided to send twenty of his new drawings to Lucy for safekeeping and to show her the work that he had done. He listed them in his journal, noting happily that eight of them were "not described by Wilson": a common gallinule (common moorhen), a common gull, a marsh hawk, male and female boat-tailed grackles, a common crow, a fish crow, a sora, a marsh tern (gull-billed tern), a snipe, a hermit thrush, a yellow red-poled warbler (palm warbler), a Savannah finch, a battleground warbler (a designation of Audubon's invention, not identifiable), the brown pelican, a great-footed hawk (peregrine falcon), a wild turkey hen, a double-crested cormorant, a black vulture, an imber diver (common loon) and his white-headed eagle—"the fruits of a long journey," he blessed them. None of them yet had backgrounds, which he would have painted in later. They went off in Berthoud's keelboat finally on February 22, 1821.

LUGGING HIS BULKY tin-lined wooden portfolio up the rue de la Levée surprised so many passersby—white men rarely shouldered burdens in Louisiana—that Audubon had changed his daily route to the less-traveled rue

Royale. There in mid-February he was approached by "a female of a fine form," a young woman wearing a veil that hid her face "who addressed me quickly in . . . French—'Pray sir are you the one sent by the French Academy to draw the birds of America?' I answered that I drew them for my pleasure. 'You are he that draws likenesses in black chalk so remarkably strong?' " He told her that he did. She asked him to call on her in thirty minutes at number 26 rue Amour and walk upstairs; "I will wait for you." He bowed and must have moved to follow her—"Do not follow me now." He bowed again and she left. He wrote down the number she had given him and went on to a bookstore "where I waited some time having a feeling of astonishment undescribable." The rue Amour was downriver in a newly opened suburb of the city, the Faubourg Marigny, a long walk; Audubon composed himself and got started.

I arrived, and as I walked upstairs I saw her apparently waiting. "I am glad you have come, walk in quickly." My feeling became so agitated that I trembled like a leaf. This she perceived, shut the door with a double lock and throwing back her veil shewed me one of the most beautiful faces I ever saw. "Have you been or are you married?" Yes, madam. "Long?" Twelve years. "Is your wife in this city?" No, madam. "Your name [is] Audubon?" Yes, madam. "Set down and be easy." And with the smile of an angel: "I will not hurt you." I felt such a blush and such deathness through me I could not answer. She raised and handed me a glass of cordial. So strange was all this to me that I drank it, for I needed it, but awkwardly gave her the glass to take back.

She sat again immediately opposite me and looking [at] me steadfastly asked me if I thought I could draw her face. Indeed, I fear not, answered I. "I am sure you can if you will, but before I say more what is your price?" Generally twenty-five dollars. She smiled again most sweetly. "Will you keep my name if you discover it and my residence a secret?" If you require it. "I do. You must promise that to me, keep it forever sacred although I care not about anything else." I promised to keep her name and her place of residence to myself. "Have you ever drawn a full figure?" Yes. *"Naked?"* Had I been shot with a 48-pounder through the heart my articulating powers could not have been more suddenly stopped. "Well, why do you not answer?" I answered yes. She raised, walked the room a few times and sitting again said, "I want you to draw my likeness and the whole of my form naked, but as I think you cannot work now, leave your portfolio and return in one hour. Be silent."

She had judged his feelings precisely, Audubon wrote. He was abashed. He took his hat, she opened the door and as he descended the stairs he "felt like a

bird that makes his escape from a strong cage filled with sweetmeats; had I met a stranger on the stairs no doubt I would have been suspected for a thief." He walked away and tried to pull himself together. Her composure had surprised him because he had judged her to be no more than sixteen—he understood later that she was older—yet "apparently not at all afraid to disclose to my eyes her sacred beauties."

He returned and she waved him in. "Well, how do you feel now? Still trembling a little, what a man you are—come, come, I am anxious to see the outline you will make, take time and be sure do not embellish any parts with your brilliant imagination." She had chalks and a sheet of elephant paper. "The drawing will be completed in this room." The sight of the art materials calmed him; he says he "felt at once easy, ready and pleased." Curiously, for a man so attentive to women, he seems to have been afraid he was being seduced. Certainly he had been unnerved. She reminded him of his promise and they began:

> The couch in the room was superbly decorated. She drew the curtains and I heard her undress. "I must be nearly in the position you will see me unless your taste should think proper to alter it by speaking." Very well, was my answer, although I felt yet very strange and never will forget the moment. "Please to draw the curtains and arrange the light to suit yourself." When drawing hirelings in company with twenty more I never cared but for a good outline, but shut up with a beautiful young woman as much a stranger to me as I was to her, I could not well reconcile all the feelings that were necessary to draw well without mingling with them some of a very different nature— yet I drew the curtain and saw this beauty. "Will I do so?" I eyed her but dropped my black lead pencil. "I am glad you are so timid, but tell me will I do so?" Perceiving at once that the position, the light and all had been carefully studied before, I told her I feared she looked only too well for my talent. She smiled and I begun.

He checked the time on his watch and then drew for fifty-five minutes, when she asked him to close the curtain, dressed and came eagerly to see his work. "Is it like me? Will it be like me? I hope it will be a likeness." She was chilled and asked if he could work further without her. He said he could correct his sketch. "Well, be contented and work as much as you can. I wish it was done. It is a folly, but all our sex is more or less so." Then she surprised him by pointing out an error in his lines and making him correct it.

She called a servant, who served them cakes and wine. While he rested she asked him "a thousand questions about my family, residence, birds, way of

traveling or living &c. &c. and certainly is a well-informed female, using the best expressions and in all her actions possessing the manners necessary to insure respect & wonder."

He worked almost two hours more. Preparing to leave, he pressed her for her name and she rebuked him. "Not today and if you are not careful and silent you never will see me again. . . . I have thought well of you from hearsay and hope not to be mistaken." She had heard of him, he would learn, from the circle of people around the British consul; she was Italian or French. He asked her when he should return. "Every day at the same hour until done," she told him, "but never again with your portfolio."

The next day when he returned she asked him what he would charge her for his work. He said he would be satisfied with whatever it would please her to give him. "I take you at your word, it will be *un souvenir*. One who hunts so much needs a good gun or two. This afternoon, see if there is one in the city & give this on account if you wish to please me to the last." She handed him a $5 bill. "I must see it and if I do not like it you are not to have it." He thanked her and told her it would probably be expensive. "Well, that probably is necessary to insure good quality, do as I bid." He found a fine gun that sold for $120 and paid down the bill.

For nine more days, with the exception of a Sunday when she went out of town, he "had the pleasure of this beautiful woman's company about one hour naked and two talking on different subjects. She admired my work more every day, at least was pleased to say so," and halfway through the sittings "she worked herself in a style much superior to mine." He managed to fit a $25 likeness into his daily schedule as well, "to be sure a little at the expense of my eyes at night, but how could I complain? How many artists would have been delighted in such lessons?"

In this version of the story, which Audubon (remarkably) sent to Lucy in a letter, his work advances to a happy conclusion. "I finished my drawing, or rather she did, for when I returned every day I always found the work much advanced. She touched it, she said, not because she was fatigued of my company but because she felt happy in mingling her talents with mine in a piece she had had in contemplation to have done, even before she left the country she came from." The project did not in fact proceed so smoothly, however. Audubon's journal entry for February 21, 1821, indicates that a serious conflict nearly derailed it:

> I met this morning with one of those discouraging incidents connected with
> the life of the artists; I had a likeness spoken of in very rude terms by the fair

lady it was made for, and perhaps will lose my time and the reward expected for my labors—*Mrs. André* I here mention the name as I may speak more of the likeness as the occasion will require.

Mrs. André's pique at Audubon's inabilities—probably his difficulties with foreshortening again—may have stemmed from the conflict between her wish to have such a portrait done and her judgment that more experienced portraitists such as John Wesley Jarvis could not be trusted to respect her privacy. Her corrections resolved the problem, but she made sure Audubon felt the sting of being corrected. On the last morning he visited her, he wrote, "she had a beautiful frame" in which to mount the drawing. "She put her name at the foot of the drawing as if [it were] *her own* and [my name] in a dark shaded part of the drapery; when I had closed it and put it in a true light she gazed at it for some moments and assured me her wish was at last gratified, and taking me by one hand gave me a delightful kiss." She gave him as well the rest of the money with which to buy the gun, for which she had composed a design and a French inscription. "Had you acted otherwise than you have," she told him, "you would have received a very different recompense. Go, take this, be happy, think of me sometimes as you rest on your gun, keep forever my name a secret." He asked to kiss her hand and she let him. "We parted, probably forever."

The inscription that the woman whom Audubon came to call the Fair Incognito composed for his souvenir gun reminded him of the trust she had placed in him: "Do not refuse this gift from a friend who is in your debt; may its goodness equal yours." For his part, Audubon chose to have engraved under the ramming rod the phrase "Property of LaForest Audubon, February 22nd 1821"—a form of his name he otherwise only used in his intimate correspondence with Lucy. He further revealed his conflicted feelings about the Fair Incognito by trying several times to see her again. Her servants always told him she was not home. To Lucy he wrote, perhaps ingenuously, that he had "felt a great desire to see the drawing . . . to judge of it as I always can do best after some time [has passed]."

Mrs. André may have been the mistress of a French aristocrat of noble antecedents, Bernard de Marigny, who befriended Audubon in New Orleans. (Two Audubon investigators, Mary Durant and Michael Harwood, proposed this connection in a 1980 book.) A wealthy roué who ran through a fortune of $7 million—nearly $100 million today—that he had inherited when he was fifteen, he had just begun developing the Faubourg Marigny on the lands of his subdivided downriver plantation; significantly, the rue Amour was the street where he set up his several mistresses. Besides this sly contribution to

Audubon's welfare, Marigny introduced America to the French game of dice called hazard, renaming it "le crapaud" because gamblers squatted froglike to play it—thus today's "craps." There had been a Craps Street in the Faubourg Marigny as well, a name later changed to Burgundy.

AFTER AUDUBON FINISHED DRAWING the Fair Incognito and Berthoud's keelboat left New Orleans on February 22, Audubon and Mason moved into rooms at 34 Barracks Street. Renting for $10 a month, they were positioned "between two shops of grocers and divided from them and our yellow landlady by mere board partitions," which meant they received "at once all the new matter that issues from the thundering mouths of all those groups." The noise may have bothered Audubon, but he usually enjoyed the challenges of his impoverished but robust life—at least he enjoyed writing about it in his journal and his letters to Lucy.

"We cannot be Epicures," he told her of the life he and Mason led on Barracks Street—"our purse is [one] that suits best strong appetites. We generally have a ham on a nail, and convenience makes us cook it by slices when hungry. During cooler weather we had cheese, but the heat that disperses and sends off one part of the inhabitants of this place brings on myriads of others called maggots with which we are not Englishmen enough to desire very close acquaintance." He reported on one such close acquaintance in March in his journal when they were "all surprised at the astonishing leaps that some maggots took about our table. They issued out of a very good piece of cheese" and by bending and flipping their bodies "threw themselves about 50 or 60 times their length, sometimes one way, sometimes another, apparently in search of the cheese." They ate salt mackerels, which were cheap, but "suffer[ed] the want of pure cool water, this cannot well be purchased by us." The vegetable market was excellent. "Fresh meat we never taste. We see it hanging in the market house and that [satisfies] us completely." They rambled to a nearby coffeehouse to hear free music. As the spring advanced they were increasingly troubled by mosquitoes, which drove them from their rooms after dark; "we fix ourselves about the middle of the street until bedtime, piping the flageolet or blowing the flute. We sometimes have a painter for company and then we talk of the arts." Proud as he was, Audubon was never a pretentious man; he had too much experience of want.

He had tried out his souvenir gun on a Sunday morning walk with Mason on March 11 and "found it an excellent one," but the woods outside of New Orleans had been flooded because the river was higher then by four or five feet

than the ground behind the levee. On March 16, to his infinite relief, Audubon heard from Natchez that his smaller portfolio had been found. Alexander Gordon wrote a friend "to have it forwarded immediately and pay whatever charges there might be," a generous gesture that Audubon thought "remarkable to a man who is no more than a stranger to him."

That same Friday Audubon "took a walk with my gun . . . to see the passage of millions of Golden Plovers [American golden plovers] coming from the northeast and going nearly west." They were "innocent fugitives from a winter storm," but they drew crowds of New Orleans sportsmen and market hunters, who were "more numerous and at the same time more expert at shooting on the wing than anywhere in the U. States." In large parties the gunners lined up at points where they knew from previous experience that the birds would pass, "called in a masterly astonishing manner" to attract the birds lower and fired in rotation as the flocks flew the gauntlet. Their dogs retrieved their kill while they reloaded. "This continued all day; when I left one of those lines of sharp-shooters [at sunset] they appeared as intent on killing more as when I arrived at the spot at 4 o'clock." One man near him had killed sixty-three dozens—756 birds. Figuring two hundred gunners in the field and assigning twenty dozen kills to each, Audubon estimated that at least "forty-eight thousand Plovers would have fallen that day. The next morning the markets were amply supplied with Plovers at a very low price," but most of the birds were lean from migration, and he had found no food in the gizzards of those he had opened.

Across the rest of March he drew a blue crane (little blue heron) and then a great white heron (common egret), which he found "the most difficult to imitate of any bird I have yet undertaken," following the heron with male and female blue yellow-backed warblers (northern parulas). The March 21 morning newspapers, which he read at Roman Pamar's, carried the text of the treaty between Spain and the United States that ceded East and West Florida, which had finally been ratified on February 22. Scanning its articles Audubon noticed in Article IV a provision for commissioners and surveyors from both treaty parties to meet within the year west of New Orleans at Natchitoches on the Red River to run a line out to the "South Sea"—the Pacific—to divide Louisiana Territory from Mexico. He was struck with the idea that here at last was his "so long wished-for journey." He hastened to Alexander Gordon for advice on how to contact the governor of Louisiana, Thomas Robertson, to offer his services as the expedition's artist-naturalist. Gordon sent him to an influential New Orleans attorney, Joseph Hawkins, who promised to speak to the governor and asked Audubon to check back with him on March 23.

He could hardly wait and arrived early, having spent the previous day torn between the excitement of "join[ing] in such an enterprise" and dread of having to "leave all I am attached to, perhaps for ever." Hawkins disappointed him with the governor's stolid opinion "that nothing more would be done than to run the line in question and that none but surveyors would be necessary." Audubon decided immediately to bypass the governor and write President James Monroe. Gordon concurred—why, he asked Audubon, would "a journey so interesting . . . be performed only to say that men had gone & come back"?

Next Audubon fired up a Louisville acquaintance who promised him letters of introduction to members of Congress but encouraged him to write the President as well. "Full of my plans I went home & wrote to N. Berthoud to request his immediate assistance. Walked out in the afternoon seeing hundreds of new birds in imagination and supposed myself [off] on the journey." Pursuing his contacts across the next several days ("going through the streets not unlike . . . a wild man thinking too much to think at all"), Audubon encountered George Croghan, who told him he had put in a good word for him when the subject had come up at dinner at the governor's, and sought out David Prentice to help him draft his letter to Monroe. The Scotsman thought Audubon should write the letter himself. When he did, Prentice pronounced it excellent, much to Audubon's surprise. Gordon was less impressed and made revisions.

"Feeling a great weight off my shoulders I returned to my room, took gun, ammunition & Joseph & to the woods went in search of new species. My life has been strewed with many thorns, but could I see myself & the fruits of my labor safe with my beloved family all well after a return from such an expedition, how grateful would I feel to my country and full of the greatness of my Author." So Audubon expected to survive and return after all—if the expedition was even possible, and if he might be chosen for it.

Thirteen

LESSONS TO A YOUNG LADY

A T THE END OF MARCH 1821, to build his credentials for the Pacific expedition he imagined that President James Monroe might commission, Audubon sought a letter of recommendation from another celebrity artist working in New Orleans, the historical and portrait painter John Vanderlyn. Then forty-five years old, a native of Kingston, New York, Vanderlyn had studied with Gilbert Stuart in Philadelphia and the French Neoclassicist François-André Vincent in Paris under the patronage of Aaron Burr. He had painted Burr, Albert Gallatin, James Madison, John C. Calhoun, DeWitt Clinton and many other American worthies, as well as classical subjects and a historical panorama, *The Palace and Gardens of Versailles.* He had recently nearly bankrupted himself investing in a building in New York City, designed to house a collection of such panoramas, that had cost almost double its original estimate of $8,000. Like John Wesley Jarvis, he was visiting New Orleans painting portraits to bolster his finances.

"When I arrived at Mr. V's room," Audubon complained of their encounter, "he spoke to me as if I had been an abject slave and told me in walking away to lay my drawings down *there* [on the vestibule floor], the dirty son-of-a-bitch, and that he would return presently to look them over. I felt so vexed that my first intention was to pack off, but the expedition was in view." Instead he waited sweating in the heat for thirty minutes, "although not laying my drawings *down there.*" The artist returned "with an [army] officer, and with an air more becoming a man who once was much in my situation ask[ed] me in[to] his private room. Yet I could plainly see in his eye that selfish confidence that always destroy[s] in some degree the greatest man's worth." Audubon knelt to lay his drawings on the cleaner floor of Vanderlyn's private room and looked up to the artist just as the officer exclaimed, "*By God* that's handsome!" His

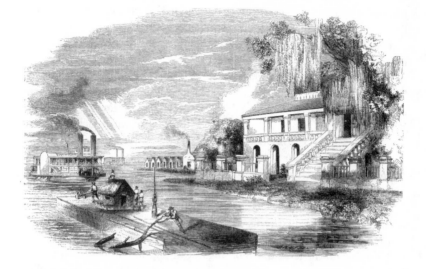

interest piqued, Vanderlyn gathered one of the drawings, studied it, put it down and "said they were handsomely done."

Although glad for Vanderlyn's approval, since he was considered an excellent judge of art, Audubon was still fuming. He took in the paintings hung on the walls of the artist's room and immediately "saw a great defect in one of his figures of women (the defect that had been corrected by the lady I drew lately)." Vanderlyn praised the "beautiful coloring and good positions" of Audubon's birds but then wounded him further by offering to give him "a certificate of his having inspected them," and further yet by criticizing a black-chalk portrait Audubon showed him, saying it was "hard and without effect, although he acknowledged it must have been a strong [likeness]." Needing the artist's endorsement, Audubon bit his tongue and saved his outrage for his journal: "Are all men of talent fools and rude purposely or naturally?" Vanderlyn nevertheless gave him a letter endorsing both his bird drawings and his portraits as "appear[ing] to be done with great truth & accuracy of representation, as much so as any I have seen in any country." Truth and accuracy, after all, were the skills an expedition artist required.

Leaving the encounter with such mixed feelings, Audubon was delighted when the officer followed him outside and "asked me the price of my black chalk likenesses and where I resided—all answered; I thought how strange it was that a poor devil like me could steal the custom of the great Vanderlyn, but

fortune if not blind certainly must have her lunatic moments." That afternoon he was further delighted when Joseph Hawkins, the New Orleans attorney who had been Audubon's go-between with the governor of Louisiana, reviewed his drawings and his letter to the President "and told me he would do all in his power for me." Audubon warmed to Vanderlyn in the weeks ahead, judging him "amiable" after paying him a further visit and commenting that "this gentleman like all substantial men gained on acquaintance." Reviewing Vanderlyn's portrait of Andrew Jackson against the original when Jackson passed through New Orleans, Audubon decided it was the only good one he had seen.

On April 5 his lost portfolio finally arrived, sent down from Natchez by John Garnier, the hotelier. Whoever had picked it up on the Natchez riverbank where Nicholas Berthoud's servant had forgotten it had taken good care of it: "When I carefully examined the drawings in succession I found them all present and uninjured save one, which had probably been kept by way of commission."

Lounging on the levee one morning in early April Audubon noticed John Wesley Jarvis going by carrying a cage filled with painted buntings. As Audubon told the story later, Jarvis was fantastically dressed in a wide-brimmed straw hat; "his neck was exposed to the weather; the broad frill of a shirt, then fashionable, flapped about his breast, whilst an extraordinary collar, carefully arranged, fell over the top of his coat. The latter was of a light green color, harmonizing well with a pair of flowing yellow nankeen trousers and a pink waistcoat, from the bosom of which, amidst a large bunch of the splendid flowers of the magnolia, protruded part of a [live] young alligator." Jarvis carried the cage of songbirds in one hand, "whilst in the other he sported a silk umbrella, on which I could plainly read 'Stolen from I,' these words being painted in large white characters." He walked "as if conscious of his own importance, that is, with a good deal of pomposity, singing 'My love is but a lassie yet' " in a Scotch brogue.

Audubon claimed that he approached this "original painter" about his cage of painted buntings, Jarvis invited him back to his studio, and there in the course of showing off a novel new percussion-lock gun Jarvis fired it several times indoors trying to drive a pin into his easel and to blow out a candle, frightening the birds and terrifying the little alligator. Jarvis was certainly capable of such displays—he drank heavily and ended his years in drunkenness and ruin—but what seems to have gone unnoticed in Audubon's description of this real or fanciful encounter is his dressing up the painter (or the painter dressing himself) in the same range of colors as the buntings, which Audubon

lists as "azure, carmine, yellow and green." The cage of painted buntings that this painted bunting of a painter carried probably supplied the five that Audubon finished drawing on April 9: two adult males, a one-year-old male, a two-year-old male and a female "fighting together" in a Chickasaw wild plum bush, "moving round each other to secure an advantageous position, pecking and pulling at each other's feathers with all the violence and animosity to which their small degree of strength can give effect."

A letter Lucy Audubon wrote to her cousin Euphemia Gifford came to her husband from Louisville on April 11 to read, add to and forward to England by ship. It carried news of the death of Lucy's father William Bakewell at Fatland Ford on March 6. After her father's long illness Lucy was prepared to count his death a blessing:

> His departure from this scene of trouble can hardly be regretted when his misfortunes are considered, particularly as he has not left his room or been sensible of any external object scarcely for the last twelvemonth not even the knowledge of Sister Ann who has been with him all the time. Still we feel as his children and lament the loss of one so exemplary and every way prepared to join his Maker.

Lucy and her two sons were living now with the Berthouds in Shipping-port—Nicholas and Eliza had three children themselves—as was Nicholas's widowed mother Marie-Anne-Julia Berthoud and Lucy's brother Will, who clerked for the Berthouds. Lucy's sister Sarah lived in Louisville with her brother Tom Bakewell and his wife Elizabeth, who also had three children. Deferring to these family matters, Audubon merely sent Lucy's cousin his "best wishes for her happiness" and moved the letter along.

As Audubon's residence in New Orleans extended into its fourth month, the number of his acquaintances lacking black-chalk portraits was declining and his funds were running low, so he began giving drawing lessons at $1.50 or $2 each. On Saturday, April 14, a New Orleans physician and his wife had left their cards at his Barracks Street rooms while he was out hunting birds in "the thickest woods I believe I have yet seen." He called on Dr. Louis Heermann on Monday and arranged to give Mrs. Heermann a program of six weeks of daily drawing lessons for no less than $200, to be paid upon conclusion. Tuesday he gave the first lesson. Thursday, "low in funds again," he and Mason carried his portfolio to the home of the elderly Dr. George Hunter, the early Ouachita River expedition leader. More low comedy: "We came on him rather unaware;

the good man was pissing. We waited and I gave him my letter of David Prentice. This physician may have been a great doctor formerly but [is] now deprived of all that I call mind; I found it necessary to leave."

The Roman Pamar family had made Audubon welcome. He escaped to the Pamar home for meals whenever he could, particularly on Sundays, when his students, "all religiously inclined," scrupled to be instructed. The Pamar children adored him, as children usually did. He missed his own; a late-April letter from Victor, now almost twelve, with improved handwriting, delighted him. After Sunday dinner at the Pamars' on April 22 he finished a drawing of a snowy heron (snowy egret), "a beautiful male." Mason spent the day drawing flowers.

Audubon had not heard from Lucy for two weeks, which was beginning to worry him. For a few days, working around his lessons, he added to his cash on hand by boarding steamboats and soliciting portraits, including one of a Ste. Genevieve friend of Ferdinand Rozier, Jean Baptiste Bossier. With the proceeds he paid his and Mason's board, rent and washing—$20—and then on Sunday, April 29, sent Lucy a numbered U.S. Note for $100 via the steamboat *Columbus.* No letter from Lucy arrived on Monday, which left him "sadly disappointed, almost sickened"—he had passed his thirty-sixth birthday the previous Thursday and could have expected an acknowledgment. He wrote again on Tuesday, "extremely uneasy about my wife's health or her children," and once more on Wednesday. Thursday in the disagreeable heat he bought fifteen yards of nankeen for summer clothes for him and Mason and learned that the first cases of yellow fever had appeared in the city. While he worried about Lucy, he tried to hold off Mrs. Heermann; at her Thursday lesson she had been "more amiable if possible than usual, [and] talked freely to me."

Finally a letter from Lucy arrived on the *Cincinnati* on Sunday, May 6, but it was "not very agreeable to my feelings." Lucy had delayed writing because she was unhappy with her situation and with him. Her letter brought news that Joseph Mason's father had died. When Audubon told the young man, "Joseph . . . bore it well." Nicholas Berthoud had not responded to Audubon's request for help promoting the Pacific expedition. He wrote Lucy a long response, sent Berthoud a note and went about his business, adding three new pupils and cryptically recording in his journal on Wednesday his "thought . . . that a certain gentleman to whom I go daily felt uncomfortable while I was present. Seldom before my coming to New Orleans did I think that I was looked on so favorably by the fair sex as I have discovered lately." He would soon learn that the self-regarding lesson he took from Dr. Heermann's discomfort was the wrong one.

That Wednesday he had dined with the Governor of Louisiana, Thomas Robertson, "a man of strong information [and] extremely polite," and Robertson had promised him a letter to the President recommending his services. Four days later both Hawkins and the governor delivered on their promises. He was surprised and a little awed. "Favors from men of high stations are favors indeed," he wrote in his journal. No further favors had come from Lucy, however. "Since so long without any news from my family my spirits have failed me and it is with difficulty that I set to write at all—my journal suffers through the same cause that affects me—attention." It would be almost a month before he wrote in his journal again.

The record is far from barren, however. During the last two weeks of May 1821 Audubon finally received a series of letters from his wife that first grieved and then angered him. He answered them as he received them in one long letter written between mid-May and June 1 that tracked the twists and turns of both their feelings.

Lucy's first letter asked about his situation in New Orleans, which he described at length. She wondered why he had not started a drawing school rather than simply taking individual pupils. He should have done so, he answered honestly, and had "lost a great deal not to have one," but when he arrived he had not known how long he would stay, he had no models for students to draw from and "from week to week I expected to go elsewhere"—a reference to his plans to explore the Louisiana Territory wilderness either on his own or as part of a government expedition. In her letter to her cousin in April Lucy had expressed her hope of accompanying her husband to England when he went there to publish his book of American birds. Now she had doubts, primarily because she was worried about how to provide for her older son's education and about her younger son's inattention to his studies (Lucy called both boys by their middle names, Gifford and Woodhouse). Audubon was sharply disappointed:

Thou art not it seems [as] daring as I am about leaving one place to go to another without the means. I am sorry for that. I now never will fear want as long as I am well, and God will grant me that as I have received from nature my little talents. I would dare go to England without *one cent*, one single letter of introduction to anyone, and on landing would make shillings or pence if I could not make more but no doubt I would make enough. . . .

If I do not go to England in the course of twelvemonth we will send *Victor* (do call him) to Lexington College. [I] hope my dearest friend that our sweet Woodhouse will lose the habits that make thee at present fear he has

not the natural gifts about him—I think his eyes are extremely intelligent, he is quick of movements, these are indications of natural sense—but he is yet a boy and has not had the opportunities of Victor to improve; the latter was thy only attention for some years before John required any. I will agree with thee that the educating of children is perplexing.

Painful toothaches had required Lucy to have several teeth pulled, and she had lost weight. It was painful to hear of her pain, Audubon sympathized, adding clumsily but affectionately that "if my Lucy would try to amuse herself and have good spirits, she would soon recover and have her flesh again. Dear girl how much I wish to press thee to my bosom." He knew her cash reserves were small but hoped to augment them. He doubted if she had seen any payments from the managers of the Western Museum; Robert Best, the curator, had sworn he had "not received $10 since I left, this however I doubt." Lucy had sent him a good pair of suspenders, "but thou doest not say that they are from thy hands, I hope they are; I am so much of a lover yet that every time I touch them I will think [of] & bless the maker—thank thee, sweet girl, for them." She had asked him if he had seen the "*Fair Incognito* who bestowed the gun." He proceeded to narrate that episode to her at length with the open, boyish naïveté that sometimes caused him trouble—he evidently felt safe sharing it with the woman he consistently called his best friend. The point of the story, after all, besides its novelty, was that Mrs. André had trusted him not to take advantage of her and that he had not betrayed her trust. The fine double-barreled shotgun she bought him proved his fidelity.

Lucy next asked him what he would do with Joseph Mason if he went to England. "As long at least as I travel," he answered, "I shall keep him with me. I have a great pleasure in affording that good young man the means of becoming able to do well. His talent for painting if I am a judge is fine—his expenses very moderate and his company quite indispensable. . . . He now draws flowers better than any man probably in America." Mason was also valuable as a walking advertisement for Audubon's skills as a teacher; "to show his performance will bring me as many pupils as I can attend to, anywhere."

He could not tell her yet where he expected to spend the next winter. "Migratory birds or beasts follow the mast. Certainly if it is in this place I shall be I hope blessed with thy company." She had written of giving up her music. He thought she was wrong to abandon it, "yet please thyself."

Her brother Tom had offered her the use of a house. Audubon was glad she had not accepted the offer. "We are poor but not beggars I assure thee." He had

harder words for Nicholas Berthoud, whom Lucy had written had "done wonders" for them. "According to my way of thinking," Audubon responded sarcastically, "he has acted indeed wonderfully—but here I must hush—I am a painter and know no more than my business—his silence on the second aid I have been fool enough to ask of him since I have fooled what I had—gags me." The first aid Audubon had asked of Berthoud had been help finding work on a steamboat when Audubon had first arrived in Shippingport after selling out in Henderson in 1819. The second aid had been his recent request for endorsements for a position on the U.S.-Spanish surveying expedition out to the Pacific.

Lucy had sent her good wishes. He thanked her for them—"they are *all I want*, to deserve them *all* I am intent on"—and closed out the letter for the night.

The next day, May 24, brought another letter from Lucy, warmer than the previous one had been. "I must thank thee again & again" for it, Audubon responded gratefully, "it is kind and written as if to a beloved friend, and may this be or not, I wish to be deceived in that way forever." She had not yet received the U.S. Note he had sent her on April 29. She was bitter about a recent disappointment or deception, which he encouraged her not to overgeneralize: "But my Lucy thou must not be quite so hard on the world—there are a few yet that are good and do something for others besides themselves."

He had important news:

> I give lessons to a young lady here, of drawing. She is the daughter of a rich widow lady, her name Eliza Pirrie, and resides near Bayou Sarah during the summer heat. Yesterday I begged to hear her sing and play on the piano, I played with her on a flute and made the mother stare. She was much surprised to hear me sing the notes. This lady asked me if I would go with them and teach her daughter (about 16, an interesting age) until next winter. I am to think of the terms, and give an answer, this I have already formed in my mind: She must pay me $100 per month in advance, furnish us with one room, our board & washing, and I will devote one half of each day for her daughter. It is very high but I will not go unless I get it. If she accedes I will have a very excellent opportunity of forwarding my collection being able to draw every day.

It was his turn to be bitter, at the disapproving silence of Nicholas Berthoud, whom he had finally understood was "determined not to favor me even with a

letter." He thanked him sarcastically—"it will make me use my own powers [all] the more"—and enjoined Lucy to "never mention the Pacific journey to friend Nicholas again; no commissions will come from that quarter." He closed by assuring his wife that he was dedicated to doing "all in my power to enable thee to live with comfort and satisfaction, wherever I may chance to be carried by circumstances." His in-laws might misunderstand and disapprove, but he had taken the lesson of his business failure to heart, had assessed his prospects realistically and now judged art and book publication to be his best chance to recoup.

He was ready to send this long correspondence at the end of May when another letter arrived from Lucy that made him mad. "Wert thou not to give me *hints* about money I should be sorry," he responded sharply, "as I know it is as necessary for the support of thy life as thy affection is to the comfort of mine." She had defended Nicholas Berthoud and had warned him not to return to Shippingport empty-handed. He was angry and insulted:

> I am very sorry that thou art so intent on my not returning to thee—if that country we live in cannot feed us why not fly from it? . . . If Mr. Berthoud has wrote me it is more than *I* know of yet—Why Lucy do you not cling to your better friend, your husband? Not to boast of my intentions any more toward thy happiness I will merely say that I am afraid *for thee*. We would be better, much better, happier [together]. . . . Your great desire that I should stay away is, I must acknowledge, very unexpected—if you can bear to have me go [on] a voyage [to England] of at least three years without wishing to see me before—I cannot help thinking that Lucy probably would be better pleased should I never return—and so it may be.

Despite his threat of abandoning her, he still signed off "for life, your really devoted *Audubon*," adding in a postscript, "I can scarce hope now to go to the Pacific. My plans, my wishes will forever be abortive. . . . But I assure you that I shall ever remember [this expedition] *and feel my love for you*. Farewell."

Unspoken across this painful exchange between two people who loved each other deeply were Lucy's grief at her father's death and her disappointment about her inheritance. Tom Bakewell, her handsome and manipulative brother, was her father's widow's favorite. When William Bakewell died Tom had assured Rebecca without authorization that he "and, I doubt not, Lucy, will also relinquish all pretensions to any claim . . . until the debts by the firm of Audubon & Bakewell be fully discharged." Debts against the estate would

have to be settled, but it was not Tom's place to speak for his sister and her needs.

Audubon had lashed out in frustration. After a night's sleep he was contrite:

> My Dearest Girl: I am sorry of the last part I wrote yesterday, but I then felt miserable. I hope thou wilt look on it as a momentary incident. I love thee so dearly, I feel it so powerfully that I cannot bear anything from thee that has the appearance of coolness. Write me always care of Mr. R. Pamar. I will leave in a few days. Know not where for. . . . God bless thee. *Thine forever.*

Audubon did know where he was going and soon let Lucy know as well: to Oakley Plantation in West Feliciana Parish, 125 miles upriver from New Orleans and about 5 miles inland from Bayou Sarah, to spend half of each day tutoring sixteen-year-old Eliza Pirrie and the other half collecting and drawing birds. Oakley's owner, Lucretia Alston Gray Pirrie, had indeed been a widow—she had inherited Oakley's 3,100 acres when her husband Ruffin Gray died—but she had since remarried. She had countered Audubon's demand for $100 per month with an offer of $60, which he had had the good sense to take. The number 100 stuck with him when he wrote about their bargain, commenting drolly that "after the one hundred different plans I had formed as opposite as could be to this, I found myself bound for several months on a farm in Louisiana."

He was leaving New Orleans with his pockets nearly empty. When he had failed to respond to Mrs. Heermann's advances she had accused him to her husband of making advances toward *her* and the doctor had angrily dismissed him:

> How agreeable the first lessons were I shall always remember; she thought herself endowed with superior talents, and her looking glass pleasing her vanity I daresay made her believe she was a star dropped from the heavens to ornament this earth. But difficulties augmented and of course drawing ceased to please. I could not well find time to finish every piece that I had began for her, and constancy the lady said was never to be found the companion of genius. Towards the last she would be unwell when I walked in, yawned and postponed to the morrow. I believe the husband saw her weakness, but the good man, like one or two more of my acquaintance, was weaker still.
>
> I knew well that my conduct had been correct and I felt a great pleasure in leaving them, and the one hundred dollars I had earned with them.

For his innocent but ill-advised flirting he received, he wrote, "the rudest of dismissals." He had forgone his wages because his insulted "pride would not admit me to the house to ever ask any compensation."

So on June 16, 1821, having packed their few possessions, Audubon and Mason boarded the *Columbus* and departed New Orleans, arriving at Bayou Sarah on June 18, a sultry day. They climbed the bluff to St. Francisville, where dinner was offered them at the home of a local judge, Robert Semple. Audubon had no heart for dining. "I wished myself on board the *Columbus,* I wished for my beloved Lucy, my dear boys." He felt that he would be awkward at table, and when several Pirrie slaves arrived to escort them to Oakley they went on. The fragrant Louisiana woods revived Audubon's spirit:

> The aspect of the country entirely new to us distracted my mind from those objects that are the occupation of my life—the rich magnolia covered with its odoriferous blossoms, the holly, the beech, the tall yellow poplar, the hilly ground, even the red clay I looked at with amazement—such entire change in so short a time appears often supernatural, and surrounded once more by thousands of warblers & thrushes, I enjoyed nature.

He saw a Mississippi kite and then a swallow-tailed hawk (swallow-tailed kite), both birds he needed to draw, and would have collected them had his guns not been packed. Despite the afternoon heat, the five-mile walk seemed short. Lucretia Pirrie's fifty-two-year-old husband James, a Scotsman long resident in the parish, met them outside the elegant white three-story West Indies–style house, with its two floors of jalousie-shaded galleries raised on a lower story of brick. Audubon inspected James Pirrie closely, anxious to know the man who would be his host. He liked what he saw. *"We were received kindly."*

BAYOU SARAH

W HEN AUDUBON AND JOSEPH MASON arrived at Oakley Plantation on June 18, 1821, they were shown to a cool room on the red-brick ground floor with an outside entrance set back under the jalousied galleries. The large white house above them faced east on grounds shaded by live oaks and magnolias softened with Spanish moss; outside stairs in the rear connected spacious upper floors, with a parlor and a dining room on the second floor and bedrooms on the third. The detached kitchen occupied a separate building behind the house built over the original homestead. Through the summer Oakley would be fully occupied, with James and forty-nine-year-old Lucretia Pirrie in residence; their daughter Eliza, Audubon's pupil; a guest from England, Mrs. Harwood, visiting the Pirries with her little girl; and a friend of Eliza's from New Orleans, Eliza Throgmorton. Mary Ann and Jedediah Smith, Lucretia's daughter by her first marriage and son-in-law, who lived near Oakley on their own plantation, Locust Grove, would be frequent visitors. Almost unmentioned in the contemporary record but present and visible everywhere were the Pirries' several hundred slaves, the engines of their wealth: the Pirries grew cotton.

Three good cotton crops made a millionaire in the rich lands along the Mississippi above New Orleans in the first decades of the nineteenth century. Liverpool customs agents had justified seizing eight bags of cotton as contraband in 1784 with the argument that the United States could not possibly have produced so much; by 1821 the total U.S. production had reached 180 million pounds. A decade later, when production had further tripled and was still increasing, U.S. Treasury Secretary Levi Woodbury would write that the United States had been "much aided" in dominating the world cotton market "by the good quality of their cotton, the low price of land, and the great improvements in cleaning cotton by [Eli] Whitney's cotton gin since 1793. One

Oakley today

person is able to perform with [Whitney's invention] in a day the work of 1,000 without it." In 1821 U.S. raw cotton exports accounted for almost half the total dollars earned from all U.S. commodity exports, four times as much as either tobacco or wheat; and 40 percent of British export earnings came from finished cottons. Connecticut technology, New England shipping, English steam-powered mills and New York merchants supported the emergence of large slave plantations across the American South, which sustained families like the Pirries in opulence.

By July 4 Audubon had thoroughly surveyed the Oakley woods and questioned everyone in the neighborhood who had knowledge of the local bird populations, filling pages of his journal with notes on a total of sixty-five species. Blue jays were few, he found, because they had been poisoned in large numbers "with corn boiled with arsenic" the previous April for "annoy[ing] the corn rows." The wood thrush was "extremely plent[iful] in its usual haunts, i.e., deep shady woods." It was "the first bird that sings at the dawn of day," but Alexander Wilson's depiction of it looked to Audubon nothing like the original. Fat robins were plentiful in winter and "the sport to all the gunners." Golden-winged woodpeckers were plentiful, bluebirds "scarce, about one pair to each plantation," nesting in holes in peach and apple trees. The orchard ori-

ole was "very abundant. . . . I found seventeen nests on Mr. Pirrie's plantation with eggs or young during two days looking for them. . . . Was deceived one day by one imitating the cry of the logger-head shrike and followed it a great distance before I found my mistake." Indigo buntings were "tolerably plenty," American redstarts "very plenty," red-bellied woodpeckers "plentiful as anywhere else," black-capped titmice "very plenty," mockingbirds "extremely plenty," hummingbirds "plentiful" and "easily caught by pouring sweetened wine in the [chalices] of flowers—they fall intoxicated." And so on through green-crested flycatchers, pewit flycatchers, blue-eyed yellow warblers, American sparrow hawks, yellow-rumped warblers and white-eyed flycatchers ("the commonest of all the birds in our woods"). Audubon also wrote that he had glimpsed three red ibises flying in a line above the trees, a rare sighting that modern ornithologists doubt, since the bird is not native to North America—but Audubon knew his silhouettes.

His luck had delivered him once again into a paradise of birds. The rush of notes in his journal measured not only his excitement but also his relief from depression. He had Wilson's volumes in hand and commented frequently and usually critically in the margins and in his journal on Wilson's work, indicating his renewed focus on surpassing his predecessor as he completed his collection. His competitiveness with Wilson, which some have thought unseemly, had a practical basis: as Daniel Drake had emphasized in his address at the Western Museum, improving on Wilson was Audubon's primary justification for seeking to publish a new American ornithology. "The great many errors I found in the work of Wilson astonished me," Audubon explained in his journal. "I tried to speak of them with care and as seldom as possible, knowing the good [intentions] of that man, the hurry he was in and the vast many hearsay [statements] he depended on."

In a summer of adventures Audubon produced some of his finest work. He and Mason routinely searched through as much as twenty miles of woods and swamp in a day. Late in July they encountered several red-cockaded woodpeckers in the pinewoods; using mustard-seed shot in his elegant gold-chased souvenir shotgun, Audubon slightly wounded two males. The blackish-brown, short-necked birds were marked distinctively with white stripes that traversed their entire upper bodies; a streak of bright red margined the black behind their eyes. Audubon quickly caught the first of the fallen birds. "The second one shot did not lose a moment to think of its misfortune. The moment it fell to the ground it hopped briskly to the nearest tree, and would soon have reached the top" had he not barked it down with a well-thrown clod. "It

defended itself courageously, and pecked at my fingers with so much vigor that I was obliged to let it drop several times out of my hand." He continues the story:

> Confined in my hat on my head, they remained still and stubborn. I looked at them several times, when I found them trying to hide their heads as if ashamed to have lost their liberty. The report of my gun alarmed them every time I shot when they both uttered a plaintive cry.
>
> One of them died before I reached the house, probably through the great heat; the other however was well, and I put it into a [wooden] cage, every part of which it examined, until finding a spot by which it thought it might escape, it began to work there, and soon made the chips fly off. In a few minutes, it made its way out, and leaped upon the floor, uttering its common *cluck*, hopped to the wall, and ascended as if it had been on the bark of one of its favorite trees. The room being unfinished, the bricks were bare, and as it passed along, it peeped into the interstices, and seized the spiders and other insects which it found lurking there. Remarking often his looking under cracks and the little shelves in the rough wall, I drew him in that position.

Audubon kept the woodpecker two days to draw it alive. By then its wing wound had nearly healed. He checked it once more against his drawing—it smelled strongly of pine, he notes—and then released it "and was glad to think it most likely would do well as it flew 40 to 50 yards at times and seemed much refreshed by its return to liberty." When it was possible to do so, he clearly preferred to work with live specimens.

The drawing Audubon made of a swallow-tailed hawk (swallow-tailed kite) was the crowning achievement of the summer. He had seen these elegant, glossy blue-black birds, with their deeply forked tails and white heads, necks and underparts, migrating from west to east in flocks of up to a hundred in New Orleans in the spring. Around Bayou Sarah they were difficult to approach, because they were "generally on wing through the day, and at night rest on the highest pines and cypresses bordering the river bluffs." They always fed on the wing. "In calm and warm weather, they soar to an immense height, pursuing the large insects called *mosquito hawks* [dragonflies], and performing the most singular evolutions that can be conceived, using their tail with an elegance of motion peculiar to themselves." More typically they fed on grasshoppers, caterpillars, snakes, lizards and frogs. "They sweep close over the fields, sometimes seeming to alight for a moment to secure a snake, and holding it

fast by the neck, carry it off and devour it in the air." He painted his hawk as if seen from above in flight with a knotted green-golden garter snake grasped in its claw, the bird's forked tail and wide-spread, backward-swept wings repeating their strong black diagonals from upper left to lower right against a white background, dramatically foreshortened and iconic. To capture the luminous gloss of the bird's blue-black tertial and back feathers and its white head, he worked almost entirely in watercolor, even brushing in the fine hatching of the wing feathers.

On two occasions in August Audubon and Mason left Oakley after an early breakfast to explore the swamps that bordered the Mississippi for miles above the clear flow of Bayou Sarah, sometimes staying out overnight. "When we left the ridges," Audubon wrote, "we at once saw a different country in aspect, the tall white & red cypress being the principal trees in sight with their thousand knees raising like so many loafs of sugar. Our eagerness to see the lake [at the center of the swamp] engaged us to force our way through deep stiff mud and water—we came to it and saw several large alligators sluggishly moving on the surface, not in the least disturbed by our approach." They encountered a white ibis, "a great number of Prothonotary Warblers on the low bushes of the swamp," yellow-throated warblers, a cerulean warbler that Audubon collected, several pairs of ivory-billed woodpeckers, water thrushes and more.

One small bird, a seemingly nondescript flycatcher, he carried back to Oakley and "had the pleasure of drawing . . . while alive and full of spirit." He thought he had found a new species. "It often made off from my hand, by starting suddenly, and then would hop round the room as quickly as a Carolina Wren, uttering its *tweet, tweet, tweet* all the while, and snapping its bill every time I took it up." For the time being he named it the cypress swamp flycatcher. He never saw another, which should have alerted him to the probability that he had misidentified it; the bird in his careful drawing is an immature Canada warbler.

No fewer than four letters had arrived from Lucy in one packet at the end of July, as well as letters from Benjamin Bakewell and, finally, Nicholas Berthoud, but what Lucy had to say made Audubon worry that she had not yet received the packet of letters for the President that he had sent her from New Orleans by the steamboat *Car of Commerce* before he moved up to Oakley. Evidently she had at least received the long letter he sent at the same time. She would certainly have been happy to hear that he had found regular, paid employment that allowed him time for extensive bird collection and illustration. He was so focused on collecting that after noting the letters he wrote not one more word in his journal about his family until October. Which does not mean he forgot

them; he addressed his journal to them, knowing that they would read it when they were reunited.

While collecting and drawing Audubon also gave regular daily lessons to Eliza Pirrie "of drawing, music, dancing, arithmetic and some trifling acquirements such as [plaiting] hair." Teaching was "seldom troublesome . . . and not caring for or scarcely ever partaking or mixing with the constant transient visitors at the house, we were called *good men* and now & then received a cheering look from the mistress of the house and sometimes also one glance of approbation" from "the more circumspect" Eliza. Five of the six children born of Lucretia Pirrie's first marriage had died, her grown son Ruffin within the year. Eliza, born in 1805, was Lucretia's only child by James Pirrie, and she was frequently ill.

"Raised to opulence," Audubon characterized Carolina-born Lucretia Pirrie, "by dint of industry [she had become] an extraordinary woman." She was a large woman with a broad, plain face. Perhaps in response to the fatality of her children's illnesses, she had studied pharmacy in New Orleans. She prescribed for the Oakley slaves and evidently for the neighbors as well. At the beginning of August Audubon had been awakened to accompany her to "a dying neighbor's house" about a mile away. The neighbor, James O'Connor, had died by the time Mrs. Pirrie and her resident artist arrived. Audubon "had the displeasure of keeping his body company the remainder of the night. . . . The poor man had drunk himself literally to an everlasting sleep; peace to his soul. I made a good sketch of his head" while "the ladies engaged at preparing the ceremonial dinner." He thought Lucretia Pirrie was generous but saw her at times in rages, "giving way for want of understanding . . . to the whole force of her violent passions." She was "fond of quizzing her husband and idolatrizing her daughter Eliza."

The Pirrie household was not a peaceful place. When he was sober James Pirrie was a good man but "extremely weak of habit and degenerating sometimes into a state of intoxication remarkable in its kind, never associating with anybody on such occasions and exhibiting all the madman's actions whilst under its paroxysm." Eliza was demanding, "of a good form of body, not handsome of face, proud of her wealth and of herself, cannot be too much fed on praise." Audubon flattered her and fixed up her drawings to keep his job; her willingness to pass off her teacher's work as her own measures the burden she bore of her mother's expectations. He judged she "had no particular admirers of her beauties but several very anxious for her fortunes." The visitor from England, Mrs. Harwood, was "a good little woman, very kind to us in mending

our linen," but Audubon thought Lucretia Pirrie hated her little girl, perhaps for being healthy. "Miss Throgmorton was also [a] good deal disliked, the poor girl was nearly drove off . . . although she had been invited to spend the summer." Mary Ann Smith, Lucretia Pirrie's daughter, disliked Audubon, and the feeling was mutual—she was "of temper much like her mother, of heart not so good." Her husband Jedediah he admired. His respect for Thomas Robertson increased when the governor visited Oakley during the summer. Henry Clay's brother John visited as well, as did "a rather singular character, rich William Brand," middle-aged friend of the Pittsburgh Bakewells who had recently married a neighborhood girl not much older than Eliza and who would become a supporter.

When Eliza was stricken with fever early in September, these conflicts flared. Lucretia Pirrie entertained "much fear . . . of the survival of this [only remaining unmarried child] and no doubt too much care was taken of her; kept in bed long after she was convalescent and not permitted to leave her room for a long time she became low of flesh and crabbed of speech." A young doctor had been called, whom Audubon thought she developed a crush on—he calls him dryly "the *man she loved.*" The doctor may have reciprocated; at least he seems to have concluded that Audubon was a competitor. He "would not permit her reassuming her avocations near me" and convinced Mrs. Pirrie "that it would be highly improper Miss Eliza should draw, write &c. until some months" had passed. ". . . I saw her during this illness at appointed hours as if I was an extraordinary ambassador to some distant court—had to keep the utmost decorum of manners and I believe never laughed once with her the whole 4 months I was there."

With his teaching hours limited, Audubon devoted correspondingly more time to ornithology, to Lucretia Pirrie's evident annoyance. On October 5 she dismissed him and he presented her with a bill for three months and twenty days of teaching, $204. Since he had been prepared to teach but had been prevented from doing so, he included in the bill the fifteen days when Eliza had been sick. "Mrs. P. in a perfect rage fit told me that I cheated her out of $20. My coolness suffered all her vociferations to flow, I simply told her our former mutual engagements on that score." Stymied with Mrs. Pirrie he sent his bill to her husband instead, but James Pirrie "was then laboring under one of his unfortunate fits of intoxication" and in no condition to adjudicate. Despite the disagreement, Audubon had work to finish before he could leave Oakley, so he braced himself and "begged of [Mrs. Pirrie] that we should remain 8 or 10 days longer if the family would please to consider us as visitors; this agreed on, I

continued my close application to my ornithology, writing every day from morning until night, correcting, arranging from my scattered notes all my ideas and posted up partially all my land birds."

Rancor about money further thickened the humid Feliciana air, and the Pirrie women began avoiding Audubon at table or glaring at him when they could not. Eliza's sister ridiculed a portrait of James Pirrie that Audubon was finishing for his pupil "and afterward never looked directly at me." In the meantime James Pirrie sobered up, sought Audubon out, "apologized in the kindest manner for his lady's conduct, ordered his son-in-law Mr. Smith to pay me, and shewed me all the politeness he is possessed of. Mr. Smith congratulated my firmness of acting and all went on pretty well that day." Pirrie gave him a note for $100, which he sent off to Lucy by steamboat on October 10.

Expecting Audubon and Mason to leave on Saturday, October 20, even though their steamboat would not put in at Bayou Sarah until Sunday morning, the women had gone in to St. Francisville for the day to avoid having to say goodbye. James Pirrie invited the two men to stay overnight, however, and they were still around when the women returned late that afternoon. Mason was a noncombatant in the Pirrie-Audubon feud. Lucretia Pirrie chose to emphasize the point by sending for him and presenting him with "a full suit of fine clothes of her deceased son" Ruffin. Understanding the implied insult of the plantation owner's charity, Audubon insisted that Mason reject the offer, "knowing too well how far some gifts are talked of."

The ceremonies that evening were farcical, the women barely acknowledging Audubon's stiff goodbyes but sending "a volley of farewells" after Mason as the two men retired from the parlor for the last time. Audubon was not intimidated: "The effect was lost and it raised a smile on my lips." The two husbands, James and Jedediah, descended to Audubon's room and parted more cordially. The next morning James Pirrie lent Audubon and Mason horses and they were happy to "vault . . . our saddles and [leave] this abode of unfortunate opulence," but Audubon knew he would miss the "sweet woods around us; to leave them was painful." He and his assistant boarded the steamboat *Ramapo* at Bayou Sarah at ten o'clock on Sunday morning, October 21, 1821, and reached New Orleans on Monday.

Walking to Roman Pamar's house Audubon noticed that people were staring at him. He looked bizarre. His long chestnut hair was pinned back with a buckle and he was still wearing his "large, loose [suit] of whitened yellow nankeen" in October. He stopped at a barber and had his hair cut and soon bought some cloth and visited a tailor. The Pamars received him warmly, a welcome he needed. Thursday he rented a small but pleasant stuccoed brick cottage with a

rear garden and a room he could use as a studio at 55 (now 505) Dauphine Street for $17 a month. By Sunday, "dressed all new, hair cut, my appearance altered beyond my expectations," he was ready to begin looking for pupils but chagrined at his shortened hair, "fully as much as a handsome bird is when robbed of all its feathering. . . . Good God that 40 dollars should thus be enough to make a gentleman—ah, my beloved country, when will thy sons value more intrinsically each brother's worth?" From wounding experience he answered his own question emphatically: "Never!!"

Yet an inventory of his production since he left Cincinnati a year before encouraged and cheered him:

> I have finished 62 drawings of birds & plants, 3 quadrupeds, 2 snakes, 50 portraits of all sorts and my [watercolor portrait of the storied local priest] Father Don Antonio—have made out to live in humble comfort with only my talents and industry, without one cent to begin on at my departure—
>
> I have now 42 dollars, health and as much anxiety to pursue my plans of accomplishing my collection as ever I had and hope God will grant me the same powers to proceed—
>
> My present prospects to procure birds this winter are more ample than ever being now well known by the principal hunters on Lake Borgne, Barataria, Pontchartrain and the country of Terre a Boeuf—

Through November Audubon hustled drawing lessons wherever he could find them. Wealthy New Orleans developer William Brand began paying $2 a day for lessons for his young wife Anne and his son by a previous marriage, William. Roman Pamar's daughter Euphrosine, "the brightest genius I believe I ever met with," started lessons after seeing how much Mason had progressed across the summer and fall, as did a Miss Dellfosse, whom Audubon thought "beautiful and extremely agreeable." The attorney Joseph Hawkins visited Dauphine Street when Audubon was out and left behind an engraving of the head of John Vanderlyn's controversial classical nude *Ariadne* for Audubon to copy in color; when they met the next day they agreed on a $50 fee. Several academies and colleges that Audubon visited were already staffed with drawing and French instructors. With an acquaintance he traded lessons on the violin for lessons in drawing for the acquaintance's son.

Before and after lessons he found time to draw the birds his hunters collected for him on the surrounding lakes: an American avocet on November 7, a gadwall duck on November 10, a wild goose "not represented by Wilson" on the thirteenth, male and female black-bellied darters (anhinga) on the nineteenth

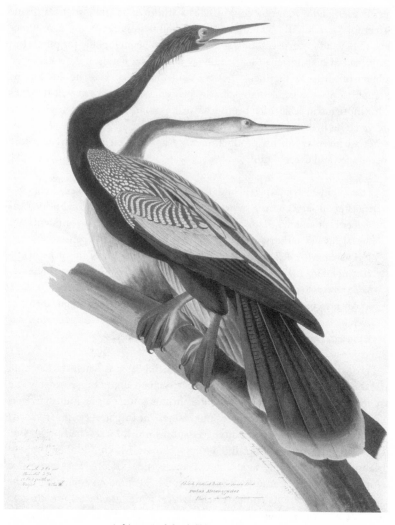

Anhinga, Audubon's "black-bellied darter"

that he finished on the next day, a sandhill crane on the twenty-first, male and female tufted ducks (ring-necked ducks) on the twenty-seventh, a nondescript hawk on December 1 and 2, an American bittern on December 4. When a painter named Basterot proposed that Audubon join him in working up a

panorama of New Orleans for paid public exhibition, he turned him down. "My birds, my beloved birds of America fill all my time," he wrote, "and nearly my thoughts. I do not wish to see any other *perspective* than the last specimen of them drawn."

His communications with his wife were sporadic and still contentious. "A letter from my beloved friend, my Lucy," received on October 29 was "unfortunately of old date." He encountered John Gwathmey, the Louisville hotelier who owned the Indian Queen, on November 3 and learned of "the death of my constant enemy Mrs. [Rebecca] Bakewell, my wife's [step]mother. God forgive her faults." (Unknown to Audubon, his adoptive mother Anne Moynet had died as well at Couëron that month at ninety-two, leaving her much-reduced estate equally to "Rose Bouffard and brother Jean Rabin called Audubon.")

Five days later he still had no further word from Lucy, leaving his feelings "much harassed." Then on Sunday, November 11, Gwathmey told him that "my wife [had] intended leaving Louisville [on] about the first [of November] in a small steamboat for this place—and this news kept me nearly wild all day, yet no boat arrived, no wife, no friend yet near." Why had Gwathmey not let him know before? A letter rather than Lucy herself arrived on Wednesday, "the purport of which lower[ed] my spirits very considerably—alas where does comfort keep herself now; retired certainly on a desolate rock unwilling to cast even a look on our wretched species." Lucy's letter gave him "little expectations of seeing my family before the latter part of winter." The next day, vexed beyond bearing, he was "very low of spirits—wished myself off this miserable stage."

Money was the problem, money for Lucy and the boys' passage down from Shippingport. James Pirrie's note for $100 had not been honored. Friday Audubon sent Mason to Dr. Heermann with a bill for the $100 he had been too proud to collect for Mrs. Heermann's lessons in June, and to his surprise "it was accepted and . . . Joseph [was promised] payment for next week." But when next week came, Heermann had changed his mind and "refused paying my well-earned bill." Audubon understandably felt "shabbily used" and "suffer[ed] much from sore eyes and violent headache the whole day." Yet another $100 note he had sent to Lucy the previous winter had not been honored and was returned to him on November 22. Two days later he paid a one percent premium for a check for that amount drawn on the U.S. Bank of Philadelphia that he knew would be honored. Finally Lucy had funds; on December 1 he heard from her that he could "expect her in a few days." He was so eager to see her and his boys that he began meeting steamboats as they docked. Mrs. Harwood, the Oakley guest from England, arrived on one and delivered his bitch

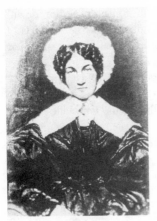

Lucy Audubon,
from a miniature painted in 1831

Belle. By December 13 he was frantic: "So anxious am I during the whole of my present days to see my family that my head is scarce at right with my movements and yet I must feel my sad disappointments and retire to rest without the comfort of her so much wanted company." On December 15 he was greatly relieved to hear that their steamboat, the *Rocket,* had been delayed and that they were due soon.

And finally on Tuesday, December 18, the *Rocket* docked in dark and rainy weather and they came down the gangplank: Lucy, one month from turning thirty-five, thin, graceful and impeccable as she always was, and very glad to see him; Victor, twelve; John, nine. "My wife & my two sons arrived at 12 o'clock all in good health—I took them to Mr. Pamar where we all dined and then moved to our lodgings in Dauphine Street. After 14 months' absence the meeting of all that renders life agreeable to me was gratefully welcome and I thanked my maker for this mark of mercy."

Lucy brought with her all his earlier drawings, including the twenty that Audubon had sent to her by Nicholas Berthoud the previous February. When he reviewed the twenty, Audubon "found them not so good as I expected them to be when compared with those drawn since last winter." That was a mixed blessing. It meant he would have to redraw them if he could find fresh specimens, but it meant as well that his work had improved even further across the past year. He and Lucy put their heads together and began planning a campaign for completing his collection that most artists would have considered impossibly ambitious, especially since the drawing lessons he gave that paid the bills would have to continue: "I am to draw 99 birds in that number of days for which I am to pay one dollar for each to Robert the hunter—who is to furnish me with one hundred specimens of different kinds. Should he not fulfill the contracts, he is to have only 50 cents for each furnished."

The day of Christmas Eve brought cold weather to New Orleans and a visit from his old partner Ferdinand Rozier, now a prosperous forty-four-year-old Ste. Genevieve bourgeois. "It is eleven years," Audubon noted, "since he, I, and my family were all together." Rozier had lived a full life, but the Audubons had lived half a dozen. It snowed all Christmas Day and froze hard.

A NEW START

AUDUBON WORKED HARD IN NEW ORLEANS in the winter of 1822 to accomplish his goal of drawing a bird a day. If his output fell short, it was still prodigious. "Every moment I had to spare I drew birds for my ornithology," he wrote, "in which my Lucy and myself alone have faith." Besides preparing drawings for the great work he was now calling *The Birds of America*, he was responsible for the welfare of his family and of his assistant Joseph Mason. "During January my time was principally spent in giving lessons in painting and drawing," he summarized in March, "to supply my family and pay for the schooling of Victor and Johnny at a Mr. Branards', where they receive notions of geography, arithmetic, grammar and writing for six dollars per month each."

He drew "strenuously" in February as well. To meet his voracious need for specimens, he hired "two French hunters who swept off every dollar that I could raise." The technical improvements he had achieved in the past year, such as underpainting multiple coats of watercolor before applying pastels, led him to review his earlier drawings, and when he did so he "discovered . . . many imperfections . . . and formed the resolution to redraw the whole of them"—adding several hundred more drawings to his burden. Thus on February 2 he not only drew a hermit thrush but also redrew the chestnut-sided warbler that he had collected and drawn in May 1808 in Pennsylvania and never encountered again. A modern critic, Theodore E. Stebbins, Jr., summarizes Audubon's remarkable technical and artistic breakthrough:

> He literally started over, developing a new technique and a new compositional format for the birds. . . . During 1821 and 1822 Audubon . . . learned a full range of techniques for drawing with color. He already knew the traditional French medium of pastel very well; he had been perfecting it since he

was a young man. Now he added to his repertoire a crystal-clear watercolor technique, the ability to use gouache effectively, and an extraordinary varied use of the pencil, together with the talent for combining all these graphic means to render a single bird. No one in America equaled him for graphic inventiveness until Winslow Homer some sixty years later; as for European parallels, one can only think of the great English watercolorists, both contemporaries of Audubon: J.M.W. Turner and Samuel Palmer.

Audubon developed two different formats for his drawings, Stebbins continues, "one for the small songbirds, another for the larger species, the hawks, owls, and shorebirds. The small species—the warblers, finches, sparrows, swallows, and the like—were drawn to scale on small to medium-sized sheets of paper, always in vertical compositions" and usually on and in bushes or trees characteristic of their habitat. Audubon would position the birds "so that the viewer can learn as much as possible about their appearance. Thus if one bird is seen from the side or top, its mate will be viewed from underneath; one bird's wings will be closed, another's spread. For the larger species, a much larger sheet was employed, up to 26 × 38 inches; the composition might be either horizontal or vertical." Drawing, as Audubon said, "in the size of life" meant fitting the larger birds into a frame that could encompass the largest of

them only by ingenious positioning, which would have seemed forced had he not observed the birds themselves twisting and bending so elaborately as they preened and courted and fed—positions he confirmed were anatomically correct by wiring up freshly killed specimens before rigor mortis seized them. Further to suggest their scale, he would draw birds like his wild turkey, golden eagle and great white heron with a tail feather or a beak projecting slightly out of frame. He was approaching his full maturity as an artist. No one has ever drawn birds better.

He had more in mind than simply scientific illustration: he meant to make art. Art, an older discipline than science, would substitute its reverberant verisimilitude for the life the bird had lost, revivifying it just as he had fantasized in childhood. Restoring life to the inanimate was an emerging theme in the cultural dialogue of the day, a hope projected perhaps from the transforming success of technology; the same decade saw the publication (in 1818) of Mary Shelley's ambivalent fantasy *Frankenstein*, in which electricity is the revivifying medium.

The ironic contrast between the scale of Audubon's ambition and the poverty of his present circumstances was not lost on him or on Lucy. "I have few acquaintances," he wrote one day defensively; "my wife and sons are more congenial to me than all others in the world, and we have no desire to force ourselves into a society where every day I receive fewer bows." When he encountered an old friend from Louisville, an elderly professional flutist named Matabon, wandering in the Halles ragged, broke and hungry, he invited the man into his home as a guest and regretted his departure two months later. Matabon added another instrument to Lucy's piano and Audubon's violin or flageolet during musical evenings on Dauphine Street, but he also added another mouth to feed.

As Anne Brand, William Brand's young wife, approached term she no longer felt up to taking drawing lessons. She had little education. Brand proposed to correct that deficiency by hiring Lucy to substitute for her husband as Anne's companion and teacher and as governess to Brand's cherished son William, freeing Audubon for drawing while continuing the flow of fees.

But despite their best efforts the Audubons slowly fell behind. The Panic of 1819 had settled into a prolonged depression and money was scarce. "I find great difficulty in collecting what is owing me," Audubon complained. In March, when he was offered a position in Natchez in the home of a Majorcan Spaniard named Joseph Quegles teaching drawing, music and French to Quegles's thirteen-year-old daughter Melanie, he reluctantly accepted. Lucy and the boys moved in with the Brands. "Griev[ing] to leave my family," Audubon

traded passage for him and Mason on the steamboat *Eclat* for portraits of the captain and his wife and departed New Orleans on March 16, 1822.

Between March and May, "hunting, drawing and attending to my charge," Audubon completed fourteen drawings, including his king bird (Eastern king-bird), orchard oriole, wood thrush, catbird and male and female chuck-will's-widow. He discovered and first described a new flycatcher (willow flycatcher), which he drew singing from the topmost branch of a sweetgum tree. He painted, powerfully, the turkey buzzards (turkey vultures) that hopped and scavenged in the Natchez streets. In his notes he defended the much-maligned king birds and catbirds in similar terms, arguing that their benefits to the farmer far outweighed their occasional theft of his fruit: "The many eggs of the poultry which [the King Bird] saves from the plundering Crow, the many chickens that are reared under his protection, safe from the clutches of the prowling Hawks, the vast number of insects which he devours, and which would otherwise torment the cattle and horses, are benefits conferred by him more than sufficient to balance the few raspberries and figs which he eats." The two chuck-will's-widows he depicted harassing a "harlequin snake" by "open-ing their prodigious mouth and emitting a strong hissing murmur." He wrote that he believed the snake to be "quite harmless," but in fact the snake he or Mason drew coiled around a branch between the two birds was a coral snake, a venomous American relative of the cobra distinguished by yellow bands touching red. If they handled it they were lucky to have survived.

As he always did, Audubon found friends and supporters among the local Natchez gentry. Twenty-five-year-old amateur naturalist Benjamin Wailes col-lected an orchard oriole nest for Audubon on his plantation outside Washing-ton, Mississippi, eight miles northeast of Natchez on the Natchez Trace. Benjamin and his younger brother Edmund hunted with Audubon. They also commissioned black-chalk portraits of themselves and their father and mother, Levin and Eleanor Wailes, and Levin Wailes in mid-May arranged for Audubon to teach drawing at Washington's Elizabeth Female Academy. As soon as he began teaching, Audubon sent for his family. Lucy felt respon-sible for attending Anne Brand, but she forwarded Victor and John, whom Audubon entered in school in Natchez.

Hiking back and forth between Natchez and Washington—seven miles each way—was fatiguing in the heat of Mississippi summer. Early in July 1822 Audubon was prostrated by yellow fever. Illness terminated his six weeks of teaching. The loss of income might have been disastrous if another local friend, William Provan, a young doctor, had not come to his aid, nursing him through his illness and "actually insist[ing] on my taking his purse to pay for

the expenses connected with the education of my sons." When Audubon recovered he found another teaching position at a new academy just opened in Natchez. That was good for his purse but not for his art: "While work flowed upon me, the hopes of my completing my book upon the birds of America became less clear; and full of despair, I feared my hopes of becoming known to Europe as a naturalist were destined to be blasted."

Then Joseph Mason decided it was time to go home to Cincinnati. He was probably ready to strike out on his own; he may also have come to doubt that Audubon's birds would ever see print. "We experienced great pain at parting," Audubon wrote when Mason left on July 23. "I gave him paper and chalks to work his way with, and the double-barreled gun I had killed most of my birds with, and which I had purchased at Philadelphia in 1805."

To raise money Audubon began painting a watercolor copy of John Trumbull's popular *Death of General Richard Montgomery at Quebec, 1775,* working from a print. With Provan's help the history painting hit the jackpot:

> My drawing was highly praised by my friends at Natchez, and Dr. Provan, like a good genius [i.e., a genie], insisted it should be raffled. I valued it at three hundred dollars, and Dr. Provan sold all the tickets but one, at ten dollars each. He then put my name down for that, saying he hoped it would be the winning one. The raffle took place in my absence, and when I returned, my friend the doctor came and brought me three hundred dollars and the picture, beautifully framed, saying, "Your number has drawn it, and the subscribers are all agreed that no one is more deserving of it than yourself."

At the beginning of September Audubon heard from Lucy that Anne Brand's infant had died. The death, recalling the two little girls Lucy had lost, released her to move up to Natchez. Audubon met his wife at the Natchez landing "with great pleasure" and together they rented a small frame house off an alley at 118 South Union Street in the upper town. Quegles, the Spaniard whose daughter Audubon had been tutoring, helped Lucy find a position as a governess with the family of a local clergyman. She seems to have lived at home; in a later year Audubon reminisced that they used to have breakfast together at six a.m. in their Natchez days, "when the good old Doctors Dowe and Provan were pleased to drink of our coffee and eat of thy toast." By mid-October the clergyman had not yet found it possible to pay her. She and Audubon began advertising in the Natchez newspapers that she would tutor young women and he would "open a school for Drawing (at Mr. Davis' Seminary) in Chalks, and Painting in Water Colours, in all the various styles most fashionable in Europe

and our Eastern Cities . . . [and] will also give lessons of vocal Music." Evidently students were scarce. He had not deigned to paint panoramas in New Orleans, but he was working on a panorama of Natchez in November. An English traveler, a naturalist named Leacock, found him out on the river bluff sketching the view, called on him that evening, "examined my drawings and advised me to visit England and take them with me." Leacock thought Audubon would have to spend several years perfecting his work and winning recognition, a prospect the artist understandably found discouraging.

A portrait painter named John Steen, from Washington, Pennsylvania, turned up in Natchez that autumn 1822, fresh from having taught the young American painter Thomas Cole. He agreed to teach Audubon oil painting if Audubon would teach him pastels. Painting in oil took longer than drawing in chalk, and Audubon despised the tedium of grinding his own colors (artists' oils were not yet available commercially), but oil portraits and paintings commanded higher fees. "He gave me the first lesson in painting in oils I ever took in my life," Audubon wrote of Steen; "it was a copy of an otter from one of my watercolors." The gory *Otter in a Trap*, chewing off its own leg to free itself, would become a staple of Audubon's repertoire of hurried and somewhat awkward oils, a medium in which he was never entirely comfortable. They would command high prices and serve his larger purpose, but he knew them for what they were; he called them potboilers.

Lucy put these various experiences and assessments together and decided to find a way to help raise the money her husband needed, as she wrote many years later, "to go to Europe and obtain complete instruction in the use of oil." Provan served once again as the Audubons' guardian angel. The young physician was engaged to Sarah Percy, a daughter of a formidable widowed Scotswoman, Jane Middlemist Percy, who owned and operated Beech Woods plantation on the west bank of Bayou Sarah northeast of St. Francisville in West Feliciana Parish. There were enough daughters of plantation owners in the neighborhood in addition to Jane Percy's four to support a plantation school; the position might be worth as much as $1,000 a year. Lucy, English-born and -educated, socially poised, an accomplished musician, agreed to become the schoolmistress. She moved to the detached cottage and schoolhouse at Beech Woods early in the new year 1823, taking John with her. Victor, who would be fourteen in June, stayed in Natchez with his father, who was teaching him to draw.

By mid-February 1823 "Messrs. Audubon & Steen" were advertising their services in the *Mississippi State Gazette* as portrait painters at $50 for a full-sized oil portrait and $30 for a miniature. Oils may have commanded higher

prices, but fewer people could afford them; March found Audubon and Steen departing Natchez in a horse-drawn wagon for a tour down through the plantation country of southwestern Mississippi and the Feliciana parishes as itinerant portrait painters, taking Victor with them as an assistant. "I regretted deeply leaving my Natchez friends," Audubon wrote. He had assembled a large flock of birds to sell in Europe, where American species were fashionable and highly valued. "The many birds I had collected to take to France I made free; some of the doves had become so fond of me that I was obliged to chase them to the woods, fearing the wickedness of the boys, who would, no doubt, have with pleasure destroyed them."

Audubon's idea of their itinerary differed from Steen's. "I had finally determined to break through all bonds and pursue my ornithological pursuits. My best friends solemnly regarded me as a madman, and my wife and family alone gave me encouragement." Steen thought they would proceed expeditiously from place to place and do portraits; he had little patience for the birding that delayed them along the way. When they got to Beech Woods he left Audubon and Victor and went on alone. Audubon probably celebrated his thirty-eighth birthday at Beech Woods with his wife and sons on April 26.

Like the collection of live birds Audubon freed in Natchez, a letter of introduction that Henry Clay sent him from Washington City in mid-March 1823 confirms Audubon's intention to carry his portfolio abroad to be engraved as soon as he accumulated enough drawings and mustered the funds. "He proposes going to Europe," Clay wrote, "to avail himself of the artists and opportunities of that quarter in executing some of his sketches and designs, so as to give them a wider diffusion."

JANE PERCY HAD BEEN a widow for three years. She had met and married her late husband Robert, a British naval officer, in London and they had settled with their two English-born daughters Jane and Margaret near Bayou Sarah in 1802, after which five other children were born, including Sarah and Christine. Feliciana had been briefly an independent republic after Percy and others led a revolt against Spanish rule in 1810, a year before the United States annexed the district as part of the Louisiana Purchase. With twenty years of pioneering behind her, Jane Percy spoke with authority and expected to be obeyed. As long as her schoolmistress's startling French husband was in residence, she thought he might as well make himself useful. She engaged him for the summer, he wrote, to "teach the young ladies music and drawing." The young ladies remembered especially the Audubons teaching them to swim in the Beech

Woods springhouse. (Before refrigeration, cold springs enclosed and lined with stone served as coolers for milk and other perishables and doubled as swimming pools.)

At Beech Woods Audubon continued working at painting in oil "and greatly improved myself." He painted his two sons that summer with serious faces and dark eyes: Victor Gifford was made to look wary; John Woodhouse is clearly still a child, with a child's snub nose and rounded cheeks, but Victor's features are more defined. Audubon painted his own unsmiling portrait as well, the earliest image of him that survives. In a shawl coat and a high-collared white shirt, his left shoulder turned away, he looks across his right chest into the mirror he painted from, warier even than Victor. His eyes are large, dark and alert, his mouth set and almost frowning, as if he disapproves of what he sees—or perhaps simply wonders at the persona in the mirror, a lean, complicated, Byronic being suspended between a difficult past and an uncertain future. His dark hair, full but not long, is a mass of curls, the sideburns springing out far enough to cover the inner whorls of his ear. If the man in the portrait had just heard himself threatened he could not be more tensed.

Inevitably he painted the Percy girls. He "found their complexions difficult to transfer to canvas." Complexion was a crucial marker in the multiracial milieu of nineteenth-century Louisiana, as Audubon's comment in his journal in 1821 about "the citron hue of almost all" shows he knew very well. Yet he painted the Percy girls with yellowish complexions, looking jaundiced. In that

Audubon's 1823 portraits of his sons, Victor Gifford and John Woodhouse

malarial environment they may well have been, but Jane Percy was not about to allow her girls to be portrayed in colors that hinted of African blood. She demanded repainting and Audubon denounced her, in language so harsh that not even Lucy would take his side.

Jane Percy fired him and he stormed off to Bayou Sarah. Three nights later he tiptoed back to reconcile with Lucy. Their reconciliation led them into bed. One of the Percy slaves had seen Audubon arrive and reported him. Jane Percy raided the cottage, found husband and wife in bed and ordered Audubon off the premises. He reminded Lucy later that his expulsion forced him to walk back "15 miles on foot to Bayou Sarah." From there, at a loss, he

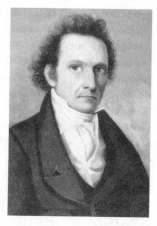

The 1823 Audubon self-portrait

sent for Victor and returned with his son to Natchez, "but did not know what course to follow. I thought of going to Philadelphia, and again thought of going to Louisville and once more entering upon mercantile pursuits, but had no money to move anywhere."

His friends welcomed him and put him up. He cast about for employment. The black-chalk portrait vein was worked out. Then he found a patron, an elderly and wealthy widow named Griffith. She agreed to pay him $300 (about $4,500 today) to scale up his Natchez panorama into a grand four-by-eight-foot oil painting. He worked through the summer. By the time he was finished Mrs. Griffith had died. Her heirs refused to honor her pledge. In August both Audubon and Victor were stricken with yellow fever. Dr. Provan treated them and sent word to Lucy at Beech Woods. She ordered a horse harnessed to a gig, raced up the Woodville road to Natchez and settled in to nurse her husband and her son. In September, needing her schoolmistress, Jane Percy offered amnesty and invited Lucy to bring her charges back with her to Beech Woods to convalesce, which she did.

It made sense then to Audubon to go ahead to Philadelphia, where he hoped to "obtain employment as a teacher." He could further improve his oil painting technique there by taking lessons from one of the Peales or another of the many distinguished painters the city sustained. Philadelphia had engraved and published Alexander Wilson's work; Audubon could show his portfolio of drawings in the preeminent city of science and art in America and perhaps find support for publishing them. He packed them up and shipped them ahead,

and on October 3, 1823, he and Victor said their goodbyes to Lucy and John and left Bayou Sarah aboard the steamboat *Magnet* bound for Louisville.

The Ohio was Audubon's favorite. "The very sight of the waters of that beautiful river filled me with joy as we approached the little village of Trinity," he remembered of this first return in four years. The river was too low to allow the *Magnet* passage, nor were horses available for hire. Audubon proposed to Victor that they walk the 250 miles to Louisville and he agreed. Two other passengers asked to join them. Audubon arranged with a tavern keeper to have his personal effects forwarded and they set out.

Victor was still convalescent. Keeping up soon became a struggle. One of the two passengers, "a burly personage" who was frequently drunk, derided the boy's weakness. They stopped overnight at private cabins where they were not always well fed. Audubon had special praise for one accommodation, on the second morning out: "Better breakfast I never ate: the bread was made of new corn ground on a tin grater by the beautiful hands of our blue-eyed hostess; the chickens had been prepared by one of her lovely daughters; some good coffee was added, and my son had fresh milk." Despite the milk Victor became faint later that day. "Dear boy! never can I forget how he lay exhausted on a log, large tears rolling down his cheeks. I bathed his temples, spoke soothingly to him, and chancing to see a fine turkey cock run close by, directed his attention to it, when, as if suddenly refreshed, he got up and ran a few yards towards the bird. From that moment he seemed to acquire new vigor." Not so the burly personage. As the long walk continued he faded fast.

They filled their pockets with October peaches at an orchard and met "a fine black wolf quite tame and gentle" at one of the cabins where they lodged. They bathed in the Ohio and made twenty miles a day. Victor grew ever more vigorous; the burly personage and the other passenger finally had to ask to be left behind. Going on alone father and son avoided Henderson, crossed to the Ohio side on the Green River ferry "with our legs hanging in the water," enjoyed "a good supper, sparkling cider, and a good bed" at an inn and arranged to be driven the last hundred miles to Louisville in a Dearborn wagon. When they arrived, on October 25, they had $13 between them.

Nicholas Berthoud had agreed to train Victor as a clerk. Father and son settled in for the winter in a rented room in Shippingport and Audubon got busy raising money for Philadelphia and Europe. Through the end of 1823 and the early months of 1824 he produced black-chalk portraits, oil portraits, landscapes (including the Falls of the Ohio), murals for the parlors of the steamboats that the Berthouds and the Tarascons built, even signs for shops. Only edited fragments of his journal from this period have survived, but they hint

that his moods swung to extremes as they always did when he lived away from Lucy. In November he wrote grandiosely that he was "busy at work when the weather permits, and resolve[d] to paint one hundred views of American scenery," a diversion he fortunately did not indulge. On January 20 he was grieved:

> I arose this morning by that transparent light which is the effect of the moon before dawn, and saw Dr. Middleton passing at full gallop towards the white house [of the Berthouds: Madame Berthoud had been stricken]; I followed—alas! my old friend was dead! What a void in the world for me! I was silent; many tears fell from my eyes, accustomed to sorrow. It was impossible for me to work; my heart, restless, moved from point to point all round the compass of my life. Ah, Lucy! what have I felt to-day! how can I bear the loss of our truest friend? This has been a sad day, most truly; I have spent it thinking, thinking, learning, weighing my thoughts, and quite sick of life. I wished I had been as quiet as my venerable friend, as she lay for the last time in her room.

Audubon left Shippingport for Philadelphia as soon as the ice broke up on the Ohio, early in March 1824, and arrived there on April 5. His appearance was his first order of business that Monday. He bought a new black suit, had his hair trimmed at least to shoulder length, "dressed myself with extreme neatness" and called on an old friend from Mill Grove days, James Mease, a fifty-two-year-old physician, geologist and encyclopedist who was one of the founders of the Philadelphia Athenaeum. Mease welcomed Audubon and arranged access for him to the Athenaeum and to the library of the American Philosophical Society, where he could consult an array of ornithologies, including Alexander Wilson's.

At Audubon's request Mease also introduced him to Thomas Sully, the best portrait painter in the country, trained in London by Benjamin West and Audubon's senior by two years (Audubon would be thirty-nine on April 26). In 1821 Sully had spent twelve days at Monticello painting a full-length portrait of Thomas Jefferson for the U.S. Military Academy at West Point. He had painted Martha Jefferson Randolph, Patrick Henry and many other notables. Sully was impressed with Audubon's birds; in a letter of introduction he wrote for Audubon a few months later he said that "for copiousness and talent" the collection "bids fair in my estimation to surpass all that has yet been done, at least in this country." Audubon told Sully he wanted to learn to paint oil portraits. Sully had survived years of poverty before achieving commercial success. He

would accept no payment from Audubon but agreed to exchange lessons in oils for lessons for his daughter Sarah in watercolor and pastels. Audubon praised Sully as "a man after my own heart" and "a beautiful singer." Like the Audubons, the Sullys were musical; they welcomed the itinerant artist into their family circle that spring and summer.

On Saturday of that first week Mease introduced Audubon to a small, poised, patrician twenty-year-old whose uncle Audubon had long admired: Charles-Lucien Bonaparte. Behind his uncommon beard the young man strongly resembled the deceased emperor. He was nominally a prince, of Canino and Musignano, two marginal Italian principalities that his father Lucien had bought from Pope Pius VII in 1806 when the Pope needed money but refused to accept a loan. Despite his youth, Charles Bonaparte had made himself an expert on American ornithology since his arrival in the country in September 1823. He had just begun work on an *American Ornithology* intended to revise and update Wilson. He made collections at his uncle Joseph Bonaparte's luxurious 1,700-acre estate at Point Breeze, twenty-five miles north of Philadelphia on a bluff overlooking the Delaware River. The many specimens he and his ser-

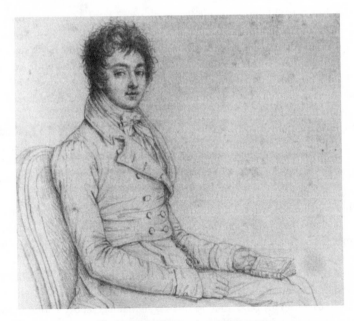

Charles-Lucien Bonaparte as a young man

vants had collected he preserved and stuffed himself, but he was neither an artist nor a field naturalist.

The artist and the prince talked for two hours. Stretching his credentials, Audubon told Bonaparte that he had studied under Jacques-Louis David, though he had previously claimed only to have studied under "good French masters." David had been Napoleon's court painter, so Audubon was probably only trying to ingratiate himself, but he was taking a great risk. Along with paintings by Rubens, Correggio, Titian and Vandyke, there was a David hanging at Point Breeze—one of the three copies David had painted of his *Bonaparte Crossing the Saint-Bernard*—and the painter was still alive, living in exile in Brussels. He had painted Charles Bonaparte's wife Zénaïde and her sister Charlotte in 1821. Bonaparte did not question Audubon's claim at the time. He took Audubon along that evening to a meeting of the Academy of Natural Sciences, which the entomologist Thomas Say had founded in 1812. Audubon showed his drawings, the prince "pronounced my birds superb, and worthy of a pupil of David" and they won general praise.

Taking exception to Audubon's work was a long-faced, quarrelsome, wealthy English dilettante named George Ord, then vice president of the Academy of Natural Sciences, a man known for his rudeness. One of Alexander Wilson's executors, Ord had edited the eighth volume of Wilson's *American Ornithology* after Wilson had died in 1813, had written and published the ninth volume on Wilson's behalf and was currently organizing a three-volume octavo edition. He had "no heart for friendship," a contemporary would say of him, because "nature has denied him such a blessing." He was certainly not interested in competition. After he studied Audubon's drawings at the Academy meeting, he objected to their mingling plants and birds. Others at the meeting defended Audubon. Ord marked him down for destruction, first of all blocking his election to the academy.

On Monday Charles Bonaparte called for Audubon in his carriage and took him to see Titian Ramsey Peale, whom Audubon had first met as a nineteen-year-old when Peale passed through Cincinnati with the Long Expedition in 1819. Peale was drawing the illustrations for Bonaparte's ornithology. Audubon was unimpressed and said so: "From want of knowledge of the habits of birds in a wild state, he represented them as if seated for a portrait, instead of with their own lively animated ways when seeking their natural food or pleasure." Peale resented the criticism, although he would try later to imitate Audubon's style and fail. Bonaparte, far from being offended, began thinking about partnering with Audubon to produce a joint work.

To that end, Bonaparte picked up Audubon once again after breakfast on Wednesday, April 14, and took him to see Alexander Lawson, the huge Scotsman who had been Wilson's engraver and was now engraving Peale's drawings for Bonaparte. Lawson's daughter Malvina remembered Audubon arriving with the prince: "He looked like the backwoodsmen that visit the city. His hair hung on his shoulders and his neck was open." Audubon wrote of Lawson and the meeting that "this gentleman's figure nearly reached the roof, his face was sympathetically long, and his tongue was so long that we obtained no opportunity of speaking in his company. Lawson said my drawings were too soft, too much like oil paintings, and objected to engrave them." Lawson's version of the meeting, reported to a contemporary, William Dunlap, is equally acerbic:

> One morning, very early, Bonaparte roused him from bed—[the prince] was accompanied by a rough fellow, bearing a portfolio. They were admitted and the portfolio opened, in which was a number of paintings of birds, executed with crayons, or pastels, which were displayed as the work of an untaught wild man from the woods, by Bonaparte, and as such, the engraver thought them very extraordinary. Bonaparte admired them exceedingly, and expiated upon their merit as originals from nature, painted by a self-taught genius.
>
> Audubon—for the "rough fellow" who had borne the portfolio was the ornithologist and artist—sat by in silence. . . .
>
> Lawson told me that he spoke freely of the pictures, and said that they were ill drawn, not true to nature, and anatomically incorrect. Audubon said nothing. Bonaparte defended them and said he would buy them and Lawson should engrave them. "You may buy them," said the Scotchman, "but I will not engrave them." "Why not?" "Because ornithology requires truth in forms, and correctness in the lines. Here are neither." In short, he refused to be employed as the engraver, and Audubon departed with the admirer who had brought him.

Lawson's hostility is puzzling. He mentioned no previous conversation with George Ord, only that he had heard about Audubon from "a well-known Quaker gentlemen" who had praised him as "a self-taught original genius." His reaction to seeing Audubon's work seems excessive for an untutored initial encounter. Bonaparte and Audubon consulted another Philadelphia engraver, Gideon Fairman, who raised no such objections, Audubon writes, "but he strongly advised me to go to England, to have them engraved in a superior manner."

Discussions with Bonaparte about a joint venture continued. "I should have been very happy to join you or to have you join me," Bonaparte reminded Audubon several years later. ". . . We might have given all your drawings & begun by those 'not given by Wilson,' thus combining our two places in one. . . . We talked of it you recollect in Philadelphia . . . but *men* interfered . . . & besides you had not kept the skins of your birds. Had you had them, with your drawings & your valuable observations, no power on earth could have separated us & I should have been the editor (if nothing else) of your work!" But Audubon had not gone to Philadelphia to see if his work might be published there. He went to Philadelphia for lessons in oil painting and to try to find support—presumably either patronage or endorsement or both—for publication in Europe. Meeting Charles Bonaparte led him to consider joining forces, since Bonaparte knew ornithological science better than he and carried a famous name. Engraving such large drawings was beyond Philadelphia's resources, however—even copper sheets of sufficient size were unavailable—nor had Audubon preserved the skins of the new birds he had discovered that Bonaparte would need for proper descriptions and to deposit as type specimens. The Philadelphia science establishment as represented by the likes of George Ord also did all it could to block the venture, and succeeded.

Bonaparte bought one of Audubon's drawings—of a great crow blackbird (boat-tailed grackle)—to use in his ornithology and carried it to Lawson to engrave. This time, Dunlap writes:

> Lawson consented, but it was found too large for the book. Bonaparte wanted him to reduce it. . . . "Let [Audubon] reduce it [Lawson said] and I will engrave it." Soon after, Audubon came to the engraver with the same picture, and said, "I understand that you object to engraving this." "Yes, it is too large for the book." "And you object to my drawing?" "Yes." "Why so?" "This leg does not join the body as in nature. This bill is, in the crow, straight, sharp, wedge-like. You have made it crooked and waving. These feathers are too large." "I have seen them twice as large." "Then it is a species of crow I have never seen. I think your painting very extraordinary for one who is self-taught—but we in Philadelphia are accustomed to seeing very correct drawing." "Sir, I have been instructed seven years by the greatest masters in France." "Then you made damned bad use of your time," said the Scotchman.
>
> "Sir," said Lawson to the writer [i.e., Dunlap], "he measured me with his eye, and but that he found me a big fellow, I thought he might have knocked me down."

Audubon "worked incessantly" on his bird collections during May and June 1824 while he studied oil painting and supported himself "giving lessons in drawing at thirty dollars a month"—half what he had been able to charge in New Orleans. "I found the citizens unwilling to pay for art," he assessed Philadelphia, "although they affected to patronize it. I exhibited my drawings for a week, but found the show did not pay." On May 11 he drew a ring plover (semipalmated plover) he collected near Philadelphia. Bank swallows clinging to their nesting holes he drew from birds collected on the banks of the Schuylkill River that month. At the end of May, hunting near Camden, New Jersey, with a French artist named Charles LeSeur who had defended Audubon's work against George Ord's complaints at the Academy of Natural Sciences meeting, he collected a ruddy turnstone and drew that harlequin-patterned bird as if seen from above in flight, a bravura perspective that revealed the complex colorings of its back feathers and wing feathers. Joseph Mason, now twenty-three, came by on May 30, a "delightful visit." Mason had moved to Philadelphia from Cincinnati and found employment as an artist at William Bartram's Botanic Garden at $60 a month, though Bartram himself had died in 1823.

Rembrandt Peale, Titian's older brother, visited Audubon in mid-June, liked his drawings and invited him to call at his studio to see his portrait of George Washington. Audubon did, but loyal as always to those who helped him, "preferred the style of Sully." Bonaparte as well as the French consul in Philadelphia advised Audubon to have his drawings engraved in France. A physician and naturalist originally from Louisville, Henry McMurtrie, "whose study of shells has made him famous," reviewed Audubon's drawings and advised him to go to England rather than France. By the end of the month Audubon was restless to move on but undecided: "Anxious to carry out my project of a visit to Europe—anxious to see my wife before leaving—anxious to see my old quarters of Mill Grove—anxious to get more instruction from my kind master, Sully; and altogether unable to settle what course would be most preferable."

Circumstances focused him. At the beginning of July the engraver Gideon Fairman commissioned him to draw a small grouse for engraving on a New Jersey banknote. Accompanying Fairman on his visit to Audubon's rooms was a wealthy young gentleman farmer from Moorestown, New Jersey, Edward Harris. Harris wrote Audubon a few days later inviting him to shoot snipe in the marshes near his farm. Audubon countered by inviting Harris to stop in the next time he visited Philadelphia. Harris did, on July 19, when Audubon showed him several dozen of his Mill Grove–, New York–, Falls of the Ohio– and Henderson-era drawings that remained unsold from

Audubon's disappointing public exhibition. Harris surprised and delighted him by saying "he would take them *all*, at my prices. I would have kissed him, but that is not the custom in this icy city." Audubon then offered Harris his oil of the Falls of the Ohio. Harris declined it, but as he was leaving he handed the artist a $100 bill, saying, "Mr. Audubon, accept this from me; men like you ought not to want for money."

Modest and generous, Harris had just made a friend for life. Audubon immediately reciprocated by adding to Harris's armload of American draw-

New Jersey gentleman farmer Edward Harris

ings the drawings of European birds he had done at Couëron in 1805–6 and carefully kept in his collection for nearly twenty years. "This is the second instance of disinterested generosity I have met with in my life," Audubon wrote gratefully, "the good Dr. Provan of Natchez being the other. And now I have in hand one hundred and thirty dollars to begin my journey of three thousand miles."

He had one more mission before he left Philadelphia for New York. He accomplished it on Monday, July 26, 1824:

> Reuben Haines, a generous [Quaker] friend, invited me to visit Mill Grove in his carriage, and I was impatient until the day came. His wife, a beautiful woman, and her daughter accompanied us. On the way my heart swelled with many thoughts of what my life had been there, of the scenes I had passed through since and of my condition now. As we entered the avenue leading to Mill Grove, every step brought to my mind the memory of past years, and I was bewildered by the recollections until we reached the door of the house. . . . The cordial welcome of Mr. Wetherill, the owner, was extremely agreeable. After resting a few moments, I abruptly took my hat and ran wildly toward the woods, to the grotto where I first heard from my wife the acknowledgement that she was not indifferent to me. It had been torn down, and some stones carted away; but raising my eyes towards heaven, I repeated the promise we had mutually made. We dined at Mill Grove. . . . Everybody was kind to me and invited me to come to the Grove

whenever I visited Pennsylvania, and I returned full of delight. Gave Mr. Haines my portrait, drawn by myself, on condition that he should have it copied in case of my death before making another, and send it to my wife.

Audubon left Philadelphia on August 1 "in good health, free from debt and free from anxiety about the future." He knew what he had to do, or thought he did: finish his collection, raise the necessary money, see Lucy again and then sail for England. Easier said than done.

ENTHUSIAST OR LUNATIC

AUDUBON CAUGHT THE FIVE A.M. STAGE from Philadelphia to New York on the last day of July 1824, a Saturday. The stage cost $10, carried seven passengers and usually reached the city by seven or eight in the evening. Sunday Audubon crisscrossed New York admiring the city's "beautiful streets and landings" but "found most of the parties to whom I carried letters of introduction absent"—as New Yorkers usually are in August. The missed connections made him regret his hurry to leave Philadelphia. He wondered if he should go on to Albany or Boston, where he might be able to put money in his pocket selling portraits. Monday, strolling near the Battery, he bumped into Charles Bonaparte and was introduced to Charles's uncle Joseph, the former king of Spain, and Joseph's two daughters, all visiting from their Point Breeze estate. Tuesday he called on John Vanderlyn, who had returned from New Orleans. Before Audubon left New York Vanderlyn would use him as a stand-in for Andrew Jackson, whose full-length portrait Vanderlyn was finishing for the New York City Hall—he told Audubon that "my figure considerably resembled that of the General, more than any he had ever seen."

Wednesday, more productively, Audubon paid his respects to Samuel Latham Mitchill, the physician and former senator. Mitchill, who had founded the New York Lyceum of Natural History, penciled a note to the Lyceum secretary while Audubon was sitting with him, endorsing Audubon for membership and authorizing an exhibition of his bird drawings. Audubon showed his drawings, which Mitchill had called "elegant performances," on Monday, August 9, feeling "awkward and uncomfortable." In the presence of the physicians and academics who were Lyceum members his lack of formal education embarrassed him despite his hard-won ornithological expertise. "Among such people," he wrote, "I feel clouded and depressed; remember that I have done nothing, and fear I may die unknown."

Two days later he read before the Lyceum a paper he had written as a membership requirement on the migration of swallows, a subject he had investigated thoroughly, scotching the old myth that swallows burrowed into the mud in wintertime and hibernated. Ten years earlier the mayor of New York at the time, DeWitt Clinton, had mentioned the life history of swallows in a public lecture about subjects that needed more study, predicting that "if another Wilson shall arise, endowed with genius and invincible industry, the rich treasures of natural science which are now hidden from our view will be drawn from the darkness which covers them and exposed to the full view of an admiring world." Clinton's man of genius and invincible industry had arrived in the person of John James Audubon, but almost everyone was out of town. "In a few days I shall be in the woods," Audubon feared, "and quite forgotten." His fear was unfounded: "Facts and Observations Connected with the Permanent Residence of Swallows in the United States," his first published work, would appear in the Lyceum *Annals* for 1824.

Someone may have mentioned Clinton's prediction to Audubon. He had planned to sail for Boston on August 15; he changed his mind at the last minute and boarded a steamboat for Albany to introduce himself to Clinton, who had been the governor of the state from 1817 to 1823. Steaming up the Hudson among Audubon's more than three hundred fellow passengers was a delegation of twenty-three Indians representing six tribes; they were returning to the

West from Washington. Clinton was not at home. Audubon's pocket was beginning to lighten, but he decided he wanted to see Niagara Falls.

The Erie Canal, dug by hand 360 miles from Buffalo to Albany beginning in 1817, shored and sealed with clay, was nearly finished. Clinton had promoted it and served for many years as canal commissioner; he would formally open it in 1825 by pouring a barrel of Lake Erie water into New York Harbor. Audubon booked passage on a canal boat. Seven dollars and six days later, "obtain[ing] some new birds by the way," he arrived at Rochester on Lake Ontario, paused long enough to view and sketch "the beautiful falls of the Genesee River" and went on to Buffalo.

From Buffalo he walked up to Niagara Falls, noting the poverty of the country and the "lank and sallow" people. The falls awed and even frightened him; he decided that "the whole grand rush of the water" never had been "and never will be painted." He admired the double rainbows the falls made and noticed through "the falling sheet of water . . . thousands of eels lying side by side, trying vainly to ascend the torrent." Writing his name in the hotel register he added, "who, like Wilson, will ramble, but never, like that great man, die under the lash of a bookseller." He was not yet certain if *The Birds of America* would ever be published, much less reach the booksellers, but he went to bed that night "thinking of Franklin eating his roll in the streets of Philadelphia [when he arrived as an impoverished boy of seventeen], of Goldsmith traveling by the help of his musical powers, and of other great men who had worked their way through hardships and difficulties to fame, and fell asleep hoping by persevering industry to make a name for myself among my countrymen."

Buffalo had been burned to the ground during the War of 1812. Audubon found it recovering, with "about two hundred houses, a bank and daily mail." It was crowded with Indians when he toured it on August 25, "here to receive their annuity from the government. The chief Red Jacket is a noble-looking man; another, called the Devil's Ramrod, has a savage look." He encountered an itinerant colleague in Buffalo and the two artists decided to travel together. For $1.50 each they booked deck passage on a Lake Erie schooner bound for Erie, Pennsylvania. Before they left Buffalo they were robbed; they boarded the schooner with only $7.50 between them. "To repine at what could not be helped would have been unmanly," Audubon dismissed the robbery. "I felt satisfied Providence had relief in store." Providence had a storm in store. As they approached Presque Isle Harbor, off the Erie shore, a violent gale prevented them from crossing the harbor bar and they were forced to anchor in the lake. After an unpleasant night of wallowing in the whipped-up lake they removed into a United States Navy gig that rescued them and delivered them to shore.

Audubon had been concerned for his portfolio. He was relieved when it was safely landed.

After bread and milk in Erie, Audubon's usual travel meal, he and his colleague hired a cart for $5 to haul their belongings thirty miles inland to Meadville, Pennsylvania. There Audubon enticed customers by showing them the portrait he carried of "the best friend I have in the world," meaning Lucy, and the two men stopped over long enough to replenish their pocketbooks drawing portraits. Then they walked on ninety miles to Pittsburgh, where Audubon was surprised to find himself "more politely received [by his relatives] than on former occasions . . . due to the reception I had met with in Philadelphia . . . some rumors of which had reached the West."

He had intended to go on by steamboat from Pittsburgh directly to Bayou Sarah, but the Ohio was too low for navigation. Since he was stuck in Pittsburgh, he made the best of it, "scouring the country for birds and continuing my drawings." He wrote Edward Harris, the New Jersey gentleman farmer who had befriended him in Philadelphia, inviting Harris to join him on a ramble along Lake Ontario and Lake Champlain to view the autumn migrations. Harris declined because his sister was ill, so Audubon went alone. The country was new to him and he reported himself "delighted with the tour." During the week or two he spent drawing shorebirds on the Great Lakes he thought through how he would arrange his drawings in *The Birds of America* and made up his mind "to leave nothing undone which my labor, my time or my purse could accomplish."

Back in Pittsburgh he found work teaching drawing to the daughter of an Irishwoman who ran a female seminary, Mrs. Charles Basham. The Bashams—her husband was English—welcomed him into their family much as the Roman Pamars had in New Orleans. "In Pittsburgh he charmed all who saw him," Mrs. Basham would reminisce. She recalled finding him one day painting a male and a female passenger pigeon. He depicted the birds billing—that is, courting by sharing regurgitated food—a behavior borrowed from the method pigeons use to feed their young. The birds perched on separate branches, the female above and the pink and blue-gray male below, the male's head curved back sinuously to receive the female's offering.

By mid-October Audubon was ready to start home regardless of the river. He bought and provisioned a skiff and hired an Irish laborer to row. Two new Pittsburgh acquaintances who were also waiting for higher water, a young Swiss landscape artist named George Lehman and an older French physician named LaMotte, decided to join him. The group departed Pittsburgh on October 24.

Audubon hauled the skiff ashore at night and slept in it. He did not record

where his passengers slept, but by the time the expedition reached Wheeling, "after suffering much from wet and rain," they "were disgusted with boating, and left." The Irishman quit as well. Nearly broke, Audubon tried his hand at selling commercial woodcuts of the Marquis de Lafayette, who had been appointed the first honorary U.S. citizen in 1823 and who was then in the midst of a triumphal fiftieth-anniversary tour of the United States. He was not due to visit Wheeling for another year, however, and the woodcuts failed to sell. Audubon sold the skiff instead and took passage on a keelboat to Cincinnati.

There he found himself dunned by creditors of the Western Museum for supplies he had purchased on the museum's behalf, a particularly galling experience, since the museum had never paid him his full salary. To get out of town "without money or the means of making it" he decided to borrow $15 from his former bankers; he "walked past their house several times" before he could steel himself against the embarrassment. "I got the loan cheerfully and took deck passage [on a steamboat] to Louisville." He was allowed to take his meals in the cabin but had nothing better to sleep on than a pile of shavings he scraped together on deck. Yet his decision to publish his work regardless of obstacles had inoculated him against depression. "The spirit of contentment which I now feel is strange," he wrote in his journal, "it borders on the sublime; and, enthusiast or lunatic, as some of my relatives will have me, I am glad to possess such a spirit."

After Audubon found lodgings in Louisville he "hastened to Shippingport to see my son Victor." Nicholas Berthoud handed him a letter from Andrew Jackson introducing him to the Governor of the Floridas, but the high-level endorsement—Jackson was a popular candidate for the presidency at the time—left Audubon's sanctimonious brother-in-law unmoved. "I discover that my friends think only of my apparel, and those upon whom I have conferred acts of kindness prefer to remind me of my errors." He saw no reason to linger. "I decided to go down the Mississippi to . . . Bayou Sarah and there open a school, with the profits of which to complete my ornithological studies." Since his New Orleans steamboat ticket cost only $8, he probably bought deck passage; the man he described being delivered ashore at Bayou Sarah in the middle of the night in late November 1824 had "rent and wasted clothes and uncut hair." On a borrowed horse he managed to wander lost through the Feliciana woods for the rest of the night, but "a black man" he encountered in the middle of nowhere pointed him in the right direction. At Beech Woods just after dawn he found Lucy already up and teaching "and holding and kissing her I was once more happy, and all my toils and trials were forgotten."

UNDERSTANDING THAT AUDUBON would leave for Europe as soon as he completed his collection and accumulated a stake, Jane Percy allowed him to live with his wife in her cottage at Beech Woods. Complementing Lucy's program, he began teaching music, French and drawing there, as well as cotillion dancing at regular soirees held in the swept-out barn where cotton was ginned. On the Randolph plantation in Woodville, Mississippi, fifteen miles northwest of Beech Woods, he taught Judge Peter Randolph's three sons how to fence. As long as he was trekking to Woodville for two days a week, he decided to teach dancing there as well:

> A class of sixty was soon organized. I marched to the hall with my violin under my arm, bowed to the company assembled, tuned my violin; played a cotillion, and began my lesson.
>
> I placed all the gentlemen in a line reaching across the hall, thinking to give the young ladies time to compose themselves and get ready when they were called. How I toiled before I could get one graceful step or motion! I broke my bow and nearly my violin in my excitement and impatience! The gentlemen were soon fatigued. The ladies were next placed in the same order and made to walk the steps; and then came the trial for both parties to proceed at the same time, while I pushed one here and another there, and was all the while singing myself, to assist their movements. Many of the parents were present, and were delighted.
>
> After this first lesson was over I was requested to *dance to my own music,* which I did until the whole room came down in thunders of applause, in clapping of hands and shouting, which put an end to my first lesson and to an amusing comedy.

"When I would make a misstep," one of his young ladies remembered, "he would throw up his hands and 'De udder foot, my darling!' was his affectionate admonition."

Audubon had been surprised and delighted to find his former Louisville and Henderson clerk Nathaniel Pope settled in St. Francisville. Pope had trained as a physician and in 1823 had married a local girl of English descent, Martha Johnson. The young doctor and his former employer took up birding together again. Another hunting companion was a Cajun plantation owner, Augustin Bourgeat. They hunted not only birds but also alligators and bears.

Martha Pope recalled her encounters with the Audubons in a memoir, a rare glimpse from outside the family circle. Lucy's nose "was short and turned up,"

which Martha thought spoiled her face, otherwise distinguished by "fine dark gray eyes shaded by long dark lashes. Expression was her chief attraction. She was very gentle and intelligent. Her whole appearance impressed me with respect and admiration." Sometime in 1825 the Audubons had profile silhouettes cut in New Orleans. Lucy's silhouette reveals her nose to be pert, but it hardly spoils her face.

Like many women, Nat Pope's young wife found Lucy's husband dazzling:

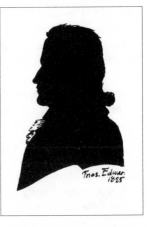

Audubon's profile silhouette. (For Lucy's, see p. 9.)

> Audubon was one of the handsomest men I ever saw. In person he was tall and slender, his blue eyes were an eagle's in brightness, his teeth were white and even, his hair a beautiful chestnut brown, very glossy and curly. His bearing was courteous and refined, simple, and unassuming. Added to these personal advantages he was a natural sportsman and natural artist.
>
> He kept his drawings in a watertight tin box, which remained in my parlor for months. His reputation was spread far and wide, and often our home was filled with visitors who came to see his drawings and paintings, which he would spread on the floor for inspection, and he never seemed weary of unpacking and explaining them. He was very sociable and communicative, being the center of attraction in every circle in which he mingled.

Audubon felt sufficiently comfortable around Martha Pope to tell her about his Henderson business failure—she would have known about it anyway from her husband—and reveal his self-mocking fantasy of eventual vindication. "I mean to get me a coach-and-six and ride through the streets of Louisville yet!" he told her. To intrigue her, or perhaps simply wistfully, he closed a narrative of his travels with the declaration, "If I were to tell you one half of what I see in those lonely ravines and swamps, it would make your hair stand up on your head! I do not like to relate my adventures to everyone—for I might not be believed, *madame*. Yet everything I would say would be the truth!" He would find a use for his travel experiences when he came to write about birds. He valued the Popes' hospitality enough to give them no fewer than four of his oil paintings: a portrait of a famous boxer, Hare Powell; a portrait of a local

matron that Martha believed to be "his first attempt in this line of art"; and two still lifes, one of vegetables, one of fruit. (They would be lost in the Civil War.)

Martha remembered preparing "a glass of weak whiskey and water, which he called grog, for his breakfast." She described him going off "on his lonely journey in the woods, with his knapsack on his back, alone and on foot, often remaining in the open until his clothes were tatters, and his hair in long curls on his shoulders." She thought "it grieved him" that Lucy had to work. "Every time he returned home he found her fading and drooping and he could not help but compare her to 'a beautiful tobacco plant cut off at the stem and hung up to wither with head hanging down.' " If the simile was his, Lucy probably had words with him about it.

Audubon had begun corresponding regularly with Charles Bonaparte. He initiated the correspondence in January 1825 by apologizing for the disappearance of a file of information that he had mailed to Bonaparte when they were both in New York the previous summer and promising to send a duplicate. He heard from Bonaparte in April and assured the prince that his great crow blackbird was drawn life-sized. Bonaparte had seen skins that seemed to be either much smaller or much larger, which Audubon speculated had been badly prepared. "If such a person as Mr. [Alexander] Lawson [Bonaparte's cantankerous engraver]" had changed his drawing as a result, Audubon responded, "I shall be sorry as long as I live." He hoped that "time will prove to you that I am sincere and that probably my fault most predominately is too much frankness towards all those who have anything to do with me." Changing the subject, he reported that "the season has been opened here with an unusual degree of brilliancy; nature is really all alive in our woods [and] I have drawn much since I saw you for posterity." Lafayette's tour of all twenty-four states was progressing; that day, April 14, 1825, the general was to pass Bayou Sarah on his way up to Natchez from Baton Rouge. Bonaparte had dined with Lafayette the previous September. A large group of notables that Joseph Bonaparte had assembled in a sixteen-oared barge had met Lafayette's steamboat coming down the Delaware from Trenton and feted him at Point Breeze, where bearded, liveried servants presented multiple courses on solid silver in rooms hung sumptuously in blue merino with gold-fringed drapes.

(Lafayette moved on from Natchez. In late May Benjamin Bakewell, Lucy's uncle, wrote to Derbyshire from Pittsburgh that the city was "all in a bustle preparing for the reception of General Lafayette, whose intention it is to visit every state in the Union." Between Nashville and Louisville there had been an accident; "in ascending the Ohio . . . [Lafayette's] [steam]boat struck a sunken

log & sunk. Happily no lives were lost, altho' it was near midnight and very dark." Bakewell's son-in-law and one of his granddaughters had been aboard, "but escaped without damage except the wetting of their clothes." Another steamboat had rescued them.)

In September Audubon heard from Bonaparte that the prince had sent him the first volume of his *American Ornithology,* which drew on Audubon's field observations of wild turkeys. In his October 1, 1825, response Audubon announced his plans for going abroad: "I have . . . now concluded to leave the U. States sometime in spring for Europe. I shall first land in England and exhibit my drawings there; if not successful in London I shall go to the Continent, pass through Brussels & proceed to that capital where I fervently wish the great Napoleon was still existing, Paris." Bonaparte had frequently offered him letters of recommendation and he asked him now "please to forward me some." His work proceeded "as fast as it can [given his circumstances]. My courage is not the least abated and every new bird enlarges my collection."

He had killed seven anhingas on his last excursion to the area lakes, he told Bonaparte, intending to preserve and send along the skins, "but the weather was so hot that I could not bear the odor of their flesh and gave up skinning them." Anhingas, he added, were "passengers" in the Bayou Sarah neighborhood rather than residents but bred "abundantly within ten miles." In a postscript that reflected his increasing ornithological confidence he chided Alexander Wilson as well as William Bartram for claiming that wood ducks "never go in flocks." At that time on the nearby lakes, he assured Bonaparte, "the beautiful wood ducks are assembled in juvenile congregations and the gunners are busily engaged in killing them for the flavorful flesh of the young. . . . I have seen, and any man can . . . flocks of thousands clearing a lake of its fish by wading along the margins, and so innocent are they that a man might load a horse with them in a few hours."

With spring 1826 now determined as his season of departure, he put aside correspondence, as he wrote Bonaparte later, "to absent myself and to ransack all the lakes and swamps within my reach to enlarge my collection." Later in October he sent Bonaparte the preserved skins of male and female wood ibises, as well as "the skin of a young white ibis and a species of heron perhaps scarce with you." He had intended to forward specimens of anhinga and red ibis as well "but the appearance of winter had already drove those species far from us." At the house of a French planter named Martin LeNoir he had observed anhingas raised from the nest "walking over the floor of his house" and feeding on Indian corn as well as shrimp.

Busy as he was building his collection, Audubon still necessarily made time to raise money. In November 1825 and perhaps through the winter as well he revived his Woodville dancing school, traveling there now twice a week rather than staying overnight. However late at night he returned, he reminded Lucy flirtatiously in a journal entry the following year, returning meant that "twice each week I could kiss thee and gaze on thy features with delight."

Before the end of the year Audubon drew three blue jays stealing eggs. His description of the jays' behavior abandoned scientific reserve to veer playfully toward La Fontaine, but touching the fabulous then moved Audubon to more serious allegories that anticipate the rich language of Melville and Thoreau:

Reader, [here are] represented three individuals of this beautiful species,—rogues though they be, and thieves, as I would call them, were it fit for me to pass judgment on their actions. See how each is enjoying the fruits of his knavery, sucking the egg which he has pilfered from the nest of some innocent dove or harmless partridge! Who could imagine that a form so graceful, arrayed by nature in a garb so resplendent, should harbor so much mischief;—that selfishness, duplicity, and malice should form the moral accompaniments of so much physical perfection! Yet so it is, and how like beings of a much higher order are these gay deceivers! Aye, I could write you a whole chapter on this subject, were not my task of a different nature. . . .

The Blue Jay is truly omnivorous, feeding indiscriminately on all sorts of flesh, seeds, and insects. He is more tyrannical than brave, and, like most boasters, domineers over the feeble, dreads the strong, and flies even from his equals. In many cases in fact, he is a downright coward. The Cardinal Grosbeak will challenge him, and beat him off the ground. The Red Thrush, the Mocking Bird, and many others, although inferior in strength, never allow him to approach them with impunity; and the Jay, to be even with them, creeps silently in their absence, and devours their eggs and young whenever he finds an opportunity. I have seen one go its rounds from one nest to an other every day, and suck the newly laid eggs of the different birds in the neighborhood, with as much regularity and composure as a physician would call on his patients. I have also witnessed the sad disappointment it experienced, when, on returning to its own home, it found its mate in the jaws of a snake, the nest upset, and the eggs all gone. I have thought more than once on such occasions that, like all great culprits, when brought to a sense of their enormities, it evinced a strong feeling of remorse.

Not by accident would Henry David Thoreau begin his first important essay to appear in print, in 1842, with a tribute to Audubon's "reminiscences of luxuriant nature."

Sometime that winter, after he finally received Charles Bonaparte's first volume, Audubon collected the wild turkey cock that would become his most famous drawing; three of Lucy's students as well as Martha Pope remembered seeing him drawing it. Robert Dow Percy, one of Jane Percy's sons, claimed to have accompanied Audubon on the hunt through a Mississippi canebrake when he called it into range with a turkey call made from a wing bone. Percy remembered later that the cock "weighed twenty-eight pounds. Audubon pinned it up beside the wall to sketch and he spent several days sketching it. The damned fellow kept it pinned up there till it rotted and stunk—I hated to lose so much good eating." Twenty-eight pounds is an exaggeration; wild turkey cocks exceeding twenty-two pounds are unknown, but the one Audubon collected was a superbly healthy specimen. Martha Pope remembered him comparing his drawing with the illustration in Bonaparte's volume; she said he "maintained that the superiority of his painting consisted in the shading of the legs, which Bonaparte had painted all one color, while those of his were shaded in different hues."

FINALLY IN APRIL Audubon was ready to leave. He said goodbye to Lucy and John Woodhouse at Beech Woods on Tuesday, April 25, 1826, the day before his forty-first birthday, loaded his tin-lined wooden portfolios heavy with more than three hundred drawings, rode fifteen miles to St. Francisville, stayed overnight with Nat and Martha Pope and boarded the *Red River* for New Orleans at four p.m. on Wednesday. Thursday afternoon in New Orleans he "visited many vessels for my passage and concluded to go in the ship *Delos* of Kennebunk, Captain Joseph Hatch, bound for Liverpool, loaded with cotton entirely."

He checked into a boardinghouse to await the *Delos*'s sailing. New Orleans was as disappointing as ever. "I saw my old and friendly acquaintances the family Pamar, but the whole time . . . was heavy and dull. A few gentlemen called to see my drawings. I generally walked from morning until dusk, my hands behind me, paying but very partial attention to all I saw. New Orleans to a man who does not trade in dollars or any other such stuff is a miserable spot." When he learned that the *Delos* would not be ready for several weeks he caught the *Red River* back to Bayou Sarah. After "a dark ride through the magnolia

woods" he reached the Percy plantation at three o'clock in the morning, "but the moments spent afterwards full repaid me"—he and Lucy made love. In the next days they attended a wedding of one of Lucy's pupils. When it was time to return to New Orleans they doubled up on Lucy's horse to ride together to breakfast at Augustin Bourgeat's plantation. Audubon's hunting companion lent him a horse to ride to Bayou Sarah and he escorted Lucy to within two miles of Beech Woods, where he "gave and received the farewell kiss to my beloved wife and her to me." Knowing painfully that they would not see each other again for years, they parted.

In New Orleans Audubon called on Louisiana Governor Henry S. Johnson (Thomas Robertson had resigned in 1824 to become a federal judge) and collected a letter of introduction sealed with the state seal, "obviating the necessity of taking a passport." His wealthy and influential acquaintance Vincent Nolte, whose expensive horse he had raced and with whom he had traveled by flatboat, gave him a letter of introduction to Richard Rathbone, the head of a family of wealthy Liverpool Quakers that had been the first in England to import American baled cotton; Nolte had recently helped the Rathbones avoid serious financial losses. His letter said Audubon's "collection of upwards of 400 drawings . . . far surpasses anything of the kind I have yet seen" and "conveys a far better idea of American birds than all the stuffed birds of all the museums put together." It also recommended Audubon to Rathbone's "hospitable attentions," importantly affirming "the respectability of his life and of his family connections" and predicting that Rathbone would "derive much gratification from his conversation." Audubon carried letters from DeWitt Clinton, Henry Clay and others as well.

He wrote two letters to Lucy and a letter to Victor in Shippingport, making his older son a present of his pencil case and "a handsome knife." He wrote Charles Bonaparte on May 16 announcing that he would sail the next day for Europe and sending the young prince a large box of bird skins. His baggage went on board the *Delos* on May 17. Audubon followed, stopping to pay a dollar for a baby alligator. He had £340 sterling in his pocketbook, $1,500, the equivalent of about $27,000 today. Most of it was money he had earned teaching dancing. Lucy had contributed £112 to buy her a watch and a piano. The money she had saved from her teaching would support her and John Woodhouse, then thirteen years old, while her husband was abroad. She had also undertaken to pay his modest local debts from her savings.

The *Delos* was fully loaded with 924 bales of cotton. The steamboat *Hercules* came alongside her at seven in the evening, harnessed her with lines and began towing her downriver. Ten hours later, paddlewheels churning through the

muddy chop of the South Pass, the *Hercules* put the ship to sea. "We calculated our day of departure from the 18th May [1826] at 12 o'clock," Audubon noted in his journal. James Fenimore Cooper's *The Last of the Mohicans* had been published in London in April and was blooming to a nationwide fad. Now Natty Bumppo was sailing for England armed with a spectacular portfolio of American birds—concentrated essence of wilderness.

AUDUBON AT SEA

W ITHIN MINUTES OF PASSING BEYOND the old Fort de la Belize
into the Gulf of Mexico Audubon was seasick. On this voyage, unlike
previous ones, his nausea would subside in a few days and only reappear when
he ventured into the *Delos*'s skiff to retrieve birds shot from the deck or visit
passing ships.

After the *Hercules* turned and paddled back up the South Pass the *Delos* lay
becalmed under the hot Gulf sun. "There was not a breath of wind," Audubon
wrote, "the waters were smoother than the prairies of the Opelousas, and
notwithstanding our great display of canvas, we lay like a dead whale floating
at the mercy of the currents. The weather was uncommonly fair and the heat
excessive; and in this helpless state we continued for many days." They drifted
for a week before they lost sight of the Belize. "The sailors whistled for wind
and raised their hands in all directions, anxious as they were to feel some
motion in the air; but all to no purpose; it was a dead calm."

Fortunately the Gulf around them was alive with dolphins—not the mam-
mal but the fish, dorado, the flashing narrow- and deep-bodied predator of fly-
ing fish and tuna, with a dark-blue upper fin raking its back from its forehead
nearly to its tail—dorado "glancing like burnished gold through the day and
gleaming like meteors by night." The crew caught them with hooks baited with
strips of shark or gigged them with five-pronged forks they called grains, the
plural of the old dialect term for a tine. Audubon caught his share, studied the
fish as he would have studied a bird and filled a full page of his journal with a
pencil sketch of one he caught on May 28 that was more than four feet long.

They were still becalmed on June 4, seventeen days out, but they had drifted
six hundred miles eastward by then past Florida and "a few miles south of the
line"—south of the Tropic of Cancer, which almost grazes the north coast of
Cuba. The location was significant for Audubon, who noted he was south of

The dolphin (dorado) Audubon drew aboard the Delos *on May 28, 1826*

the line for "the second time in my life." The first time had been his birth, infancy and early childhood on what was now Haiti and had been Saint Domingue:

> I feel rather an inclination to write. I am thinking daily and I might say almost constantly of my wife, of my family and my hopes, all in the breeze. . . . My time goes on dully—lying on the deck on my mattress which is a hard bale of cotton, having no one scarcely to talk to and only a few books and but indifferent fare to engage me even to raise from that situation to feed myself. But to the purpose—I am really south of the line. What ideas it conveys to me, of my birth, of the expectations of my younger days, &c., &c.

He wrote more, but his descendants, determined to keep the secret of his illegitimacy, obliterated the lines from his journal. The next page was the one on which he drew his dorado, and on the next, vexed with weeks of windless drifting, he advised his sons never to sail "from New Orleans for Europe in June, July or August, as, if you do, you may calculate on delays incalculable in the Gulf."

The little alligator Audubon had bought as he was leaving New Orleans had died on the ninth day out; he had not understood that it could not tolerate salt

water. Three hundred miles from shore a rice bunting had flown aboard, panting and exhausted. Audubon had seen sooty terns, noddy terns and a frigate pelican (frigate bird) and had collected a great-footed hawk (peregrine falcon). He slept on deck in a hammock. He let his beard grow and acquired a tan and discovered he enjoyed bathing in seawater, which he did every night before climbing into his hammock to sleep.

And then finally on June 23 a breeze blew them into the Atlantic:

> The land birds have left us and I—I leave my beloved America, my wife, children and acquaintances. The purpose of this voyage is to visit not only England but all Europe, with the intention of publishing my work of the Birds of America. If not sadly disappointed, my return to these happy shores will be the brightest birthday I shall have ever enjoyed: Oh America, Wife, Children and acquaintances, Farewell!

Making remarkable time, the *Delos* on July 4 passed near the Grand Banks off Newfoundland in thick fog. Audubon felt the lack of celebration on that fiftieth-anniversary Independence Day after the boisterous revels he remembered from Kentucky and Philadelphia. "The day passed as I conceive one might be spent by a general who has lost a great advantage over an enemy. . . . I felt sorrowful in the extreme, as if America had lost much this day." He could not know it then, but America *had* lost much: Jefferson had died at Monticello and John Adams in Quincy.

A sense of the distance he had traveled and the distance he had yet to go before he could think of returning slowly penetrated through the tedium of the long voyage and moved and alarmed him:

> My leaving the United States had for some time the appearance and feelings of a dream. I could scarce make up my mind fixedly on the subject. I thought continually that I still saw my beloved friend [Lucy] and my dear children. I still believed, when every morning I awaked, that the land of America was beneath me, that I would in a moment throw myself into her shady woods and watch for and listen to the voice of her many lovely warblers. But now that I have positively been at sea since *fifty-one days,* tossing to and fro, without the sight nor the touch of those objects so dear to me, I feel fully convinced, and look forward with anxiety that I do not believe ever [formerly] ruffled my mind. When I calculate that not less than four months (a third of a year) must elapse before my friend and her children can receive any tidings of my arrival on the distant shores that now soon will divide us—when I

Captain Joseph Hatch and crew filling time making powder horns on the deck of the Delos

think that many more months . . . must run out, and that the time of my returning to my country and friends is yet an unfolded and unknown event—my body and face feel a sudden glow of apprehension that I can neither describe nor represent. I know only the acuteness of the feeling that acts through my whole frame like an electric shock. I immediately feel chilled, and suddenly throw my body on my mattress and cast my eyes towards the azure canopy of heaven, scarce able to hold the tears from flowing.

The day lengthened as they moved northeastward toward the British Isles. The sky began to lighten at two in the morning, and at nine at night he could still read large print. They had a stiff breeze now that pushed them at nine knots. Breaking the waves made the ship shudder and gave him "violent headaches far more distressful than any seasickness feeling ever experienced."

To ease the headaches he found "food highly seasoned and spirituous liquors of great benefit." He was no drunkard, but he was easily intoxicated. A young fellow passenger whom he knew from St. Francisville, John Swift, bound for Dublin to join his parents on a tour, had brought aboard no less than eleven gallons of whiskey and shared it freely. Under its influence Audubon's handwriting deteriorated and his subject matter coarsened comically as he tried to describe his accommodations in minutely drunken detail:

> The mate's cabin [is] still further on my right. Several mice are running about the floor, picking the scanty fare. The cockroaches begin to issue from their daily retreat. My bottom is sore from sitting on the mate's hard chest. I look at the sea through two windows, and shut this book. Why? Because the last object on which my eyes rested was the captain's hammock, swinging so immediately over my bunk that it reminded me most painfully of the many hurried times I have been obliged to put my nostrils between my thumb and index, for safekeeping from winds neither from the southwest nor northwest but from——. Ah my dears, what strange incidents happen at sea.

A whale sighting interrupted this Aeolian reverie—"A whale! A whale! Run, Mr. Audubon, there's a whale close alongside." Audubon dropped his pen and his journal, the mice scampered away in fright, he ran up on deck "and lo! there rolled most majestically the wonder of the oceans. It was of immense magnitude. Its dark auburn body fully overgrew the vessel in size. One might have thought it was the God of the Seas beckoning us to the shores of Europe. I saw it and therefore believed its existence."

By mid-July he was beyond boredom. He might have taken instruction from his windy, energetic captain, whom he had watched tailoring pants, plaiting straw, bending fishhooks from common needles, scraping powder horns, planing a piece of beechwood that Audubon recognized to have been salvaged from flatboat lumber "that probably grew on the banks of the Ohio." His time was "really dull, not a book on board that I have not read twice since here—I mean, on board this ship—and, I believe, twice before. . . . I move from the deck here, from here to the deck; lay there a little, and down here longer. It is all alike, dull, uncomfortable. Nay, was it uncomfortable only, I do not believe I would complain, but it is all idle time I spend here—all dreary, idle time: the most miserable, pitiful, sinful way of spending even one moment." On land he was never idle.

Then the sun was shining clear over Ireland and he felt apprehension, as he appealed to Lucy, of "the immense ocean that divides us and the time that must

be spent far from thee." He was brooding his portfolio as birds brood their eggs: "The bird seized when sitting on her nest could not be more terrified. I look up—yes, for mercy—I look up, and yet how much I dread it!" Passing up St. George's Channel between Ireland and Wales on July 20, 1826, he was surprised at the nakedness of the shore lands "with scarce a patch of timber to be seen" compared with America. "Our fine forests of pine, of oak, of heavy walnut trees, of magnificent magnolias, of hickory, or ash, or sugar trees, are represented here by a diminutive growth named *furze*." He chided himself: "Come, come, no criticism—I have not seen the country." England burned coal because it had exhausted its forests.

Later that Thursday he came alive with the excitement of his adventure:

> Fifty-six vessels with spreading sails are in view on our lee, and mountain after mountain fading into the horizon are on our right. Lucy, I have now cast my eyes on the land of England. From the bow it is plainly distinguishable. My dull thoughts have all abandoned me; my heart is elated. I see the dear country that gave thee birth and I *love it,* because I love thee!!!!

And finally that evening after an interminable sixty-four-day crossing they dropped anchor in the broad Mersey River opposite Liverpool, which was glowing with gas lighting. The next day, July 21, 1826, he would go ashore to claim his future.

Part Three

THE BIRDS

OF

AMERICA

LIVERPOOL

JOHN JAMES AUDUBON STEPPED FROM the sailing ship *Delos* onto the substantial Liverpool docks on a rainy Friday morning. He thought the gray stone city looked "agreeable" until the coal smoke that fouled it made his eyes smart and filled his lungs, "so oppressive . . . that I could scarcely breathe." He and his young cabin mate John Swift stopped for breakfast at a dockside inn and then walked together to the Exchange Building near the quay.

After Lucy Audubon's father died in 1821, her younger sister Ann had married Alexander Gordon, the English cotton factor who had helped Audubon establish himself in New Orleans. Subsequently the Gordons had moved to Liverpool, where Gordon was a partner of the firm Gordon & Forstall, with offices in the Exchange. Audubon carried letters for him from New Orleans. When Gordon saw Audubon in loose provincial clothes with his hair down to his shoulders, tanned like a sailor, he pretended not to recognize him until Audubon identified himself. "I was coldly received," Audubon wrote for Lucy's eyes in his journal. ". . . I was asked when I took my leave . . . if I would not call there again!!!!" Gordon offered his sister-in-law's husband neither card nor invitation to visit the Gordons at home. "It is severe, but it must be endured. Yet what have I done? Ah, that is no riddle, my friend, *I have grown poor.*"

It was not a propitious beginning. Audubon was further mortified when he was unable to redeem one of the bills of exchange he carried because authorization to pay it had not yet arrived from New Orleans. The two encounters flooded him with anxiety:

> I knew not an individual in the country; and although I was the bearer of letters from American friends and statesmen of great eminence, my situation appeared precarious in the extreme. I imagined that every individual

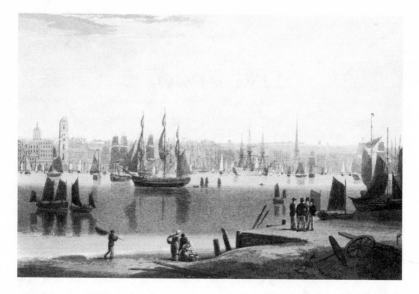

whom I was about to meet might be possessed of talents superior to those of any on our side of the Atlantic! Indeed, as for the first time I walked on the streets of Liverpool, my heart nearly failed me, for not a glance of sympathy did I meet in my wanderings.

His solution that first Friday was to go shopping. At a watchmaker's shop where the looks were sympathetic (since he was potentially a paying customer) he examined several gold watches. "No better watch was made in England," the watchmaker told him. Lucy had given him money to buy one for her. He planned to buy one for himself as well to signal that he was a man of substance despite his provincial clothes and unfashionably long hair. Sometime that day he and Swift also moved their possessions from the *Delos* to the Commercial Inn, near the Exchange, where they were "well fed and well attended."

Saturday Audubon tackled Customs in the company of one of Alexander Gordon's clerks. On this second encounter Gordon had reluctantly given the artist his card, thus authorizing him to call on his sister-in-law Ann "if I feel inclined or think it proper." But sending a mere clerk with Audubon to Customs denied him the courtesy the customs officers would have extended to a Liverpool businessman; the several hundred watercolor drawings of American birds in his two heavy portfolios were assessed 2 pence each when fine art would have been admitted free.

And then on Monday the doors of Liverpool society began to open. Audubon had delivered his letter from Vincent Nolte to Richard Rathbone's offices on the Friday he arrived but had not found the Liverpool businessman in. Saturday, to his surprise and relief, he had received a note from Rathbone inviting him to dine on Wednesday with William Roscoe, a distinguished Liverpool poet, attorney, banker, biographer and editor. Monday Audubon rose uncharacteristically late after an evening of drinking port with John Swift, shaved, dressed, "bustled about briskly," took up his hat, gloves and the sword cane he carried for protection and strode off to call on Rathbone at home. In the streets he cut a romantic figure, as he was well aware. "My locks flew freely from under my hat, and every lady that I met looked at them and then at me until—she could see no more." Not finding Rathbone at home, Audubon "almost ran to his countinghouse at the salt dock, down on Duke Street. . . . My name was taken to the special room of Mr. Rathbone, and in a moment I was met by one who acted towards me *as a brother ought to do!* How truly kind and really polite. *He* did not give *his card* to poor Audubon. He gave me the most polite invitation to call at *his house* at 2."

There he dined with Rathbone, a wealthy and prominent cotton merchant a decade younger than Audubon, his twenty-eight-year-old wife and their children. After dinner the Rathbones walked with their guest to an exhibition to see a panorama painting of Edinburgh's Holyrood Chapel. Back at the Exchange Rathbone introduced Audubon to the American consul, James Maury, and gave him the standard tour, ending up high in the building's dome looking over Liverpool and beyond: "I could see the Irish channel, a steamboat issuing from the river Dee in Wales, the Mersey filling the interior with the world's produce and the heavens bounding the scene divinely." The extended Rathbone family—Richard, his older brother William Rathbone IV, his widowed mother, his younger sister Hannah Mary—moved cotton and other goods internationally in their large commercial fleet of sailing ships. They were literate, philanthropic Quaker social reformers and abolitionists despite having built their fortune on cotton grown by slaves; William would become mayor of Liverpool in 1837.

Wednesday the doors opened wider. Up early, Audubon drew his shipmate John Swift's portrait in black chalk, his first drawing in England. After breakfast he went off to Roskell & Son, the watchmaker, and with extravagant optimism spent £120—about $9,400 today, more than a third of his stake—on two gold watches, watch chains and seals, Lucy's "as good and as handsomely trimmed as any duchess's watch in the three kingdoms," his equally fine. When he returned to the Commercial Inn he found an invitation from Richard

Rathbone, ordered up a hackney coach, loaded in his larger portfolio and rushed off to the Rathbone house in Duke Street. A servant there reported that the Rathbones had left for Greenbank, Rathbone's mother's suburban estate some three miles southeast of the Liverpool center. Before he could go on they returned to pick him up: they had just left and had seen Audubon's hackney passing.

"The country gradually opened to our view," Audubon wrote happily. They "passed beneath a cool arbor of English trees" to "a sweet delectable mansion." The mansion was English Gothic in stone and brick, softened with evergreens, one wall a row of pointed arches, almost Moorish in appearance, on a bank above a brook before a broad, sloping lawn where a few sheep grazed. Introduced to Rathbone's mother and her guests, Audubon was seized with shyness at first, "but so much truth was about me that I became calmer." In the entry-way he remarked "a beautiful collection of the birds of England, well prepared"—a display of stuffed birds—and overheard Rathbone say sotto voce to one of the guests that Audubon was "simple intelligent." Someone less in need at that moment might have been offended; Audubon instead "was struck with the power of the truth. I was quite sure that what was then said was really [Rathbone's] thoughts, and as I know myself to be positively very *simple* and yet somewhat intelligent, I was delighted; and thought of Richard Rathbone from that moment as I would of an excellent kind brother." He was panting like a wounded bird when he opened his portfolio; then he breathed easier: "Ah Lucy, these *friends* praised my Birds, and I felt the praise."

The glow of the Rathbones' reception still warmed him when he awoke the next morning. Then anxiety surged and filled him with dread: "My heart swelled and involuntarily bursted with acute sensations of unknown sorrows accumulating so mistily fast before my imagination that I could not refrain from shedding an abundance of tears. I felt as if some great misfortune was neared. I felt [he addressed Lucy in his journal] how much I need thee!" He went out that Wednesday to call on the American consul. He said goodbye to John Swift, who was leaving for Dublin. He "called in vain at the Post Office for news from America," returned to his room and again broke down, then pulled himself together. Richard Rathbone called to introduce his brother William, who invited Audubon to dine with him on Friday.

At six-thirty a hackney delivered Audubon to the Richard Rathbones' house. He panicked once more when the coachman rang the bell and he was delivered upstairs to a sitting room full of guests. Yet he noticed that what he called his "*observatory nerves*"—his quick perception, honed by studying birds—never failed him. "I remarked immediately . . . that no one shook hands unless they

thought fit. This pleased me." If he felt himself to be a hapless bumpkin at such times, the hawk in him was keen. An anonymous observer, looking back a decade later to the first weeks after Audubon's arrival in England, identified several components of his charismatic presence:

> The man . . . was not a man to be seen and forgotten, or passed on the pavement without glances of surprise and scrutiny. The tall and somewhat stooping form, the clothes not made by a West End but a Far West tailor, the steady, rapid, springing step, the long hair, the aquiline features, and the glowing angry eyes—the expression of a handsome man conscious of ceasing to be young, and an air and manner which told you that whoever you might be he was John Audubon—will never be forgotten by anyone who knew or saw him.

William Roscoe came into the Rathbones' parlor, the Liverpool literary man, "tall, with a good eye under a good eyebrow, all mildness. He shook hands with me." Then seventy-three years old, Roscoe had endured a failure of his banking business ten years previously much like Audubon's merchant failure in Henderson; among other losses, Roscoe's extensive and cherished private library had been sold at public auction. The Rathbones had rescued him and helped him back on his feet. Audubon probably knew of these troubles, since Washington Irving had written about Roscoe in *The Sketch-Book of Geof-frey Crayon, Gent.*, published in 1819. "He was advanced in life," Irving had written of meeting him just as Audubon was meeting him now, "tall, and of a form that might once have been commanding, but it was a little bowed by time—perhaps by care. He had a noble Roman style of countenance; a head that would have pleased a painter; and though some slight furrows on his brow shewed that wasting through had been busy there, yet his eye still beamed with the fire of a poetic soul." Roscoe had edited Robert Burns in 1822 and Alexander Pope in ten volumes in 1824. He took Audubon's arm and they went in to dinner together with the American consul, a young Swiss entomologist engaged to a Rathbone relative, a London banker and other guests.

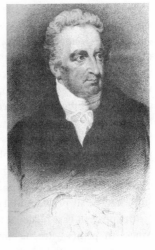

William Roscoe

After dinner the lights were arranged and Audubon's portfolio opened. "The company is all expectation. . . . Mr. Roscoe, seeing my drawings, does not give me any hopes, but neither can he destroy a hopeful feeling." In his journal Audubon reminded Lucy of a saying of hers: " 'Expect not too much and thou shalt not be disappointed.' Yes, it is better so." But as he turned the tissue paper that separated and protected the hard-won drawings and the vivid, passionate birds arose to be inspected scene by scene, "Mr. Roscoe is—yes, I believe— rather surprised. I sincerely hope so." At the end of the evening Roscoe made it clear that Audubon had passed muster by inviting the artist to visit him the next day at his house.

There Audubon found Roscoe drawing an illustration for a book he was writing about monandrous plants—plants with single stamens, a Linnaean class that includes many orchids. Since it was too early for dinner, Roscoe drove his guest to the Liverpool Botanic Garden in a pony cart, calling it his "little car." It surprised Audubon that a pony could pull them both at a trot "with apparent ease." They toured the Botanic Garden hothouses filled with American plants—Roscoe himself had founded the institution in 1803— returned to Roscoe's house in a good neighborhood with a view of the Mersey

and dined with his several daughters. (On a later occasion Audubon would meet his seven sons.)

After dinner Roscoe read Audubon's packet of letters of introduction and told the American that he would try to introduce him to Edward, Lord Stanley, a magnificent natural history collector and patron who would become the thirteenth Earl of Derby upon his father's death in 1834. "Ah yes, Lucy, this is nearing the 'Equator' fast. In a word, he assured me that nothing would be left untried to meet my wishes." As if confirming Roscoe's commitment, when Audubon returned to his inn he found that the Secretary of the Liverpool Royal Institution, F. J. Martin, had called and left a note for "Mr. Ambro" and would call again the next day. Audubon forgave him the misnaming but quipped that if the man had added an "i" to make it Ambrio—embryo—it would have been "*almost correct* and very much more appropriate." Emerging into the Liverpool limelight had become a rebirth.

The Royal Institution secretary called on Friday morning to announce that Audubon would exhibit his drawings to the members there for two hours a day on the first three days of the following week. Going out, Audubon passed Alexander Gordon in the street and finally won permission to call on his sister-in-law. He dined with the William Rathbones, another success. Saturday after he visited the Royal Institution to check out the lighting he walked to the house where the Gordons lived and "kissed thy sister, Ann . . . I thought more than she wished; at all events *she* did not kiss me." Ann warmed to him a little as they talked and "was *rather* surprised that I should have been so well treated by Messrs. Rathbone [and] Roscoe." With the news of his successful entry into Liverpool society the Gordons finally dared to invite him to dine. (When he joined them, the following evening, Gordon pumped him about the Bonapartes, and Ann "recommended my hair to be cut and a coat cut fashionably.")

A second letter from Vincent Nolte had gone to a Rathbone partner, Adam Hodgson. Hodgson called on Audubon that Saturday and asked him to dinner the following week. "He has written to Lord Stanley about me. He very kindly asked me if my time passed heavily, gave me a note of admittance for the Atheneum and told me that he would do all in his power for me."

Audubon had not failed to observe his surroundings as he ran these social gauntlets. The gaslight that illuminated Liverpool—the gas manufactured from coal—fascinated him. He had not seen gaslight in America, although Baltimore had begun installing gas street lighting in 1816 after Rembrandt Peale introduced it into the museum he operated there and impressed the city fathers with its value. Lafayette on his triumphal tour had marveled at the city

of Fredonia, New York, lighted with natural gas from the first well in America; he was astonished that gas had cooked his dinner. The new Liverpool market, Audubon noted, "a large, high and long building divided into five spacious avenues, each containing their specific commodities," was so well lighted with gas "that at 10 o'clock this evening I could plainly see the colors of the eyes of living pigeons in cages." Throughout the city the shops had a gaslight in each window "and many about the [showrooms]."

The population was less dense than he expected. "I have not been at all annoyed by the elbowings of the greater numbers that I still remember having seen in my youth in the largest cities of France." But the prostitutes made him shudder. He ended one night's journal entry advising Lucy that he would "not soil my paper with details of the last objects I saw." A few days later he reported at slightly greater length: "There are many orange women in this city. I will describe one of them as quickly as possible: They sell sweets during the day, and poison during the night." He was a man who admired women and he was long away from home, but he hardly sounds here like a husband merely reassuring his wife facilely of his fidelity: he was viscerally repelled by the "poison" of venereal disease—crippling and eventually lethal in those times—and perhaps by something more. In the first version of the autobiographical essay he had drafted for his sons when he floated down the Mississippi to New Orleans in autumn 1820, he had written of his father, Jean Audubon, "most men have faults, he had one that never left him until sobered by a long life, common to many individuals, but this was counterbalanced by many qualities." Lechery had been his father's fault; it had clouded Audubon's birth and complicated his life, and it seems to have scalded him.

Audubon arranged a selection of his drawings on display at the Royal Institution on Monday morning, the last day of July. The doors opened at noon "and the ladies flocked in. . . . 'La, that's beautiful,' again and again repeated, made me wish to be in the forests of America." A man walked up, asked if he had ever lived in New York, asked if he had married a "Miss Bakewell" and told him his lady "was very handsome"—small world. He exhibited again on Tuesday to a larger crowd and was introduced to the physician and naturalist Thomas Stewart Traill, a Royal Institution officer for whom he would eventually name a bird (Traill's flycatcher—willow flycatcher today). Traill and other officers proposed he use the room free after Wednesday to exhibit his collection and encouraged him to begin charging admission. He was concerned that paid admission would reduce his social status to "a mere *showman*" and require him to "give up the title of *J. J. Audubon, Naturalist*"; his "heart revolted at the thought . . . although I am poor enough, God knows." Wednesday he put

up more drawings to a total of 235 and the crowd surged again; even the Gordons came to see and be seen. On Thursday "persons of wealth arrived [all the way] from Manchester to view them"; in two hours that day more than four hundred people went through. "I was broke down bowing and scraping to all the new faces I was introduced to." Adam Hodgson, the Rathbone partner, invited him to dine on Saturday with Lord Stanley.

He walked out to Greenbank that Thursday evening to spend the night. People stared at him as he passed them at his quick five-mile-an-hour walk. "The Queen Bee," as he called the auburn-haired family matriarch, Mrs. William Rathbone III—"dark eyes sparkling with all the good sense a *man* can possess"—was becoming his champion. For the first time in his journal he also mentioned her attractive, dark-eyed, unmarried daughter by name: "Miss Hannah Mary Rathbone has just entered the salon and comes toward me with an open hand, and I press that hand with pleasure, I assure thee, yes the hospitable hand out to be pressed." At dinner the brothers Rathbone and Mrs. Rathbone's father "asked many questions respecting the religious inclinations and rites of the Indians"; they also "spoke a good deal about American trees." Audubon would continue to be surprised how little anyone in England or Scotland seemed to know about America; his knowledge and his novelty alike served him well.

Hannah Mary delivered him back to Liverpool in the morning in her carriage drawn by "two little Welsh ponies that two common men could take up on their backs." He was busy through the day and the evening, and then on Saturday afternoon the English aristocrat rode in to Hodgson's house on a hunter from his family's vast Knowsley estate inland seven miles due east of the Liverpool center, where he kept a menagerie that included gnus, elands, zebras and kangaroos, as well as more than a thousand living birds housed in a steam-heated aviary. "Here he comes," Audubon, somewhat overawed, wrote of this important encounter with the fifty-one-year-old Stanley—"tall, well formed, formed for activity, simply dressed, well dressed. 'Sir, I am glad to see you.' Believe me I was gladder of the two to hear Lord Stanley thus address poor Audubon." Continuing in a letter:

> He, Lucy, knelt down on the rich carpet to examine my style closely. This renowned scientific man received me as if [he were] a schoolmate, shook hands with me with the warmth of friendship, and wished me kindly to visit him often in Grosvenor Street, London. I dined with him and he spent five hours looking at my drawings, and said, "Mr. Audubon, I assure you this work of yours is unique, and deserves the patronage of the Crown."

The Queen Bee, Mrs. William Rathbone III

William Roscoe had to encourage Audubon twice at length to convince him to exhibit his drawings for money. "I never had any desire not to be remunerated," he addressed Lucy in his journal, "quite to the contrary, but I wished it done in a most honorable manner." Roscoe made it honorable by convening a Royal Institution committee that officially ordered it done, taking any onus upon itself. By early September 1826, when the exhibition closed, it had earned Audubon £100.

The Rathbones drew him closer as they came to know him better. Before long he was reading them entries from his journal that allowed them to feel the intensity of his hopes. Privately, as he wrote to Lucy on August 7, he was lonely and fragile; he longed to hold her in his arms:

It is now three long months since I pressed thy form to my bosom. It is now three long months since thy voice vibrated in my ear with sound that none but a wife can utter. Absence from thee, my Lucy, is painful, believe me, and was I not living in hope to be approaching the long wished for moment of being at last received in the learned world, and of being also likely to be remunerated for my labors, I could not stand it much longer. No really, Lucy, I could not. I am fonder of thee than ever in my life. The reason is simply this, that I hope shortly to gain the full cup of thy esteem and affection. God bless thee.

Separated almost three months, he had not yet heard from her, and it frightened him; she lived in a place where epidemic fevers scythed lives away. Midway through August, returning to his room from the latest of many dinners where he was asked to produce turkey calls, owl hoots and Indian war cries and sitting down to write in his journal, he had a premonition of her in grave clothes: "My ideas flew suddenly to America so forcibly that I saw thee, dearest friend!!—ah, yes, saw thee covered with such an attire as completely destroyed all my powers. The terror that ran through my blood was chilling, and I was like stupefied for a full hour. . . . I undressed slowly, mournfully, and bedewed my pillow with bitterest tears." He connected the premonition to his premonition at sea on Independence Day that America had lost something, giving it fearful weight because he had read since then that Jefferson and Adams had died that day. He begged her to write him, "or *I will not be able to write at all.*"

His "shameful bashfulness" inhibited him from visiting Greenbank for more than a week. The Rathbones wondered what had become of him and welcomed him once he arrived. In his vulnerability he was drawn to Hannah Mary, the Queen Bee's dark-eyed daughter, a quietly thoughtful young woman, and evidently she to him. She walked with him from Greenbank to William Roscoe's house after dinner on August 14. They walked a family dog (acquired for them in Kamchatka, so far-flung was the Rathbone shipping enterprise) after dinner again at Greenbank the following evening, all the way down to the Mersey and back. Audubon was shocked by signs along the way forbidding trespass—crossing other people's land had been a cherished and legal right in frontier Kentucky—shocked as well by beggars begging not for money but for bread. "England is now rich with poverty," he wrote Lucy, "gaping, aghast, every way you may look." Hannah Mary presented him with a volume of William Roscoe's poems. He drew a Byronic black-chalk profile of himself as a souvenir for her, his face fuller than it had been in his 1823 Beech Woods self-

portrait, his expression intent, his long hair flowing onto the collar of his coat, and inscribed it "Audubon at Green Bank / *Almost* Happy!!"

He drew a robin for her—she had asked him to spare a pet robin when he shot birds on the Greenbank grounds—and wrote ambiguously on the back of the drawing that his "greatest wish" was "to have affixed on the face of this drawing my real thoughts of the amiable Lady for whom I made it . . . but an injunction from Hannah Rathbone against that wish of my Heart has put an end to it—and now I am forced to think only of her benevolence! of her filial love! of her genial affections." How intimate they became is indeterminable. Hannah Mary, wealthy and marriageable (she would marry a physician cousin in 1831), would seem to have demarcated the limits of their intimacy carefully, and Audubon to have respected them—however reluctantly. He was lonely, but he was not foolish; at forty-one, his failures nipping at his heels, he was focused on achievement, which offending the Rathbones could foreclose.

His need, emotional and physical, fed his impatience to see Lucy even as the quality and originality of the art he was exhibiting made him a celebrity. When he wrote his wife on September 6 he seemed to believe she had chosen not to communicate even though he had heard from no one else either:

> I have not had a single word from thee yet, or any one person from America. I beg thee will write. . . . When thee writes to me speak plainly I pray thee about thy wishes for the future—if thee wish [to] remain in America or come to visit this industrial garden Europe. Should thee prefer removing to New York only and board in an agreeable family I could easily make thee remittance of all [the income] I will gather and know that *thou wouldst be prudent.* The difference of communication is immense between New York and New Orleans. We could hear of each other every week after the correspondence would be established. Speak freely to [me] and depend on it, my being flattered here about my talents will not put a stop to my exertions; to the contrary I will paint more and better than ever.

His celebrity delighted and amused him; when he wrote Lucy about it he invoked Lafayette's triumphal tour for an analogy: "If I was not dreading to become proud, I would say that I am, in Liverpool, a shadow of Lafayette and his welcome in America." It seemed, he wrote Victor, "that I am considered unrivaled in the art of drawing even by the most learned of this country. The newspapers have given so many flattering accounts of my productions and of my being a superior ornithologist that I dare no longer look into any of them." More soberly he told Lucy, "I have been received here in a manner not to be

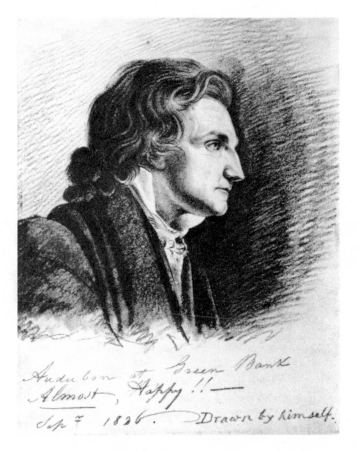

Audubon at Green Bank. Almost, Happy!! — Sep 7 1826. Drawn by himself.

expected during my highest enthusiastic hopes. I am now acquainted—I will say cherished—by the most prominent persons of distinction in and near Liverpool. . . . I feel elevated from my painful former situation, and no longer have about me that dread felt in the company of some of those ostentatious persons with whom I have been obliged . . . to live."

He hammered the facts of his success like nails into an August letter to one of those ostentatious persons, his brother-in-law Nicholas Berthoud, adding in a postscript a list of the famous people to whom his new Liverpool friends had given him letters of introduction:

As you may wish to know whom I am likely to become acquainted with shortly, I will say: the Baron von Humboldt, Sir Walter Scott, Sir Thomas

One of Audubon's Otter Caught in a Trap *potboilers*

Lawrence [the English portraitist], Sir Humphry Davy [the chemist, president of the Royal Society]; and, as the venerable Roscoe was pleased to say, "it would not be a wonder, Mr. Audubon, if our King might wish to take a peep at the *Birds of America;* and it would do no harm."

He also made Berthoud privy to his developing plans for publication. He expected, he wrote, to "proceed slowly [exhibiting his collection] towards and to London, Edinburgh, and most of the principal cities of . . . Europe, and proceed to Paris to show them there also. My wish is to publish them in London if possible, if not in Paris; and should I, through the stupendousness of the enterprise and publication of so large a work, be forced to abandon its being engraved, [then] I will follow a general round of remunerating exhibitions and take the proceeds home." Along the way, as he wrote Lucy, "I will keep myself at drawing & painting birds & quadrupeds for sale all the time, and I hope thus to do well."

When his exhibition at the Royal Institution came down, in early September, it was time to move on to Manchester. In twenty-three hours of nonstop

work in late August he had painted a four-by-five-foot oil copy of his wild turkey cock drawing for the Royal Institution. He had also painted his *Otter Caught in a Trap* in oil and presented it to Mrs. Richard Rathbone. She feigned delight at receiving it even though the wounded, bloody-mouthed animal horrified her. (She suffered the painting to hang in her house for twenty years before she could bear to commit the disloyalty of giving it away.) He paid his bills, received the gift of a penknife from Hannah Mary, astonished William Roscoe by eating some raw tomatoes (believed in that era to be poisonous uncooked), shared the expense of booking a private coach with the Swiss entomologist, made his final rounds with Hannah Mary in her carriage, loaded his portfolios and left with the Swiss for Manchester, thirty-eight miles east of Liverpool, late on the afternoon of September 10, 1826. They passed Knowsley and he compared the game, allowed to grow tame there within the walls, to the wild free game of the forests he knew in America. They crossed a canal where sails moved through the meadows and he thought of the Erie Canal, the wide falls of the Genesee River and then of Lucy. He would sweat blood to move her and his sons to his side, he swore to his journal: when finally they met again, he swore, they would never again live apart.

Eighteen

"I WILL PUBLISH THIS"

MANCHESTER MILLED COTTON. It was not interested in birds. Wherever he walked in its "small, dirty, narrow, crooked lanes" after his arrival on September 10, 1826, Audubon heard the whir of the jennies spinning cotton thread in the mills. After 1820 the mills had rapidly converted from water power to steam power and the city was even more fouled with coal smoke than Liverpool. Two letters from Lucy dated May 28 and June 3, sent up from London in mid-September, relieved Audubon's anxieties about her, but his exhibition failed to pay for itself, he found no welcoming family to buffer his nerves and he caught a bad cold. The one benefit he took from Manchester was a suggestion by the American consul, Samuel Brookes, that he consider opening a subscription register at his exhibitions so that people could sign up for the grand volumes of hand-colored engravings that he hoped to publish from his portfolios of drawings.

It was customary in Audubon's era to issue the plates for such books sequentially over a period of months or years in unbound sets called "numbers," each set paid for at the time of delivery, making the enterprise pay-as-you-go. When the whole issue was complete, the sets were bound into one or more volumes. Audubon thought about the consul's suggestion overnight and on September 23 "concluded . . . to have a book of subscriptions open to receive the names of all persons inclined to have the *best American illustrations of birds of that country ever yet transmitted to posterity.* And I will do so." At the end of a month devoted to dining with the Manchester gentry, drawing a pheasant, touring a cotton mill, replenishing his stock of linen shirts, missing Lucy and his boys and sneezing his way deeper into a new habit of taking snuff, Audubon left a hired doorkeeper to watch over his exhibition and retreated to Liverpool.

The Liverpool streets, in contrast to Manchester's, now looked "very wide,

Robert Havell, Jr., engraved this view of Edinburgh from the Castle.

very clean, very well lined with very handsome buildings." Audubon went to see William Roscoe at his house in Lodge Lane to discuss preparing a prospectus to enlighten potential subscribers. Roscoe told him "nothing could be done . . . without more knowledge of what [*The Birds of America*] could be brought out for" and referred him for guidance to Thomas Stewart Traill, the Liverpool Royal Institution officer. Traill had experience with publishing (he would later become the editor of the eighth edition of the *Encyclopædia Britannica*). He invited Audubon to breakfast to meet a successful London bookseller who was visiting Liverpool, Henry Bohn. "I was introduced to this mighty book warehouse man who has 200,000 volumes as a regular stock, and saw a handsome, well formed young gentleman, possessing all the ease and good manners requisite to render him fit for his situation." The confident thirty-year-old advised Audubon

To proceed at once to London and through my [letters of introduction] . . . to form the acquaintance of the principal naturalists of the day, and by their advices to see the best engraving, lithography, colorists, printers, paper merchants, &c., &c., and with a memorandum book note down on the spot all required to give a tolerably fair idea of what could be expected.

Then to go immediately to Paris [and do the same and compare the two prospects]. . . .

[*The Birds of America*] to be announced, during this lapse of time, to the

world, through the medium of those able and connected correspondents of scientific societies in some of the most-read periodical publications.

"Then, Mr. Audubon," he said, "issue a Prospectus, and bring forth a Number of your ornithology, and I think that you will succeed and do well."

Bohn had not yet seen Audubon's drawings, but that lack did not prevent him from insisting that engraving them at their full size would limit their sale to "large public institutions only and only a few noblemen"—amounting to no more than one hundred copies, Bohn estimated. People wanted art books to display on a table when they received company, he told Audubon; too large a book would shame their other books and crowd the table. Audubon's book should be no more than double the size of Alexander Wilson's. Follow his advice, Bohn concluded, and "Paris would take 100, London 250, Holland 100, Russia 100, America 450—in all, 1,000." He may not have been a publisher, but he talked like one.

Audubon fell for it, for a few days at least, even though he knew that the scale of his drawings was part of their originality and distinction and had insisted since the beginning that his birds must be engraved as they were drawn, at life size. "I will follow [Bohn's] plan and no other," he pledged in his journal, "until I find it impossible to proceed." He did nothing of the kind. He went on to Greenbank, where the Queen Bee invited him to sketch his wild turkey for a seal she proposed to have cut and cast on his behalf. He returned to Manchester at the beginning of October to check up on his exhibition, found his doorkeeper drunk and replaced him. He began wearing a new coat a tailor had made up to his order that was distinctively styled after a coat Lafayette had worn on his triumphal tour of America. And when Henry Bohn passed through Manchester he was able to show the bookseller his stunning drawings, whereupon Bohn "after examining [them] a long time . . . advised me to publish them full size of life, and that they must pay well. May God grant it." Bohn even offered to publish them himself if no publisher was prepared to take the risk—an offer Audubon rejected.

With the Queen Bee, Hannah Mary and several Rathbone children Audubon made a two-day carriage tour of the Peak District where Lucy had spent her childhood, visiting Matlock, Buxton and the market town of Bakewell, the presumed point of origination of Lucy's family. She was born in Burton-upon-Trent in Staffordshire, but the village of Crich, near Matlock, in Derbyshire, was her childhood home. Ann Bakewell Gordon had commemorated Crich in a verse she wrote as a child shortly after the Bakewells arrived in America in 1801:

I

I am a little girl come here
From Crich a town in Derbyshire,
 America to view;
I hope you will be good and kind,
For I have left many friends behind,
 to come and live with you.

II

We crossed the Ocean in a Ship
w[h]ere I was taken very sick
 and laid me down quite sad;
Mama & Lucy, Tom & Bess
Papa & Sarah & the rest
 were every one as bad.

III

But in a while we came about
and now I am grown pretty stout
 and hope you will like my song;
I have a great deal more [to say]
but will leave it till another day
 for fear you will think me long.

By Sunday, October 22, Audubon was preparing to leave Manchester for Edinburgh. He wrote Lucy that his time in Manchester had not been productive. Trying to advance his publishing project, he wrote Charles Bonaparte soliciting the prince's name and Joseph Bonaparte's to lead his list of subscribers. He had not yet found an engraver, but without following Bohn's expensive and time-consuming rigmarole of traveling to London and Paris to survey the available resources, he had thought through a program and a schedule: "I have some hopes," he told Bonaparte, "of forwarding my first Number (size of life, 20 engravings) in about four months." On the copy he made of this letter he noted to himself that he had sent "the same, nearly, to DeWitt Clinton, Henry Clay, General Andrew Jackson, General William Clark." The campaign to publish *The Birds of America* was begun.

Monday at five a.m. Audubon left Manchester by coach for Edinburgh, his drawings inside their portfolios buttoned up in slips of oiled silk and his heavy

trunk lashed to the roof. He paid £3.15 for his seat and noted regretfully that he was leaving Manchester "much poorer than when I first entered it." He was alone in the coach during the early part of the journey when he would have preferred company, but two passengers joined him at a way-stop where the horses were changed. They were silent until Audubon offered them a pinch of his Number 37 snuff; then "the chat begun and in less than ten minutes we all had traveled through America, part of India, crossed the ocean in New York packets, discussed the emancipation of slavery and the corn law, and reached the point of political starvation of the poor in England and Ireland."

At a village beyond Preston "it was discovered that a shocking smell existed on the top of the coach." The guard who rode there told them it was so foul "he could not keep his seat." Abruptly the guard rounded accusingly on Audubon:

> Judge of my dismay, Lucy, when I was asked if *my trunk* belonged to me, and if it did not contain a dead body intended for dissection at Edinburgh. I answered no, thou may be sure. The guard smiled as if quite sure my trunk contained such a thing, and told my companions that he would inform against me at Lancaster. I bore all this very well. I was innocent! I offered to open my trunk and would have certainly done so at Lancaster; but whilst we were proceeding, the guard came to the door and made an apology. [He] said the smell had been removed, and that it was positively *attached to the inside parts of the man's breeches* who was on the seat by him. This caused much laughter and many coarse jokes.

"My poor *chevelures* [i.e., his long hair] so went against me," Audubon added in a letter to an acquaintance about this incident, "that everyone said I was an eminent foreign physician." Buying corpses for dissection in anatomy classes was one reason Edinburgh's medical school had remained preeminent in Britain since Erasmus Darwin's time, supporting the Scottish capital's reputation as a center of science—one of the qualities that drew Audubon. Within a year the infamous William Burke and William Hare would begin smothering indigents to sell their bodies in Surgeon's Square.

The first day out the coach made 122 miles and stopped at Carlisle. It entered Scotland at nine-fifty the next morning. At lunch that day Audubon "for the first time in my life" drank Scotch whisky. He "found the taste extremely agreeable" but discovered it "was too powerful for my weak head" and "felt it for some time afterward." Told they were passing near Sir Walter Scott's grand Border Country estate, Abbotsford, he "raised from my seat and stretched my neck some inches [out the coach window] to see it, but it was all in vain and I

did not see it and who knows if ever I will." Scott was one of Audubon's heroes, a narrative poet who had virtually invented the historical novel. The coach from Manchester rolled into gaslit Edinburgh on Wednesday, October 25, 1826, at eleven o'clock at night and Audubon settled down to sleep in his hotel room with apprehension: "I thought so much of the multitude of learned men that abound in this place that I dreaded the delivering of my letters tomorrow."

In Edinburgh's New Town, at 2 George Street, which he called "the most beautiful street here," Audubon the next morning arranged with a Mrs. Dickie "for a fine bedroom and a fine, well-furnished setting-room" at a rent of one guinea per week—21 shillings, one more than a pound—which he considered a bargain. From his sitting room he could see steamboats plying the Firth of Forth. That Thursday he carried his letters all over the city—to the Circus, to the Royal Infirmary south past Edinburgh Castle in the Old Town, to Surgeon's Square and the university—to introduce himself to the learned men, but few took time to speak with him. The anatomist Robert Knox, who would be Burke and Hare's first unwitting customer, at least came out from his dissecting room, still gowned and with bloody hands. After he had washed up, Knox read Thomas Traill's letter of introduction and agreed to pay Audubon a visit to see his drawings.

A crucial contact was University of Edinburgh natural history professor Robert Jameson, a rugged mineralogist who had founded Edinburgh's Wernerian Natural History Society and the *Edinburgh New Philosophical Journal*. Jameson received Audubon more coolly than Knox had done, perhaps because Audubon had barely introduced himself before he importuned the professor for an introduction to Sir Walter Scott. Jameson told Audubon that Scott "was now quite a recluse, much engaged with a novel and the life of Napoleon, and that probably I would not see him. Not see Walter Scott, thought I—by Washington I shall, if I have to crawl on all fours for a mile!" Scott had reduced his public appearances because he had gone bankrupt at the beginning of the year and his wife Charlotte had died in May. Determined to write his way back to solvency, he had just returned from researching Napoleon in London and Paris. Jameson also told Audubon condescendingly "that it would be several days before he could pay me a visit, that his business was great and must be attended to." Audubon couldn't complain—so was *his* business, and so must it be—but the rebuff reaffirmed the benevolence of the Rathbones.

Edinburgh had formerly been a notoriously filthy town. Approaching visitors had smelled it from miles away. The North Loch below Edinburgh Castle had been the city's open cesspool as well as its water supply. Erasmus Darwin,

who attended medical school in Edinburgh in 1754, remembered that on dark nights he would pick up one of the rotting fish heads that people threw out, its phosphorus content fluorescing, to read the hour on his watch. Beginning in 1759 the North Loch had been drained and cleaned out and the New Town built to the north. After Audubon made his rounds on Thursday he spent the rest of the day falling in love with the new Edinburgh:

> I walked a good deal and admired this city very much, the great breadth of the streets, their good pavement and foot ways, the beautiful uniformity of the buildings, their natural grey coloring and wonderful cleanliness of the [whole] was felt perhaps more powerfully, coming direct from dirty Manchester. But the picturesque *tout ensemble* here is wonderful. A high castle here, another there, a bridge looking at a second city below, here a rugged mountain and there beautiful public grounds, monuments, the sea, the landscape around, all wonderfully managed indeed.

The city, Audubon noted another day after visiting the Old Town market, "is built mostly on the slopes of two long ranges of high broken hills." Where the North Loch had stunk, between the two ranges of the Old and New Towns, was now the "second city below."

Before he went to bed on Thursday he looked at his bird drawings "with pleasure and yet with a considerable degree of fear that they never would be published." He felt alone and longed for America and for Lucy. Dark thoughts rolled in like bad weather: "I feared thee sick, perhaps lost forever to me, and felt deathly sick [myself]." He went for a walk, which cleared away some of the gloom, but when he returned and looked at himself in the mirror he saw not only his own face "but such a powerful resemblance to that of my venerable father that I almost imagined it was him that I saw"—a recognition that he was no longer young. He wrote a little more, large thoughts about lost opportunities, then closed his journal with determination.

Friday Audubon made a breakthrough contact, with a printer and naturalist named Patrick Neill. "At first the gentleman . . . believed that the letter I handed him was an advertisement for insertion [in one of his publications]. But after having read it he shook hands cordially, offered me his services, and proved to me in a few words that he was a gentleman and a very clever one." Audubon whiled away Saturday and Sunday touring Edinburgh and showing his drawings to a few visitors, friends of people he had met on the coach up from Manchester. Robert Knox, the anatomist, brought a colleague on Sunday and promised Audubon to arrange his presentation to the Wernerian Society.

By Monday afternoon, however, having waited impatiently all morning for the learned men to whom he had delivered letters of introduction to visit George Street to view his drawings, he took his umbrella "and marched direct, rather stiffened, to Fish Market Close and passed the files of printers to Mr. Neill's office as if the world was about being convulsed. I reached the owner of the establishment . . . and merely told him that I regretted very much my not deserving the attentions of those for whom I had letters, and that, if so, I must [be] off to London." Neill immediately led Audubon to St. James Square to meet the best engraver in Edinburgh, William Home Lizars, an open, friendly thirty-eight-year-old Scotsman with curly hair and sideburns and a face like a fox.

*William Home Lizars,
Audubon's first engraver*

For several years Lizars had been finishing and printing the life-sized bird etchings of a wealthy Northumberland naturalist and artist named Prideaux John Selby, whose elephant-folio *Illustrations of British Ornithology* Lizars issued in nineteen numbers over thirteen years. Selby and a young Scottish baronet, Sir William Jardine, were also working with Lizars on a book of previously uncatalogued bird specimens held in British museums, *Illustrations of Ornithology.* Lizars immediately followed Audubon back to 2 George Street to see his work:

> He talked of nothing else (as he walked along under the same umbrella) besides [Selby's] astounding talent . . . how quickly he drew and how well, had I seen his work, &c., &c., until, having ascended the stairs of my lodgings and entered my room, his eye fell on my portfolio and gave him some other thoughts I am quite sure. It is a doubt with me if I opened my lips at all during all this. I slowly unbuckled the straps, and putting a chair for him to set, without uttering a word, I turned up a drawing! Now Lucy, poor Mr. Selby was the sufferer by that movement. Mr. Lizars, quite surprised, exclaimed, "My God, I never saw anything like this before!"

Lizars made things happen. He promised to write Selby and Sir William Jardine. On his walk back to St. James Square he alerted a fellow engraver, who left

his card when he found Audubon away (the artist had run out after Lizars left to continue shopping for a keepsake for Lucy). Tuesday morning, just as Audubon was finishing a letter to his son Victor, the "warm-hearted" engraver turned up with the elusive Professor Jameson, president of the Wernerian Society, who looked over Audubon's drawings and told him "he will announce my work to the world with my permission" but whose manner Audubon still thought imperious. That evening at Lizars's shop, where he lived, the engraver showed Audubon some of Selby's and Jardine's engravings, meticulously drawn but statically composed, and Audubon knew he had trumped them; "my Johnny can do as good," he wrote dismissively in his journal.

Breakfast on Wednesday with Jameson and his sister changed Audubon's mind about the university professor. "He accosted me most friendly, chatted with an uncommon degree of cordiality and promised me his powerful assistance so forcibly, convincingly, that I am quite sure I can depend upon him." Back at his sitting room, which had begun to crowd with viewers, Audubon welcomed Jameson at noon with a group of gentlemen in tow, including a baronet. "He . . . made them praise my work [and] said he would call again." Audubon spent the rest of the day holding up drawings until his arms were tired—"I thought once that my left fist was about to assail my own so well formed nose," he wrote happily. He visited Lizars again that evening—his host "uncorked a bottle of warmed London porter"—enjoyed the company of Lizars's pretty wife Henrietta, watched "for the first time in my life" artists coloring engravings by gaslight, went to bed to read, fell asleep and dreamed he was making love to Lucy at Beech Woods.

When Lizars called again at 2 George Street the next day Audubon showed him what he had not seen before, the large drawings—the hen turkey and her poults, the turkey cock, the hawk attacking a bursting covey of quail, the whooping crane tearing and devouring newborn alligators. "All were, he said, wonderful productions," but "when the 'Great-Footed Hawks' came [out] with bloody rage at their beak's ends and with cruel delight in the glance of their daring eyes, he stopped mute for perhaps an instant. His arms fell [and] then he said, 'I will engrave and publish this.'" Audubon had found his engraver at last—or so he thought.

That evening over wine and "let me see, one, two, yes three glasses of warm Scotch whisky toddy" at Lizars's studio Audubon told the enthusiastic engraver about his Liverpool and Manchester exhibitions and showed him his many letters of recommendation. Lizars took the point. "Mr. Audubon," he said, "the people here don't know who you are at all. But depend on it, they shall know." In his journal that night in whisky-powered prose Audubon gratefully

invoked one of his winged deities before falling into bed: "Then Fame, expand thy unwearied pinions, and far, far and high, high soar away!"

ABOUT NOVEMBER 10, 1826, a day or two after Audubon received a letter from the Queen Bee enclosing his miniature wild turkey cock seal haloed with the motto "America My Country," William Lizars began engraving Audubon's lifesized drawing of a wild turkey cock looking back warily as it crossed a Louisiana canebrake for the first plate of *The Birds of America.* Lizars produced colored plates—prints—derived from drawings by transferring the outlines of the drawing using tracing paper onto a large sheet of copper, which was then etched with acid to "bite" furrows into the metal wherever the drawing lines had touched. The etched copper plate was inked with black ink, wiped to leave ink only in the furrows and pressed with dampened paper, which picked up the ink and thereby duplicated the outlines of the original. After the print was pulled and allowed to dry, a staff of colorists, following pattern plates that Lizars had colored to Audubon's approval, then filled in the black-and-white outlines with transparent watercolors, each individual colorist applying one color as the print passed from one workstation to the next.

The plan for *The Birds of America,* as Audubon described it to Lucy in a letter, was to have it "come out in Numbers of five prints [each], all the size of life and in the same size paper [as] my largest drawings, that is called double elephant. They will be brought up and finished in such superb style as to eclipse all of the kind in existence. The price of each Number is two guineas [i.e., £2.2—about $164 today], and all individuals have the privilege of subscribing for the whole or any portion of it." The whole would comprise some 400 plates, to be bound into four volumes of 100 plates each. British copyright law required that books containing text be deposited at crown libraries throughout the country, which would have been a crippling burden for so expensive a work. Instead, Audubon told William Rathbone, he would write and publish a separate set of letterpress volumes of bird "biographies" that would also include "many localities and anecdotes connected with my eventful life." He thought at first to sell these volumes separately to subscribers but decided eventually to include them in the original price.

"America My Country," Audubon's seal

Audubon of course followed Lizars's work closely, but he also faced the continuing problem of raising money to support the project. He had devised three ways to do that: by collecting admission to his exhibitions of drawings (and, once Lizars began issuing them, of colored engravings), by selling subscriptions and by pumping out nature paintings in oil—his "potboilers"—to sell on the side. He organized all three activities simultaneously while continuing to attend a sleep-depriving series of dinners to make himself and his work ever better known. "The great round of company I am thrown in," he wrote, "has become fatiguing to me in the extreme, and does not agree with my early habits—I go to dine out at 6, 7 or 8 o'clock in the evening and it is 1 or 2 in the morning when the party breaks up. Then painting all day, until, with my correspondence that increases daily, my head is like a hornet's nest and my body wearied beyond calculation. Yet it has to be done. I *must not* refuse a single invitation."

Audubon summarized events in the first half of November in his journal entry for November 19. "It was settled by Mr. Lizars that he would undertake the publication of the first Number of my *Birds of America*," he wrote, "and that was enough to put all my powers of acting and thinking in a high paroxysm of fever." Since he could hardly paint in a sitting room crowded with viewers, he was grateful when the Edinburgh Royal Institution, lobbied by his new friends, invited him to exhibit in its rooms without charging him a fee. On one Monday his Royal Institution exhibition took in £6.3, on a good Saturday £15. With his room cleared of visitors "I was no longer *at home*. . . . I painted [oils] from day to night closely and perhaps more attentively than I ever have done before." The first painting he worked up was of a wild turkey family—"a Turkey cock, a hen, and nine young, all the size of life"—a wholesome but anthropomorphic combination, since hens raising poults drive turkey cocks away. Pursuing subscription sales, the other leg of his support tripod, would have to wait until his first Number of five plates, expected in mid-January, was available to show.

Rock pigeons were the subject of his next oil. Audubon noted with amusement that the Scots called them wood pigeons, "although woods there are none." Success is as disturbing as failure or disaster: because Audubon's life was undergoing great change, he felt great turmoil. He had not heard from Lucy for more than a month, since he left Manchester. He reasoned in his journal that the problem was the mail, not her intentions: "I am quite dispirited about thy silence, or better say at my not receiving the letters that I know thou must certainly have wrote." But his feelings resisted his logic; he felt abandoned: "It seems to me as if thou hadst entirely forgotten that poor Audubon who never

ceases to think of thee. Ah my Lucy, this is severe indeed, and how long it will continue I cannot even guess." Working on his wood pigeons on a Sunday in late November, he laid the painting on the floor and climbed onto a chair to take in the whole image:

I had thought a thousand times of thee, and my chagrin was greater than usual. I could not well understand why no tidings from thee reached me. Oh how much I thought of the dear wife, the dear girl, the dear woods, all in America. I walked in thought by thy lovely figure, kissed thee, pressed thee to my bosom, heard, I thought, thy sweet voice. But good God, when I positively looked around me and found myself in Edinburgh, alone, quite alone—without one soul to whom I could open my heart—my head became dizzy and I must have fallen to the floor, for when my senses came again to

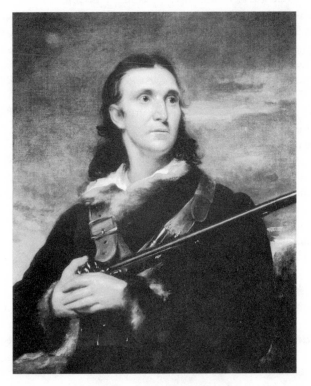

John Syme's 1826 portrait of Audubon

me I was stretched on the carpet and wet with perspiration, although I felt quite cold and as if recovering from a fit of illness.

Just then Henrietta Lizars knocked on his door to invite him to dine with her and her husband "on roasted sheep's head, a Scotch dish, and I was glad to accept, for I now felt as if afraid to remain alone at my lodgings." At dinner, feeling safer, he found the sheep's head "delicious," learned from Lizars that Sir William Jardine was interested in buying the oil of the turkey family and offered to sell it marked down to £70—about $5,500 today—from the £100 he would ask of a stranger. (On another occasion, dining with the Edinburgh Antiquarians at the Waterloo Hotel, Audubon would tuck into "a sumptuous dinner . . . of Scotch messes of old fashion, such as marrow bones, cod fish heads stuffed with oatmeal and garlic, black puddings, sheep's heads, tracheas of the same, and I do not know what all." For a man who ate abstemiously and was easily made seasick he had an adventurous stomach.)

The painter John Syme asked to paint Audubon's portrait in oil. Lizars encouraged the venture and proposed to engrave the result and distribute it. Audubon stood for his portrait in his frontier wolfskin coat holding his gun, looking out of frame to his left, clean-shaven, his hair below his shoulders, "a strange-looking figure," he wrote the Queen Bee, "with gun, strap and buckles and eyes that to me are more those of an enraged eagle than mine." When Syme came to visit on November 27 he was surprised to find that Audubon had already finished the wood pigeons and was outlining yet another otter in a trap. The next day, after posing standing in his hunting clothes for two tedious hours, Audubon learned "that Sir Walter Scott was in the rooms of the Royal Institution and wished to see me." Without taking time to change he raced across Edinburgh, arriving "quite out of breath." By then Scott had gone into a meeting and the sun had set—the exhibition was not illuminated at night—so Audubon did not meet his hero that day. Syme finished the portrait on November 30. "I cannot say that I thought it a very good resemblance," Audubon concluded, "but it was a fine picture and the public [is] the best judge as to the other part." He hung it at the entrance to his exhibition (it hangs in the White House today).

Audubon saw the first proof impression of the wild turkey cock engraving on November 28, 1826, the day he tried to chase down Sir Walter Scott. He was not entirely happy with Lizars's first effort; he thought it only "looked pretty well." He was "well pleased" with the second plate, however, of yellow-billed cuckoos assaulting a butterfly in a pawpaw tree, which he saw on December 7.

Jameson wrote him that day that the University of Edinburgh would subscribe to *The Birds of America,* the second name on his subscription list. The first, a physician visiting Edinburgh from Trinidad, had signed on the previous week. The anatomist Robert Knox was proposing Audubon as an honorary member of the Wernerian Society and had cautioned him that Jameson was jealous of him and "might bear against me at the trial for election," but Jameson helped Audubon prepare a report on the habits of the turkey buzzard for his maiden speech to the Wernerians and not only offered Audubon as an honorary member when the time came, later in December, but also proposed waiving the rules and electing the artist in January rather than putting him through the usual four-month trial.

It took Audubon only thirteen hours, spread across several busy days in early December, to paint his *Otter,* a large oil on canvas but a familiar composition. Unaware of the composition's history, Syme was astonished. "No man in either England or Scotland could paint that picture in so short a time," he told Audubon, who reflected in his journal:

> Now to me this is all truly wonderful. I came to this Europe fearful, humble, dreading all, scarce daring to hold up my head and meet the glance of the learned, and I am praised so high. It is quite unaccountable and I still fear it will not last. These good people certainly give me more merit than I am entitled to. It is only a mere glance of astonishment or surprise operating on them, because my style is new and different from what has preceded me.

On Sunday, December 10, after weeks of painful silence when he had found letter writing impossible, he sat down to write Lucy. Three days earlier he had been "positively quite done, harassed about thee; so apprehensive am I that I cannot enjoy anything, not even a few hours repose at night," and even as he wrote and copied a long letter to her that Sunday he felt "as if I was writing in vain." In his mind's eye he saw her moving around his room "in such sickly appearance that I again was almost afraid to remain alone . . . so distracted was I with the idea that some most shocking accident had befallen thee or one of our dear boys. Oh my God, destroy that suspense," he appealed to her. When he had written her from Liverpool in September he had proposed that she move from Louisiana to New York, where "we could hear of each other every week after the correspondence would be established" because packet ships regularly crossed the Atlantic to and from New York. Now he asked her to consider leaving Louisiana and joining him in England, and the tone and content of his

request echoed the appeals he had made to Lucy from New Orleans when she had been living in Shippingport with the Berthouds in 1821:

> It is now about time to know from thee what thy future intentions are. I wish thee to act according to thy dictates, but wish to know what those dictates are. Think that we are far divided, and that either sickness or need may throw one into a most shocking situation without either friend or help, for as thou sayest thyself, "The world is not indulgent." Cannot we move together and feel and enjoy the natural need of each other? Lucy, my friend, think of all this very seriously. Not a portion of the earth exists but will support us amply, and we may feel happiness anywhere if careful. When you receive this, sit and consider well. . . . Then . . . in a long, plain, explanatory letter give me thy own heart entire.

The first of the two appearances of the word "need" in this urgent paragraph would seem to refer to financial difficulty, but "the natural need of each other" surely concerns both emotional support and sexual intimacy. Husband and wife had now been apart for nearly seven months since Audubon had left New Orleans the previous May. He wished their separation to end. Though he still worried that disaster was the reason he had not heard from her, he appears to have assumed as well that Lucy's seeming silence reflected her financial concerns. Elsewhere in the letter he wrote of bringing seventeen-year-old Victor Gifford over "to travel for me to see about the collection of payments for the work and to procure new subscribers constantly," which would "afford him the means of receiving a most complete education and a knowledge of Europe surpassing that of probably any other man." John Woodhouse, now fourteen, could receive in England "an education that America does not yet afford," and because he had shown talent as a painter, working with his father would mean "he would be left at my death possessor of a talent that would be the means of his support for life."

All of these prospects depended, of course, on Audubon's success with publishing *The Birds of America* and finding subscribers. "I assure thee I cannot at present conceive failure on my part," he closed his long letter, "and may God grant that it may be true. If I can procure, in the whole of two years, three hundred subscribers, we will be rich indeed."

Lucy had in fact written her LaForest regularly, but the letters, like his to her, had been slow to find their way. Monday morning, feeling dull, Audubon had walked out to make his rounds of the Royal Institution and Lizars's workshop without even bothering to shave or dress for business, but when he came back

Mrs. Dickie handed him a letter from London—from the wife of Jane Percy's brother Charles Middlemist, who had been visiting Beech Woods—containing two letters from Lucy dated August 14 and August 27. "How I read them!" Audubon exclaimed in his journal. "Perhaps never in my life were letters so welcome, and they were such sweet letters, my Lucy!" He was especially happy to hear that during August, "the most sickly time" in Louisiana, both she and John "had escaped illness." That she was well "and anxious that I should be so, was all thy LaForest could wish." The letters indicated that Lucy expected to come to England "some time next summer." She still maintained that expectation as late as November 29, when she wrote her Derbyshire cousin from Beech Woods that "should Mr. Audubon conclude on remaining in Europe I shall join him in the autumn," although she did not then know where he was. As of mid-December 1826, then, both the Audubons agreed that their long separation would end and they would be reunited in England midway through the year 1827.

Much was written and said in praise of Audubon's exhibition at the Edinburgh Royal Institution. "The newspapers," he wrote Thomas Sully, "the people, the nobility, all have paid me homage due only to very superior men. . . . If I do not become a proud fool (and God forbid) I cannot help but succeed." A French critic visited the exhibition in December. Better than any other reviewer, borrowing the lush language of Chateaubriand's *Atala*, he identified the combination of originality and vivid authenticity that made Audubon's art so resonant for European viewers in an age when the New World was still a novelty beyond most people's range and all images were made by hand:

A magic power transported us into the forests which for so many years this man of genius has trod. Learned and ignorant alike were astonished at the spectacle. . . .

Imagine a landscape wholly American, trees, flowers, grass, even the colors of the sky and the waters, quickened with a life that is real, peculiar, trans-Atlantic. On twigs, branches, bits of shore, copied by the brush with the strictest fidelity, sport the feathered races of the New World, in the size of life, each in its particular attitude, its individuality and peculiarities. Their plumages sparkle with nature's own colors; you see them in motion or at rest, in their plays and their combats, in their fits of anger and their caresses, singing, running, asleep, just awakened, beating the air, skimming the waves, or rending one another in their battles. It is a real and palpable vision of the New World, with its atmosphere, its imposing vegetation, and its tribes which know not the yoke of man. The sun shines athwart the clearing in the

woods; the swan floats suspended between a cloudless sky and a glittering wave; strange and majestic figures keep pace with the sun, which gleams from the mica sown broadcast on the shores of the Atlantic; and this realization of an entire hemisphere, this picture of a nature so lusty and strong, is due to the brush of a single man; such an unheard-of triumph of patience and genius!

Ironically, Audubon's disillusionment with Europe's "industrial garden," fouled with coal smoke and partly denuded of trees, led him at the same time to realize that the American landscape would be similarly transformed. Writing in the privacy of his journal that December the appeal he felt too shy to direct in person to Sir Walter Scott, he predicted the extirpation of the American primeval that he had been privileged to experience at first hand:

> Neither this little stream, this swamp, this grand sheet of flowing water, nor these mountains will be seen in a century hence as I see them now. Nature will have been robbed of her brilliant charms. The currents will be tormented and turned astray from their primitive courses. The hills will be leveled with the swamp, and probably this very swamp have become covered with a fortress of a thousand guns. Scarce a magnolia will Louisiana possess. The timid deer will exist no more. Fishes will no longer bask on the surface, the eagle scarce ever alight, and these millions of songsters will be drove away by man. Oh Walter Scott, come, come to America! Set thee hence, look upon her, and see her grandeur. Nature still nurses her, cherishes her. But a tear flows in her eye. Her cheek has already changed from the peach blossom to sallow hue [and] her frame inclines to emaciation.

He meant that Scott should "describe her now for the sake of future ages," just as Audubon had drawn her. For the American primeval as well as for Audubon and his Lucy, time was pressing and there was much to be done.

INTO THE MONSTER'S MOUTH

A UDUBON'S EXHIBITION OF DRAWINGS at the Edinburgh Royal Institution closed its doors on December 23, 1826. It had earned him £173.10.6—about $14,000 today—from which about £30 would have to be deducted for doorkeepers and other services. In appreciation for the free exhibition space, Audubon gave the institution his oil painting of the wild turkey family, which he estimated he might have sold for 100 guineas. He had painted potboilers energetically throughout December—besides his *Otter*, an oil of two cats fighting over a dead squirrel for Lizars's younger brother Daniel—and in January 1827 began a large painting of a covey of pheasants bursting upward to escape an attacking fox. On January 8 he saw a finished, colored copy of the first plate of *The Birds of America*, the wild turkey cock, which was captioned GREAT AMERICAN COCK MALE in prominent calligraphic engraving. Even though the sheet of heavy matte paper was more than two feet wide and more than a yard high, the majestic bird crowded it, the tips of two of its tail feathers even deliberately lost at the plate edge in the lower left corner, demonstrating at the outset of publication the value of Audubon's determined choice of life-sized, large-scale reproduction.

He had taught Prideaux John Selby and Sir William Jardine how he mounted specimens on wires projecting from a gridded backboard and how he mixed media to create realistic textures of feathers, beak and skin. "It was like a dream," he wrote in his journal, "that I should have come from America to teach men so much my superiors." (Selby, reviewing Jardine's recent work in February, reminded the young baronet of a "great maxim" Audubon had cited about positioning birds in a drawing that is one key to Audubon's own work: "To place them on the center of gravity.") Audubon had demonstrated his mounting system to the Wernerian Society as well, had delivered papers on the

habits of turkey buzzards and alligators and was preparing one on rattlesnakes, delivered in late February, that led to great controversy later, when George Ord got his hands on it in Philadelphia. In January Audubon had been fully invested as a foreign member of the society; he had already been elected to the Edinburgh Society of Arts. He had spent several nights at Dalmahoy, eight miles west of Edinburgh, as a guest of the Earl of Morton, whose palatial house and large estate dazzled Audubon but who proved to be a small, tottering elderly man "weaker than a new-hatched Partridge." The Countess, the real force in the household, enjoyed a drawing lesson and subscribed to *The Birds of America.*

"It is Mr. Audubon here, and Mr. Audubon there, and I can only hope they will not make a conceited fool of Mr. Audubon at last," he joked happily of all this attention. On a January day when he was unable to work for want of a white pheasant "for a keystone of light" in his fox-and-pheasant painting, he found time to sit for a life mask. A fellow artist brushed oil on his face, "the almost liquid plaster of Paris . . . poured over it as I sat uprightly until the whole was covered; my nostrils only were exempt." In a few minutes it had set and he rushed on to his next appointment. "On my return from the Antiquarian Society that evening"—another membership to add to his credentials—"I found *my face* on the table, an excellent cast."

After missing Sir Walter Scott on three occasions—once because he was too

shy to allow himself to be introduced to the cele-
brated poet and novelist in the midst of a crowd—
Audubon finally met his hero on January 22. He
had dined several times during December and
January with a tall, darkly handsome captain of
the Royal Navy, Basil Hall, who was preparing to
tour the United States to gather impressions for a
travel book and was pumping Audubon for advice
and contacts. Hall had already published a book
about his experiences in China, where he had been
an embassy attaché, and Korea, and had famously
interviewed Napoleon at St. Helena on his way
home. His personal impressions of the French
emperor in exile had probably extended his con-
nection to Scott, at work writing Napoleon's life.

A life mask:
Audubon in his early forties

Audubon was painting away diligently on a brace of black cocks that Mon-
day morning when Hall knocked on his door. "Put on your coat and come with
me to Sir Walter Scott; he wishes to see you *now,*" Hall told him. Audubon was
ready in a moment, "for I really believe my coat and hat came to me instead of
my going to them," he wrote puckishly. Off they went to Scott's Edinburgh res-
idence, Audubon feeling overwhelmed:

> We were shown forward at once, and entering a very small room Captain
> Hall said: "Sir Walter, I have brought Mr. Audubon." Sir Walter came for-
> ward, pressed my hand warmly and said he was "glad to have the honor of
> meeting me." His long, loose silvery locks struck me; he looked like Franklin
> at his best. He also reminded me of Benjamin West; he had the great benev-
> olence of William Roscoe about him, and a kindness most prepossessing. I
> could not forbear looking at him, my eyes feasted on his countenance. I
> watched his movements as I would those of a celestial being; his long, heavy,
> white eyebrows struck me forcibly.

With Audubon staring dumbstruck, Scott called in his accomplished and
articulate daughter to rescue them. The appearance of a woman in the room
usually relaxed Audubon, but on this occasion the two Scotts and the English-
man talked and he listened. After Hall and Audubon left, the great man
sketched an impression of the artist in his journal:

Jan. 22, 1827. A visit from Basil Hall with Mr. Audubon the ornithologist, who has followed that pursuit by many a long wandering in the American forests. He is an American by naturalization, a Frenchman by birth, but less of a Frenchman than I have ever seen—no dash, no glimmer or shine about him, but great simplicity of manners and behavior; slight in person and plainly dressed; wears long hair which time has not yet tinged; his countenance acute, handsome and interesting, but still simplicity is the predominant characteristic.

Audubon was many things, including mortally shy in the presence of people he feared might be his superiors, but he was never simple. Richard Rathbone had similarly misread him when he first arrived in Liverpool. Two days later he visited Scott again, this time taking along some of his drawings. Scott praised them politely but wrote later in his journal that although they were "of the first order" he thought them "laborious." He was put off by their "extreme correctness," which seemed to him to make them stiff, an opinion evidently uninformed of the stiffer tradition of drawing from stuffed specimens perched on taxidermy stands. Audubon drew in the detailed, sharp-edged Neoclassical tradition, one reason why he identified his work with David's; Scott preferred the softer focus of Romantic art. They talked—Audubon now talked—more productively of the American primeval Audubon had wished in his journal that Scott might chronicle. "The Indians, he says [Scott wrote], are dying fast; they seem to pine and die whenever the white population approaches them. The Shawnee, who amounted, Mr. Audubon says, to some thousands within his memory, are almost extinct, and so are various other tribes." Audubon told Scott he had sought but had never found a memory of the mammoth in Indian tradition, nor did he believe that a "more civilized people" had preceded the Indians in North America.

Audubon found this second visit "agreeable and valuable." Never too shy to solicit an endorsement, he tried for one from Scott before he left Edinburgh. The great man candidly admitted to little knowledge of natural history in the letter he gave Audubon, but was prepared to say "that what I have had the pleasure of seeing, touching your talents and manners, corresponds with all I have heard in your favor."

Three letters from Lucy arrived on the last day of January. The surviving journal extracts, neutered by a granddaughter's destructive genteelizing, say nothing about them except that they gave Audubon "delight." The first of February he finished his black cocks sunning and dusting themselves in the fore-

ground of a Loch Lomond view; like his fox-and-pheasants painting, now titled *Sauve Qui Peut*—"Save himself who can," the French expression for a rout—the oil was vast, six feet by nine; he had already been offered 200 guineas for it (about $16,500 today).

William Lizars had also been busy in January engraving the first five plates of *The Birds of America*—the first Number. Fifty copies of each plate were struck off late in the month for coloring. On February 5 Audubon had the pleasure of displaying the first colored, finished set to his colleagues at the Royal Society of Edinburgh in the presence of Sir Walter Scott. The five plates included images of one larger, one medium-sized and three smaller species, a sequence that Audubon had worked out during his ramble on the Great Lakes in 1824 to give each Number variety: the wild turkey cock crossing a canebrake, two yellow-billed cuckoos in a pawpaw tree, two prothonotary warblers in a cane vine, two male purple finches and a female on a tamarack branch, and a single immature female Bonaparte's flycatcher (Canada warbler) perched at the center of gravity on a magnolia branch with a bright red seed pod jutting up to balance the large, pendent magnolia leaves. When Audubon laid the sheets on the table at the Royal Society, he wrote, "the astonishment of every one was great, and I saw with pleasure many eyes look from them to me." He was unanimously elected a foreign member of the society.

By March 1827 he was collecting letters of introduction from his friends, preparing to leave Edinburgh for London, with stops along the way to sell subscriptions to *The Birds of America*. Letters had arrived from Lucy written as recently as December 31, January 3 and January 8, revealing that she had left Beech Woods abruptly after a falling-out with Jane Percy. (She failed to tell him why, and the missed opportunity to enjoy a story at his old enemy's expense galled him.) A valuable resource in wealthy but backwater Louisiana, Lucy had quickly reestablished her school on the nearby Beech Grove plantation of William Garrett Johnson; Johnson had agreed to board and house her and John Woodhouse while guaranteeing her $1,000 a year. But her watch had still not arrived, leaving Audubon worried that it might have been lost along the way.

He wrote her on March 12 after a blizzard dumped sixteen feet of snow on Edinburgh and the Scottish countryside. His election as a Fellow of the Royal Society of Edinburgh, he told her proudly, making him "at last an F. R. S.," was "like a dream," as was his connection with Sir Walter Scott. By now he had met and knew personally "all the great men of Scotland and many of England," achievements that he thought would give Lucy great pleasure. His life was

turning out to be as distinctive as he had long dreamed it might be: "What a curious interesting book a biographer—well acquainted with my life—could write. It is still more wonderful and extraordinary than that of my father!" His work was considered unrivaled and he would soon know how well it would pay. If he succeeded as well as he expected on his subscription tour, he would write for her to come to England, "and when I do so my Lucy may come without the least hesitation for I will then be ready to receive her!" He regretted that they had not undertaken this great adventure together from the beginning: "It has perhaps been an error in our lives that thou didst not come with me." He ached for their intimacy, closing suggestively, "Oh my Lucy, what I would give now in my possession for a kiss on thy lips and————."

As Lizars prepared to begin work on a large horizontal engraving of a wild turkey hen with nine poults to lead off the second Number of *The Birds of America*, Audubon finally issued a *Prospectus*. It emphasized the difference between his art and that of his ornithological contemporaries:

> The author has not contented himself, as others have done, with single pro-file views, but in very many instances has grouped his figures so as to repre-sent the originals at their natural avocations, and has placed them on branches of trees, decorated with foliage, blossoms and fruits or amidst plants of numerous species. Some are seen pursuing their prey through the air, searching for food amongst the leaves and herbage, sitting in their nests, or feeding their young; whilst others, of a different nature, swim, wade or glide in or over their allotted element.

The work was to be of "double elephant folio" size, on "the finest quality" paper, with hand-colored engravings "of the exact dimensions of the draw-ings, which, without any exception, represent the birds and other objects of their natural size." Five Numbers would be published annually, "each Number consisting of five plates" (not twenty, as Audubon had first conceived in Liver-pool after his conversations with the bookseller Henry Bohn), and the price of each number was "two guineas, payable on delivery." Since Audubon expected to produce eighty Numbers (400 plates), he was committing himself to sixteen years of work, at a minimum cost for Lizars's services alone for 100 sets (40,000 prints) of about £140 per Number, for eighty Numbers thus £11,200 or $49,280—more than $880,000 today. He would have to raise the money as he went along. To his program of exhibiting, soliciting subscribers and painting potboilers he had recently added the hope of establishing himself in Edinburgh or London "as an artist under the patronage of some great

Nabob." If he succeeded at his ambitious project, no one could ever again in fairness question his ability as a businessman.

WEATHER AND WORK DELAYED Audubon's departure from Edinburgh until April 5, 1827. Before then he finally yielded to increasing pressure from his friends—from the Countess of Morton to Basil Hall—to have his hair cut to make himself more presentable in London. He drew a heavy black border around a page of his journal to memorialize the shearing. Within the black border he wrote an obituary to his chevelure that revealed behind his seeming vanity the serious reason he wore his hair unfashionably long: to avoid the shudder of a painful recollection: "As the barber clipped my locks rapidly, it reminded me of the horrible times of the French Revolution when the same operation was performed upon all the victims murdered by the guillotine. My heart sank low." The trauma of his childhood lingered long after.

Audubon's route followed the North Sea coast southeastward from Edinburgh. He was glad to leave the city. At his first weeklong stop at Twizel House, the country residence of Prideaux John Selby in Northumberland, he "ran about like a bird just escaped from a cage" birdwatching, picking flowers, hunting birds' nests and enjoying the Selby children as he and Selby drew. He reached Newcastle-upon-Tyne in mid-April and lingered another week exhibiting and meeting with seventy-three-year-old Thomas Bewick, the English woodcut artist whose volumes of British birds and quadrupeds had inspired Alexander Wilson as well as Audubon. The large old man, "full of life and energy . . . very witty and clever," chewed tobacco while he talked art and natural history with Audubon and "expressed himself as perfectly astounded at the boldness of my undertaking." He knew America better than most of his countrymen, Audubon noticed: "Now and then he would start and exclaim, 'Oh, that I were young again! I would go to America too. Hey! what a country it will be, Mr. Audubon.' I retorted by exclaiming, 'Hey! what a country it is already, Mr. Bewick!' "

Audubon's forty-second birthday passed on April 26. On May 1 he wrote Lucy hurriedly from Leeds—turning inland, he was now crossing England toward Manchester and Liverpool—apologizing for a monthlong silence and adding up subscriptions: three at Twizel, eight at Newcastle, ten at York. He said no more about coming together but remembered unhappily that the day marked their parting twelve months before, "and [during] these [you] might just as well have been with me as not but it seems it was not ordered to be so."

He added five subscribers in Leeds. Manchester in one astounding week

redeemed itself from its previous neglect by presenting him with no fewer than eighteen. He reached Liverpool on May 14 and added five more subscribers in the next two days; these forty-nine new subscriptions moved his total to ninety-four. He might have celebrated, but on his arrival William Rathbone handed him a letter from Lucy dated March 15 that soured and angered him. Fearful of traveling alone, she had hoped to cross to England during the summer with Charles Middlemist, Jane Percy's brother, returning home from Beech Woods, but she had been trying for some time to collect $500 of delinquent tuition fees and did not feel she could leave until she did so. Nor did she like the idea of sending Victor to England to turn him into a traveling salesman. (She had written Victor at about the same time, telling him his father no longer spoke of their going to Europe or of his returning to America, which suggests that she was blaming her delay on her tuition-collection problem as a way of temporizing until she understood better what her husband's circumstances were.)

Incensed at his wife's seeming lack of confidence in him at the very moment when his ambitious project was beginning to look wildly successful, Audubon took these hesitations and misunderstandings as challenges to his ability and authority. "Just pause for a moment," he instructed Lucy sharply on May 15, "think coolly, and wonder how thy husband is proceeding in such a work as his." The forty-four subscribers he had signed in thirty-eight days of travel between Edinburgh and Liverpool would ultimately pay him for eighty Numbers no less than 7,040 guineas. "What *thou* may feel is unfortunately quite unknown to me, but my friend Rathbone and all my acquaintances are astounded." He had almost given up hoping that she would come to him, because as she herself said, her habits and her ideas of things were so different from his:

> I am married, everyone knows it—and yet I have no wife [here] nor am I likely to possess one. I have come to a highly civilized country where talents are appreciated and where anyone with industry and care can live as well as anywhere under the sun, without my wife and my children, nay I am denied the privilege of every father in the world, that of judging what is best for them to do [a reference to his plans for Victor], and have perhaps lost sight of them forever. Such is the situation of thy husband that after years of labors, in the midst of encouragement, the strongest pangs of sorrow fret my poor mind constantly. . . . [But] I have no wish to give thee pain.

He was sorry he ever sent the gold watch, still not delivered, sorry he bought one for her. She had wanted to buy one for herself; "I am vexed I did not in that let thee have thy own way." He was glad she expressed pleasure at

his successes; he was pursuing them now, he wrote bitterly, merely to prove that he loved her, had loved her, loved her still, much more than she had seemed to think or say ever since he had failed at business in Henderson and they had gone from rich to poor—a cruel accusation born of his wounded pride and their different tolerances for financial insecurity. (Lucy in fact had worried in the years since Henderson that he had ceased to love *her*.) In her letter she had asked him if he intended to settle permanently in Europe or to return to America. He did not yet know, he told her, and he blamed her in part for the uncertainty:

> It is impossible for me to say if I will remain here forever, or for any particular number of years. For the same reason it is quite impossible for me to say if, or not, I will return to America shortly. Thou knowest well how anxiously and often I . . . repeated to thee when in America that I wished to draw more, to finish my collection entirely, &c., when thou wert always for my making a trial in Europe before [I finished] and [to] judge [from that if I should]. I have done so, and I say, all now bids fair towards ultimate success, but [whether or not I may be] obliged to go again to the [American] woods and draw to finish my work is indeed uncertain.

Despite his anger and bitterness, Audubon loved and respected his wife; he understood how easily their long, difficult lines of communication could mislead them. If and when he could get away, he announced in this letter for the first time, he might sail to America and collect her. She would have to trust his judgment:

> At this great distance letter writing is next to nothing. A word, or a sentence, may be misunderstood. . . . I may think thee cold to me, and thou me unkind to thyself when neither of us mean to cross our ultimate intentions to please each other and during all that time we are 5,000 miles apart.
>
> I have almost a mind to say now, my beloved Lucy, I will go for thee myself, but I have not subscribers enough for that. I cannot bear to be without thee. It vexes me, frets me to death. But when I have been in London I may have such a number [of subscribers] as to prompt me to go to America and bring thee over. Recollect that I wish thy happiness and nothing else but recollect also that I am becoming a judge [of] what is best for *both of us*.

He wrote her again the next day, May 16, to repent of his anger and follow up his appeal:

Do not think my sweet wife that my letter was wrote to thee with any wish to discomfort thee. It may sound to thee of an angry tone, but if so believe me it is only the result of the constant want of thee that I am in—and as well as thou I intend well and most sincerely wish thy happiness—so by no means do thou feel hurt if any of the expressions appear harsh. God bless thee.

He repeated his tale of triumph collecting subscribers and went on to lay out in great detail the finances of the Numbers and the book. The gist of it was that one hundred subscribers would pay for the engraving plates and give him a profit of £212.6.8 per year. Two hundred subscribers would more than double that amount; his annual profit then would be £879.7.4, "which makes in dollars about 3902 per annum, enough to maintain us even in this country in a style of elegance and comfort that I hope to see thee enjoy."

Despite the frustration he had expressed in his earlier letter about having to live and work in England without her, what he saw as her caution about financial security had apparently led him overnight to second thoughts:

Thou art quite comfortable I know in Louisiana; therefore wait there with a little patience. I hope the end of this year will see me under headway sufficient to have thee with me with comfort here. . . . I need not tell thee that I long for thee every hour of the time I am absent. I conceive it best to be prudent. . . . If I fail, America is still my country, and thou I will still find my friend; I will return to both and forget forever the troubles and the expenses I will have been at; when walking together arms in arms we can see our sons before us, and listen to the mellow-sounding notes of the thrush so plenty in our woods of magnolia. God bless thee.

Having dispatched these mixed signals across the Atlantic to his puzzled and worried wife, Audubon left Liverpool for London. He arrived there on Monday, May 21, 1827.

AUDUBON CARRIED EIGHTY-TWO LETTERS of introduction with him to London, addressed to such notables as Robert Peel, the government minister and future prime minister; Albert Gallatin, the American ambassador, who had been secretary of the treasury under Thomas Jefferson and James Madison; the publisher John Murray; Sir Humphry Davy; the Duke of Northumberland; the painter Sir Thomas Lawrence. He bought a map and wandered London delivering his letters, he wrote, "like a post-boy," but "after wandering

the greater part of three successive days, early and late, and at all hours, I had not found a single individual at home!" He decided to mail the letters instead. He held back one addressed to John George Children, the head of the zoology department of the British Museum and secretary of the Royal Society of London. Children, fifty years old, was in when Audubon called and welcomed him, but advised him that mailing the letters had been a great error. Children was right: more than half the notables to whom they were addressed never responded.

Fortunately, others did. Children took Audubon under his wing. On the evening of the day they met, May 23, he introduced the artist to the Linnean Society—a prestigious natural history society founded in 1783 to honor Carl Linnaeus and house his extensive collections—where the plates of Audubon's first Number won general approval. Audubon found lodgings at 55 Great Russell Street, near the British Museum. Tuesday, May 30, he showed his work to Albert Gallatin, a Swiss-born American patriot who confided to Audubon in good French that he detested the English and considered London "the most disagreeable place in Europe." Gallatin's wife and daughter recognized every plant in Audubon's drawings and Gallatin nearly every bird.

The artist shared Gallatin's distaste for London, "the overgrown city of London," where he felt himself once again on trial; on first impression it was "like the mouth of an immense monster, guarded by millions of sharp-edged teeth from which if I escape unhurt it must be called a miracle. I have many times longed to see London, and now I am here I feel a desire beyond words to be in my beloved woods." He was shocked by the poverty "groping in filth and rags"; when he heard one day that "three poor fellows were hanged at Newgate this morning for stealing sheep" he was horrified. "My God! How awful are the laws of this land, to take a human life for the theft of a miserable sheep." But he put on the new black suit Basil Hall had insisted he have made for the fashionable city, "and thus attired like a mournful Raven," he went out to engage the monster.

Hall had supplied the letter of introduction to the publisher John Murray that Audubon carried. Written in late February, it spoke of Audubon's "intention of publishing a Complete Ornithology of America," advised that "he is now going to London in order to set this gigantic work in motion" and asked Murray "to introduce engravers, printers & so forth to him, and generally speaking to put him in the way of bringing out his work in an advantageous manner to himself." Despite Audubon's personal friendship with William Lizars, he had been disappointed with the quality and the timeliness of the engraver's work. Lizars's plates were not as technically advanced as the colored

engravings produced in London, and Audubon found Lizars's delay in delivering the first Number to new subscribers increasingly frustrating. Hall's letter to John Murray implies that Audubon had gone to London in part to explore other possible arrangements. Lizars had only begun engraving the second Number at the beginning of May. Since Audubon had promised his subscribers five Numbers each year, that meant he was a month or more behind schedule.

A letter from the Edinburgh engraver that Audubon received in London on June 14 revealed the reason for Lizars's delay, "informing me that his colorers had struck work and everything was at a standstill; he requested me to try to find some persons here who would engage in that portion of the business, and he would do his best to bring all right again. This was quite a shock to my nerves." Despite the shock Audubon kept his appointments that day, including meeting with a recently arrived Charles Bonaparte, who looked over the plates of the first Number and immediately subscribed. But as soon as the Prince of Musignano and some other visitors left his rooms Audubon went out looking for colorists. (Bonaparte would descend to the bottom of the Thames in a diving bell that month to inspect from the outside the first tunnel then being dug under the river, using tunneling techniques borrowed from coal mining.)

Audubon searched for three days in "the suburbs and dirtier parts of London, and more misery and poverty cannot exist without absolute starvation." He found one colorist willing to work more cheaply than his Edinburgh counterparts, a man who had not eaten for more than a day when Audubon interviewed him in his home among his hungry children. More promisingly, someone directed Audubon to the shop of a well-known London engraver and publisher, Robert Havell, Sr., established in the Marylebone district at 79 Newman Street. On June 19, after visiting the studios of the painter Sir Thomas Lawrence and watching him paint, Audubon "went five times to see Mr. Havell the colorer, but he was out of town. I am full of anxiety and greatly depressed. Oh! how sick I am of London."

Two days later, on Thursday, he heard again from Lizars, worse news than before. The coloring of Audubon's plates had not yet resumed. Lizars hoped he would be able to do so at the beginning of the week (the letter was dated the previous Saturday, June 16), but that depended on the colorers giving up their demands for better pay for their piecework and continuing on the terms they had gone out on strike to improve. "This I have some doubt of them doing *immediately*," Lizars allowed, "although in the end they must do so. They cannot afford to hold out more than two or three days." Lizars believed they had struck because the higher prices Prideaux John Selby had been paying them for

coloring his work had "poisoned their ideas completely." Lizars concluded: "This has been and yet continues to be a most distressing business and the more so as I cannot as yet inform you how it is to turn out."

Reading between the lines, Audubon "was so struck with the tenor of [Lizars's letter] that I cannot help thinking now that he does not wish to continue my work." He immediately packed up a portfolio with his first Number and several of his drawings and went off to Marylebone to talk to Robert Havell, Sr. Fifty-eight years old, Havell maintained a "Zoological Gallery" stocked with natural history artifacts and specimens, as well as his engraving and publishing business. The details of Audubon's first meetings with Havell were lost when most of Havell's journals were destroyed, but a Havell descendant reported several generations later from family tradition that Havell senior "became intensely interested in Audubon's plans" when he saw the artist's work, "and mutual confidence was soon established." Havell was not prepared to undertake engraving *The Birds of America,* the descendant heard, "on the plea that he was too old for such a long and arduous task," but he did agree to undertake the coloring and printing and to "try to find an engraver who could work under his supervision." Audubon accepted Havell's offer, returned to his lodgings and spent the rest of the day working on an *Otter*—one of seven of the old reliables that he would paint and sell or give away during his years in England.

Havell turned to a colleague, an engraver and publisher named Colnaghi whose company commissioned work from young engravers. Colnaghi showed Havell an engraving of a Monmouthshire landscape. "It so greatly pleased the elderly engraver," the Havell descendant writes, "that he commended the work most highly, exclaiming, 'That's just the man for me!' To Havell's great surprise Mr. Colnaghi replied, 'Then send for your own son.'" Havell was estranged from his oldest son Robert, his namesake. He had educated Robert for a profession, but the young man had determined to be an artist and engraver like his father and grandfather. He had left his father's house in 1825 at the age of thirty-two, gone off on an extensive drawing tour along the river Wye in Monmouthshire and returned with work good enough to win him commissions from publishers such as Colnaghi.

Havell sent for his son, and father and son were reconciled. They agreed to enter into partnership to produce *The Birds of America* if Audubon chose them. Audubon gave them a drawing to engrave so that he could judge the quality of their work. Two weeks later, in mid-July 1827, the Havells pulled a proof and called Audubon in to see it. The descendant tells what must have become a favorite family story:

[Audubon] looked at the proof long and intently, then grabbed it up and danced about crying with his slight French accent, "Ze jig is up, ze jig is up." The Havells first thought this meant that the work was unsatisfactory, but Audubon, throwing his arms around Havell Junior, embraced him in genuine enthusiasm and gave ample evidence that he realized that, at last, he had found an engraver.

It may have happened that way. Audubon emphasized the commercial benefits of affiliating with the Havells when he wrote Lucy on August 6, the day after he received from Lizars all the extant copper plates and uncolored and colored prints on hand in Edinburgh:

> I have made arrangements with a Mr. Havell, an excellent engraver, who has a good establishment containing printers, colorers and engravers so that I can have all under my eye when I am in London and no longer will be stopped by the want of paper or coppers that Mr. Lizars was obliged to order from here, sometimes with risks and at all events with a considerable expense *extra*. Indeed [because of] the difference of cost from the Number which Mr. Havell is engraving (the 3rd) and those done by Mr. Lizars I save about 25 pounds Sterling which is nearly one fourth of what Mr. L. charged—and yet the work is quite equal, and the sets colored by [Havell] are far surpassing in beauty those of Mr. L.

In the midst of these mingled worries and opportunities, on June 20, just as he was beginning to deal with Lizars's strike, Audubon had written Lucy a troubled but hopeful letter that spoke candidly of the resentments he felt. He apologized again for the angry letter he had sent her from Liverpool. "I did not mean to offend thee in the least," he told her, "only I do wish for thy dear self, that I am tormented day *& night* for the comforts thou art so well able to grant me." If he could trust sending for her now, he continued, he would, but he felt he had to wait "until the ways and means are quite and safely secured."

He had approached the British Museum for a position, but it was "quite too poor to afford me." Charles Bonaparte had similarly written a baron as well as the London Zoological Society on his behalf. He expected Albert Gallatin to present him to King George IV if the king held a levee before Audubon left London. If he continued to add subscribers he would need Victor's help in about twelve months. Lucy was "quite mistaken about the habits of this country"; a young man "attending to such business is neither a rambler or considered as such by anyone." Lucy's opinion of subscription salesmen of course

applied implicitly to her husband. He defended himself: "On the contrary, I am looked on and received with more kindness under the appellation of author of *The Birds of America* than nine-tenths of the rich merchants who travel as I do to collect and settle their affairs." But in any case his wish was "not that Victor should collect subscribers but superintend the whole management of the work and give me the means of settling myself awhile."

The next twelve months would be crucial, Audubon told Lucy. That did not mean it would be another year before he asked her to move to England with him. He hoped to be able to invite her much sooner:

> But from many thoughts and recollecting yet alas too pointedly present to my mind, I have no wish to have thee unless thou art convinced at being *comfortable in thy own way*. It is probable that many blame me much in America for this *appearance* of carelessness and absence from my family, and the same doubtless think and say that I am pleasuring whilst thou art slaving thy life away, but can they know my hopes, my intentions, my wishes or my exertions to do well and for the best? I am sure they cannot for they do not know me a jot: yet I have to bear the blame and hear of those things by various channels much to the loss of my peace. . . . It is impossible to foresee [whether] I may be induced to remain in England the rest of my life, or accidents may send me to America once more. But whatever takes place, and whatever my situation may be hereafter, I have and will always have the consolation to think that I have done all I can, or could since my misfortunes in Kentucky, to restore thee to comfort. The difference of habits between us are very different; so much so, indeed, that what I conceive real comfort is misery to thee. Those are misfortunes indeed, but it is too late to take such things in consideration and I am still anxiously inclined to meet thy wishes and procure all I can for thy sake.

Those were hard words, especially the implication that only "accidents," meaning the failure of his great enterprise, would send him home to her.

He was less defensive when he wrote Lucy again in early August with the news of his promising arrangements with the Havells. He had painted six oils since he came to London, he told her: "One of ducks—one of rabbits—one of common fowls, one of pigeons, one of partridges, one of an otter," all of which he hoped to sell at the annual Liverpool exhibition in September for 20 to 30 guineas each. He now intended to stay in England "as long as I will have drawings to keep my work going on; say 5 years exclusive of the present year." But if, in January 1828, he felt himself "*substantially settled,*" meaning probably if he

felt production of *The Birds of America* under the Havells was going smoothly and he had enough subscribers, then he would "write for thee to come and when that does take place I will have everything ready to receive my sweet wife in comfort." Alternatively, if he found that he could be spared, "I would go for thee with pleasure"—that is, he would travel to America to fetch her.

No wonder Lucy, far away from all this tumult in Louisiana, felt neglected and confused. She was so confused about Audubon's situation that when her brother-in-law Alexander Gordon passed through New Orleans at the beginning of the summer Lucy sent her LaForest two hundred of her hard-earned dollars to help him survive in the mouth of the immense London monster. Dumbfounded at her charity when he was receiving and disbursing thousands, he wrote her, "But why did thou not keep it?"

Twenty

"I HAVE WISHED
FOR THEE EVERY DAY"

THE FIRST NUMBER OF AUDUBON'S *The Birds of America* migrated
across the Atlantic to New York with Charles Bonaparte in the summer
of 1827, arriving at night on August 23 after a fifty-three-day passage. At that
time Audubon had only one American subscriber, a New York heiress named
Harriet Douglas who regularly visited Edinburgh. The same barriers that were
snarling communications between Audubon and his Lucy limited American
awareness of the existence and value of his publication, which in any case
was just begun. Celebratory newspaper articles had appeared in New Orleans
because Lucy had passed on the clippings from the British press that her hus-
band had sent her. But in Philadelphia the vicious Wilson manqué George Ord
had nosed up a wallow of denunciation and ridicule of the papers Audubon
had published in Edinburgh on turkey buzzards and rattlesnakes; one newspa-
per editorial would call Audubon's observations "a pack of lies." At least in
public, the artist took the long view. "Had I wished to invent marvels," he sen-
sibly told an American journalist who looked him up to hear his side of the
story, "I need not have stirred from my garret in New York or London."

Europe was more curious to know America than America was yet curious to
know itself. Audubon in a letter to Victor written from London that summer
would speak of "the superfluity of refinement here"—England's prosperity, he
meant, and the luxurious subtleties it supported—which he found "a source of
wonder inexhaustible" while preferring forever "the unbounded freedom of
our beloved America." Bonaparte would write cynically about Audubon's early
reception in America to his New York Lyceum colleague William Cooper. "Few
will patronize poor Audubon in America," the young Prince of Musignano told
the man for whom he named the Cooper's hawk that year, ". . . but if with the
giraffe [newly arrived and drawing crowds at the London Zoo] & [a] thousand

other things he has got into the London view of fashion . . . he can do without his adopted countrymen."

"The American woodsman," as Audubon had begun to present himself, was paralleled in European celebrity that summer by a party of six Osages that arrived at Le Havre in late July for a Continental tour. Four men and two women—Little Chief, Black Bird, Big Soldier and the untranslatable Minckchatahooh, and Hawk Woman and Sacred Sun—had been persuaded by a promoter named David Delauney to make the long voyage from Missouri so that he could line his pockets at their expense. They drew crowds at Le Havre and even larger crowds in Paris (where their only competition was another giraffe, newly installed at the Jardin du Roi), attended the opera and the theater and met Charles X at Saint-Cloud. Little Chief, whose eagle totem protected him from heights, went up in a hot-air balloon. Eighteen-year-old Sacred Sun gave birth in Belgium to twin daughters, one of whom was adopted by a wealthy Liège woman and left behind. After touring the Osages through Holland and Germany as well as France while somehow going broke, Delauney dumped them in Breslau. The French rescued them in 1830, the indefatigable seventy-three-year-old Lafayette leading the collections, and sent them home from Bordeaux. Big Soldier claimed afterward that he had been married three times to ladies of the French court.

With his third Number due out in mid-September 1827—the first to be produced under the new arrangements with the Havells—Audubon was increasingly optimistic that he could support Lucy in the style he had come to believe she demanded. "The moment that I write to thee," he told her in late August, "(and I now sincerely hope it will not be later than January) I will arrange everything for thy comfort and on arriving at my house my Lucy may set either on an easy sofa or a soft bed to be kissed by her 'old man'—I feel so much as [if] it is the case that my heart bounces at the idea." Yet even as he wrote, his funds were temporarily in decline. "I attended to my business closely," he explained in his journal, "but my agents neither attended to it nor to my orders to them." To attend to his agents and collect the £550 his subscribers owed him he left London on September 16 and made the rounds of Manchester, Leeds, York, Newcastle-on-Tyne and Belford, delivering Numbers as he went and ending up in Edinburgh on October 22.

Along the way he discovered that after he had left Edinburgh the previous April, William Lizars had distributed "miserably poor" copies of his first plates, "scarcely colored at all." The poor quality embarrassed Audubon; he collected the inadequate sets and sent them back to Lizars to be redone. In contrast, the Havells' work on the third Number delighted him. It was "so greatly superior to the first two that I am told by all those who see it that I will do well altogether." Plates 11 through 15 depicted an immature bald eagle that Audubon misidentified as a new species and named the "Bird of Washington," two male Baltimore orioles and one female nesting in a tulip tree, male and female snow birds (dark-eyed juncos) on a water tupelo branch, male and female prairie warblers in a spray of sedge, and male and female blue yellow-backed warblers (northern parulas) on an iris. When Audubon showed Lizars the plates of the third Number, the Edinburgh engraver "admired them much; called his workmen, and observed to them that the London artists beat them completely."

Robert Havell, Jr., was a more painstaking engraver than William Lizars, and his father supervised the London colorers perhaps more carefully, but there was a qualitative difference between the technologies Lizars and the Havells used to make Audubon's colored plates. For colored shadows and shadings Lizars had to apply more concentrated watercolor washes, which therefore depended for their success on the skills of his workmen. The Havells used a process known as aquatint, which allowed them to *print* shadows and shadings in a range from light gray to black, leaving their colorists only the more limited task of applying a uniform wash of color over the aquatinted area: the shading made the color appear darker.

Aquatint was invented in Europe in the mid-eighteenth century. Goya was

an early master of the process and used it to produce the monochrome plates of his *Los Caprichos, Desastres de la Guerra, Proverbios* and *Tauromaquia,* all engraved between 1793 and 1815. So named not because it involved water but because it used acid, *aqua fortis* ("strong water"), aquatint worked by chemically stippling an engraving plate to produce the desired gradations of shade, or "tint." Stippling could be done by hand using a graver or the point of a brush, but for work on the scale of Audubon's *Birds,* hand-applied stippling would have been prohibitively time-consuming and expensive.

The Havells probably used the aquatint dust process: finely powdered resin—dried and ground tree sap, which resists acid—sifted like flour over a copper engraving plate made sticky by rubbing it with an oiled cloth. Warming the back of the plate until the resin dust changed color fixed it to the plate. Areas of the plate that were not to be aquatinted had to be stopped out— protected from the acid—by coating them with varnish. The Havells used aquatint on Audubon's engravings to tint gradations of shading on feathers, leaves, tree limbs and trunks, stones, clouds, water surfaces and other pictorial elements.

Once prepared, the plate was bitten with acid—immersed in an acid bath. Brushing the aquatint areas with a feather cleared any bubbles away. Wherever the fine, uniform particles of resin had stuck to the plate, the dot of plate surface under each particle was protected from the bite of the acid. Around and between the particles, a finely reticulated network of plate surface was left exposed and was etched away. How deep the network was bitten depended on how long the plate was bathed in acid or how many repeated acid baths it received; with each biting, the depth of the etched area and undercutting of the resin particles increased, preparing the aquatinting to hold more ink and thus print darker. (When the etching process was complete, the resin particles were of course dissolved away and the plate cleaned before printing.)

Aquatinting was a delicate process that required great skill, because the resin particles tended to detach with repeated bitings and washings, but it produced subtleties of chiaroscuro beyond the range of traditional engraving, enhancing the drama and the dimensionality of the print. The Havells were masters of aquatint; *The Birds of America* is generally acknowledged to be the finest work of colored engraving involving aquatint ever produced. It was also one of the last; beginning around 1830, lithography quickly replaced engraving in art book production.

Lizars offered to continue working on the *Birds* as a second supplier at the Havells' standards and prices, including delivery of the plates to London. Audubon was not impressed. "I think he regrets now that he decided to give

my work up," he wrote. He doubted Lizars's ability and no longer entirely trusted the man. "If [Lizars] can fall twenty-seven pounds in the engraving of each Number and do them in superior style to his previous work, how enormous must his profits have been; good lesson this for me in the time to come." But Audubon held the offer in reserve, writing Lucy that it gave him "a double advantage as it affords me a check on the conduct of each of the gentlemen." To reinforce the relationship he appointed Lizars's younger brother Daniel, a bookseller, as his Edinburgh agent.

In four days of canvassing, Glasgow, though "a city of 150,000 souls, rich, handsome and with much learning," produced only one subscriber, the university. Audubon concluded that "the Scotch in Scotland are the same as they are in all parts of the world . . . tight dealers and men who with great concern untie their purses." Halfway along between Manchester and Liverpool on a bitterly cold early morning in late November a guard mounted the coach with four felons "bound to Botany Bay. These poor wretches were chained to each other by the legs, had scarcely a rag on, and those they wore [were] so dirty that no one could have helped feeling deep pity for them." In Liverpool he found Lucy's sister Ann "*in a certain way*" and sold one of the Rathbones his *Hawk Pouncing on Partridges* for 15 guineas. He told Ann that he expected Lucy in England in May. Ann was skeptical. "I look upon her coming as rather doubtful," she wrote Euphemia Gifford.

In a long late-November letter to Lucy responding to four of hers that Audubon had picked up in Manchester, all written in August, he reported that he now had "114 substantial subscribers, to whom this year I will deliver in all 570 sets," which cost him 570 guineas but brought him "double that amount." He was thriving:

> My health is good and I wear well; indeed I am, I think, as active as ever. I rise as always at daylight, walk whenever I have time to spare, keep as regular in all my habits as when in the woods and have only suffered once in attempting to dry my clothes on me instead of changing them, on my way to Scotland. I have had a few fits of the ague [i.e., fever], but quinine and port wine soon recovered me.

He had walked into Liverpool from Greenbank one morning beside Richard Rathbone on horseback and "kept by his side all the way, the horse walking. I do not rely as much on my activity as I did twenty years ago, but I still think I could kill any horse in England in twenty days." He still had all his teeth; they ached in the cold but were otherwise "perfect."

The King of England had subscribed, he told Lucy, a coup he had blazoned above the title of his book in the latest issue of his *Prospectus:*

UNDER THE PARTICULAR PATRONAGE AND APPROBATION OF
HIS MOST GRACIOUS MAJESTY

When he returned to London he intended "to send a set of the 5 Numbers that will then be published to our newly-elected President"—Andrew Jackson, swept into office on his second attempt—"and ask his public patronage." Yet he was feeling cautious, citing the trouble and expense that establishing himself had cost. He hoped that his enterprise "will *more than pay.* However I am not such an enthusiast as to run quite wild with it." He would balance his accounts at the beginning of January 1828 "and then I will *most positively decide*" whether or not Lucy should join him.

His indecision, amplified by distance, had hurt her, and she let him know it in a letter written in late September that he received in Liverpool early in December 1827. She asked him why he doubted her goodwill toward him. She asked him if he still loved her. Responding defensively, he made excuses for himself—he had written when he "had the blues," he often felt forsaken, he had been without friends and with very little money when he came to England, travel and duty and the need constantly to sell himself were enough "to raise & lower my spirits a thousand times." Then his resentment of what he understood to be her financial expectations sharpened the edge of his response:

> I have wished for thee every day, every moment; and yet at my present age I have postponed daily with what *thou* callest prudence to write for thee positively to come. I feel quite convinced that it is thy wish to join me; did I think differently for a moment, my travels would cease and my happiness would be only a vapor. No, my dear wife, I assure thee I never have doubted thy goodwill towards me, but have more than once sighed, and deeply too, at thy . . . fears of suffering *as much as me* by being together. . . . Wert thou here I only would have to work a very little harder than I do now [but] the comforts I would really feel, I am afraid my Lucy will never feel. How often have I told thee dearly I love thee? Well, my Lucy, I am convinced that I feel more attached and truly devoted to thee than ever.

He sold two more of his six Liverpool exhibition oils—an *Otter* for 12 guineas, the ducks for 20 guineas—but a week later he was still undecided. January, he wrote Lucy, was "the collecting time for the gentlemen to pay in their

bills and I hope to collect my dues in the course of that month." She should at least "be prepared as much as thou canst, collect thy dues &c." He shuddered to find William Roscoe, the editor and botanist, disabled by a stroke and shuddered again when a Liverpool physician showed him a collection of prints of the men of the French Revolution, the leader of the Vendéan counterrevolution among them, François Charette: "Poor Charette, whom I saw shot on the Place de Viarme at Nantes" in 1797, when Audubon was twelve.

The message of strokes and executions should have been *carpe diem,* and the day after Christmas, going over his income and expenses, he found the balance due from his subscribers in his favor was £777—about $61,000 today. With that, he wrote Lucy, "I am sure we can live much more comfortably than any time since my failure at Henderson." He hoped she would wish to come to him. John could attend a good school near them, and the following year they could bring over Victor. If he had known what his success was going to be he would have had her with him from the beginning. Yet he still hesitated to commit.

He did commit to giving up snuff, locking his snuff box in his trunk on New Year's Day 1828 but habitually searching his pockets for it afterward. On January 6, settled in London again at 95 Great Russell Street, he "spent the whole day going over my drawings and decided on the twenty-five that are to form the Numbers for 1828." He conceived *The Birds of America* as a visual tour through the lives of birds as well as a series of separate scenes. Turning the successive pages of plates when they were bound into finished volumes would extend the experience temporally, like turning the panoramic scrolls of battles and views that people went to see in his era (and like the videos and films that people watch today). When he was criticized for not sequencing his plates in Linnaean order he found the criticism amusingly myopic and told his readers so:

> I do not present to you the objects of which my work consists in the order adopted by systematic writers. Indeed, I can scarcely believe that you yourself, good-natured reader, could wish that I should do so; for although you and I, and all the world besides, are well aware that a grand connected chain does exist in the Creator's sublime system, the subjects of it have been left at liberty to disperse in quest of the food best adapted for them, or the comforts that have been so abundantly scattered for each of them over the globe, and are not in the habit of following each other as if marching in regular procession to a funeral or a merry-making.

He was not producing a catalogue but a work of art. Organizing the sequence of his bird images aesthetically to make it varied and surprising was

another way of animating them, supporting his childhood fantasy of bringing the dead back to life.

As Audubon finished his January collections, even though he found himself "well ahead in funds," even though he bought and shipped Lucy a 40-guinea piano, his confidence failed him. Although he was the partner on the scene and thus better informed, he abdicated his responsibility to decide and left the decision up to her:

> When at Liverpool . . . I thought that I would feel sufficiently settled after balancing my accounts to write to thee to come directly to England . . . yet thy entire comfort is the only principle that moves me, and fearing that thou might expect more than I can yet afford I refrained from doing it for the present. However, my love, do not be disheartened. . . . I leave thee from my heart perfectly at liberty to do whatever may be most agreeable to thee. To enable thee to spend thy time in peace and comfort and to know thou art happy & quite well must suffice me until we meet to part no more. . . . From the beginning to the last of the full completion [of *The Birds of America*] 16 years are wanted, so that certainly my Lucy must come to me sometime.

As for Victor, who was angry on his mother's behalf and had not written in months, "if he does not answer my letters I will relinquish writing [him] any more."

While this Congreve rocket of a letter accelerated toward America, Audubon continued his energetic round of drawing, painting, mingling and soliciting subscriptions. He was nominated for membership of the Linnean Society. After a long discussion with his friend J. G. Children at the British Museum he "decided to write nothing more except the biographies of my birds." Writing journal articles took too much time and generated too much controversy, which claimed more time to answer; "when Nature as it is found in my beloved America is better understood, these things will be known generally." He rode an elephant at the London Zoo and began a new journal, his twenty-seventh (of which only three and a fragment survive).

In mid-February he began revising his bald eagle, "which I drew on the Mississippi some years ago feeding on a wild goose; now I shall make it breakfast on a catfish." He had a catfish drawing at hand as well, marked with the talons of another eagle he had disturbed on the banks of the Mississippi on his escape downriver in 1821. He wrote Lucy the same day he began work on the eagle, having received a letter from her the previous morning, and mentioned the piano he had sent her along with a collection of sheet music. He was "deferring

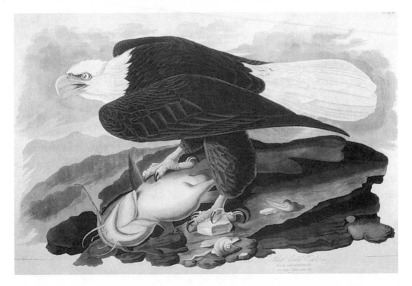

Audubon's bald eagle, Plate 31 of The Birds of America

still to write to thee to come to England," he told her, "but I hope it will be for the best at least; do, my Lucy, anything thou likes."

He was still temporizing at the end of February as he prepared to visit Cambridge University to solicit subscriptions. "I dare not yet invite thee to come to me," he told his wife. ". . . I think it is best on all accounts not to hurry to repent afterward." From the Cambridge stagecoach on March 3, England opened to early spring. "I saw with pleasure many tender flowers peeping out of the earth . . . a few lambs gamboling by their timorous dams, a few rooks digging the new-ploughed ground for worms, a few finches on the budding hedges."

Audubon's host at Cambridge was the Reverend John Stevens Henslow, a professor of botany who was also at that time nineteen-year-old Charles Darwin's influential tutor at King's. The record does not reveal if young Darwin met Audubon in Cambridge, but he had heard Audubon lecture to the Wernerians on turkey buzzards in Edinburgh during the time he attended medical school there, before giving up medicine and transferring to the English university. Audubon's careful field observation of courtship rituals and transitional physical features such as the vestigial webbing on the feet of the frigate bird would influence Darwin. The text volumes of *The Birds of America*—the five-volume *Ornithological Biography* that Audubon in 1828 had yet to write—would be quoted three times in Darwin's 1859 *The Origin of Species;* other than

Constantine Rafinesque, Audubon was the only American or British ornithologist cited there. Darwin would quote Audubon even more frequently in two of his later works, *The Variation of Animals and Plants Under Domestication* and *The Descent of Man and Selection in Relation to Sex*. However harshly some of Audubon's contemporaries might judge his field observations, most stood the test of time.

He dined at high table at Trinity with William Whewell, another of the young Darwin's mentors, a mathematician and geologist who in 1840 would coin the term "scientist." He dined as well at Corpus Christi and privately at Henslow's house, exhibiting his drawings and engravings on each occasion and answering questions about "the woods, the birds [and] the aborigines of America." He regretted not having received a university education. Cambridge nevertheless received him "as if indeed *I* was a great man." Returning to London in mid-March with five more subscriptions, he found the Havell colorists working on his sixth Number. The first plate, Plate 26, featured not a single large bird but a *tour de force* of seven lively Carolina paroquets in seven different attitudes feeding in a stout cocklebur. Audubon thought it "a beautiful piece of work," which it was.

Oxford, where he arrived later in March "shrunk to about one half my usual size by the coldness of the weather, having ridden on top of the coach, facing the northern blast," was far less accommodating; not one college but only the Anatomical School subscribed, as the Radcliffe Library had done previously. Oxford would defer to Cambridge in science for another hundred years.

Audubon had written Lucy in mid-March that he was thinking of visiting Paris in May and would "go to see my sister [in Couëron]." At the end of the month, as his election to the Linnean Society was confirmed, he wrote again. His three weeks of traveling had brought good luck; if it continued, he would put aside £1,000 that year. His sixth Number was finished by then and paid for in full. The piano he had bought for her had left Liverpool a month ago; now he was sending her six cambric dresses with French printing, ten pieces of French lawn for dressmaking and six pairs of gloves. He was "still undetermined about writing for thee to come over, but I assure thee it is only because I wish to have thee comfortable at last. I have of course much trouble to surmount, but I bear it all with a good heart. I am now getting old and I feel extremely anxious to retire from the world. I have seen quite enough of it." His forty-third birthday was a month away.

Looking for additional sources of income, he was exploring other possible moneymaking ventures. In April 1828, writing to Charles Bonaparte, who was now in Italy, he asked the prince's opinion of a wildly ambitious scheme. "I

have many idle moments," he wrote, "and I have the wish to draw the birds & plants aboriginal to England and to publish this myself on the scale and style of *The Birds of America.*" He may have hoped Bonaparte would join him; he expected to "[attach] myself to another person who may take care of the letterpress [text], nomenclature &c. whilst I attend to the illustration." His seventh Number was out, he told Bonaparte, led off by his bold white-headed eagle poised with one foot commanding a belly-up catfish, just as he had seen it in Peale's Museum more than a decade earlier when Alexander Wilson had been drawing it.

While he pursued these plans he struggled with depression. "My spirits have been much too low for my own comfort," he addressed Lucy privately in his journal. In his despair he wrote down for the first time a decisive alternative to Lucy's passage to England: "I thought strongly of returning to America; such a long absence from thee is dreadful. I sometimes fear we shall never meet again *in this world.*" He appealed to the notion again a few days later, complaining that he "longed to look at a *blue* sky" instead of London's coal-smoked yellow:

> I hate it, yes, I cordially hate London, and yet cannot escape from it. I neither can write my journal when here, nor draw well, and if I walk to the fields around, the very voice of the sweet birds I hear has no longer any charm for me, the pleasure being too much mingled with the idea that in another hour all will again be bustle, filth, and smoke. . . . Ah, cannot I return to America?

Elation soon cleared at least the personal fog. At the beginning of May a glowing review of the first Numbers of *The Birds of America* appeared in the popular *Loudon's Magazine of Natural History,* the product of the British naturalist William Swainson. "To represent the passions and the feelings of birds," Swainson wrote, "might, until now, have been well deemed chimerical. Rarely, indeed, do we see their outward forms represented with anything like nature. In my estimation, not more than three painters ever lived who could draw a bird. Of these the lamented [Jacques] Barraband, of whom France may be justly proud, was the chief. He has long passed away; but his mantle has at

William Swainson

length been recovered in the forests of America." Swainson praised Audubon's "genius and . . . ardor," which he thought were unparalleled.

A trim thirty-nine-year-old whose bald crown like a large egg surmounted a nest of ruddy curls, Swainson was preparing a book of American fauna based on skins preserved in British museums. Thinking him wealthy and a possible Nabob, Audubon wrote him on the day the review appeared, expressing hope of returning "to the woods of our vast western continent supported by a patron of wealth of such taste & knowledge as yours." His Birds of England project was defunct, he told Swainson, because "the few men to whom I have spoken on the subject say nothing, and I am too poor when alone to attempt it." After a page of flattery—he was merely a soldier but Swainson was a general, he imitated nature but Swainson was nature itself—he mentioned offhandedly having sent a copy of Swainson's review to the London Times for possible reprinting. The American woodsman left no tree unblazed.

He enjoyed walking out to Hampstead village with a friend on Sunday morning, May 4, "but only transiently"; his thoughts were full of returning to America:

> I have been summing up the pros and cons respecting a voyage to America, with an absence of twelve months. The difficulties are many, but I am determined to arrange for it, if possible. I should like to renew about fifty of my drawings; I am sure that now I could make better compositions, and select better plants than when I drew merely for amusement, and without the thought of ever bringing them to public view. To effect this wish of mine, I must find a true, devoted friend who will superintend my work and see to its delivery—this is no trifle in itself. Then I must arrange for the regular payments of twelve months' work, and that is no trifle [either].

A long weekend at the end of May with the Swainsons in their modest house on the green at Tyttenhanger, northwest of London near St. Albans, removed the English naturalist from Audubon's Nabob list; Swainson made his living writing. Audubon enjoyed talking birds with a knowledgeable colleague and liked Mary Swainson's piano playing and her children "blooming with health and full of spirits." She judged him less generously to be a "guileless simple character," which he confirmed in small part by failing to notice her condescension, but the two men connected; Swainson, "a superior man indeed," was delighted to learn Audubon's wire-and-board method of mounting specimens.

Audubon spent the summer of 1828 painting oils, working on no fewer than eight at the same time. "With the exception of such exercise as has been necessary," he wrote in August, "and my journeys (often several times a day) to Havell's, I have not left my room, and have labored as if not to be painting was a heinous crime. I have been at work from four every morning till dark; I have kept up my large correspondence, my publication goes on well and regularly, and this very day seventy sets have been distributed." He had painted an eagle pouncing on a lamb "on the top of a dreary mountain" under a "dark and stormy" sky and a copy of the group of black cocks sunning on a Loch Lomond heath that he had completed in Edinburgh and sold for £100. The other oils were "smaller and less important." (The seventy sets began the distribution of Audubon's eighth Number, plates 41–45, led off by three animated ruffed grouse feeding on moonseed berries. Though the senior Robert Havell's name continued to appear with his son's on the plates, he had in fact retired in June at sixty years of age. With Robert Havell, Jr., responsible afterward for the entire production process—printing and coloring as well as engraving—the quality of the Numbers steadily improved.)

Audubon had just written Lucy when he described his oil paintings in his journal on August 9. He had received from her the day before three letters written at the beginning of May and finally delivered, he wrote her in return, "after nearly four months of anxious expectations and fears." He was happy that she and John were well, happy that she had received the Numbers he had sent. He hoped the dresses and the piano had also arrived. He had 125 subscribers, he reported; his ninth Number was engraving and the tenth also begun, which would complete the second year of his vast project. His anxiety to have Lucy with him was "greater every day—we are growing older and have been parted so long that I feel as if abandoned to myself." Victor had written him only three letters since he left America; Audubon was especially hurt that his son had not sent a letter with Basil Hall when Hall on his American tour had met Victor at Shippingport in late May.

Through Lucy he passed along opportunities for John Woodhouse—he needed many more bird drawings as well as skins and would pay John to draw and collect them—but the core of the long letter was his latest assessment of when they might come together:

Now my dearest friend my present situation is such that I have *lately* thought that *with care* we might live together in England, indeed so much so that I wrote to Mr. Gordon respecting the passage of thyself and John from New

Orleans payable at Liverpool by me. . . . I have not made up my mind pre-
cisely to write to thee to that effect *now* because I feel *timid* and *fearful* that
our style of living in London or near it might not meet with the ideas that
thou may have formed of my situation, which I will try to explain as much as
I can and hope may be properly understood by thee.

His situation was that he realized something more than £500 per year,
$2,200 (about $40,000 today), and hoped she would not expect more. They
could afford lodgings for that amount or a "snug house." He was trying to find
a permanent situation in one of the public institutions, but doing so would
take time. If she were with him she could watch over Havell's production when
Audubon needed to travel: "Two heads are better than one and I think it would
be of great mutual advantage." Choosing not to mention his developing plan to
return to America himself to make collections—of birds and of his reluctant
wife—he once again postponed a decision and made her responsible for her
choice:

> With such views I will wait with patience until the 1st of January because by
> that time having 10 numbers out I may expect that all those persons or insti-
> tutions who have taken the work that far will continue; it will have tried
> their taste, constancy and means of paying for the work during its further
> continuance. And should I then feel as solid as I now do I will hope to see
> thee in answer to my first request from after that date. . . .
>
> Shouldst thou however after having read this and thought maturely and
> deliberately prefer still to remain longer in America through fear of meeting
> with disappointments here, thou art at full liberty to judge and to act for
> thyself. . . . [But] if it be possible for thee to make up thy mind on the con-
> tents of this letter to come to me write me so; and if I on receiving thy
> answer feel as confident for the future as I now do I will write for thee to
> come at once.

Well, Lucy could take responsibility if her husband could not. What *she* was
feeling she revealed in a letter she wrote to Victor in mid-June. She continued
to have trouble collecting her fees from the planters whose daughters she
taught. She had been "terribly imposed upon this last six months. . . . These
people are selfish beyond my calculations." As Victor knew, she had sent John,
now fifteen, to Louisville to attend the Bardstown school and then to appren-
tice in business under her brother William, an arrangement that she hoped
would relieve her of some of the burden she had been carrying:

If I could see you both supporting yourselves and put $2,000 at interest here I need not work so hard and could afford to live near you all; this is a prospect to which I turn my thoughts and hopes. From your Papa I am quite at a loss to grasp anything. He complains of your silence, says it will be long before he has finished the *Birds,* that in the meantime as soon as he is *able* he will ask me to go over if I like with John, that England is not what it was, that I might not like it, that "if I do not choose to go he will when he does come to America bring me a Piano worth having." What he really means I cannot tell. Those are his words and we must interpret them as we can. The piano you bought [when Victor visited her in Louisiana] is so much better than the [piano Audubon sent her] that I shall keep it exclusively for myself and the other for the girls. The music [Audubon shipped her] is not worth a cent but I cannot tell this to your Papa. Any letter from you, my dear boy, is a treasure that says you are well and doing well. All my anxiety and hope turn to you two, if any good comes from any other quarter so much the better but I have ceased to expect it.

She had skeptical words as well for the first three Numbers that Audubon had sent her, which she was glad to have sold because "they do not seem to be much sought after." He had not sent her piano wire "nor hammer nor key, and such a rough ugly-looking instrument I fear it will never sell."

That was what Lucy told Victor. She spoke plain truths to her husband as well in a letter he received from her on August 13; Swainson heard his howl all the way out on Tyttenhanger Green:

I have had sad news from my dear wife this morning, she has positively abandoned her coming to England for some indefinite time, indeed she says that she looks anxiously for the day when tired myself of this country I will return to mine and live although a humbler (public) life, a much happier one. Her letter has not raised my already despondent spirits in *some things* and at the very instant I am writing to you it may perhaps be well that no instrument is at hand with which a woeful sin might be committed—I have laid aside brushes, thoughts of painting and all except the ties of friendship—I am miserable just now and you must excuse so unpleasant a letter— Would you go to Paris with me?

"I WILL SAIL FOR AMERICA"

T HE DAY AFTER WILLIAM SWAINSON HEARD Audubon's cry for help in mid-August 1828 the English naturalist went in to London and escorted the frustrated husband back to Tyttenhanger Green. As the two friends boarded the coach in London, a stranger handed Audubon a carrier pigeon confined in a paper bag and asked him to release it five miles out. "The poor bird could have been put in no better hands," Audubon wrote; when he boosted it into the air outside London he "wished from my heart I had its powers of flight; I would have ventured across the ocean to Louisiana." In the English countryside in the high-summer days that followed he pulled himself together "shooting, painting, reading, talking and examining specimens" with Swainson while they planned an excursion to the Continent.

Audubon, William and Mary Swainson and an American painter visiting from Natchez who had been painting Audubon's portrait, C. R. Parker, crossed the English Channel to France on September 1, Audubon distinctive in a fox-tailed cap on the deck of the channel boat, seasick. In Calais the American woodsman discovered that the French *commissionaire* who had processed their entry documents had described his complexion as "*copper red;* as the Monsieur at the office had never seen me, I supposed the word American suggested that all the natives of our country were aborigines." The Monsieur may have been thinking of the visiting Osages, still wandering Europe, though Audubon seems to have missed them.

The travelers rode through "shocking dust" from Calais to Paris in an "ugly and clumsy" five-horse *diligence.* The land was good, Audubon observed, but the country "poorly cultivated," without "cleanly trimmed hedges," gates or fences; it reminded him of "one of the old abandoned cotton plantations of the South," and the peasants along the way occupied "wretched mud huts." The

Industrial Revolution had not yet restored a country that decades of wars and revolution had impoverished. Even then, in 1828, Audubon remarked beyond St. Omer "the lights of the fires from an encampment of twelve thousand soldiers."

Arriving in Paris early in the morning on Thursday, September 4, after traveling all night, the four found rooms, Mary Swainson met her brother and the three men went off to the Jardin des Plantes to look up Georges Cuvier, a leader of French science, the founder of vertebrate paleontology and a professor and administrator at the Musée National d'Histoire Naturelle. Cuvier found time for them because he had heard of Swainson; Audubon's name was still a cipher. When Audubon informed the French scientist that he had christened a wren in his honor (Cuvier's wren—a mystery bird today, perhaps a ruby-crowned kinglet—soon to be Plate 55 of *The Birds of America*) Cuvier began paying attention. The future baron as Audubon described him was "corpulent, five feet five," with a large head, a "wrinkled and brownish" face, gray eyes, a large, red, aquiline nose, a large mouth and only a few remaining teeth, blunted "excepting one on the lower jaw measuring nearly three-quarters of an inch square." He invited the travelers to dine with him on Saturday.

In the intervening days Audubon and Swainson made their rounds while Parker painted. Audubon thought the Seine "not so large as the Bayou Sarah" and found walking disagreeable in the crowded, disorderly streets. He and

Swainson were surprised at "the immense numbers of birds offered for sale along the quays," including rare specimens from Bengal and Senegal. They met again briefly with Cuvier, who gave them museum tickets, and met two more French naturalists who promised their good offices, and then Audubon left Swainson to work in the museum while he visited the Louvre, where Parker had set up among a crowd of artists making oil copies of classics. A tragedy at the Théâtre Français finished out the evening.

When they dined on Saturday at the Cuviers' among a lively party of sixteen "Cuvier stuck to us and we talked ornithology." He asked Audubon the price of *The Birds of America* and the artist gave him a *Prospectus.* Sunday Audubon and Parker cabbed out to Saint-Cloud, on the Seine five miles below Paris, to attend a festival. Audubon was fascinated by the festival crowd, distinctly un-English in its orderly nonchalance; "everyone seemed joyous and happy." He toured the gardens of the King's palace and admired the orange trees heavy with fruit, but with his eye partial to English faces counted among the fifty thousand festival-goers "only three women of noticeable beauty," all three "short brunettes." Among the booths on the festival midway, hitting a bull's-eye with a crossbow released "an inflated silken goldfish as large as a barrel" that "rose fifty yards in the air," fluttering gauze fins, and "turned about almost as a real fish would do in his element."

On Monday, with an elegant hired portfolio and with Cuvier sponsoring him, Audubon took the seat of honor and presented his work at the Académie Royale des Sciences. He endured "a tedious lecture on the vision of the Mole," but Cuvier's praise and the approval of the membership more than made up for the tedium. Stuck in the audience playing second fiddle to someone he considered his intellectual inferior, Swainson was chagrined.

Thereafter for the rest of the month, as the Swainsons resentfully withdrew, Audubon made the rounds of science and society, soliciting subscriptions. The ailing thirty-year-old Prince of Massena, a son of one of Napoleon's marshals, received him languishing on a sofa, identified him from Charles Bonaparte's description as "the man of the woods," thought his work was very beautiful and signed on while regretting that "there were so few persons in France able to subscribe to such a work." Walking home one night from the opera (Rossini's *Semiramide,* in its fifth year of performance), Audubon noted that "the pure atmosphere of Paris, the clear sky, the temperature, almost like that of America" made him "light-hearted," but the air less polluted than London's also signaled France's lesser state of industrial development that supported fewer wealthy bourgeois. Though the Académie Royale members praised his plates

when he displayed them there for a second time on September 15, they judged the price too dear:

> "Beau! bien beau!" issued from every mouth, but "Quel ouvrage!" "Quel prix!" as well. I said I had thirty subscribers at Manchester; they seemed surprised, but acknowledged that England, the little isle of England, alone was able to support poor Audubon. Poor France! Thy fine climate, thy rich vineyards, and the wishes of the learned avail nothing; thou art a destitute beggar, and not the powerful friend thou wast represented to be. Now I see plainly how happy, or lucky, or prudent I was. . . . Had I come first to France my work never would have had even a beginning; it would have perished like a flower in October.

With the flower painter Pierre Joseph Redouté Audubon exchanged compliments and works. Redouté as well arranged an introduction to Louis Philippe, the Duc d'Orléans, a formerly Jacobin noble who had fought on the side of the people until the regicide, had fled to America and supported himself teaching French and drawing at a dollar a lesson and had returned to France after 1817 and restored the family fortunes (and would be crowned King of France after the 1830 revolution). "I have . . . seen many a noble-looking Osage chief," Audubon wrote of the handsome fifty-five-year-old, "but I do not recollect a finer-looking man, in form, deportment and manners, than this Duc d'Orléans." Of America, which the duke remembered fondly, he told Audubon, "You are a great nation, a wonderful nation." He signed his name with a flourish in Audubon's subscription book.

A protégé of Jacques-Louis David, the portrait painter François Gérard, welcomed Audubon to his apartments as a "brother in the arts." When he saw Audubon's Carolina paroquet and mockingbird plates he shook his hand again, saying, "Mr. Audubon, you are the king of ornithological painters. We are all children in France or Europe. Who would have expected such things from the woods of America!" Despite the risk of being exposed, Audubon would continue to maintain the fiction that he had studied under David; a more secure artist might have learned from Gérard's extravagant praise that he needed no credentials beyond his own unique work. Cuvier praised him equally warmly in a report to the Académie Royale des Sciences on September 22, calling his *Birds* "the most magnificent monument which has yet been erected to ornithology." Formerly, Cuvier said, "the European naturalists were obliged to make known to America the riches she possessed; but now . . . we

shall be obliged to acknowledge that America, in magnificence of execution, has surpassed the old world."

Cuvier accepted and repeated Audubon's claim that he had been born in Louisiana and had studied under David. His illegitimacy threatened to emerge when Audubon learned from a French zoologist, René-Primavère Lesson, that the man had known Audubon's old Couëron mentor Dr. Charles-Marie d'Orbigny, and that a d'Orbigny son, also named Charles and twenty-one years old, was a medical student in Paris. If Lesson knew the elder d'Orbigny, Audubon realized, then he might know that Audubon had been born a bastard: "Lucy, my blood was congealed in my veins." He had already decided not to go to Nantes because "the cloud that still hangs over my birth requires silence." What would become of his great work if the nobles who received him and paid for subscriptions learned that his origins were backstairs? Audubon was torn. "I felt to remain in France and to be known as I now must shortly be known . . . was dreadful and made me tremble." At the same time, he wondered "if now was the moment to dispel the cloud . . . I reflected on the consequences, wiped the stream of water that ran cold over my forehead and concluded to carry my extraordinary secret to the grave."

He met the younger Charles d'Orbigny on October 8. "He told me he had often heard of me from his father and appeared delighted to meet me. He too, like the rest of his family, is a naturalist, and I showed him my work with unusual pleasure. His father was the most intimate friend I have ever had, except thee, my Lucy, and my father." From the young d'Orbigny Audubon learned for the first time that his adoptive mother Anne Moynet had died in 1821. Protecting his public reputation from scandal to protect his grand project, he had limited his communication with Couëron all too well. Night found him sleepless with anxiety: "I turned over and over in my sweated bed until wearied by sorrow; I was glad to see glimpses of daylight to change the scene. . . . The strange scenes attached to my own early life so stared me in the face that I saw naught but specters before me. St. Domingo, France and my beloved country all had their turn. How dreadful. . . . Oh! My Lucy! How I regret this journey— it has opened all my wounds afresh."

The King subscribed, Cuvier, the Prince of Massena, the Duke and, separately, the young Duchess of Orléans, the minister of the interior on behalf of six royal libraries and three other patrons, for a modest total of fourteen subscriptions harvested during two months in France that set Audubon back £40. "Paris is a small town compared to London," he concluded. Returning to Calais at the end of October 1828 he was struck again with "the great poverty of the country. . . . The peasantry are beggarly and ignorant, few know the name of

the *Département* in which they live; their hovels are dirty and uncomfortable, and appeared wretched indeed after Paris." Two elegant young Angola cats and a new pair of boots he had purchased in Paris were stolen from the *diligence* between Paris and Calais, but he was grateful at least not to be seasick on his passage across to Dover, and his secret was safe.

Two more letters from Lucy in which she refused to leave America had reached him in Paris and hardened him from grief to anger. A letter from Victor he found on his return to London fueled the fire. November 2, the day after his return, he challenged Lucy at length about the consequences of her decision:

> I wrote this day a very long letter to Victor which if he receives it will make him open his eyes respecting my publication that *you all* seem not to know any thing correct about. Do my Lucy understand me well: my work will not be finished for 14 years to come from this very present date, and if it is thy intention not to join me before that time, I think [it] will be best [for] both of us to separate, thou to marry in America and I to spend my life most miserably alone for the remainder of my days. . . .
>
> Thy views are different from mine and no doubt must remain so forever to the great disadvantage of both. . . .
>
> From thy last two letters . . . I have now most positively concluded never to write to thee to join me until indeed I find myself so overflowing with cash as to be able to give thee these extraordinary comforts without which it appears my being thy husband is of but little consequence. In every letter of thine thy words are the same: thou art *comfortable in the extreme.* I wish I could say half as much. I am sick of being alone and from thee and how much longer I will bear [it] is a little doubtful.
>
> I have not jumped yet into a fortune in Europe. I am I *think* doing extremely well in a pecuniary point of view and could maintain comfortably a wife desirous to render her husband happy as I know some in the world [are]. My income now annual[ly] is rather more than 600 pounds sterling or $2664. . . . Not a friend have I on *this earth* to whom I can speak openly. All my business is locked up in my own bosom, scarcely now can I give a single letter of business to copy. This, my Lucy, [is] the situation of a man who is married to a woman clever herself, amiable as much as I possibly could wish but unfortunately fond of a style of life that [her] husband . . . cannot at present at least meet for the want of thousands per annum.
>
> I write now most candidly, I write as a man who esteems his wife as a valuable friend, who loves her tenderly and would render her happy to the

utmost of his means with all his heart and soul. Thou sayest in thy last that to come to Europe without thy children would break thy heart, and at the same time seem not to care about *my* heart being broken, because *they* will not come to Europe. Depend upon it, Lucy, our affections are not of adamantine substance. Distance, long separation works strong[ly] on the mind and the physique at our age; who knows but some many years more of such separation as thou seemest willing to undergo will not unroot the feelings of our early days [so] that when we meet again we may find each other strangers to both in new habits, manners & feelings? Thy means of living at present do not I am sure exceed 5 or 6 hundred dollars per annum, why not receive that same sum from thy husband and half as much again and be with him—comfort him in times of troubles and sorrows and assist him in his labors?

The delay and overlap of their correspondence made for recurring heights and depths of misunderstanding. When Audubon wrote Lucy again on November 17, responding to letters she had posted long before receiving his angry ultimatum, her earlier willingness to travel to him softened his tone. "I am truly happy at the thought," he told her; if he sounded cautious it was only because he did not wish her "to expect too much—and to see thee unhappy and discontented now would infringe on my faculties." He had "a parlor, a painting room, a bedroom, a kitchen and a servant room" as well as a servant, but she could choose other lodgings when she came over if she preferred.

To Victor he confided "how grieved I have been and am still at the regularity of the silence of your Uncle Berthoud towards me." Audubon had written Nicholas Berthoud eight times since he arrived in Europe, he told his son, and Berthoud had answered not one of his letters. Berthoud had not even asked to be remembered to Audubon in Victor's correspondence. "Can *you* give me any reason why?" But the reason—Berthoud's paternalistic disapproval of Audubon's entire venture, of leaving his wife and children behind to fend for themselves—was all too obvious. That Lucy had encouraged her husband to gamble on European publication and was perfectly capable of shouldering the responsibility for herself and their children counted for little with her prosperous brother-in-law.

Since Audubon was bound by his early agreement never to discuss politics or religion in his correspondence with his wife, he queried Victor about the new president. "I would be glad to know the sentiments of the Americans generally respecting the election of General Jackson. Here where everything that is

Yankee is ridiculed it appears to make a sensation, but I daresay like everything else in London it will live but one week!"

Audubon himself and his electrifying birds were a notable exception to his one-week rule, neither ridiculed nor short-lived. As of December 23, when he wrote Lucy again, he had 144 subscribers, whose payments would net him almost £800 a year provided he could collect it. Victor and John, he told his wife, had written that they wanted to stay in America and live and work with their uncle William Bakewell. As Audubon was collaborative rather than paternalistic in his relations with Lucy, so also was he tolerant of his sons: "I have not the least objection. I love my sons dearly but I love them for their own sake and not the mere idea that because they are my sons I must dictate to them when they are sufficiently able to act for themselves & their comforts."

Christmas Day he dined with a Yankee businessman, George Goddard, "with a company mostly American, principally sea captains." Swainson, despite his resentments, had presumed on their friendship to borrow £80 and Audubon had lent it willingly. Thomas Bewick, the woodcut artist, whom Audubon had seen again briefly in London shortly before the excursion to Paris, had died at seventy-five.

Audubon's angry letter of early November finally reached Lucy in Louisiana in late January 1829. She immediately wrote Victor to confide to her nineteen-year-old son what she could not confide to any of the people she lived among or to her husband far away in England:

> Now I must revert to the subject of your Papa's last letter received tonight which is a very severe and painful one, and poor consolation for all my labor. You are now of an age to be my friend, my comforter and confidante. The date of the letter is early in November, when he had just come from Paris. He obtained 14 subscribers and says he was much pleased with his trip, not a word of his relations [in Couëron], has now 144 subscribers—much less than I expected from former advice, that he has got a letter from you in which he finds that neither of his boys will join him, and doubts whether I will, that we have no consideration for him, that I require from him a "Princely Domain," but I must say whether I mean to go over soon or not because if not we had better have a formal separation, as he cannot answer for the continuance of his affections much longer. . . .
>
> Surely your father is blind to the real state of affairs. For these eight years I have relieved him of all expense but himself, paid him $500 with him [when he left New Orleans for Liverpool] and three hundred since he went

away in demands here, and he says I write "I am extremely happy here" which I'm sure I never did. I only have said I had the comforts of life and did not wish to move till he could ensure me the continuance of them, which I had not at Cincinnati, Natchez, or [New] Orleans.

I have however concluded to give up my school after *this* year and take John with me, to whom a few years more of instruction in Europe either in a school or counting room would be beneficial, and trust to Providence for my happiness and yours. In a few years it is possible we may be able to afford [for] you to take the voyage and bring your brother back to his country if I cannot come then.

This is what I now think of but will not speak of it to anyone but you, and circumstances may change. . . . I shall only write to your father that I will wind up my business and cross over as soon as I can; now it is impossible, for half the year would be gone before I could send him word . . . and I hope this year if nothing happens to me to save a thousand [dollars]. But keep this to yourself. . . . Do not write to your Papa anything about it, my dear son. Leave it to me to settle with him.

Before Lucy Audubon in Louisiana could let her husband know that she would give up her work and her children and cross the Atlantic to join him rather than risk losing him, Audubon in London received an *earlier* letter of hers *refusing* to leave her school and its security until he was more settled and more certain of his income. And just as she had changed her mind when she realized she risked losing him, now *he* changed *his* plans rather than risk losing *her,* writing her dramatically on January 20:

Ever since [receiving your letter] I have been debating what was or would be the best thing to do. . . . I have therefore come to the following conclusions, which thou mayest take for granted if I have life within me: I will sail for America (New York) on or about the 1st day of April next and will (God willing) be on American soil once more in all May next.

I had no wish to go there so soon, although as I have often repeated to thee, I always intended to go on account of my work; but I have decided in doing so *now* with a hope that I can persuade thee to come over here with me and under my care and charge. . . .

It is not my wish to go as far as Louisiana but as far as Louisville, Kentucky, where after my landing we will make arrangements *to meet never to part again!* I have been induced to come to this firm and decided conclusion because writing is of no avail, thou couldst not understand my situation in

England or my views of the future was I to write 100 pages on it—but will understand me well in one hour's *talk!*

. . . I hope to make thee happy & comfortable here the remainder of thy days—I wish to be absent just 12 months and on my return I will have material enough to finish my stupendous work. . . .

Then until we meet bless thee my dearest friend & thy husband forever

John J. Audubon

The letter would arrive none too soon. In Louisiana, ten days after Audubon wrote it, Lucy had sent Victor $400 for his and John Woodhouse's support and described her financial situation, which was tangled up with unpaid notes but still prosperous. She had fifteen "music scholars," she told her son, sounding like her husband in his tallies of subscribers, and had added another since she began her letter. "This last year till November I had no school scarcely from the expectation of leaving. Now I have really a profitable and agreeable school, and though it is my serious intention to give it up the last of December next, I do not mean to say so until the moment comes." But she was far from happy: "I sometimes consider why I wish any longer to live. All my best days are over and yourself and John will soon be able I trust to provide for yourselves."

Audubon had realized, months before, that he needed to redraw a number of birds from original specimens as well as to draw other birds he had not yet collected to make his volumes comprehensive. In one letter to Lucy in 1828 he had estimated that he would "have to go to America in about 3 years but only for 3 to 6 months at most." What had torn him and rendered him indecisive— besides the private struggle over whether or not he could support Lucy better than he had done in the difficult years after Henderson and how much support Lucy expected—was his fear that the "stupendous work" he had undertaken might founder for lack of his management if he absented himself abroad. In his January 20 letter he spoke of making "all such preparations & arrangements as I can best adopt for the safety of the progression of my publication, the collection of my dues, the insurance of my drawings, copper plates & oil paintings &c." He was so concerned about losing subscribers, he told Lucy in that letter, that he was thinking of leaving England incognito, traveling under the name John James, for fear subscribers would defect if they knew that the Numbers for 1829 were being produced without his direct supervision.

By February 1 he had resolved these issues. J. G. Children of the British Museum had generously offered to serve as his agent and watch over his drawings while he was absent. Children had talked him out of traveling incognito; his subscribers, Children sensibly advised Audubon, would be glad to know he

had returned temporarily to America to collect new birds. Audubon felt he could trust Robert Havell, Jr., he wrote Lucy, with "the drawings wanted to keep the work going for 12 months, all my unsold paintings, books and stuffs &c." He warned her that he would have no time for leisure in America; he would have to "*draw hard* from nature every day." He was confident that Lucy would agree to return to England with her husband, "but we will talk of that when again our lips will meet." It had been a long absence, he wrote with feeling, "a great change in manners," but he offered her "the same sound heart as ever and as ever devotedly attached to thee." He signed the letter "thy husband for life."

And Lucy also, not yet having heard that her husband had decided to come and get her but having decided to go to him at the end of the year, had put aside her despair and was writing him multiple letters, as he had requested her to do to assure that at least one would be delivered, telling him she was preparing to meet him in England if he still wanted her. She wrote him on February 8:

> You say you must not speak as a "man in love." I do not see why, if you do love, which there seemed some doubt of from your last; I must attribute it to a fit of blues, for I cannot believe you so lost to reason and sense as to blame me for the part I am performing. I am however come to the resolution of giving up my occupation, and joining you as soon as I hear from you finally that you desire it, and can place John for a year or so at a first-rate school; then in a counting room, and by that time we may be able to return with him to America. I beg of you my husband to be plain and clear in your reply, if any circumstance has occurred to change your affection for me as you rather insinuate be explicit and let me remain where I am. If on the contrary you still think I can add to your happiness and John can finish his education, you will find me prompt in preparing to quit Louisiana as soon as I can collect my funds to travel with.

And again on February 20:

> I shall be endeavoring to have all ready by the close of this year, and nothing but your letters will change my plans, however as both the boys will remain behind for some time I can leave my business to be settled by them, and come over to you and try what we can do for them. I hope that it will not be long before you can return to them and America for my thoughts will be often, very often of this side the globe. . . . I cannot help hoping you may some day realize enough to enable me to live near them or with them. And

my leaving them and going to you is a proof of affection and duty towards you of the highest kind I could give.

And again on March 22:

When I see you I can fully detail all. It is enough now for me to say if I come I give you myself, my endeavors to increase your happiness, and my heart. Nothing more have I, and if it is your opinion or wish I should continue my avocation longer say so, if not in a few months now we shall meet, and I hope and trust for the advantage and comfort of us both.

In this third letter she also stated plainly how she looked and who she was:

I am now forty, I have no indication of age but gray hair and loss of teeth, I may live many years yet, and must have a good constitution to endure the unceasing fatigue I do and have not had a fever since I left Mrs. Percy—the headache and want of breath being all I ever suffer from and change of life would I am pretty sure remove them, however this is uncertain and I live, and regulate all concerns relative to me as if I was to be called to the other world any moment.

As he had sworn to Lucy he would do, Audubon sailed from Portsmouth for New York on the packet ship *Columbia* on April 1, 1829. Before he left England he selected twenty-five original drawings from his portfolios for Robert Havell, Jr., to engrave, color and publish in his absence as Numbers 12 through 16 of *The Birds of America*. Among the twenty-five was a drawing of a swamp sparrow perched on a May-apple stalk, which would become Plate 64. Audubon was certainly the artist who created it, but he singled out the drawing to honor the woman he loved, missed terribly and was crossing the Atlantic to claim. "Drawn from Nature by Lucy Audubon," he wrote on the drawing for Havell's instruction. "Mr. Havell will please have Lucy Audubon's name on the plate instead of mine."

Twenty-two

A MAN IN A HURRY

A UDUBON OBSERVED his forty-fourth birthday at sea. He was "seasick all the way," however, and grateful for a swift thirty-five-day passage. The *Columbia* docked in New York at eleven in the morning on May 5, 1829. When the customs collector read the three-year-old letter of introduction Audubon carried from Andrew Jackson, now President, the man "gave free admission to my books and luggage." Audubon carried a bound volume of his first fifty prints, an "immense book," which he exhibited at the New York Lyceum within a day or two of his arrival. He also looked up his early mentor Samuel Latham Mitchill, but found him sadly "lost to himself and to the world . . . half dead with drunkenness." The New Orleans packet was about to sail; to take advantage of the opportunity Audubon scribbled a hasty note to Lucy. "I have come for *thee*, dearest Lucy!" he told her, promising a full report "in a couple of days."

Sunday, May 10, Audubon sat down to draft that freighted report, even numbering his several points as if he were writing a legal contract. Since he had not yet received Lucy's letters of February and March in which she proposed to leave Louisiana at the end of the year to join him in England, he was unaware of her need to continue teaching until she could collect her full year's fees in January 1830. So the first point he made in his May 10 letter—that the advice of his friends in England overseeing the production of *The Birds of America* would determine whether he returned to England on "the 1st of October next" or on the following "1st of April 1830"—already seemed to pit Lucy's necessities against his own.

His second point challenged her hopes as well. He needed to collect and draw more than one hundred species of birds on this visit to America to make his publication as comprehensive as possible. To do so he would have to "remain as *stationary* as possible in such parts of the country as will afford me

most of the subjects"—which meant that he would not be able to travel to Louisiana to meet her, at least not immediately. Louisiana in any case seemed to him too far from reliable contact with London to risk.

He wrote her that he had left behind in England accounts receivable, valuable engraving plates, stock, cash and salable paintings worth almost $7,000 and traveled with cash and personal property—his gun, his watch, the bound volume—worth about $1,500. Some $3,000 would accrue from subscribers in England in his absence; he expected to add more subscribers as well. With this "present stock of thy husband" as collateral he proposed a bargain couched self-consciously in sacramental rhetoric but meant to be loving:

> To my Lucy I now offer myself with my stock, wares and all chattels and all the devotedness of heart attached to such an enthusiastic being as I am—to which I proffer to add my industry and humble talents as long as able through health and our God's will, to render her days as comfortable as such means may best afford with caution and prudence. In return for these present offers I wish to receive as *true* and as *frank* an answer as *I know my Lucy will give me,* saying whether or no, the facts and the prospects, will entice her to join her husband and to go to Europe with him; to enliven his spirits and assist him with her kind advices.

The "no" or the "yes" will stamp my future years. If a "no" comes, I *never will put the question again* and *we probably* never will meet again. If a "yes," a kind "yes" comes bounding from thy heart, my heart will bound also, and it seems to me that it will give me nerve for further exertions!

We have been married a good time; circumstances have caused our voyages to be very mottled with incidents of very different natures, but our *happy days* are the only days *I now remember.* The tears that now almost blind me are the vouchers for my heart's emotions at the recollection of those happy days! I have no wish to *entice thee to come by persuasions;* I wish thee to consult *thy own self* and that only, and to write to me accordingly thy determination.

None of this was problematic, since Lucy had already written him that she would join him and trust him to provide for them. He added next, however, that he wanted her decision promptly: he expected her to close her school, settle her accounts and meet him in Philadelphia, or at least Louisville or Wheeling, before October 1, "because should I be recalled to England on account of [publication problems] we must sail on *that day* in the same vessel that has brought me here."

While this latest exercise in confusion and misunderstanding made its fortunately shorter way from New York to Louisiana, Audubon removed first to Philadelphia and then to Camden, New Jersey, in search of birds. From Camden on June 5 he wrote the New York Lyceum's William Cooper, Charles Bonaparte's friend, that he was enjoying "once more that style of life of which I am and always were fondest." He had seen "nothing new, but some very rare specimens for this part of the Union." He had learned in England that British and Continental museums would pay well for specimen skins to add to their display collections; in the swamps of New Jersey in the previous two weeks he had "killed a great number of whippoorwills, night hawks, fish hawks &c., in all more than 300 specimens, the skins of which are now safely prepared." If he had "felt a dampening chill run through me" as he had walked the streets of Philadelphia remembering "the poor support the great Wilson met with" there, shooting, skinning and putting up three hundred specimens had worked out the chill in blood. Between Audubon and Philadelphia there was never any love lost.

He crossed the New Jersey barrens the next evening, a Saturday, to Great Egg Harbor, riding with one of the "fisherman gunners" who "passed daily between Philadelphia and the various small seaports with Jersey wagons laden with fish, fowls and other provisions" in a caravan of horse-drawn wagons that followed

the New Jersey roads of "loose and deep sand." Around midnight they stopped at a halfway house. A runaway wagon that came up behind them on the post-midnight leg of their crossing nearly overturned them. Dawn started mead-owlarks singing. At a fisherman's cabin only a few hundred yards from the shore his host's wife served him his first meal on the shoreline, a plate of oys-ters "as large and white as any I have eaten." He spent the rest of the day writing letters and settling in. Monday at daybreak he shouldered his gold-chased double-barreled shotgun (souvenir of his New Orleans Fair Incognito adven-ture), his fisherman-gunner host took up a fowling piece, the man's wife and daughter hauled along a seine and they rowed out through the marshy inlets in search of birds and fish.

Audubon produced one of his finest drawings at Great Egg Harbor, his iconic fish hawk (osprey) seen from the bird's own eye level as if the viewer were flying alongside, Plate 81 of *The Birds of America*. The big, intent predator, two feet long from beak to tail, with a nearly five-foot wingspan, carries a weakfish as iridescent as a trout and as long as the bird itself, and the fish's gasping mouth repeats the beak of the bird opened in a cry. White below, dusky brown above, with a barred tail of broad, rounded feathers, the fish hawk flies in Audubon's drawing with its far wing nearly vertical, fully ex-tended, and its near wing edge-on and foreshortened, making the powerful wings seem to beat—motions in the air, Audubon wrote, as "graceful and as majestic as those of the Eagle." The image could hold its own chiseled in mar-ble or stamped on a gold medallion.

"When it plunges into the water in pursuit of a fish," Audubon wrote of the fish hawk, "it sometimes proceeds deep enough to disappear for an instant. The surge caused by its descent is so great as to make the spot around it present the appearance of a mass of foam. On rising with its prey, it is seen holding it in the manner represented in the Plate. It mounts a few yards into the air, shakes the water from its plumage, squeezes the fish with its talons, and imme-diately proceeds towards its nest to feed its young." Fish hawks were plentiful at Great Egg Harbor, he added, where he had seen "upwards of fifty of their nests in the course of a day's walk." To Lucy he wrote on June 18 that he was "once more do[ing] just as I am fondest of doing, i.e. eat, walk, shoot, draw, get up or lay down when it suits my purpose—very different indeed is this *moment of life* from that spent in smoky London."

Lucy, now forty-two years old, had received Audubon's first letters from New York but not yet his long letter of sacramental bargaining when she wrote him in exasperation in mid-June. She had expected him to proceed directly to New Orleans from New York, she complained; she was "surprised and grieved"

that he had stopped instead to collect and draw, his letters were "dubious and cold," nor was she in any mood to persuade him to come for her "because the result would be fatal." (She meant fatal to their relationship, of course; she was not personally violent.) If he had anything to do in the North "you had better do it now since things are as they are and we can settle all here and leave together in the winter." She had written him three times in the past three days and hoped those letters would reach him. "I would beg you to believe all for the best and wait my explanations in fullest measure." She added what she called "smaller things," which were blunt and bitter:

> I am glad to hear your hair is short, however handsome some might call it when long, but the recollection of it would bring ideas and appreciations to mind which I wish ever to *bury*. For myself I must say there is a considerable change. I am gray quite, no teeth, and thinner than ever I was and of course older. But my heart [and] my head [are] the same and yours for "better or worse" as the saying is, after December.

Back in Philadelphia in mid-July, preparing for an expedition to the Great Pine Swamp along the Lehigh River below Wilkes-Barre in northeastern Pennsylvania, still unaware of Lucy's situation and her determined correspondence, Audubon wrote her blithely asking her to "put thy hand to the pen oftener and write clearly." He had "thousands of things to say" to her; "indeed, I long much to be assured that I have a wife in this world." He had "found a young gentleman of the name of Lehman, a German, who I knew at Pittsburgh 5 years since, who is helping me [with] my plants." George Lehman was Swiss. He had floated the Ohio with Audubon in October 1824 and would serve as Audubon's artist for backgrounds and plants in the years to come, much as Joseph Mason had served during the New Orleans years.

By the time Audubon wrote Victor in Louisville on July 18, he had heard that Lucy did not expect to conclude her work in Louisiana before the end of the year. He had been in America "for two months and 13 days," he complained, but had not yet had one word from his firstborn son. "Where are you?" he asked Victor impatiently. "What are you doing? Are you as your mother seems to be quite unwilling to believe that I am doing all I can for the best for all of us; and in such a case have you abandoned the idea of ever answering my letters?" It was "neither kind as a man or dutiful as a son," Audubon scolded, "to keep such an extraordinary silence." Most of the long letter that followed recapitulated what Audubon had already told Lucy about his publication, his resources and his schedule. But just as Lucy had done when her husband was challenging her

from England, Audubon now made Victor his confidant, hoping that to persuade the son was indirectly to persuade the mother:

> I came to America with two views in thought—one to engage your dear mother to go to England with me if agreeable to herself and secondly to make a series of drawings such as I think necessary to enable me to continue my publication on the same plan and regulations that have existed since its beginning. I wrote to this effect to your Mamma, explained my plans as well as my poor style of writing will permit me to do, &c. Three long years have elapsed since I saw your Mamma and about 5 since you and I walked together. . . .
>
> [Arriving in America] I felt as if the world smiled to me once more and wrote to your mother to join me as I would write to my only friend in the world. I wrote to you to say all this and more, and now I am with 2 letters of your mother only. Those two are full of doubt & fear, nay quite the contrary of which I expected. She is not able to come to me for the want of funds; neither can she collect any until fall or winter, and *I cannot go to her* because was I to lose my summer by so doing I would miss the birds that I want and that are not at all to be found *west of the mountains.* She does not seem to understand this; she complains of my want of affection; of the coolness of my style of writing &c., and thinks that my not going to Louisiana for her is quite sufficient proof for all these her doubts and fears. Ever since I left her I never have had from her a letter containing the *facts of her situation,* never have known how much or how little she made or received; but on the contrary from her independent manner of expressing herself have always hoped that she was doing well and happy. . . .
>
> When I left London I had it in contemplation to have returned to England by the 1st of October from New York. Now that I know of your mother *that at all events* she cannot join me before December or thereabouts, I have written to my engraver and my friendly agent Mr. Children of the British Museum to say to them *that it was very probable* that my sailing from New York would not take place before April or May next. Your Mamma is afraid, it appears, of traveling by herself.

Even in the midst of these painful family disputes there was good news: Audubon had finished twenty drawings so far, which he quantified for Victor, a businessman after all, as "positively worth £400!" He still hoped to renew a hundred drawings as well, which made "every day . . . of the greatest importance." Of all the misconceptions that frustrated Audubon in his relations

with his wife and children, the most painful was their lack of understanding of the extent of his success. Having no experience by which to comprehend the celebrity that supported his publication, a phenomenon still confined in America to military and political leaders such as Lafayette and Andrew Jackson (and certainly not visited upon artists), they could only read his enthusiastic but factually accurate reports as inflated special pleading or, worse, as dilettantish dereliction of his duty to the wife and sons he had left behind. The urgency of his need to collect and to draw to sustain his ambitious publication was therefore lost on them. Audubon tried to explain his conflict to Victor, but doing so reminded him of Nicholas Berthoud's long, cold withdrawal from correspondence (and Victor's complicity in it) and he ended his explanation defensively:

> You, my dear son, must not conceive that the want of affection keeps me east of the mountains and that should I not ever see you or your brother [while in America] it is because I have not the wish. No, my dear boy, I am more pained at such a visit to America than anyone may conceive: and I foresee the numberless critics of my conduct tearing me into piecemeals about it. Nevertheless, neither these critics nor no one in the world but you and I know the reasons and the force of those reasons and therefore little will I care about the criticism. I probably might have had other inducements to go to Kentucky had I had a friend there besides my son, but at present I know no one in that country by that precious name, and I may safely say that I *paddle my canoe* in the face of the storm, and against strong contrary currents—but no matter.

After he wrote Victor in mid-July Audubon organized his expedition into northeastern Pennsylvania. He departed Philadelphia by coach at four in the morning, "with no other accoutrements than I knew to be absolutely necessary for the jaunt which I intended to make. These consisted of a wooden box containing a small stock of linens, drawing paper, my journal, colors and pencils together with some 25 pounds of No. 10 shot, perhaps 50 flints and as much cash as I supposed would pay the expenditure of my stay; my gun *Tear-jacket* and a heart as well-disposed as ever to enjoying the situation to come." Eighty-eight miles from Philadelphia in the middle of the night he left the coach at Mauch Chunk—"sleeping bear" in the language of the Lenape Indians—a small village on the Lehigh River below the rounded mountain from which it took its name. After a few excursions Audubon realized to his disappointment

that the Mauch Chunk neighborhood was destitute of birds, so he hired a horse and cart to carry him through a drenching rainstorm into the Great Pine Swamp—more a forest than a swamp—northeastward of Mauch Chunk along the Lehigh. There, with his usual wilderness luck, he found a cabin by a noisy stream in a dark section of laurel and pine forest occupied by a tall, skillful woodsman named Jediah Irish, a millwright for the Lehigh Coal Company, and his family. The Irishes took Audubon in and boarded and guided him for the next six weeks.

"The long walks and long talks we have had together I never can forget," Audubon wrote of his time with Irish, "or the many beautiful birds which we pursued, shot, and admired. The juicy venison, excellent bear flesh, and delightful trout that daily formed my food, methinks I can still enjoy." Irish read his favorite poetry—the verse of Robert Burns—aloud to Audubon "while my pencil was occupied in smoothing and softening the drawing of the bird before me."

The millwright directed his company's logging operations in the Great Pine. Audubon found them fascinating technically, but he recognized their destructiveness. He had explored a frontier wilderness in his Henderson years; now he collected in a forest that teams of hired loggers were working relentlessly to strip:

> No sooner was the first sawmill erected than the axemen began their devastations. Trees one after another were, and are yet, constantly heard falling during the days; and in calm nights the greedy mills told the sad tale, that in a century the noble forests around should exist no more. Many mills were erected, many dams raised in defiance of the impetuous Lehigh. One full third of the trees have already been culled, turned into boards and floated as far as Philadelphia.... Shall I tell you that I have seen masses of ... logs heaped above each other to the number of five thousand? I may so tell you, for such I have seen. My friend Irish assured me that at some seasons, these piles consisted of a much greater number, the river becoming in those places completely choked up.

Audubon recognized that one consequence of this invasion was a decline in bird populations. Bear and deer were still plentiful, since "many of both kinds are seen and killed by the resident hunters." He thought that "the Wild Turkey, the Pheasant and the Grouse" were also "tolerably abundant," but his own experience with wild turkeys qualified that conclusion:

In the course of my rambles through Long Island, the State of New York and the country around the Lakes, I did not meet with a single individual, although I was informed that some exist in those parts. Turkeys are still to be found along the whole line of the Allegheny Mountains, where they have become so wary as to be approached only with extreme difficulty. While in the Great Pine Forest in 1829 I found a single feather that had been dropped from the tail of a female, but saw no bird of the kind.

Audubon "made many a drawing" during his sojourn in the Great Pine. His red-crested, pileated woodpecker family harvesting grubs in a dead tree entwined with fox grapes (Plate 111 of *The Birds of America*) dates from this excursion; he tracked the family of male, female and two young for several days before he succeeded in collecting it. He collected a Canada warbler and a black-throated blue warbler on August 11, a black and yellow warbler (magnolia warbler) on August 13, an autumnal warbler (bay-breasted warbler) on August 20. Alexander Wilson had been in the forest before him; Audubon followed his predecessor's track through the stands of "gigantic hemlocks" to collect the so-called hemlock warbler that Wilson had written he had discovered there. Wilson had in fact misidentified a female Blackburnian warbler as his new species; Audubon followed Wilson's lead. In all, the Great Pine gave him specimens for ten new drawings, increasing his production so far in 1829 to thirty.

He mentioned the number when he wrote to Victor from the Great Pine on August 25. To a challenging letter from Victor he responded impatiently that "it is useless for me to write a quarto volume to assure you of my affection for you." He would see his son soon enough. One of Victor's comments prompted Audubon to write the only deliberately cruel sentence to be found in all his voluminous surviving correspondence. He felt keenly what he took to be his family's demand—Victor's as well as Lucy's—that he accumulate a large reserve of capital before they would risk giving up their independence, which was a response to their past hardship but also a question of trust. Victor's present employer in Louisville was Will Bakewell, Lucy's younger brother, now twenty-nine and a successful businessman, who had followed Nicholas Berthoud's lead in cutting off communication with Audubon across the past three years. Victor had mentioned that his uncle had lost a child. Bitterly measuring Victor's mistrust against Will Bakewell's family tragedy, Audubon slashed back: "I am sorry to hear of your Uncle W[ill's] loss of a child, but it is an easier matter to make another than to make a fortune for one."

Although Audubon in his July letter to Victor from Philadelphia had seemed to understand that Lucy was bound to her work for the rest of the year

by the impossibility of collecting her fees before January 1830, he continued to write her as if she were free to pack up and move north at her own discretion, as he did on August 28:

> I feel so very uneasy and uncomfortably that I have not a line from thee yet saying, "I will leave such month; and will be at Louisville in Kentucky about such time or thereabouts." I have been in America now 4 months full, and although I expressed my extreme wish to have thee to join me as soon as thou couldst settle affairs and arrange thy business to the best advantage and at thy convenience, not a word have I yet [that is] at all satisfactory. Let me beseech thee, my dearest Lucy, not to pine away and make out conjectures and all sorts of ideal fears. Let me beseech thee also to be assured that my not going to Louisiana is much more to our mutual advantage than if I had done so, as my poor heart thoroughly dictated. I do write thee to come, and that as soon as thou canst. Have no fears whatever, I am thy friend and thy husband as fond of thee as ever and as ever anxious, oh, devotedly anxious, to render thee comfortable. Come, confide in me, throw thy heart in my care and I will be bound all will go on pretty well! Only let me know thy convenience and time and I will be at Louisville waiting for thee.

"For God's sake, my Lucy," he added passionately, "do not be troubled with curious ideas such as my liking the birds better than thee, &c., &c., &c. Come and be mine."

Coincidentally, Lucy in Louisiana wrote her errant husband the next day, responding to one of his July letters. She had "only four months [more] to serve," she assured him, "and by the time this reaches you at the usual rate, one more month may be put off the list." She particularly wanted him to understand her financial situation. She worked not only for herself but also for her sons; if he needed her funds he could have them, "but then I must remain and fill my purse again." Whatever fees she collected she meant to leave behind in America for Victor and John; Audubon must be prepared "to support an idle wife, for you must be sensible I do not look to anything like labor after I give up these toils. Do not think me harsh, dear LaForest, but it is absolutely necessary for our happiness to be sincere in our views and wishes." That said, she wanted to "drop this painful and resolved subject forever":

> We meet as friends. I view you as such and conceal nothing from you. I am much afraid the greater part of my money [due] will be left behind for the children to collect, this is a horrible money country, and just now the yellow

fever has made its appearance in all the little neighboring towns as well as [New] Orleans. . . . I cannot say anything more but that my heart is yours; only I cannot overlook justice and comfort to our sons.

A month later she explored these issues again at length in a letter that Audubon took to be decisive for the future of their marriage when he received it in late October:

Had you landed in [New] Orleans and come up, after seeing me and understanding one another it would have saved much pain; that, I hope, is all over & if I have said anything harsh allow for my peculiar situation—for my disappointment—and forget it. . . .

Even if my word was nothing, many of my employers are now on to the eastward, and I could not possibly collect more than a hundred dollars, if that. I have done *all* I could preparative, even to agreeing for the sale of one of my pianos; spoken to all my employers, &c., but with all this it will be sometime in January before I can finish it all conclusively. You want to remember what trouble you had to collect money [here], and every year the country has been getting worse though ultimately good. . . .

Either you, Victor or John must come down for me. I will only say that when it is positively known I am no longer of any service to the world, the world will take no interest in me! I have not lived so long not to *know that.* I shall, I hope, bring with me between seven and eight hundred dollars but I cannot tell till all my accounts are paid. I am not famous for economy. If you prefer meeting me at Louisville do so; but be so good as to reply to this and let me know as soon as possible, *whether* I may *expect* you and *when.* . . . You say fame is not felt while living, most true, but I am persuaded nevertheless you will never be happy but in toiling for it; should you also realize a pecuniary reward your recompense will be tenfold. I hope you will find all well on your return to England; to me it will be quite a new country. And if you have plenty to support both, which I cannot now doubt as you say so, we shall enjoy many things till our return, which I must always look forward to, even till I come to America again. You will I hope believe [that I am] speaking to you with the utmost sincerity and seriousness and meaning just what I say.

Despite the acceptance of her husband's plans evident in this letter, Lucy still worried that his pursuit of fame might be putting their future security at

Audubon studied and drew eggs as well as birds.

risk. Which of course it was; Audubon was counting on his good health to sustain him in the years ahead as he labored to finish the four volumes of his *Birds* and the multiple volumes of the accompanying letterpress field notes, the *Ornithological Biography* he had yet to write. Very hesitantly she mentioned that she had been offered no less than $1,800 to teach her twelve music students for another year. In doing so she turned the tables on Audubon, who had insisted so often from England that she *choose* whether to stay in Louisiana or join him abroad: "*Mind, my dear husband*, I do not tell you it is my choice, I only state the fact . . . and *you must choose* what I shall do." She wrote more pointedly on the same subject on October 11:

> You must not suppose, my dear husband, that my intention or feeling to join you has wavered in the least, but it appears to me rather a pity in our situation to reject so pretty an income and which nothing but my death could disappoint me of. I wish you only to weigh coolly the facts, you know your own means, I do not, and then let me beg of you to know that *nothing* but pure desire for the *money* could induce me to go through what I do; but if you say it is best, I should continue teaching as I began from duty and our mutual benefit till it was no longer required. . . . I really am afraid my dear that you are toiling for posterity, but if so I cannot help it, there is no know-

ing how long we have to live. If I had continued a few years longer at my business I should have had enough to have insured a support at least from the interest for old people, but you will never hear me regret the move if once you make it, unless I should indeed want for the means of life.

Audubon, his cache of drawings renewed, finally felt free to follow his heart. The message of Lucy's recent letters was clear: if he wanted her beside him, he would have to go to Louisiana and claim her. By the end of October 1829, with George Lehman's assistance, he had finished 42 new drawings and 52 redrawings, as well as 60 drawings of eggs. He had collected some 1,300 insects for J. G. Children—his quid pro quo for Children's careful supervision in his absence of Robert Havell's engraving and coloring work—which he shipped off to London on the packet ship *Hannibal* on November 1. He had forgone his hope of having Thomas Sully paint his portrait to be engraved as the frontispiece of *The Birds of America,* because neither of them could spare the time. He had followed the spread of yellow fever out of New Orleans as reported in newspapers and in Lucy's letters with worry and concern, writing Havell in late October that "the yellow fever has been very bad at New Orleans and now is bad within 10 miles of St. Francisville; many worthy men have died of it."

At the beginning of November 1829, with his dog and gun, "a man in a hurry," he crossed the mountains to Pittsburgh by mail coach, spent a bare half day with the Benjamin Bakewells—all he could tolerate after the Bakewell family's collective rejection of him—and boarded a steamboat for Louisville to see his sons. When the steamboat stopped in Cincinnati he looked in on the Western Museum, which he thought "scarcely improved," but pointedly did not look up his former partner Thomas Bakewell. In Louisville, he wrote in his journal, "on entering [Will Bakewell's] counting-house . . . I saw my son Victor at a desk, but perhaps would not have recognized him had he not known me at once. And the pleasure I experienced on pressing him to my breast was increased when I discovered how much my dear boy had improved, as I had not seen him for five years." Victor was twenty years old, tall and strikingly handsome, with his mother's eyes and mouth; news of his "good conduct and standing," in Lucy's words, had already given his father "heartfelt joy." Audubon presented Victor with a new gold watch bought in London. After they had talked and Audubon explained himself, father and son were reconciled.

Audubon next braved Shippingport, where he found John Woodhouse at Nicholas Berthoud's offices "also grown and improved." With a shorter face

than his brother's, a wider mouth and a more prominent nose, Johnny resembled his handsome father. He would be seventeen on November 30. "By the bye," Audubon wrote his Philadelphia physician friend Richard Harlan, "my sons are taller than me, the eldest one so much altered that I did not know him at first sight, and yet I have eyes." Of Nicholas Berthoud he wrote not a word. A canal that bypassed the Falls of the Ohio and sidelined Shippingport would open for shipping within months.

The fare by steamboat from Louisville to Bayou Sarah was $25. The Ohio "was in good order for navigation" and Audubon made the passage in a fortnight. Not only his sons were altered. Much had changed as well along the river; Audubon wrote of it as he saw it in November 1829 in an elegiac mood:

> When I see that no longer any aborigines are to be found there, and that the vast herds of elks, deer and buffaloes which once pastured on these hills and in these valleys, making for themselves great roads to the several salt springs, have ceased to exist; when I reflect that all this grand portion of our Union, instead of being in a state of nature, is now more or less covered with villages, farms, and towns, where the din of hammers and machinery is constantly heard; that the woods are fast disappearing under the axe by day, and the fire by night; that hundreds of steamboats are gliding to and fro over the whole length of the majestic river, forcing commerce to take root and to prosper at every spot; when I see the surplus population of Europe coming to assist in the destruction of the forest and transplanting civilization into its darkest recesses;—when I remember that these extraordinary changes have all taken place in the short period of twenty years, I pause, wonder, and although I know all to be fact, can scarcely believe its reality.
>
> Whether these changes are for the better or for the worse, I shall not pretend to say; but in whatever way my conclusions may incline, I feel with regret that there are on record no satisfactory accounts of the state of that portion of the country, from the time when our people first settled in it.

Lucy had hoped to receive in her far-traveled husband "a most polished and fashionable gentleman amongst us who have been rusticating and vegetating in the woods." Audubon noticed the reversing season as the steamboat wheeled down the Mississippi. "The foliage had nearly left the trees" in the north, ". . . the swallows had long since disappeared [and] severe frost indeed had rendered nature gloomy and uninteresting," but passing Natchez he found "green trees and swallows gambol[ing]" and heard mockingbirds singing.

The steamboat put Audubon off at Bayou Sarah in the middle of the night of November 17. William Garrett Johnson's Beech Grove plantation, where Lucy lived, was fifteen miles inland. Audubon told the story vividly:

> It was dark, sultry, and I was quite alone. I was aware yellow fever was still raging at St. Francisville, but walked thither to procure a horse. Being only a mile distant, I soon reached it, and entered the open door of a house I knew to be an inn; all was dark and silent. I called and knocked in vain, it was the abode of Death alone! The air was putrid; I went to another house, another, and another; everywhere the same state of things existed; doors and windows were all open, but the living had fled. Finally I reached the home of Mr. Nübling, whom I knew. He welcomed me, and lent me his horse, and I went off at a gallop. It was so dark that I soon lost my way, but I cared not, I was about to rejoin my wife, I was in the woods, the woods of Louisiana, my heart was bursting with joy! The first glimpse of dawn set me on my road, at six o'clock I was at Mr. Johnson's house; a servant took the horse, I went at once to my wife's apartment; her door was ajar, already she was dressed and sitting by her piano, on which a young lady was playing. I pronounced her name gently, she saw me, and the next moment I held her in my arms. Her emotion was so great I feared I had acted rashly, but tears relieved our hearts, once more we were together.

After Lucy had collected her school fees and Audubon had worked another month drawing, painting and collecting specimens of plants, animals and birds for British friends (among others, a wild turkey to Alexander Gordon, 1,150 saplings of American trees to William Swainson and several squirrels), she and John James left Beech Grove on January 1, 1830. In New Orleans they "took passage [on January 7] in the splendid steamer *Philadelphia* for Louisville, paying sixty dollars fare" for two staterooms—the same staterooms that Audubon's Edinburgh acquaintances Captain Basil Hall and his wife and child had occupied during their American tour in 1827. Engine trouble extended the passage upriver to fourteen days, during which Audubon collected Carolina paroquets and ivory-billed and pileated woodpeckers for their skins; he had already shipped fourteen live opossums from New Orleans to the London Zoo. "I do not remember to have spent a day without meeting a steamboat," Audubon wrote of this passage, "and some days we met several." All the Audubons reunited in Louisville at Lucy's brother Will Bakewell's house through the rest of January and across February, when the paterfamilias "amused myself hunting and stuffing birds."

Since the Atlantic would soon divide the family, parents on one side, sons on the other, and a voyage by sail was always perilous—in that era one in six ships attempting the crossing was lost at sea—Audubon prepared a will. Lucy, for her part, facing the prospect of a long separation from her sons, struggled privately with anticipatory grief. "Misfortune & circumstance threw us three together for some years . . . in adversity," she wrote in a farewell letter to her brother and sister-in-law. "This has particularly endeared to me sons from whom I have ever received kindness & obedience. . . . My thoughts and prayers will turn to America ever and I hope when we meet again it may be with the joy of finding you all well and happy. The separation from my children costs me more than anyone can tell, and all my resolution is called up to smother my feelings and tears when no one knows it."

On March 7 husband and wife traveled by steamboat to Cincinnati, then to Wheeling and on to Washington City by mail coach, contending with bedbugs in the only inns available to them along the way. In Washington "Congress was in session," Audubon wrote in a journal entry addressed to his sons, "and I exhibited my drawings to the House of Representatives and received their subscription as a body"—one of the few subscriptions he sold in the United States on this visit. The chambermaid's illegitimate son, Henderson bankrupt and American woodsman of Liverpool, Manchester, Edinburgh and London "saw the President, Andrew Jackson, who received me with great kindness, as he did your mother also afterwards." Audubon showed the President of the United States his first Numbers of *The Birds of America;* what Jackson thought of them is unknown.

John James LaForest Audubon and Lucy Bakewell Audubon sailed from New York on the packet ship *Pacific* on April 2, 1830, just as Audubon had promised Robert Havell. Along with them Audubon shipped 350 live passenger pigeons bought at 4 cents each in the New York market to distribute among his friends and the institutions that had honored him. Separately he shipped wild turkeys, opossums, blue jays and Carolina paroquets. In his pocket he carried a little screech owl, a gift from his Philadelphia friend Richard Harlan, that died at sea. The *Pacific* docked at Liverpool on April 27, the day after Audubon's forty-fifth birthday. Finally the American woodsman had a wife.

Twenty-three

WOODS, WOODS, WOODS

ARRIVING AT LIVERPOOL IN THE SPRING OF 1830 Lucy Audubon discovered her sister Ann Bakewell Gordon fevered, bedridden and in pain. Ann suffered from episodic pelvic inflammation, a consequence probably of the septic conditions of obstetric practice in that era—the condition had followed from the birth of her only child. Lucy stayed behind in Liverpool to nurse her younger sister with John James's full approval while he hurried on to Manchester to exhibit his new collection of drawings and stanch a worrisome loss of subscribers there.

Lucy found Liverpool confusing after so many years away from the country where she was born. The Industrial Revolution had transformed it in the years since her family had emigrated to America in 1801. "I thought . . . that I could find my way all over [the city]," she wrote Euphemia Gifford, "but on my arrival there I knew nothing but the Exchange." Across the next three months Ann improved under Lucy's nursing, relapsed to the point where Lucy feared for her life and then began a slow recovery. Applying leeches to Ann's head was her physician's primary treatment, which she believed brought her "great benefit."

Some of Audubon's Manchester subscribers had canceled because they were dissatisfied with the coloring of their plates. He persuaded them to resubscribe and added one new subscriber as well, but he had blunt words for his engraver:

To Robt Havell Junr Esq.

. . . Do let me urge you more than ever to pay the strictest attention to the colorers for it is doubtless through their evident carelessness that the work suffers so much at present. I could have had many new names at Manchester had not the people there seen different sets in different houses *almost of dif-*

ferent colors for the same plate.... There is no other complaint, they all agree that the engraving is better than the first Numbers [produced by Lizars].

In London at the beginning of May Audubon learned to his delight that during his absence in America he had been elected a Fellow of the Royal Society of London, the most prestigious intellectual association in Britain. Lord Stanley had engineered the election along with J. G. Children, the Royal Society secretary who had supervised the production of *The Birds of America* while Audubon was away. Benjamin Franklin had been the only other American to be honored up to that time with an F.R.S., nor would another American be elected for decades to come. Though many of Audubon's British subscribers were in arrears, so that he had to resort to painting potboilers again to sustain the flow of funds to Havell while he brought collections up to date, he unhesitatingly paid the steep £50 Royal Society entrance fee and "took my seat in the great hall" on May 6. Later that summer Richard Harlan, his physician friend in Philadelphia, reported "the *cadaverous stare* of some of our academicians

when I announced the fact [of Audubon's election to the Royal Society] at a full meeting" of the Philadelphia Academy of Natural Sciences. Harlan assured Audubon that he had friends at the academy as well: "There are not a few amongst us who rejoiced with me, among whom [the painter Thomas] Sully begs me to say how greatly he is gratified."

To Audubon's demurrer that he was "no scholar of any kind" and had "no pretensions," Charles Bonaparte responded warmly with an insightful assessment of the artist's innovative emphasis on extensive, careful observation and fieldwork:

> Believe me, you are too modest and do not value enough that which you call your slender practice; many scholars, many student naturalists occupy themselves in building . . . systems & in turning and returning in every sense the few facts (of which some are unfortunately even false) that others have brought to their notice: compilations on compilations, some well done, some as they are . . . only serve to perplex science. It is the facts, the observations, made with judgment & especially with confidence which increase the scope of science.

Audubon had a chance to examine Havell's plates more carefully as they hung on the walls around him at his exhibition in Birmingham in June 1830. He was shocked, he wrote his engraver, by the inconsistencies in engraving and coloring. Not only his reputation was at risk, he argued; so was Havell's: "When I return to London you & I must have a regular and complete overhauling of the coppers [i.e., the engraving plates] and see what can be done to redeem the character of a work . . . which you cannot but conceive of importance to your own standing as a good engraver and a good man." Potential subscribers had hesitated to sign on for fear of disappointment "equal to that of their friends who have subscribed." To provoke Havell's full attention Audubon threatened to "abandon the publication and return to my own woods until I leave this world for a better one" if the quality of Havell's work did not improve.

The engraver responded by return mail that he felt "extremely hurt with the tone of [Audubon's] letter." Subscribers might have "some room for complaint," he acknowledged, but the defects were "not sufficient to deter others from subscribing." A big-city man, Havell fell back on the big-city argument that London subscribers, implicitly more sophisticated, were "very good judges" and had not complained. Audubon fought for high standards of production on principle, but also because the work was not yet one-quarter along; small compromises now could accumulate to eventual disaster. The two men

made their peace during the summer and the quality of Havell's work, always high, continued to improve.

Audubon told Bonaparte in mid-July that he, Lucy and a restored Ann Gordon were planning several months of travel in France and elsewhere on the Continent, but the July Revolution of 1830—which saw barricades in the streets of Paris, the abdication of Charles X and the crowning of the Duc d'Orléans by the Chamber of Deputies—changed their plans. Lafayette, now seventy-three, had reemerged as a revolutionary leader—his *third* revolution, Audubon observed admiringly—commanding the national guards that drove Charles X from France and sponsoring the duke, Louis Philippe, as the citizen king of a constitutional monarchy. It was "a revolution of the noblest kind ever performed," Audubon told his sons, "and one which I think will teach crowned heads to take care of themselves and not to trample down their subjects." He had known Louis Philippe personally, he reminded them, "and I am almost sure that the adversities of his earlier life have taught the useful lessons which his thick-skulled cousin never felt."

Ann stayed home, and instead of Europe John James and Lucy canvassed Birmingham, Manchester, Leeds, York, Hull, Scarborough, Whitby and Newcastle on their way to Edinburgh, where Audubon intended to begin writing the letterpress companion volumes to *The Birds of America,* the *Ornithological Biography.* "My first volume," he explained to his English colleague William Swainson in an August 22 letter from Manchester, "will comprise an introduction and one hundred letters addressed to the reader referring to the 100 plates forming the first volume of [*The Birds*]. I will enter even on local descriptions of the country, adventures and anecdotes, speak of the trees & flowers, the reptiles or the fishes or insects as far as I know. I wish if possible to make a *pleasing* book as well as an *instructive* one." Such had been his goal for *The Birds of America* as well—art and observation yoked together to reanimate sentient birds in a living environment.

He wrote Swainson because he had a proposal for him: "I am desirous to hear from you if you can have the time to spare & the inclination to bear a hand in the text of my work, by my furnishing you with ideas & observations which I have and you to add the science which I have not!" Swainson responded immediately that he was available—on his terms. He envisioned a joint work, with his text separated from Audubon's in the form of "Scientific Notes" at the end of each "letter." He wanted 12 guineas for each sixteen-page sheet of printed text, plus another 5 to 7 shillings per sheet for proofreading. And he expected to see his name on the title page alongside Audubon's. Thinking about the large fee that Swainson was proposing as well as his request for

joint billing, Audubon replied bluntly but honestly that another name on the title page would rob him of his fame. Swainson, offended, responded angrily, and the negotiation and their friendship ended there.

Lucy enjoyed traveling with her husband through an England filled with new marvels. "Machinery is on the most extensive and improved plan here," she wrote her sons. In Liverpool she toured the gas works, where coal was heated in a sealed retort to release hydrogen and methane and the gas piped to gasometers for filtration and storage, "immense reservoirs . . . of sheet iron, square, about 20 feet [on a side], and stand[ing] in 27 feet of water" that rose as the gas bubbled up through the water "till nearly the whole body is on the surface." In a seven-story cotton mill she rode an early version of an elevator: "[There are] many rooms on each floor and thro' the middle is a square platform from which we were propelled upwards at a good speed, just stopping as we ascended at the door of each room to look in." Herself an indefatigable seamstress, she had toured the mill "to see the calendaring of calicos, the weaving of tapes, cords, worsted bindings and ribbands." Most memorably, she and John James attended ceremonies on August 28 in Manchester launching the Liverpool & Manchester Railway, powered by George Stephenson's new *Rocket*:

> We had the pleasure of seeing the locomotive engines on the railway arrive and set out. They contained about 600 passengers, the bugle was playing, and an immense concourse of people assembled to see them. Your father stationed me where I had an excellent view, but so rapid is the flight that there is not time to particularize any thing or any person. The part of the vehicle assigned to the ladies was covered and much like one of our stages. The sight was truly novel and quite amusing. This carriage came from Liverpool, 36 miles, in two hours and four minutes. It returned to Liverpool in one hour and forty minutes exactly.

Afterward they went to see "a large lunar microscope"—a telescope—which was "very fine recreation." Lucy reassured her sons that she was happy. "When you see me again I hope you will find that England & your father's goodness to me has made a change for the better in me tho' a few years more will be added to my age." Audubon confirmed the change for the better, writing Havell that "Mrs. A. has gained flesh and is growing not younger, but fairer."

Audubon saw the first plates of his nineteenth Number, Plates 91 through 95, in mid-September while he was soliciting in Leeds. Havell was proud of them, "particularly the large plate [of two broad-winged hawks in a pignut hickory tree], as you will find all the softness of the drawing preserved and not

deficient of strength." Audubon responded from Newcastle that he was "much pleased . . . and I think you have either improved very much or have been more careful than ever before as I think these the best of your productions." One more Number, taking the total of plates issued so far to one hundred, would complete volume one of *The Birds of America*. Audubon still had to find a collaborator with training in anatomy and systematics to help him write the companion volume of the *Ornithological Biography*. He had also begun to think about the work he would need to do to make his collection comprehensive. It would require returning to America, he wrote Richard Harlan from Newcastle:

> Now between you and me and the post, do you think that I could raise a company of ten good fellows, each willing to pay 1,000 [dollars] to go to the Pacific mouth of the Columbia . . . for a couple of years? . . . I will lay down that [sum] at once, although you know I am poor enough, God knows, to assist in such an undertaking. . . . Feel the pulses and let me know—our country has not been ransacked . . . thousands of prizes still lay on the wheel of knowledge.

The Audubons reached Edinburgh in mid-October and took up residence at Mrs. Dickie's house at 2 George Street, where Audubon had lodged before. During the next week, while Lucy was prostrated with what her husband called "a dreadful rheumatic pain in her right shoulder," Audubon looked up an acquaintance, a wealthy naturalist named James Wilson who had been inducted into the Edinburgh Royal Society the same day as Audubon, and asked him "if he knew of any person who would undertake to correct my ungrammatical manuscripts and to assist me in arranging the more scientific part of the [*Ornithological Biography*]." Wilson directed him to a thirty-four-year-old Scottish naturalist and university lecturer named William Mac-Gillivray. "He had long known of me as a naturalist," Audubon wrote. "I made known my business and a bargain was soon struck. He agreed to assist me and correct my manuscripts for two guineas

William MacGillivray, Audubon's Edinburgh collaborator (a self-portrait)

per sheet of sixteen pages, and I that day began to write the first volume." Audubon told Charles Bonaparte that MacGillivray was "a good scholar and fond of our study." At 2 guineas per sheet instead of 12, he would also cost Audubon about £150 less per volume than Swainson would have.

Settled in Edinburgh, the American woodsman set to work with his usual energy:

> Writing now became the order of the day. I sat at it as soon as I awoke in the morning and continued the whole long day, and so full was my mind of birds and their habits that in my sleep I continually dreamed of birds. I found Mr. MacGillivray equally industrious, for although he did not rise so early in the morning as I did, he wrote much later at night. . . . And so the manuscripts went on increasing in bulk like the rising of a stream after abundant rains, and before three months had passed the first volume was finished. Meanwhile [Lucy] copied it all to send to America to secure the copyright there.

"To render it welcome to the common reader" Audubon interlarded the hundred bird biographies in the first volume with twenty "episodes," closely observed stories of his experiences in America. He wrote about the Ohio River, the Great Pine Swamp, the prairie, Kentucky sports, deer hunting, Niagara, the New Madrid earthquake, Louisville, John Wesley Jarvis and much more, introducing the British readers he had found to be ill-informed about his adopted country to its manners, its natural history and its evolving national character. The episodes were vividly told and mostly true, but Audubon felt free to reshape and even to invent in the frontier tradition to improve a story. He described spending a night with Daniel Boone, for example, and listening to Boone's tale of his captivity among the Indians, a meeting that Boone's known visits to Kentucky during the years when Audubon lived there make improbable.

Similarly, after the text was completed in March 1831 (written by candlelight in the gloom of Scottish winter), Audubon adjusted and embellished his personal history in the Introductory Address that opened the first volume. Biographers and art historians have invoked these variances as evidence of a character flaw without recognizing their larger purpose. (Robert Hughes, for example, describes Audubon unrecognizably in *American Vision* as "self-inflated, paranoid and a bit of a thug.") They miss the point. Just as Audubon had transformed himself from a Frenchman of doubtful antecedents into a prominent

American, just as he had simplified himself into an American woodsman to shape his British celebrity, so also in the autobiographical introduction to the text that accompanied his unique volumes of life-sized engravings of American birds did he deepen and elaborate his semifictional public persona. In the *Ornithological Biography* he became a Candide figure, an innocent of the woods whose art had evolved in passionate purity through years of Romantic struggle until a prince encouraged him to consider publication:

> For a period of nearly twenty years, my life was a succession of vicissitudes. I tried various branches of commerce, but they all proved unprofitable, doubtless because my whole mind was ever filled with my passion for rambling and admiring those objects of nature from which alone I received the purest gratification. I had to struggle against the will of all who at that period called themselves my friends. I must here, however, except my wife and children. The remarks of my other friends irritated me beyond endurance, and, breaking through all bonds, I gave myself entirely up to my pursuits. . . . Years were spent away from my family. Yet, reader, will you believe it, I had no other object in view than simply to enjoy the sight of nature. Never for a moment did I conceive the hope of becoming in any degree useful to my kind, until I accidentally formed acquaintance with the Prince of Musignano at Philadelphia.

Only after he went up the Hudson and crossed the Great Lakes, he continued, did he "for the first time" consider traveling to Europe and submitting his drawings to "the multiplying efforts of the graver." Which was not, of course, true.

A fundamental problem for almost every artist is finding financial support. Audubon's subscribers in Britain were wealthy businessmen, heirs and heiresses and titled nobility. Both groups reinforced their identity by disdaining craftwork and even public intellectual enterprise as plebian and inferior. Despite his vast natural history collections, for example, Lord Stanley published very little, although he was generous in sharing his holdings with others who did. The persona Audubon invented for *The Birds of America,* that of a gifted amateur, Richard Rathbone's "simple intelligent," who published his art from a sense of *noblesse oblige,* slipped past their prejudices and thereby supported the production of the work, which was always, relentlessly, Audubon's determined goal. As he wrote in his journal on his first visit to Edinburgh in 1826, "Since Napoleon became, from the ranks, an Emperor, why should not

Audubon be able to leave the woods of America a while and publish and sell a *book?*" If Napoleon could mask and costume himself in pursuit of power, why should Audubon do less in pursuit of art? What could be more American?

THE OPENING OF THE NEW YEAR found Audubon actively planning a return to the United States to add to his collections. "I am going to America again," he wrote Charles Bonaparte in Rome on January 2, 1831, "and I assure you that if life is granted me I will leave no place in the whole of the U.S. unsearched." He asked Bonaparte in particular to send him a letter of recommendation to a Bonaparte relative "now residing in the Floridas," a region he intended to explore extensively. He hoped to visit "the interior of the Northwestern Territory" as well, and to draw not only birds there but also four-legged animals for a projected work on American quadrupeds "which if I do not live to see finished will I hope at least be completed by one of my sons." He thought he might be absent from England for more than two years and was making appropriate arrangements with Havell for engraving and publication to proceed without him. Those included speeding up production; he asked Havell in mid-January "if you can . . . manage to publish 6 Numbers per annum instead of 5 and if you can do this the present year?" Six Numbers per year would shorten production of the remaining sixty Numbers of *The Birds of America* from twelve years to ten—a significant reduction for a man who was forty-five years old—and increase the annual profit accordingly. Havell could and did.

By mid-February plans were firm. Audubon wrote Victor that he and Lucy expected to arrive in mid- to late September. The tenacity of his Henderson creditors still cautioned him; he was copyrighting the American edition of the *Ornithological Biography* in Victor's name because he was "not very anxious to possess any property in the United States." Lucy wrote a few days later that in case of accident Victor should "always remember [that] your brother is to share equally any profits." Finances were on her mind that day. "This Ornithological Biography takes a great deal of money away," she confided to her son, "before it begins to throw back any." Audubon was publishing it himself. She passed along his request that Victor and John skin birds, blow eggs and collect nests for him at every opportunity. "Every object in nature has a great value attached to it in Britain, and even Europe in general is now natural history mad."

The Audubons left Edinburgh on April 15, serviced subscribers between Edinburgh and Liverpool and then traveled "on that extraordinary road, called

the railway, at the rate of twenty-four miles an hour" from Liverpool to London, where Audubon balanced his books, finished organizing two years' worth of work for Robert Havell and closed out a volume of his journals with a proud, grateful but sobering summary of his qualified commercial success:

> Several reviews of my work have appeared. . . . We have received letters from America of a cheering kind . . . which raised my dull spirits, but in spite of all this I feel dull, rough in temper, and long for nothing so much as my dear woods. I have balanced my accounts with *The Birds of America* and the whole business is really wonderful; forty thousand dollars [about $770,000 today] have passed through my hands for the completion of the first volume. Who would believe that a lonely individual who landed in England without a friend in the whole country and with only sufficient pecuniary means to travel through it as a visitor could have accomplished such a task as this publication? Who would believe that once in London Audubon had only one sovereign left in his pocket and did not know of a single individual to whom he could apply to borrow another when he was on the verge of failure in the very beginning of his undertaking; and above all, who would believe that he extricated himself from all his difficulties not by borrowing money but by rising at four o'clock in the morning, working hard all day and disposing of his works at a price which a common laborer would have thought little more than sufficient remuneration for his work? . . . And . . . with all my constant exertions, fatigues and vexations, I find myself now having but one hundred and thirty standing names on my list.

One hundred and thirty subscribers would sustain him, and more should turn up in America, but he had work to do.

AFTER VISITING PARIS IN JULY the Audubons sailed from Portsmouth on August 1, 1831, in company with a young English taxidermist named Henry Ward whom Audubon had hired to assist him in preparing skins of the birds he expected to collect. They landed in New York on September 4. Nicholas Berthoud had moved his business and his family there from Shippingport; the Audubons stayed with the Berthouds for a week and then moved on to Philadelphia. From New York Audubon had written a Scottish friend that "the [American] papers and scientific journals . . . are singing the praises of my work." In Philadelphia he found his "enemies . . . droop[ing] their heads like frosted leaves in autumn; not one of them did I meet at the societies I went to."

Swiss artist George Lehman, who had worked with him after his collecting expedition to the Great Pine Swamp, was still resident in Philadelphia and Audubon hired him to paint landscape backgrounds again.

Victor crossed the mountains from Louisville to meet his parents in Philadelphia. In early October the Audubon entourage—Audubon, Lucy, Victor, Henry Ward and George Lehman—traveled down to Baltimore, from which Victor and his father visited Washington City to solicit the Audubon expedition's transportation around the Floridas by government revenue cutter. The Secretary of the Navy, the Secretary of the Treasury and the Bureau of Topographical Engineers all approved the request; the two secretaries also added letters of introduction to the large stock of these Audubon had already accumulated. His friend Senator Edward Everett of Massachusetts promised to arrange a special act of Congress to allow all his work to enter the United States duty-free.

Then Victor escorted his mother back to Louisville to live with her brother Will Bakewell while her husband collected and explored. On the way, waiting in Wheeling for a steamboat to carry them down the Ohio, Lucy wrote Audubon plaintively that she already missed him "notwithstanding Victor's kind affection . . . but on this journey I know much of your future fame and success depends. For the world has its eyes upon you, my dear LaForest, but in the midst of fame remember the friend of 25 years' standing and the prosperity of our beloved children." She repeated her appeal at the end of her letter: "I have nothing more to say my dear husband now but every good wish that can attend him, to beg he will take care of himself, do nothing that affects his health or intellect, to remember the *three* individuals behind you who are not many minutes without thinking of you and whose happiness is linked to yours forever."

Audubon, Ward and Lehman left Baltimore on October 7 on the steamboat *Pocahontas*, "progressed down the Chesapeake Bay," which Audubon found "truly beautiful," endured a night of rain, wind and "boisterous" waves and put in the next morning at Norfolk. By steamboat and mail coach, "the roads most horrible," they pushed on in the next days to Richmond and then to Fayetteville, North Carolina. After forest-deprived England and Scotland Audubon was glad to see "country bounded as [it] is always in America by woods, woods, woods!" But the travel was rough: "poor coaches, dragged through immense deserted pine forests, miserable fare and neither birds nor quadrupeds to be seen."

The point of the expedition was to follow the autumn migrations down into the Floridas. Time was money with two assistants to pay. Where were the birds?

"We at length approached Charleston, and the view of that city from across the bay was hailed by our party with unfeigned delight." They entered Charleston on Sunday, October 16, 1831, and found a boardinghouse that charged them an exorbitant $5.25 per night for beds and board. Promptly the next day Audubon walked out to the edge of town in the morning heat to present a letter of introduction to a Harvard-educated Unitarian minister, Samuel Gilman, whose distinctions included having written "Fair Harvard" (". . . Be the herald of light, and the bearer of love,/'Til the stock of the Puritans die"). Walking back into Charleston, Gilman noticed one of his fellow ministers riding along

The Reverend John Bachman of Charleston, South Carolina

Pinckney Street—the Reverend John Bachman, the forty-one-year-old pastor of St. John's Lutheran Church—and called out to him to stop and meet Mr. Audubon.

"Upon my being named to him," Audubon wrote, "he leaped from his saddle, suffered his horse to stand at liberty and gave me his hand with a pressure of cordiality that electrified me." Warmhearted, sturdy, blond and blue-eyed, of Swiss and German descent, Bachman had been an amateur naturalist since his childhood on an upstate New York farm. In school in Philadelphia in 1804 he had occupied weekends and vacations naturalizing in William Bartram's garden on the Schuylkill. As an adolescent he had befriended Alexander Wilson, who had later helped him find a position as a teacher. He had been driven south, into a warmer climate, by consumption, which had attacked him with fever and hemorrhaging more than once as he grew and matured. (The famous Philadelphia physician Benjamin Rush had given up on him in 1806, which had spared him Rush's debilitating all-purpose regimen of severe purging and bloodletting.) In 1815, when he was twenty-five years old, he had accepted the pastorate at St. John's, expecting the semitropical climate of Charleston to heal him. His consumption in remission, he had married, had fathered a nurseryful of children and not long before meeting Audubon had moved into a fine new house on Pinckney Street.

"Mr. Bachman!!" Audubon wrote Lucy, spelling his new friend's name "Backman," as it was pronounced. "Why my Lucy Mr. Bachman would have us all to stay at his house. He would have us to make free there as if we were at our

own encampment at the headwaters of some unknown rivers. . . . He looked as if his heart had been purposely made of the most benevolent materials granted to man by the Creator to render all about him most happy. Could I have refused his kind invitation? No! It would have pained him as much as if grossly insulted. We removed to his house in a crack."

It was a full house, high and white: fifteen rooms on three stories, with open second- and third-floor galleries facing Pinckney Street supported by brick columns, set amidst gardens and trees, with an aviary in back, duck pens and a chicken yard, as well as slave quarters. Bachman's wealth came from his marriage in 1816 to Harriet Martin, whose prosperous father had settled a considerable estate on his wife and daughters before running away to Philadelphia with a mistress he loved. Harriet's unmarried younger sister Maria, a thirty-five-year-old artist and helpmate, lived with her invalid sister and her sister's husband, as did their mother. The Bachmans' numerous children, Audubon told Lucy, included "two fine young daughters," fifteen-year-old Maria Rebecca and fourteen-year-old Mary Eliza, and "3 pairs more of cherubs." Now Audubon and his two assistants moved in as well. "A room [was] already arranged for Henry to skin our birds—another for me & Lehman to draw and a third for thy husband to rest his bones in on an excellent bed!"

In Bachman Audubon had found a friend for life, a competent and knowledgeable naturalist whose mellow steadiness balanced Audubon's stormy intensity. "We laugh & talk as if we had known each other for twenty years," the artist wrote Lucy. Bachman took his pastoral duties seriously, but he devoted his two days off each week, Monday and Tuesday, to helping Audubon. "Ornithology is, as a science, pursued by very few persons," Bachman wrote Lucy later—"and by none in this city. How gratifying it was, then, to become acquainted with a man who knew more about birds than any man now living—and who, at the same time, was communicative, intelligent and amiable to an extent seldom found associated in the same individual. . . . We were inseparable. We . . . engaged in talking about ornithology—in collecting birds—in seeing them prepared and in laying plans for the accomplishment of that great work which he has undertaken."

"I jumped at once into my wood-hunting habits," Audubon chronicled. "All hands of us were up before daybreak and soon at work, either in the way of shooting, taking views or drawing birds; after sunset—scribbling in our journals." He and Bachman first collected waterbirds in the Charleston marshes: blue herons, yellow-crowned night herons, cranes, common egrets. They kept Ward busy in the Bachman skinning room, flaying birds and piling up their dress, spectacular carnage that locals stopped by to watch; by the end of the

first week of November Ward had "skinned and preserved 220 specimens of 60 different species" destined for the museums of Britain and Europe. The flayed carcasses Ward disposed of at the bottom of the Bachman gardens, where the black vultures and turkey buzzards that patrolled the city—protected by law for the purpose—scavenged them. A local physician gave Audubon a fine black-and-white Newfoundland dog named Plato for retrieving. Another donated a collection of shells. Charleston socialites maintained his supply of snuff, a vice to which he had inevitably returned. Bachman nicknamed him Old Jostle to immortalize his frequent complaints of being jostled on the rutted Southern roads and appointed himself Young Jostle to twit Audubon about their five years' difference in age.

When the marshes gave out, the Jostles hunted through the back country. Plantation owners welcomed them. "I certainly have met with more kindness in this place than anywhere else in the United States," Audubon wrote Lucy. "Here I am the very pet of everybody and had I time or inclination to visit the great folk I might be in dinner parties from now until January next. However I have other fish to fry." He had drawn nine birds in five drawings by the end of October, including five lovely ground doves ranged on a branch of wild orange that became Plate 182 of *The Birds of America,* three generations of "one of the sweetest birds" Audubon had ever seen that had been tamed and raised by another Charleston physician.

Several expeditions to nearby islands culminated on November 7 in an overnight excursion to Cole's Island, a nesting site that Audubon subsequently chronicled in his *Ornithological Biography* entry for the long-billed curlews that he collected there:

Accompanied by some friends, I left Charleston one beautiful morning . . . with a view to visit Cole's Island, about twenty miles distant. Our crew was good, and although our pilot knew but little of the cuttings in and out of the numerous inlets and channels in our way, we reached the island about noon. After shooting various birds, examining the island, and depositing our provisions in a small summer habitation then untenanted, we separated; some of the servants went off to fish, others to gather oysters, and the gunners placed themselves in readiness for the arrival of the Curlews. The sun at length sunk beneath the waterline that here formed the horizon; and we saw the birds making their first appearance. They were in small parties of two, three or five and by no means shy. . . . As the twilight became darker the number of Curlews increased . . . until they appeared to form a continuous procession, moving not in lines, one after another, but in

an extended mass, and with considerable regularity, at a height of not more than thirty yards, the individuals being a few feet apart. Not a single note or cry was heard. . . . They flew directly towards their place of rest, called the "Bird Banks."

After dark the expedition settled down to feast:

Fish, fowl and oysters had been procured in abundance; and besides these delicacies, we had taken with us from Charleston some steaks of beef and a sufficiency of good beverage. But we had no cook, save your humble servant. A blazing fire warmed and lighted our only apartment. The oysters and fish were thrown on the hot embers; the steaks we stuck on sticks in front of them; and ere long everyone felt perfectly contented. It is true we had forgotten to bring salt with us; but I soon proved to my merry companions that hunters can find a good substitute in their powder-flasks. Our salt on this occasion was gunpowder, as it has been with me many a time; and to our keen appetites, the steaks thus salted were quite as savory as any of us ever found the best cooked at home. Our fingers and mouths no doubt bore marks of the "villainous saltpeter," or rather of the charcoal with which it was mixed, for plates or forks had we none; but this only increased our mirth. Supper over, we spread out our blankets on the log floor, extended ourselves on them with our feet towards the fire and our arms under our heads for pillows. I need not tell you how soundly we slept.

Audubon's drawing of long-billed curlews, filled in with Lehman's landscape of Charleston and its harbor in the distant background, became Plate 231 of *The Birds of America,* one of Audubon's most elegant compositions. The two curlews in their spotted and barred light-orange plumage, the male in the foreground hunched low with its long, curved bill pointed downward ready to probe a burrow for a fiddler crab, the female behind it turned back and alert, looking out of the drawing directly at the viewer, its bill raised and pointing in the opposite direction from the male's, balance and repeat each other's curves. Bending spikes of sea oats behind them further echo the curves and positions of their bills. The vantage of the viewer is from below looking upward—the vantage of the curlews' prey. As always in Audubon's work, the point of view is creaturely rather than human. The human world—Charleston—retreats insignificantly into the background, flat and silent under one of Havell's overarching aquatinted skies, blue and white, filled with summer cumulus glowing pink along the horizon after sunset.

By early November Audubon was preparing to move on. "It was somewhat difficult," he wrote. ". . . My friends had increased in number; they were in the habit of accompanying me in my shooting excursions; I was becoming very much attached to them; invitations poured in from various parts of the country." But hunting and celebrity were not his business; birds were, and he had run out of new collections. "I have been idle for a full week," he wrote Lucy unhappily, adding later in his letter, "had I known what I now know I would certainly have . . . remained in Pennsylvania one month or six weeks longer— we have passed the birds of the North and not overtaken those of the South; therefore I have lost time both ways." He had also begun "to feel ashamed of the trouble we must inevitably have given to the kind family under whose roof we have resided for one month." Most of all, he still expected to fulfill his dream of rounding the entire continent before he returned to England, in which case there was no time to lose: "My mind was among the birds farther south—the Floridas, Red River, the Arkansas, that almost unknown country California and the Pacific Ocean. I felt myself drawn to the untried scenes of those countries and it was necessary to tear myself away from the kindest friends."

A packet schooner, the *Agnes,* shuttled regularly between Charleston and St. Augustine, carrying passengers, supplies and mail. Audubon wired up a bittern for Bachman's sister-in-law Maria Martin to draw, left behind racks of drying, arsenic-dusted bird skins for Bachman to pack, appointed Bachman his Charleston agent—no subscriptions had yet been forthcoming, but there had at least been inquiries—and bought passage on the *Agnes* for himself, Henry Ward and George Lehman. They sailed at eight o'clock in the morning on Tuesday, November 15, 1831, Bachman at dockside seeing them off, Audubon on deck with Plato large and placid beside him. "The wind was fair," Audubon remembered, "and we hoisted all sails for the Floridas."

THE VARIED SPLENDOR
OF AMERICAN NATURE

A STIFF WIND DEAD AHEAD on the second day out of Charleston forced the *Agnes* to put back to St. Simons Island halfway down the Georgia coast. Never one to waste time, Audubon went ashore, encountered a local planter who had read of him and his great project, toured the man's gardens, enjoyed a free shave and an afternoon of conversation, declined an invitation to stay for a month and was preparing to sit to dinner when Henry Ward came running up to say the *Agnes* was hoisting sail again. The planter, Thomas Butler King, escorted the two men back to the boat, gave Audubon his card and rounded out the hospitable encounter by signing on for a subscription to *The Birds of America*.

St. Augustine disappointed Audubon intensely. "Whatever it may have been," he assessed, "[it] is far from being a flourishing place now." He told Lucy more pungently that it resembled "some old French village" and was "the poorest hole in the Creation, the living very poor and very high." Later he would describe it as "quite Spanish, the streets narrow, the church not very remarkable and the marketplace the resort of numerous idlers." Oranges "and plenty of good fish seem to constitute the wealth of the place. Sands, poor pine forests and impenetrable thickets of cactus and palmettos form the undergrowth." And, perhaps the real reason for his disappointment: "Birds are rare, and very shy."

He intended no less than to walk and row down the entire Atlantic coast of East Florida from St. Augustine to the Keys, making forays inland and stopping to collect birds wherever he could find them. Since he did find birds in the neighborhood of the old Spanish port, he collected there until mid-December. In Philadelphia he had arranged to write letters for publication in the *Monthly American Journal of Geology and Natural Science*. He sent his first letter from St. Augustine on December 7, 1831; it sketched vividly the conditions under which he and his assistants worked and his purpose in doing so:

We are up before day and our toilette is soon made. If the day is to be spent at drawing, Lehman and I take a walk, and Ward [goes off collecting with] his gun, dog and basket, returning when hungry or fatigued or both. We draw uninterruptedly till dusk, after which [we take] another walk, then write up journals and retire to rest early. When we have nothing on hand to draw, the guns are cleaned overnight [and] a basket of bread and cheese, a bottle with old whiskey and some water is prepared. We get into a boat and after an hour of hard rowing we find ourselves in the middle of most extensive marshes as far as the eye can reach. The boat is anchored and we go wading through mud and water amid myriads of sand flies and mosquitoes, shooting here and there a bird, or squatting down on our hams for half an hour to observe the ways of the beautiful beings we are in pursuit of. This is the way we spend our day. At the approach of evening, the cranes, herons, pelicans, curlews, and the trains of blackbirds are passing high over our heads to their roosting places; then we also return to ours.

If some species are to [be drawn] the next day and the weather is warm they are *outlined* that same evening to save them from incipient putridity. I have ascertained that *feathers* lose their brilliancy almost as rapidly as flesh or skin itself, and am of [the] opinion that a bird alive is 75 percent more rich in colors than twenty-four hours after its death; we therefore skin those first which have been first killed, and the same evening. All this, added to our

other avocations, brings us into the night pretty well fatigued. Such . . . is the life of an active naturalist; and such, in my opinion, it ought to be. It is nonsense ever to hope to see in the closet what is only to be perceived—as far as the laws, arrangements and beauties of ornithological nature is concerned—by that devotion of time, opportunities and action to which I have consecrated my life.

"I know I am engaged in an arduous undertaking," Audubon concluded proudly; "but if I live to complete it, I will offer to my country a beautiful monument of the varied splendor of American nature."

Before he left the St. Augustine area Audubon was excited to collect "a hawk of great size, entirely new." He wrote Lucy that it was "an exotic bird, probably very common in South America but quite unknown to me or to anyone else in this place." Feeding among vultures on a dead horse, it looked to him like "a mixture of buzzard and hawk." He understood later that it was a caracara (crested caracara), or Brazilian eagle, "a new genera for the United States," adapted like vultures and buzzards for feeding on carrion with bare red skin around its beak and eyes and a large bare space on its breast, features that minimized the load of septic decomposed tissue it accumulated on its head and body when it fed. The specimen faded fast in the 90-degree heat while Audubon made a double drawing, from below and from above, to show all its feathers. Ward had difficulty saving the skin, and on December 8 Audubon wrote his physician friend Richard Harlan in Philadelphia asking him to purchase and send "20 more pounds of powdered arsenic," to restore Ward's supply of the preservative. The two drawings became two caracaras—one attacking, the other defending—in Plate 161 of *The Birds of America*. "I work now harder than ever I have done in my life," Audubon told Lucy, "and so do my young men . . . with me it is *neck or nothing!*"

Audubon presented letters of introduction he had carried all the way from England to General José Mariano Hernández, a Havana-educated attorney, militiaman and sugar-cane planter who operated three plantations along the Matanzas River south of St. Augustine. The artist and his party spent ten days on the Matanzas as Hernández's guests, but the Hispanic general was not a hunter and the relationship progressed no further than cool formality, nor did Hernández subscribe. With better prospects for birds and a friendlier reception from a young, wealthy, Paris-educated American planter fifteen miles farther south, Audubon had a wagon packed with his party's gear and set out walking to Bulowville on Christmas morning.

John J. Bulow was twenty-five, only three years older than Victor Audubon, but he owned and operated a 5,000-acre sugar and cotton plantation on Bulow Creek built and worked by three hundred slaves that he had inherited when he was only seventeen. Contemporaries remembered him as "very wild and dissipated." Audubon described him as "a very wealthy planter without ostentation and perfectly well off" and "one of the most deserving and generous of men," perhaps because they shared nearly mortal adversity during the course of Audubon's visit.

While they were boating down the Halifax River on a collecting expedition in January 1832, Audubon wrote, a nor'easter drained the channel of the tidal river and left them and their boat "fast in the mud about 300 yards from a marshy shore without the least hope of being able to raise a fire." They were not dressed for a night of wind and cold, and the next morning, shivering and exhausted, "all hands half dead," realizing that another night of exposure could be fatal, they forced their grounded boat for three hours through waist-deep mud to achieve a grove on the margin of the marsh "where a few scrubby trees seem to have grown to save our lives." Audubon struck fire, and after they had warmed themselves they waded downriver through more mud until their boat finally floated. But the storm had also emptied Bulow Creek; when they came to it they had to leave their boat and slog up the beach in deep sand "for many a long mile" before they finally reached Bulow's landing.

Despite the limited variety of birds Audubon had found so far, he told Lucy, they had managed to accumulate "550 skins, two boxes of shells, some curious seeds and 29 drawings, eleven of which only are finished for the want of male or female birds to them." Finding East Florida nearly barren of new birds—"not one drawing have we made since one whole month," he reported unhappily at the beginning of February—encouraged him to judge its marsh and savannah landscape barren as well; by experience he was a woodsman more familiar and comfortable with forests:

> I felt unquiet . . . in this singular scene, as if I were almost upon the verge of creation, where realities were tapering off into nothing. The general wildness, the eternal labyrinths of waters and marshes, interlocked and apparently never-ending; the whole surrounded by interminable swamps—all these things had a tendency to depress my spirits, notwithstanding some beautiful flowers, rich-looking fruits, a pure sky and ample sheets of water at my feet. Here I am in the Floridas, thought I, a country that received its name from the odors wafted from the orange groves to the boats of the

first discoverers, and which from my childhood I have consecrated in my imagination as the garden of the United States. A garden, where all that is not mud, mud, mud, is sand, sand, sand; where the fruit is so sour that it is not eatable and where in place of singing birds and golden fishes you have . . . alligators, snakes and scorpions.

Yet he found time that January for an excursion with a Scottish engineer to one of the region's celebrated springs, a source of the St. John's River, inland a day's ride from the Bulow plantation. Springs are openings from which groundwater flows; upper East Florida, with its spongelike eroded limestone bedrock, had more springs than any other location in the United States. In some springs a constricted opening underground accelerates the flow and pushes the cold water above the surface of the spring pool, making it seem to boil; such a "boil" was what Audubon saw at Spring Garden, "a circular basin having a diameter of about sixty feet, from the center of which the water is thrown up with great force although it does not rise to a height of more than a few inches above the general level." Spring Garden flowed about a half million gallons per hour, Audubon estimated—12 million gallons per day, mid-range for Florida, where more than thirty first-magnitude springs each flow at least 64 million gallons per day. It stank of sulfur when he visited it, a temporary disturbance that distant rains or underground settling might have caused; it was normally a pure source, filtered as springs are by flowing through soil and sand underground from their wide watersheds. Audubon's host, the planter Orlando Rees, wanted to divert the spring's flow to operate a water mill to press the sugar cane he grew. Such was the work of the Scottish engineer and the reason for his visit.

Audubon also made early report of a planter sideline that would become Florida's most celebrated industry:

> Nothing can be more gladdening to the traveler, when passing through the uninhabited woods of East Florida, than the wild orange groves which he sometimes meets with. As I approached them, the rich perfume of the blossoms, the golden hue of the fruits, that hung on every twig, and lay scattered on the ground, and the deep green of the glossy leaves, never failed to produce the most pleasing effect on my mind. . . . The pulp of these fruits quenches your thirst at once, and the very air you breathe in such a place refreshes and reinvigorates you. I have passed through groves of these orange trees fully a mile in extent. . . . The Seminole Indians and poorer squatters feed their horses on oranges, which these animals eat with much

relish. The immediate vicinity of a wild orange grove is of some importance to the planters, who have the fruits collected and squeezed in a horse mill. The juice is barreled and sent to different markets, being in request as an ingredient in cooling drinks. The straight young shoots are cut and shipped in bundles, to be used as walking sticks.

When Audubon heard that the Secretary of the Treasury had ordered officers commanding U.S. revenue cutters from Charleston down to Key West to carry him and his party anywhere within their cruising limits, he headed for St. Augustine to find a boat to board. By then, he told Lucy, he was "so tanned and burnt that thou might easily take me for an Indian," and since it was January, the month of his annual pledge, he had once again "*abandoned snuff forever!*" He found no cutters in port in St. Augustine on January 15 but a war schooner, the U.S.S. *Spark,* commanded by Lieutenant William Piercy. The navy officer needed charming; an evening over a bottle of Madeira warmed him to the task. Audubon expected to spend four or five weeks on the *Spark* ascending the St. John's River "as far as navigation will permit." He would scout birds; the *Spark* would survey the live oaks along the river and claim the best of them for the navy's shipbuilding inventory.

Having a government gunboat for his personal conveyance was a heady experience. "What will my Philadelphia friends say or think," Audubon asked Lucy rhetorically—meaning, of course, his enemies—"when they read that Audubon is on board of [a] U.S. schooner of war . . . going around the Floridas after birds?" Thinking of Philadelphia enemies reminded him of faithless relatives: "I assure thee my sweet girl I begin to be proud of myself when I see that my industry, perseverance and honesty has thus brought me so high from so low as I was in 1820 when I could not even procure through my relations and former partners the situation of a clerk on board an Ohio steamer."

The *Spark* expedition proved ill-fated. First a bad storm forced the boat back to St. Augustine, delaying the excursion up the St. John's until early February. Then "a dreadful accident" changed Audubon's plans when they had ascended only one hundred miles up the river and encountered, besides dense flocks of cormorants, not much more than fog and alligators. "One of our sailors accidentally shot himself through the hand and forehead," he wrote Lucy on February 17, "and our captain is going to convey him at daybreak tomorrow to St. Augustine."

Rather than idle with the *Spark* until the captain returned, Audubon hired a boat and two local men to row it, loaded his party's gear and set out downriver with Lehman and Ward to return to St. Augustine by a shortcut. Forty miles

along, the boat deposited party and gear onshore at a place where a wagon was supposed to be available for hire. When no wagon turned up Audubon and Lehman struck out on an old Seminole trail with Plato scouting ahead, leaving Ward behind to guard their belongings. A storm blew up; night fell; in the pitch darkness "Plato was now our guide, the white spots on his [coat] being the only objects that we could discern." Then lightning fired tall pines along the way that "illuminated the trees around." Hours after it began the storm passed "and suddenly the clear sky became spangled with stars." By then they were muddy and drenched and concerned that they might be lost, but they picked up the smell of the salt marshes along the coast, "and walking directly towards them, like pointers advancing on a covey of partridges, we at last to our great joy descried the light of the beacon near St. Augustine." They sent a wagon back the next day to collect Ward and their gear.

Rather than wait in dreary St. Augustine for a revenue cutter to happen along they bought passage again on the *Agnes* for Charleston, sailing on March 5. Forty miles out from Charleston another storm blew them back to Savannah. Long hair was commonplace in frontier outposts, so Audubon drew no looks for his chevelure when he put up at the city hotel, but "with a beard and a pair of mustachios" and in rough clothes he nevertheless "at once attracted all attention." He again befriended the local gentry, winning no fewer than four new subscribers in Savannah before catching the mail coach up to Charleston; at the end of March he would transfer £300 ($1,332) to London for Robert Havell, $1,000 of it from advances his Savannah admirers paid. Lucy compressed the achievement into a moment of marvel when she next wrote the London engraver: "Mr. Audubon was driven into Savannah by a severe gale of wind and obtained four subscribers." From John Bachman's house on March 13 Audubon crowed happily that he now had twenty-two subscribers in America.

Their American success had begun to worry Lucy, biding her time in frozen Louisville waiting with increasing impatience for her husband to finish his work. Each subscription was potentially worth $1,000, the sum she had earned from a long year of teaching school. She cautioned him to be careful in transferring funds: "Trust no one but your wife and children." Watch out especially for Nicholas Berthoud, she warned; he was carrying on his books a debt against Audubon of $7,000. "Now these people will take every advantage, depend upon it, the moment they think we are above want, and I cannot bear to think your labor should forever be wrested from you, which it may be." It seemed Berthoud had not given public notice of Audubon's bankruptcy back in 1819, had not acted "according to *law* in your affairs and never advertised or

made known to the world and your creditors that you had *given all up,* which he ought to have done." That presumably deliberate omission left Audubon exposed to collections and lawsuits—and still in Berthoud's debt.

Lucy had asked around about an expedition across the Rockies and found her informants all in agreement about "the danger at this period to be encountered from the disturbed Indians." She was worried that Audubon was staying so long in the South, worried that he might cross into fever season and fall ill. "Do come away, of what avail to see a little more or less of Florida if you lose your health or life? Your work calls for the birds of the United States but you are multiplying it into a universal history." London needed him as well, she challenged him. "Do come home and put us all at ease. . . . Oh do come away, come away."

Most of all Lucy was concerned for her sons. They were both killing time in unpromising clerkships, waiting dutifully for their father to reveal to them their roles in his publishing enterprise. "John has had three or four slight attacks of illness," Lucy wrote, "which plainly shew his mode of life does not agree with [him], yet he perseveres manfully in what he dislikes extremely in the hope you will be able to make a change. . . . As to Victor, he toils like a horse for [$]550 [a year] which is just enough to feed and clothe him, and I do not think W[ill] B[akewell] has it in his power to do anything for him, not even to raise his salary. . . ." Think of us, Lucy concluded, "think of our dear sons . . . and do come home."

"I will take care of N.B.!!!" Audubon had responded confidently, knowing he had long surpassed his brother-in-law in power and influence. "Do not suffer thy dear self to be vexed at thy relations' business I pray thee!" he reassured Lucy about Victor and John. "Very shortly after my return . . . we will all meet and form arrangements for our dear sons—tell them this and do you all be happy together." He knew, better than Lucy could, how important this year of collection was to the future of his work. He trusted her to be patient, but reality was already truncating his overambitious plans. "With a heavy heart" he was abandoning his dream of a Pacific expedition, he told Lucy and Victor in a March 29 letter from Charleston. "My friends advise me not to go further than Key West & that only for a month." He was thinking of going north "to spend the summer along our northern sea coast," John Bachman wrote Lucy in April, "when the revenue cutter *Marion* arrived" in Charleston Harbor. The *Marion* was much larger than the *Spark,* sixty feet long and twenty-two feet wide. She carried "8 guns and 24 men," Audubon wrote. ". . . The captain has orders to do all in his powers to meet my [needs] and I look forward to a fine harvest."

In late April 1832 the *Marion* carried Audubon and his party to Indian Key, a

third of the way down the bow of coral islands that culminates at Key West. A new acquaintance on Indian Key introduced the artist to a type of heron he had never encountered before. He drew it as a great white heron (considered today to be a color morph of the great blue), bent low with a fish clamped crosswise in its beak, its neck sinuous and its head cocked up, caught in the moment of preparing to flip the fish into headfirst position to swallow. George Lehman later painted Key West into the background below a dark, stormy sky; the finished drawing became Plate 181 of *The Birds of America*.

The live herons that Audubon's acquaintance had delivered were fearless; one of them locked onto Plato's nose when the dog approached it and could only be detached by forcefully spreading its wings, whereupon it shook itself free and "walked off as proudly as any of its tribe." Four of these herons that Audubon delivered to Bachman took over the clergyman's garden, "where at night they looked with their pure white plumage like beings from another world." They attacked Bachman's chickens and ducks, impaled and murdered one of his cats and finally began attacking his children, at which point Bachman in self-defense had them put down.

On his forty-seventh birthday, April 26, 1832, Audubon drew a Florida cormorant (a double-crested cormorant subspecies) collected amid thousands he found nesting on mangroves in the maze of smaller islands around Indian Key. In the next days he collected and drew roseate terns, a brown pelican, a Louisiana heron (tricolored heron) and a pair of white-headed pigeons (white-crowned pigeons). In May he saw the third of the only three Tennessee warblers he had encountered up to that time—the first and second he had seen near Bayou Sarah in 1821 and 1829. More pigeons revealed themselves in Key West: the Key West pigeon (Key West quail-dove), which Audubon named; and a pair of blue-headed pigeons (blue-headed quail-doves) from Cuba. Then on May 7, to his great delight, he "for the first time saw a flock of Flamingoes . . . advancing in 'Indian line' with well-spread wings, outstretched necks and long legs directed backwards. . . . I thought I had now reached the height of all my expectations." But despite multiple excursions from Indian Key and later from Key West, he failed to collect even one of these large, showy, pink, long-necked birds and had to draw his plate in London from specimens preserved in spirits.

Key West in 1832 was a raffish town with a population of about five hundred, most of whom made their living—for some a very good living—salvaging the contents of ships wrecked on the treacherous reefs around the Keys. Nor were the wreckers above moving or removing the reef markers to create the salvage they redeemed.

Everywhere Audubon went in frontier America he almost always befriended physicians. They were usually the only people in frontier settlements with any scientific training. A physician and surgeon named Benjamin Strobel had arrived in Key West from Charleston in 1829 and risen to prominence as doctor, newspaper editor and town councilman. He was a correspondent of John Bachman, with whom he traded shells and specimens. Bachman had given Audubon a letter of introduction to Strobel, which he handed the physician when the *Marion* put him ashore in one of its boats in early May. Strobel guided Audubon around Key West, observed him and testified in a newspaper account to his style and his stamina:

> Mr. Audubon is a very extraordinary man. An acquaintance of half an hour enabled me to enter at once into his character and feelings. Divested of everything like pedantry, he is frank, free and amiable in his disposition and affable and polite in his manners. His engaging manner and mild deportment . . . enable him to accomplish many things which to another person would be unattainable; everyone appears to enlist at once in his service and to be disposed to promote his views. . . . Mr. Audubon is the most enthusiastic and indefatigable man I ever knew. It is impossible to associate with him without catching some portion of his spirit. . . .
>
> In order to give some faint idea of Mr. Audubon's exertions, I will briefly relate the occurrences of one day's excursion on which I accompanied him. At half past two o'clock a.m. our party assembled. . . . At three o'clock we started. . . . Our boats were hauled over a [tidal] flat nearly a mile in length before we could get them afloat. . . . Not a pond, lake or bog did we leave unexplored, often did we wade through mud up to our knees, and as often were we obliged to scramble over the roots of the mangrove trees. . . . About 8 o'clock the sun came out intensely hot. . . . Often we were driven from the woods by myriads of mosquitoes and sand flies. . . . Onward we went, baking and broiling, and what was more discouraging still, we could discover not a single bird worthy of note. Mr. Audubon was neither dispirited by heat, fatigue nor bad luck, whilst we began to lag and occasionally would dodge under some tree to catch a breath or sit down to blow.

Strobel accepted the use of a horse to ride home; the rest of the party went by boat. He reached his house around eleven a.m., collapsed in bed and slept soundly for several hours. The experience occasioned no further desire "to repeat the jaunt," he wrote. However:

To Mr. Audubon this was an everyday affair; he rose every morning at 3 o'clock and went out in a boat, cruised in search of birds, etc., until 12 or 1 o'clock, at which time he usually returned to dinner. During these expeditions he took no refreshments but biscuit and molasses and water. . . . Before and after dinner, as soon as he returned from the morning jaunt, Mr. Audubon employed himself in drawing such birds as he might have procured during the morning, and in the evening he was on the hunt again. Thus has Mr. Audubon been employed day after day for weeks and months. . . .

Not soon will the recollection of this surprising man pass from my memory.

During the second week in May the *Marion* carried Audubon beyond Key West to the Tortugas. No fort had yet been built there; the small islands Audubon visited were furnished instead with flocks of sooty terns and noddy terns (brown noddies), the latter, the *Marion*'s first lieutenant told him, "called Noddies because they frequently alighted on the yards of vessels at night and slept there." The officer promised that the birds would "rise in swarms like those of bees when disturbed in their hive, and their cries will deafen you." Their cries were indeed deafening, Audubon wrote:

All those not engaged in incubation would immediately rise in the air and scream aloud; those on the ground would then join them as quickly as they could, and the whole forming a vast mass, with a broad extended front, would as it were charge us, pass over for fifty yards or so, then suddenly wheel round, and again renew their attack. When the sailors, at our desire, all shouted as loud as they could, the phalanx would for an instant become perfectly silent, as if to gather our meaning; but the next moment, like a huge wave breaking on the beach, it would rush forward with deafening noise.

At another island Audubon found a party of Cuban eggers from Havana. "They had already laid in a cargo of about eight tons of the eggs of this [sooty] tern and the noddy." He asked the men how many eggs they had collected; they said they never counted them even when they sold them but simply sold them by the gallon. A shipload earned them about $200 and they could make a round trip, collecting and selling, in a week. Audubon would encounter eggers again elsewhere far more exploitative than these.

The Tortugas took their name from the turtles—green, hawksbill, loggerhead and leatherback—that migrated there annually in the thousands to lay

their eggs. Audubon was one of the first observers to describe the phenomenon in detail. Since it was May, he probably witnessed loggerheads laying:

> Slowly advancing landward, their heads alone above the water, are observed the heavily-laden Turtles anxious to deposit their eggs in the well-known sands. On the surface of the gently rippling stream I dimly see their broad forms as they toil along, while at intervals may be heard their hurried breathings, indicative of suspicion and fear. The moon with her silvery light now illumines the scene and the Turtle, having landed, slowly and laboriously drags her heavy body over the sand, her "flappers" being better adapted for motion in the water than on shore. Up the slope, however, she works her way, and see how industriously she removes the sand beneath her, casting it out on either side. Layer after layer she deposits her eggs, arranging them in the most careful manner, and with her hind-paddles brings the sand over them. The business is accomplished, the spot is covered over and with a joyful heart the Turtle swiftly retires towards the shore and launches into the deep.

From local turtlers Audubon learned and reported that turtles removed from the beaches where they laid their eggs, carried hundreds of miles out to sea and released would return to the same beaches, either immediately or in breeding season the following year. "Should this prove true," he wrote perceptively, "and it certainly may, how much will be enhanced the belief of the student in the uniformity and solidity of Nature's arrangements, when he finds that the turtle like a migratory bird returns to the same locality."

Audubon observed a sandbar barely above sea level about eight miles northeast of the Tortugas lighthouse covered with booby gannets (brown boobies) "basking in the sunshine and pluming themselves." The birds flew off when he approached in the *Marion*'s yawl but returned after he landed and minimized his profile by lying flat in the sand. He drew one of the brown-and-white, yellow-billed, plunge-fishing seabirds on May 14, 1832, which became Plate 207 of *The Birds of America*. Writing about it from the perspective of his exceptional field experience, he wondered why the species had been maligned with a disparaging name:

> I am unable to find a good reason for those who have chosen to call these birds *boobies*. Authors, it is true, generally represent them as extremely *stupid;* but to me the word is utterly inapplicable to any bird with which I am acquainted. . . . My opinion, founded on pretty extensive observation, is that

it is only when birds of any species are unacquainted with man, that they manifest that kind of *ignorance* or *innocence* which he calls *stupidity,* and by which they suffer themselves to be imposed upon. A little acquaintance with him soon enables them to perceive enough of his character to induce them to keep aloof.

Thinking about it further on another day, Audubon added "that the animal truly deserving to be called stupid yet remains to be discovered, and . . . the quality designated by that epithet occurs nowhere else than among the individuals of that species which so thoughtlessly applies the opprobrium." In simple English: the only boobies Audubon had come across were humans.

Cape Sable, where the Everglades merge with the sea, was Audubon's last port of call, at the end of May. While the *Marion* waited at Indian Key he crossed the lagoon of Florida Bay in a rented barge to explore the spectacular cape. Again the pickings were slim. He emphasized at a later time how hard water birds were to study. "The Land Bird flits from bush to bush, runs before you and seldom extends its flight beyond the range of your vision." The waterbird, in contrast, "sweeps afar over the wide ocean, hovers above the surges, or betakes itself for refuge to the inaccessible rocks on the shore." He would have to look elsewhere for the waterbirds he needed to fill out his inventory of species.

The *Charleston Courier* lauded Audubon's return there at the beginning of June 1832. "His collection of specimens in natural history was with difficulty conveyed [from the *Marion*] in five cartloads," the newspaper reported. "It consists of plants, seeds, shells, coral, amphibious animals and skins of quadrupeds and birds." John Bachman helped place Henry Ward at the Charleston Museum as a salaried taxidermist. (The devious young Englishman later absconded with part of the museum's exceptional collection of skins.) After a few weeks renewing his friendship with the Bachmans, Audubon left Plato with them and traveled by coach to Philadelphia in late June: "6 days & nights," he reported to Bachman on July 1—"roads fine—good company—poor fare &c." George Lehman returned to Philadelphia separately.

Lucy in Louisville had not yet heard from her husband on June 24, when she wrote Havell about business matters and mentioned that she and John Woodhouse had both been ill that spring. But the Audubons had communicated by the time the artist wrote Bachman on July 1. He was hoping then that "my good wife & sons will arrive soon for I feel almost crazed and quite at a loss in this city." The next week he removed to a Camden boardinghouse from his more

expensive Philadelphia hotel to wait for his family to join him. In New Jersey he calmed his craziness by birding, collecting and drawing a king rail, a rough-legged hawk (rough-legged falcon) and two barn owls.

Cholera had crossed the Atlantic that spring 1832 and entered the New World for the first time, spreading down the Hudson Valley from Montreal and directly into New York on immigrant ships from Ireland. The pandemic chain led back to Liverpool and London, Paris, Germany, Poland, Russia and Afghanistan and ultimately to India. At the beginning of July Audubon had joked to Bachman with his usual bravado that "the cholera [is] all fudge." By the middle of the month, when Lucy and the boys arrived from Louisville to join him, New York was reporting more than one hundred deaths per day. Deaths in New Jersey and Philadelphia as well made Audubon a believer. "That dreadful scourge the cholera was devastating the land," he wrote later, "and spreading terror around its course. We left Philadelphia under its chastening hand and arrived at New York, where it was raging, while a heavy storm that suddenly burst over our heads threw an additional gloom over the devoted city, already bereft of a great part of her industrious inhabitants." The family reached New York on July 30. They saw Nicholas and Eliza Berthoud the next morning; Lucy's sisters Ann and Sarah happened to be visiting the Berthouds as well. They departed for Boston the same afternoon. "New York looked dismal in the extreme," Audubon wrote his Philadelphia physician friend Richard Harlan from Boston. "The city was in fact dilapidated and a dismal feeling affected us all while we remained in it, which however was only 24 hours. . . . We proceeded by steam[boat] to New London in Connecticut and thence in coach to this place . . . having traveled by day only, expecting to enjoy the sight of the country, which is indeed very beautiful."

They had escaped Philadelphia just in time, Harlan responded in August:

The cholera has raged dreadfully in some localities here—I was engaged on Monday superintending the removal of sick prisoners from the jail in Arch St. at the request of the city authorities—I was there three times during the day—60 were sick at one time, the suffering and agony of the dying wretches was an awful sight to witness, 26 died there that day, and about as many more who were removed to the various local hospitals. . . . The newspapers do not give an accurate account, because numbers are cured in the early stages whose cases are never reported. The statements of deaths are more accurate and I suppose the greatest mortality has not exceeded 100 per diem. Today only 26 deaths [have been] reported, there will probably be more

tomorrow. . . . My time is usefully, at least, if not profitably employed, night and day. Cholera, cholera, cholera! ! ! !

The Audubon family had not lived together since Henderson; reuniting it after the debacle of business failure there had been a labor for both industrious parents of twelve difficult years. Now their sons learned what their work would be. Victor would sail to England in September to become his father's business manager, sustaining subscriptions and supervising Havell. John Woodhouse, an increasingly skillful artist, would assist with northern bird collections. In the meantime Boston, lavishing the American woodsman with six new subscriptions in the first week of his visit, was earning a reputation in Audubon's mind as "the Athens of our Western World."

Twenty-five

LABRADOR

B OSTON WELCOMED THE AUDUBONS in the summer of 1832 with uncharacteristic warmth. "The outpouring of kindness which I experienced [there]," Audubon would recall sentimentally, "far exceeded all that I have ever met with." By the middle of August the Boston Athenaeum was displaying his drawings and he had added nine names to his *Birds of America* subscription list. Thomas Nuttall, a botanist and professor of natural history at Harvard, walked out birding with Audubon and collected an olive-sided flycatcher, a species that Nuttall had first described. Edward Everett, the congressman and future Harvard president and U.S. secretary of state, included the Audubons among notables at his fashionable dinners.

With Victor soon to leave for England, the family renewed its intimacy during late August and September on a long ramble together up the Maine coast and into New Brunswick, a rare experience of fieldwork for Lucy Audubon. A crowded excursion boat carried them from Portland to Eastport—"the extreme boundary of the U.S.," Lucy advised Euphemia Gifford—opposite Campobello Island at the wide entrance to the Bay of Fundy. Farther up on the New Brunswick shore of the bay the schooner entered the St. John River, where horses on a riverside towpath hauled it tediously upstream. Where the river shoaled over a rapids, the men went onshore to help with the towing, which reminded Audubon of cordelling his and Ferdinand Rozier's flatboat through broken ice up the Mississippi to Ste. Genevieve in 1811. He managed a drawing or two in four days at Fredericton, to Lucy "a very pretty village on the bank of the river." Farther up at Woodstock, near the international border, the Audubons left the tedious two-mile-an-hour haul and hired a cart and driver. Crossing back into Maine, they traveled downstream along the Penobscot River to Bangor. Audubon celebrated the river's "broad transparent waters" that supported "canoes filled with Indians" that "swiftly glided in every direc-

tion, raising before them the timorous waterfowl that had already flocked in from the north." Later, returning from market, the Penobscots crowded the road between Old Town and Bangor as the Audubons passed.

Victor sailed from New York on the packet ship *South America* on October 16, 1832. Robert Havell, Sr., long retired from business, died within days of Victor's arrival in England. Lucy's letters of early November followed her older son to London, reporting his father and brother busy with ducks, a few cases of cholera in Boston and Andrew Jackson reelected President for a second four-year term. "John is a good fellow," she confided, "and his drawing is of great use to his father," but his "habits of carelessness" fretted her. She had noticed what other contemporary observers had remarked as well in the character of young white males raised in the South where slaves relieved them of responsibility: "I am very apt to attribute that want of vigilant and persevering industry which we should like to see in him to the bringing up in a slave state where indolence is too much fostered." Indolence as it was measured in the Audubon family was a vigorous business, however; she reported further that John had "skinned about a hundred birds which are hanging up in the adjoining rooms." Audubon was painting a trio of eider ducks and hoped to have a hundred drawings in hand by spring.

IN LATE NOVEMBER 1832 Audubon heard from a forty-six-year-old physician and botanist, Jacob Bigelow, who taught medical botany (materia medica)

at Harvard Medical School. Bigelow's letter summarized public experiments he had conducted in 1816 on a bald eagle destined for a museum display that were intended "to destroy him without injuring his plumage." Feeding the big eagle small fish packed first with mercuric chloride and then with arsenic had no apparent effect, however, "so that in the end the refractory bird was obliged to be put to death by mechanical means." Audubon presumably solicited this information, since the experiments had happened years before. Sacrificing a large captured bird without damaging it was difficult. He had put word out to Boston-area market hunters that he would buy large birds alive in good condition; his inquiry to Bigelow, if such it was, probably anticipated deliveries.

Luck rather than word of mouth brought him what he called "the finest *Golden Eagle* alive which I have ever seen" on February 24, 1833. The acquisition resulted from a call—probably a subscription sales call—on the Boston portrait painter and museum proprietor Ethan Allen Greenwood. Greenwood's Columbian Museum included natural history specimens among its wax figures and portraits of prominent Americans. He had recently purchased a captive eagle from a New Hampshire trapper and asked Audubon to identify it. The trapper had found the eagle caught by one toe in one of his fox traps. The powerful bird had carried the trap more than a mile before grounding itself, and the trapper had to chase it several hundred yards farther through the woods to catch it. Audubon needed a golden eagle, a species common in the American West but rare in the East. Greenwood agreed to sell it. The price, $14.75, was probably what the museum proprietor had paid the trapper—"a pretty good price," Audubon acknowledged to Victor the same day, but not the $100 that a "rascal in Philadelphia" had tried to charge him "for a far less handsome specimen." He told Victor he intended to draw the eagle "tearing a young fawn or a northern hare."

Audubon draped a blanket over the golden eagle's cage, carried it back to his rooms and began observing it. He had always identified with eagles, ambivalently admiring and envying them. Eagles were conquerors, the nobility of birds, majestic, "muscular, strong and hardy, capable of bearing extreme cold without injury and of pursuing their avocations in the most tempestuous weather." A full-grown golden eagle female—the bird that stared out at him from its cage in frozen winter Boston—weighed twelve pounds (a male two pounds less); its length from beak to tail tip was more than three feet, its extended wings fully seven feet across. Audubon also identified Napoleon with eagles and himself with Napoleon. "Had I been so fortunate as to procure a new Eagle," he had written in the biography of the little merlin he had christened *le petit caporal*, "I should have adopted the names Napoleon or Bonaparte."

He thought of the female golden eagle he had procured as a male:

> I placed the cage so as to afford me a good view of the captive and I must
> acknowledge that as I watched his eye and observed his looks of proud dis-
> dain, I felt towards him not so generously as I ought to have done. At times I
> was half inclined to restore to him his freedom, that he might return to his
> native mountains; nay, I several times thought how pleasing it would be to
> see him spread out his broad wings and sail away towards the rocks of his
> wild haunts; but then . . . someone seemed to whisper that I ought to take
> the portrait of this magnificent bird, and I abandoned the more generous
> design of setting him at liberty.

Taking the portrait meant taking the eagle's life. He studied the bird for two
days, looking for the best position in which to draw it, "and on the third [day]
[I] thought of how I could take away his life with the least pain to him."
Bigelow's previous experiments—directed not to alleviating suffering but to
preserving plumage—had not worked, so Audubon talked to his family physi-
cian and fellow hunter George Parkman, who advised using "carbonic gas"
(carbon dioxide and monoxide) from burning coal or, alternatively, electrocu-
tion. "We both concluded that the first method would probably be the easiest
for ourselves and the least painful to him," Audubon would write in the second
volume of his *Ornithological Biography.* He explained the conclusion some-
what differently to Richard Harlan in a March 1833 letter: "I had a great desire
to try electricity but could not obtain a battery sufficiently powerful to be
trusted for a single stroke."

So Audubon moved the golden eagle in its cage into a closet, covered the
cage with blankets, set a pot of smoldering coal on the floor, tucked the blan-
kets around the pot and retreated into the adjoining room:

> I waited, expecting every moment to hear him fall down from his perch; but
> after listening for *hours,* I opened the door, raised the blankets and peeped
> under them amidst a mass of suffocating fumes. There stood the Eagle on
> his perch, with his bright unflinching eye turned towards me and as lively
> and vigorous as ever!

More hours of fumes failed to accomplish Audubon's purpose, although by
then the air in the larger room where he and John Woodhouse waited had
begun to make them ill. Wearied and disappointed, Audubon removed the coal
pot and the blankets, vented the closet and went to bed.

The next morning he added sulfur to the smoldering coal. "We were nearly driven from our home in a few hours by the stifling vapors, while the noble bird continued to stand erect and to look defiance at us whenever we approached his post of martyrdom." The bird was too large and fierce to throttle; in the end Audubon had to resort to "a method always used as the last expedient. . . . I thrust a long pointed piece of steel through his heart, when my proud prisoner instantly fell dead without even ruffling a feather."

To a modern reader, sheltered from the vast commercial slaughter that sustains the retail food industry today, these halting antique experiments must sound cruel. Killing animals and birds was unremarkable in Audubon's day, before refrigeration—no doubt Lucy could wring a chicken's neck with the best of them—and in any case Audubon believed he was performing a service, conducting an experiment, hoping to devise a less painful way than shooting or throttling to kill and to preserve. "A fine tale this to relate to Monsieur G[eorge] Ord of Philadelphia," he wrote, with a wink to Harlan. ". . . Tell all this to your Society and assure them in my name that the experiments were made with care by an F.R.S. of some merit!"

The encounter with the golden eagle did not end with its death, of course. Audubon immediately arranged the bird on mounting wires in the position he had studied and selected: beating powerfully upward as if lifting away from a kill with prey seized in its talons, its coverts catching the sun, its beak opened in a cry that Audubon would describe as "harsh and sharp, resembling at times the barking of a dog." For prey he gave the great eagle a northern hare in its white winter coat, bought at the Boston market. He worked on the drawing for sixty hours, he wrote Victor in early March, across about four days—about fifteen hours a day—which left him exhausted. It was "the severest labor I have experienced since I drew the Wild Turkey."

Below and behind the eagle Audubon painted in bare mountains, rocky in the middle ground and white and snow-covered in the distance. Above the mountains, conquering them by dominating the foreground, filling the visual space, the bird rears up through blue sky torn with white clouds shredded by the mountain winds. Two curious details have drawn comment to this drawing: one of the eagle's talons cruelly pierces the hare's eye, releasing a drop of bright-red blood (blood also drips from the hare's nostril); and diminutively in the lower left corner a buckskinned, long-haired, fur-capped woodsman shinnies across a fallen log bridging a sheer chasm—Audubon himself, with a gun and the golden eagle's mate slung on his back. Thus the eagle preys on the hare as Audubon preys on the eagle, which returns with its prey to its nest to find its partner seized and taken: the hare's revenge, so to speak, enacted by Audubon:

"this back-stroke, this kick of the gun," as Ralph Waldo Emerson was writing at about the same time, "certifying that the law is fatal; that in nature nothing can be given, all things are sold."

At least one more layer, this one allusory, enriches this complex drawing. The art historian Theodore Stebbins, Jr., identified its basis—that Audubon modeled his *Golden Eagle* on a painting by Jacques-Louis David—without elaborating on its implications. "Audubon's composition," Stebbins writes— "with the huge bird pushed to the front plane, the small figure seen in the distance, and the Alpine setting—all recall Jacques-Louis David's Romantic masterwork of 1801, *Bonaparte Crossing the Saint Bernard.*" Many details in Audubon's drawing make it a reasonable conjecture that he consulted a copy of David's painting, possibly a colored engraving, in composing his *Golden Eagle.* Or he may simply have remembered it from seeing at Joseph Bonaparte's country estate at Point Breeze, New Jersey, one of the three copies David had painted.

His triple-peaked, snow-covered mountains are borrowed from the distant far right of *Bonaparte,* moved forward and centered behind his dark, rocky landscape to mirror-image the colors and forms of the white hare and the dark eagle. Light flooding into both pictures from the upper left illuminates the eagle and its white prey as it illuminates Napoleon and his white horse. The drop of blood sweating from the hare's torn eye duplicates a red touch of embroidery at Napoleon's waist. But the conqueror and his rearing white horse combine in the eagle into one magnificent raptor, urging upward: the eagle's beating wings duplicate Napoleon's golden, wind-swirled cape, while the eagle's open-beaked cry is the horse's openmouthed whinny and the eagle's glare of defiance is the horse's bulging wild eye.

And where in all these bravura resonances is Audubon? Audubon in seeming modesty is positioned in his drawing as Napoleon's common soldiers wrestling cannon into the Saint Bernard pass are positioned in David's painting. But unlike the common soldiers (whose fate he escaped by emigrating to America), Audubon has slipped past the would-be conqueror, has already climbed the mountain, has seized a Napoleonic eagle from its high aerie and is now—precariously, to be sure—shinnying down the chasm with his prize.

Whether or not Audubon ever studied under David—and he almost certainly did not—he clearly meant to show by this drawing that within his range of subject matter and technique he was David's equal. As he did in many other drawings, he intended to visualize something else as well, something less personal and more universal, something La Fontaine taught him that he deepened and enriched beating through forests and wading swamps observing birds

House wrens nesting in a hat

going about their complex lives: the equivalence of ambition, passion, violence, endurance, even of good and evil between the animal world and the human. His invocation of that equivalence has led some critics to dismiss his work as anthropomorphic, as if he were no more than an illustrator of textbooks, as if animals cannot feel and fear and hope.

In fact, Audubon's supposed anthropomorphism is an attempt to recover meaning, a system for translating the alien experience of a different animal

order into human terms and parallels. Thus his passenger pigeons ecstatically billing, sharing in their passion the crop milk they also make for their young. Thus his house wrens nesting in a hat, an image of tender family life that the hat's startling splash of bird shit bleaches of sentimentality. Thus his ferruginous thrushes (brown thrashers) defending their nest and nestlings against a blacksnake, the birds all ferocity and the snake warily testing the air with its tongue.

Graphic and precisely rendered violence especially distinguishes Audubon's art from traditional wildlife painting. He knew that the natural world was no suburban idyll, as the Romantic poets who were his contemporaries were pretending. Ralph Waldo Emerson was groping toward a comparable American realism. "Nature is a tropical swamp in sunshine," he declared in *The Sovereignty of Ethics,* "on whose purlieus we hear the song of summer birds and see prismatic dewdrops—but her interiors are terrific, full of hydras and crocodiles." Though Emerson was a cleric, he seems like Audubon to have found his way at least intermittently beyond the Christian hierarchy that seated humankind above the animals, a little lower than the angels, to a modern understanding, before Darwin, that humans are also animals and share the cage of the world. As he told an after-dinner audience:

> The way of Providence is a little rude. The habit of snake and spider, the snap of the tiger and other leapers and bloody jumpers, the crackle of the bones of his prey in the coil of the anaconda—these are in the system, and our habits are like theirs. You have just dined, and however scrupulously the slaughterhouse is concealed in the graceful distance of miles, there is complicity, expensive races—race living at the expense of race.

Compassion is an exclusively human gesture, though tenderness is not. The natural world is pitiless. Audubon, intent to penetrate the alien avian surface to reveal the feeling life beating in common with our own, refused to sentimentalize the scenes he drew. The golden eagle's talon piercing the northern hare's eye, or, elsewhere, the bleeding American hare urinating in pain and terror in the grip of a female red-tailed hawk itself under attack from a swooping, larcenous male, are images fully as harrowing as Goya's nightmare aquatints. Audubon despised the black-backed gull (great black-backed gull) that preyed on fledglings in nesting colonies while the desperate parents fluttered helplessly overhead. In its biography he castigated it as a "remorseless spoiler," a "destroyer," a glutton, "tyrannical . . . a coward . . . ravenous and merciless." He might have shown it nesting, caring for its young—no doubt it did, as all birds

do—but since he could choose to illustrate any moment in its life, he chose the moment he collected it and depicted it gutshot and bleeding on the ground screeching in pain. Which implicated him as an agent of retribution and thus as a spoiler and destroyer in turn. He drew the world he knew. "If I were to tell you one half of what I see in those lonely ravines and swamps," he had cautioned Mrs. Pope in St. Francisville, "it would make your hair stand up on your head!" His hair had stood up on his head at Nantes in the days of the Terror; he had known pitiless human beings before he encountered predatory birds. In the larger world of the animals, whatever classifying naturalists thought, a golden eagle *was* Napoleon *and* his horse.

Whether on his own or on Audubon's instruction, Robert Havell removed the little woodsman from the plate he made of the *Golden Eagle,* Plate 181 of *The Birds of America,* removing along with it a level of meaning that only the original watercolor has sustained.

AUDUBON HAD INTENDED TO TRAVEL to Labrador with John Woodhouse in the middle of March to collect waterbirds. The slow crossing from England of the ship by which Victor had sent funds needed for the expedition delayed their departure. In any case the artist was exhausted. Six days after he finished the *Golden Eagle,* on March 16, a month away from his forty-eighth birthday, Audubon had a stroke. He was sufficiently recovered four days later to spin the tale for Richard Harlan:

> The hand which now drives my pen was paralyzed on Saturday last for about one hour. The attack seized on my mouth & particularly my lips, so much so that I neither could articulate or hold anything. My good dear wife was terribly frightened and yet acted so promptly with prudence & knowledge that I was relieved as I already said in about one hour. Doctor [Joseph C.] Warren came in with our ever worthy friend [Dr. George] Parkman and administered me a dose [i.e., a purgative] which kept me "a-going" for 24 hours. Now much debility is all that ails me. Moderate exercise and a cessation of work will reverse this and I hope soon to be myself again.

Delayed by his illness—which had frightened Audubon at least as much as it had Lucy—the family traveled to New York at the end of April to settle Lucy with the Nicholas Berthouds in their house on Washington Square and to organize the Labrador expedition. They had fifty-five American subscriptions to *The Birds of America,* $1,300 cash on hand and another $3,000 due. "We have

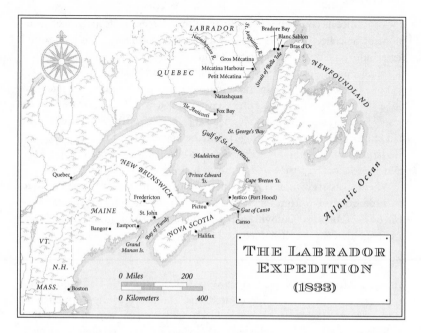

THE LABRADOR
EXPEDITION
(1833)

been extremely fortunate of late on this side of the water," Audubon advised Victor. On May 1 father and son sailed for Boston. A week later they had reached Eastport, Maine, where Audubon decided to charter a nearly new 100-ton schooner, the *Ripley,* to carry him, John and the four young men he had invited to join the expedition wherever they might find birds: George Shattuck of Boston, a young physician; Thomas Lincoln, a stoic downeaster whose father was a judge; William Ingalls, a medical student in Boston; and Joseph Coolidge, the son of an Eastport revenue cutter captain. John Woodhouse, now a vigorous, outgoing twenty-one-year-old, would be their leader, since his father expected to spend much of his time aboard the *Ripley* drawing the birds they collected.

Audubon had the boat fitted out appropriately:

> The hold of the schooner was floored [over ballast] and an entrance made to it from the cabin, so that in it we had a very good parlor, dining room, drawing room, library &c., all those apartments, however, being united into one. An extravagantly elongated deal [i.e., pine] table ranged along the center;

one of the party had slung his hammock at one end, and in its vicinity slept the cook and a lad who acted as armorer [loading and maintaining their guns]. The cabin was small; but being fitted in the usual manner with side berths, was used for a dormitory. It contained a small table and a stove, the latter of diminutive size but smoky enough to discomfit a host.

He found humor for Lucy in the clothes he provisioned in Eastport for the Labrador cold:

A strange figure indeed do we cut in our dresses I promise thee: fishermen boots, the soles of which are all [hob]nailed to enable us to stand erect on the [rocks]; pantaloons of fearnaught [wool] so coarse that our legs look more like bear's legs than anything else; oil jackets & over-trousers for rainy weather and round white wool hats with a piece of oil cloth dangling on our shoulders to prevent the wet running down our necks; a coarse bag strapped on the shoulder to carry provisions during inland excursions, hunting knife at our sides and guns on the back. Add to these the full-grown beard which thy friend will have on his return and form an idea of his looks next autumn.

Before the *Ripley* sailed, Audubon had time for a side excursion to Grand Manan Island, ten miles out from Eastport. Catching ravens alongside the "young gentlemen" by lowering themselves "down ropes from the top of the precipitous rocks in which [the birds] place their nests" shook off the last of his stroke-induced debility, he wrote Harlan. ". . . We have had rare sport & plenty of it and I am Audubon again!"

The young gentlemen were the pleasure of the summer for Audubon, who felt acutely that he was growing old. They respected him and looked up to him. Most gratifying of all, they were prepared to *learn* from him. Seventy years later William Ingalls, the medical student, would remember Audubon's "great amiability and manliness [and] his humanity. . . . It has always seemed to me he was one of those men who on meeting, one would say at once, 'Bless you, dear man.' " Lincoln, the downeaster, sparer with compliments, still judged him "a nice man, but as Frenchy as thunder."

Departing Eastport on June 6, they crossed "that worst of all dreadful bays, the Bay of Fundy"—"all seasick," Audubon noted—rounded Nova Scotia and on June 12 anchored at the entrance to the narrow Gut of Canso, which separated Nova Scotia at its north end from Cape Breton Island. The Gut, "truly beautiful," reminded Audubon of the Hudson River. They "went near the fine,

beautiful clear rocks of the shore" in their rowboat, Ingalls recalled; "the water was so clear we could see lobsters on the bottom, so we tickled their backs with oars which they grasped with their great [claws] and held on till they were let into the boat." Forty lobsters made a feast for stomachs just settling.

They passed through the Gut, entered the Gulf of St. Lawrence and sailed beyond Prince Edward Island to the small cluster of the Madeleines, midway to the Labrador coast, where they found Blackburnian warblers and piping plovers. After several days of exploring they moved on eagerly to encounter the great gannet rocks, four towering monoliths rising perpendicularly from the sea where their pilot told them the long-billed white birds bred.

Everywhere they went that summer they exclaimed over the incredible numbers of birds and fish they encountered: the sea in one place covered with foolish guillemots (common murres); Eskimo curlews arriving in another place in such dense flocks that they reminded Audubon of passenger pigeons; the several hundred cod boats piled to the gunnels every week with more than half a million cod, mackerel, halibut and herring; herring gulls filling the trees with their nests to avoid human predation on the ground; puffins so numerous in the water and overhead that "one might have imagined half the Puffins in the world had assembled there." But even compared to these wonders the gannets were exceptional:

> For several days I had observed numerous files [of gannets] proceeding northward, and marked their mode of flight while thus traveling.... At length, about ten o'clock, we discerned at a distance a white speck, which our pilot assured us was the celebrated rock of our wishes. After a while I could distinctly see its top from the deck, and thought that it was still covered with snow several feet deep. As we approached it, I imagined that the atmosphere around was filled with flakes, but on my turning to the pilot, who smiled at my simplicity, I was assured that nothing was in sight but the Gannets and their island home. I rubbed my eyes, took up my glass, and saw that the strange dimness of the air before us was caused by the innumerable birds, whose white bodies and black-tipped pinions produced a blended tint of light-grey. When we had advanced to within half a mile, this magnificent veil of floating Gannets was easily seen, now shooting upwards, as if intent on reaching the sky, then descending as if to join the feathered masses below, and again diverging toward either side and sweeping over the surface of the ocean. The *Ripley* now partially furled her sails, and lay to, when all on board were eager to scale the abrupt sides of the mountain isle, and satisfy their curiosity.

"This magnificent veil of floating Gannets. . . ."

A storm blew up suddenly that prevented the group ascent. Instead John Woodhouse, Tom Lincoln and four sailors rowed a whaleboat in to collect birds and eggs. The boat was almost swamped in the stormy sea returning. "My son stands erect, steering with a long oar, and Lincoln is bailing the water which is gaining on him. . . . But they draw near, a rope is thrown and caught, the whaleboat is hauled close under our leeboard; in a moment more all are safe on deck, the helm round, the schooner to, and away under bare poles she scuds toward Labrador." Audubon recorded the adventure on Plate 326 of *The Birds of America*, where behind a black-pinioned white male and a young first-winter gannet in mottled brown plumage, the stormy sea and one of the great rocks are visible in the gloom, the rock veiled—Audubon's fine, precise metaphor—with gannets.

If the expedition encountered vast numbers of birds and fish around the Gulf of St. Lawrence, it also encountered parties of men busy at prodigal expropriation and slaughter. The *Ripley*'s pilot knew the gannet rocks because he had visited them for ten seasons with other fishermen to club to death hundreds of the big seven-pound birds and skin them for cod bait. At Bras d'Or, on the Labrador coast, where the cod fishermen processed their catch—"hundreds of men engaged in cleaning and salting [codfish] and enlivening their work with Billingsgate slang and stories and songs"—Audubon found

"the whole bottom of this harbor . . . paved with cod heads." Nearby in the countryside fifteen hundred seal carcasses lay piled in a mangled heap, fed on by dogs; "the stench filled the air for half a mile around."

Far worse in Audubon's eyes were the eggers, men who collected wild eggs fresh for commercial sale:

> We heard today that a party of four men from Halifax, last spring, took in two months four hundred thousand eggs, which they sold in Halifax at twenty-five cents a dozen. Last year upwards of twenty sail of vessels were engaged in this business; and by this one may form some idea of the numbers of birds annually destroyed in this way, to say nothing of the millions of others disposed of by the numerous fleet of fishermen which yearly come to these regions, and lend their hand to swell the devastation. The eggers destroy all the eggs that are sat upon, to force the birds to lay fresh eggs, and by robbing them regularly compel them to lay until nature is exhausted, and so but few young ones are raised. These wonderful nurseries must be finally destroyed, and in less than half a century, unless some kind government interposes to put a stop to all this shameful destruction.

Labrador made Audubon melancholy despite the fresh breeze of his young gentlemen's eagerness. It was partly the prodigal slaughter, partly the bleak landscape of moss and stunted trees, bare rock and fog; partly it was the limited choice of collections despite the abundance of birds and partly again that he felt himself growing old.

Late in June on the coast of Labrador, William Ingalls remembered, Audubon joined his young gentlemen on an expedition to a small island "well covered with nests of guillemots and other seabirds [and] there was much shooting." Ingalls was standing near Audubon "watching the actions of the birds" when "presently a Tern . . . flew toward me swiftly, falling very near my feet seeming to be in consternation or fright; with flashing swiftness another Tern descended and in his dart came within a very few inches of the terror-stricken bird." Audubon must have noticed Ingalls's gesture of protection toward the bird cowering on the ground. The next evening, when the young medical student returned to the *Ripley*, he found Audubon painting a tern mounted on his positioning board: "I darkened the little table at which Mr. Audubon sat. He looked up and saluted me with 'Hello, Sangrido' (he gave me this name the first day), 'He is here, he is scared, affrighted, he is looking up at you, you cannot help him.' "

Audubon had been taken with the arctic tern, he wrote in his journal, had

"admired its easy and graceful motions," had "felt agitated with a desire to pos-
sess it" and with his comrades at its nesting grounds had emptied his gun but
then had felt pain "to pass and execute sentence" upon "the gentle birds." And
had reverted once again to Nantes and the Terror: "At that very moment I
thought of those long-past times when individuals of my own species were
similarly treated." As the two Audubon children, Fougère and Rose, might have
looked up terrified from crouching in the street in bloody Nantes or in the
prison where the family was held, so the tern was looking up at Ingalls—but
"you cannot help him." The artist was too honest not to acknowledge the irony
of his own response: "But I excused myself with the plea of necessity as I
recharged my double gun."

Audubon distinguished between his collections and those of the eggers by
weighing their seriousness of purpose. For the egger, he felt, "the dollars alone
chink in his sordid mind and he assiduously plies the trade which no man
would ply who had the talents and industry to procure subsistence by honor-
able means." Audubon's own purpose, though it also required killing, was to
record and to celebrate. His aging hurried him. So did the depredations he saw.

Several times during the summer the *Ripley* had encountered the *Gulnare*,
a larger British Navy schooner at work charting the Labrador coast. The
Gulnare's captain, Henry Bayfield, had welcomed Audubon and his party
aboard for dinner and had sent them a leg of mutton for their celebration of
Independence Day, a nice gesture from an English officer. Late in July the two
schooners met each other again at Gros Mécatina Island, below Bras d'Or in
the narrowing strait between Labrador and Newfoundland. Audubon found
the officers "encamped in tents on shore, living in great comfort; the tea things
were yet on the iron bedstead which served as a table, the trunks formed their
seats and the clothes bags their cushions and pillows. Their tent was made of
tarred cloth which admitted neither wind nor rain."

Passing the time "in company with intelligent officers of the royal navy of
England" was a pleasure, Audubon wrote. But they had all seen the ravages of
the unchecked reaping of wildlife from the water and the air, and their intelli-
gence did not allow them to ignore it:

> We talked of the wild country around us and of the enormous destruction of
> everything which is going on here except of the rocks; of the aborigines, who
> are melting away before the encroachments of a stronger race, as the wild
> animals are disappearing before them. Someone said it is rum which is
> destroying the poor Indians. I replied, I think not; they are disappearing
> here from insufficiency of food and physical comforts, and the loss of all

hope, as he loses sight of all that was abundant before the white man came, intruded on his land and his herds of wild animals and deprived him of the furs with which he clothed himself. Nature herself is perishing. Labrador must shortly be depopulated, not only of her aboriginal men but of every thing and animal which has life and attracts the cupidity of men. When her fish and game and birds are gone, she will be left alone like an old worn-out field.

So again the issue, finally, was purpose and responsibility. Farmers who cropped their fields without replenishing their nutrients wore them out. The wild world might be harvested, as the "aboriginal men" had done, but cropping the wild world too greedily wore it out as well.

AT THE BEGINNING OF AUGUST they encountered an iceberg at Bras d'Or, driven in by a storm and grounded at the entrance of the bay. "It looks like a large man-of-war," Audubon noted, "dressed in light greenish muslin instead of canvas; and when the sun shines on it it glitters most brilliantly." By now the time was passing tediously, "nothing to be seen, nothing to be shot, therefore nothing to be drawn." Time to sail home. On August 22, 1833, the *Ripley* landed Audubon and his young gentlemen at Pictou, on the north coast of Nova Scotia across the channel from Prince Edward Island:

> We were now, thanks to God, positively on the mainland of our native country; and after four days' confinement in our berths, and sick of seasickness, the sea and [our] vessel and all their smells and discomforts, we felt so refreshed that the thought of walking nine miles seemed like nothing more than dancing a quadrille. The air felt uncommonly warm and the country, compared with those we had so lately left, appeared perfectly beautiful, and we inhaled the fragrance of the new-mown grass as if nothing sweeter ever existed. Even the music of crickets was delightful to my ears. . . . [We] took to the road, along which we moved as lightly as if boys just released from school.

In Pictou they put up at the best hotel in town.

TOTING UP HIS RESULTS IN NEW YORK in early September, Audubon found that he had produced twenty-three large drawings of birds and collected seventy-three bird skins, along with a plenitude of shells and plants. The char-

ter had cost him $2,000, he wrote Victor, "but I am glad I went. It will give me a decided superiority over all that has ever been undertaken or ever will be on the birds of our country." He planned to winter in Charleston with the Bachmans, drawing and writing, after which he was divided between returning to England in June "to publish the 2nd volume of letterpress"—of the *Ornithological Biography*—or "remain[ing] in the U.S. one year more, to complete [the] water birds as far as [it is] in our power to do."

John left for Charleston by boat in late September; Audubon and Lucy traveled by coach. In Philadelphia, horribly, a Louisville creditor unaware of Audubon's bankruptcy or unwilling to acknowledge it learned that he was in town and filed suit; the court sent a bailiff to arrest him. "I was on the point of being taken to prison had I not met with [a friend] who kindly offered to be my bail." The suit was transferred to Charleston. Philadelphia, Audubon's eternal nemesis, produced no subscriptions either. In Virginia "a locomotive . . . dragged us twelve miles an hour and sent out sparks of fire enough to keep us constantly busy in extinguishing them on our clothes." They crossed the Roanoke River "by torchlight in a flatboat." From there they traveled by coach and arrived in Charleston on October 24.

Lucy worked into the winter transcribing and arranging her husband's Florida and Labrador journals and notes to make drafting his bird biographies easier. John began drawing birds and soon was turning out scenes that his father thought were "as good as any I ever made"—high praise. Audubon sat so many hours at work, producing "nearly *one hundred* drawings of water birds ready for publication . . . equal to any previous ones," that he developed painful piles; he needed ten days in bed in early December to ease them. He had no time to waste, he chivied Havell:

> Can we not push the work even faster? Can you not publish the 2nd volume . . . at the rate of 10 Numbers per annum? It would be a great satisfaction to me, as I conceive myself growing old very fast. So much traveling exposure and fatigue do I undergo that the machine methinks is wearing out; and it would indeed be a pleasure for me to see the last plate of the present publication.

He expected to be off to the Floridas and the Gulf of Mexico by February, he wrote his son in London. His condition delayed him and then on January 2, 1834, a letter arrived from Victor urging his father to return to England. Victor was vague about the reason for his request. He seems to have had trouble collecting subscription payments and panicked. Audubon told Bachman that his

son was "extremely anxious . . . that we should go to England on account of
our present subscribers who feel anxious to see me &c." The request frustrated
his parents, Lucy because it meant the Gulf collections would have to be post-
poned and the family therefore separated yet again, Audubon because it
delayed finishing the long work. They loved their son enough to trust him.
"The die is cast," Audubon responded to Victor's appeal; ". . . I have given up
my urgent wish to revisit the Floridas [and] God willing, we will be with you
about the 4th of July!"

With nothing to do and few subscribers to be found between Charleston and
New York, the Audubons and their younger son sailed earlier, on April 16, on the
fine 650-ton packet ship *North America*, sending ahead £500, collecting and car-
rying with them another £600. After a passage of less than twenty days during
which Lucy had alleviated her seasickness, much to her husband's amusement,
with morning, noon and evening doses of brandy, they landed at Liverpool on
May 5. A week later they reached London—John Woodhouse was astonished by
the scale of the place—"and found our son Victor quite well and we were all
happy. My work and business were going on prosperously." The second volume
of *The Birds of America* was finished at the beginning of June. By then Havell
was well along toward publishing ten Numbers a year. Once again Audubon
had celebrated his birthday at sea. He was forty-nine years old and thinking of
writing his autobiography, of publishing a smaller popular edition of *The Birds
of America*, of working up a definitive edition of all the American mammals as
well with John Bachman's help. But first he had to finish the great work.

CHUCK-WILL'S-WIDOW

BLUE JAY

WILD TURKEY

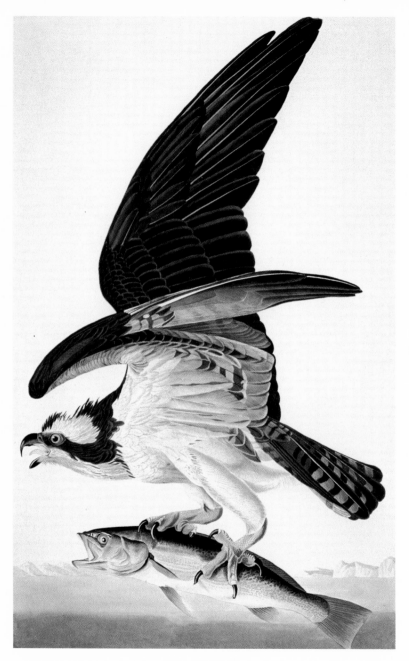

FISH HAWK

LONG-BILLED CURLEW

GOLDEN EAGLE

BONAPARTE CROSSING THE SAINT-BERNARD

Jacques-Louis David

HEAD OF BUFFALO CALF

John James Audubon

A MONUMENTAL WORK OF ART

W ILLIAM MACGILLIVRAY, THE EDINBURGH NATURALIST who had edited Audubon's text and written the scientific descriptions for the first volume of the *Ornithological Biography,* agreed at the end of May 1834 to collaborate on the second and later volumes as well. By mid-July he had already transcribed and corrected eighteen of the draft bird biographies Audubon had brought with him from the United States. He advised Audubon that the second volume of the *Biography* would "certainly be much richer and more interesting" than the first. Audubon had drafted three-fourths of the text by late July, when Robert Havell began binding volume two of *The Birds of America* for British subscribers and shipping bound sets across the Atlantic to the United States.

By then Havell had also distributed the first three Numbers of plates for volume three. Waterbirds—wading, diving, fighting, nesting, feeding against backgrounds of shore grasses, bays and marshes, water and rock—would fill volume three, engraved from the confident, masterful drawings Audubon had prepared in Florida and Labrador. Havell expected to complete seven Numbers in 1834—thirty-five plates—and increase his output to ten Numbers in 1835. "I have fine hopes," the artist confided to Charles Bonaparte in Rome, "that in 3 years from now the 4 immensely large volumes of *The Birds of America* will be completed and I [will] retire from the world!"

Havell employed as many as fifty colorists and had hired a second engraver. Audubon, with his family's support, sustained Havell's large operation on his own, visiting his shop daily to supervise production while supplying drawings and coordinating collections to pay Havell £100 a week. At the end of August, after sitting at writing for two months during which he drafted one hundred biographies and thirteen episodes, the artist was again forced to take to his bed with piles. "Between you & I and the post," he complained to John Bachman, "I hate this infernal smoky London as I do the Devil!!"

77. Oxford Street.

John Woodhouse, now twenty-two, encountered the Old World with an "untutored simplicity," as Lucy called it, that the Audubons' English friends found "striking." He had been "accustomed only to the woods and wilds of America," his mother explained to Euphemia Gifford, and so found "much to astonish and admire" in a nation that was then the most prosperous and technologically advanced in the world. His mother chose not to say so, but her son also found much to condemn. John summarized his first impressions of London in an August letter to his Labrador expedition compatriot Tom Lincoln that was remarkable for its maturity:

> I have been truly astonished with the wealth and poverty of this wonderful city. It is a poor man's hell. To the rich it is a paradise at least in point of luxuries and amusements. The rich have the best of everything and are as much above the poor . . . [as] the rich whites of the South are above their slaves. If you walk the fashionable streets you see liveries of the richest materials and colors, the most beautiful carriages and horses and dresses such as our richest men could only afford one-half off, while perhaps in the next street all is poverty and the most filthy vagabonds fill the streets begging on every corner. This is truly the state of London. . . . None of that happy poverty which we see in America, where a man owns a little house and a little land around and from that gains all he makes and is contented. All the poor are literally the slaves of the rich. But I must not run down a country that I find it convenient to live in.

John corresponded regularly with seventeen-year-old Maria Bachman, the eldest of the Bachman girls. Firstborn daughter and second-born son had fallen in love the previous season, when the Audubons had lived with the Bachmans in Charleston. Maria's letters arrived by packet weekly, deepening a bond that both families expected would lead to marriage. "John will be what every man ought to be," Audubon assured Maria's father later that fall: "a good husband to his wife."

His family was "a working family," Audubon wrote proudly, "happy and contented":

> Our dear sons are studying every day. My old friend mends our socks, makes our shirts, reads to us at times but drinks no brandy nowadays. She has cast off her purchased sham curls [and] wears her own dear gray locks and looks all the better. John can now make a pretty good portrait in black chalk and Victor a pretty landscape in oil. They are studying music & other matters.

(Knowing that Bachman disapproved of drinking, Lucy defended herself against her husband's teasing in a flustered postscript: "I am so completely *set against it* by being obliged to drink it when sick at sea that I shall not attempt to touch it again till I set out to return towards you. When at sea I take anything to give me one moment's relief.")

Audubon went up to Edinburgh at the beginning of October 1834 to collaborate more closely with MacGillivray. Lucy followed later in the month, leaving the boys behind in London. When Audubon needed drawings that Lucy had sent Euphemia Gifford from Fatland Ford in the long-ago days before her marriage, Lucy finally traveled to Derbyshire to visit her wealthy cousin—a subscriber who paid promptly as well as a correspondent—after a separation of thirty-three years. "It seems like a pleasing dream to me to have seen and conversed with you," Lucy wrote afterward, promising to keep the drawings carefully. The second volume of letterpress went to the printer on December 1. "We have all labored at it," Audubon credited his family in the introduction, "and every other occupation has been laid aside." Praising his sons, he pointed to the future: "Of their natural or acquired talents it does not become me to speak; but should you some day see the *Quadrupeds of America* published by their united efforts, do not forget that a pupil of David first gave them lessons in drawing, and that a member of the Bakewell family formed their youthful minds."

By mid-March 1835, back in London, Audubon had written nearly half of the third volume of letterpress, having decided to finish it before he returned to America for a final expedition to the Gulf of Mexico and perhaps across the

Rockies to the Pacific. He could not return before April 1836, he wrote John Bachman. "My intention is to go to America with John . . . this time twelve months. No more subscribers are, or can be expected in this country. I hope I may gather some in our dear own land and take a tremendous concluding journey, the Lord knows where." He estimated correctly that "not more than 50 or 60 copies completed will exist in Europe when I close the concern. . . . The *Birds of America* will then raise in value as much as they are now depreciated by certain fools and envious persons." The distraction of politics in England was one reason for the loss of subscriptions, Audubon thought. Tastes had changed as well, birds falling out of favor, insects, fish and botany coming in. He pressed Bachman to join him on the expedition. The Lutheran minister responded with a droll dialogue: "The Gulf of Mexico: Where has the parson gone? Parishioner: He has gone on a mission around Cape Florida. What mission? To convert the Indians or civilize the inhabitants of Key West? No, he has gone to kill birds with Audubon. A fine employment for a clergyman."

Later that spring John and Victor went on excursion to Wales while their parents moved to more spacious and comfortable quarters in Edinburgh at 5 India Street, where they would remain settled for the rest of the year. Through Havell's wife, Lucy ordered new silver forks made up in London, revealing in her letter that she had never recovered the family silver she had sold to Nicholas Berthoud in Henderson when her husband's business had failed. Audubon learned from Bachman that the Louisville debt lawsuit moved to Charleston from Philadelphia had gone against him in the amount of $650; he asked his friend to pay the judgment from Charleston subscription collections. "All I have to say," he concluded ruefully, "[is that] I am cheated only anew and perhaps when the least expected and also at a rather unwelcome time."

Back from Wales at the end of June, Victor returned to managing the family business while John began painting portraits. His father advised his younger son to keep his fee low to encourage subjects. Charging only £2 for an oil portrait, John fulfilled thirty commissions by October, when he began separate portraits of the mayor of Edinburgh and his wife. Volume three of the *Ornithological Biography* was finished on December 1. Audubon thought its diversionary episodes only "so-so," he wrote Bachman, but the bird biographies "pretty fair."

Many of the family's possessions, including books and bedding, Audubon's pre-1821 journals and correspondence and his guns, were stored in Nicholas Berthoud's warehouse in New York. On the bitterly cold night of December 16, 1835, a fierce north wind spread a fire that started at around nine p.m. in a dry-goods store across the city. Water pumped from wells to fight the fire froze in

the fire hoses. Some six hundred buildings were burned out—most of the old Dutch district downtown, including parts of Wall Street, Water Street, South Street and Exchange Street. The fire was visible over the horizon from the northeast end of Philadelphia, eighty miles away. Berthoud's warehouse was among the buildings blown up with gunpowder to make a firebreak.

In consequence, Audubon told Bachman, he would have to delay his departure from England until May to have new guns made. He knew that Maria Bachman, whom he was now styling "our dear daughter," would be disappointed at the delay and asked Bachman to reassure her that they would be under way by the first of August. Bachman warned his friend in turn that Florida was "in a great measure ruined" by the ongoing Seminole War: "all the plantations from St. Augustine up the St. John's River are ruined—houses burnt, negroes carried off and cattle killed and many of the inhabitants murdered. . . . Our army too has in several encounters from our great inferiority of force been beaten and the soldiers scalped."

More happily, by early in the new year 1836 the third volume of *The Birds of America* was binding and by March the first Number of the fourth and final volume had been engraved, Plates 301–5: canvasback ducks wading near Baltimore, dusky ducks (American black ducks) preening, Bartram sandpipers (upland sandpipers) feeding at Bayou Sarah, turnstones (ruddy turnstones) wading a generic shore and a purple gallinule stalking on the edge of a marsh. Victor and John had gone off to Europe for a grand tour before the family again divided. On their way down to Rome they stopped in Couëron, where they met their father's half-sister Rose and her husband Gabriel du Puigaudeau, who wrote in April that they had enjoyed meeting the sons but still waited "for . . . our reunion [with Audubon himself]. . . . We get together [with other relatives] every night and your family is almost always the topic of our conversation." Victor told them privately that his father would not claim his share of Anne Moynet's estate, relieving one of their concerns.

As of June, Audubon told Bachman, Havell had "already on copper finished and unfinished all the drawings . . . up to plate 350." In July his new guns had arrived "and splendid guns they are." Lucy had been ill off and on throughout the year with dizziness, general weakness, chest pains and heart palpitations that sometimes left her too weak to walk or even to get out of bed. Audubon was concerned to leave her, but she encouraged him to go, as she explained later, to "do all [you can] for this great monument of your own whilst [it is] in your power [to do so]." She was "well attended to both by our dear son [Victor] and [her physician] kind Mr. Phillips [who] generally steps in and sits awhile chatting on his way home to dinner." Reassured, Audubon and John assembled

a menagerie of 260 live birds, three pointers and "a brace of tailless [Manx] cats," packed their clothes and guns and drawing materials and sailed from Portsmouth on the American packet ship *Gladiator* on August 2, 1836.

They reached New York in thirty-three days. "Our birds are nearly all dead," Audubon wrote Lucy on September 7, still feeling the ship's roll when he walked the New York streets; only fifteen had survived the crossing. "The cats [are] well." One of the pointers had whelped seven pups. A letter from Bachman warned them away from Charleston until mid-October because of cholera fears. John was bitterly disappointed to delay seeing Maria. His father found distraction in news from Philadelphia that botanist and professor of natural history Thomas Nuttall and young Philadelphia ornithologist John Kirk Townsend, traveling with the second Wyeth Expedition to the Columbia River, "had forwarded [skins of] about 100 new species of birds from the Pacific side of the Rocky Mountains!" Townsend had been sponsored by the Academy of Natural Sciences, and the skins belonged to that institution, but Audubon learned from his physician friend Richard Harlan, an academy member, that "Townsend has duplicates of all of them."

Here was opportunity, if he moved quickly, to round out the final volume of *The Birds of America* with new species "not given by Wilson" from the Far West without having to trek there himself. He said as much to his wealthy gentleman-farmer friend Edward Harris, also an academy member, on September 12:

> You well know how anxious I am to make my work on the birds of our coun-
> try as complete as possible within my power. . . . But I am becoming old, and
> though very willing, doubt whether I could support the fatigues connected
> with a journey of several years and separated from my dear family. Well, the
> desiderata has come to Philadelphia at least in part, and if I could be allowed
> to portray the new species now there as an appendix to *The Birds of America,*
> I should be proud and happy to do so, but do you think that the Academy is
> likely to indulge me in this my wish? Do join me at Harlan's as soon as you
> can and lend me a hand.

He left for Philadelphia the next day to review the collection—it included about forty new species, not one hundred—but George Ord and his crowd at the academy objected even to Audubons seeing it, much less drawing and describing the new species it contained. Ord, the wealthy, horse-faced Scots-man who had been Alexander Wilson's posthumous editor, had been attacking Audubon for years, ever since their initial encounter in Philadelphia in 1824,

challenging Audubon's claims for the sight-hunting skills of buzzards and vultures and the tree-climbing skills of rattlesnakes and disparaging his art. For the past decade Ord had aligned himself with a confrontational amateur English naturalist and travel writer named Charles Waterton who had picked over Audubon's writings in British journals as well, the two vicious pedants carrying on a poisonous correspondence to coordinate their attacks. Audubon had pointedly ignored them while his friends defended his reputation in print, although privately their hostility had rankled. "As to Waterton," Audubon had written to Harlan as recently as 1834, "let him lie in his own filth. As to Ord, forgive the fool. Selfishness has been the object of both."

If he had not been able to force his way past George Ord in 1824, Audubon trusted he wielded more influence now. He returned to New York and then sped up to Boston to track down Nuttall, who had just returned home after delivering Townsend's collection to Philadelphia (Townsend stayed out on expedition until 1837). "Nuttall has arrived," Audubon wrote Harris on September 25—"he breakfasted with me the other day—gave me 6 new species of birds and tells me that he will urge both Townsend and the Society at Philadelphia to allow me to portray all the species which they have produced within the limits of our Territories."

Urging alone had not been enough, Audubon concluded his war story in the *Ornithological Biography,* but with the aid of Harlan and four other friends who were members of the Academy and the aid and support of Harris, who had offered to put up $500 to buy the entire collection, "it was agreed that I might *purchase duplicates, provided* the specific names agreed upon by Mr. Nuttall and myself were published in Dr. Townsend's name. . . . I therefore paid for the skins which I received, and have now published such as proved to be new, according to my promise. But, let me assure you, Reader, that seldom, if ever in my life, have I felt more disgusted with the conduct of any opponents of mine, than I was with the unfriendly boasters of their zeal for the advancement of ornithological science, who at the time existed in the fair city of Philadelphia." To Bachman he crowed that he had "purchased *ninety-three bird skins.* . . . Naught less than 93 bird skins sent from the Rocky Mountains and the Columbia River by Nuttall & Townsend! Cheap as dirt, too—only $184 for the whole of these. . . . Such beauties! Such rarities! Such novelties! Ah, my worthy friend, how we will laugh and talk over them!" Never one to waste time, Audubon while chasing down allies had picked up twelve new subscribers in Massachusetts and New York, to which Nicholas Berthoud, now serving as Audubon's New York agent, shortly added eighteen more.

When Charleston ended its quarantine in late October, father and ardent son headed south, stopping off in Washington City to solicit travel by government revenue cutter from Andrew Jackson, then in the final months of his second term:

> [Col. John J. Abert, the head of the Topographical Bureau, and I] walked together toward the President's House to present my letters. . . . The next moment I was in the presence of this famed man and had shaken his hand. He read [one of my] letters twice with apparent care, and having finished said, "Mr. Audubon, I will do all in my power to serve you, but the Seminole War, I fear, will prevent your having a cutter—however as we will have a Committee at 1 o'clock this day we will talk of this and will give you an answer tomorrow." The General looked well. He was smoking his pipe, and I thought was more complaisant to me than ever. . . . He was very kind, and as soon as he heard that we intended departing tomorrow evening for Charleston, invited us to dine with him *en famille.*
>
> At the named hour [the next day, November 9] [John and I] went to the White House (which is the vulgar name for the President's residence) and were taken into a room where the President soon joined us. I sat close to him; we spoke of olden times and touched slightly on politics, and I found him very averse to the cause of the Texans. . . . I dined from a fine young turkey, shot within twenty miles of Washington. The general drank no wine, but his health was drunk by us more than once; and he ate very moderately, his last dish consisting of bread and milk.

Since Audubon was an artist, he was shown Gilbert Stuart's unfinished portrait of George Washington and told the story of Dolley Madison cutting it from its frame to save it from destruction during the War of 1812. The portrait impressed him, but not the décor: "It is the only picture in the whole house—so much for precious republican economy." His reservations about Old Hickory were more serious: "Coffee was handed, and soon after John and I left, bidding adieu to a man who has done much good and much evil to our country." Doing good, Jackson through his Treasury Secretary authorized Audubon to travel on U.S. revenue cutters anywhere between Chesapeake Bay and the mouth of the Sabine River at the Louisiana-Texas border, as well as on U.S. Navy ships stationed in the Gulf. He also gave the artist the use of a new, fast sailing cutter of 55 tons and only seven feet draft from Mobile west along the Gulf Coast—the *Campbell,* commanded by Lieutenant Napoleon Coste, who had been the first officer of the *Marion* in Florida and knew Audubon's needs.

Father and son traveled on by railroad from Washington to Charleston, arriving on November 17. They spent the winter at the Bachmans' working and hunting, John basking in the presence of his bride-to-be, Audubon exhausting himself embodying Townsend's skins in lively drawings—"31 in 20 days," he bragged to Havell in mid-December. Edward Harris, an asthmatic, had finally agreed to accompany his old friend on an expedition; Audubon advised him to supply his provisions from Philadelphia:

> Do not forget to ship gunpowder, very [fresh] & hot at least 6 bags—15 pounds of pulverized arsenic [for specimen preservation] from Wetherill & Est.—apples &c. (the latter ought to be kept back as long as possible as they do not keep well in warm climates). Good fresh butter also is an article which I recommend—and I wish you to purchase on my own account one hundred pounds to be sent as soon as you conveniently can to c/o John Bachman here. Also a barrel of buckwheat meal. I think we can purchase claret wine here better and cheaper than in Phila. I wish you to buy as much mosquito net (French manufacture and of flax) as will make 4 bars sufficiently large to sleep under, both on shore or on the decks of vessels. . . . This is most essential. Purchase also some fishing lines and hooks, for sea and river fishing. I think that all other wanting articles can be had here.

Just as Harris and the Audubons were about to leave Charleston, in mid-February 1837, they learned that the Seminole leader, Osceola, had been captured—the army commander, Major General Thomas S. Jesup, had violated a flag of truce to seize the charismatic warrior—and the Seminole War had ended. On their way south the three men passed through the line of Indian removal in Alabama between Columbus and Mobile, a preliminary of the Cherokee Trail of Tears of 1838:

> [On February 19] we breakfasted at the village of—where 100 Creek warriors were confined in irons, preparatory to leaving forever the land of their births! Some miles onward we overtook about two thousands of these once free owners of the forest, marching towards [Mobile] under an escort of rangers and militia mounted men, destined for distant lands unknown to them and where, alas, their future and latter days must be spent in the deepest of sorrows, affliction and perhaps even physical want. This view produced on my mind an afflicting series of reflections more powerfully felt than easy of description—the numerous groups of warriors, of half-clad females and of naked babes trudging through the mire under the residue of

their ever-scanty stock of camp furniture and household utensils—the evi-
dent regret expressed in the masked countenances of some and the tears of
others—the howlings of their numerous dogs and the cool demeanor of the
chiefs—all formed such a picture as I hope I never will again witness in real-
ity. Had Victor been with us, ample indeed would have been his means to
paint Indians in sorrow.

On March 26 in New Orleans the logbook of the *Campbell*, Napoleon
Coste's cutter, recorded "Mr. Audubon, son & Mr. Harris join[ing] us on an
Ornithological expedition." Two days later, the *Campbell* at anchor in the
Mississippi, Audubon noted sandhill cranes still in residence along the shore
and John in the swamps "outlining cypress trees . . . for Victor." John used a
camera lucida, a portable mirror prism mounted on a jointed arm invented in
1807 that its inventor had named in ironic challenge to the ponderous, room-
sized camera obscura of the Renaissance. Looking through a camera lucida
mounted at eye level made it possible to view a reduced version of a distant
scene as if projected onto a sheet of drawing paper laid on a table below the
instrument. Keeping the image in focus could be difficult, but with care the
scene—in this instance cypress trees—could be outlined directly on the sheet.

THE
CAMERA LUCIDA;
*An Instrument for drawing Objects in true Perspective, and for
copying, reducing, or enlarging other Drawings.*

Fig. 1. *Fig. 2.*

Collecting both birds and quadrupeds as well as a twelve-ton escort tender, the *Crusader*, the party traveled gradually westward along the Gulf Coast: Grand Terre, Cayo Island, Bayou Salle Bay, Cote Blanche, Atchafalaya Bay and then after "a fine run" Galveston Bay on April 25, where the *Campbell* logbook noted the cutter "fired a salute of 24 guns in honor of the Texian Government. Was returned by the fort at Galveston, also by the Texian man-of-war schooner *Invincible*." Despite Andrew Jackson's displeasure—Old Hickory was a Manifest Destiny man—Texas had won its independence from Mexico in the battle of San Jacinto almost exactly one year earlier, on April 21, 1836. On May 8 Coste ran the *Campbell* up to Red Fish Bar and moored her. The Audubon party transferred to the lighter-draft *Crusader* and started for Houston up Buffalo Bayou at the mouth of the San Jacinto River through marshes dense with ivory-billed woodpeckers, ibises and wild turkeys. It poured rain and they put in for the night. The bayou flooded the neighboring prairies, they were eight hours rowing twelve miles against the flood current, but finally on May 15, "drenched to the skin," they landed at Houston, where "shanties, cargoes of hogsheads, barrels &c. were spread about the landing and Indians drunk and hallooing were stumbling about in the mud in every direction." The captain of a steamboat let them change clothes in his stateroom and fed them dinner. Soon they encountered the president of the raw new nation, Sam Houston himself:

> We first caught sight of President Houston as he walked from one of the grogshops, where he had been to prevent the sale of ardent spirits. He was on his way to his [double-pen log cabin] house, and wore a large gray coarse hat. . . . He is upwards of six feet high and strong in proportion. But I observed a scowl in the expression of his eyes that was forbidding and disagreeable. We reached his abode before him, but he soon came and we were presented to his excellency. He was dressed in a fancy velvet coat, and trousers trimmed with broad gold lace; around his neck was tied a cravat somewhat in the style of '76. He received us kindly . . . and offered us every facility within his power. He at once removed us from the anteroom to his private chamber, which by the way was not much cleaner than the former. We were severally introduced by him to the different members of his cabinet and staff and at once asked to drink grog with him, which we did, wishing success to his new republic. . . .
>
> We returned to our boat through a melee of Indians and blackguards of all sorts.

A heavy head sea on the way back to New Orleans made everyone seasick. New Orleans was hot, dull and depopulated. Audubon had lost twelve pounds on the expedition, confirming his judgment that his days of strenuous exploration were over. He had celebrated his fifty-second birthday on Galveston Island, but more serious had been his loss in the last few years of most of his teeth—writing Bachman from New York the previous September he had referred to his "old toothless mouth"—which had made it difficult to eat enough coarse expedition fare to sustain his weight. In New Orleans he met Will Bakewell and his wife, "neither of whom I had seen for several years," and learned that a business crash had started another round of bankruptcies across America and in England as well. In a joint letter from London Lucy encouraged him "not [to] neglect anything for the sake of being at home a few weeks sooner," while Victor advised his father to be "*very cautious* how you leave your money affairs in America" and said they were "fearful of the result of the commercial distress both in this country & America." With more than three hundred different preserved specimens at hand to sell to European museums but having found "not a single new bird," Audubon concluded it was time to go home.

Bachman converged on Charleston from a synodal conference in Philadelphia as the Audubons bounced eastward by mail coach. The minister had been invited to meet General William Clark, the co-leader of the Lewis and Clark expedition, who was sixty-seven. "He is now very aged and in failing health," Bachman wrote his wife Harriet; "he is on a visit to Philadelphia, accompanied by an interesting and beautiful family. I was quite pleased with him. He is intimately acquainted with Mr. and Mrs. Audubon, and spoke in raptures of her talents and his beautiful taste. He seemed to retain his recollection of past events in a remarkable way." Clark would die the following year.

The Reverend John Bachman married his eldest daughter Maria Rebecca Bachman to John Woodhouse Audubon on Saturday, June 24, 1837. Audubon and the newlyweds left Charleston by steamboat the same day. (Edward Harris had traveled north separately from New Orleans when the Gulf expedition disbanded.) They stopped off in Washington long enough for Audubon to present a letter of introduction that Washington Irving had given him to the new President, Martin Van Buren. From there they traveled on to Harris's farm in Moorestown, New Jersey, where Audubon based himself while the newlyweds hurried up to Niagara Falls for a ten-day honeymoon. Business conditions had made traveling difficult, he wrote Bachman, and the crash had hit close to home:

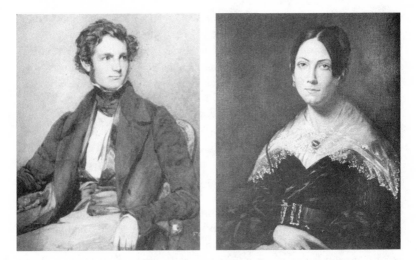

John Woodhouse and Maria Bachman Audubon

N. Berthoud has not failed but suspended payment and all my concerns then are safe enough. . . .

There is scarcely a dollar of silver in circulation and the present trashy paper medium [i.e., local banknotes—the young nation had not yet created a national currency] is beyond endurance, at every change of state or towns you are obliged to see to what you have and spend or give it away, for in fact it soon becomes useless. Business of all description is at a stand and it is not everyone who cries in sorrow of Van Buren [replacing Andrew Jackson], I assure you.

In the last days before sailing Audubon went to New York to wait for John and Maria. He settled his accounts with Berthoud, who agreed to continue serving as his agent, and heard his previously imperious brother-in-law call him "one of the happiest of men—free of debts and having *available funds* and *talents!*" He was leaving behind about $8,000 in cash on hand, and Berthoud estimated he was currently due $10,000 from American subscriptions. Another £1,106 (about $90,000 today) he converted into gold—981 half-eagles, 125 sovereigns—to carry with him. "This of course I have insured," he told Bachman. "Now, barring accidents, this sum will suffice us to finish our work with the usual annual collections we make in England." He was ready to finish:

What a strange realization of a dream [is] this finishing of a work that has cost me so many years of enjoyment, of labor and vexations, and yet a few more months will I trust see it ended, aye, ended, and myself a Naturalist no *longer!* No more advertisements of this poor me. No more stares at my face whilst traveling. No, I have some idea of even revising myself and altering my very name, not to be pestered any more.

With his son and daughter-in-law Audubon sailed for Liverpool on the American packet ship *England* on July 17, 1837. The ship had a library and a "fine bathhouse," cooled its provisions with ice cut on New England ponds the previous winter and served ice cream. The captain had given the newlyweds a room in the stable center of the ship and Audubon a midship stateroom to himself; none of the three was seasick on the eighteen-day passage. In London on August 14 they found Lucy "not very well," Audubon wrote Bachman. "Our arrival produced a great revolution of her nervous system, but after awhile all was gayety and happiness at our house on Wimpole Street." Robert Havell informed him that *The Birds of America* would be finished "on the first of January next. . . . Think of that!! What a glorious Christmas I will then enjoy."

By October 1837 the four hundredth plate had been engraved. The previous three volumes had each incorporated one hundred plates, but Townsend's skins and the Florida and Labrador collections added enough new species that Audubon decided to extend volume four by another seven Numbers—thirty-five plates. At Plate 353 he had reluctantly begun grouping species as well: Plate 400 depicted an Arkansas siskin (lesser goldfinch), a mealy redpoll (hoary redpoll), a Louisiana tanager (western tanager), a Townsend's finch (Townsend's bunting) and a buff-breasted finch (Smith's longspur), one bird standing on a bluff above a shoreline, the other four perched on convenient dead branches nearby. The composition was crowded and inelegant; as Audubon explained to Edward Harris, "I am forced to finish my work in as few Numbers of plates as possible (not to lose any more subscribers in this country). [And therefore] I am forced to introduce as many new species of the same genera in the same plate as circumstances will afford."

So *The Birds of America* was not finished on the first of January, as Havell had hoped, and Christmas was marred by Lucy's continuing illness, which confined her indoors and prevented her from helping with household affairs. In January 1838 she began to feel she might be improving, however, and looked forward to the return of warmer weather. In compensation, Maria was a delight, fresh-faced and wide-eyed at London's wonders of culture and wealth,

and by mid-April Audubon was announcing to Bachman that they would both soon be grandfathers.

Robert Havell finished engraving the last plate of *The Birds of America*—two American dippers perched on precipitous rocks—at his shop at 77 Oxford Street on Saturday, June 16, 1838. The monumental four volumes, large and nearly as heavy as flagstones, large enough to require two people, one at each end, to turn the thick, luxurious pages, consisted of "435 plates including 497 species!" Audubon wrote a friend a few days later; in their varieties of age and sex the species were represented by no fewer than 1,065 figures, most drawn from life. Ten were John's contributions; all the rest were Audubon's. Victor had painted some of the backgrounds; Joseph Mason, George Lehman and Maria Martin had drawn backgrounds and plants. William Lizars had engraved the first ten; the Havells had engraved the rest and printed and colored the lot, a mighty labor.

Opening the heavy leather-covered boards to the luminous clarity of the boldly colored plates, with their vivacious birds and their ornately decorative, stylized, almost Oriental flora of grasses, vines, flowers, branches, leaves and fruit, was like opening a window into Eden. "In the beginning all the world was America," John Locke had aphorized in the second essay of his *Two Treatises of Government*. In *The Birds of America*, Audubon had imagined the world that beginning might have been, a refinement of the actual world he had explored. So also were his birds exceptional specimens, not averages or types.

The great work's final revelation, clearly an effect that Audubon planned but hardly hinted at along the way, was its scroll-like sequency: the colored engravings changed their strategies of presentation from plate to plate, so that rather than the work merely being illustrations of birds bound together for convenience, one plate seemed to anticipate the next, to comment on the next or the previous, to segue or repeat, to surprise or shock, to combine ultimately to *perform* themselves in the theater of sequent memory, animating the plates when they were bound together in their four volumes and in that way also enlarging the range and scale of the work.

By Audubon's own estimate, the actual cost of producing *The Birds of America*, "not calculating any of my expense or that of my family for upwards of 14 years," was $115,640—in today's dollars, about $2,141,000. Unsupported by gifts, grants or legacies, he raised almost every penny of that immense sum himself from painting, exhibiting and selling subscriptions and skins. He paced the flow of funds to Havell so that "the continuity of [the work's] execution" was not "broken for a single day." He paced the flow of drawings as well,

and before that the flow of expeditions and collections. He personally solicited most of his subscribers; until Victor joined him he personally serviced most of his accounts. Lucy supported herself and their children while he was establishing himself; thereafter he supported them all and the work as well. If he made a profit it was small, but in every other way the project was an unqualified success. These facts should lay to rest once and for all the enduring canard that John James Audubon was "not a good businessman." His retail business failed in Henderson in 1819, like nearly every other business in the trans-Appalachian West, in the wake of an economic disaster that was beyond his control. When he set out to create a monumental work of art with his own heart and mind and hands, he succeeded—a staggering achievement, as if one man had single-handedly financed and built an Egyptian pyramid.

Finishing the work, he wrote in June from Edinburgh, had lifted "an immense weight from off my shoulders and [was] a great relief to my ever-fidgety anxious mind." He had not yet finished the last volumes of the *Ornithological Biography,* however; that final work had taken him once again to Edinburgh to collaborate with William MacGillivray, "Mac" now and a close friend. Lucy, recovering but still frail, stayed behind in London with her sons and her daughter-in-law, who delivered a little girl at the beginning of July whom she and John named Lucy for John's mother and perhaps as well for the little Lucy his mother had lost. When he wrote on July 5 Audubon was delighted and amused:

> Mamma's short letter announcing the safe delivery of our dear daughter Maria reached me. . . . I am happy to know that she and little "Lulu" as John calls the young stranger are both doing well, and that dearest mamma is also better from the effects of warm weather. . . . The newborn thing must be a considerable size, just the weight of a Loon and according to John's account almost as greedily inclined, though more anxious for mother's milk than for fish. . . . Two sheets of the biography are now finished, and on Saturday I will have another. Mac and I are working like horses.

DAYS OF DEEPEST SORROW

J OHN BACHMAN, TRAVELING FOR HIS HEALTH, landed at Liverpool at the beginning of July 1838 with a cageful of mockingbirds and an anhinga for Lord Stanley, the thirteenth Earl of Derby now, whose ornate steam-heated aviary on his estate, Knowsley, sustained a breeding population of more than twelve hundred exotic birds. After three days in London visiting his daughter Maria, his new granddaughter and the Audubon family, the Charleston cleric steamed up to Edinburgh with Victor to work with Audubon and William MacGillivray finishing the *Ornithological Biography*. "We shall be pretty busy," Victor wrote his mother on July 10, "and I begin reading the proofs at once." Bachman returned to London at the end of July to study American mammals at the British Museum, which had an extensive collection of uncatalogued skins; Victor returned two days later to help his mother pack for Edinburgh. Bachman christened his granddaughter and said his goodbyes, then traveled on to Germany to attend a conference. Lucy gave up the Wimpole Street house and the whole family moved to Edinburgh on August 8.

Audubon was trying to cram as many new species, as much new informa-tion and as many corrections as possible into the last part of the *Ornithological Biography,* just as he had with the final volume of *The Birds of America*. "I have 336 pages of the 4th volume printed," he wrote Robert Havell on August 20, "and I now suspect that I shall have to make *two volumes* of it unless I make one most enormous." He did make two volumes, encompassing a total of 232 species, allotting 618 pages to volume four and another 664 to volume five. Before he finished that work, however, needing to come up for air and hoping to promote Lucy's health, he treated his family to a one-week tour of the Scot-tish Highlands. MacGillivray went with them for a holiday. Lucy enjoyed the tour but fell ill again a few days after they returned. Then she had the luck to find an Edinburgh physician, John Robertson, who was able to nurse her back

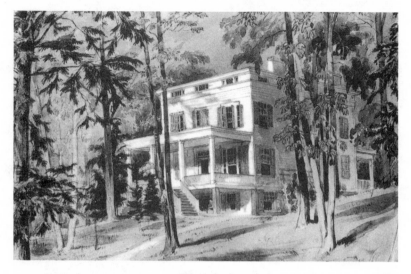

Minniesland

to health. Like Benjamin Phillips in London, Robertson provided his services to the now-celebrated family free of charge, a courtesy Audubon acknowledged in the Introduction to the last volume of letterpress. He had so exhausted his fund of American stories that he included no Episodes in volumes four and five—not that there was room with all the species he had to cover—and devoted much of the Introduction to the last volume to chronicling the family vacation.

Volume five was not in press until May 1839. Well before then the Audubons began preparing to move back permanently to the United States. "We are all fully sensible of the advantage of our living in the United States as soon as we can with our limited means," Lucy wrote Euphemia Gifford. In December the family agreed that Victor should return to America immediately to begin organizing their American business; he sailed in January 1839. In March Audubon asked Havell to have waterproof packing cases made for the "coppers"—the big *Birds of America* engraving plates—the cases to be "bound with *iron hoops* and *remarkably* well-secured" and the shipment insured for no less than £5,000. Havell would also ship all the original drawings, oil portraits and on-hand letterpress sets and fifteen extra bound sets of *The Birds of America*. Now forty-six years old, having devoted the past twelve years to engraving American birds, Havell had decided to emigrate to America as well; selling his stock and real estate, he told Audubon, was making him "as busy as a bee in a tar barrel." Mrs.

Havell asked Lucy which household goods to leave and which to take and Lucy advised that her family "shall not take anything but our table & bed linen and silver."

Audubon finished and dated the Introduction to the last volume of the *Ornithological Biography* five days after his fifty-fourth birthday, on May 1, 1839. "How often, Good Reader," it began, "have I longed to see the day on which my labors should be brought to an end!" He wrote of sickness and poverty endured in the quest; more luridly the American woodsman painted in the dangers he claimed to have faced of "Red Indians" and "white-skinned murderers," of "venomous" snakes and "ravenous" vultures. He revealed a dream "when asleep on a sandbar on one of the Florida Keys that a huge shark had me in his jaws and was dragging me into the deep." He remembered "pleasing images" as well and invoked his enduring affinity for eagles:

> The sky was serene, the air perfumed, and thousands of melodious notes from birds all unknown to me urged me to arise and go in pursuit of those beautiful and happy creatures. Then I would find myself furnished with large and powerful wings, and cleaving the air like an eagle, I would fly off and by a few joyous bounds overtake the objects of my desire.... Many times indeed have such thoughts enlivened my spirits; and now, good reader, the task is accomplished. In health and in sickness, in adversity and prosperity, in summer and winter, amidst the cheers of friends and the scowls of foes, I have depicted the Birds of America, and studied their habits as they roamed at large in their peculiar haunts.

Even then he was not quite done. He still needed to finish writing and editing a *Synopsis*—it would run to a further 300 typeset pages—to list the species in scientific order (as then understood), silently correct some of his mistaken identifications and describe briefly five new species that had turned up since he had closed out volume five. That text began going to the printer on May 4. John and Maria hurried off to Paris in mid-May with Lulu and a nurse so that Maria could at least have a glimpse of Europe before returning to America. Audubon teased Havell about continually postponing his departure that summer of 1838. "I should not be surprised," the artist wrote, "if my work on the quadrupeds of America . . . may not be out and finished before I meet with you fishing or shooting or resting beneath the shade of some lofty tree in my native land." But tying up loose ends delayed the Audubons as well.

Finally they settled on an August departure on the *Great Western,* the first oceangoing steamship—a hybrid, with side paddlewheels but also a full com-

plement of sails—only to learn that the staterooms they wanted on the fashionable vessel had already been booked. "Last night the *Synopsis* was done!!" Lucy wrote Victor from Edinburgh on June 30. ". . . Tomorrow Papa is beginning to pack up and we shall go to Liverpool as soon as we can." She was disappointed that they would have to cross by packet after all because she expected to be seasick. "A disagreeable anticipation it is to me but perhaps for the best; at any rate it must be. . . . Papa thinks I am very well but I am as weak as a cat and good for nothing." Audubon added in a postscript that he expected "to see you all well about the 1st of September."

From France, John and Maria had gone on to New York, where they settled in with the Berthouds on Washington Square. Bachman's sister-in-law Maria Martin and one of his younger daughters, Harriet Bachman, visited them there in July. "John is a kind and indulgent husband," Martin wrote to a Charleston family friend, "and Maria's comfort and happiness seem to be his only aim in life. The baby is lively and healthy and does not give much trouble. It walks about since its landing and I expect will be a little prattler before you see it." Maria was expecting a second child in October. Washington Square, her aunt noted, was "quite out of the business part of the city and consequently remote from noise and bustle which annoy me so much on Broadway."

The last message in Martin's letter from New York was an apology from Victor to Maria Audubon's younger sister Mary Eliza for not writing her that day. When John and Maria had become betrothed in 1837 Victor, a fashionable bachelor in London who squired actresses, had written his father waggishly, "I hope John will be happy with his Maria. Some day or other I may perhaps follow his example, but at present I am not at all likely to put on the *silken chains!*" Seeing John and Maria's happiness when they moved to London had evidently changed his mind. After he arrived in New York to prepare the way for his parents' permanent return he had traveled to Charleston pointedly to meet Eliza, then twenty years old. Victor had fallen in love with Maria's livelier younger sibling and the two now kept up an intense correspondence.

Victor found quarters for his family at 86 White Street. "We are all quite sorry not to be able to settle permanently (as far as buying a house or small place &c.)," he wrote Charleston in late July, "but I look for the arrival of Papa with hope we may come to some conclusion." John, he reported, "has taken a room at 300 Broadway to paint all the *phizes* of all who will pay therefore." He himself "bathe[d] every day in the sea, at the Battery floating bath, and find it the only *real* luxury I can enjoy here just now." When the Audubons arrived in early September 1839 they had not yet made up their minds whether to live in New York, Philadelphia or Baltimore. Until they did, the family settled on White Street.

The Havells arrived in September as well. They settled at first in Brooklyn, but on an upriver steamboat excursion Robert Havell fell in love with the Hudson River Valley and bought a home in Sing Sing (Ossining today—the town changed its name in 1901 to distinguish itself from the prison). (The Havells moved to Tarrytown in 1857, where Robert Havell died in 1878; he was buried there in Sleepy Hollow Cemetery.)

THE NEWSPAPERS HERALDED AUDUBON'S RETURN. He had not returned to secure retirement, however. Only about 160 to 170 subscribers had seen *The Birds of America* through to the end. (Audubon listed 79 Europeans and 82 Americans at the end of volume five, but the list was not inclusive; although 308 people had at least started subscriptions over the years, not everyone had followed through.) "It is strange rather how few complete copies of *The Birds of America* there will be," Lucy had commented to her cousin before she left England. With such a limited sale, Audubon was only a little ahead financially and still owed Havell for the fifteen extra sets, which he meant to sell. To begin generating income he immediately began working on two new publications that he hoped would finally make him financially secure. Shortly after his arrival he described them to his Philadelphia agent Samuel George Morton, the corresponding secretary of the Academy of Natural Sciences:

> Having determined to publish the *Quadrupeds of North America* in our own country, of a handsome folio size, all the objects drawn on stone by myself, I hope to be able to present that work to the public at a price which ought to enable me to meet the expenses of such a publication without difficulty. I am also going to publish immediately a new edition of *The Birds of America* (royal octavo), the figures of which will all be reduced from the plates or original drawings of my large work. These two publications will be issued in monthly Numbers, along with the matter appertaining to each of the subjects, &c., &c., &c.

Audubon and Bachman had originally talked of working up the mammals, but Bachman had sensibly demurred that they could not possibly cover the porpoises and whales and they had settled on viviparous quadrupeds instead—mammals with four feet—limiting their range to the land. Both the *Quadrupeds* and the Octavo edition of *The Birds of America* would take advantage of the newer and less expensive technology of lithography, invented in Munich in 1796 and well developed in the United States by 1838. The process of

drawing or transferring an image onto a limestone block using a grease pencil or oil-based ink and printing directly from the stone had substantially replaced copperplate engraving for art reproduction in the early 1830s; the last great work of natural history to be produced using the older technology was Audubon's original *Birds.* In Philadelphia in 1832 Audubon had executed a large lithograph of a clapper rail to assess the process's merits. "Octavo" was a printing term for a page size produced by folding a standard press sheet into eight parts; "royal octavo" designated an oversized octavo page, about 6.5 by 10 inches rather than 5 by 9. Audubon or John would reduce the double-elephant plates to octavo size using a camera lucida, simplifying the mise-en-scène where necessary to accommodate the smaller format.

The Octavo *Birds*—its full title would be *The Birds of America from Drawings Made in the United States and their Territories*—took precedence over the *Quadrupeds.* Audubon would have to collect, study and draw the quadrupeds, while the birds were already drawn and only needed to be scaled. He found an able lithographer in John T. Bowen of Philadelphia, a thirty-eight-year-old English immigrant then preparing the multivolume *History of the Indian Tribes of North America,* a work that included more than one hundred colored lithograph portraits of Native Americans. By November Bachman had seen and praised the first Octavo proofs and Audubon was rambling the East Coast and up into Canada selling subscriptions—160 by the end of the year. He had also collected $1,030 for a full set of *The Birds of America* and the *Ornithological Biography* sold to John Jacob Astor, the wealthy fur trader whom Washington Irving had recently chronicled in his literary narrative *Astoria.*

But illness had struck Bachman's two older daughters and shaken Audubon's sons. Like their father, and probably because he had inadvertently infected them, Maria and Eliza were consumptives, suffering from the chronic illness now known as tuberculosis, for which in their day there was no effective treatment nor any cure. At best the body encapsulated the disease inside granulomas in the lungs, where it could linger in dormancy for years. In November 1839 Eliza Bachman's dormant consumption reactivated and she hemorrhaged, coughing up bright-red blood. Bachman dismissed the attack to Audubon as "breakbone fever, which lasts 24 hours [and] makes people cross but not very sick," but Victor rushed to his fiancée's side, and when the crisis passed the two decided to marry immediately. Bachman united them on Wednesday, December 4, 1839, in the parlor of his Charleston house. He would have liked to keep Eliza in the warmer Southern climate for the winter. Audubon needed his son to manage the deluge of Octavo subscriptions. Within days of their wedding Victor and Eliza sailed for New York, where she seemed to recover.

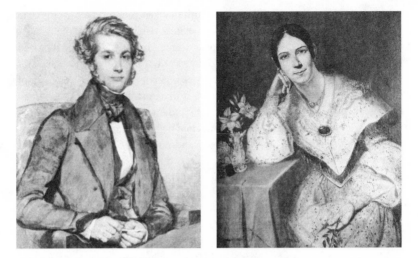

Victor Gifford and Eliza Bachman Audubon

Maria, John's wife, also suffered a return of active consumption that winter in the wake of the birth of her second child, a daughter whom she and John named Harriet after her mother. The illness took the form initially of sores in her mouth that refused to heal and made it difficult for her to eat. Eliza wrote her grandmother on January 21, 1840, that she was cheering her ailing older sister while her new mother-in-law saw to Maria's children:

> By this time you will be aware of the indisposition of dear Ria. . . . Mamma's [i.e. Lucy Audubon's] time has been so fully occupied in taking care of the little ones and in preparing delicacies to tempt the appetite of the invalid that my time has been fully taken up in keeping dear Ria company and trying to raise her spirits. The poor girl has suffered severely from a sore mouth and a general weakness which rendered us all for a few days quite anxious about her but she has had such kind attendance and so skillful a physician that she is now in a fair way of recovering. This morning we took a ride through the city together, which seemed to refresh her very much and this evening she is downstairs eating her bread and milk on the sofa.

The Bachmans believed Maria needed a warmer climate than winter New York. Since John was being paid to draw the camera lucida reductions for the Octavo and his work was portable, the family moved south to Charleston in

mid-February minus baby Harriet, whom Lucy kept behind to care for. The Bachman household was shocked to see what its patriarch called "the ravages which disease had made on [Maria's] poor frame." In early March he reported to Victor that she was "better in some points but has not gained in others. Her mouth & throat are well & she scarcely has any cough left. Her weakness of body together with a constant pain in the stomach still continue, so much so that the doctor has requested her to lie down today & rest." John was painting, Bachman added, and Lulu "has fairly attached herself to me. She flings the epithet *bad child* to almost everyone else, Grandmother included." In New York Victor, wanting to be settled now that he was married, was agitating to buy a house; his father cautioned him to hold off in a letter from Baltimore that arrived at about the same time as Bachman's, adding for encouragement that their subscription list for the Octavo edition was now "positively above 500 subscribers." Baltimore alone, where Audubon had made the rounds piloted by local society leaders, had delivered 168.

Martin reported in late April that Maria had "not improved according to our expectations." Audubon had just arrived in Charleston to begin working with Bachman on the quadrupeds. Besides her niece and her invalid sister, Martin also had to care for her bedridden and helpless elderly mother, Rebecca Martin. Impending grief, the stress of a house full of sickness, his money worries and perhaps as well a sense that his true lifework was done encouraged Audubon to drink beyond his usual moderation. Some days he started after midday dinner, other days in the morning, and his resulting garrulousness and occasional profanity offended both Bachman and Martin.

Bachman wrote Victor in mid-May that he had "nothing favorable" to report about Maria's condition; there had been "no abatement of her disorder." Stomach pains had given way to diarrhea, which Bachman tactfully called "operations." Her "constant operations," he told Victor ("from 10 to 20 . . . in a day," he wrote elsewhere), "render her weaker every day. . . . The physicians fear that there are ulcerations along the whole line of the intestinal canal & leave us nothing to hope for but the interposition of providence in her behalf." Infection coughed up from the lungs and swallowed with saliva had ulcerated Maria's stomach and now her intestines; hence the debilitating diarrhea.

Faced with the loss of his adult daughter after losing more than half of his fourteen children to illness in the first years of their lives, and probably feeling guilty that he was the source of her infection, the Lutheran minister confessed to being near despair: "I have had philosophy & I hope religion to stay me under other calamities, but now I am bewildered & unhappy." He hoped "dear Eliza will be fortified to bear up under this visitation." Audubon added in a

postscript that he went "to town and return without scarcely seeing or caring about anyone, and when I return home, it is only to augment the pains of my poor heart. Johnny is thank God quite well, though much fatigued by his constant attendance on Maria."

Bachman, seeing in Audubon's drinking "one whom I esteemed beyond almost any other living man ruining his health & his intellect, setting a bad example to my children & rendering me perfectly miserable," asked John to encourage his father to move on. Audubon brushed aside what he took to be his son's concerns. He meant to stay to support Maria, whom he had come to love for the beauty, youth and innocence she had brought to lighten the years of his aging. His cherished hair was gray and thinning now and he was down to eight teeth. "Never in my whole life have I enjoyed traveling so much as I have with my beloved daughter," he had written Bachman when he and the newlyweds had first journeyed north together after their wedding in 1837:

> Everything has been new to her senses—hills and dales, trees & fruits, bridges, rail cars and highly fashionable circles have danced before her alternately like so many novelties of nature and of the world, and her own descriptions of the feelings which have accompanied these transitions are so simple and meantime so truly poetical and just that I have envied her situation a thousand times!

Now this innocence was dying in its youth, dying before her parents, a loss that all of them, but Bachman and Audubon for their different reasons in particular, could hardly bear. Finally at the beginning of June at dinner the tension between the two old friends erupted in a short, sharp argument—significantly, an argument over which one had spoken more despairingly about Maria's condition. "I told him he must have lost his brains," Bachman confessed to Victor. "He had taken too much whiskey & I was angry." Deeply offended, much as he had been with Lucretia Pirrie at Oakley, Audubon stalked off, stopped drinking, began treating Bachman with formal correctness and prepared to leave. "I am glad that he is going," the minister wrote in a joint letter the two men sent to New York on June 6, 1840, the day of Audubon's departure. "He has been unoccupied & quite miserable here, and I think the traveling & occupation may divert his mind." Audubon stiffly added no more than the details of his travel arrangements and an accounting of his funds.

Bachman's statement that Audubon had been "unoccupied" implied another conflict between them that probably contributed as much to the diminution of their friendship as their anxieties over Maria's mortal illness: the quadrupeds

were Bachman's birds, the focus of his lifelong commitment, about which he was deeply knowledgeable; whereas for Audubon, who knew much less about them and for whom they had little emotional resonance, working them up was primarily a commercial enterprise. If Audubon had been unoccupied during his visit, then the two men had not collaborated on the quadrupeds as they had planned. Yet the work was announced and moving forward, and it would bear Bachman's as well as Audubon's name.

Later that summer, writing Victor from New Bedford, where he was soliciting subscriptions, Audubon implicitly admitted his fault of behavior in Charleston, asking his son if he would believe "that I have not drink a drop of anything but water since I left [the] steamer *Massachusetts* on my way to Boston?" Bachman for his part wrote Victor in late June "with reluctance and regret" that Audubon was welcome in Charleston only "whilst he uses liquor in moderation." The two former friends would reestablish a courteous working relationship, necessary to produce the *Quadrupeds,* but though the clergyman would visit New York, Audubon would never again set foot in John Bachman's house.

Bachman had assured New York on June 6 that "the case," meaning Maria, "does not threaten to terminate soon." Audubon in New Bedford at the end of July responded to a letter from Victor that he was "glad to hear that our beloved Maria is much better." Maria was not better, however. She grew progressively weaker as she slowly starved to death, and on Tuesday, September 15, 1840, twenty-three years old, she died, leaving two children whom the families would love and Lucy Audubon would raise, ironic replacements in middle age—she was fifty-three—for the two little girls she had lost in Kentucky years before.

Then Victor and Eliza's travail began, spurred perhaps by the trauma of losing Maria. When Victor had written his father on September 19 to relay the news of Maria's death—it had been "easy," he had reported, ". . . she was sensible and free from fever"—he had confessed to having "a good deal of anxiety about my dearest Eliza." She had a persistent cough "attended with expectoration." He wanted to confer with Audubon "about her going probably to Havana with me in the winter." Richard Harlan, the Philadelphia physician, was treating her and thought such a voyage "would benefit her greatly." John returned to New York with Lulu and Maria Martin in October, after his wife was buried, and they were shocked to see Eliza's condition. Victor determined to leave immediately accompanied by the indefatigable Martin, bypassing Charleston but sailing first to New Orleans. Bachman wrote there in late October 1840 encouraging his daughter with the story of his own recovery:

I was, at your age, much worse that you are. I had broken a blood vessel, was confined six months to my bed and was given over [i.e., abandoned] by Dr. [Benjamin] Rush and physic. A voyage to Jamaica and a subsequent residence in Charleston affected a cure—without medicine. Be cheerful and content. Look as I always try to do on the bright side of the picture.

Reports of cholera in Cuba kept the invalid party in New Orleans through November. Victor worked at selling Octavo subscriptions but was no more successful at breaching the carapace of the city's philistine commercialism than his father had been. In Cuba they rented a house in San Pedro, a colony of fellow consumptives outside Santiago de Cuba on the mountainous southeastern coast. Eliza did not improve despite the tropical climate, however. By March 1841 they had returned to Havana. Eliza wrote her next-eldest sister Jane from there on March 14 to assure her that they would stop in Charleston on their way up to New York:

Do not think that when we meet you will find no traces of disease in me; every breath I draw convinces me that there is something to be removed before health can return. Yet when I see invalids in the last stage of disease come flocking to this island, I feel grateful that loving friends have removed me in time that my life may be prolonged—perhaps for years. . . . You will see me in a few weeks.

Maria Martin allowed Jane to replace her as Eliza's nurse for the journey from Charleston to New York. By then her Charleston doctors had examined the invalid. Bachman's wife Harriet was bedridden with painful tic douloureux, a facial neuralgia. Unhappy to let his daughter go, Bachman reported the results of her examination mournfully to the Audubons in a letter written on May 8, the day the party sailed: "Eliza has not improved. Drs. Geddings and Horlbeck pronounce the case hopeless. We have yielded to a sad and bitter necessity in parting from her under these circumstances."

Eliza, lighter in color than her sister and freckled, had sung and written poems. Audubon, enchanted, had identified her with his half-sister Rose and called her "Rosy." She was twenty-two years old. She died in New York early on the morning of Tuesday, May 25, 1841. The grieving artist drew a young gray rabbit that day, a common forest species of the eastern United States. It would find its place in Plate 22 of the *Quadrupeds,* facing its settled mother, tender and vulnerable, its father leaping above. "I drew this Hare during one of the days of deepest sorrow I have felt in my life," Audubon wrote on the back of the

drawing, "and my only solace was derived from my labor. This morning our beloved daughter Eliza died at 2 o'clock. She is now in Heaven, and may God forever bless her soul!" In late June he shared his sorrow with a friend:

> I will now close my letter with the most dismal part of it. This is no less than the loss of our own beloved daughter-in-law, the wife of our son Victor, who died 5 weeks ago of that insidious disease, consumption. Thus in 8 months, both our sons have lost their partners and best of friends.

WITH SO MUCH LOSS TO RECOVER FROM, it was time to build a house. "We bought 14 acres of land fronting 550 ft. on the Hudson River," Audubon wrote Charles Bonaparte. The densely forested land, a Revolutionary War battleground, was located about a mile above the village of Manhattansville. It ran back from the river to Bloomingdale Road, between present-day 155th and 158th Streets, back to Tenth Avenue, far up Manhattan Island from New York City, which had not yet expanded above Fourteenth Street. There were big pines along the river, and hemlock, hickory, oak, chestnut, tulip and dogwood trees on the slopes.

John supervised the construction of a two-story, green-shuttered, white clapboard house that faced the Hudson a little above river level, with long porches running the length of the house front and back. The kitchen was located in the basement. A first-floor parlor served as Audubon's painting room. He and Lucy would occupy the second-floor master bedroom, sharing the room with their grandchildren Lucy and Harriet in a trundle bed. Open wooden-manteled fireplaces with iron grates would supply heat in the winter. Steps were put in that led down to the river, where the family could swim; a seine was permanently installed that could be let out into the river to catch fish. Audubon caught an eight-foot sturgeon there the first summer that weighed more than two hundred pounds.

In February 1842 the artist wrote a friend in Pennsylvania requesting a shipment of fifty peach trees to plant, laying the foundation for an orchard of nearly two hundred peach, pear, apple, quince, apricot, plum and nectarine trees. The family planned to raise pigs and poultry as well, to keep milk cows and grow vegetables. The men of the family, borrowing the traditional Scots word for mother, named the property Minniesland in honor of Lucy, who had lived so many years without a home of her own. Audubon registered the title in her name to protect the property from seizure for debt collection, a specter that continued to haunt him from his Henderson days. In October John had

married a young Englishwoman, Caroline Hall, whose father was a merchant in Brooklyn. The families moved to Minniesland in April 1842 when the house was finished. Once again they lived in comfort beside a great river.

ONE LAST EXPEDITION AWAITED AUDUBON before age confined him close to home. He had never crossed beyond the Rocky Mountains into the wilderness of the Far West. The pursuit of quadrupeds, many of which were prairie and mountain residents, gave him reason finally to do so. He was once again in correspondence with John Bachman, who encouraged the adventure. He began planning it in the summer of 1842, traveling to Washington City in July to solicit letters of introduction from President John Tyler, Secretary of State Daniel Webster, Secretary of the Treasury John C. Spencer and the highest-ranking general in the U.S. Army, Winfield Scott.

He had proposed to Webster the previous autumn that the government should "establish a Natural History Institution to advance our knowledge of natural science and place me at the head of it," but nothing had come of his bold initiative—some of the congressmen who looked at his *Quadruped* lithographs could not distinguish squirrels from rats. When Webster, whose *Birds*

Victor and John painted their father in a wilderness setting in 1841.

subscription was in arrears, offered him a high-salaried sinecure now, he dismissed it as "humbug." The government could afford no expeditions such as his "Great Western Journey," as he called it. The government could not even afford to publish the results of the U.S. Exploring Expedition that had discovered Antarctica, just returned after occupying "so many scientific men in no less than four years of constant toil and privation." Always optimistic, Audubon calculated that the results of his journey, following the Missouri River into the West as Lewis and Clark had done, would justify the personal expense.

He planned to leave as soon as the ice broke on the Ohio in late winter 1843, which meant he would see his fifty-eighth birthday on the Missouri. Edward Harris would go with him and share the expense. In January 1843 he heard indirectly, through Victor, from his younger brother-in-law Will Bakewell in Louisville, news that he must have received with mixed feelings:

> I have just returned from Henderson. It made me melancholy to think of the happy days I spent there & to see the old house ready to fall down & all the fences gone. The source of all your father's troubles there (the mill) still stands & is used as a tobacco storehouse. . . . Game is almost as scarce there as here and now the Long Pond (where your Father & I have had so much enjoyment), instead of being full of geese, ducks &c &c [and] surrounded by a grand & solitary forest of largest hickory, pecan & cypress trees & evergreen canebrakes, is in the midst of log cabins.

The eastern wilderness was filling up with new Americans, moving out in ever-greater numbers from the tidewater. If there was wilderness yet to see, it was west, up the Missouri River to the Yellowstone River and beyond. "To render [the *Quadrupeds*] more complete," Audubon advised Bonaparte in February 1843, "I will leave the comforts of my home and beloved family on the 10th of next month bound to the Rocky Mountains. . . . I cannot tell how long I may be absent, but look to return loaded up with knowledge new and [an] abundance of specimens on the shot and not from stuffed museums' moth-eaten remains. I am told that I am too old to undertake such a long and arduous journey, but I reply that having the will, I will no doubt safely bear or even surmount the difficulties that may present themselves in the course of this journey." Down to his last tooth, he was Audubon still.

THE REAL COURSE
OF NATURE'S INTENTIONS

B EFORE AUDUBON DEPARTED FOR THE WEST he attended a wedding. His son Victor had been drawn to Georgianna Mallory, a friend of John's new wife. They became engaged before Christmas 1842 and were married in New York on March 2, 1843. Audubon left for Philadelphia a week later. He met the other members of his party there: his wealthy farmer friend Edward Harris; a Massachusetts artist named Isaac Sprague, whom Audubon had hired to share the work of drawing; a talented Hudson River taxidermist, John G. Bell; and a young assistant, Lewis Squires. From Philadelphia the party traveled by train first to Baltimore and then to Cumberland, Kentucky, from there by stagecoach to Wheeling and then by steamboat to Louisville, where they arrived late on the evening of March 18.

Newspapers followed the progress of the famous American. Audubon danced late at assemblies held in his honor, Will Bakewell reported back to Victor:

> Your father after spending a day or two with us, attending parties at Mr. Hale's and Mr. Fellows', out-dancing the whole of us & keeping all the ladies in the range of his acquaintance, left yesterday on the steamboat *Gallant* for St. Louis with Mr. Harris, Bell, Sprague & Squires & I hope will have a pleasant trip, although no doubt he will be detained by ice in the Mississippi, the weather having turned very cold. In fact no one ever saw the like at this time of the year.

Will, recently bankrupted because he had cosigned $125,000 worth of notes that his brother Tom Bakewell had defaulted on, had to refuse Audubon's invitation to join the party, but he lent the American woodsman his best gun.

The *Gallant*—"the very filthiest of all filthy old rat-traps I ever traveled

in," Audubon called it—bumping its way down the Ohio through ice floes, struck a submerged tree one night and shuddered as if stoved and sinking. "The ladies screamed, the babies squalled, the dogs yelled, the steam roared, the captain . . . swore . . . and all was confusion and uproar," Audubon wrote home. He went on to paint a memorable portrait of steamboat travel at its worst:

> Our *compagnons de voyage,* about one hundred and fifty, were composed of Buckeyes, Wolverines, Suckers, Hoosiers and gamblers, with drunkards of each and every denomination, their ladies and babies of the same nature and specifically the dirtiest of the dirty. We had to dip the water for washing from the river in tin basins, soap ourselves all from the same cake and wipe the one hundred and fifty with the same solitary one towel rolling over a pin. . . . My bed had two sheets, of course, measuring seven-eighths of a yard wide; my pillow was filled with corn shucks. Harris fared even worse than I, and our "state room" was evidently better fitted for the smoking of hams than the smoking of Christians. When it rained outside, it rained also within, and on one particular morning when the snow melted on the upper deck or roof, it was a lively scene to see each person seeking for a spot free from the many spouts overhead.

In St. Louis the artist of the Eastern wilderness encountered the first genera-tions of explorers of the West: Pierre Chouteau, the ninety-year-old cofounder, with John Jacob Astor, of the American Fur Company; his son Pierre Jr., who

was sponsoring Audubon's expedition to the extent of allowing the party to travel up the Missouri on the fur company's steamboat, the *Omega;* Étienne Prévost, who discovered the South Pass through the Rockies that had made it possible for families in wagons to begin emigrating to Oregon and California and whom Audubon hired to hunt and trap for him at $50 a month. Sir William Drummond Stewart, a veteran of fur-trader rendezvous, tried unsuccessfully to enlist Audubon in his expedition that summer to the Wind River Mountains; mountain man William L. Sublette was going as his guide. Despite their experience, Audubon found, the Western generations were focused on commerce, not science: "To my utter astonishment, none of the men who have actually spent years and years in the mountains and upper Missouri know anything of the quadrupeds there, beyond the beaver, the otter, the coons and such foxes as pay in the skin. The same with buffaloes." As always, as a hybrid hunter and field naturalist he was breaking new ground.

Nicholas Berthoud had just opened "a large store filled with goods on commission" in St. Louis, Audubon wrote home. His wife Eliza was still in transit from New York. "He is pleased with his present prospects and regrets not having come here instead of his having gone to N.Y." Berthoud's latest move once

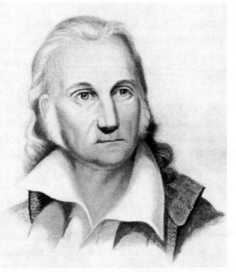

Audubon at the beginning of the
Missouri River expedition, drawn by Isaac Sprague

again supplied Audubon with convenient warehousing and a place to stay while he waited for the Missouri to thaw; it had been "a solid mass of ice" when he arrived.

Spring opened at the beginning of April, the river rising four or five feet, but the *Omega* remained in dry dock undergoing repairs until the middle of the month, when the party moved aboard to save expenses. The superintendent of Indian affairs, D. D. Mitchell, issued Audubon a document authorizing "permission . . . to pass through Indian country to the falls of the Missouri on a Scientific tour," and then two days before the *Omega* left St. Louis presented the artist "a gem . . . which is no less than one of Lewis and Clark's MS journals containing the year 1805. It is written by General Clark." Into Berthoud's St. Louis warehouse the treasure went. From bitter cold the weather had turned "quite warm and beautiful, indeed it feels like summer again. The river is *very high* and the current runs like a millrace." Audubon was happy they had an "abundance of cornmeal" aboard the boat: "My last upper tooth fell out of my mouth the other day, and now I must soak my biscuits &c."

The *Omega's* primary function was transporting the Chouteaus' army of trappers. With these *engagés* aboard, as well as Indians who had come to St. Louis to trade and Audubon's party, the narrow steamboat pulled away from the St. Louis wharf at ten-thirty on the morning of April 25, 1843, amid shouts and gunfire:

> We have upward of one hundred individuals with us, mostly French Creoles and Canadians, and it would have been a curiosity for you to have seen them when they were mustered . . . some drunk, some half so and a very few sober. . . . When we left the wharf they fired different scattering salutes and were somewhat uproarious, but now that they have dined, those that are sober are all singing on the top deck and hallowing as if mad Indians. The drunken ones are all below sound asleep. . . . The yells of the Indians we have [on board] as well as those of the white rascals above have distracted [me] ever since I began this.

Audubon's party quickly discovered "that our berths were too thickly inhabited for us to sleep in" and slept after that "on our India rubber beds [that] have no bugs." Somewhere between St. Charles, Missouri, and the mouth of the Gasconade River the artist passed his fifty-eighth birthday. He allowed the Indians aboard to enter his stateroom in a group to view his drawings and "one of the women actually ran off at the sight of the woodchuck exclaiming that they were alive." Unlike the fur traders, the Indians knew almost all the animals

Audubon had drawn "and laughed curiously and said that if I would go to their villages I would be treated as a Great Man!"

Jefferson City offered little more than an ornate marble statehouse and a grim penitentiary, but there were vultures and eagles nesting in the limestone bluffs upriver from the crude state capital and Harris saw a peregrine falcon. Audubon perceived a stern lesson in the Missouri's flooding power that undercut the riverbanks "along with perhaps millions of trees" that were "ever tumbling, falling and washing away from the spots where they may have stood and grown for centuries past"—an "awful exemplification of the real course of Nature's intentions, that all should and must live and die." Sprague, the artist, and Bell, the taxidermist, were both a little over thirty, but Audubon found

them "astonished" at the "gigantic" timber along the river, another indication that the Eastern wilderness had been reduced in the course of Audubon's longer life. Nor had the party seen any large game yet. The steamboats also logged the riverside to feed their boilers, which drew on muddy river water and had to be shoveled free of a foot or more of silt almost every night.

From a passing steamboat carrying several hundred soldiers up to Fort Leavenworth a crowd of officers crossed over to the *Omega* to meet the famous woodsman. Another visitor was Father Pierre-Jean De Smet, on his way to Europe to raise funds for his Indian missions. At Independence the party shot rabbits, squirrels and pheasants for dinner and found "all around . . . under water except the bluffs or hills where only the ground is dry and looks well." They steamed past Fort Leavenworth and the Kickapoo Nation in "rain, lightning and thunder" and came to the Black Snake Hills—present-day St. Joseph, Missouri—"a truly magnificent natural situation" where "a broad and extensive prairie" reached "to the water's edge. . . . There are a few houses, one or two grist and sawmills and an abundance of loafers of all descriptions." Harris shot a "fine, large and handsome new finch" that Audubon believed to be a nondescript; it turned out that Thomas Nuttall had described it previously, but the name stuck that Audubon gave it, Harris's finch. Woodchucks were "abundant beyond description," as were Carolina paroquets.

Confined largely to the steamboat deck by its captain's determination to keep pushing upriver, which limited the party's hunting hours, Audubon thought as much of home as he did of the expedition. The comments he directed to Victor mostly concerned keeping the business going and the cash flow steady, but he imagined Johnny planting trees, laying sod and spurring on the gardener. John seems to have voiced a dream of going West and pioneering; when the *Omega* approached "the bounds of civilization"—the upper border of Missouri, where the Platte River Purchase began—Audubon teased his younger son that if he wanted "rich land and a hard life he may come and try his luck here, but he must leave behind him my dear Caroline [John's second wife] and our sweet babes."

At the mouth of the Platte they saw "extensive prairie (low & flat) that have been so inundated as to have at present deposits of mud . . . through which no grass can force its way this year! Glorious times, this, for the geese, ducks and gulls which are breeding all over these great plains now of mud and water puddles instead of the lovely flowers that usually at this season adorn them." They had skinned more than one hundred specimens of quadrupeds and birds by then but had still seen no large game; "we are told however that next week the

wolves, the foxes, black-tailed deer &c. will show themselves." They landed their party of Indians "and we saw about 80 that came not to welcome them precisely but to eat all the eatables they had brought with them from St. Louis."

Audubon's feelings were decidedly mixed about the hungry, traumatized Indians he would meet through the summer on the northern plains, sometimes pitying them, more often expressing condescension and even contempt. They were not the well-fed, confident Osages of his Mississippi River days. Since 1837 they had been ravaged by smallpox, which a deckhand had brought upriver on an American Fur Company steamboat. The deckhand had infected others, including three Arikara women; the disease had spread as the boat made its way from fort to fort, and in the next several years some seventeen thousand Native Americans perished. "The Mandans practically disappeared," a modern historian concludes. "Three-quarters of the Blackfeet, one-half of the Assiniboine and Arikara and one-quarter of the Pawnee died." Audubon told the smallpox story at length in the journal he kept of his Missouri River expedition, so he had reason to understand why the Indians he met were dirty, louse-ridden and hungry, prepared to steal anything in sight. That his empathy failed him was another sad sign that he was growing old, picking up the prejudices of the hard-eyed Western men around him.

By the mouth of the Vermillion River, 1,100 miles above St. Louis—in the southeast corner of present-day South Dakota—they began to see "a number of dead buffalo floating past us." Elk, deer, bear and wolves were now plentiful as well. Audubon explained the dead buffalo in a letter home from Fort Pierre Chouteau on June 1:

> The buffalo are so remarkably abundant this season and the snow that fell 2 feet deep on the 5th of [May] has destroyed almost all the calves and reduced the old ones to the last stage of poverty. They swim the river in vast multitudes, are drowned and left on either shore for hundreds of miles above; and many have already passed us floating, bloated and putrid!

Going native, Audubon switched to moccasins, which were easier to walk in than boots. He, Harris and Squires had not shaved since they left St. Louis, "and I have not once pulled off my breeches when I have tumbled down at night to go to sleep." Of buffalo they began seeing "many, many thousands, for either from any part of the boat or even from my own room door I see them in large herds feeding quietly . . . on the great prairies or on the crests or edges of the hills and ravines." He had acquired "an Indian lodge of great dimen-

sions"—a tepee—that he wanted his sons to set up at Minniesland "on the sweet spot that overlooks the river downwards." He was preparing to use the camera lucida to "make several outlines of very young [buffalo] calves . . . and group them to form part of the Plate of the *Buffalo*."

At Fort Clark (above present-day Bismarck, North Dakota) Audubon walked out on the prairie and "saw heaps of earth thrown up to cover the poor Mandans who died of the smallpox." The country was overgrown with lamb's-quarters and he wondered why the Indians had not exploited the plant for food. Of the Mandans there remained only "fifteen or twenty huts"; their mass graves were each marked with a buffalo skull. The Arikaras—"Riccarees," Audubon called them—had taken over the Mandan village.

In mid-June the *Omega* disembarked Audubon's party at Fort Union, high up near the present northern border of the United States where the Yellow-stone River enters the Missouri (and the Missouri crosses today from North Dakota to Montana, below Williston). The steamboat had made the trip from St. Louis in record time, forty-eight days and seven hours. Chouteau's men would have to build a flat-bottomed Mackinaw boat to float the party back down to St. Louis. "I am going to collect all possible information about Quadrupeds &c. during my stay here," Audubon wrote home. ". . . My head is actually swimming with excitement and I cannot write any more. In a few days, after we are settled, I will feel better for it and will send you another and a bet-ter letter."

When he wrote late on the evening of June 17 his letter was still hasty, because a Mackinaw boat that would carry the mail down to St. Louis was leav-ing early the next morning. Hunters were going out for him then "to procure antelopes, mountain rams &c. and our [hunter Étienne] Prévost is going to a lake to trap beavers and otters for us." Sprague, the artist, was turning out to be "an industrious young man"—he had mounted a gray wolf that day on one of Audubon's impaling boards and then had taken over drawing a fawn Audubon had started so the older artist could work on the wolf. Ed Harris had become the trading fort's resident physician, letting blood and dispensing medications to trappers and Indians "consumed with defects too bad for me to name," meaning venereal diseases.

"We have bread only twice a day, morning and evening," Audubon contin-ued in his report home, "but we have very excellent milk and butter and prob-ably the best catfish found in the world." They also had abundant currants and gooseberries. He had acquired "a fine young badger," which he was taming and hoped to take home. Lucy wrote from Minniesland a few weeks later—

Audubon would not have seen the letter for several months—that the family had begun "bathing" in the Hudson in mid-June and had "hatched many chickens and turkeys. . . . I will only say the dear little ones are quite well as also the dear big ones and we only want you at home."

The first order of business at Fort Union was hunting buffalo, which Harris did from horseback as often as there were buffalo to be found. Sport hunting no longer appealed much to Audubon. In mid-July, with hunters from the fort, the party explored up the Yellowstone on horseback and by wagon. For several days the hunters failed to locate game, until the gentlemen were reduced to bad coffee and hardtack and the ordinaries to empty bellies and river water. Audubon's journal narrative of Sunday, July 16, measures both the intensity of their hunger and the extent of their ingenuity:

July 16, Sunday. The weather pleasant with a fine breeze from the westward, and all eyes were bent upon the hills and prairie . . . to spy if possible some object that might be killed and eaten. Presently a wolf was seen, and Owen went after it, and it was not until [the wolf] had disappeared below the first low range of hills, and Owen also, that the latter came within shot of the rascal, which dodged in all sorts of manners; but Owen would not give up, and after shooting more than once, he killed the beast.

A man had followed him to help bring in the wolf, and when near the river he saw a buffalo, about two miles off, grazing peaceably, as he perhaps thought [himself] safe in his own dominions; but alas! white hunters had fixed their eyes upon him, and from that moment his doom was pronounced. Mr. Culbertson threw down his hat, bound his head with a handkerchief, his saddle was on his mare, he was mounted and off and away at a swift gallop more quickly than I can describe not towards the buffalo but towards the place where Owen had killed the wolf.

The man brought the wolf on old Peter, and Owen, who was returning to the camp, heard the signal gun fired by Mr. Culbertson and at once altered his course. His mare was evidently a little heated and blown by the wolf chase, but both hunters went after the buffalo, slowly at first, to rest Owen's steed, but soon, when getting within running distance, they gave whip, overhauled the bison and shot at it twice with balls; this halted the animal. The hunters had no more balls, and now loaded with pebbles, with which the poor beast was finally killed.

The wagon had been sent from the camp. Harris, Bell and Squires mounted on horseback and traveled to the scene of action. They met Mr.

Culbertson returning to camp and he told Bell the buffalo was a superb one
and had better be skinned. A man was sent to assist in the skinning who had
been preparing the wolf which was now cooking, as we had expected to dine
upon its flesh; but when Mr. Culbertson returned, covered with blood and
looking like a wild Indian it was decided to throw it away. So I cut out the
liver and old Prévost and I went fishing and caught eighteen catfish. I
hooked two tortoises but put them back in the river. I took a good swim
which refreshed me much and I came to dinner with a fine appetite. This
meal consisted wholly of fish and we were all fairly satisfied. Before long the
flesh of the buffalo reached the camp as well as the hide. The animal was
very fat and we have meat for some days.

The temperature rose to 102 degrees on July 22, but by August 3 "the atmo-
sphere was thick and indicated the first appearance of the close of summer,
which here is brief. The nights and mornings have already become cool and
summer clothes will not be needed much longer except occasionally." Chas-
tened by the continual slaughter of buffalo and wolves in the neighborhood of
the fort—Harris had taken to shooting wolves at night from the parapet—
Audubon had begun protesting. He was impressed on August 8 when "[a
hunter] and two men had been dispatched with a cart to kill three fat cows but
no more"; he felt his "remonstrances about useless slaughter have not been
wholly unheeded."

Audubon was smelling the slaughter that three decades later would reduce
the North American bison nearly to extinction. He may have connected the
casual slaughter he saw with the slaughters he had witnessed of passenger
pigeons, which flocked in even greater numbers than the buffalo. A trader had
told him of riding one recent summer "in a heavily laden cart for six successive
days through masses of buffalo, which divided for the cart, allowing it to pass
without opposition. He has seen the immense prairie back of Fort Clark look
black to the tops of the hills though the ground was covered with snow, so
crowded was it with these animals. . . . In fact it is *impossible to describe or even
conceive* the vast multitudes of these animals that exist even now and feed on
these ocean-like prairies."

The fur company men had begun building the party's Mackinaw boat. "Her
name will be the *Union* in consequence of the united exertions of my compan-
ions to do all that could be done on this costly expedition." The boat was
launched on August 12, but though it was forty feet long, it proved to be too
small to hold men and equipment, and a larger boat had to be substituted. The

John Woodhouse's 1843 portrait of his father

river was rising again and it was getting cold. They left Fort Union finally on Thursday, September 14, at two in the afternoon, stopping at the farm below the fort to collect "a few potatoes, some corn and a pig."

On October 5, near Council Bluffs, Audubon noted the line above which European honeybees had not yet migrated. Then they were in pawpaw country, crossing through Missouri, and game had become scarce again. They reached St. Louis at three in the afternoon on October 19. "Unloaded and sent all the things to Nicholas Berthoud's warehouse. Wrote home."

Victor's wife Georgianna remembered Audubon's homecoming to Minniesland on November 6, 1843:

> It was a bright day and the whole family, with his old friend Captain Cummings, were on the piazza waiting for the carriage to come from Harlem. There were two roads, and hearing wheels some ran one way and some another, each hoping to be the first to see him; but he had left the carriage at the top of the hill and came on foot straight down the steepest part, so that

those who remained on the piazza had his first kiss. He kissed his sons as well as the ladies of the party. He had on a green blanket coat with fur collar and cuffs; his hair and beard were very long, and he made a fine and striking appearance. In this dress his son John painted his portrait.

THE AUDUBONS PUBLISHED the last five Numbers of the Octavo edition of *The Birds of America* on May 29, 1844. It had gleaned eleven hundred subscribers and earned them a profit of about $36,000—about $840,000 today. Audubon called the Octavo edition his "salvator"—his savior. It paid for Minniesland and sustained the growing families for years.

Bachman was surprised and disappointed to find that his *Quadruped* partner had collected far fewer species on his Missouri River expedition than their work required. The large animals were well represented in the collections, as were curiosities like the pouch rat (pocket gopher), which had intrigued Audubon with the pendulous pouches that hung off its cheeks. Missing were the more exotic of the meat-and-potatoes species, the rats, mice, bats and squirrels that made up the majority of American quadrupeds and that could not be collected on horseback or from the stateroom of a steamboat. Audubon had chosen to spend his time sightseeing and wolf and buffalo hunting rather than digging out burrows and turning over rocks. He had lost his keen edge. He still drew more than half of the 150 species that made up the *Quadrupeds*. John drew the rest.

"He painted little after his return from the Yellowstone River," Georgianna Audubon remembered, "but as he looked at his son John's animals, he said: 'Ah, Johnny, no need for the old man to paint any more when you can do work like that.' " His two sons took up the slack, as their father had trained and prepared them to do. Victor coordinated printing and subscription fulfillment and supplied Bachman with specimens and information, not always to Bachman's satisfaction. John went out to Texas on expedition for six months in the winter and spring of 1846, following in his father's footsteps, and then moved his family to England and Europe for more than a year to draw from skins in museums there. The first proofs of the *Quadrupeds* had already been pulled before Audubon left for the Yellowstone—they were the plates he had shown to the Indians on the *Omega*. Numbers appeared regularly thereafter. Three imperial folio volumes of *The Viviparous Quadrupeds of North America*, with lithographed and hand-colored 22 by 28-inch plates, were published in 1845, 1846 and 1848. Hampered by lack of specimens and information, Bachman's three accompanying volumes of letterpress took longer; they were issued in 1846,

1851 and 1854. Audubon's sons produced several octavo editions of the *Quadrupeds* as well.

Audubon's world narrowed to Minniesland, but Minniesland was not a narrow world. The magazine writer Rufus Griswold visited Audubon there in 1846 and somewhat fulsomely described the setting, missing the badger, the fox, the buffalo cow and calf, the tepee and the many birds:

> The house was simple and unpretending in its architecture and beautifully embowered amid elms and oaks. Several graceful fawns and a noble elk were stalking in the shade of the trees, apparently unconscious of the presence of a few dogs and not caring for the numerous turkeys, geese and other domestic animals that gabbled and screamed around them. Nor did my own approach startle the wild, beautiful creatures that seemed as docile as any of their tame companions.
>
> "Is the master at home?" I asked of a pretty maidservant who answered my tap at the door and who . . . led me into a room on the left side of the broad hall. It was not, however, a parlor or an ordinary reception room that I entered, but evidently a room for work. In one corner stood a painter's easel with a half-finished sketch of a beaver on the paper; in the other lay the skin of an American panther. The antlers of elks hung upon the walls; stuffed birds of every description of gay plumage ornamented the mantelpiece; and exquisite drawings of field mice, orioles and woodpeckers were scattered promiscuously in other parts of the room, across one end of which a long rude table was stretched to hold artist materials, scraps of drawing paper and immense folio volumes filled with delicious paintings of birds taken in their native haunts.

Audubon's greeting—"How kind it is to come to see me and how wise to leave that crazy city!"—was alert enough and characteristic. Griswold also saw the steady, faithful intimacy that bound the artist to his Lucy after their long years together.

> The sweet unity between his wife and himself, as they turned over the original drawings of his birds and recalled the circumstances of the drawings, some of which had been made when she was with him; her quickness of perception and their mutual enthusiasm regarding these works of his heart and hand, and the tenderness with which they unconsciously treated each other, all was impressed upon my memory. Ever since, I have been convinced that Audubon owed more to his wife than the world knew or ever would. That

she was always a reliance, often a help and ever a sympathizing sister-soul to her noble husband was fully apparent to me.

Georgianna Audubon remarked the loving husband and the public man and grandfather as well:

> Mr. Audubon was of a most kindly nature; he never passed a workman or a stranger of either sex without a salutation, such as, "Good-day, friend," "Well, my good man, how do you do?" If a boy, it was "Well, my little man," or a little girl, "Good morning, lassie, how are you to-day?" All were noticed, and his pleasant smile was so cordial that all the villagers and work-people far and near, knew and liked him. . . . He was most affectionate in his disposition, very fond of his grandchildren, and it was a pleasant sight to see him sit with one on his knee, and others about him, singing French songs in his lively way. It was sweet too, to see him with his wife; he was always her lover, and invariably used the pronouns "thee" and "thou" in his speech to her. Often have I heard him say, "Well, sweetheart! always busy; come sit thee down a few minutes and rest."

He could read with reading glasses, but he lost the middle-distance focus he needed to draw. According to a biographer who worked from Lucy's dictation, "The first day he found that he could not adjust his glasses so as to enable him to work at the accustomed distance from the object before him, he drooped. Silent, patient sorrow filled his broken heart. . . . [But] he took great pleasure in listening to reading and to the singing of one of his daughters-in-law [Georgianna], who had an exceedingly sweet and well-cultivated voice. He found much amusement too in walking through his grounds."

In 1847 dementia began to reveal itself in a loss of words and of interest. His vivid personality faded into vacancy. "His eye lost its brightness," Lucy saw. Bachman, who by then had buried his wife and yet another daughter, came up from Charleston in May 1848 to see him and masked his shock and sorrow in a coolly blunt appraisal he wrote home to Maria Martin (he would marry his sister-in-law in December):

> The old Gentleman has just gone to bed after having eaten his eleventh meal, handed his [snuff] box all round, kissed all the ladies & heard his little evening song in French after having seen that John had fed all the dogs. . . . All is well here as far as health is concerned. The old Lady is as straight as an arrow, in fine health but much worried . . . looking over the advertisements

"The mind is all in ruins. . . ."

for maids . . . & taking care of the poor old gentleman. His is indeed a most melancholy case.

I have often sat down sad & gloomy in witnessing a ruin that I had seen in other years in order & neatness, but the ruins of a mind once bright & full of imagination is still more melancholy to the observer. The outlines of his countenance & his general robust form are there, but the mind is all in ruins. . . . Imagine to yourself a crabbed, restless, uncontrollable child, worrying & bothering everyone, & you have not a tithe of a description of this poor old man. He thinks of nothing but eating—scarcely sits down two minutes at a time, hides hens' eggs—rings the bell every five minutes calling the people to dinner & putting the old lady into all manner of troubles. But I turn away from the subject with a feeling of sadness.

A vacant expression and especially perseveration about meals from a loss of short-term memory make it probable that Audubon was suffering from the dementia that Alois Alzheimer would first describe in a medical journal in 1906. By January 1849 the crabbed restlessness had given way to lassitude, Victor wrote Maria Martin: "My poor old Father is apparently comfortable, and enjoys his little notions, but has no longer any feeling of interest for any of us,

and requires the care and attention of a man. This is the hardest of all to bear, among the trials in store for us."

Among the trials in store for them was a decision the family made to support a California gold rush adventure. John would join "Colonel H. L. Webb's California Company" as second in command, lead the company on an untested Mexican route through Durango and Sonora to California, look for gold but also draw, paint and collect specimens. "His journey is undertaken," Victor wrote the new Mrs. Bachman, "with the hope, based on the intelligence we have been able to obtain, that he will be able to get at least $20,000 worth of the gold! What may be the result only God knows, but we are all willing and as heretofore our family is united in their views of what is best to be done." No surviving document contradicts Victor's testimony, but it is hard to believe that Lucy concurred. Nor could Audubon be consulted.

John left New York in February 1849 with eighty men, including most of the men employed at Minniesland, and $27,000 in investors' money and returned in July 1850. The adventure was a disaster. Even before the company reached California it was decimated by desertions and by cholera—John survived two attacks—and its huge stake was stolen. The several hundred watercolors John painted in California went down with the *Central America,* the ship of gold lost in the deep blue sea. The Audubons had to repay John's investors, which nearly impoverished them again. John had hoped to make a name for himself as prominent as his father's, but he lacked his father's luck, or his fire.

Audubon had long since gone silent when Will Bakewell visited Minniesland for the Christmas holidays in 1850. Yet his old memories of Henderson lingered somewhere amid the wreckage, never mind that the house had fallen down and the game was gone. When Will walked up, the vacant old man glanced at him and glanced again and briefly he was aware, back in Henderson in the halcyon days before the infernal mill and the Crash: "Yes, yes, Billy!" Audubon burst out. "You go down that side of Long Pond and I'll go this side and we'll get the ducks!" No later words have been discovered.

For several months Lucy had noticed her LaForest failing. During the third week of January 1851 he stopped eating. Lucy had him put to bed—in the downstairs painting room, where he had been moved some time before to share the room with his caretaker, among his specimens and his art. He died there on Monday, January 27, 1851, with his family around him.

A year later Lucy invited John and Maria Bachman to visit Minniesland and mentioned her husband's grave in nearby Trinity Cemetery. "You will find some changes in the outward as well as inward circumstances around us," she wrote. "I have been planting various favorite shrubs and creepers over the rest-

ing place of your old friend; his cell is as quiet and solemn a resting place as the mind can conceive—and all but the remembrance of his goodness is gone forever."

For Lucy all was gone. As for the rest of us, wherever there are birds there is Audubon: *rara avis.*

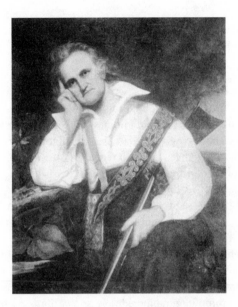

ENVOY

VICTOR GIFFORD AND JOHN WOODHOUSE AUDUBON sustained the Audubon enterprise with their mother's guidance for another decade. John James Audubon's two sons built homes for themselves at Minniesland in 1853 to make room for their growing families, which together counted thirteen living children by 1855. After 1853 Lucy rented out her house and lived alternately with Victor or John and their families. The two brothers published a second Octavo edition of *The Birds of America* in 1856.

The following year Victor stepped into a window well at his house and injured his spine. According to a niece, the fall "at the time was thought to be of no moment," but it made Victor an invalid and initiated a decline that ended with his death on August 17, 1860, at the age of fifty-one. As Victor had weakened, the whole burden of supporting the two families had devolved upon John, and around 1858 he began work on an ambitious new full double-elephant-sized chromolithographic edition of *The Birds of America* that he hoped might recoup the family fortunes. The first volume of the J. Bien & Company edition, with 106 plates, was issued the year Victor died, but the Civil War, which began a few months afterward in 1861, cut off Southern and distracted Northern subscribers, and with the failure of the Bien edition the Audubons were ruined. "Worn out in body and spirit," his daughter writes, "overburdened with anxieties, saddened by the condition of his country," John Woodhouse Audubon was stricken with pneumonia in the winter of 1862 and died on February 21 at forty-nine.

In 1857, when she was seventy, Lucy had returned to teaching to reduce John's burden. She taught her grandchildren and the neighborhood children as well. With John gone she became responsible for the family debts. To reduce them she offered Audubon's original drawings for *The Birds of America* to the New-York Historical Society for $5,000. The society bought them for $2,000 in

Victor Gifford Audubon, 1853

John Woodhouse Audubon, 1853

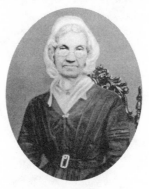

Lucy Audubon, 1854

1863–about $28,000 today. Lucy also sold the copper engraving plates for scrap when no organization would buy them to preserve them. (Most were melted down; a few were saved.) After Minniesland itself was sold she lived with family and friends in New York and Kentucky.

Lucy Bakewell Audubon, born in Burton-upon-Trent, Staffordshire, on January 18, 1787, died of pneumonia at eighty-six in Shelbyville, Kentucky, on June 18, 1874. Two of her granddaughters returned her remains to New York and saw her buried in Trinity Cemetery beside the man she had loved and inspired. Their marriage had lasted forty-three years—exactly half her life.

NOTES

ABBREVIATIONS

APS: American Philosophical Society, Philadelphia.

AUDUBON MUSEUM: John James Audubon Museum, John James Audubon State Park, Henderson, Kentucky.

BMNHN: Bibliothèque Centrale, Musée Nationale d'Histoire Naturelle, Paris.

BOA: John James Audubon, *The Birds of America.*

FILSON: Filson Historical Society, Louisville, Kentucky.

HARVARD: Houghton Library, Harvard University.

LOA: Library of America, *John James Audubon, Writings and Drawings.*

OB: John James Audubon, *Ornithological Biography.*

PRINCETON: John James Audubon Collection, Manuscripts Division, Department of Rare Books and Special Collections, Princeton University Library.

STARK MUSEUM: Stark Museum, Orange, Texas.

UMSL: University of Missouri–St. Louis.

YALE: Beineke Rare Book and Manuscript Library, Manuscripts Division, Department of Rare Books and Special Collections, Yale University.

One MIGRATION

3 AUGUST 1803: According to his citizenship application, JJA arrived in the United States "on or about" 27 August 1802, but other documents confirm 1803 rather than 1802.

3 "THEY CAME ON BOARD": *OB* I, p. 50.

4 "DEEP SORROW OR": *OB* II, p. v.

4 "PROMPTED BY AN INNATE": LoA, p. 753.

4 JEANNE RABIN'S AGE: JR was born on 15 March 1758 in the village of Les Mazures, about 20 km. from Nantes: Guy Lorcy, Couëron, personal communication.

5 "I MEASURED FIVE FEET": Quoted in Herrick (1938) I, p. 172.

5 "HE IS THE HANDSOMEST BOY": Quoted in Audubon and Coues I (1898), p. 74.

6 MILL GROVE: See Herrick (1938) I, pp. 103ff.

6 $200,000 TODAY: Inflation conversion factors for the years of Audubon's life are taken from "Inflation Conversion Factors for Years 1665 to Estimated 2013" by Robert C. Sahr, downloadable from http://oregonstate.edu/Dept/pol_sci/fac/sahr/sahr.htm. Audubon valued English pounds at $4.44.

6 JJA MOVED TO FRANCE: This chronology follows Ford (1964), pp. 22ff, the most credible reconstruction. No document has yet turned up that establishes precisely when JJA was removed from Saint Domingue to France, but removal at the same time as his half-sister Rose is more plausible than separate departures if the reason for the removals was danger from the impending slave uprising.

6 "WAS OPPOSED TO MUSIC": LoA, pp. 773–74.

7 "HUNTING, FISHING, DRAWING": LoA, p. 774.

7 "[AT] ABOUT THE EXPIRATION": Yale Box 4, f. 151, 3 April 1802.

8 LEASE PAYMENT, ETC.: See Jean Audubon to Francis Dacosta, Herrick (1938) I, pp. 116ff.

8 "REMEMBER, MY DEAR SIR": Herrick (1938) I, p. 117.

8 "A FEATHER-BED": Quoted in King-Hele (1999), p. 301.

8 SHENANDOAH VALLEY: B. Bakewell to Euphemia Gifford (hereafter EG), Princeton, 31 May 1803.

8 "THAT THE NAME": William Bakewell (hereafter WB) to EG, Princeton, 12 Oct. 1804.

9 "THY BLOOD WILL COOL": Audubon and Coues (1897) I, p. 216.

9 "I WAS STRUCK": LoA, pp. 774–75.

9 "IT HAPPENED THAT": LoA, p. 775.

9 SEVENTEEN: Ford (1964), p. 45, has "eighteen," but LB was born on 18 Jan. 1787.

9 "A FINE LIVELY GIRL": Eliza Atterbury to EG, Stark Museum, 2 Mar. 1804.

9 TOM BAKEWELL ABOUT TO LEAVE FOR NEW YORK: See Thomas Bakewell to EG, Stark Museum, 6 Nov. 1803.

10 "SHE NOW AROSE": LoA, p. 775.

10 "WE ALL REPAIRED": LoA, pp. 775–76.

10 "I WAS WHAT IN PLAIN TERMS": LoA, pp. 783–84.

11 "TO COMPLETE A COLLECTION": LoA, p. 753.

11 "THE FIRST COLLECTION OF DRAWINGS": LoA, p. 759.

11 "I BETOOK MYSELF": LoA, p. 759.

12 "AS IF THE ABSENT OWNER": OB II, p. 123.

12 "I CONCLUDED THAT THEY": OB II, p. 123.

12 "ONE DAY WHILST WATCHING": LoA, p. 760.

13 "ABOUT THE VALUE OF": WB to EG, Princeton, 12 Oct. 1804.

13 HIRED HAND AND THOMAS: Ford (1964), p. 49, citing WB's manuscript journal.

13 LUCY FIRST TOLD AUDUBON: See Audubon (1868), p. 104.

13 "REMARKABLE AND CURIOUS TWITTERING": OB II, p. 124.

13 "BY MEANS OF THREADS": LoA, p. 760.

13 "COGITATED HOW FAR": LoA, p. 760.

14 ROZIER'S VISIT, LUCY'S VISIT: Ford (1964), pp. 49–50.

14 "THE VEIN PROVES TO BE": Quoted in Herrick (1938) I, p. 114, n. 2.

14 "LONG BEFORE DAY": LoA, pp. 760–61.

15 "NOW, THE DEAR": Deane (1910), p. 47.

16 "A MR. AUDUBON": WB to EG, Princeton, 12 Oct. 1804.

16 LUCY'S MOTHER: WB to EG, Princeton, 12 Oct. 1804.

16 "MY SON SPEAKS TO ME": Jean Audubon to Francis Dacosta, 1804, Herrick (1938) I, pp. 116–18.

16 "TOOK IT INTO HIS HEAD": LoA, p. 778.

16 "A GREAT LOSS": unknown to EG, Princeton, 7 Nov. 1804.

16 "NOT QUITE AS WELL": LB to EG, Stark Museum, 7 Nov. 1804.

17 "WHERE SHE EAT": WB to EG, Princeton, 12 Oct. 1804.

17 "FOR THE FIRST WEEK": WB to EG, Stark Museum, 18 Nov. 1804.

Two "I SHALL SAIL ON A SHEEP"

18 "WE WERE SKATING": LoA, pp. 777–78.

18 AUDUBON'S ILLNESS: See Ford (1964), p. 54.

19 "NONE WERE GOOD": LoA, p. 769.

20 "WE MUST RULE BY IRON": Quoted in Hibbert (1980), p. 225.

20 "JEAN AUDUBON, COMMANDING": Quoted in Herrick (1938) I, p. 59.

20 "I OUGHT TO WARN YOU": Quoted in Hibbert (1980), p. 339.

21 "KILL AND KILL": Quoted in Hibbert (1980), p. 228.

21 "MR. AUDUBON . . . GIVES US": WB to EG, Stark Museum, 18 Nov. 1804. Five more lines that follow and presumably elaborate this text have been obliterated with black ink, probably by the notorious Audubon granddaughters who bowdlerized so many Audubon documents.

21 "A LADY OF SPANISH EXTRACTION": LoA, p. 765.

21 "SEVERAL BEAUTIFUL PARROTS": LoA, p. 766.

22 "WOULD . . . SPEAK OF": OB I, pp. v–vi.

22 "THE MOMENT A BIRD": OB I, p. vii.

22 "MY PENCIL GAVE BIRTH": OB I, p. viii.

23 "TODAY I SAW THE SWIFTEST": Audubon & Coues (1898) I, p. 75.

23 "BUT EVEN MORE": Audubon & Coues (1898) I, p. 39.

23 "I . . . ENTERED HIS ROOM": LoA, p. 778.

23 "IN CONSEQUENCE OF THE LETTERS": LB to EG, Princeton, 2 Sept. 1805.

23 THEOLOGICAL REPOSITORY: Herrick (1938) I, p. 124, n. 15.

23 PASSENGER PIGEONS: OB I, p. 325.

23 "HE READ [IT]": LoA, p. 779.

23 JJA'S NEW YORK ACTIVITIES: See Ford (1964), p. 56.

24 "I AM [VEXED], SIR": Herrick (1938) I, pp. 118–19.

25 "TO THEM MY APPEARANCE": LoA, p. 780.

25 AUDUBON SAYS: See LoA, p. 780.

26 "BE SO GOOD AS TO ASSURE": JJA to WB, Princeton, 20 May 1805.

26 "WAS AT THAT TIME": LoA, p. 781.

26 "I AM HERE IN THE SNEARS": JJA to WB, Princeton, 20 May 1805.

26 "MUST MAKE IT OUT": WB to EG, Princeton, 19 July 1805, quoted in Delatte (1982), p. 32.

27 "THE DOCTOR WAS": Audubon & Coues (1898) I, p. 39.

27 JJA'S JUNE-JULY BIRD DRAWINGS: These dates appear on the originals in Houghton Library.

27 DUBUISSON: Information supplied from Nantes archival records by Guy Lorcy, Couëron, Oct. 2002.

27 "YOU ARE ABOUT TO APPEAL": Herrick (1938) I, p. 120.

28 "WOULD IT NOT BE BETTER": Herrick (1938) I, pp. 122–23.

28 "INDEED I DO NOT KNOW": LB to EG, Princeton, 2 Sept. 1805.

29 "A LOVELY FORM": LB & WB to EG, Princeton, 7 Sept. 1805.

30 "OF A DELICATE FORM": Thomas Bakewell to EG, Stark Museum, autumn 1806.

30 "WOULD BE SURPRISED": Sarah Atterbury to EG, Stark Museum, 9 Nov. 1806.

30 "MY PAPA HAS": LB to EG, Stark Museum, 4 Oct. 1806.

30 "I ENTERED THE NAVY": LoA, p. 30.

30 DU PUIGAUDEAU JJA'S SUPERIOR AT ROCHEFORT: Herrick (1938) I, p. 96.

30 WAGTAIL, GREEN FINCH: On 22 and 27 Dec. 1805, the dates on the original drawings in Houghton Library.

31 "I UNDERWENT A MOCKERY": LoA, p. 781.

31 AUDUBON/ROZIER PARTNERSHIP AGREEMENT: Herrick (1938) II, p. 344ff.

31 "I HAD A PASSPORT": Audubon and Coues (1898), p. 40.

31 525 LIVRES PAID 11 APRIL 1806: See Herrick (1938) I, p. 135, n. 9.

31 "WE WERE FAIRLY SMUGGLED": Audubon and Coues (1898), p. 40.

31 "AN OFFICER CAME ON BOARD": LoA, p. 781.

32 "INDEED, OUR PASSENGERS": Audubon and Coues (1898), p. 40.

32 TRAVELING UNDER ASSUMED NAMES: Audubon and Coues (1898), pp. 40–41.

32 "WE WERE RUNNING": LoA, pp. 781–82.

32 "FOR THE EAST END": LoA, p. 782.

32 "MR. AUDUBON (LUCY'S BEAU)": BB to EG, Princeton, 6 May (sic: June) 1806.

Three SETTLING THE INTERIOR

34 PEALE'S MUSEUM: See Sellers (1980).

35 "BY SHOWING THE NEST": Quoted in Sellers (1980), p. 28.

35 PEALE'S TAXIDERMY TECHNIQUES: Sellers (1980), pp. 24–25.

36 BALD = WHITE: A point made to me by Bill Steiner, personal communication, May 2003.

36 MILL GROVE LEAD ORE: Sellers (1980), p. 61.

36 "SO VALUABLE": OB I, p. 57.

36 "AUDUBON TOOK ME": Quoted in Herrick (1938) I, pp. 111–12.

37 "[I] RETURNED WITH A PARTNER": LoA, p. 31.

37 "DON'T LIKE THEIR BEING": Quoted in Ford (1964), p. 64.

37 "THESE THEY INVARIABLY REMOVED": OB II, pp. 126ff.

38 WHIPPOORWILL: See original at Princeton.

38 OSPREY: See original at Houghton Library.

38 WOOD THRUSH: See original at Houghton Library.

38 WATCHING THOMAS PEARS: Ford (1964), pp. 63–64.

38 AGREEMENT WITH DACOSTA: Herrick (1938) I, p. 150.

38 "THE MINE MAY PROMISE": Ferdinand Rozier to Claude Rozier, 12 Sept. 1806, Herrick (1938) I, pp. 149–52.

38 AUDUBON CITIZENSHIP APPLICATION: See Dallett (1960), p. 90.

39 PEARS-PALMER MARRIAGE: On 5 Oct. 1806; see LB to EG, Stark Museum, 4 Oct. 1806.

39 "EXTREMELY USEFUL, STEADY": BB to EG, Stark Museum, 12 Nov. 1806.

39 BAKEWELL'S PROFITS: JJA mentions "nearly 20 p. c." and "one hundred per cent" in his letters to Claude Rozier; see Herrick (1938) I, p. 156, p. 157.

39 "IN SEVERAL OF YOUR LETTERS": JJA to Claude Rozier, 24 April 1807, in Herrick (1938) I, pp. 157–58.

39 CONSIGNMENT REQUEST . . . "GOOD BOOKS": JJA to Claude Rozier, 6 May 1807, in Herrick (1938) I, pp. 161–62.

40 "YOU CAN JUDGE": JJA to Claude Rozier, 6 May 1807, in Herrick (1938) I, p. 161.

40 "I RENTED IT": JJA to Claude Rozier, 24 April 1807, in Herrick (1938) I, p. 158.

40 "THE LAND, WHICH": JJA to Claude Rozier, 30 May 1807, in Herrick (1938) I, p. 165.

40 "I AM ALLWAYS": JJA to JA, 24 April 1807, in Herrick (1938) I, pp. 159–60.

40 "A SMALL BOX": JJA to JA, n.d., in Herrick (1938) I, p. 163.

41 DUCK DRAWINGS AND NOTES: See originals in Houghton Library.

41 "MY DUCK COLLECTION": JJA to Charles d'Orbigny, Princeton, 29 April 1807. (Trans. Julie Peters.)

41 SAMUEL LATHAM MITCHILL: See Hall (1934).

42 "PERFECTLY HONEST AND SINCERE": Quoted in Hall (1934), p. 13.

42 "TAP THE DOCTOR": Quoted in Hall (1934), p. 15.

42 LUCY'S FAVORITE BOOK: Delatte (1982), p. 4.

42 "IN A SHORT TIME": JJA to Claude Rozier, 19 July 1807, in Herrick (1938), pp. 165–66.

42 "SPRIG-TAIL DUCK": Herrick (1938) I, p. 172.

43 "DR. MITCHILL MENTIONED": Nevins (1951), p. 47.

43 "RECOMMENDED IN UNEQUIVOCAL": Nevins (1951), p. 49.

44 "THE CAUSE . . . IS SOLELY": BB to EG, Stark Museum, 22 Jan. 1808.

44 "HE HAS THE MORTIFICATION": WB to EG, Princeton, 17 April 1808.

44 "THOMAS IS IN NEW ORLEANS": WB to EG, Princeton, 17 April 1808.

44 DATE OF MARRIAGE: Ford (1964), p. 73, n. 1, citing the *Norristown Weekly Register.* JJA got it right in a sketch of his life he inserted in his journal on 28 Nov. 1820; the sketch also emphasizes that he married when he attained his majority: "On my return [from Louisville] and being of age I married your beloved mother on the 5th of April 1808 and removed to Kentucky." LoA, p. 30; see also Arthur (2000), p. 120.

44 "A CONSIDERABLE QUANTITY": WB to EG, Princeton, 17 April 1808.

Four LOUISVILLE IN KENTUCKY

46 JEHU: Coleman (1955), pp. 84–85.

46 "GOOD TAVERNS": Rozier's diary translated in Herrick (1938) I, pp. 187–92.

47 "AFTER THE FIRST TWO DAYS": LBA to EG, Princeton, 27 May 1808.

47 "FOR WHILST THE STAGE": LBA to EG, Princeton, 27 May 1808.

47 "A SAD ACCIDENT": LoA, p. 785.

48 "VERY STONY": LBA to EG, Princeton, 27 May 1808.

49 "HIGH MOUNTAINS ON ALL SIDES": LBA to EG, Princeton, 27 May 1808.

49 "ON THE SPOILS": Flint (1932), p. 19.

49 "THE FIRST THING THAT STRIKES": Flint (1932), pp. 14–15.

50 " 'COVERED SLEDS' ": Flint (1932), p. 15.

50 OCEAN-WORTHY HULLS: Merrill (1976), p. 103.

50 "PERFECTLY FLAT": LBA to EG, Princeton, 27 May 1808.

50 "WITH HORSES, CATTLE": *OB* I, p. 292.

51 "POULTRY, EGGS": LBA to EG, Princeton, 27 May 1808.

51 "NEARLY THE WHOLE LENGTH": *OB* I, p. 30.

51 "THE HOOTING OF THE": *OB* I, p. 30.

51 "FIDDLES SCRAPING": Flint (1932), p. 17.

51 BISON AND ELK: See "Anonymous observations on Kentucky 1800–1820," Yale, Box 9, f. 537.

51 "MR. AUDUBON REGRETTED": LBA to EG, Princeton, 27 May 1808.

51 "THE RIVER SEEMED": Flint (1932), p. 23.

52 "WIDE, CLEAN SANDBARS": Flint (1932), pp. 27–28.

52 "I WAS GRATIFIED": LBA to EG, Princeton, 27 May 1808.

52 "WE GLIDED DOWN": *OB* I, p. 29.

52 "WOULD PLEASE EVEN": *OB* I, p. 437.

53 "HAD MARKED LOUISVILLE": LoA, p. 785.

53 "BUT ABOVE ALL": *OB* I, p. 437.

53 "I CANNOT QUITE TELL": LBA to EG, Princeton, 27 May 1808.

53 "MY YOUNG WIFE": LoA, p. 785.

53 "THE MATRONS ACTED": *OB* I, p. 437–38.

53 TOWN FULL OF CLARKS: See Hall (2003), p. 84.

53 JJA OBSERVING OSPREYS: *OB* I, p. 419.

53 "OUR GREAT TRAVELER": *OB* I, p. 437.

54 TARASCON, BERTHOUD AND COMPANY: Hunter (1977), p. 67.

54 SCHOONER BROKE UP: "Nicholas Roosevelt's 1811 Steamboat New Orleans," *Pittsburgh Post,* 30 Oct. 1911.

54 TARASCON'S MILL: Jefferson County History and Timeline, http://www.co.jefferson.ky.us/AboutHistory.html.

54 BERTHOUDS: Streshinsky (1993), p. 57.

54 "AT SHIPPINGPORT": M246-2-02 journal, St. Louis Mercantile Library, UMSL.

54 PUTTING HORSES AT STUD: Merrill (1976), p. 108.

55 "ON THE SAND-BARS": *OB* IV, p. 88.

55 ORCHARD ORIOLES: Drawings in Houghton Library collection.

55 DRAWINGS SENT TO EG: *OB* V, p. 291.

55 "PROCURED . . . WHILE SEARCHING": *OB* V, p. 291.

55 ITS NEAR EYE DIRECTLY ENGAGING THE VIEWER: Don Boarman, curator of the Audubon Museum, Henderson, KY, offered this insight. Personal communication, July 2001.

55 "WHEN I FIRST WENT": *OB* III, p. 13.

56 KENTUCKY BARBECUE: for Audubon quotations see *OB* II, pp. 576–79.

57 INDIVIDUALISM: See Appleby (2000), passim.

57 "IF I HAD SEEN THE TREES": See "The Chimney Swallow, or American Swift," *OB* II, pp. 329–35.

58 CHIMNEY SWALLOW DRAWING: No. 214 in Houghton Library collection.

60 THOMAS BAKEWELL RE TOBACCO: TB to A&R, 13 Dec. 1808, in Herrick (1938) I, p. 197.

61 "ON A VERY COLD MORNING": *OB* I, p. 306.

61 SWAN-HUNTING EXPEDITION: *OB* I, p. 147.

Five ALEXANDER WILSON

62 "HE HAS THE MORTIFICATION": WB to EG, Princeton, 17 April 1808.

62 HELP FROM THOMAS KINDER: cf. BB to EG, Stark Museum, 4 Nov. 1809; Thomas Kinder to EG, Princeton, 12 Nov. 1811.

62 "THE PRESENT BUSINESS": BB to EG, Stark Museum, 4 Nov. 1809.

63 "A COLLECTION OF BLACKSMITH": Quoted in Herrick (1938) I, p. 204.

63 100,000 PENNY BROADSIDES: Cantwell (1961), p. 75.

64 "FLAT WOODY COUNTRY": Quoted in Jardine (1877), p. xxiv.

64 "ALL THE BIRDS": Quoted in Jardine (1877), p. xxxix.

64 "I REMEMBER PERFECTLY": Quoted in Cantwell (1961), p. 122.

65 "I BEGAN A VERY": Quoted in Herrick (1938) I, p. 205.

65 "MY STOCK OF PROVISIONS": Quoted in Jardine (1877), p. lxix.

66 "I CAUTIOUSLY COASTED": Quoted in Jardine (1877), p. lxxviii.

66 "THE MAN WHO BOUGHT IT": Quoted in Jardine (1877), p. lxxviii.

66 "EVERY MAN HERE": Quoted in Jardine (1877), p. lxxix.

66 "RAMBLING ROUND": Quoted in Welker (1955), p. 50.

66 "LONG, RATHER HOOKED": *OB* I, p. 438.

67 A HOT MEAL 36 CENTS: Durant and Harwood (1980), p. 31.

67 "MR. WILSON ASKED ME": *OB* I, p. 439.

67 "EXAMINED MR. [AUDUBON]'S": Quoted in Welker (1955), p. 50.

67 "AND WHEN I ANSWERED": *OB* I, p. 439.

67 "I PRESENTED [WILSON]": *OB* I, p. 439.

68 TUESDAY: Wilson says "the twentieth of March": Welker (1955), p. 51.

68 "THAT THE WHITE BIRDS": *OB* III, pp. 203–4.

68 WILSON'S MISTAKE: Quoted in Welker (1955), p. 51.

68 SANDHILL CRANES: Since Wilson never used the name "sandhill" in his *Ornithology,* the phrase "Saw a number of sandhill cranes," supposedly reprinted from his diary entry for March 21, must be an invention, probably of George Ord's.

68 SAW PASSENGER PIGEONS: Wilson's diary entry for 21 March, quoted in Welker (1955), p. 50.

68 DECEMBER PASSENGER PIGEON JJA DREW: The drawing, No. 109, dated 11 Dec. 1809, is part of the Houghton Library collection.

68 WILSON *SYNOPSIS*: JJA mentions this gift at *OB* III, p. 303, mistakenly and meaningfully calling it "*Synopsis of the Birds of America.*"

68 "OPEN A CORRESPONDENCE": *OB* I, p. 439.

68 "I MUST *TRUDGE*": JJA to Charles Bonaparte (hereafter CB), BMNHN, 29 May 1828.

68 "RETIRED HABITS": *OB* I, p. 439.

68 "LEFT MY BAGGAGE": Quoted in Jardine (1877), p. lxxix.

69 "MARCH 23": Quoted in Welker (1955), p. 50.

69 "TO HAVE SAID": Quoted from "Louisville in Kentucky" autograph manuscript in Sotheby's catalogue "The Library of H. Bradley Martin," 1989, Lot 14.

69 "LOUISVILLE DID NOT": LoA, p. 786.

69 WB SELLING MILL GROVE: WB to Audubon & Rozier, 10 April 1810, received 5 May, in Her-

rick (1938) I, pp. 199–200. Herrick misconstrues this sale to be of Fatland Ford land, but the acreage is clearly that of the unsold Mill Grove parcel.

69 LUCY'S CLAIM OF DOWER: WB to Audubon & Rozier, ibid., p. 200.

69 "THE COUNTRY AROUND": *OB* III, p. 122.

70 HENDERSON, THE BARRENS, ETC.: See Aron (1996), pp. 59ff; pp. 150ff.

70 "FEW AS THE HOUSES": *OB* III, p. 122.

70 "OUR GUNS AND": LoA, p. 786.

70 "THE WOODS WERE AMPLY": *OB* III, p. 122.

70 ONE VAST CANEBRAKE: The phrase is Herrick's, at (1938) I, p. 237.

71 BISON GRAZING CANE IN DANIEL BOONE'S DAY: Boone, quoted in Coleman (1955), p. 18.

71 "IF YOU PICTURE": *OB* I, pp. 458–59.

71 TROTLINES AND CATFISH: "Fishing in the Ohio," *OB* III, pp. 122–27.

71 FROGS: JJA says "toads," but catfish do not eat toads more than once. Bill Steiner, personal communication, May 2003.

72 STOPPED USING FRENCH: Partridge (1992), p. 178.

72 "AN EXCESSIVELY SHY BIRD": *OB* III, p. 27.

73 "THE BROAD EXTENT": *OB* I, p. 341.

73 "WHEN TAKEN BY THE HAND": *OB* I, p. 346.

73 PELICANS: "American White Pelican," *OB* IV, pp. 88–102.

74 SANDHILL CRANES: *OB* III, p. 204.

75 LONG POND: Henderson Lot 57 map, Audubon Museum, Henderson, KY.

75 "SPOKE ENGLISH BUT BADLY": LoA, p. 31.

76 THIRTEEN CHILDREN: Keating (1976), p. 40.

76 FLATBOAT: LoA, p. 787.

Six BY FLATBOAT TO STE. GENEVIEVE

77 "THE OHIO RIVER WIDENS": Ford (1969), p. 44.

77 "HAD FROZEN ALL": Audubon (1869), p. 35.

77 FRENCH-CANADIAN TRAPPERS: *OB* IV, p. 538.

77 "FRENCH ARTIST": Ford (1969), p. 44.

78 "COVERED WITH HEAVY": Audubon (1942), p. 152.

78 "NEITHER HUNTER NOR": Ford (1969), p. 45.

78 "WHILE I WAS STRAINING": Audubon (1869), pp. 36–37.

79 "SHE HAD CUT": Audubon (1869), p. 38.

79 "A TALL, ROBUST": Audubon (1869), p. 38.

80 "BECAUSE A BEAR": Audubon (1869), pp. 38–39.

80 "THEY MADE UP": Audubon (1869), p. 39.

80 "A STOUT SWARTHY MAN": Ford (1969), p. 46.

80 "STATED THAT HE WAS": Audubon (1869), p. 39.

81 "AND AT DAYLIGHT": Audubon (1869), p. 40.

81 "AS UNCONCERNED AS IF": Audubon (1869), p. 40.

81 "THE WATERS WERE UNUSUALLY": *OB* III, p. 408.

81 "HUGE FIRE": *OB* III, p. 409.

81 "A FLAME THAT WOULD ROAST": Audubon (1942), p. 160.

82 "THE SORROWS OF": Audubon (1869), p. 40.

82 "A NEW FIELD": Audubon (1869), p. 40.

82 "GRADUALLY ACCUMULATED": Audubon (1869), p. 41.

82 "WELL-FORMED": Audubon (1869), p. 41.

82 THE OSAGES: See Mathews (1961).

82 "BEING A NEW RACE": Audubon (1869), p. 41.

83 "THEY WERE DELIGHTED": Audubon (1869), p. 41.

83 "THE SURROUNDING TREES": Ford (1969), p. 48.

83 "COOKING UTENSILS": *OB* III, p. 409.

83 "INVESTIGATING THE HABITS": Audubon (1869), p. 41.

83 "CHASED WOLVES": Ford (1969), p. 47.

83 "AFTER USING THE BREAST": Audubon (1869), p. 42.

83 "MANY *SHOE-TRACKS*": Audubon (1942), p. 161.

83 "FINDING THAT WE HAD": Audubon (1869), p. 42.

83 "PUMPKIN": Ford (1969), p. 48.

83 "THAT NIGHT I WROTE": Audubon (1869), p. 43.

84 "TO PRESERVE THEM": Audubon (1942), p. 164.

84 "THE INDIANS MADE BASKETS": Audubon (1869), p. 43.

84 "THE WATERS HAD KEPT": *OB* III, pp. 409–10.

85 "PARTED LIKE BRETHREN": Ford (1969), p. 49.

85 "BOB RULY": Flint (1932), p. 94.

85 JJA'S DESCRIPTION OF LOUIS LORIMIER: Ford (1969), p. 49; Audubon (1942), p. 166ff.

85 "NOT EXCEEDING FOUR FEET": Audubon (1942), p. 167.

85 ANOTHER OBSERVER: See Durant and Harwood (1980), p. 61.

85 "THE UPPER PART": Ford (1969), p. 49.

85 BOONE AND HIS SALTMAKERS: Faragher (1992), pp. 154ff.

86 "A NOBLE AND MASSIVE": Flint (1932), p. 93.

86 "CURRENT RUSHES": Audubon (1942), p. 168.

86 "AN OLD FRENCH TOWN": Ford (1969), p. 50.

86 MUD-WALLED HOUSES: Flint (1932), p. 97.

86 "THE FRENCHMAN WHO": Audubon (1869), p. 45 (emphasis added). Henry Brackenridge confirms the presence of Charbonneau and a wife in the area a month later; see Brackenridge (1966, 1814), p. 202.

86 "A CONSIDERABLE DEGREE": Flint (1932), p. 97.

86 "SMALL AND DIRTY": Ford (1969), p. 50.

86 "I FOUND AT ONCE": LoA, p. 787.

86 "FOUND PLENTY OF FRENCH": LoA, p. 787.

87 QUITCLAIM: Reproduced at Herrick (II), p. 359.

87 "THE WEATHER WAS FINE": *OB* I, p. 81.

87 "[AS] SOON AS I": Audubon and Coues (1897), pp. 44–45.

87 BUFFALO SKULLS: Audubon (1942), p. 170.

87 "A MOUND COVERED": Audubon and Coues (1897), p. 45.

87 "GAVE EACH OF": Audubon (1942), p. 172.

87 "MANY SMALL CROSSROADS": Audubon and Coues (1897), p. 45.

87 SHAWNEETOWN SALT WORKS: See Durant and Harwood (1980), p. 78.

88 "WITH MY WIFE": Audubon and Coues (1897), p. 46.

88 GREAT COMET: See http://comets.amsmeteors.org.

88 CARBONATED WARBLER: *OB* I, p. 308.

88 FLYCATCHER AND PEWEE: Nos. 200, 201, Houghton Library.

88 BANK SWALLOW, PAROQUET: Nos. 202, 207, Houghton Library.

88 "FLOWERS WITHOUT NUMBER": *OB* II, pp. 490–91.

88 HOT SUMMER: Merrill (1976), p. 129.

88 SQUIRRELS AND OTHER ODDITIES: See Merrill (1976), pp. 248–49.

89 AUDUBONS IN LOUISVILLE SINCE MIDSUMMER: LBA to EG, Princeton, 5 Jan. 1812.

89 "WE DETERMINED": LBA to EG, Princeton, 5 Jan. 1812.

Seven BIRDS IN FLIGHT

90 "THE FRENCH QUALITIES": Quoted in Delatte (1982), pp. 63–64.

90 "ALMOST ALL": LoA, p. 788.

90 *AUDUBON & BAKEWELL*: See Nolte (1854), p. 178. I omit "(Pork, Lard, and Flour)," which is probably conjectural on Nolte's part; e.g., such perishables would not have been shipped from Liverpool.

91 DUNNING NOTICE: JJA to FR, 2 Nov. 1811, in Herrick (1938) I, p. 243.

91 "WE WERE ON HORSEBACK": LBA to EG, Princeton, 5 Jan. 1812.

92 "REALLY MOST DREADFUL": LBA to EG, Princeton, 5 Jan. 1812.

93 "VERY MUCH GROWN": LBA to EG, Princeton, 5 Jan. 1812.

93 WILSON ELICITED TESTIMONY: Wilson (1878), p. xci.

93 JJA'S AND AW'S BALD EAGLES: For comparison, see *BoA,* Plate 31; *American Ornithology,* v. 4, Plate 8; and Peale's original mounting at the Harvard Museum of Comparative Zoology, reproduced in Sellers (1980), p. 89.

93 DRAWN FROM PEALE: Partridge also notices this connection; see Partridge (1992), pp. 288–89.

93 "REMBRANDT'S PICTURE GALLERY": Sellers (1980), pp. 221–22.

94 "FEELING, AS I WAS": *OB* I, p. 440.

94 "I AM VERY MUCH": Quoted in Delatte (1982), p. 67.

94 AUDUBON'S HORSE BARRO: See "A Wild Horse," *OB* III, pp. 270ff.

94 "NOT VERY COURTEOUSLY": *OB* III, p. 273.

94 "BENEFICIALLY AFFECTED": Nolte (1854), p. 176.

95 "AT A SMALL INN": Nolte (1854), p. 177.

95 "NOW I AM GOING": Nolte (1854), p. 178.

96 "A GREAT DEAL": Nolte (1854), pp. 178–79.

96 RICHTER SCALE OF QUAKES: Penick (1981), p. 141.

97 1,874 SHOCKS: Penick (1981), p. 6.

97 15 FELT IN WASHINGTON: Penick (1981), p. viii.

97 "WE HAVE HAD": BB to EG, Princeton, 22 Dec. 1811.

97 *NEW ORLEANS*: See Penick (1981), pp. 76–82.

97 DETAILS OF NEW MADRID EARTHQUAKES: See Penick (1981), passim.

98 "WE HAD TO FLEE": Mitchill (1814), p. 5.

98 "THE HOUSES OF BRICK": Quoted in Penick (1981), p. 15.

98 "AS IF WALKING": *OB* I, p. 239.

98 "SHOCK SUCCEEDED SHOCK": *OB* I, p. 240.

99 METHODIST INCREASE: Penick (1981), p. 117.

99 "BAPTISTS ARE ALL": Quoted in Aron (1996), p. 186.

99 "THE INDIANS WERE": Quoted in Penick (1981), pp. 120–21.

99 "IT WAS SAID THAT": Nolte (1854), pp. 181–83.

100 ROZIER OWED $1,000: Ford (1964), p. 86.

100 "WE WERE IN": *OB* I, pp. 240–41.

101 SWAMP SPARROW, LBA ATTRIBUTION: *BoA,* Plate 64; Blaugrund and Stebbins (1993), p. 310.

101 "WHILST IN PURSUIT": *OB* I, p. 381.

101 WHITE-THROATED SPARROW: No. 26, Houghton Library.

101 SONG SPARROW: Low (2002), p. 43.

102 WHIPPOORWILL: No. 11, Houghton Library.

102 NIGHTHAWK: No. 10, Houghton Library.

102 TWO BIRDS IN FLIGHT: A point Stebbins makes in Blaugrund and Stebbins (1993), p. 10.

102 "MARVELS OF AN": Stebbins, in Blaugrund and Stebbins (1993), p. 10.

102 "THE MALE WAS": *OB* I, pp. 428–29.

102 "MUCH TO THE ANNOYANCE": Quoted in Arthur (2000), pp. 80–81.

103 "THE WOODS WERE ALL": *OB* I, p. 461.

103 "A HIGH TREE": Quoted in Arthur (2000), p. 81.

103 "I PUT THE BIRD": *OB* I, pp. 461–62.

104 "TORN FROM THEIR COUNTRY": War Message of President James Madison, 1 June 1812.

104 "IF THE ENGLISH": Quoted in Remini (1977) I, p. 167.

105 "I HAVE NO DOUBT": JJA to FR, 10 Aug. 1812, in Herrick (1938) I, pp. 243–44.

105 "LARGE, COMMODIOUS": *OB* I, pp. 29–30.

105 WORKING ON AN OTTER: LoA, p. 788.

106 "DEFEATED IN THE BRILLIANT": Quoted in Delatte (1982), pp. 70–71.

Eight FLOCKING TO KENTUCKY

107 "MY PECUNIARY MEANS": LoA, p. 788.

107 MILL STREET: Second Street today.

107 HENDERSON CONDITIONS: See Delatte (1982), pp. 73–74.

107 "EXTREMELY SCARCE": JJA to FR, 10 Aug. 1812, in Herrick (1938) I, p. 244.

107 "TOOK TO HORSE": LoA, pp. 788–89.

108 LOG BUILDINGS, FINNS: See Jordan and Kaups (1989), passim.

109 "THE PLEASURES WHICH": LoA, p. 789.

109 "MILLIONS OF VARIEGATED": Audubon (1942), p. 171.

109 HONEYBEES: See Evans (1997), p. 50.

109 BUFFALO GNATS: Bill Steiner, personal communication, April 2003.

109 "I HAD RIDDEN": Audubon (1942), p. 171.

110 WILSON'S DEATH: See Cantwell (1961), pp. 254ff.

110 "I THINK THAT A GREAT": Quoted in Cantwell (1961), p. 257.

110 "THE SMALLER SCALE": Quoted in Delatte (1982), p. 71.

111 PASSENGER PIGEONS: See Schorger (1955), passim.

111 "STEERED BY A LONG": *OB* I, p. 320.

111 "I DISMOUNTED": *OB* I, pp. 320–21.

112 "IMMENSE LEGIONS": *OB* I, pp. 321–22.

112 WILSON TWO BILLION, "PROBABLY FAR BELOW": Quoted in Schorger (1955), p. 201.

112 A MODERN EXPERT: Schorger (1955), p. 205.

112 "THE PEOPLE WERE ALL": *OB* I, p. 321.

113 CARTIER, 1534: Schorger (1955), p. 3.

113 "WEARIED WITH KILLING": *OB* I, p. 325.

113 "A SPACE ON THE FACE": Quoted in Schorger (1955), p. 61.

113 HARDLY WORTH THE PRICE: As Will Bakewell comments: see Arthur (2000), p. 80.

113 SHAWNEETOWN PROFITS: Delatte (1982), p. 75.

113 "I AM MUCH CONCERNED": BB to EG, Stark Museum, Jan. 1814.

114 "APPEARS TO HAVE": Quoted in Delatte (1982), pp. 84–85.

114 HENDERSON STORIES: Herrick (1938) I, pp. 253ff; Merritt Alves paper, Audubon Museum, 23 July 1923.

114 VIOLIN, FLUTE, FLAGEOLET, GUITAR: All these instruments and the piano appear in the "Indenture selling Henderson House and Property" dated 13 July 1819 on file in the Audubon Museum, Henderson, KY.

114 ENCOUNTER WITH BROADSWORD MASTER: According to Will Bakewell, quoted in Arthur (2000), pp. 81–82.

114 "RIVER PIRATE": Merritt Alves paper, Audubon Museum, 23 July 1923.

115 "A MAN OF SCRUPULOUS": Ibid.

115 SLAVES WORTH $10,500: Arthur (2000), p. 78.

115 LAND ACROSS THE STREET: Herrick (1938) I, p. 252.

116 SLAVERY: See Hunt (1914), p. 39ff.

116 AUDUBON'S FOCUS ON BUSINESS: Partridge makes this important point: Partridge (1992), p. 145.

116 "TO PUT ASIDE": LoA, pp. 754–55.

116 "PLACED THEM CAREFULLY": *OB* I, pp. xiii–xiv.

116 "SUNK IN QUICKSAND": *OB* I, p. 315.

117 "BUT WHENEVER I WENT": *OB* III, p. 56.

117 "I TOOK IT HOME": *OB* II, pp. 249–50.

117 "WHERE IT USUALLY": *OB* II, p. 250.

118 "IT BECAME SO TAME": *OB* I, p. 14.

119 "WHAT DO YOU THINK": Quoted in Delatte (1982), p. 88.

119 "BE ASSURED": Quoted in Ford (1964), p. 90.

119 "BUT BEING IN": Quoted in Delatte (1982), p. 87.

119 "INCLUDING CASTINGS": Quoted in Ford (1964), pp. 90–91.

119 $15,000 INVESTMENT: Keating (1976), p. 62.

119 "EVER SINCE HE KNEW": Quoted in Delatte (1982), p. 85.

120 "I HAVE HAD AN INFLAMMATION": WB to EG, Stark Museum, 28 Nov. 1814.

120 WILL BAKEWELL'S ARRIVAL: His father in his 28 Nov. 1814 Stark Museum letter to EG says "Thomas & William are there also" as of 5 Nov.

120 "PREPARE MYSELF": Quoted in Delatte (1982), p. 88.

120 PRENTICE'S STEAMBOAT: Frank Boyett, personal communication, Sept. 2003.

121 CREEK WAR: See Remini (1977) I, p. 178ff.

121 "THE TRACES OF DEVASTATION": Bachman (1888), p. 27.

122 "DROPSY OF THE HEAD": Ann Bakewell to EG, Stark Museum, 28 Jan. 1819.

122 "THIS PLACE SAW": Quoted in Arthur (2000), p. 121.

Nine THE BAD ESTABLISHMENT

123 "THE PUBLIC EXHILARATION": *New York Evening Post,* 13 Feb. 1815.

123 "WE HAVE ENTERED": *National Advocate,* 17 Feb. 1815.

123 ECONOMIC STATISTICS: See Rothbard (2002), pp. 1–4.

123 EMBARGO: Enacted 6 July 1812.

124 AUDUBON HOUSEHOLD GOODS: See "Indenture Selling Henderson House and Property," 13 July 1819, Audubon Museum, Henderson, KY.

125 "THE WHOLE OF": Quoted in Rothbard (2002), p. 11, n. 47.

125 STEAM FLOUR MILLS: Hunter (1949), p. 124.

126 "ANOTHER FRENCHMAN": Sarah Atterbury to EG, Stark Museum, 3 May 1816.

126 MILL SITE LEASE: Henderson Deed Book C, p. 277. Frank Boyett, a Henderson resident and journalist, checked the original record for me in the Henderson County Clerk's Office. Frank Boyett, personal communication, Oct. 03.

126 "THOMAS PEARS": LoA, p. 789.

126 JULY 27, 1816: Delatte (1982), p. 90.

126 MILL CONSTRUCTION: See Herrick (1938) I, pp. 254ff; Merritt Alves narrative, 23 July 1923, Audubon Museum, Henderson, KY.

126 AUDUBON BUILT STEAMBOATS: Merritt Alves narrative, 23 July 1923, Audubon Museum, Henderson, KY.

126 AUDUBON ADVERTISEMENT: Quoted in Durant and Harwood (1980), p. 82.

127 $771 LAND SALE: See deed of sale dated 31 Dec. 1816, Yale, box 10, f. 543.

127 PRENTICE LOT, $275: See ibid.

127 "[HENDERSON] NEVER HAVING": Quoted in Delatte (1982), pp. 90–91.

127 "TO HAVE THE BEST . . . ," PITTSBURGH STEAM MILL: Ford (1964), p. 93.

127 "IT WAS THE FIRST": Merritt Alves narrative, 23 July 1923, Audubon Museum, Henderson, KY.

127 "AT AN ENORMOUS EXPENSE": LoA, p. 789.

127 "MR. PRENTICE HAS": Quoted in Delatte (1982), p. 92.

128 "[THE WILD PIGEONS' CURIOUS ROOSTING-PLACE]": *OB* I, pp. 323–24.

130 "FILLED FOUR LARGE BAGS": Quoted in Arthur (2000), p. 80.

130 SAWMILL IN 1817: See Merritt Alves narrative, 23 July 1923, Audubon Museum, Henderson, KY.

130 "WAS GULLED": LoA, p. 790.

130 BRANCH STORES: Audubon (1868), pp. 56–57.

130 "WE WOULD JUST BE SMALL PEOPLE": JA to JJA, Yale, 24 Sept. 1817.

130 "THE COUNTRY YOU LIVE IN": Ibid.

131 JEAN RABIN: Ibid.

131 TOM, WILL, PRENTICE DEPART HENDERSON: Ford (1964), p. 93.

131 ANN AND SARAH BAKEWELL TO HENDERSON: Rebecca Bakewell to EG with Ann Bakewell addendum, Stark Museum, 14 Jan. 1819.

131 "ALAS! . . . THE POOR": LoA, p. 793.

131 "THE LOSS OF MY DARLING": Quoted in Arthur (2000), p. 121.

131 "BAD ESTABLISHMENT": LoA, p. 791.

131 FEDERAL LAND GRANT: See Ford (1964), pp. 96–97.

132 "HARD-FISTED YANKEES": Quoted in Arthur (2000), p. 79.
132 "WHEN THE YOUNG": *OB* IV, pp. 562–63.
132 GALL SOLD THE LAND: Ford (1964), p. 97.
132 ECONOMICS OF 1819 PANIC: See Rothbard (2002), Chapter I.
132 TWELVE TRACTS SOLD: Delatte (1982), p. 93.
133 "ILLEGITIMATES": Quoted in Ford (1964), p. 97.
133 AUDUBON ON RAFINESQUE: See "The Eccentric Naturalist," *OB* I, pp. 455ff.
135 "THIS MAY BE RECKONED": Quoted in Herrick (1938) I, p. 293.
136 "THE HAPPIEST PART": Rebecca Bakewell to EG with Ann Bakewell addendum, Stark Museum, 14 Jan. 1819.
136 1817, 1820 STEAMBOATS: Hunter (1949), Table 1, p. 33.
136 "CONVINC[ING] THE DESPAIRING": M'Murtrie in 1819, quoted in Hunter (1949), p. 17.
136 "ACT MOST POWERFULLY": Quoted in Hunter (1949), p. 28.
136 "FACILITATING RAPID COMMUNICATIONS": Quoted in Hunter (1949), p. 28.
137 "AN ATLANTIC CITIZEN": Quoted from the *Western Monthly Review* (Cincinnati, 1827), in Hunter (1949), p. 29.

Ten "HOPES ARE SHY BIRDS"

138 "THE PURCHASING OF": Quoted in Arthur (2000), p. 121.
138 "FULLY PERSUADED": LoA, p. 790.
138 "A *REVOLUTION*": Quoted in Arthur (2000), p. 121.
138 "AMERICA'S FIRST GREAT": Rothbard (2002), p. ii.
138 "ONE THING SEEMS": Quoted in Rothbard (2002), p. 15.
138 "HOW I LABORED": LoA, p. 790.
139 EAGLES' NEST: LoA, p. 26.
139 "THAT SPECTACLE SO COMMON": Flint (1932), p. 244.
140 "PRIOR CLAIMANTS": Quoted in Arthur (2000), p. 86.
140 "ON MY ARRIVAL": LoA, pp. 790–91.
140 "OTHERS . . . WERE HASTENING": LoA, p. 791.
141 "WITH HIS WHITE HAIR": Quoted in Arthur (2000), pp. 87–88.
141 "MR. AUDUBON": Quoted in Herrick (1938) I, p. 259. See also LoA, p. 791.
141 "I HAD HEAVY BILLS": LoA, p. 791.
141 *LOUISVILLE PUBLIC ADVERTISER*: The advertisement, quoted in Durant and Harwood (1980), p. 82, appeared on 10 April 1819.
141 "CURRENT MONEY": "Indenture Selling Henderson House and Property," 13 July 1819, Audubon Museum, Henderson, KY. For Berthoud payments, see Delatte (1982), p. 98, citing the original deeds.
141 "DID ALL THE GRINDING": Merritt Alves narrative, 23 July 1923, Audubon Museum, Henderson, KY.
141 NB TOOK OVER VINCENNES TRACT: Ford (1964), p. 106, citing Henderson Records Office.
142 INDENTURE: 13 July 1819, Audubon Museum, Henderson, KY.
142 "PARTED WITH EVERY": LoA, p. 791.
142 "SADDEST OF ALL": Quoted in Audubon and Coues (1897) I, p. 47.
142 "*SHE FELT THE PANGS*": LoA, p. 791.
142 NEW BANKRUPTCY LAW: Keating (1976), p. 82.

142 "I TOOK THE BENEFIT": JJA to John Bachman. 5 Apr. 1834, quoted in Herrick (1938) I, p. 260n.

142 "ON ACCOUNT OF": LoA, p. 791.

143 "GAVE ME A SPIRIT": Quoted in Arthur (2000), p. 121.

143 "AFTER OUR DISMAL REMOVAL": LoA, p. 794.

143 DRAWING FEATURES: See Partridge (1992), pp. 39ff.

144 "BY HER AFFECTIONATE": Quoted in Partridge (1992), p. 42.

144 "NOTHING WAS LEFT": LoA, p. 792.

144 "WITH ITS PURSED": Partridge (1992), p. 67.

144 "A PARTICULARLY GOOD": Quoted in Arthur (2000), p. 121. Several of JJA's biographers believe the JB portrait was posthumous. Had he drawn JB posthumously, JJA would have said so, as he did of other instances; see LoA, p. 792.

145 "TO BE A GOOD": LoA, p. 792.

145 "A CLERGYMAN": LoA, p. 792.

145 "IN THIS PARTICULAR": LoA, p. 792.

145 "DURING MY DEEPEST": LoA, p. 794.

145 "DREW BIRDS FAR BETTER": LoA, p. 792.

145 "HAVING A TOLERABLY": LoA, p. 32.

145 SIGNING HIS DRAWINGS: Partridge (1992), p. 47.

146 "DEAR SIR—YOU WILL": Quoted in Durant and Harwood (1980), p. 111. Italics added. Delatte (1982) locates this letter in the Lytle Papers, Cincinnati Historical Society.

146 TWO HUNDRED HOUSES: Delatte (1982), p. 104.

146 "A LARGE STEAM GRIST": Quoted in Delatte (1982), p. 104.

147 "HOW I HAVE DWELT": LoA, p. 32.

147 "OUR LIVING HERE": Audubon and Coues (1897) I, p. 49.

147 "FOWLS, DOMESTIC": Flint (1932), pp. 40–41.

147 "AN ENGLISHMAN": LoA, p. 793.

147 AUDUBON'S VERBS: LoA, p. 793.

147 CONTENTS OF COLLECTION: Adams (1966), pp. 189–90.

148 "MR. BEST AND I": LoA, p. 793.

148 "RETURNED TO MY": LoA, p. 792.

148 MISS DEEDS ADVERTISEMENT: Reproduced in Durant and Harwood (1980), p. 115.

148 "VERY GOOD NATURED": Anna Blake to Harriet Corlis, Corlis-Respess Family Papers, Filson Historical Society, Louisville, KY, 21 Dec. 1819.

148 "TO WHICH I ATTENDED": LoA, p. 793.

148 "WAS USUALLY THE SCENE": Quoted in "Biographical Sketch of Daniel Drake, M. D.," in Drake (1948), p. xix.

148 "THE STYLE & EXECUTION": Quoted in New-York Historical Society (1966), p. xix.

148 LONG EXPEDITION: See Evans (1997), pp. 3–31.

149 "IF THEY LOST": Quoted in Evans (1997), p. 24.

149 "THE PRESENT POPULATION": Quoted in Evans (1997), p. 31.

149 "WELL DO I RECOLLECT": LoA, p. 793.

149 TO "GIVE . . . TO THE INDIANS": Quoted in Evans (1997), p. 26.

150 "ANNIVERSARY DISCOURSE": Shapiro and Miller (1970), p. 131ff.

150 "IT WOULD BE AN ACT": Shapiro and Miller (1970), p. 135.

150 "AS A PROOF": Ibid.

151 "AFTER HAVING SPENT": Quoted in Adams (1966), pp. 195–96.

151 "OF COMPLETING A": LoA, pp. 42–43.

151 SEVEN OR EIGHT MONTHS: LoA, p. 32.

152 "DRAWN FROM NATURE": LBA to EG, Stark Museum, 1 April 1821.

152 MASON EIGHTEEN YEARS OLD: As Audubon himself noted (LoA, p. 3) and as recent research by Douglas Lewis, Curator of Sculpture and Decorative Arts at the National Gallery of Art, Washington, D.C., confirms. Lewis has located both the census record of Mason's birth and his gravestone. According to Lewis, Stanley Clisby Arthur confused another, thirteen-year-old Joseph Mason he found in the Cincinnati census records, with Audubon's actual assistant to set in motion the long misconception of Joseph Mason's age. Douglas Lewis, personal communication, May 2003.

152 "OF GOOD FAMILY": LoA, p. 3.

152 $1,200, $400: Audubon and Coues (1897), p. 49, n. 1.

152 "MY TWO CHILDREN": LBA to EG, Stark Museum, 1 April 1821.

152 "THE VARIOUS LOSSES": LBA to EG, Stark Museum, 1 April 1821.

153 "THREE DOORS NORTH": Quoted in Durant and Harwood (1980), p. 121.

153 DATE AND TIME OF JJA'S DEPARTURE: LoA, p. 3.

153 "HOPES ARE SHY": LoA, p. 44.

153 "READY TO EXERT": LoA, p. 3.

Eleven DOWN THE MISSISSIPPI

157 "WITHOUT ANY MONEY": LoA, p. 3.

157 LOVELACE: LoA, p. 66.

157 "IN BEAUTIFUL PLUMAGE": LoA, p. 3.

157 "A HANDSOME MALE": LoA, p. 4.

157 "THE SECOND TIME": LoA, pp. 4–5.

158 "FORTUNATELY ANOTHER": LoA, pp. 5–7.

158 "4 RAVENS": LoA, pp. 6–7.

159 "ANXIOUS TO KNOW": LoA, p. 7.

159 "EXTREMELY TIRED": LoA, pp. 8–9.

159 "SCARCELY CONCEIVE": LoA, p. 9.

160 "THE INDIAN SUMMER": LoA, p. 9.

160 "FOR THE WANT": LoA, p. 10.

160 "HOW SWEET THIS MAY BE": LoA, pp. 11–12.

160 LOVELACE: JJA has "Loveless." LoA, p. 11.

160 "NOW I ENTER [THE MISSISSIPPI]": LoA, p. 21.

161 "THE MEETING OF THE": LoA, p. 21.

161 "THE MOST RETIRED": Flint (1932), p. 91.

161 ATALA: Chateaubriand (1952/1801).

162 "THE MAGNIFICENT WILDS": Chateaubriand (1952), p. 21.

162 "DOWN AVENUES OF TREES": Chateaubriand (1952), p. 19.

162 "GREEN SERPENTS": Chateaubriand (1952), p. 18.

162 "WHAT SORROW": Chateaubriand (1952), p. 85.

162 "IVORY-BILLED WOODPECKERS": LoA, p. 23.

163 "AND OFTEN HAVE BEEN": LoA, p. 22.

163 "WANTED SOFTNESS": LoA, p. 763.

163 "ONE DAY AFTER HAVING": LoA, p. 763.

163 DÜRER: See Kemp (2002).

163 "ALMOST DESERTED": LoA, pp. 23–24.

164 "SHOT A BEAUTIFUL": LoA, pp. 27–28.

164 "I THOUGHT IT WAS ALTERED": LoA, p. 28.

164 "WAS AN EXTRAORDINARILY": LoA, p. 30.

164 "IT WAS IMPOSSIBLE": LoA, p. 33.

164 "LIKE A TORRENT": LoA, p. 36.

165 "LOOKED FAT": LoA, p. 39.

165 "THE NOBLE FELLOW": LoA, p. 41.

165 "THE EAGLE HISSED": LoA, p. 41.

165 "NEVER BE UNDER": LoA, p. 20.

165 "IF THERE IS": LoA, p. 44.

165 "FULL AND RUN[NING]": LoA, p. 45.

166 "THAT HE HAD FOR SEVERAL": LoA, pp. 46–48.

166 "CONSTANT CRY": LoA, p. 51.

166 "SPANISH BEARD": LoA, p. 53.

167 "MUCH LIKE MAY": LoA, p. 58.

167 "A BEAUTIFUL STREAM": LoA, p. 57.

167 "FLYING CONSTANTLY LOW": LoA, pp. 58–60.

167 "THESE CIRCUMSTANCES": OB III, p. 540.

167 "AVENUES OF REGULARLY": LoA, p. 60.

167 COTTON-PICKING SEASON: Bruchey (1967), p. 174.

168 "HAVING NOT USED": LoA, pp. 62–63.

168 "A FRENCH GENTLEMAN": LoA, p. 63.

168 DICKERSON: LoA, p. 67.

169 "BUT NO HOPES": LoA, p. 64.

169 "THIS DAY 21 YEARS": LoA, pp. 64–65.

169 "MANY FLATBOATS": LoA, p. 65.

169 "THE PLANTATIONS INCREASE": LoA, pp. 65–71.

171 "THESE IMMENSE SUGAR": LoA, p. 72.

171 "AT NEW ORLEANS": LoA, p. 72.

Twelve THE FAIR INCOGNITO

172 "DASHING DOWN": LoA, p. 73.

172 "SHIPS OF MANY NATIONS": OB III, p. 566.

172 "FRENCH GAYETY": LoA, p. 73.

173 HALLES: Arthur (2000), p. 156.

173 "WE FOUND VAST": LoA, pp. 73–74.

173 BARRED OWLS IN GUMBO: OB I, p. 243.

174 "SPIRITS VERY LOW": LoA, p. 74.

174 JOHN WESLEY JARVIS: See Dunlap (1969) II.1, pp. 72ff.

174 "SPENT 3000 DOLLARS": Quoted in Dunlap (1969) II.1, p. 81.

174 "DO YOU PAINT": OB I, p. 413.

174 "OPPOSITE THE MARKET": LoA, p. 75.

175 "VERY ROUGHLY": LoA, p. 75.

175 MASON WOULD REVEAL: Arthur (2000), p. 152.

175 "AUDUBON WAS POOR": LoA, p. 76.

175 "I ROSE EARLY": LoA, p. 76.

176 "BUT I HAVE": LoA, pp. 76–77.

176 "VERY SIMPLY TOLD": LoA, p. 77.

176 "CROWDED BY PEOPLE": LoA, p. 77.

177 "SAW SOME WHITE": LoA, pp. 77–78.

177 "CUTTING [THE] MATTER": LoA, pp. 78–79.

178 "I WAS ASSURED": LoA, p. 80.

178 BROWN PELICAN TECHNIQUE: Blaugrund and Stebbins (1993), pp. 13, 83.

178 "COLLECTED MY EARNINGS": LoA, p. 79.

178 "NOT DESCRIBED": LoA, p. 81.

179 "A FEMALE OF A FINE FORM": the text of the Fair Incognito episode is given in its entirety at LoA, pp. 886ff.

179 26 RUE AMOUR: According to Arthur (2000), p. 159.

181 "I MET THIS MORNING": LoA, p. 82.

182 BERNARD DE MARIGNY: See Garvey and Widmer (1982), p. 80; Durant and Harwood (1980), p. 272; Partridge (1992), pp. 80–81.

182 TWO AUDUBON INVESTIGATORS: See Durant and Harwood (1980), pp. 271ff.

183 "BETWEEN TWO SHOPS": LoA, p. 83.

183 "WE CANNOT BE": JJA to LBA, APS, 24 May–1 June 1821.

183 "ALL SURPRISED": LoA, p. 86.

183 "SUFFER[ED] THE WANT": JJA to LBA, APS, 24 May–1 June 1821.

183 "FOUND IT AN": LoA, p. 85.

184 "TO HAVE IT FORWARDED": LoA, p. 87.

184 "TOOK A WALK": LoA, p. 87.

184 "FORTY-EIGHT THOUSAND": *OB* III, p. 625.

184 "THE MOST DIFFICULT": LoA, p. 92.

184 "SO LONG WISHED-FOR": LoA, p. 89.

185 "JOIN[ING] IN SUCH": LoA, p. 90.

185 "FULL OF MY PLANS": LoA, p. 90.

185 "FEELING A GREAT WEIGHT": LoA, p. 91.

Thirteen LESSONS TO A YOUNG LADY

186 JOHN VANDERLYN: See Dunlap (1969) II 1, pp. 31–42.

186 "WHEN I ARRIVED": LoA, pp. 93–94. JJA's expletive is indicated in Arthur's unexpurgated transcription of this journal entry at Arthur (2000), p. 176.

187 "SAW A GREAT DEFECT": LoA, p. 94.

187 "APPEAR[ING] TO BE DONE": LoA, p. 95.

187 "ASKED ME THE PRICE": LoA, p. 94.

188 "AMIABLE": LoA, p. 98, p. 100.

188 "WHEN I CAREFULLY": *OB* III, p. 567.

188 "HIS NECK WAS": *OB* I, p. 410.

189 "AZURE, CARMINE": *OB* I, p. 280.

189 "HIS DEPARTURE": LBA to EG, Princeton, 1 April 1821.

189 "BEST WISHES": Ibid.

189 "THE THICKEST WOODS": LoA, p. 95.

189 "LOW IN FUNDS": LoA, p. 97.

190 "ALL RELIGIOUSLY INCLINED": LoA, p. 97.

190 LETTER FROM VICTOR: LoA, p. 98.

190 "A BEAUTIFUL": LoA, p. 97.

190 BOSSIER: LoA, p. 98.

190 "SADLY DISAPPOINTED": LoA, p. 99.

190 THREE NEW PUPILS: LoA, p. 101.

190 "NOT VERY AGREEABLE": LoA, p. 100.

191 "A MAN OF STRONG": LoA, p. 101.

191 JJA MID-MAY TO JUNE 1 LETTER: JJA to LBA, APS, 24 May–1 June 1821 (APS 90).

194 "AND, I DOUBT": Quoted in Ford (1964), p. 123.

195 "*THINE FOREVER*": End of APS #90 extracts.

195 OAKLEY'S 3,100 ACRES: According to Audubon State Historic Site tour guide. Malone (1989), p. 62, gives 1,000 acres plus 700 arpents = 1,700 acres.

195 "AFTER THE ONE": LoA, p. 103.

195 "HOW AGREEABLE": LoA, p. 102.

196 "THE RUDEST OF": LoA, p. 102.

196 "I WISHED MYSELF": LoA, p. 104.

196 "THE ASPECT OF": LoA, p. 104.

196 "*WE WERE*": LoA, p. 104.

Fourteen BAYOU SARAH

197 OAKLEY SUMMER RESIDENTS: Arthur (2000), p. 201.

197 1784: Bruchey (1967), p. 45.

197 180 MILLION: Bruchey (1967), Table 3A.

197 "MUCH AIDED": Bruchey (1967), p. 71.

198 U.S. 1821 EXPORTS: Bruchey (1967), Table 3L.

198 BRITISH EXPORTS: Chapman (1972), p. 52.

198 "WITH CORN BOILED": LoA, pp. 104–11.

199 RED IBISES: *OB* V, p. 62.

199 "THE GREAT MANY ERRORS": LoA, p. 126.

199 "THE SECOND ONE SHOT": Combining text from LoA, p. 113, and *OB* V, p. 12.

200 "CONFINED IN MY HAT": Combining text from LoA, pp. 113–14 and *OB* V, p. 13.

200 "AND WAS GLAD": LoA, p. 114.

200 "GENERALLY ON WING": *OB* I, p. 369.

201 PAINTING TECHNIQUE: Blaugrund and Stebbins (1993), pp. 13–14.

201 "WHEN WE LEFT": LoA, pp. 117–20.

201 "HAD THE PLEASURE": *OB* I, p. 27.

201 LETTERS FROM LUCY: LoA, p. 112.

202 "OF DRAWING, MUSIC": LoA, p. 124.

202 "RAISED TO OPULENCE": LoA, p. 125.

202 "A DYING NEIGHBOR'S": LoA, p. 115.

202 "GIVING WAY FOR WANT": LoA, p. 125.

202 "EXTREMELY WEAK": LoA, p. 125.

202 "A GOOD LITTLE WOMAN": LoA, pp. 125–26.

203 "MUCH FEAR": LoA, p. 126.

203 OCTOBER 5: JJA in his journal says October 10, but see the facsimile of his October 5 jour-
 nal entry in Arthur (2000), p. 206. I take his figure of $204 from LoA, p. 127, however, the
 employment total calculated in the October 5 journal entry. This correction also allows
 James Pirrie time to sober up before apologizing for his wife, explains why the Pirrie
 women became so hostile during the time when JJA stayed on as a guest (because of the
 money dispute) and locates the source of the money JJA sent to Lucy—a note endorsed by
 James Pirrie.

203 "MRS. P. IN A": LoA, p. 127.

203 "WAS THEN LABORING": LoA, p. 127.

203 "BEGGED OF": LoA, p. 126,

204 "AND AFTERWARD": LoA, p. 127.

204 $100 TO LUCY: LoA, p. 124.

204 "A FULL SUIT": LoA, p. 127.

204 RUFFIN'S CLOTHES: Ruffin was a full-grown young man, Douglas Lewis points out; his
 clothes would have been much too large for a thirteen-year-old. Personal communication,
 May 2003.

204 "LARGE, LOOSE": LoA, p. 129.

205 "DRESSED ALL NEW": LoA, pp. 130–31.

205 "I HAVE FINISHED": LoA, p. 130.

205 "THE BRIGHTEST GENIUS": LoA, p. 140.

205 "NOT REPRESENTED": LoA, p. 138.

207 "MY BIRDS": LoA, p. 137.

207 "A LETTER FROM": LoA, pp. 131–32.

207 "THE DEATH OF MY": LoA, p. 133.

207 "ROSE BOUFFARD AND": Quoted in Ford (1964), p. 131.

207 "MUCH HARASSED": LoA, p. 136.

207 "MY WIFE [HAD]": LoA, p. 137.

207 "THE PURPORT": LoA, p. 138.

207 "IT WAS ACCEPTED": LoA, pp. 138–39.

207 "EXPECT HER": LoA, p. 141.

207 "SO ANXIOUS AM": LoA, p. 145.

208 "MY WIFE &": LoA, pp. 146–47.

208 "FOUND THEM NOT": LoA, p. 147.

208 "I AM TO DRAW": LoA, p. 148.

208 "IT IS ELEVEN": LoA, p. 148.

Fifteen A NEW START

209 "EVERY MOMENT I HAD": Audubon and Coues (1897) I, p. 51.

209 "DURING JANUARY": Audubon and Coues (1897) I, p. 51.

209 "STRENUOUSLY": Audubon and Coues (1897) I, p. 51.

209 HERMIT THRUSH, CHESTNUT-SIDED WARBLER: Low (2002), pp. 62–63.

209 "HE LITERALLY": Blaugrund and Stebbins (1993), p. 12.

210 "ONE FOR THE SMALL": Blaugrund and Stebbins (1993), pp. 12–13.

211 "I HAVE FEW": Audubon and Coues (1897) I, p. 51.

211 MATABON: Audubon and Coues (1897) I, pp. 51–52.

211 "I FIND GREAT": Quoted in Arthur (2000), p. 247.

211 "GRIEV[ING] TO LEAVE": Quoted in Arthur (2000), p. 247.

212 "HUNTING, DRAWING": Audubon (1868), p. 91.

212 "THE MANY EGGS": *OB* I, pp. 404–5.

212 "OPENING THEIR PRODIGIOUS": *OB* I, p. 276.

212 BENJAMIN WAILES, ORIOLE NEST: Lewis (1990), p. 70.

212 WAILES PORTRAITS: Arthur (2000), opposite p. 225.

212 "ACTUALLY INSIST[ING]": Audubon (1868), p. 91.

213 "WHILE WORK FLOWED": Audubon (1868), pp. 91–92.

213 "WE EXPERIENCED GREAT PAIN": Audubon (1868), p. 92.

213 "MY DRAWING WAS HIGHLY": Audubon (1868), p. 92.

213 "WITH GREAT PLEASURE": Audubon (1868), p. 92.

213 118 SOUTH UNION STREET: Lewis (1990), p. 72.

213 "WHEN THE GOOD OLD": Ford (1967), p. 81.

213 "OPEN A SCHOOL": Quoted in Streshinsky (1993), p. 143. Lewis (1990), p. 72, dates these advertisements to October 1822, however.

214 NATCHEZ PANORAMA: Audubon (1868), p. 93.

214 "EXAMINED MY DRAWINGS": Audubon (1868), p. 93.

214 JOHN STEEN, THOMAS COLE: Lewis (1990), p. 73.

214 "HE GAVE ME": Audubon and Coues (1897) I, p. 52.

214 "TO GO TO EUROPE": Audubon (1868), p. 93.

214 BEECH WOODS, JANE PERCY: Arthur (2000), pp. 258–59; Lewis (1990), p. 73.

214 JANE PERCY'S FOUR: Jane, Margaret, Sarah, Christine. Arthur (2000), pp. 258–59.

214 "MESSRS": Lewis (1990), p. 74.

215 "I REGRETTED DEEPLY": Audubon and Coues (1897) I, pp. 52–53.

215 "I HAD FINALLY": Audubon (1868), pp. 93–94.

215 "HE PROPOSES GOING": Ford (1967), p. 377.

215 "TEACH THE YOUNG LADIES": Audubon (1868), p. 94.

216 BEING TAUGHT TO SWIM: Arthur (2000), p. 261.

216 "AND GREATLY": Audubon (1868), p. 94.

216 "FOUND THEIR": Audubon (1868), p. 94.

216 "THE CITRON HUE": LoA, p. 77.

217 "15 MILES": Quoted in Arthur (2000), p. 263.

217 "BUT DID NOT": Audubon (1868), p. 94.

217 "OBTAIN EMPLOYMENT": Audubon (1868), p. 94.

217 TAKING LESSONS: Audubon and Coues (1897) I, p. 55.

217 FIND SUPPORT: Audubon (1868), p. 101.

218 "THE VERY SIGHT": This and other passages below from "A Tough Walk for a Youth," *OB* III, pp. 371ff.

218 PAINTING IN SHIPPINGPORT: Audubon and Coues (1897) I, p. 54.

219 "BUSY AT WORK": Quoted in Arthur (2000), p. 267.

219 "I AROSE THIS MORNING": Audubon and Coues (1897) I, p. 54.

219 SULLY PAINTING JEFFERSON: Dunlap (1834) I, p. 135.

219 "FOR COPIOUSNESS": Quoted in Audubon (1868), p. 105.

219 AUDUBON TOLD SULLY: Dunlap (1834) II.2, p. 405.

220 "A MAN AFTER": Audubon (1868), p. 100.

220 CHARLES-LUCIEN BONAPARTE: See Stroud (2000).

220 TWO ITALIAN PRINCIPALITIES: Stroud (2000), pp. 9–10.

221 A DAVID AT POINT BREEZE: Stroud (2000), p. 37.

221 "PRONOUNCED MY BIRDS": Audubon (1868), p. 101.

221 ORD KNOWN FOR RUDENESS: According to Malvina Lawson, quoted in Stroud (2000), p. 63.

221 "NO HEART FOR FRIENDSHIP": Richard Harlan to JJA, APS, 27 Jan. 1832.

221 "FROM WANT OF": Audubon (1868), p. 101.

221 PEALE IMITATING AUDUBON: According to Charles Bonaparte (hereafter CB), quoted in Stroud (2000), p. 66.

222 BONAPARTE JOINING FORCES WITH AUDUBON: Quoted in Stroud (2000), p. 106.

222 "HE LOOKED LIKE": Quoted in Stroud (2000), p. 56.

222 "THIS GENTLEMAN'S FIGURE": Audubon (1868), p. 101.

222 "ONE MORNING": Dunlap (1834) II.2, pp. 403–4. I omit Lawson's story about the owl JJA supposedly copied from Wilson; Audubon would not have sat by in silence in the face of such an accusation, which Lawson made later.

222 "A WELL-KNOWN QUAKER": Dunlap (1834) II.2, p. 403.

223 "I SHOULD HAVE BEEN": Quoted in Stroud (2000), p. 106.

223 "LAWSON CONSENTED": Dunlap (1834) II.2, p. 404.

224 "WORKED INCESSANTLY": Audubon (1868), p. 102.

224 "I FOUND THE CITIZENS": Audubon (1868), p. 102.

224 MASON AT BARTRAM'S GARDEN: Ford (1964), p. 146.

224 "PREFERRED THE STYLE": Audubon (1868), p. 102.

224 FRENCH CONSUL; MCMURTRIE, "WHOSE STUDY OF SHELLS": Audubon (1868), p. 102.

224 "ANXIOUS TO CARRY": Audubon (1868), p. 103.

225 "HE WOULD TAKE": Audubon and Coues (1897) I, p. 57.

225 "MR. AUDUBON, ACCEPT": Audubon (1868), p. 103.

225 HARRIS DRAWINGS: Now at Houghton Library, Harvard University.

225 "THIS IS THE SECOND": Audubon (1868), p. 104.

225 "REUBEN HAINES": Audubon (1868), p. 104.

226 "IN GOOD HEALTH": Audubon (1868), pp. 105–6.

Sixteen ENTHUSIAST OR LUNATIC

227 PHILADELPHIA-NEW YORK STAGE: Hunt (1914), p. 49.

227 "BEAUTIFUL STREETS": Audubon (1868), p. 106.

227 STROLLING NEAR THE BATTERY: JJA to CB, BMNHN, 12 Jan. 1825.

227 "MY FIGURE": Audubon (1868), p. 107.

227 PENCILED A NOTE: Reproduced in Herrick (1938) I, p. 337.

227 "ELEGANT": Quoted in Herrick (1938) I, p. 336.

227 "AWKWARD": Audubon (1868), p. 107.

227 "AMONG SUCH PEOPLE": Audubon (1868), p. 107.

228 "IF ANOTHER WILSON": Quoted in Partridge (1992), p. 14.

228 "IN A FEW DAYS": Audubon (1868), p. 107.

229 "OBTAIN[ING] SOME NEW": Audubon (1868), p. 107.

229 "THINKING OF FRANKLIN": Audubon (1868), p. 109.

229 "ABOUT TWO HUNDRED": Audubon (1868), p. 109.

229 "TO REPINE": Quoted in Herrick (1938) I, p. 341.

230 "THE BEST FRIEND": *OB* I, p. 184.

230 "MORE POLITELY RECEIVED": Audubon (1868), p. 113.

230 "SCOURING THE COUNTRY": Audubon (1868), p. 113.

230 "DELIGHTED WITH": Quoted in Herrick (1938) I, p. 344.

230 "TO LEAVE NOTHING": *OB* I, p. xi.

230 "IN PITTSBURGH": Quoted in Ford (1952), p. 15. Serious and probably fatal doubts have been raised about the authenticity of the supposed Audubon butterfly sketchbook that is the subject of this early Ford publication. Bill Steiner, personal communication, June 2003.

230 PASSENGER PIGEON PAINTING: *BoA*, Plate 62.

231 "AFTER SUFFERING MUCH": Audubon (1868), p. 113.

231 "WITHOUT MONEY OR": Audubon (1868), p. 114.

231 "HASTENED TO SHIPPINGPORT": Audubon (1868), p. 114.

231 "A BLACK MAN": Audubon (1868), p. 116.

232 "A CLASS OF SIXTY": Combining text from Audubon (1868), pp. 116–17, and Arthur (2000), p. 293.

232 "WHEN I WOULD MAKE": Quoted in Arthur (2000), p. 292.

233 PROFILE SILHOUETTES: See Delatte (1982), pp. 150–51.

233 "AUDUBON WAS ONE": Quoted in Arthur (2000), pp. 298–99.

233 "I MEAN TO GET": Quoted in Arthur (2000), pp. 299, 301.

234 "A GLASS OF WEAK": Quoted in Arthur (2000), p. 302.

234 INITIAL BONAPARTE CORRESPONDENCE: JJA to CB, BMNHN, 12 Jan. 1825.

234 "IF SUCH A PERSON": JJA to CB, BMNHN, 14 April 1825.

234 POINT BREEZE DETAILS: Stroud (2000), pp. 36ff.

234 BAKEWELL LATE MAY LETTERS: BB to EG, Stark Museum, 13 and 20 May 1825.

235 "I HAVE . . . NOW": JJA to CB, BMNHN, 1 Oct. 1825.

235 "BUT THE WEATHER": Ibid.

235 "TO ABSENT MYSELF": JJA to CB, BMNHN, 16 May 1826.

235 "THE SKIN OF": JJA to CB, BMNHN, 19 Oct. 1825.

236 "TWICE EACH WEEK": Ford (1967), p. 261.

236 "READER, [HERE ARE]": *OB* II, p. 11.

236 "THE BLUE JAY IS": *OB* II, p. 14.

237 "REMINISCENCES OF": Henry David Thoreau, "Natural History of Massachusetts," *The Dial* III(1), July 1842.

237 "WEIGHED TWENTY-EIGHT": Quoted in Arthur (2000), p. 300.

237 WILD TURKEY COCK WEIGHTS: Schorger (1966), pp. 84ff.

237 "MAINTAINED THAT": Quoted in Arthur (2000), p. 300.

237 "VISITED MANY VESSELS": Ford (1967), p. 3.

237 "I SAW MY OLD": Ford (1967), p. 4.

238 JOHNSON LETTER: Ford (1967), p. 378.

238 "OBVIATING THE NECESSITY": Ford (1967), p. 4.

238 NOLTE HELPING THE RATHBONES: Ford (1964), p. 160.

238 "COLLECTION OF": Ford (1967), p. 379.

238 BABY ALLIGATOR: Ford (1964), p. 160.

238 £340: According to JJA in a 26 Dec. 1827 letter from Liverpool. Corning (1930), p. 54.

238 LUCY'S £112: LBA to VGA, Yale, 19 Jan. 1829, converting $500.

238 924 BALES: Arthur (2000), p. 313.

239 THE LAST OF THE MOHICANS PUBLISHED IN LONDON: Waples (1938), p. 64.

Interlude AUDUBON AT SEA

240 "THERE WAS NOT": *OB* III, p. 491.

240 "GLANCING LIKE": *OB* III, p. 491.

240 "A FEW MILES SOUTH": Ford (1967), pp. 10–11.

241 "FROM NEW ORLEANS": Ford (1967), p. 11.

242 "THE LAND BIRDS": Ford (1967), p. 16.

242 "THE DAY PASSED": Ford (1967), p. 19.

242 "MY LEAVING": Ford (1967), pp. 18–19.

243 "VIOLENT HEADACHES": Ford (1967), p. 22.

244 "THE MATE'S CABIN": Ford (1967), p. 31.

244 "A WHALE!": Ford (1967), p. 31.

244 "THAT PROBABLY GREW": Ford (1967), p. 24.

244 "REALLY DULL": Ford (1967), pp. 34–35.

244 "THE IMMENSE OCEAN": Ford (1967), pp. 37–38.

245 "WITH SCARCE A PATCH": Ford (1967), p. 42.

245 "FIFTY-SIX VESSELS": Ford (1967), p. 43.

Seventeen LIVERPOOL

249 "AGREEABLE . . . SO OPPRESSIVE": Ford (1967), p. 45.

249 "I WAS COLDLY": Ford (1967), p. 45.

249 "I KNEW NOT": *OB* I, p. xiv.

250 "NO BETTER WATCH": Ford (1967), p. 326.

250 "WELL FED": Ford (1967), p. 46.

250 "IF I FEEL": Ford (1967), p. 47.

251 "BUSTLED ABOUT": Ford (1967), pp. 51–52.

251 "I COULD SEE": Ford (1967), p. 54.

251 EXTENDED RATHBONE FAMILY: Ford (1967), p. 46, n. 1, and p. 123, n. 61.

251 "AS GOOD AND": Ford (1967), p. 326.

252 "THE COUNTRY": Ford (1967), p. 55.

252 "A SWEET": Ford (1967), p. 136.

252 "BUT SO MUCH": Ford (1967), p. 55.

252 "SIMPLE INTELLIGENT": Ford (1967), p. 125.

252 "AH LUCY": Ford (1967), p. 56.

252 "MY HEART SWELLED": Ford (1967), pp. 57–58.

253 "THE MAN . . . WAS NOT": Quoted in Herrick (1938) II, p. 200.

253 "TALL, WITH A GOOD": Ford (1967), p. 58.

253 "HE WAS ADVANCED": Irving (1983), p. 752.

254 "THE COMPANY IS ALL": Ford (1967), p. 59.

254 "LITTLE CAR": Ford (1967), pp. 61–62.

254 "MR. AMBRO": Ford (1967), p. 62.

255 "KISSED THY SISTER": Ford (1967), p. 67.

255 "RECOMMENDED MY HAIR": Ford (1967), p. 72.

255 "HE HAS WRITTEN": Ford (1967), p. 70.

256 "A LARGE, HIGH": Ford (1967), p. 69.

256 "I HAVE NOT BEEN": Ford (1967), p. 69.

256 "NOT SOIL MY": Ford (1967), p. 60.

256 "THERE ARE MANY": Ford (1967), p. 63.

256 "MOST MEN HAVE FAULTS": LoA, p. 29.

256 "AND THE LADIES": Ford (1967), p. 73.

256 "A MERE SHOWMAN": Ford (1967), p. 75.

257 "PERSONS OF WEALTH": Ford (1967), p. 235.

257 "I WAS BROKE": Ford (1967), p. 77.

257 "DARK EYES SPARKLING": Ford (1967), pp. 77–78.

257 "TWO LITTLE WELSH": Ford (1967), p. 80.

257 KNOWSLEY ESTATE: *Knowsley Hall: A Guide Book for Visitors* (1955), p. 16.

257 "HERE HE COMES": Ford (1967), p. 83.

257 "HE, LUCY": Ford (1967), p. 325.

258 "I NEVER HAD": Ford (1967), p. 91.

258 ROSCOE MADE IT HONORABLE: Ford (1967), p. 94.

258 £100: Ford (1967), p. 332.

259 "IT IS NOW": Ford (1967), p. 324.

259 "MY IDEAS FLEW": Ford (1967), p. 100.

259 "SHAMEFUL BASHFULNESS": Ford (1967), p. 101.

259 "ENGLAND IS NOW": Ford (1967), p. 108.

260 "GREATEST WISH": Quoted in Bland (1977), p. 11.

260 HANNAH MARY MARRIAGE IN 1831: Ford (1967), p. 46, n. 1.

260 "I HAVE NOT HAD": JJA to LBA, Yale, 6 Sept. 1826.

260 "IF I WAS NOT": Ford (1967), pp. 324–25, 327.

260 "THAT I AM": Corning (1930), p. 3.

261 "AS YOU MAY WISH": Ford (1967), p. 330.

262 "PROCEED SLOWLY": Ford (1967), pp. 329–30.

262 "I WILL KEEP MYSELF": Corning (1930), p. 5.

263 MRS. RICHARD RATHBONE AND *OTTER*: Dr. Clemency Fisher, personal communication, Liverpool Museum, March 2003.

Eighteen "I WILL PUBLISH THIS"

264 "SMALL, DIRTY": Ford (1967), pp. 139, 141.

264 AFTER 1820: Chapman (1972), p. 18.

264 SAMUEL BROOKES'S SUGGESTION: Ford (1967), p. 158.

264 "CONCLUDED . . . TO HAVE": Ford (1967), p. 161.

264 "VERY WIDE": Ford (1967), pp. 173, 175.

265 "I WAS INTRODUCED": Ford (1967), p. 175.

265 "TO PROCEED AT ONCE": Ford (1967), pp. 175–76.

266 "LARGE PUBLIC INSTITUTIONS": Ford (1967), p. 176.

266 "I WILL FOLLOW": Ford (1967), pp. 176–77.

266 "AFTER EXAMINING": Ford (1967), p. 200.

266 BOHN OFFERED PUBLICATION: Ford (1967), p. 366.

267 "I AM A LITTLE GIRL": Bakewell Papers, Stark Museum.

267 HE WROTE LUCY: Ford (1967), p. 337.

267 "I HAVE SOME HOPES": Ford (1967), p. 355.

267 SLIPS OF OILED SILK: Ford (1967), p. 361.

268 "MUCH POORER": Ford (1967), p. 226.

268 "THE CHAT BEGUN": Ford (1967), p. 227.

268 "JUDGE OF MY DISMAY": Ford (1967), p. 228.

268 "MY POOR *CHEVELURES*": Ford (1967), p. 365.

268 "FOR THE FIRST TIME": Ford (1967), pp. 230–31.

269 "I THOUGHT SO MUCH": Ford (1967), p. 231.

269 "THE MOST BEAUTIFUL": Ford (1967), p. 232.

269 "WAS NOW QUITE": Ford (1967), p. 233.

269 DARWIN FISH HEADS: King-Hele (1999), p. 18.

270 "I WALKED A GOOD DEAL": Ford (1967), p. 234.

270 "IS BUILT MOSTLY": Ford (1967), p. 235.

270 "WITH PLEASURE": Ford (1967), pp. 234–35.

270 "AT FIRST THE GENTLEMAN": Ford (1967), p. 237.

271 "AND MARCHED DIRECT": Ford (1967), p. 243.

271 LIZARS: See portrait at Jackson (1985), p. 33.

271 SELBY AND JARDINE: See Jackson (1985), pp. 201ff, 214ff.

271 "HE TALKED OF NOTHING": Ford (1967), p. 244.

272 "HE WILL ANNOUNCE": Ford (1967), p. 245.

272 "MY JOHNNY": Ford (1967), p. 246.

272 "HE ACCOSTED ME": Ford (1967), pp. 245–48.

272 "ALL WERE, HE SAID": Ford (1967), pp. 249–50.

272 "LET ME SEE": Ford (1967), p. 250.

273 "COME OUT IN NUMBERS": Ford (1967), p. 346.

273 "MANY LOCALITIES": Ford (1967), p. 369.

274 "THE GREAT ROUND": Ford (1967), p. 349; LoA, pp. 800–801.

274 "IT WAS SETTLED": Ford (1967), p. 255.

274 ROYAL INSTITUTION EXHIBITION INCOME: Ford (1967), pp. 258, 346.

274 "I WAS NO LONGER": Ford (1967), p. 255.

274 MID-JANUARY 1827: Ford (1967), p. 346.

274 "ALTHOUGH WOODS": Ford (1967), p. 259.

274 "I AM QUITE DISPIRITED": Ford (1967), p. 254.

275 "I HAD THOUGHT A THOUSAND": Ford (1967), p. 261.

276 "ON ROASTED": Ford (1967), p. 261.

276 "A SUMPTUOUS DINNER": Ford (1967), p. 267.

276 "A STRANGE-LOOKING FIGURE": Ford (1967), p. 375.

276 "THAT SIR WALTER": Ford (1967), p. 264.

276 "I CANNOT SAY": Ford (1967), p. 266.

276 "LOOKED PRETTY": Ford (1967), p. 279.

277 "MIGHT BEAR AGAINST": Ford (1967), p. 272.

277 "NO MAN IN EITHER": Ford (1967), p. 272.

277 "WE COULD HEAR": JJA to LBA, Yale, 6 Sept. 1826.

278 "IT IS NOW ABOUT TIME": Ford (1967), p, 348.

278 "TO TRAVEL FOR ME": Ford (1967), pp. 347–48.

278 "I ASSURE THEE": Ford (1967), p. 350.

279 "HOW I READ": Ford (1967), pp. 282–83.

279 "SOME TIME": Ford (1967), p. 352.

279 "SHOULD MR. AUDUBON": LBA to EG, Stark Museum, 29 Nov. 1826.

279 "THE NEWSPAPERS": Ford (1967), p. 356.

279 "A MAGIC POWER": Quoted in Herrick (1938) I, pp. 359–60.

280 "NEITHER THIS LITTLE": Ford (1967), p. 285.

Nineteen INTO THE MONSTER'S MOUTH

281 £173.10.6: Ford (1967), p. 305.

281 "IT WAS LIKE": Ford (1967), p. 298.

281 "GREAT MAXIM": Quoted in Jackson (1985), p. 206.

282 "WEAKER THAN": Ford (1967), p. 309.

282 "IT IS MR. AUDUBON": Quoted in Herrick (1938) I, p. 362.

282 "THE ALMOST LIQUID": Audubon and Coues (1897), p. 205.

283 "PUT ON YOUR COAT": Audubon and Coues (1897), p. 206.

284 "JAN. 22, 1827": Quoted in Audubon and Coues (1897), p. 206, n. 1.

284 "OF THE FIRST ORDER": Quoted in Herrick (1938) I, p. 367.

284 "THE INDIANS, HE SAYS": Quoted in Herrick (1938) I, p. 368.

284 "AGREEABLE AND VALUABLE": Audubon and Coues (1897), p. 208.

284 "DELIGHT": Audubon and Coues (1897), p. 209.

285 FIFTY COPIES OF FIRST NUMBER: JJA to LBA, Filson Collection, 19 Jan. 1827.

285 FEBRUARY 5: Audubon and Coues (1897), p. 209. Audubon (1868), p. 135, has Feb. 3.

285 "THE ASTONISHMENT": Audubon and Coues (1897), p. 209.

285 JJA TO LBA, 12 MARCH 1827: Herrick (1938) I, p. 370ff.

285 ELECTED TO ROYAL SOCIETY: Herrick (1938) I, p. 370.

286 *PROSPECTUS*: Text given at Audubon (1868), pp. 146–47.

286 £140: JJA gives £115 as Havell's charge per hundred sets of each number and says Lizars charged £25 more: Corning (1930) I, p. 30.

286 "AS AN ARTIST": Corning (1930) I, p. 18.

287 "AS THE BARBER": Audubon and Coues (1897) I, p. 221; see facsimile of page opposite.

287 "RAN ABOUT LIKE": Audubon and Coues (1897) I, p. 226.

287 "FULL OF LIFE": Audubon and Coues (1897) I, pp. 232–33.

287 "NOW AND THEN": *OB* III, p. 302.

287 "AND [DURING] THESE": Corning (1930) I, p. 22.

288 LBA 15 MAR. 1827 LETTER: Cited in Ford (1964), p. 210.

288 LBA TO VGA LETTER: VGA to JJA, Yale, 17 April 1827.

288 JJA TO LBA, 15 MAY 1827: LoA, pp. 803–6.

289 JJA TO LBA, 16 MAY 1827: Corning (1930) I, pp. 22–29.

290 ". . . POST-BOY": Audubon and Coues (1897) I, p. 253.

290 "AFTER WANDERING": *OB* II, p. ix.

291 CHILDREN AND LETTERS: *OB* II, p. ix.

291 "THE MOST DISAGREEABLE": Audubon and Coues (1897) I, p. 253.

291 "THE OVERGROWN": JJA to LBA, H. Bradley Martin Collection, 28 May 1827, in Sotheby's (1990).

291 "LIKE THE MOUTH": Audubon and Coues (1897) I, p. 251.

291 "GROPING IN FILTH": *OB* II, p. viii.

291 "THREE POOR FELLOWS": Audubon and Coues (1897) I, p. 254.

291 "AND THUS ATTIRED": Audubon and Coues (1897) I, pp. 253–54.

291 "INTENTION OF PUBLISHING": Basil Hall to John Murray, 23 Feb. 1827, in Herrick (1938) I, pp. 378–79.

292 "INFORMING ME THAT": Audubon and Coues (1897) I, pp. 255–56.

292 BONAPARTE AND DIVING BELL: Stroud (2000), p. 87.

292 ONE COLORER WHO HAD NOT EATEN: Audubon (1868), p. 157.

292 "WENT FIVE TIMES": Audubon and Coues (1897) I, p. 257.

292 W. H. LIZARS TO JJA: Box 12, f. 580, Yale, 16 June 1827.

293 JJA TO HAVELL'S SHOP ON JUNE 21: Audubon (1868), p. 158.

293 "BECAME INTENSELY INTERESTED": Williams (1916), pp. 234–36.

293 SEVEN *OTTERS*: Herrick (1938) I, p. 398.

293 "IT SO GREATLY": Williams (1916), p. 236.

294 "[AUDUBON] LOOKED AT": Williams (1916), p. 240.

294 "I HAVE MADE ARRANGEMENTS": LoA, p. 807.

294 JUNE 20 LETTER: JJA to LBA, Princeton, 20 June 1827.

295 WROTE LUCY IN AUGUST: LoA, p. 807ff.

296 TWO HUNDRED . . . DOLLARS: JJA to LBA, APS, 25 Aug. 1827.

Twenty "I HAVE WISHED FOR THEE EVERY DAY"

297 CHARLES BONAPARTE ARRIVAL: Stroud (2000), p. 90.

297 "A PACK OF LIES": Audubon and Coues (1898) I, p. 271.

297 "HAD I WISHED": Quoted in Herrick (1938) II, p. 85.

297 "THE SUPERFLUITY": JJA to VGA, 25 Aug. 1827, Corning (1930) I, p. 35.

297 "FEW WILL PATRONIZE": Quoted in Stroud (2000), p. 101.

298 OSAGES: Mathews (1961), pp. 539ff.

299 "THE MOMENT THAT I": JJA to LBA, APS, 25 Aug. 1827.

299 "I ATTENDED TO": Audubon and Coues (1898) I, p. 259.

299 "MISERABLY POOR": Audubon and Coues (1898) I, p. 260.

299 "SO GREATLY SUPERIOR": JJA to LBA, APS, 20 Sept. 1827.

299 "ADMIRED THEM MUCH": Audubon and Coues (1898) I, p. 265.

299 MORE CONCENTRATED COLOR WASHES: Bill Steiner makes this point in Steiner (2003).

299 AQUATINT: See Prideaux (1909), especially Chapter I.

300 "I THINK HE REGRETS": Audubon and Coues (1898) I, p. 265.

301 HE DOUBTED LIZARS'S ABILITY: Corning (1930) I, p. 44.

301 "IF [LIZARS] CAN FALL": Audubon and Coues (1898) I, p. 265.

301 "A DOUBLE ADVANTAGE": Corning (1930) I, p. 41.

301 "A CITY OF 150,000": Audubon and Coues (1898) I, p. 267.

301 "THE SCOTCH": Corning (1930) I, p. 45.

301 "BOUND TO BOTANY": Audubon and Coues (1898) I, pp. 268.

301 "I LOOK UPON": ABG to EG, Stark Museum, 4 Jan. 1828.

301 A LONG LATE-NOVEMBER LETTER: JJA to LBA, APS, 25 Nov. 1827, in Corning (1930) I, p. 43ff.

301 "KEPT BY HIS SIDE": Audubon and Coues (1898) I, p. 270.

301 STILL HAD ALL HIS TEETH: Audubon and Coues (1898) I, p. 276.

302 LBA LATE-SEPTEMBER LETTER: Contents inferred from JJA's response: JJA to LBA, APS, 5 Dec. 1827.

303 "THE COLLECTING TIME": JJA to LBA, Princeton, 21 Dec. 1827.

303 "BE PREPARED": JJA to LBA, APS, 11 Dec. 1827.

303 "POOR CHARETTE": Audubon and Coues (1898) I, p. 273.

303 "I AM SURE": JJA to LBA, APS, 26 Dec. 1827, in Corning (1930) I, p. 54.

303 "SPENT THE WHOLE": Audubon and Coues (1898) I, p. 275.

303 "I DO NOT PRESENT": *OB* I, p. xix.

304 "WELL AHEAD": Audubon and Coues (1898) I, p. 276.

304 "WHEN AT LIVERPOOL": JJA to LBA, APS, 6 Feb. 1828, in Corning (1930) I, p. 57ff.

304 "DECIDED TO WRITE": Audubon and Coues (1898) I, p. 276.

304 "WHICH I DREW": Audubon and Coues (1898) I, p. 282.

304 "DEFERRING STILL": JJA to LBA, APS, 10 Feb. 1828.

305 "I DARE NOT YET": JJA to LBA, APS, 26 Feb. 1828, in Corning (1930) I, p. 60.

305 "I SAW WITH PLEASURE": Audubon and Coues (1898) I, p. 290.

305 DARWIN AND AUDUBON: See Weissmann (1998), pp. 9ff.

306 "THE WOODS, THE BIRDS": Audubon and Coues (1898) I, pp. 288–89.

306 "AS IF INDEED": JJA to LBA, 17 Mar. 1828, in Corning (1930) I, p. 62ff.

306 "A BEAUTIFUL PIECE": Audubon and Coues (1898) I, p. 291.

306 "SHRUNK TO ABOUT": Audubon and Coues (1898) I, p. 291.

306 "GO TO SEE": JJA to LBA, 17 Mar. 1828, in Corning (1930) I, p. 62ff.

306 "STILL UNDETERMINED": JJA to LBA, APS, 31 Mar. 1828.

306 "I HAVE MANY IDLE": JJA to CB, BMNHN, 18 and 29 Apr. 1828.

307 "MY SPIRITS HAVE BEEN": Audubon and Coues (1898) I, p. 295.

307 "LONGED TO LOOK": Audubon and Coues (1898) I, pp. 295–96.

307 "TO REPRESENT THE PASSIONS": Quoted in Herrick (1938) II, p. 404.

308 "TO THE WOODS": JJA to William Swainson, Princeton, 1 May 1828.

308 "BUT ONLY TRANSIENTLY": Audubon and Coues (1898) I, pp. 297–98.

308 "BLOOMING WITH HEALTH": Audubon and Coues (1898) I, p. 299.

308 "GUILELESS SIMPLE CHARACTER": Quoted in Stroud (2000), p. 102.

308 "A SUPERIOR": Audubon and Coues (1898) I, p. 299.
309 "WITH THE EXCEPTION": Audubon and Coues (1898) I, pp. 299–300.
309 AUDUBON WROTE LUCY: JJA to LBA, 8 Aug. 1828, in Corning (1930) I, pp. 66ff.
310 LETTER TO VICTOR: LBA to VGA, Yale, 15 June 1828.
311 "I HAVE HAD SAD": JJA to WS, 13 Aug. 1828, in Herrick (1938) I, p. 409.

Twenty-one "I WILL SAIL FOR AMERICA"

312 "THE POOR BIRD": Audubon and Coues (1898) I, pp. 300–1.
312 "COPPER RED": Audubon and Coues (1898) I, pp. 304–5.
312 "SHOCKING DUST": Audubon and Coues (1898) I, pp. 304–5.
313 "CORPULENT, FIVE FEET": Audubon and Coues (1898) I, p. 306.
313 "NOT SO LARGE": Audubon and Coues (1898) I, p. 307.
314 "CUVIER STUCK TO US": Audubon and Coues (1898) I, pp. 309–11.
314 "A TEDIOUS LECTURE": Audubon and Coues (1898) I, p. 312.
314 "THE MAN OF": Audubon and Coues (1898) I, p. 314.
314 "THE PURE ATMOSPHERE": Audubon and Coues (1898) I, p. 315.
315 "BEAU!": Audubon and Coues (1898) I, p. 317.
315 "I HAVE . . . SEEN": Audubon and Coues (1898) I, p. 329.
315 "BROTHER IN THE": Audubon (1868), p. 179.
315 "THE MOST MAGNIFICENT": Audubon (1868), pp. 174–76.
316 "LUCY, MY BLOOD": Maria Audubon Little Black Book journal transcriptions, Audubon Museum, Henderson, KY. MA thought these excerpts concerned her grandfather's royal birth as the Lost Dauphin.
316 "HE TOLD ME": Audubon and Coues (1898) I, p. 333.
316 "I TURNED OVER": Maria Audubon Little Black Book journal transcriptions, Audubon Museum, Henderson, KY.
316 FOURTEEN SUBSCRIPTIONS: JJA to William Swainson, Princeton, 1 Nov. 1828.
316 "PARIS IS A SMALL": Audubon and Coues (1898) I, p. 334.
316 "THE GREAT POVERTY": Audubon and Coues (1898) I, p. 339.
317 "I WROTE THIS DAY": LoA, pp. 811ff.
318 "I AM TRULY": JJA to LBA, APS, 17 Nov. 1828.
318 "HOW GRIEVED I": JJA to VGA, APS, 22 Dec. 1828, in Corning (1930) I, p. 73.
318 "I WOULD BE GLAD": JJA to VGA, APS, 22 Dec. 1828, in Corning (1930) I, p. 73.
319 144 SUBSCRIBERS: JJA to LBA, APS, 23 Dec. 1828.
319 "I HAVE NOT": JJA to LBA, APS, 23 Dec. 1828.
319 "WITH A COMPANY": Audubon (1868), p. 182; Audubon and Coues (1898) I, p. 341.
319 LUCY WROTE VICTOR: LBA to VGA, Yale, 19 Jan. 1829.
320 "EVER SINCE": JJA to LBA, Yale, 20 Jan. 1829, in Corning (1930) I, pp. 77ff.
321 "MUSIC SCHOLARS": LBA to VGA, Yale, 30 Jan. 1829.
321 "HAVE TO GO": JJA to LBA, APS, 23 Dec. 1828.
322 1 FEB. LETTER TO LUCY: JJA to LBA, Yale, 1 Feb. 1829, in Corning (1930) I, pp. 79ff.
322 "YOU SAY YOU MUST": LBA to JJA, Yale, 8 Feb. 1829.
322 "I SHALL BE ENDEAVORING": LBA to JJA, Yale, 20 Feb. 1829.
323 "WHEN I SEE YOU": LBA to JJA, Yale, 22 Mar. 1829.
323 "DRAWN FROM NATURE": Low (2002), p. 68.

Twenty-two A MAN IN A HURRY

324 "SEASICK": Audubon (1868), p. 183.

324 "GAVE FREE ADMISSION": Audubon (1868), p. 184.

324 "IMMENSE BOOK": Corning (1930) I, p. 85;

324 "LOST TO HIMSELF": LoA, p. 817.

324 "I HAVE COME": JJA to LBA, APS, 6 May 1829.

324 MAY 10 LETTER: JJA to LBA, Yale, 10 May 1829, in Corning (1930) I, pp. 81ff.

326 "ONCE MORE THAT": JJA to William Cooper, APS, 5 June 1829.

326 "FISHERMAN GUNNERS": OB III, pp. 606–8.

327 "GRACEFUL AND": OB I, p. 416.

327 "WHEN IT PLUNGES": OB I, pp. 417, 420.

327 "ONCE MORE DO[ING]": JJA to LBA, APS, 18 June 1829.

327 LBA MID-JUNE LETTER: LBA to JJA, Yale, 12 June 1829.

328 "PUT THY HAND": JJA to LBA, APS, 15 July 1829.

328 AUDUBON WROTE VICTOR: JJA to VGA, Yale, 18 July 1829, in Corning (1930) I, pp. 88ff.

330 "WITH NO OTHER": OB I, p. 52, collated with text from autograph manuscript cited in Sotheby's (1990), Lot 2.

331 "THE LONG WALKS": OB I, p. 54.

331 "NO SOONER WAS": OB I, pp. 54–55.

331 "MANY OF BOTH": OB I, p. 56.

332 "IN THE COURSE": OB I, p. 3.

332 "MADE MANY A": OB I, p. 56.

332 "IT IS USELESS": JJA to VGA, Yale, 25 Aug. 1829, in Corning (1930) I, pp. 93–94.

333 AUGUST 28 LETTER: JJA to LBA, APS, 28 Aug. 1829.

333 LUCY WROTE JJA: LBA to JJA, Yale, 29 Aug. 1829.

334 A MONTH LATER: LBA to JJA, Yale, 29 Sept. 1829.

335 OCTOBER 11: LBA to JJA, Yale, 11 Oct. 1829.

336 NEW DRAWINGS, INSECTS, HANNIBAL: Corning (1930) I, p. 99.

336 "THE YELLOW FEVER": Corning (1930) I, p. 100.

336 "A MAN IN A HURRY": Herrick (1938) I, p. 427.

336 "SCARCELY IMPROVED": Herrick (1938) I, p. 428.

336 "ON ENTERING": Audubon (1868), p. 197.

336 "GOOD CONDUCT": LBA to JJA, Yale, 11 Oct. 1829.

336 "ALSO GROWN": Audubon (1868), p. 197.

337 "BY THE BYE": Herrick (1938) I, p. 429.

337 "WHEN I SEE": OB I, pp. 31–32.

337 "A MOST POLISHED": LBA to JJA, Yale, 30 Oct. 1829.

337 "THE FOLIAGE HAD": Herrick (1930) I, p. 428.

338 "IT WAS DARK": Audubon and Coues (1898) I, pp. 62–63.

338 "TOOK PASSAGE": Audubon (1868), p. 203.

338 TWO STATEROOMS: OB I, p. 134.

338 BASIL HALL: JJA to Robert Havell, Jr., Stark Museum, 29 Jan. 1830.

338 OPOSSUMS: OB III, pp. 456–57, which has sixteen opossums shipped, but in a letter dated 29 Jan. 1830 to Robert Havell (Stark Museum), closer to the event, he says fourteen.

338 "I DO NOT REMEMBER": *OB* I, p. 134.

338 "AMUSED MYSELF": Audubon (1868), p. 203.

339 "MISFORTUNE & CIRCUMSTANCE": LBA to Mrs. William Bakewell[?], Cincinnati Museum, 3 March [?] 1830.

339 BEDBUGS, JACKSON SAW NUMBERS: Audubon-Bakewell-Shaffer Family Papers, cited in eBay Live Auctions Item #2169963214.

339 "CONGRESS WAS": Audubon (1868), p. 203.

339 APRIL 2, APRIL 27: Ford (1964), p. 265, has the Audubons arriving on April 2, but on April 27 JJA wrote Havell that they would be landing at Liverpool by two p.m. that day, and their passage according to JJA required twenty-five days: Audubon (1968), p. 203.

Twenty-three WOODS, WOODS, WOODS

340 "I THOUGHT": LBA to EG, Stark Museum, 5 May 1831.

340 "GREAT BENEFIT": ABG to EG, Princeton, 4 Apr. 1831.

340 "DO LET ME URGE": JJA to RH, 7 June 1830, in Corning (1930) I, p. 107.

341 FRANKLIN AND F.R.S.: Weissmann (1998), p. 9.

341 "TOOK MY SEAT": Audubon (1868), p. 204.

341 "THE *CADAVEROUS STARE*": Richard Harlan to JJA, Yale, 19 Aug. 1830.

342 "BELIEVE ME": Quoted in Stroud (2000), pp. 115–16.

342 "WHEN I RETURN": JJA to RH, Harvard, 29 June 1830.

342 "EXTREMELY HURT": RH to JJA, APS, 30 June 1830.

343 "A REVOLUTION OF": JJA to VGA and JWA, 20 Apr. 1836, quoted in Sotheby's (1990), Lot 28.

343 "MY FIRST VOLUME": JJA to William Swainson, 22 Aug. 1830, in Herrick (1938) II, pp. 101–3.

343 "I AM DESIROUS": Ibid.

343 SWAINSON RESPONDED IMMEDIATELY: JJA to WS, "Thursday," in Herrick (1938) II, pp. 103–5.

344 AUDUBON REPLIED: As paraphrased in Swainson's reply: WS to JJA, 2 Oct. 1830, in Herrick (1938) II, pp. 106ff.

344 LUCY WROTE HER SONS: LBA to VGA and JWA, Yale, 30 Aug. 1830.

344 "MRS. A.": JJA to RH, 7 June 1830, in Corning (1930), pp. 106ff.

344 "PARTICULARLY THE LARGE": RH to JJA, Harvard, 10 Sept. 1830.

345 "MUCH PLEASED": JJA to RH, Harvard, 20 Sept. 1830.

345 "NOW BETWEEN YOU": Quoted in Ford (1964), pp. 272–73.

345 "A DREADFUL": JJA to RH, Yale, 20 Oct. 1830.

345 JAMES WILSON: Chalmers (2003), p. 41.

345 "IF HE KNEW": Audubon (1868), p. 205.

345 "HE HAD LONG": Audubon (1868), p. 205.

346 "A GOOD SCHOLAR": JJA to CB, BMNHN, 2 Jan. 1831.

346 "WRITING NOW BECAME": Audubon (1868), pp. 205–6.

346 "TO RENDER IT": JJA to CB, BMNHN, 2 Jan. 1831.

346 "SELF-INFLATED": Hughes (1999), p. 152.

347 "FOR A PERIOD": *OB* I, p. xi.

347 LORD STANLEY: Fisher (2002), pp. 48–49.

347 "SINCE NAPOLEON": Ford (1967), p. 292.

348 "I AM GOING": JJA to CB, BMNHN, 2 Jan. 1831.

348 "IF YOU CAN": JJA to RH, APS, 16 Jan. 1831.

348 "NOT VERY ANXIOUS": JJA to VGA, 21 Feb. 1831, in Corning (1930) I, p. 126.

348 "ALWAYS REMEMBER": LBA to VGA, Yale, 26 Feb. 1831.

348 "ON THAT EXTRAORDINARY": Audubon (1868), pp. 207–8.

349 "THE [AMERICAN] PAPERS": JJA to Joseph Kidd, 7 Sept. 1831, in Herrick (1938) II, p. 2.

349 "ENEMIES": JJA to Mrs. RH, APS, 2 Oct. 1831.

350 "NOTWITHSTANDING VICTOR'S": LBA to JJA, Yale, 12 Oct. 1831.

350 OCT. 7: Herrick (1938) II, p. 5, has "about October 15," but JJA wrote RH on 6 Oct. 1831 from Baltimore that he would "leave this place for the South tomorrow morning," and wrote LBA from Richmond on 9 Oct. 1831.

350 "PROGRESSED DOWN": JJA to LBA, 9 Oct. 1831, in Corning (1930) I, pp. 137ff.

350 "COUNTRY BOUNDED": JJA to LBA, 9 Oct. 1831, in Corning (1930) I, p. 140.

350 "POOR COACHES": Quoted in Herrick (1938) II, p. 9.

351 "WE AT LENGTH": Quoted in Herrick (1938) II, p. 9.

351 $5.25: JJA to LBA, 23 Oct. 1831, in Corning (1930) I, p. 143.

351 GILMAN, "FAIR HARVARD": Shuler (1995), p. 4.

351 "UPON MY BEING": Quoted in Herrick (1938) II, p. 9.

351 "MR. BACHMAN!!": JJA to LBA, 23 Oct. 1831, in Corning (1930) I, p. 143.

352 BACHMAN HISTORY: Many details from Shuler (1995), passim.

352 "TWO FINE YOUNG": JJA to LBA, 23 Oct. 1831, in Corning (1930) I, p. 144.

352 "WE LAUGH": JJA to LBA, 7 Nov. 1831, in Corning (1930) I, p. 147.

352 "HOW GRATIFYING": Quoted in Herrick (1938) II, p. 6.

352 "I JUMPED AT ONCE": Quoted in Herrick (1938) II, p. 10.

353 "SKINNED AND PRESERVED": JJA to LBA, 7 Nov. 1831, in Corning (1930) I, p. 147.

353 "I CERTAINLY HAVE MET": JJA to LBA, 30 Oct. 1831, in Corning (1930) I, p. 145.

353 "ONE OF THE SWEETEST": JJA to LBA, 30 Oct. 1831, in Corning (1930) I, p. 146.

353 "ACCOMPANIED BY SOME FRIENDS": OB III, pp. 241–43.

354 SEA OATS: Bill Steiner generously searched out this identification. Bill Steiner, personal communication, Aug. 2003.

355 "IT WAS SOMEWHAT": Quoted in Herrick (1938) II, p. 11.

355 "I HAVE BEEN IDLE": JJA to LBA, 13 Nov. 1831, in Corning (1930) I, pp. 149–50.

355 "MY MIND WAS": Quoted in Herrick (1938) II, p. 11.

355 "THE WIND WAS FAIR": Quoted in Herrick (1938) II, p. 11.

Twenty-four THE VARIED SPLENDOR OF AMERICAN NATURE

356 ST. SIMONS ISLAND: See Corning (1930) I, p. 152; Herrick (1938) II, pp. 11–12.

356 "WHATEVER IT MAY": Quoted in Herrick (1938) II, p. 12.

356 "SOME OLD FRENCH": Corning (1930) I, p. 152.

356 "THE POOREST HOLE": Corning (1930) I, p. 163.

356 "QUITE SPANISH": OB II, p. 360.

356 "AND PLENTY OF": Quoted in Herrick (1938) II, p. 12.

357 "WE ARE UP": Quoted in Herrick (1938) II, pp. 12–13.

358 "A HAWK OF": JJA to LBA, 23 Nov. 1831, in Corning (1930) I, p. 154.

358 "AN EXOTIC BIRD": JJA to LBA, 29 Nov. 1831, in Corning (1930) I, p. 155.

358 "20 MORE POUNDS": Quoted in Herrick (1938) II, p. 14.

358 "I WORK NOW": JJA to LBA, 29 Nov. 1831, in Corning (1930) I, p. 157.

359 JOHN J. BULOW: See Bulow Plantation Ruins State Historic Site website; Durant and Harwood (1980), pp. 361ff.

359 "A VERY WEALTHY PLANTER": JJA to LBA, 4 Jan. 1832, in Corning (1930) I, p. 169;

359 "ONE OF THE": Quoted in Herrick (1938) II, p. 15.

359 "FAST IN THE MUD": Quoted in Herrick (1938) II, pp. 17ff.

359 "550 SKINS": JJA to LBA, 4 Jan. 1832, in Corning (1930) I, p. 170.

359 "NOT ONE DRAWING": JJA to LBA, 1 Feb. 1832, in Corning (1930) I, p. 179.

359 "I FELT UNQUIET": Quoted in Herrick (1938) II, p. 22.

360 SPRING GARDEN: Ponce de León Spring today.

360 "A CIRCULAR BASIN": OB II, p. 266.

360 "NOTHING CAN BE": OB II, p. 260.

361 "SO TANNED": JJA to LBA, 16 Jan. 1832, in Corning (1930) I, p. 172.

361 WAR SCHOONER: According to JJA in JJA to LBA, 16 Jan. 1832, in Corning (1930) I, p. 173.

361 "AS FAR AS": JJA to LBA, 16 Jan. 1832, in Corning (1930) I, p. 173.

361 "WHAT WILL": JJA to LBA, 16 Jan. 1832, in Corning (1930) I, p. 175.

361 "A DREADFUL ACCIDENT": JJA to LBA, 17 Feb. 1832, in Corning (1930) I, p. 182.

362 "PLATO WAS NOW": OB II, pp. 294–95.

362 "WITH A BEARD": JJA to LBA, 13 March 1832, in Corning (1930) I, p. 184.

362 £300: JJA to LBA, 29 March 1832, in Corning (1930) I, p. 192.

362 "MR. AUDUBON WAS": LBA to RH, APS, 1 April 1832.

362 TWENTY-TWO SUBSCRIBERS: JJA to LBA, 13 March 1832, in Corning (1930) I, p. 185.

362 "TRUST NO ONE": LBA to JJA, Yale, 22 Jan. 1832.

363 "THE DANGER AT": LBA to JJA, Yale, 19 March 1832.

363 "JOHN HAS HAD": LBA to JJA, Yale, 19 March 1832.

363 "DO NOT SUFFER": JJA to LBA, 15 April 1832, in Corning (1932) I, p. 194.

363 "WITH A HEAVY": JJA to LBA and VGA, 29 March 1832, in Corning (1930) I, p. 191.

363 "TO SPEND THE": JB to LBA, Yale, 21 April 1832.

363 MARION DIMENSIONS: Proby (1974), p. 38.

363 "8 GUNS": JJA to LBA, APS, 18 April 1832.

364 "WALKED OFF": OB III, p. 543.

364 "WHERE AT NIGHT": OB III, p. 549. "The cranes [sic: herons] are skinned," Bachman wrote JJA on 11 Nov. 1832; "one is set up in the Museum, and one I have. They became dreadfully dangerous, and long confinement would have ruined their plumage."

364 "FOR THE FIRST TIME": OB V, p. 255.

365 STROBEL: See Proby (1974), pp. 41ff.

365 STROBEL REPORT: Proby (1974), pp. 42–44.

366 "ALL THOSE NOT": OB III, p. 267.

366 "THEY HAD ALREADY": OB III, p. 268.

367 "SLOWLY ADVANCING": OB II, p. 371.

367 "SHOULD THIS PROVE": OB II, p. 376.

367 "I AM UNABLE": OB III, p. 67.

368 "THAT THE ANIMAL": OB III, p. 80.

368 "THE LAND BIRD": OB III, pp. x–xi.

368 "HIS COLLECTION OF": *Courier* report as paraphrased in a London newspaper.

368 LEFT PLATO: Bachman (1888), p. 106.

368 6 DAYS &": JJA to JB, APS, 1 July 1832.

368 LUCY ON JUNE 24: LBA to RH, APS, 24 June 1832.

368 "MY GOOD WIFE": JJA to JB, APS, 1 July 1832.

368 CAMDEN BOARDINGHOUSE: JJA to Edward Harris, Harvard, 9 July 1832. (Joseph Jeanes's transcription is misdated 9 June, when JJA had not yet left Charleston.)

369 ROUGH-LEGGED HAWK: No other reports locate this bird in New Jersey in July. (Bill Steiner, personal communication, Oct. 2003.) Audubon wrote "New Jersey, July, 1832" on the drawing, however. Low (2002), p. 109, writes, "There is no record that Audubon was in New Jersey on this date," but JJA to Edward Harris, cited above, contradicts her.

369 MID-JULY ARRIVAL OF FAMILY: VGA wrote RH from Philadelphia on 21 July 1832; APS.

369 "THAT DREADFUL SCOURGE": *OB* II, pp. xvi–xvii.

369 THEY SAW NB: JJA to RH, APS, 31 July 1832.

369 LUCY'S SISTERS: LBA to EG, Stark Museum, 7 Oct. 1832.

369 "NEW YORK LOOKED": JJA to Richard Harlan, Audubon Museum, Henderson, KY, 5 Aug. 1832.

369 "THE CHOLERA HAS RAGED": RH to JJA, Aug. 1832, in Herrick (1938) II, pp. 28–29.

370 VICTOR TO ENGLAND: VGA to RH, APS, 21 July 1832.

370 "THE ATHENS": *OB* II, p. xvii.

Twenty-five LABRADOR

371 "THE OUTPOURING OF": *OB* II, p. xvii.

371 NINE SUBSCRIPTIONS: JJA to Edward Harris, Harvard, 14 Aug. 1832.

371 COLLECTED OLIVE-SIDED FLYCATCHER: *OB* II, p. 422.

371 "THE EXTREME BOUNDARY": LBA to EG, Stark Museum, 7 Oct. 1832.

371 "BROAD TRANSPARENT WATERS": *OB* II, pp. 461–62.

372 VICTOR SAILED ON 16 OCT.: JJA to EH, Harvard, 1 Nov. 1832.

372 LUCY'S NOVEMBER LETTERS: LBA to VGA, Yale, 5 Nov. 1832.

372 "JOHN IS A GOOD": LBA to VGA, Audubon Museum, Henderson, KY, 5 Nov. 1832.

373 "TO DESTROY HIM": Quoted in *OB* II, pp. 162–63.

373 "THE FINEST": JJA to VGA, 24 Feb. 1833, in Corning (1930), p. 200.

373 GREENWOOD'S COLUMBIAN MUSEUM: Barnhill (1993).

373 GOLDEN EAGLE STORY: *OB* II, pp. 464ff.

373 "A PRETTY GOOD": JJA to VGA, 24 Feb. 1833, in Corning (1930), p. 200.

373 "HAD I BEEN": *OB* I, p. 381. I have slightly rearranged this text.

374 "I PLACED THE CAGE": *OB* II, p. 464.

374 "AND ON THE THIRD": *OB* II, p. 465.

374 "I HAD A GREAT": JJA to Richard Harlan, Filson Historical Society, 20 March 1833, at Library of Congress American Memory website.

374 "I WAITED": *OB* II, p. 465.

375 "WE WERE NEARLY": *OB* II, p. 465.

375 "A FINE TALE": JJA to Richard Harlan, Filson, 20 March 1833.

375 "HARSH AND SHARP": *OB* II, p. 467.

375 HARE BOUGHT IN BOSTON MARKET: JJA notes that they were sold there. He also says he "procured a remarkably large hare" in Newfoundland, but that animal, unlike the one in the drawing, had black-tipped ears. *OB* II, pp. 469–70.

375 SIXTY HOURS, FOUR DAYS: "Sixty hours" is JJA's contemporary estimate; in the *OB* he says "fourteen days," but that chronology is improbable. I estimate four days by subtracting three for his period of observation and one for his experiments; that leaves March 1–4 or 5.

375 LEFT HIM EXHAUSTED: JJA to VGA in Herrick (1938) II, pp. 35–36. Herrick dates this letter to 5 Feb. 1833, but since Audubon only bought the eagle on 24 Feb., the letter is almost certainly of 5 March, a date that also accounts for its reference to "Sunday last."

376 "THIS BACK-STROKE": "Compensation," in *Essays* (1841).

376 "AUDUBON'S COMPOSITION": Blaugrund and Stebbins (1993), p. 20.

378 "NATURE IS A TROPICAL": "The Sovereignty of Ethics," *North American Review*, May 1878.

378 "THE WAY OF PROVIDENCE": "Fate," in *The Conduct of Life* (1860).

378 "REMORSELESS SPOILER": *OB* III, pp. 305–6.

379 "IF I WERE": Quoted in Arthur (2000), pp. 303ff.

379 MARCH 15 TO LABRADOR: JJA to JB, 19 Feb. 1833, in Corning (1930) I, p. 197.

379 MARCH 16 STROKE: JJA to Richard Harlan, Filson, 20 March 1833.

379 "THE HAND WHICH NOW": JJA to Richard Harlan, Filson, 20 March 1833.

379 "WE HAVE BEEN EXTREMELY": JJA to VGA, 28 April 1833, in Herrick (1938) II, pp. 37ff.

380 "THE HOLD OF THE": *OB* III, p. 584.

380 "A STRANGE FIGURE": JJA to LBA, 22 May 1833, in Corning (1930) I, p. 226.

380 "DOWN ROPES": JJA to RH, Princeton, 26 May 1833.

381 "GREAT AMIABILITY": Deane (1910), p. 47.

381 "A NICE MAN": Quoted in Durant and Harwood (1980), p. 484.

381 "THAT WORST OF ALL": Audubon (1868), p. 297.

381 "TRULY BEAUTIFUL": JJA to VGA, 9 Sept. 1833, in Corning (1930) I, p. 241.

381 "WENT NEAR THE FINE": Deane (1910), p. 44.

382 "ONE MIGHT HAVE": *OB* III, p. 106.

382 "FOR SEVERAL DAYS": *OB* IV, p. 222.

383 "MY SON STANDS": *OB* IV, p. 223.

383 "HUNDREDS OF MEN": Audubon (1868), p. 342.

384 "THE WHOLE BOTTOM": *OB* II, p. 571.

384 "THE STENCH FILLED": Audubon (1868), p. 344.

384 "WE HEARD TODAY": Audubon (1868), pp. 315–16.

384 "WELL COVERED WITH NESTS": Deane (1910), p. 47.

385 "ADMIRED ITS EASY": *OB* III, pp. 366–67.

385 "THE DOLLARS ALONE": *OB* III, p. 84.

385 THE *GULNARE*: For a well-researched and credible fictional version of the encounters between the two parties, see Govier (2002).

385 "ENCAMPED IN TENTS": Audubon (1868), pp. 336–37.

386 "IT LOOKS LIKE": Audubon (1868), pp. 347–48.

386 "WE WERE NOW": Audubon (1868), p. 366.

387 "BUT I AM GLAD": JJA to VGA, 7 Sept. 1833, in Corning (1930) I, p. 243.

387 "TO PUBLISH THE 2ND": JJA to VGA, 9 Sept. 1833, in Corning (1930) I, p. 246.

387 "I WAS ON": Audubon (1868), p. 378.

387 "A LOCOMOTIVE": Audubon (1868), pp. 379–80.

387 "AS GOOD AS ANY": JJA to VGA, 21 Dec. 1833, in Corning (1930) I, p. 274.

388 "CAN WE NOT": JJA to RH, 24 Nov. 1833, in Corning (1930) I, pp. 267–68. Audubon wrote that the second volume was "all water birds," which he thought should be easier to engrave. He had been painting waterbirds, which may account for his slip: the volume that would be all waterbirds was the third.

388 "EXTREMELY ANXIOUS": JJA to John Bachman, Princeton, 13 March 1834.

388 "THE DIE IS CAST": JJA to VGA, 14 Jan. 1834, in Corning (1930) II, p. 3.

388 "AND FOUND OUR SON": Audubon (1868), p. 381.

Twenty-six A MONUMENTAL WORK OF ART

389 MACGILLIVRAY AGREED: William MacGillivray to JJA, 28 May 1834, in Herrick (1938) II, p. 126.

389 "CERTAINLY BE MUCH": Quoted in Herrick (1938) II, p. 128.

389 "I HAVE FINE HOPES": JJA to LB, BMNHN, 20 Aug. 1834.

389 £100 A WEEK: JJA to JB, 15 Sept. 1835, in Corning (1930) II, p. 87.

389 "BETWEEN YOU &": JJA to JB, 25 Aug. 1834, in LoA, pp. 821ff.

390 "UNTUTORED SIMPLICITY": LBA to EG, Stark Museum, 21 May 1834.

390 "I HAVE BEEN TRULY": JWA to Thomas Lincoln, Yale, 24 Aug. 1834.

391 "JOHN WILL BE": JJA to JB, 19 Nov. 1834, in Corning (1930) II, p. 51.

391 "A WORKING FAMILY": JJA to JB, 20 July 1835, in Corning (1930) II, p. 75.

391 "HAPPY AND CONTENTED": JJA to JB, 25 Aug. 1834, in LoA, pp. 821ff.

391 "IT SEEMS LIKE": LBA to EG, Stark Museum, 24 Dec. 1834.

391 "WE HAVE ALL": OB II, p. xxvii.

392 APRIL 1836: JJA to JB, 16 Jan. 1835, in Corning (1930) II, p. 60.

392 "MY INTENTION IS": JJA to JB, 20 April 1835, in Corning (1930) II, p. 71.

392 "NOT MORE THAN": JJA to Walter Horton Bentley, Princeton, 17 March 1835.

392 POLITICS: JJA to EH, 28 April 1835, in Herrick (1938) II, p. 141.

392 INSECTS, ETC.: JJA to LB, BMNHN, 24 April 1835.

392 "THE GULF OF": JB to JJA, Shuler Papers, 15 Jan. 1835.

392 NEW SILVER FORKS: LBA to Mrs. RH, Harvard, 22 June 1835.

392 DEBT JUDGMENT: JJA to JB, 5 May 1835, in Corning (1930) II, p. 71.

392 $650: JB to JJA, Shuler Papers, 24 Aug. 1835.

392 "ALL I HAVE": JJA to JB, 5 May 1835, in Corning (1930) II, p. 71.

392 JOHN'S PORTRAITS: JJA to JB, 20 Oct. 1835, in Corning (1930) II, p. 99.

392 "SO-SO": JJA to JB, 1 Dec. 1835, in Corning (1930) II, p. 102.

393 "OUR DEAR DAUGHTER": JJA to JB, 9 Mar. 1836, in Corning (1930) II, p. 117.

393 "IN A GREAT MEASURE": JB to JJA, Shuler Papers, 22 Jan. 1836.

393 FIRST NUMBER OF FOURTH VOLUME: JJA to JB, 7 March 1836, in Corning (1930) II, p. 116.

393 "FOR . . . OUR REUNION": Rose and Gabriel du Puigaudeau to JJA, Yale, 4 April 1836.

393 "ALREADY ON COPPER": JJA to JB, 12 June 1836, in Corning (1930) II, p. 122.

393 "AND SPLENDID": JJA to JB, 9 July 1836, in Corning (1930) II, p. 126.

393 "DO ALL [YOU CAN]": LBA to JJA, Yale, 15 Feb. 1837.

394 "OUR BIRDS ARE": JJA to LBA, 7 Sept. 1836, in Corning (1930) II, p. 127.

394 "TOWNSEND HAS DUPLICATES": In Corning (1930) II, p. 132.

394 "YOU WELL KNOW": JJA to EH, quoted in Herrick (1938) II, pp. 147–48.

395 "AS TO WATERTON": JJA to RH, Yale, 16 Nov. 1834.

395 "NUTTALL HAS ARRIVED": Quoted in Herrick (1938) II, p. 151.

395 "IT WAS AGREED": *OB* IV, p. xii.

395 "PURCHASED *NINETY-THREE*": JJA to JB, 23 Oct. 1836, in Corning (1930) II, pp. 135–36.

395 TWELVE, EIGHTEEN SUBSCRIPTIONS: Herrick (1938) II, p. 153.

396 "[COL. JOHN J. ABERT": Audubon (1868), pp. 395–99.

397 "31 IN 20 DAYS": JJA to RH, Princeton, 16 Dec. 1836.

397 "DO NOT FORGET": JJA to EH, Stark Museum, 17 Nov. 1836.

397 OSCEOLA HAD BEEN CAPTURED: JJA to LBA, 16 Feb. 1837 appended to 13 Feb. 1837, in Corning (1930) II, p. 139.

397 "[ON FEBRUARY 19]": JJA to JB, 24 Feb. 1837, in Corning (1930) II, pp. 145–46.

398 "MR. AUDUBON": Quoted in Durant and Harwood (1980), p. 492.

398 "OUTLINING CYPRESS": JJA to JB, 29 Mar. 1837, in Corning (1930) II, p. 155.

399 "FIRED A SALUTE": Quoted in Durant and Harwood (1980), p. 520.

399 HOUSTON VISIT: See Audubon (1868), pp. 410ff.

400 HEAVY HEAD SEA: *Campbell* logbook, quoted in Durant and Harwood (1980), p. 534.

400 "OLD TOOTHLESS MOUTH": JJA to JB, 10 Sept. 1836, in Corning (1930) II, p. 132.

400 "NEITHER OF WHOM": *OB* IV, p. xix.

400 A JOINT LETTER: LBA and VGA to JJA & JWA, Yale, 13 May 1837.

400 THREE HUNDRED SPECIMENS: Arthur (2000), p. 440.

400 "NOT A SINGLE": JJA to Thomas Brewer, Yale, 12 June 1837.

400 "HE IS NOW": Bachman (1888), p. 156.

400 24 JUNE WEDDING DAY: Not given in any available source; estimated from JJA's correspondence. If not this date, certainly during the third week in June.

401 "N. BERTHOUD HAS": JJA to JB, 2 July 1837, in Corning (1930) II, pp. 160ff.

401 "ONE OF THE HAPPIEST": JJA to JB, 16 July 1837, in Corning (1930) II, pp. 168ff.

402 *ENGLAND* VOYAGE: Ibid and JJA to LBA, 4 Aug. 1837, in Corning (1930) II, p. 174,

402 "NOT VERY WELL": JJA to JB, 14 Aug. 1837, in Corning (1930) II, p. 174.

402 "I AM FORCED": JJA to EH, Harvard, 6 Feb. 1838.

403 AUDUBON ANNOUNCING TO BACHMAN: JJA to JB, 14 April 1838, in Corning (1930) II, pp. 199ff.

403 LAST PLATE 16 JUNE 1838: JJA gave 20 June in *OB* IV, but cites this date in a contemporary letter, JJA to S. G. Morton, APS, 25 June 1838.

403 "IN THE BEGINNING": at §49.

403 "NOT CALCULATING": Quoted in Fries (1973), p. 114.

403 "THE CONTINUITY OF": *OB* IV, p. v.

404 "AN IMMENSE WEIGHT": JJA to S. G. Morton, APS, 25 June 1838.

404 "MAMMA'S SHORT LETTER": JJA to LBA and family, Mill Grove Audubon Wildlife Sanctuary, Audubon, PA, 5 July 1838.

Twenty-seven DAYS OF DEEPEST SORROW

405 KNOWSLEY AVIARY: See Fisher (2002), pp. 85ff.

405 "WE SHALL BE": VGA to LBA, Princeton, 10 July 1838.

405 BACHMAN SCHEDULE: See Shuler (1995), p. 157ff; Neuffer (1960), pp. 129–50.

405 "I HAVE 336": JJA to RH, Harvard, 20 Aug. 1838.

406 "WE ARE ALL": LBA to EG, Princeton, 29 Sept. 1838.

406 "BOUND WITH *IRON*": JJA to RH, Harvard, 4 March 1839.

406 £5,000: Havell (1938) II, p. 191.

406 "AS BUSY AS A BEE": Quoted in JJA to RH, 13 March 1839, in Corning (1930) II, p. 212.

407 "SHALL NOT TAKE": JJA to RH, Harvard, 4 March 1839.

407 "HOW OFTEN, GOOD": *OB* V, pp. v–vi.

407 "I SHOULD NOT": JJA to RH, 30 June 1839, in Corning (1930) II, p. 221.

408 "LAST NIGHT THE": LBA to VGA with JJA postscript, Princeton, 30 June 1839.

408 "JOHN IS A KIND": Maria Martin to Mary Davis, Charleston Museum, 23 July 1839.

408 "I HOPE JOHN": VGA to JJA, Yale, 31 March 1837.

408 "WE ARE ALL QUITE": VGA to Mary Davis, Charleston Museum, 29 July 1839.

409 SUBSCRIBERS: See Steiner (2002), pp. 257ff.

409 "IT IS STRANGE": LBA to EG, Princeton, 29 Sept. 1838.

409 "HAVING DETERMINED": JJA to S. G. Morton, APS, 9 Sept. 1839.

410 JOHN T. BOWEN: Tyler (1993), p. 52.

410 ASTOR SALE: JJA to VGA, 24 Nov. 1839, in Corning (1930) II, pp. 222ff.

411 "BY THIS TIME": EBA to her grandmother, Charleston Museum, 21 Jan. 1840.

412 "THE RAVAGES WHICH": JB to VGA, Shuler Papers, 8 May 1840.

412 "BETTER IN SOME POINTS": JB to VGA, Shuler Papers, 9 March 1840.

412 "POSITIVELY ABOVE": JJA to VGA, 5 March 1840, in Corning (1930) II, p. 242.

412 168 BALTIMORE SUBSCRIBERS: "List of Subscribers to March 21, 1840," Audubon Museum, Henderson, KY, file B92.

412 "NOT IMPROVED": MM to EBA, Shuler Papers, 24 April 1840.

412 "NOTHING FAVORABLE": JB and JJA to VGA, Shuler Papers, 10 May 1840.

412 "FROM 10 TO 20": JB to VGA, Shuler Papers, 8 May 1840.

412 "I HAVE HAD": JB and JJA to VGA, Shuler Papers, 10 May 1840.

413 "ONE WHOM I ESTEEMED": JB to VGA, Yale, 25 June 1840.

413 "NEVER IN MY WHOLE": JJA to JB, 2 July 1837, in Corning (1930) II, pp. 160ff.

413 "I TOLD HIM": JB to VGA, Yale, 25 June 1840.

413 "I AM GLAD": JB and JJA to VGA and family, Shuler Papers, 6 June 1840.

414 "THAT I HAVE NOT": JJA to VGA, 30 July 1840, in Corning (1930) II, pp. 275ff.

414 "WITH RELUCTANCE": JB to VGA, Yale, 25 June 1840.

414 "GLAD TO HEAR": JJA to VGA, 30 July 1840, in Corning (1930) II, pp. 275ff.

414 "SHE WAS SENSIBLE": VGA to JJA, Yale, 19 Sept. 1840.

414 "ATTENDED WITH EXPECTORATION": JJA and VGA to S. G. Morton, APS, 12 Oct. 1840.

415 "I WAS, AT YOUR": Quoted in Bachman (1888), p. 189.

415 "DO NOT THINK": Quoted in Bachman (1888), p. 193.

415 "ELIZA HAS NOT": Quoted in Bachman (1888), p. 195.

415 "I DREW THIS": Ford (1951), p. 49 (caption).

416 "I WILL NOW": JJA to Thomas McCulloch, Jr., Princeton, 26 June 1841.

416 "WE BOUGHT 14": JJA to CB, BMNHN, 26 Feb. 1842.

416 MINNIESLAND: See Grinnell (1927); "Report of Harriet Audubon's replies to questions," Yale, Box 12, f. 582; JJA to Benjamin Phillips, 7 Nov. 1842, in Herrick (1938) II, pp. 245ff; Maria Audubon to ?, 19 June 1925, Audubon Museum, Henderson, KY; Audubon and Coues (1897) I, pp. 71–72.

417 LETTERS OF INTRODUCTION: Herrick (1938) II, pp. 242–43.

417 "ESTABLISH A NATURAL": JJA to Daniel Webster, Harvard, 8 Sept. 1841.

418 "HUMBUG": Quoted in Ford (1964), p. 383.

418 "GREAT WESTERN JOURNEY": JJA to Spencer Baird, 30 July 1842, in Herrick (1938) II, pp. 240–41.

418 "I HAVE JUST RETURNED": WGB to VGA, Yale, 30 Jan. 1843.

Twenty-eight THE REAL COURSE OF NATURE'S INTENTIONS

419 LOUISVILLE ARRIVAL: McDermott (1965), p. 23.

419 "YOUR FATHER AFTER": WGB to VGA, Yale, 24 March 1843.

419 WILL BAKEWELL BANKRUPTCY: McDermott (1965), p. 23, n. 3.

419 "THE VERY FILTHIEST": Audubon and Coues (1898) I, pp. 450–51.

421 "TO MY UTTER": McDermott (1965), p. 43.

421 "A LARGE STORE": McDermott (1965), p. 37.

421 "HE IS PLEASED": McDermott (1965), p. 42.

422 "A SOLID MASS": McDermott (1965), p. 36.

422 PASS: Yale, Box 10, f. 552.

422 "A GEM": McDermott (1965), p. 64.

422 "QUITE WARM": McDermott (1965), p. 60.

422 "ABUNDANCE OF": McDermott (1965), p. 65.

422 "WE HAVE UPWARD": McDermott (1965), pp. 72–73.

422 "THAT OUR BERTHS": Audubon and Coues (1898) I, p. 457.

422 "ON OUR INDIA": McDermott (1965), p. 77.

422 "ONE OF THE WOMEN": McDermott (1965), p. 73.

423 "AND LAUGHED CURIOUSLY": McDermott (1965), p. 77.

423 "ALONG WITH PERHAPS": Audubon and Coues (1898) I, p. 460.

424 "ASTONISHED": McDermott (1965), p. 75.

424 "ALL AROUND": McDermott (1965), pp. 79–80.

424 "RAIN, LIGHTNING": Audubon and Coues (1898) I, p. 470.

424 "A TRULY MAGNIFICENT": McDermott (1965), p. 82.

424 "FINE, LARGE": McDermott (1965), p. 84.

424 "ABUNDANT BEYOND": McDermott (1965), p. 83.

424 "THE BOUNDS OF": McDermott (1965), p. 84.

424 "EXTENSIVE PRAIRIE": McDermott (1965), pp. 86–87.

425 "AND WE SAW": McDermott (1965), p. 89.

425 "THE MANDANS": Krech (1999), p. 82.

425 "A NUMBER OF": McDermott (1965), p. 92.

425 "THE BUFFALO ARE": McDermott (1965), p. 95.

425 "AND I HAVE NOT": McDermott (1965), pp. 94ff.

426 "SAW HEAPS": Audubon and Coues (1898) II, pp. 14–15.

426 "I AM GOING TO": McDermott (1965), p. 117.

426 "TO PROCURE ANTELOPES": McDermott (1965), pp. 118–20.

427 "HATCHED MANY CHICKENS": LBA to JJA, Yale, 2 July 1843.

427 JOURNAL ENTRY JULY 16: Audubon and Coues (1898) II, pp. 92–93.

428 "THE ATMOSPHERE WAS": Audubon and Coues (1898) II, p. 128.

428 "[A HUNTER]": Audubon and Coues (1898) II, p. 139.

428 "IN A HEAVILY": Audubon and Coues (1898) II, p. 146.

428 "HER NAME WILL": Audubon and Coues (1898) II, pp. 139–40.

429 "UNLOADED AND": Audubon and Coues (1898) II, p. 175.

429 "IT WAS A BRIGHT": Quoted in Audubon and Coues (1898) II, pp. 175–76n.

430 "HE PAINTED LITTLE": Quoted in Audubon and Coues (1898) II, p. 74.

430 QUADRUPED PROOFS, ETC.: Steiner (2002), pp. 132–33; Tyler (1993), p. 107.

431 GRISWOLD TEXT: Audubon (1868), pp. 437ff.

432 "MR. AUDUBON WAS": Quoted in Audubon and Coues (1898) I, pp. 73–74.

432 "THE FIRST DAY": Audubon (1868), p. 436.

432 "HIS EYE LOST": Ibid., p. 442.

432 "THE OLD GENTLEMAN": JB to MM, Charleston Museum, 11 May 1848.

433 ALZHEIMER'S PROBABLE: Neuropsychologist Dr. Johannes Rothlind, San Francisco Veterans Administration Hospital, personal communication, April 2003.

433 "MY POOR OLD FATHER": VGA to MM, Shuler Papers, 28 Jan. 1849.

434 CALIFORNIA GOLD RUSH ADVENTURE: See Hodder (1969).

434 "HIS JOURNEY IS": VGA to MM, Shuler Papers, 28 Jan. 1849.

434 "YES, YES": Quoted in Ford (1964), p. 422.

434 AUDUBON'S DEATH: Audubon (1868), p. 442; Audubon and Coues (1898) I, p. 77.

434 "YOU WILL FIND": Quoted in Bachman (1888), p. 291.

ENVOY

436 THIRTEEN LIVING CHILDREN: See Herrick (1938) II, p. 294, n. 3.

436 "AT THE TIME"; AUGUST 17: Hodder (1969), p. 36. Herrick (1938) II, p. 295, gives August 18.

436 "WORN OUT IN": Hodder (1969), p. 38.

BIBLIOGRAPHY

Adams, Alexander B. 1966. *John James Audubon: A Biography.* New York: G. P. Putnam's Sons.

Adams, Henry. 1880. *The Life of Albert Gallatin.* Philadelphia: J. B. Lippincott.

———. 1955 (1889). *The United States in 1800.* Ithaca, NY: Cornell University Press.

Allen, Elsa Guerdrum. 1951. *The History of American Ornithology Before Audubon.* New York: Russell & Russell.

Allen, Gay Wilson, and Roger Asselineau. 1987. *St. John de Crèvecoeur: The Life of an American Farmer.* New York: Viking.

Allister, Mark. 2001. *Refiguring the Map of Sorrow: Nature Writing and Autobiography.* Charlottesville, VA: University Press of Virginia.

Appleby, Joyce. 2000. *Inheriting the Revolution: The First Generation of Americans.* Cambridge, MA: Harvard University Press.

Aron, Stephen. 1996. *How the West Was Lost: The Transformation of Kentucky from Daniel Boone to Henry Clay.* Baltimore: Johns Hopkins University Press.

Arthur, Stanley Clisby. 2000. *Audubon: An Intimate Life of the American Woodsman.* Reprint ed., Gretna, LA.: Fireside Press.

Ashe, Thomas. 1809. "Travels in America Performed in the Year 1806." In *A Collection of Modern and Contemporary Voyages and Travels.* London: Richard Phillips.

Audubon, John James. 1826–27. "Account of the Habits of the Turkey Buzzard (*Vultur aura*)." *Edinburgh New Philosophical Journal* 2: 172–84.

———. 1826–27. "Observations on the Natural History of the Alligator." *Edinburgh New Philosophical Journal* 2: 270–80.

———. 1827. "Notes on the Rattlesnake (*Crotalus horridus*)." *Edinburgh New Philosophical Journal* 3: 21–30.

———. 1827–38. *The Birds of America.* London: Published by the Author.

———. 1831–39. *Ornithological Biography, or An Account of the Habits of the Birds of the United States of America; Accompanied by Descriptions of the Objects Represented in the Work Entitled* The Birds of America, *and Interspersed with Delineations of American Scenery and Manners.* Abbeville Press/National Audubon Society facsimile ed. 5 vols. Edinburgh: Adam Black.

———. 1926. *Delineations of American Scenery and Character.* New York: G. A. Baker.

———. 1965. *Audubon in the West.* Compiled, Edited and With an Introduction by John Francis McDermott. Norman: University of Oklahoma Press.

———. 1966. *The Original Water-Color Paintings by John James Audubon for* The Birds of America. New York: American Heritage.

———. 1999. *Writings and Drawings.* New York: Library of America.

Audubon, John James (John Francis McDermott, ed.). 1942 (1828). Audubon's "Journey Up the Mississippi." *Journal of the Illinois State Historical Society* XXXV (1):148–73.

Audubon, Lucy Bakewell. 1869. *The Life of John James Audubon, the Naturalist.* New York: G. P. Putnam.

Audubon, Maria R., and Elliott Coues. 1897. *Audubon and His Journals.* 2 vols. New York: Charles Scribner's Sons.

Bachman, Catherine. 1888. *John Bachman.* Charleston, SC: Walker, Evans & Cogswell.

Bagnall, Norma Hayes. 1996. *On Shaky Ground: The New Madrid Earthquakes of 1811–1812.* Columbia: University of Missouri Press.

Barnhill, Georgia Brady. 1993. "Extracts from the Journals of Ethan Allen Greenwood: Portrait Painter and Museum Proprietor." *Proceedings of the American Antiquarian Society,* April, 91–178.

Bartram, William. 1996. *Travels and Other Writings.* New York: Library of America.

Bates, Marston. 1950. *The Nature of Natural History.* Princeton, NJ: Princeton University Press.

Berthoff, Rowland. 1971. *An Unsettled People: Social Order and Disorder in American History.* New York: Harper & Row.

Berthré de Bourniseaux, P. Y. J. 1802. *An Historical Sketch of the Civil War in the Vendée.* Paris: The English Press.

Bland, D. S. 1977. *John James Audubon in Liverpool: 1826–1827.* Liverpool: University of Liverpool.

Blaugrund, Annette, and Theodore E. Stebbins, Jr., eds. 1993. *John James Audubon: The Watercolors for* The Birds of America. New York: Villard.

Boehme, Sarah E., ed. 2000. *John James Audubon in the West: The Last Expedition; Mammals of North America.* New York: Harry N. Abrams.

Charles-Lucien Bonaparte Papers. Paris: Bibliothèque Centrale, Musée National d'Histoire Naturelle.

Brackenridge, Henry Marie. 1814. *Views of Louisiana.* Pittsburgh: Cramer, Spear and Eichbaum (Readex Microprint, 1966).

Brainard, Michael S., and Allison J. Doupe. 2002. "What Songbirds Teach Us About Learning." *Nature* 417:351–58.

Brewster, David. 1826–27. "Mr. Audubon's Ornithology of the United States of America." *Edinburgh Journal of Science* 6:184.

Bruchey, Stuart, ed. 1967. *Cotton and the Growth of the American Economy: 1790–1860: Sources and Readings.* New York: Harcourt, Brace & World.

Burroughs, John. 1902. *John James Audubon.* Boston: Small, Maynard.

Butler, Anne. 1983. *A Tourist's Guide to West Feliciana Parish.* St. Francisville, LA.: Xlibris.

Butler, Mann. 1971 (1853). *Valley of the Ohio.* Frankfort: Kentucky Historical Society.

Calloway, Colin G. 1997. *New Worlds for All: Indians, Europeans and the Remaking of Early America.* Baltimore: Johns Hopkins University Press.

Cantwell, Robert. 1961. *Alexander Wilson: Naturalist and Pioneer.* Philadelphia: J. B. Lippincott.

Carlyle, Thomas. 1956 (1837). *The French Revolution: A History.* New York: Heritage Press.

Casas, Bartolomé de Las. 1991 (1552). *A Short Account of the Destruction of the Indies.* Translated by N. Griffin. London: Penguin.

Chalmers, John. 2003. *Audubon in Edinburgh.* Edinburgh: NMS Publishing.

Chapelle, Howard I. 1935. *The History of American Sailing Ships.* New York: Bonanza Books.

Chapman, S. D. 1972. *The Cotton Industry in the Industrial Revolution.* London: Macmillan.

Chateaubriand, François-René de. 1952 (1801). *Atala/René.* Translated by I. Putter. Berkeley: University of California Press.

Choate, Ernest A. 1985. *The Dictionary of American Bird Names.* Revised ed. Boston: Harvard Common Press.

Clark, Thomas D. 1964. *The Rampaging Frontier: Manners and Humors of Pioneer Days in the South and Middle West.* Bloomington: Indiana University Press.

Clark, Thomas D., ed. 1993. *The Voice of the Frontier: John Bradford's Notes on Kentucky.* Lexington: University Press of Kentucky.

Coleman, J. Winston. 1935. *Stage-Coach Days in the Bluegrass: Being an Account of Stage-Coach Travel and Tavern Days in Lexington and Central Kentucky 1800–1900.* Louisville: University Press of Kentucky.

Cooper, James Fenimore. 1985. *The Leatherstocking Tales.* New York: Library of America.

Corning, Howard, ed. 1929. *Journal of John James Audubon Made While Obtaining Subscriptions to His "Birds of America" 1840–1843.* Cambridge, MA: The Business Historical Society.

———, ed. 1969 (1930). *Letters of John James Audubon, 1826–1840.* Kraus Reprint, New York Edition. Boston: Club of Odd Volumes.

Crane, Elaine Forman, ed. 1994. *The Diary of Elizabeth Drinker: The Life Cycle of an Eighteenth-Century Woman.* Edited and abridged. Boston: Northeastern University Press.

Cronin, Vincent. 1971. *Napoleon Bonaparte: An Intimate Biography.* New York: William Morrow.

Cronon, William. 1983. *Changes in the Land: Indians, Colonists and the Ecology of New England.* New York: Hill & Wang.

Crosby, Jr., Alfred W. 1972. *The Columbian Exchange: Biological and Cultural Consequences of 1492.* Westport, CT: Greenwood Press.

———. 1986. *Ecological Imperialism: The Biological Expansion of Europe, 900–1900.* Cambridge: Cambridge University Press.

Dallett, Francis James. 1960. "Citizen Audubon: A Documentary Discovery." *Princeton University Library Chronicle* XXI (1 & 2):89–93.

Dangerfield, George. 1952. *The Era of Good Feelings.* New York: Harcourt, Brace.

Daniels, George H. 1968. *American Science in the Age of Jackson.* Tuscaloosa: University of Alabama Press.

Darwin, Erasmus. 1789. *The Botanic Garden, Part II, Containing The Loves of the Plants. A Poem with Philosophical Notes.* UMI Books on Demand, 2002 ed. Vol. 2. London: J. Nichols.

de Caro, Frank, and Rosan Augusta Jordan, ed. 1998. *Louisiana Sojourns: Travelers' Tales and Literary Journeys.* Baton Rouge: Louisiana State University Press.

de Tocqueville, Alexis. 2000. *Democracy in America.* Translated, edited and with an introduction by Harvey C. Mansfield and Debra Winthrop. Chicago: University of Chicago Press.

Deane, Ruthven. 1910. "Audubon's Labrador Trip of 1833." *Auk* 27: 42–52.

Delatte, Carolyn E. 1982. *Lucy Audubon: A Biography.* Baton Rouge: Louisiana State University Press.

Dillin, John G. W. 1946. *The Kentucky Rifle.* 3rd ed. New York: Ludlum and Beebe.

Dormon, James H., ed. 1990. *Audubon: A Retrospective.* Lafayette: University of Southwestern Louisiana.

Drake, Daniel. 1948 (1870). *Pioneer Life in Kentucky 1785–1800*. New York: Henry Schuman.

Drimmer, Frederick, ed. 1961. *Captured by the Indians: 15 Firsthand Accounts, 1750–1870*. New York: Dover.

Dunlap, William. 1969 (1834). *A History of the Rise and Progress of the Arts of Design in the United States*. 2 vols. Vol. 2. New York: Dover.

Durant, Mary, and Michael Harwood. 1980. *On the Road with John James Audubon*. New York: Dodd, Mead.

Dwight, Edward H. 1965. *Audubon: Watercolors and Drawings*. Utica, NY: Munson-Williams-Proctor Institute and Pierpont Morgan Library.

Dyson, Anthony. 1984. *Pictures to Print: The Nineteenth-Century Engraving Trade*. London: Farrand Press.

Elliot, Lang, and Marie Read. 1998. *Common Birds and Their Songs*. New York: Houghton Mifflin.

Elphick, Chris, John B. Dunning, Jr., and David Allen Sibley, ed. 2001. *The Sibley Guide to Bird Life & Behavior*. New York: Alfred A. Knopf.

Evans, Howard Ensign. 1993. *Pioneer Naturalists: The Discovery and Naming of North American Plants and Animals*. New York: Henry Holt.

———. 1997. *The Natural History of the Long Expedition to the Rocky Mountains, 1819–1820*. New York: Oxford University Press.

Faragher, John Mack. 1992. *Daniel Boone: The Life and Legend of an American Pioneer*. New York: Henry Holt.

Farber, Paul Lawrence. 1997. *Discovering Birds: The Emergence of Ornithology as a Scientific Discipline, 1760–1850*. Baltimore: Johns Hopkins University Press.

Fisher, Clemency, ed. 2002. *A Passion for Natural History: The Life and Legacy of the 13th Earl of Derby*. Liverpool: National Museums and Galleries on Merseyside.

Flannery, Tim. 2001. *The Eternal Frontier: An Ecological History of North America and Its Peoples*. New York: Atlantic Monthly Press.

Flint, Timothy. 1932 (1826). *Recollections of the Last Ten Years*. New York: Alfred A. Knopf.

Ford, Alice. 1964. *John James Audubon*. Norman: University of Oklahoma Press.

Ford, Alice, ed. 1951. *Audubon's Animals: The Quadrupeds of North America*. New York: Studio Publications.

———, ed. 1952. *Audubon's Butterflies, Moths, and Other Studies*. New York: Studio Publications.

———, ed. 1957. *The Bird Biographies of John James Audubon*. New York: Macmillan.

———, ed. 1967. *The 1826 Journal of John James Audubon*. Norman: University of Oklahoma Press.

———, ed. 1969. *Audubon, by Himself*. Garden City, NY: Natural History Press.

Foshay, Ella M. 1997. *John James Audubon*. New York: Harry N. Abrams.

Frank, Jr., Charles W. 1982. *Anatomy of a Waterfowl for Carvers and Painters*. Gretna, LA: Pelican Publishing.

Friend, Craig Thompson, ed. 1999. *The Buzzel About Kentuck*. Lexington: University Press of Kentucky.

Fries, Waldemar. 1960. "John James Audubon: Some Remarks on His Writings." *Princeton University Library Chronicle* XXI (1 & 2):1–7.

———. 1973. *The Double Elephant Folio: The Story of Audubon's Birds of America*. Chicago: American Library Association.

Garvey, Joan B., and Mary Lou Widmer. 1982. *Beautiful Crescent: A History of New Orleans*. New Orleans: Garmer Press.

Gibbs, F. W. 1965. *Joseph Priestley: Adventurer in Science and Champion of Truth*. London: Nelson.

Gill, Frank B. 1995. *Ornithology*. 2nd ed. New York: W. H. Freeman.

Goddu, Joseph. 2002. *Artist's Proofs for* The Birds of America. New York: Hirschl & Adler Galleries.

Gopnik, Adam. 1991. "A Critic at Large: Audubon's Passion." *The New Yorker*, February 25, p. 96.

Gotch, A. F. 1995. *Latin Names Explained: A Guide to the Scientific Classification of Reptiles, Birds & Mammals*. New York: Facts on File.

Govier, Katherine. 2003. *Creation: A Novel*. New York: Overlook Press.

Grinnell, George Bird. 1927. *Audubon Park: The History of the Site of the Hispanic Society of America and Neighboring Institutions*. Hispanic Notes and Monographs. New York: Hispanic Society of America.

Hakluyt, Richard. 1972 (1582). *Voyages and Discoveries: The Principal Navigations, Voyages, Traffiques and Discoveries of the English Nation*. Edited, Abridged and Introduced by Jack Beeching. London: Penguin.

Hall, Brian. 2003. *I Should Be Extremely Happy in Your Company: A Novel of Lewis and Clark*. New York: Viking.

Hall, Courtney Robert. 1934. *A Scientist in the Early Republic: Samuel Latham Mitchill, 1764–1831*. New York: Columbia University Press.

Harrison, Robert Pogue. 1992. *Forests: The Shadow of Civilization*. Chicago: University of Chicago Press.

Herrick, Francis Hobart. 1938. *Audubon the Naturalist: A History of His Life and Time*. 2nd Ed. 2 vols. New York: D. Appleton-Century.

Hodder, Frank Heywood, ed. 1969 (1906). *Audubon's Western Journal: 1849–1850*. Glorieta, NM: Rio Grande Press.

Hughes, Robert. 1997. *American Visions: The Epic History of Art in America*. New York: Alfred A. Knopf.

Hunt, Gaillard. 1976 (1914). *Life in America One Hundred Years Ago*. Williamstown MA: Corner House Publishers.

Hunter, Louis C. 1949. *Steamboats on the Western Rivers: An Economic and Technological History*. New York: Dover.

Huth, Hans. 1957. *Nature and the American: Three Centuries of Changing Attitudes*. Lincoln: University of Nebraska Press.

Hyde, Ralph. 1984. "Robert Havell Junior, Artist and Aquatinter." In *Maps and Prints: Aspects of the English Book Trade*, edited by R. Myers and Michael Harris. Oxford: Oxford Polytechnic Press.

Irving, Washington. 1967 (1836). *Astoria*. Portland, OR: Binfords & Mort.

———. 1983. *History, Tales and Sketches*. New York: Library of America.

Isaacson, Walter. 2003. *Benjamin Franklin: An American Life*. New York: Simon & Schuster.

Jackson, Christine E. 1985. *Bird Etchings: The Illustrators and Their Books, 1655–1855*. Ithaca, NY: Cornell University Press.

Jaffe, Bernard. 1958. *Men of Science in America*. Revised edition. New York: Simon & Schuster.

James, C.L.R. 1963 (1938). *The Black Jacobins: Toussaint L'Ouverture and the San Domingo Revolution*. 2nd ed. New York: Vintage.

Jameson, Robert. 1826–27. "Mr. Audubon's Great Work on the Birds of the United States of America." *Edinburgh New Philosophical Journal* 2: 210–11.

Jardine, William. 1877. "Life of Alexander Wilson." In Alexander Wilson and Charles-Lucien Bonaparte, *American Ornithology*. New York: J. W. Bouton.

Jennings, Humphrey, ed. 1985. *Pandemonium 1660–1886: The Coming of the Machine as Seen by Contemporary Observers.* New York: Free Press.

Jordan, Terry G., and Matti Kaups. 1989. *The American Backwoods Frontier: An Ethnic and Ecological Interpretation.* Baltimore: Johns Hopkins University Press.

Kaufman, Kenn. 1996. *Lives of North American Birds.* Boston: Houghton Mifflin.

Keating, L. Clark. 1976. *Audubon: The Kentucky Years.* Lexington: University Press of Kentucky.

Kemp, Martin. 2002. "Naturally Natural: Albrecht Dürer's Studies of Animals Have a Life of Their Own." *Nature* 420: p. 744.

King-Hele, Desmond. 1999. *Erasmus Darwin: A Life of Unequalled Achievement.* London: DLM.

Kogan, Herman. 1958. The Great EB: The Story of the Encyclopædia Britannica. Chicago: University of Chicago Press.

Krech III, Shepard. 1999. *The Ecological Indian: Myth and History.* New York: W. W. Norton.

Kukla, Jon. 2003. *A Wilderness So Immense: The Louisiana Purchase and the Destiny of America.* New York: Alfred A. Knopf.

Leaf, Ruth. 1976. *Etching, Engraving and Other Intaglio Printmaking Techniques.* New York: Dover.

Lewis, Douglas. 1990/1991. "John James Audubon (1785–1851): Annotated Chronology of Activity in the Deep South, 1819–1837." *Southern Quarterly* 29 (4):63–82.

Lewis, R.W.B. 1955. *The American Adam: Innocence, Tragedy and Tradition in the Nineteenth Century.* Chicago: University of Chicago Press.

Lindsey, Alton A., ed. 1985. *The Bicentennial of John James Audubon.* Bloomington: Indiana University Press.

Lord, Walter. 1972. *The Dawn's Early Light.* Baltimore: Johns Hopkins University Press.

Low, Susanne M. 2002. *A Guide to Audubon's Birds of America.* New Haven: William Reese Company & Donald A. Heald.

Malone, Lee. 1989. *The Majesty of the Felicianas.* Gretna, LA: Pelican.

Mann, Charles C. 2002. "1491." *The Atlantic Monthly,* March, 41–53.

Masur, Louis P. 2001. *1831: Year of Eclipse.* New York: Hill and Wang.

Mathews, John Joseph. 1961. *The Osages: Children of the Middle Waters.* Norman: University of Oklahoma Press.

Matthiessen, Peter. 1987. *Wildlife in America.* New York: Viking.

McCullough, David. 2001. *John Adams.* New York: Simon & Schuster.

McDermott, John Francis, ed. 1951. *Up the Missouri with Audubon: The Journal of Edward Harris.* Norman: University of Oklahoma Press.

———, ed. 1965. *Audubon in the West.* Norman: University of Oklahoma Press.

McGaw, Judith A., ed. 1994. *Early American Technology: Making & Doing Things from the Colonial Era to 1850.* Chapel Hill: University of North Carolina Press.

Meinig, D. W. 1986. *The Shaping of America: A Geographical Perspective on 500 Years of History,* Vol. I: *Atlantic America, 1492–1800.* New Haven: Yale University Press.

Merrill, Boynton, Jr. 1976. *Jefferson's Nephews: A Frontier Tragedy.* Princeton, NJ: Princeton University Press.

Mitchill, Samuel Latham. 1814. "A Detailed Narrative of the Earthquakes Which Occurred on the 16th Day of December 1811." *Transactions of the Literary and Philosophical Society of NY* I:281–307. (http://pasadena.wr.usgs.gov/office/hough/mitchill.html).

Morgan, William N. 1999. *Pre-Columbian Architecture in Eastern North America.* Gainesville: University Press of Florida.

Morton, Thomas (Jack Dempsey, ed.). 2000 (1637). *New English Canaan.* Scituate, MA: Digital Scanning.

Mumford, Lewis. 1966. "Larger Than Life" (review of *The Original Water-color Paintings by John James Audubon for "The Birds of America"* and Alexander B. Adams, *John James Audubon: A Biography*). *The New York Review of Books,* 1 December.

Murphy, Robert Cushman. 1956. "John James Audubon (1785–1851): An Evaluation of the Man and His Work." *New-York Historical Society Quarterly.* National Audubon Society reprint.

Muschamp, Edward A. 1929. *Audacious Audubon: The Story of a Great Pioneer, Artist, Naturalist and Man.* New York: Brentano.

Nanteuil, Luc de. 1985. *David.* New York: Harry N. Abrams.

Nash, Roderick. 1982. *Wilderness and the American Mind.* 3rd ed. New Haven: Yale University Press.

Neuffer, Claude Henry, ed. 1960. *The Christopher Happoldt Journal.* Charleston, SC: The Charleston Museum.

Nevins, Allan, ed. 1923. *American Social History as Recorded by British Travelers.* New York: Henry Holt.

———, ed. 1951. *The Diary of John Quincy Adams, 1794–1845.* New York: Charles Scribner's Sons.

Nolte, Vincent. 1854. *Fifty Years in Both Hemispheres, or, Reminiscences of the Life of a Former Merchant.* New York: Redfield.

Olmsted, Frederick Law. (Arthur M. Schlesinger, ed.) 1996 (1861). *The Cotton Kingdom: A Traveler's Observations on Cotton and Slavery in the American Slave States, 1853–1861.* New York: Da Capo Press.

Ornithophilus. 1830–31. "Remarks on Audubon's 'Birds of America' and 'Ornithological Biography.'" *Edinburgh New Philosophical Journal* 10:317–32.

Pagden, Anthony. 1993. *European Encounters with the New World: From Renaissance to Romanticism.* New Haven: Yale University Press.

Parkes, Henry Bamford. 1959. *The American Experience: An Interpretation of the History and Civilization of the American People.* New York: Vintage.

Partridge, Linda Dugan. 1992. "From Nature: John James Audubon's Drawings and Watercolors, 1805–1826." Ph.D. dissertation, Art History, University of Delaware.

Peale, Titian Ramsay. (A. O. Weese, ed.) 1947 (1819). "The Journal of Titian Ramsay Peale, Pioneer Naturalist." *Missouri Historical Review.* Columbia: State Historical Society of Missouri.

Peattie, Donald Culross, ed. 1940. *Audubon's America: The Narratives and Experiences of John James Audubon.* Boston: Houghton Mifflin.

Penick, Jr., James Lal. 1981. *The New Madrid Earthquakes.* Revised ed. Columbia: University of Missouri Press.

Peterson, Roger Tory, and Virginia Marie Peterson. 1991. *Audubon's Birds of America (The Audubon Society Baby Elephant Folio).* New York: Abbeville Press.

Phillips, Ulrich Bonnell. 1963 (1929). *Life and Labor in the Old South.* Boston: Little, Brown.

Pielou, E. C. 1991. *After the Ice Age: The Return of Life to Glaciated North America.* Chicago: University of Chicago Press.

Powell, J. H. 1993 (1949). *Bring Out Your Dead: The Great Plague of Yellow Fever in Philadelphia in 1793.* Reprint ed. Philadelphia: University of Pennsylvania Press.

Price, Robert. 1954. *Johnny Appleseed: Man and Myth.* Bloomington: Indiana University Press.

Prideaux, S. T. 1909. *Aquatint Engraving: A Chapter in the History of Book Illustration.* London: Duckworth & Co.

Proby, Kathryn Hall. 1974. *Audubon in Florida, with Selections from the Writings.* Coral Gables, FL: University of Miami Press.

Proctor, Noble S., and Patrick J. Lynch. 1993. *Manual of Ornithology: Avian Structure and Function.* New Haven: Yale University Press.

Remini, Robert V. 1998. *Andrew Jackson.* 3 vols. Baltimore: Johns Hopkins University Press.

———. 1999. *The Battle of New Orleans.* New York: Penguin.

Rhodehamel, John, ed. 2001. *The American Revolution: Writings from the War of Independence.* New York: Library of America.

Rice, Howard C., Jr. 1960. "The World of John James Audubon: Catalogue of an Exhibition in the Princeton University Library, 15 May–30 September 1959." *Princeton University Library Chronicle* XXI (1 & 2):9.

Richardson, E. P. 1965. *Painting in America from 1502 to the Present.* New York: Thomas Y. Crowell.

Rigal, Laura. 1998. *The American Manufactory: Art, Labor and the World of Things in the Early Republic.* Princeton, NJ: Princeton University Press.

Ross, Michael. 1975. *Banners of the King: The War of the Vendée 1793–4.* London: Seeley Service.

Rothbard, Murray N. 2002 (1962). *The Panic of 1819: Reactions and Policies.* Online Edition. Auburn, AL: Ludwig von Mises Institute.

Rourke, Constance. 1936. *Audubon.* New York: Harcourt, Brace.

Sahr, Robert C. "Inflation Conversion Factors for Years 1665 to Estimated 2013." PDF file at http://oregonstate.edu/Dept/pol_sci/fac/sahr/sahr.htm

Sale, Kirkpatrick. 2001. *The Fire of His Genius: Robert Fulton and the American Dream.* New York: Free Press.

Sanders, Albert E., and Warren Ripley, eds. 1986. *Audubon: The Charleston Connection.* Charleston, SC: Charleston Museum.

Sauer, Carl O. (John Leighly, ed.). 1963. *Land and Life: A Selection from the Writings of Carl Ortwin Sauer.* Berkeley: University of California Press.

Schama, Simon. 1989. *Citizens: A Chronicle of the French Revolution.* New York: Alfred A. Knopf.

Schlesinger, Jr., Arthur M. 1945. *The Age of Jackson.* Boston: Little, Brown.

Schorger, A. W. 1955. *The Passenger Pigeon: Its Natural History and Extinction.* Norman: University of Oklahoma Press.

———. 1966. *The Wild Turkey: Its History and Domestication.* Norman: University of Oklahoma Press.

Sellers, Charles Coleman. 1980. *Mr. Peale's Museum: Charles Willson Peale and the First Popular Museum of Natural Science and Art.* New York: W. W. Norton.

Shapiro, Henry D., and Zane L. Miller, ed. 1970. *Physician to the West: Selected Writings of Daniel Drake on Science & Society.* Lexington: University Press of Kentucky.

Shelley, Donald A. 1946. "Audubon to Date." *New-York Historical Society Quarterly* XXX and Annual Report:168–73.

———. 1946. "Audubon's Technique as Shown in his Drawings of Birds." *Antiques,* June, pp. 354–57.

Jay Shuler Papers, The College of Charleston, Charleston, SC.

Shuler, Jay. 1995. *Had I the Wings: The Friendship of Bachman and Audubon.* Athens: University of Georgia Press.

Sibley, David Allen. 2000. *The Sibley Guide to Birds.* New York: Alfred A. Knopf.

Slaughter, Thomas P. 1996. *The Natures of John and William Bartram.* New York: Alfred A. Knopf.

Slotkin, Richard. 1973. *Regeneration Through Violence: The Mythology of the American Frontier, 1600–1860.* Norman: University of Oklahoma Press.

Smith, Edgar F. 1920. *Priestley in America.* Philadelphia: P. Blakiston's Son.

Sotheby's. 1990. *The Library of H. Bradley Martin.* New York: Sotheby's.

Steiner, Bill. 2003. *Audubon Art Prints: A Collector's Guide to Every Edition.* Columbia: University of South Carolina Press.

Stoate, Christopher. 1987. *Taxidermy: The Revival of a Natural Art.* London: The Sportsman's Press.

Streshinsky, Shirley. 1993. *Audubon: Life and Art in the American Wilderness.* Athens: University of Georgia Press.

Stroud, Patricia Tyson. 2000. *The Emperor of Nature: Charles-Lucien Bonaparte and His World.* Philadelphia: University of Pennsylvania Press.

Swainson, Geoffrey, and Sheila Natusch. 1987. *William Swainson of Fern Grove.* Wellington, N.Z.: Published by the authors with the aid of New Zealand Founders Society.

Swainson, William. 1828–29. "Some Account of the Work Now Publishing by Mr. Audubon." *Loudon's Magazine of Natural History* I:43–52.

Terres, John K. 1987. *The Audubon Society Encyclopedia of North American Birds.* New York: Alfred A. Knopf.

Tyler, Ron. 1993. *Audubon's Great National Work: The Royal Octavo Edition of* The Birds of America. Austin: University of Texas Press.

Van Doren, Carl. 1938. *Benjamin Franklin.* New York: Penguin.

Waples, Dorothy. 1938. *The Whig Myth of James Fenimore Cooper.* New Haven: Yale University Press.

Weissmann, Gerald. 1998. *Darwin's Audubon: Science and the Liberal Imagination.* Cambridge, MA: Perseus.

Welker, Robert Henry. 1955. *Birds & Men: American Birds in Science, Art, Literature, and Conservation, 1800–1900.* New York: Atheneum.

Williams, George Alfred. 1916. "Robert Havell, Junior, Engraver of Audubon's 'The Birds of America.' " *Print Collectors Quarterly* 6 (3):227–56.

Wilson, Alexander, and Charles-Lucien Bonaparte. 1878. *American Ornithology: Natural History of the Birds of the United States.* Proquest Books on Demand. 3 vols. Vols. 1 & 2. Philadelphia: Porter & Coates.

Young, Arthur. 1929 (1792). *Travels in France During the Years 1787, 1788 & 1789.* Cambridge: Cambridge University Press.

Young, James Sterling. 1966. *The Washington Community 1800–1828.* New York: Columbia University Press.

ACKNOWLEDGMENTS

NO MAN IS AN ISLAND, especially when he's researching and writing a book. Audubon had help along the way, and so did I.

Morton L. Janklow and Anne Sibbald pointed me to biography after living through two necessary but difficult books on violence and mass killing, and then represented my interests with their usual superb professionalism. Writing the life of a man who loved and triumphed was a refreshing experience, as they knew it would be. I hope it has been for them as well.

Jon Segal and Sonny Mehta saw the potential of a new Audubon biography and in the classic Knopf tradition supported it enthusiastically. They lived through the difficult books too, and welcomed my exploration of another genre as much as I did. The indefatigable Ida Giragossian kept us connected. Victoria Pearson skillfully shepherded the manuscript through production.

Rachael Glynn—Arjaie—my protégé and pal, mastered Audubon's difficult handwriting to transcribe hundreds of his letters for me, all of them available previously only in autograph, sparing future historians and biographers great labor. Harvey Goldblatt, Master of Yale's Pierson College, arranged for a crucial translation of a Jean Audubon letter; my thanks to him and to the students he recruited to the task. Xavier Mayali of the Scripps Institute in San Diego translated three du Puigaudeau letters; Marie-Julie Peters-Déseract of the Freeman School in San Francisco translated Audubon's early letter to Charles d'Orbigny on the fly, sitting with me at her husband's outdoor café in San Francisco.

In London, Gil and Anita Elliot welcomed me and found crucial information. The incomparable Clemency Fisher, Curator of Birds and Mammals at the Liverpool Museum, put my hands on birds Audubon had stuffed, showed me Greenbank and arranged with the Earl of Derby to give me a tour of Knowsley Hall. Clem also located the engraving of the Queen Bee, which here makes its first appearance in an Audubon biography. Audubon's Edinburgh belongs to John Chalmers, who shared it with me, after which Gwyneth Chalmers graciously fed us.

Michel Rival guided me to Nantes and Couëron, helped with translation and persuaded the Bibliothèque Centrale of the Musée Nationale d'Histoire Naturelle to make scans of its Charles-Lucien Bonaparte letters. Guy Lorcy made Couëron vivid for me and subsequently identified one of Audubon's teachers, François René André Dubuisson, previously unknown. Partly through Guy's efforts, La Gerbetière is being preserved as an Audubon museum. Peter McNiven, Keeper of Manuscripts at the University of Manchester's John Rylands University Library, supplied an important letter.

Audubon recorded his life in journals and letters now preserved in libraries. At the College of Charleston, the College Archivist, Gene Waddell, oriented me and arranged for copies from Special Collections. At the Beineke Rare Book and Manuscript Library of Yale University, Head of Public Services Ellen Cordes authorized and Public Services Assistant Anne Marie Menta organized my extensive microfilm request. Manuscripts Librarian Robert S. Cox and Assistant Manuscripts Librarian Valerie-Anne Lutz helped me at the American Philosophical Society Library in Philadelphia. At Houghton Library, Harvard University, where Leslie A. Morris is Curator of Manuscripts, Reference Assistant Thomas P. Ford coordinated my copying requests. Connie Rinaldo and Dana Fisher showed me Audubon artifacts at the Ernst Mayer Library. My old friend E. O. Wilson and his assistant Kathy Horton cleared the way, and Wil Haygood vacated his Cambridge apartment for a week for me. David C. Hunt, the director of the Stark Museum in Orange, Texas, made the invaluable Audubon-Bakewell correspondence collection available to me; Librarian Nell Horton and the museum staff saw to it that I was comfortable. All these libraries reviewed my selections from Audubon's work and endorsed their publication.

One of my first contacts was Lucy Audubon's biographer Carolyn DeLatte, professor of history at McNeese State University in Lake Charles, Louisiana, who gave me valuable direction. In St. Francisville, Rachel Hall generously took time from a busy morning to orient me; Anne Butler of Butler-Greenwood Plantation brought ancient scenes to life in her family home. West Feliciana Parish plantation owner Douglas Lewis, curator of sculpture and decorative arts at the National Gallery of Art and a Yale classmate, supported with facts my instinct to trust Audubon in the matter of Joseph Mason's age (not even Picasso could draw so well at thirteen). Doug's chronology of Audubon's Louisiana days was invaluable.

At Mill Grove, Administrator Linda S. Boice welcomed me; Assistant Administrator L. Alan Gehret found an hour during a busy day of maple-sugaring to advise and guide. Neuropsychologist Johannes Rothlind of the San Francisco Veterans Administration Hospital expertly reviewed Audubon's symptoms of senility.

Joseph Goddu of Hirschl & Adler showed me artists' proofs of *The Birds of America* and helped me understand the engraving and coloring process. Maggie Yax, Archives Manager at the Cincinnati Museum, searched out several Bakewell family letters. Louis Plummer and his colleagues at PhotoAssist knew exactly where to find the right illustrations. Gwyneth Cravens, friend and experienced editor, read the finished manuscript with a keen eye.

Field ecologist Bill Steiner was my reliable guide, knowledgeable and fearlessly demanding. He read every chapter as it came off the computer, sent me detailed critiques overnight, searched out obscure information, argued birds and seasons and made it a better book while I made a fine friend.

Don Boarman of the Audubon Museum in Henderson, Kentucky, set me on the right path from the very beginning and contributed valuable insights along the way. Having studied Audubon for years and lived among the artist's artifacts, Don is retiring, which is why I dedicated this book to him.

Ginger Rhodes, Ph.D., busy with a clinical psychology internship and a postdoctoral fellowship, still found time to be there for me, as she always is.

Madison–Half Moon Bay
July 2001–February 2004

INDEX

Page numbers in *italic* refer to illustrations.
The images that appear in the color inserts are followed by I (first insert) or II (second insert).

Bakewell, Ann (sister-in-law). *See* Gordon, Ann Bakewell

Bakewell, Benjamin (wife's uncle), 8, 10, 23, 24, 26, 32–3, 97, 113–14, 119, 126, 201, 234, 336; Audubon's clerkship with, 39, 40, 42; business failure of, 44, 62; glass factory of, 62–3, 65; loans made to Audubon & Rozier by, 42, 44, 69, 91; Wilson and, 63, 66, 67

Bakewell, Eliza (sister-in-law). *See* Berthoud, Eliza Bakewell

Bakewell, Elizabeth (née Elizabeth Rankin Page) (sister-in-law), 126–7, 131, 189

Bakewell, Lucy Green (mother-in-law), 10, 16–17, 28, 29–30

Bakewell, Lucy Green (wife). *See* Audubon, Lucy Bakewell

Bakewell, Rebecca Smith (wife's stepmother), 30, 93, 105, 113, 114, 120, 136, 194, 207

Bakewell, Sarah (sister-in-law), 10, 30, 93, 131, 136, 189, 369

Bakewell, Thomas (brother-in-law), 10, 18, 23, 29, 30, 39, 40, 44, 89, 108, *111*, 131, 143, 189, 192, 336, 419; Audubon's partnership with, 90, 126–7 (*see also* Audubon & Bakewell); father's estate and, 194–5; Henderson mill and, 110–11, 113, 119, 126, 127, 138; marriage of, 126; New Orleans début of Audubon & Bakewell and, 90, 100, 105–7; steamboat venture of, 137–40

Bakewell, Thomas (wife's cousin), 61, 62, 119–20, 126

Bakewell, William (father-in-law), 8–10, 11, 19, 21, 23, 24, 26, 44–5, 62, 89, 93, 94, 103, 105, 131; death and estate of, 189, 194–5; decline of, 113–14, 120, 136; Henderson mill and, 111, 113, 127; Lucy's courtship and wedding and, 13–16, 25; Mill Grove sale and, 61, 69; remarriage of, 30; wife's death and, 16–17, 29–30

Bakewell, William, Jr. (Will) (brother-in-law), 10, 17, 30, 36–7, 93, 114, 131, 158, 189, 313, 319, 332, 336, 338, 350, 363, 400, 418, 419, 437; apprenticed to Audubon & Bakewell, 121; birding with Audubon, 102–3; passenger pigeons and, 16, 130; westward migration of, 120, 121

Bakewell & Prentice, 137–40

Baldwin, William, 148

Baltimore, Md., 255, 412

banking system, 124, 125, 132, 401

Barraband, Jacques, 307–8

Barro (horse), 94, 98

Bartram, John, 148

Bartram, William, 64, 224, 235, 351

Basham, Mrs. Charles, 230

Basterot (painter), 206

Bayfield, Henry, 385

Bayou Sarah, 169, *170*, 196, 200, 204, 217, 218, 230, 231, 234, 235, 237, 238, 338, 364

bear hunting, of Shawnees, 79–80

Beech Grove, West Feliciana Parish, La., 285, 338

Beech Woods, West Feliciana Parish, La., 214, 215–17, 279, 285, 288; Audubon's sojourn at (1824), 231–8

Bell, John G., 419, 423, 427–8

Berthoud, Eliza Bakewell (sister-in-law), 10, 30, 93, 114, 142–4, 189, 369, 421; court-ship and marriage of, 119–20, 121, 125–6; westward migration of, 119–20

Berthoud, James, 54, 140, 141, 143, 144, 172

Berthoud, Marie-Anne-Julia, 54, 143–4, 189, 219

Berthoud, Nicholas (brother-in-law), 54, 72, 107, 159, 172, 173, 176, 189, 201, 208, 264, 332, 336, 337, 349, 369, 379, 408, 422, 429; Audubon's business failure and, 141–2, 143, 362–3, 392–3; Audubon's disappointment in, 193–4, 231, 318, 330; as Audubon's New York agent, 395, 401; courtship and wedding of, 121, 125–6; journey of, to New Orleans, 167, 168–9, 188; Pacific expedition and, 185, 190, 194; portrait of, 144, *144*; warehouse fire and, 392–3

Best, Robert, 147–8, 151, 192

Bewick, Thomas, 287, 319

J. Bien & Company, 436

Bigelow, Jacob, 372–3, 374

Birch, Thomas, *19*

bird banding, 37

"Bird of Washington," 299

ILLUSTRATION CREDITS

228 Courtesy of the Charles Rand Penney Collection.

233 Zigler Museum.

241 Houghton Library, Harvard University.

243 Houghton Library, Harvard University.

250 William Daniell, *Liverpool: The Port Taken from the Opposite of the River,* © Stapleton Collection/CORBIS.

253 Liverpool City Library.

258 Liverpool Athenaeum.

265 Edinburgh City Library.

271 Scottish National Portrait Gallery.

273 John James Audubon Museum, Henderson, KY.

275 John Syme, *John James Audubon,* 1826. The White House, Washington, D.C.

282 Mary Evans Picture Library.

298 London print shop, George Brookes wash drawing, 1832, *Journal of the Printing Historical Society.* Library of Congress.

307 Smithsonian Institution.

313 Mary Evans Picture Library.

325 *St. Louis from the River Below* by George Catlin. Smithsonian American Art Museum, Washington, D.C., U.S.A./Art Resource, NY.

335 Louisiana State Museum, New Orleans, LA.

341 © Stapleton Collection/CORBIS.

351 John Woodhouse Audubon, *The Reverend John Bachman,* c. 1837. Charleston Museum.

398 Gernsheim Collection, Harry Ransom Humanities Research Center, University of Texas at Austin.

401 Private collection.

406 William Rickarby Miller, *House of John James Audubon,* 1852. Museum of the City of New York.

411 Private collection.

417 John Woodhouse and Victor Gifford Audubon, *John James Audubon,* 1841, American Museum of Natural History, New York.

420 Isaac Sprague, *View of Fort Union on the Upper Missouri,* 1843. New-York Historical Society.

421 Isaac Sprague, *John James Audubon,* 1843, Massachusetts Audubon Society, Lincoln, MA.

429 John Woodhouse Audubon, *John James Audubon,* 1843, American Museum of Natural History, New York.

433 Engraving after George P. A. Healy, *John James Audubon,* 1838.

COLOR

Golden Eagle by John J. Audubon, watercolor, pastel, graphite and selective glazing. Collection of The New-York Historical Society/1863.17.181.

Bonaparte Crossing the Saint-Bernard by Jacques-Louis David. Musée National du Château de Malmaison, Rueil-Malmaison, France.

Head of a Buffalo Calf by John James Audubon, 1843. Private collection.

All images from John James Audubon, *The Birds of America,* courtesy of Historical Museum of Southern Florida.